To the memory of Merete Bodelsen

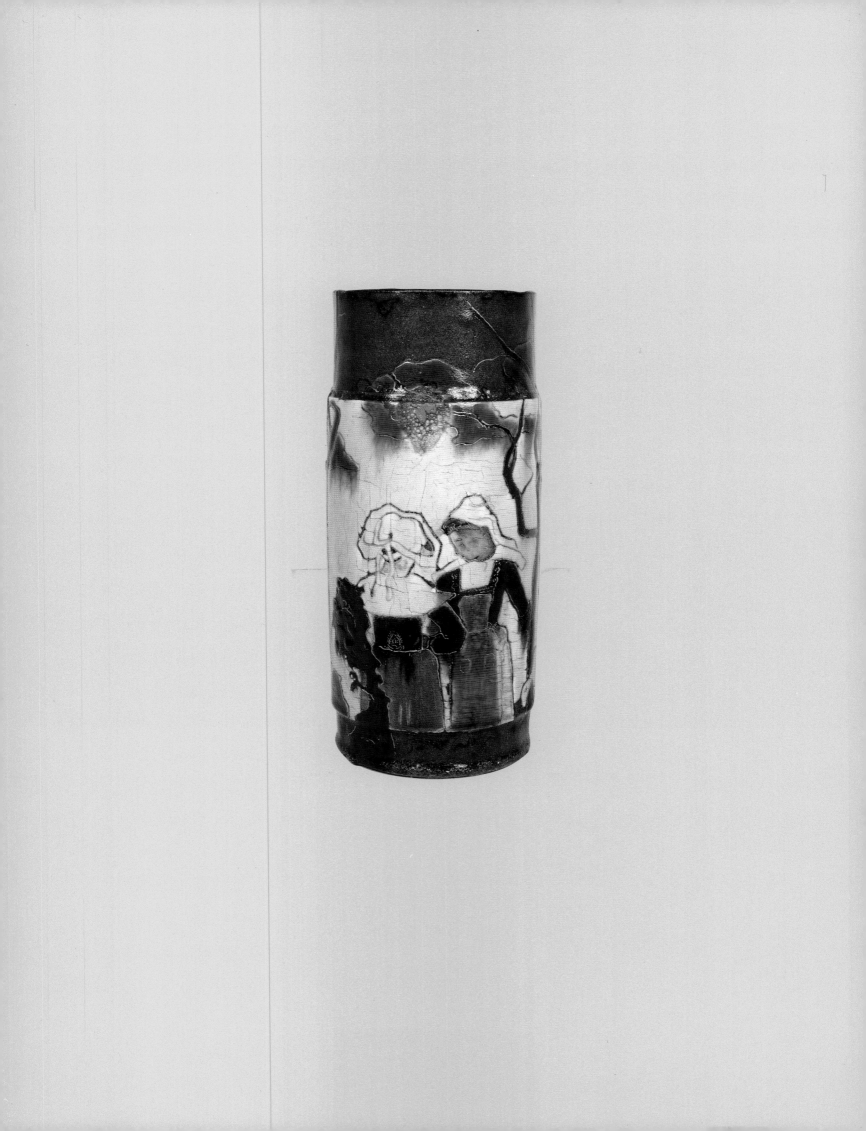

The Art of Paul Gauguin

Richard Brettell Françoise Cachin Claire Frèches-Thory Charles F. Stuckey

with assistance from Peter Zegers

National Gallery of Art, Washington
The Art Institute of Chicago

This exhibition is made possible by AT&T

An indemnity for this exhibition has been granted by the Federal Council on the Arts and the Humanities.

Exhibition dates:

National Gallery of Art, Washington
1 May - 31 July 1988

The Art Institute of Chicago
17 September - 11 December 1988

Grand Palais, Paris
10 January - 20 April 1989

This book was produced by the editors office, National Gallery of Art

Editor-in-chief, Frances P. Smyth

Senior editor, Mary Yakush

Editors, Barbara Anderman and Jane Sweeney

Translations by Anthony Roberts, assisted by Thomas Bowie, Pamela Kaleugher, Mimi Kramer, Michèle Morris, Valerie Morris, Deborah Goodman, Gloria Groom, and Marla Prather

Designed by Michael Glass Design, Inc., Chicago

Printed by Eastern Press, New Haven, Connecticut, on Warren Lustro Offset Enamel Dull

Typeset by AnzoGraphics Computer Typographers, Chicago, in Basilia Haas

Cover: cat. 143, *Vahine no te vi* (detail), 1892, The Baltimore Museum of Art, The Cone Collection, formed by Dr. Claribel Cone and Miss Etta Cone of Baltimore, Maryland

Frontispiece: cat. 24, *Vase Decorated with Breton Scenes*, winter 1886-1887, Musées Royaux d'Art et d'Histoire, Brussels

The hardcover edition of this book is published and distributed by New York Graphic Society Books.

New York Graphic Society Books are published by Little, Brown and Company (Inc.).

Published simultaneously in Canada by Little, Brown & Company (Canada) Limited.

Library of Congress Cataloging-in-Publication Data

The Art of Paul Gauguin.

Catalog of an exhibition organized by the National Gallery of Art.
Bibliography: p.
Includes index.
1. Gauguin, Paul 1848-1903—Exhibitions.
I. Brettell, Richard, R. II. National Gallery of Art (U.S.)
N6853.G34A4 1988 709'.2'4 88-5232
ISBN 0-89468-112-5 softcover
ISBN 0-8212-1723-2 hardcover

Contents

Lenders to the Exhibition

Aargauer Kunsthaus, Aarau

Albright-Knox Art Gallery, Buffalo

Walter H. Annenberg

Art Gallery of Ontario, Toronto

The Art Institute of Chicago

Monsieur Jean-Pierre Bacou

Mlle Roseline Bacou

The Baltimore Museum of Art

Anne Desloge Bates

Bayerische Staatsgemäldesammlungen, Neue Pinakothek, Munich

Annick and Pierre Berès Collection

Mr. and Mrs. Philip Berman

Bibliothèque d'Art et d'Archéologie (Fondation Jacques Doucet), Paris

Bibliothèque Nationale, Paris

Edward McCormick Blair

The Trustees of the British Museum, London

British Rail Pension Fund Collection, London

The Brooklyn Museum

Foundation E. G. Bührle Collection, Zurich

Carrick Hill Collection, South Australia

The Chrysler Museum, Norfolk, Virginia

Sterling and Francine Clark Art Institute, Williamstown, Massachusetts

The Cleveland Museum of Art

Courtauld Institute Galleries (Courtauld Collection), London

Dallas Museum of Art

Des Moines Art Center

Mrs. Robert B. Eichholz

Mr. and Mrs. Marshall Field

Collection Fujikawa Gallery, Tokyo

Dr. and Mrs. Martin L. Gecht

Graphische Sammlung Albertina, Vienna

Hamburger Kunsthalle

Marcia Riklis Hirschfeld

Hirshhorn Museum and Sculpture Garden, Smithsonian Institution, Washington

Indianapolis Museum of Art

The Israel Museum, Jerusalem

Josefowitz Collection
The Cynthia Warrick Kemper Trust
Mr. and Mrs. David Lloyd Kreeger
Kunsthaus Zürich, Vereinigung Zürcher Kunstfreunde
Laing Art Gallery, Newcastle Upon Tyne, Tyne and Wear Museums Service
Mr. and Mrs. Bernard Lande
Private collection of Joshua I. Latner
Monsieur Marcel Lejeune
Mahmoud Khalil Museum, Cairo
Marion Koogler McNay Art Museum, San Antonio, Texas
Neil A. McConnell
Mr. and Mrs. Paul Mellon
The Metropolitan Museum of Art, New York
Musée d'Art Moderne, Liège
Musée des Arts Africains et Océaniens, Paris
Musée des Arts Décoratifs, Paris
Musée des Beaux-Arts, Lyon
Musée des Beaux-Arts, Orléans
Musée Gauguin, Tahiti
Musée de Grenoble
Musée Leon Dierx, Saint-Denis
Musée du Louvre, Département des Arts Graphiques, Paris
Musée d'Orsay, Paris
Musée du Petit Palais, Geneva
Musée du Petit Palais, Paris
Musée Saint-Denis
Musées Royaux d'Art et d'Histoire, Brussels
Museo Nacional de Bellas Artes, Buenos Aires
Museu de Arte de Sao Paulo
Museum of Decorative Art, Copenhagen
Museum of Fine Arts, Boston
The Museum of Fine Arts, Houston
Museum Folkwang, Essen
The Museum of Modern Art, New York
Národní galerie v Praze, Prague
Nasjonalgalleriet, Oslo
Nassau County Museum (Museum Services Division, Department of Recreationand Parks), Syosset
The National Galleries of Scotland, Edinburgh
National Gallery of Art, Washington
National Gallery of Canada, Ottawa/Musée des Beaux-Arts du Canada, Ottawa
The National Museum of Western Art, Tokyo
The Nelson-Atkins Museum of Art, Kansas City, Missouri
Norton Gallery of Art, West Palm Beach, Florida
Ny Carlsberg Glyptotek, Copenhagen
Oeffentliche Kunstsammlung Basel, Kupferstichkabinett
Ohara Museum of Art, Kurashiki, Japan
The Ordrupgaard Collection, Copenhagen
William S. Paley
Henry and Rose Pearlman Foundation, Inc.
Philadelphia Museum of Art
The Phillips Collection, Washington
The Phillips Family Collection
Dr. Ivo Pitanguy
Private collections
Pushkin State Museum of Fine Arts, Moscow
Mr. and Mrs. Alexander E. Racolin
Rijksmuseum Vincent van Gogh (Vincent van Gogh Foundation), Amsterdam
Mrs. Arthur M. Sackler
The Saint Louis Art Museum
Mrs. Francisca Santos
Mr. and Mrs. Herbert D. Schimmel
Dr. h. c. Max Schmidheiny
Lucille Ellis Simon
Sam Spiegel Collection
Staatsgalerie Stuttgart
Rudolf Staechelin Family Foundation
State Hermitage Museum, Leningrad
Mr. and Mrs. Eugene Victor Thaw
The Toledo Museum of Art
Uno Vallman
Fondation Dina Vierny, Paris
Wallraf-Richartz-Museum, Cologne
Mr. and Mrs. Edward M. M. Warburg
John C. Whitehead
The Whitworth Art Gallery, University of Manchester, England
Worcester Art Museum, Massachusetts

Directors' Foreword

Five years ago, there were at least three separate exhibitions devoted to Paul Gauguin in the planning stages. The Art Institute of Chicago was discussing a definitive exhibition of the prints of Paul Gauguin; the Musée d'Orsay had launched a major investigation to result in an exhibition of the Pont-Aven school, an exhibition to be dominated by the work created by Gauguin in Brittany; and the National Gallery of Art, while planning a focused Gauguin retrospective, had come across other plans for an exhibition of Gauguin's Tahiti works. When these diverse and virtually simultaneous projects were discussed, it was resolved to suspend all previous plans and to join forces in creating *The Art of Paul Gauguin*.

The aim of this new exhibition was to study the whole of Gauguin's oeuvre, in all media, and to address his actual working methods, rather than to dwell on the often discussed symbolism of his most famous works. We have been fortunate to have had the generous support of AT&T since 1986, and we are pleased that, in France, the exhibition is supported by AT&T's close corporate ally, Olivetti.

The resulting exhibition is a collaboration among three museums whose combined collections of that artist's work, as the nucleus of the show, are already comprehensive. From the select and important masterpieces of painting and sculpture in the National Gallery, Washington, to the rich holdings of prints and drawings at The Art Institute of Chicago, to the immense, almost encyclopedic reserves of the Musée d'Orsay, all aspects of Gauguin's oeuvre are represented in abundance.

Our conservators and curators have examined the paintings in the three collections using all the techniques available to the modern scientist. Conservators, students, and teachers at the Art Institute have worked to "recreate" certain of the puzzling transfer drawings by Gauguin so that his idiosyncratic techniques can be understood by example. All three institutions' libraries and documentation centers have assembled rare books, articles, archival material, photographs, and manuscripts to provide a sound scholarly basis for our observations.

Building on this foundation, our exhibition's curators have traveled throughout the world to examine Gauguin's works and have, in so doing, attempted to rethink the canon of often-reproduced paintings so familiar to students of modern art. Although they have made every effort to search out important paintings, they have not neglected the *poi* bowls, ornamental ceramic vessels, doorframes, printed pieces of tissue paper, transfer watercolors, irregularly shaped drawings, or manuscript drafts of texts. As a result, *The Art of Paul Gauguin* celebrates an artistic achievement of considerable complexity.

There is another motivation behind the title. We have chosen "the art" not merely in preference to "the painting" of Paul Gauguin, but also to underscore our opposition to an exhibition centering on the artist's life. Although the catalogue contains a thoroughly documented chronology, the exhibition stresses his production as an artist rather than the exotic, troubled, and fascinating life that has attained almost mythological proportions and is better left to biography and film.

The ultimate aim of the exhibition is to inaugurate a new era in the public and scholarly appreciation of Gauguin's art. Many of the works of art included have been reinterpreted, redated, and retitled. Each of the authors has sought not only to summarize the existing literature, but also to reassess the object and its

context. In many cases, new questions are raised, the answers for which will come only in the future.

The exhibition has been made possible by a combination of private and public support. At AT&T, we would like in particular to thank Marilyn Laurie, senior vice president, public relations; R. Z. Manna, corporate advertising manager; and Jacquelyn R. Byrne, district manager, corporate advertising. At Olivetti, the help of Paolo Viti is warmly appreciated. For the support of the documentary film that accompanies the exhibition, we are grateful again to AT&T, and to the Florence Gould Foundation. An indemnity granted by the Federal Council on the Arts and the Humanities represents a major contribution from the public sector.

Our other collaborators and colleagues are so numerous that we have given them a separate section of acknowledgments. The lion's share of credit for the exhibition must go to the curators of our three institutions who have put it together: Françoise Cachin and Claire Frèches-Thory in Paris; Richard Brettell in Chicago, now director of the Dallas Museum of Art; and Charles F. Stuckey in Washington, and more recently in Chicago, have selected the objects and have been responsible for writing the catalogue.

It is, of course, to our lenders, listed on pages VI-VII, to whom we owe our deepest gratitude. In particular we would like to thank our sister institutions in the Soviet Union, the State Hermitage Museum in Leningrad and the Pushkin State Museum of Fine Arts in Moscow. It has long been known that the Soviet collections of Gauguin's paintings are the greatest in the world, yet no major exhibition since 1906 of Gauguin's work has included a single painting from these collections. It is, therefore, with immense gratitude that we thank our Soviet colleagues for their generous loans, without which *The Art of Paul Gauguin* would scarcely have been conceivable. We are happy to think that they too will be celebrating the work of Gauguin after this exhibition concludes.

J. Carter Brown
National Gallery of Art, Washington

James N. Wood
The Art Institute of Chicago

Olivier Chevrillon
Musées de France

Acknowledgments

Without the advice, hospitality, and cooperation of collectors, colleagues, dealers, and scholars around the globe, this comprehensive exhibition and the catalogue that accompanies it would hardly have been possible. We have limited our acknowledgments here to those individuals whose work on behalf of the exhibition went beyond professional courtesy.

In its early stages the exhibition team enjoyed the enthusiastic guidance of the late Merete Bodelsen, whose knowledge of Gauguin was unsurpassed. Other pioneering Gauguin scholars were equally generous with the stores of knowledge in their files, and it is a special honor for us to credit them here: Bengt Danielsson, Richard Field, Eberhard Kornfeld, Maurice Malingue, Ursula Marks-Vandenbroucke, and John Rewald. Their studies have been the foundation for a new generation of specialists, among them Kirk Varnedoe, who helped develop the initial plans for the exhibition. These scholars have rallied to help us with countless difficult problems of documentation and interpretation: Marie-Amélie Anquetil, Gilles Artur, Juliet Bareau, Douglas W. Druick, Georges Gomez y Càceres, Robert L. Herbert, Michel Hoog, Voytech Jirat-Wasiutynski, Naomi Maurer, Victor Merlhès, Kunio Motoe, Karen R. Pope, Antoine Terrasse, Robert Welsh, Bogomila Welsh-Ovcharov, and the staff of the Fondation Wildenstein, in particular Ay Wang Hsia. The Getty Archives of the History of Art was a particularly rich source of documentation material, and Nicholas Olsberg and his staff were especially helpful to the exhibition. Other librarians, archivists, or researchers who were invaluable are: Sylvie Barot, Mette Bruun Beyer, François Bordes, Leigh Bullard, R. Brucker, Catherine Cosker, Ted Dalziel, M. Debreczini, Muguette Dumont, Patrick Dupont, Josiette Galliegue, Jacques Lugand, Mr. Lupu, Mlle Jehanne, Bob Karrow, Mme Lasteyrie, Thomas McGill, Vivianne Miquet, Sue Nolan, Sophie Pabst, Isabelle Pleskoff, Catherine Puget, Mlle Renoud, Simone Roudière, Luise Skak Nielsen, and Jonas Storve.

To prepare an exhibition of this scope, we relied on our colleagues in the trade to help locate objects in private collections and make arrangements to study them. Moreover, the archives of dealers and auction houses constitute a crucial source of historical information. We especially wish to thank William Acquavella, Michael Apsis, Rutgers Barclay, France Daguet, Caroline Durand-Ruel Godfroy, M. Fabiani, Michael Findlay, Stephan Hahn, Libby Howie, Daniel Malingue, Robert Schmit, John Tancock, Eugene V. Thaw, and Daniel Wildenstein. Like all curators, we have also relied upon our colleagues in the field of conservation for essential technical data of a sort that was often unavailable to scholars in the past. The expert help of the following conservators added enormously to our understanding of Gauguin: Marianne Wirenfeldt Assmussen, Michael Auprey, Charles de Couessin, Inge Fiedler, Gisela Helmskampf, Mitsuhiko Kuroe, and Travers Newton. At the National Gallery of Art, David Bull, head of painting conservation, and Carol Christensen deserve special mention, as does William Leisher of The Art Institute of Chicago.

Many collectors and curators generously facilitated close examination of the objects in their custody. Colleagues from Pasadena to Hivaoa agreed to guide our research into collections and locales that we would otherwise have overlooked: Mr. and Mrs. R. Bissone, Mrs. Carlos Blaquier, Guillaume le Bronnec,

Micheline Colin, George Embericos, M. Jean Fontaine, Margrit Hahnloser, Evy Hirshon, Sam Josefowitz, Mr. and Mrs. Paul Josefowitz, Kristian Klemm, Marc and Elizabeth Maza, Ronald Pickvance, and Thomas M. Whitehead. Research in Chicago has also been furthered by the cooperation of Mr. Daniel C. Searle and Peter Bakwin.

The staff of the National Gallery of Art, The Art Institute of Chicago, and the Musée d'Orsay devoted themselves to dozens of behind-the-scenes operations, from monitoring correspondence, arranging for shipping, and compiling research materials, to negotiating loans. Among our many colleagues whose talents and efforts provided the backbone of this project, special thanks are due to Marla Prather at the National Gallery of Art, whose extensive knowledge of the Gauguin literature was indispensable, and Gloria Groom at The Art Institute of Chicago, who together with Isabelle Cahn at the Musée d'Orsay coauthored the detailed chronology of Gauguin's life published here. The energy and research skills of these three principal assistants were especially critical to the success of our joint endeavor.

At the National Gallery of Art we are particularly indebted to Gaillard Ravenel and Mark Leithauser, chief and assistant chief of the department of installation and design, and their staff, especially William Bowser and Gordon Anson, for the design, presentation, and lighting of this exhibition, and to matter-framers Hugh Phibbs and Virginia Ritchie. Early plans for a comprehensive Gauguin exhibition at the Gallery grew out of discussions between Lady Lisa Sainsbury and Mr. Ravenel. Charles S. Moffett, senior curator of paintings and coordinating curator for the exhibition in Washington, and his staff in the department of Modern painting—Darcy Gallucio, secretary and primary photo researcher for this catalogue; Florence E. Coman, assistant curator, and former staff member Kevin V. Buchanan—also deserve our thanks. D. Dodge Thompson, chief of exhibition programs, and his staff expertly carried out the difficult tasks of securing loans and indemnity. Cheryl Hauser, exhibition officer, ably assisted by Nancy Iacomini, was unflagging in her attention to details and deserves a special note of thanks. Mary Suzor, registrar, supervised the complicated arrangements for transporting the works of art to and from lenders. For the timely editing and production of this catalogue, warm thanks are due to Frances Smyth and her dedicated staff in the editors office, particularly Mary Yakush who managed the editing and production of the catalogue, Barbara Anderman and Jane Sweeney who edited the manuscript, and Laura Carter who cheerfully and efficiently assisted them all. We gratefully acknowledge the contributions of the many independent professionals who helped produce this catalogue under the direction of the National Gallery editors office: Michael Glass, who designed this book, and his staff, most especially Anthony Porto, and the principal translators, Mimi Kramer, Michèle Morris, Valerie Morris, and especially Anthony Roberts, who accomplished the lion's share of the translation work.

At The Art Institute of Chicago, Peter Zegers, visiting curator, collaborated on virtually every aspect of this exhibition and catalogue, with great technical expertise and creative scholarship. Mr. and Mrs. Edward M. Blair, Senior, enthusiastically supported Mr. Zegers' research, and Chris Niver and Mark Pascale, of the

School of the Art Institute helped to reconstruct Gauguin's studio practices. Volunteers and interns Constance Coburn, Melinda Couzens, Jane E. Garlock, and Kathy Ryczek also offered valuable assistance. In the department of European painting, Deborah Goodman must be singled out for her essential work as both research assistant and coordinator between curatorial and editorial offices in Chicago and Washington, respectively. Her colleagues Mary Kuzniar, editorial assistant, and Geri Banik, secretary, also provided crucial assistance during the production of the catalogue. Dorothy Schroeder, assistant to the director for exhibitions, Mary Solt, registrar, and the staff of the department of photographic services also deserve thanks. We also wish to acknowledge Yutaka Mino, curator of Japanese art, and Richard Townsend, curator of the art of Africa, Oceania, and the Americas, for adding another dimension to the scope of the exhibition.

At the Musée d'Orsay we thank Eve Alonso, registrar, Agnes Arquez-Roth, Jean Coudane, Françoise Fur, André Guttierez, Nadine Larché, Marie-Pierre Pichon, Michelle Rongus, and Elisabeth Salvan. At the Réunion des musées nationaux we especially thank Irène Bizot, deputy administrator, Claire Filhos-Petit, chief of the exhibition program, Ute Collinet, Nathalie Michel, Françoise Perri, Iseult Séverac, and Isabelle Wolf.

Note to the Reader

Contributors to the Catalogue

Richard Brettell R.B.
Françoise Cachin F.C.
Claire Frèches-Thory C.F-T.
Charles F. Stuckey C.F.S.
Isabelle Cahn
Gloria Groom
with assistance from Peter Zegers

References to liquid mediums and water-based colors are used when the exact nature of the mediums cannot as yet be conclusively determined.

Dimensions all works except those on paper are in centimeters, followed by inches within parentheses. Dimensions of works on paper are in millimeters, followed by inches within parentheses.

The general bibliography, which begins on page 495, is followed by a list of Gauguin exhibitions cited in shortened form in this catalogue, and a bibliography of Gauguin's writings, including letters, articles, manuscripts, and sketchbooks.

The exhibition heading for each catalogue entry includes important exhibitions before World War I, and selected exhibitions thereafter.

Shortened forms for frequently cited catalogues raisonnés:

B Bodelsen, Merete, *Gauguin's Ceramics: A Study in the Development of His Art* (London, 1964).

Dorival 1954 Bernard Dorival, *Le Carnet de Tahiti* (Paris, 1954).

F Field, Richard S., *Paul Gauguin, Monotypes* [exh. cat., Philadelphia Museum of Art 1973].

Field 1977 Field, Richard S. *Paul Gauguin: The Paintings of the First Trip to Tahiti*, Ph.D. diss., Harvard University, 1963 (New York and London, 1977).

FM Fezzi, Elda, and Fiorella Minervino, *"Noa Noa" e il primo viaggio a Tahiti di Gauguin* (Milan, 1974).

G Gray, Christopher, *Sculpture and Ceramics of Paul Gauguin* (Baltimore, 1963; reprinted New York, 1980).

Gerstein 1978 Gerstein, Marc, "Impressionist and Post-Impressionist Fans," Ph.D. diss., Harvard University (Cambridge, Massachusetts, 1978).

Gu Guérin, Marcel, *L'Oeuvre gravé de Gauguin* (Paris 1927; rev. ed. San Francisco, 1980).

K Kornfeld, Eberhard, Harold Joachim, and Elizabeth Morgan, *Paul Gauguin: Catalogue raisonné of his Prints* (Bern, 1988).

W Wildenstein, Georges, *Gauguin*, Raymond Cogniat and Daniel Wildenstein eds. (Paris, 1964).

Shortened forms for frequently cited sources in the chronology

DA Departmental Archives

DR Durand Ruel Archives, Paris

LA Loize Archives, Musée Gauguin, Papeari, Tahiti

MA Charles Morice Archives, Paley Library, Temple University, Philadelphia

MR Gauguin's Military Record, Musée Gauguin, Papeari, Tahiti

NA National Archives, Paris

PA Paris Archives

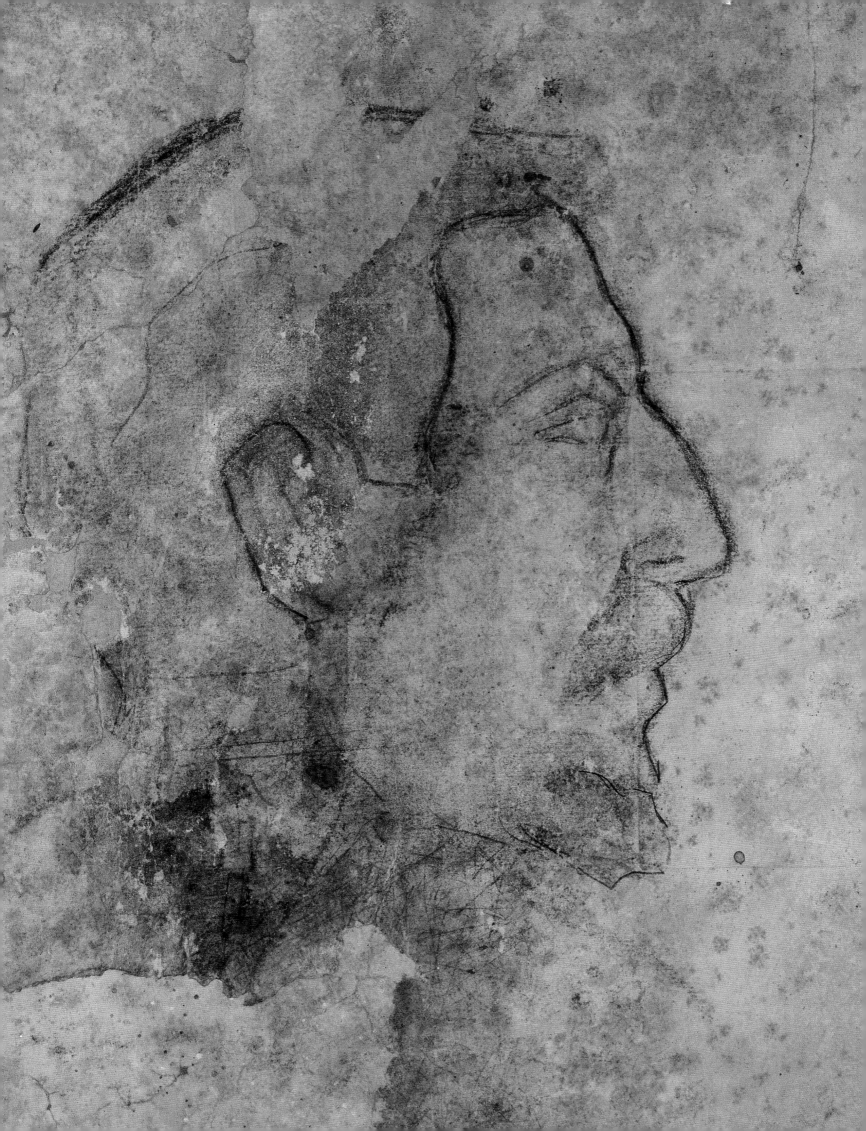

Gauguin Portrayed by Himself and by Others

FRANÇOISE CACHIN

Dieppe 1885

His strange features (of which he did such fine self-portraits), the extravagance of his dress, and a certain haggard appearance, which my father had all too often pointed out as the symptoms of megalomania, made me keep my distance from him. If that man was not a lunatic, he must at least be a frequenter of those medieval brasseries in the Pigalle quarter, to which we went with our poet friends.

Yet at this time Gauguin's leadership of the Pont-Aven school was still in the future. He had only recently left his job at the exchange office, and his artistic endeavors were confined to Sundays and holidays, when he would paint nudes and delicate landscapes in the most temperate of impressionist styles.

Blanche 1928, 5-6.

1. Robert Rey 1928, 129.

2. Published in facsimile, Cogniat and Rewald 1962, the first, 86; the second, 111.

"Something you'll notice about the way people who knew Gauguin tend to recall him: they may speak of him with love or loathing; none speaks of him with indifference."[1]

Gauguin's self-portraits, taken together, inspire two contradictory emotions: impatience, first, with the extent and diversity of Gauguin's posturing – that histrionic quality born, no doubt, of a desire to "play the artist" ("setting up shop as a great man," as Jules Renard would have said) – but there is sympathy, too, even admiration for the man's singleness of purpose. Over a crucial ten-year period, Gauguin produced a series of self-portraits; they bear witness to an ongoing search for an identity, the quest for that larger-than-life-personality to which he was gradually to sacrifice everything, and which ultimately pushed him to become the great painter he was.

Perhaps the earliest indications of how Gauguin saw himself are to be found in two sketches from the years 1884 and 1885.[2] They are tentative, circumspect; one drawing seems an attempt to divine something of the formal pos-

Gauguin, *Self-portrait*, Brittany and Arles Sketchbook, page 86 [The Armand Hammer Collection]

Left:
Gauguin, *Self-portrait in Profile*, detail, c. 1900, drawing [private collection, Paris]

sibilities in nose and eyelid; the other is a sidelong glance at the artist himself –
half mocking, half surprised. Not until 1885, the period of Gauguin's brief sojourn
in Copenhagen, was there anything like a full-fledged self-portrait. But two other
pictures of Gauguin from this period, a photograph and a cartoon drawing of the
artist and his family are worth looking at. The photograph shows Gauguin standing
behind his wife, Mette, looking solemn, domestic, and very much the respectable
homme d'affaires. In the drawing, his face in profile looms over the heads of his
family, with Emil (left) and Mette (right) framing the three children, all six sticking
up out of a soup tureen labelled "molasses." Already, Gauguin wears the studied,
supercilious expression we come to know in his later portraits. Then as now, "To
drown in molasses" meant to be up to one's ears in debt – colloquially speaking,
"flat broke." In fact, the contrast between the artist's face in the photograph and in
the caricature conveys, better than words could ever hope to express, a sense of
what was going on in his life, the complete split between Gauguin as *pater familias*
– upright member of the business community – and the Gauguin who was strug-
gling to assert himself as an artist. For Gauguin, this duality was like a physical
rending: "Sometimes I think I must be going mad and lying awake nights I become
sure of it."[3] "Here I am more than ever obsessed with painting – so much so that
financial worries and the need to attend to business can no longer keep me
from it."[4]

 It was at this point that Gauguin produced his first self-portrait, *In Front of
the Easel*. It is a crude work, with obvious blunders – the odd placement of arm

3. To Schuffenecker, 14 January 1885,
Merlhès 1984, no. 87.

4. Merlhès 1984, no. 88.

5. See Reff 1967.

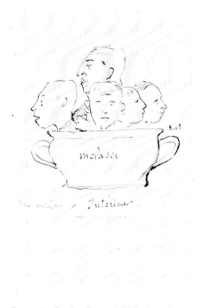

Gauguin, *In the Soup*, 1885, drawing
on Dillies & Co. Letterhead,
Copenhagen [Musée d'Orsay, Paris,
Service de Documentation]

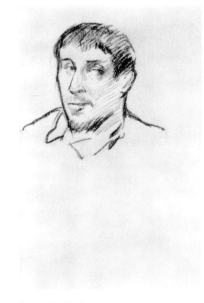

Gauguin, *Self-portrait*, Brittany and
Arles Sketchbook, page 111 [The
Armand Hammer Collection]

Gauguin, *Self-portrait in front of his Easel*, 1885,
oil on canvas [private collection, Bern]

and palette, for instance. Gauguin painted exactly what he saw in the mirror: the image is reversed, making him appear left-handed and a bit deformed (the hand that grips the paintbrush seems foreshortened, disproportionately small and shriveled). Still, what comes across is his overwhelming sense of suffocation in the shoebox-like studio where he was confined. Literally wedged in between two canvases – the one he is working on and another on the floor behind him – the face he shows to the world is one of unrest, at once abstracted and on guard. Only that piercing eye – perfectly clear and lucid as it gazes unflinchingly toward an uncertain future – contains any hint of the self-assurance Gauguin was shortly to acquire.

For some years previous (and up until 1886) Gauguin was a frequent guest of Pissarro; so he would have been familiar with two portraits that hung on the latter's walls: one, a self-portrait, in which Pissarro stands before his paintings, looking impressively patriarchal (1873, Musée d'Orsay); the other a portrait by Pissarro of Cézanne, standing before a wall hung variously with one of Pissarro's own landscapes and a caricatured self-portrait of Courbet.[5] These two conceptions of the artist stood in stark contrast to the models favored by both Courbet – for whom the artist was either a figure of beauty and nobility or a wounded hero – and Pissarro, for whom the painter was at once "humble craftsman" and exalted artisan. Gauguin must have had Courbet and Pissarro in mind when – in a painting dedicated to Laval (cat. 29) – he depicted himself in simple, impressionistic style, before an open window that looked out onto the sort of landscape he favored at

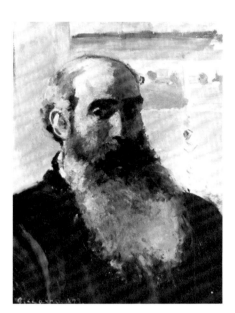

Pissarro, *Self-portrait* [Musée d'Orsay, Paris]

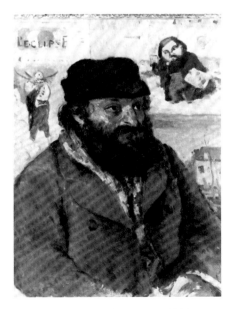

Pissarro, *Portrait of Cézanne*, c. 1874
[private collection]

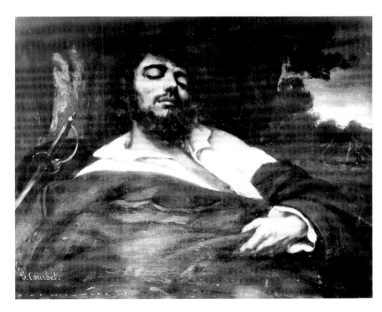

Courbet, *Wounded Man* [Musée d'Orsay, Paris]

the time; and their memory may even hover about the two later self-portraits in which he depicted himself: *Self-portrait with Yellow Christ* and *Self-portrait with Hat*, with *Manao tupapau* in the background, (cats. 99 and 164). In fact, with these two paintings – and with the self-portrait that hangs in the Pushkin State Museum, in which we glimpse a corner of *In the Waves* (cat. 80) – Gauguin is taking his place beside Cézanne and Pissarro, participants in a long tradition of artists posing before their own work. (Poussin's famous self-portrait in the Louvre offered a classical model.) Of interest here are the specific works with which Gauguin posed: in all three cases, the paintings he selected were quite recent works, and ones that Gauguin seemed to regard as daring or provocative. It is as though he were challenging the viewer: "Here is my latest! Spurn it if you dare. . . ." Gone is the moral poise that characterized the self-portraits of Poussin and Pissarro: in its place, we sense the restless impatience of one who longs to make his mark, and in a wholly different tradition – that of the Romantics. A hint of this is found in the detail of Gauguin's costume in the 1886 self-portrait in Brittany (cat. 29): the "Breton outfit" is one of the first signs of Gauguin's determination, from 1886 on, to treat his personal appearance as part of his work. "He invented everything: his easel was his own invention . . . his method for preparing his canvas – even his strange way of dressing."[6] Gauguin's "disguise" was a stage in the development of his individuality, a step toward the persona he needed to create before he could properly distance himself from Pissarro and the world of impressionism in general. Before long, Pissarro would have to admit, "He's in another world."[7]

Artists paint themselves for a variety of reasons. The simplest – the most often invoked – is the relative convenience of working from a reflection as opposed to getting someone else to pose for you. Artists make the most patient models, and the most economical. Thus, in September of 1888, we find Vincent van Gogh writing to his brother: "I've purchased a good enough mirror so that I can work from my own reflection for lack of a model."[8] That same month he requested self-portraits from Gauguin and Bernard.

Gauguin's reasons for painting himself were very different, closely bound up with his explorative style and the precise direction that it took. The character of his face – fierce, harsh, even foreign – suggested a natural alliance between his own image and the quest for a primitive style. "Enclosed is a photograph of my face," he wrote to Emile Schuffenecker from Arles: "the face of a savage – to remind you of your friend."[9] But during those crucial years, 1888 and 1889, self-portraiture was Gauguin's way to make his mark on a tradition, a means of magically becoming one with that company of artists in the history of painting – Raphael, Rembrandt, Ingres – whom he most admired.

It is worth noting that from 1888 to 1889, when Gauguin produced most of his self-portraits, also saw the appearance of a proposal calling for the creation of a national portrait museum in France, accompanied by an inventory of about 3,000 paintings.[10] In 1887 Castagnary, a former champion of realism, in his inaugural address as newly appointed Director of Fine Arts, had announced the creation of a gallery in the Louvre that would fulfill the same function as the similar collection of portraits in the Uffizi in Florence. "The portraits [to form such a collection] are there," he declared, "forty in the Louvre, fifty at Versailles, sixty in the Ecole des Beaux-Arts."[11]

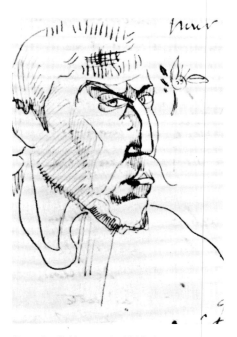

Gauguin, *Self-portrait*, 1888, drawing in a letter to Emile Schuffenecker [location unknown]

6. Séguin 1903a, 160.

7. Letter to Mette, in Rostrup 1956, 78.

8. Van Gogh 1978, vol. 3, no. 537.

9. Merlhès 1984, no. 184.

10. Jouin 1888.

11. Cited by Jouin 1888, XVIII.

Pont-Aven 1886

Tall, dark-haired and swarthy of skin, heavy of eyelid and with handsome features, all combined with a powerful figure, Gauguin at this time was indeed a fine figure of a man. Later on, his low forehead, with its suggestion of a *crétin*, was a source of grave disappointment for van Gogh, to Gauguin's vast amusement. He dressed like a Breton fisherman in a blue jersey, and wore a beret jauntily on the side of his head. His general appearance, walk and all, was rather that of a well-to-do Biscayan skipper of a coasting schooner; nothing could be farther from madness or decadence.

In a manner he was self-contained and confident, silent and almost dour, though he could unbend and be quite charming when he liked. . . . Most people were rather afraid of him, and the most reckless took no liberties wtih his person. "He's a sly one," was the sort of general verdict.

He was distinctly athletic in his tastes and had the reputation for being a formidable swordsman. I believe it was truly earned; anyway it added to the caution with which he was usually approached, for he was treated as a person to be placated rather than aroused.

Hartrick 1939, 31.

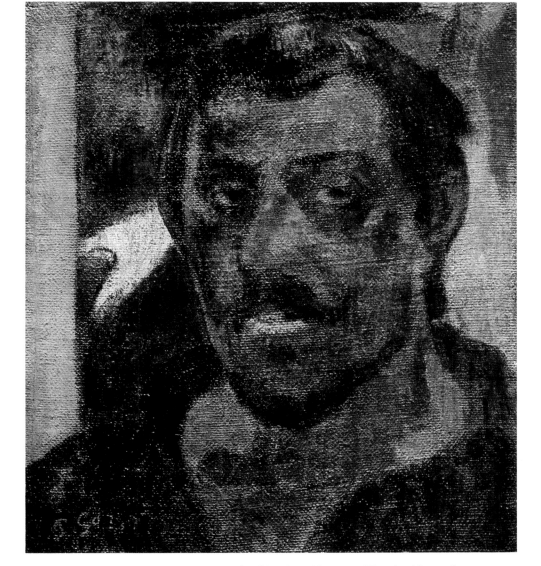

Gauguin, *Self-portrait*, c. 1888, oil on canvas [Pushkin State Museum of Fine Art, Moscow]

12. Jouin 1888, XVI.

Such a gallery was never created. The suggestion, though, like the call for a museum of portraiture, was part of a general renewal of interest in portraiture that had been stirring in official circles in Paris for at least a decade, specifically since the great *Portraits nationaux* exhibition at the Trocadero during the 1878 World's Fair. A national portrait museum seemed an excellent source of instruction for the youth of the newly established Republic. "How edifying such a museum would be!" Paul Mantz exclaimed. "An image is a text. From portraiture, we learn history."[12]

The brothers van Gogh, then – especially Vincent – were unwittingly taking part in a more general intellectual movement when they began trying, in 1887, to put together a group of artists' likenesses – trying, one might add, with an

It was in 1889, at a small restaurant down the street from the Odéon where poets, impartially described as symbolists (still) or decadents (already), would meet.

That evening, arriving late for dinner at the Côte d'Or, I spied a new face amid my group of friends, a large, bony, bulky face, with a narrow forehead and a nose not beaked, not curved, but broken-looking. The mouth was straight and thin-lipped; the eyes were lazy, heavy-lidded and slightly bulging, with bluish pupils that glanced and swiveled from right to left in their sockets, their owner making only a token effort to move his head and body in concert.

This unknown individual seemed thoroughly lacking in charm; but nonetheless he exercised a definite attraction on account of his singular expression. This was a blend of natural nobility, pride, and a simplicity that verged on the commonplace. One quickly perceived that the mixture translated as strength, the moral strength of an aristocrat among the common people. Also, Gauguin may have lacked charm, but he had a strangely sweet and ingenuous smile: a smile that went so ill with those too straight, too thin lips, that they seemed to regret, even to deny as weakness, their owner's open acknowledgment of gaiety.

Morice 1920, 25, 26.

13. For example, Vincent asks for Bernard's self-portrait in the summer of 1887, van Gogh 1978, vol. 3, no. B1 [1].

14. Cooper 1983, 11.

15. Painting, sculpture, or ceramics; the drawings are not included in this detailed account.

16. "But you can see that if I had not written to them rather strongly, this portrait would not exist. . . ." wrote Vincent to Theo after Gauguin had painted Les Misérables, van Gogh 1978, vol. 3, no. 544.

17. Van Gogh 1978, vol. 3, no. B7 [7].

extraordinary degree of optimism or prescience about the fortunes of their young friends, then as yet unknown.[13] Their main concern seems to have been to have kept a visual record of all of them: it was always a source of regret to Vincent, for example, that he had no portrait of Seurat. Gauguin's relationship with the brothers was stormy at this period, yet their influence on him was considerable.[14] In fact, Gauguin's tempestuous alliance with the van Gogh brothers – artist and entrépreneur – was quite fruitful intellectually. It is clear that the crystallization in Gauguin's mind of the idea of the self-portrait, which was to become almost an obsession with him in 1888 and 1889 (nine self-portraits, out of a total of about fifteen, in less than two years), was due to the van Goghs' influence.[15] Vincent's pressing need to acquire portraits of his friends had a formative influence on the little group that had assembled at Pont-Aven in the summer of 1888: Gauguin, Bernard, and later Laval.[16]

The chronology of events is significant here. As early as June 1888, Vincent had sought to lure Gauguin and Bernard to Arles; his object was to create a community of artists similar to the that which was installed at Pont-Aven.[17] Gauguin waited until 21 October before complying. Meanwhile, the artists at Pont-Aven had sent their portraits, duly dedicated to Vincent, who from Arles, in his turn, had dispatched his own – addressed "à l'ami Gauguin" – to Brittany.[18]

The two self-portraits, by Gauguin and Bernard, must have been made in mid-September.[19] They arrived in Arles on 9 October, following hard upon Gauguin's letter describing his own offering. It seems that the original idea had been for the two artists to paint each other, but that Bernard, intimidated by Gauguin's personality, had been unable to comply with Vincent's request.[20] Gauguin, meanwhile, for his part wrote Vincent of his intention to paint Bernard. "I will do the portrait you want but not just yet. I'm not ready to do it, particularly since what you want is not a mere facial replica but a portrait in the sense in which I understand the term. I am studying our little Bernard, but don't quite have him, yet. I don't know. Maybe it will come to me tomorrow in a flash."[21] What came to him, then, in a flash – what actually was painted (and apparently very quickly) – was his own self-portrait, Les Misérables, which he dedicated to his friend Vincent (and which, sadly, is not exhibited here because of the condition of the canvas). "The deed is done," wrote Gauguin, "not, perhaps, exactly as you would have wished; but what matter, so long as the end result is the same: our two portraits." He goes on the describe his own portrait at length. "I feel compelled to explain myself, not because you're not capable of understanding the work on your own, but because I fear it is not successful. It is the face of an outlaw, ill-clad and powerful like Jean Valjean – with an inner nobility and gentleness. The face is flushed, the eyes accented by the surrounding colors of a furnace-fire. This is to represent the volcanic flames that animate the soul of the artist. The line of the eyes and nose, reminiscent of the flowers in a Persian carpet, epitomize the idea of an abstract, symbolic style. The girlish background, with its childlike flowers is there to attest to our artistic purity. As for this Jean Valjean, whom society has oppressed, cast out – for all his love and vigor – is he not equally a symbol of the contemporary impressionist painter? In endowing him with my own features I offer you – as well as an image of myself – a portrait of all wretched victims of society who avenge us by doing good."[22] Referring to the portrait, some days later, in a letter to

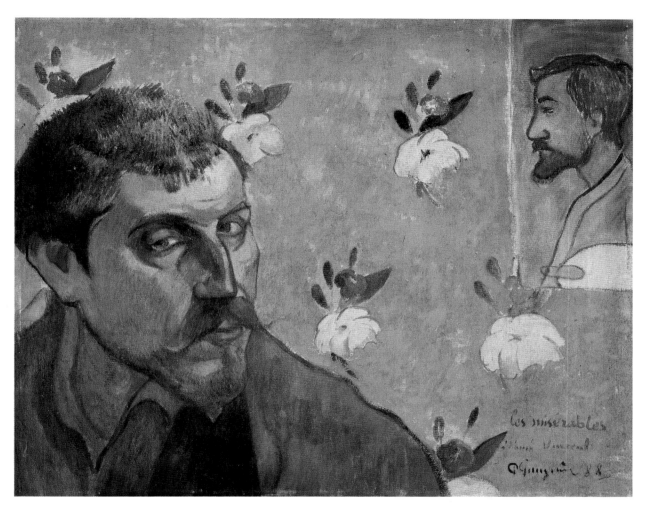

Gauguin, *Les Misérables*, 1888, oil on canvas [Rijksmuseum Vincent van Gogh, Vincent van Gogh Foundation, Amsterdam]

18. Jirat-Wasiutynski et al, 1984.

19. Sent, but received around 29 September (letter to Theo, Merlhès 1984, no. LXVII). Laval's portrait, probably older (see cat. 30) will be sent next.

20. Vincent to Theo, van Gogh 1960, vol. 3, 539F.

21. Gauguin to Vincent van Gogh, Cooper 1983, nos. 32.1-32.2.

22. Cooper 1983, nos. 33.1-33.2.

23. Letter to Schuffenecker, 8 October 1888, in Malingue 1949, LXXI.

Schuffenecker, Gauguin stated that it was "so abstract as to be absolutely incomprehensible. . . . the color is far from anything in nature: vaguely reminiscent – if you can picture it! – of burnt earthenware, twisted by intense heat. All the reds and violets streaked with bursts of flame as though from a glowing furnace, the site of many battles in the painter's thoughts."[23]

These excerpts from his letters – the only known texts by Gauguin on the subject of his self-portraits – suggest the degree to which everything in his work had become premeditated. In those forays into what he called "the abstract" – which, for him, only meant a more concrete and symbolic reality, one that went below the surface of appearances – Gauguin hoped, through formal research, to find a place where style would supersede observation. One need only compare *Les Misérables* (cat. 29) with the earlier self-portrait dedicated to Laval and Carrière to grasp

Gauguin, *Self-portrait*, drawing [Musée des Beaux-Arts, Strasbourg]

24. To Albert Aurier, February 1890, van Gogh 1960, vol. 3, 626 AF.

25. Van Gogh 1978, vol. 3, no. 531.

26. Van Gogh 1978, vol. 3, no. 604.

27. Van Gogh 1978, vol. 3, no. W 22.

28. In Cooper 1983, no. 31.1.

29. Example: "Pissarro and *others* are not happy with my exhibition, *therefore*, it is good for me," Cooper 1983, 14.4.

30. *Avant et après*, ms, 16.

31. Séguin 1903a, 163.

32. Letter to Vincent, 20 November 1889, Cooper 1983, nos. 22.4-22.5.

33. Note that the series of chapters on the Hero (as King, poet, priest, etc,) left an empty place for Gauguin: Carlyle had not forseen the hero as a painter.

34. de Wysewa 1886, 102-104.

35. Aurier 1891, 159.

the weight of ideas he was attempting to use as ballast. Granted, the painting was meant to impress Vincent (and, through him, Theo), to inspire admiration and awe and to convince them that Gauguin was worthy of their compassion, respect, and assistance. But it has its foundation in a literal truth, a very real despair – a sentiment that was wholly justified by Gauguin's new-found power, the mastery over new forms that he aimed to acquire in the face of all opposition. There is an element of burlesque in his left-leaning stance; even in the painting Gauguin seems almost about to sink to the floor; he has the air of a drunkard who has just finished making a speech. But there is something moving that comes through – a violence, a facility of expression, and, in the pure chrome yellow behind his dejected figure (it was to become one of his favorite colors), a kind of pictorial joy.

Gauguin's brief stay in Arles can only have led him to think more carefully about the subject of portraits and self-portraits: it was an interest Vincent also shared. Indeed, Vincent would have liked to get Gauguin to pose for him but the tension between the two men made this impossible. Vincent had to content himself with evoking not Gauguin himself but an image of his absence: "I tried to paint his empty corner . . . , a study of his armchair. . . . In his place, a lighted torch and some modern novels."[24]

The substance of conversations between the two men – echoes of which come across in Vincent's letters – cannot but have made an impression on Gauguin: "I should like my paintings of men and women to be characterized by that eternal quality that used to be symbolized by a halo and which we seek to express with color – in vibrancy and brightness."[25] A year later he recalled (à propos of his "desire . . . to paint a portrait of the age"): "Gauguin and I chatted on this and related subjects until our nerves were strained to breaking-point."[26] And again: "I should like to paint portraits that, a hundred years later, would seem like apparitions."[27]

In fact, one senses Vincent's indirect presence – his shadow – behind a good many of Gauguin's later self-portraits, when a shared experience becomes the subject of a painting, for example. *Bonjour Monsieur Gauguin* (cat. 95) recalls their visit to the Museum at Montpellier where they saw Courbet's unorthodox self-portrait with the title *Bonjour Monsieur Courbet*. Again, the depiction of himself in *Christ in the Garden of Olives* (cat. 90) dramatizes a point Gauguin had made in one of his letters to Vincent: "There is a Road to Calvary that all we artists must tread and it is this, perhaps, that keeps us going. It is that which keeps us alive and we die when there is nothing more to feed it."[28] This must have been a refrain in their ongoing dispute. "Your overall conception of the impressionist painter – symbolized in your painting – is arresting," wrote Vincent in response to Gauguin's letter introducing *Les Misérables*. But when the painting arrived, he was not enthusiastic: he reproached Gauguin for making the skin tones unnaturally dark and – above all – for exhibiting his wounds and forcing others to share his anxieties and distress. Implied in the self-portrait that Vincent, in turn, sent Gauguin – in which he portrayed himself somewhat in the aspect of a Buddhist monk – was something about stoicism and asceticism, virtues that the recipient did not himself possess. What Gauguin thought of the painting we have no way of knowing, but it is not inconceivable that he took Vincent's point – and the implied reproach – in silence. In any case, Vincent's criticisms and objections

Le Pouldu 1889-1890

Gauguin was forty-two years old in that year. His health was still intact, and he had the strength of maturity; he was tall, with tanned face, hair dark and long, an aquiline nose, big green eyes, a sparse horse-shoe-shaped beard and a clipped moustache. His manner was grave and imposing, and he behaved calmly and reflectively, though with a touch of sarcasm when philistines were present. He had great strength of body, that he was loath to use. His slow movements, sober gestures, and ascetic countenance endowed him with considerable natural dignity, which served to keep strangers at a distance. Behind this cold, impassive mask hid the ardent temperament of a sensualist, constantly attuned to new impressions and pleasures. Gauguin had never completed his formal education, so he viewed the Greeks and Romans with suspicion and incomprehension, being unversed in their classics. During his wanderings as a sailor, he had picked up one or two rudimentary precepts, which he liked to inscribe on the everyday objects he took such pleasure in decorating. His motto was "Wine, love, and tobacco!" Fortunately, his consumption of alcohol was limited to the occasional glass of brandy; he was abstemious in this regard, and drank for good cheer, not for the taste of it. On the other hand, there is no question that he was excessively fond of "love and tobacco."

So Gauguin had an insatiable appetite for sensations, but an almost total lack of sentimentality. His character was founded on ferocious cynicism; he had the selfishness of the genius, who believes the entire world to be a vehicle for the glorification of his power, or raw material for his personal creations. It was this insane egotism which prevented him from turning into a banal bourgeois or a barfly: on the contrary, he was, and remained, the heroic artist . . .

Letter from Mothéré to Chassé, Chassé 1955, 68-69.

only provoked Gauguin to assert himself still further.[29] Gauguin knew well that the depiction of himself as Christ would offend and appall the van Gogh brothers – who would disapprove as heartily of the painting's unrealistic subject matter as they did of its grandiloquent style. Moreover, he was desperately in need of Theo's financial support. One cannot help but detect a kind of coquettery – defiance – in the manner in which Gauguin, in later years, systematically accentuated the narrowness of his forehead in his self-portraits either by brushing his hair forward or by wearing hats – fifteen years later, he was to remark of Vincent, "It enraged him having to recognize my vast intellect – particularly as I have an unusually low brow, always a sign of stupidity."[30]

In Gauguin, a need to persuade always went hand in hand with a desire to offend. Hostility, for him, was a way of establishing his own identity, a certificate of originality. He was impervious to all but two things: poverty and indifference. Hence the masks, the provocations; hence the frowning, depressing portraits, heavy with defiance or reproach.

That Gauguin's style had been predetermined by the features he was born with is an idea that dominates his portraits from 1889 onward – a period during which his principal moral and financial supporters (Pissarro, Theo van Gogh, and for a time, Degas) seriously contested the direction his art was taking. It was at this point that Gauguin began depicting himself as a sort of monster – a lecherous little quasimodo, sucking his thumb in the upper right-hand corner of the woodcut *Soyez amoureuses* (cat. 241), and stifling a cry of pain in the tobacco-jar ceramic (cat. 65). Soon he would portray himself as Christ, broken, bloody and betrayed (cat. 90), as a victim of the guillotine (cat. 64), and finally as a caricatured demon: "proud and straight as a young tree, snickering like the angel whom pride brought low" (cat. 92).[31]

Each of these images is highly individual and strikingly realized; but each represents an idea of the self that Gauguin would have found floating around in the spirit of the time – in books and lectures – seized upon and made particularly his own. The self-portraits mark the stages of Gauguin's progress toward "an object I have long sought but only recently begun to articulate."[32]

The hero of his own history, he also saw himself as the hero of painting in his age, which seemed to him decadent. The neo-Romantic strain in his painting took its moral impulse from the thinking of Carlyle, whose "Heroes and Hero Worship" had appeared in French in 1886.[33] The aesthetic impulse came from Wagner – or, at any rate, in ideas about Wagner popularized by Teodor de Wysewa, whose 1886 article on "Wagnerian painting" must have made a big impression on Gauguin. It was at this point that the Pont-Aven aesthetic – as formulated first by Sérusier, later by Maurice Denis and the Nabis – began to take shape. The ethic that Gauguin espoused was essentially that of Wagner: "It is necessary, above this world of conventional appearances, to build the sacred image of an ideal world, . . . that is the function of art . . . to transform reality, thereby recreating it . . . for the colors and lines in a painting are not duplicates of the colors and lines in reality; they are mere conventions. . . ."[34]

It is this that Gauguin called "abstraction" in painting: a level of reality that was more *real* because it was more primitive. In depicting himself alternately as savage, rebel, outlaw, Christ, or magus, Gauguin was portraying the artist as

Le Pouldu 1890

I can see Gauguin now, on the beach at Le Pouldu, with his eagle's nose, clear sailor's eyes, longish black hair, beret, bathing trunks and forty-year-old's belly. He reminded one of a fair-ground barker, a troubadour, or a pirate. He was a great admirer of the character of Vautrin in "La Comédie Humaine," and the idea occurred to me that in other times and circumstances, without his consuming love of art, he might have been Vautrin's brother. He exuded energy from every pore, and he always seemed to be hatching some huge artistic scheme. He had read widely, and I understood that he had a special preference for the Bible, Shakespeare, and Balzac.

I always thought there was something savage in him; he too believed this, speculating that he was descended from the Aztecs of old whom he so much resembled.

Letter from Paul-Emile Colin to Chassé, Chassé 1955, 82.

36. Aurier 1891, 164.

37. Breton 1957, 216.

38. At Le Barc de Boutteville's gallery, September 1893.

39. Mauclair 1893, 118.

40. Mauclair 1893, 119.

41. Mauclair 1893, 119.

42. Christophe 1893, 416.

43. Helleu, cited by Blanche 1928.

44. Introduction signed by Edmond Girard and P.-N. Roinard in *Essais d'art libre*, October 1893, 124-126: the first volume, devoted to writers, appeared in 1894 (see Roinard et al, 1894). The second, which should have been devoted to painters, never appeared. The portrait of Gauguin was to have been written by Jean Dolent.

45. Joly-Segalen 1950, XXIX.

martyred, omniscient redeemer. Already, long before Gauguin's departure for Tahiti, Albert Aurier had seen in him "a sublime visionary, . . . the creator of a new form of art[35] . . . who wanted to install with us, in our shamefully petrified society, a new kind of artist – spirited, primitive, even a little bit wild."[36] It is understandable that André Breton was later to bless Gauguin as "the only painter prior to the advent of surrealism who understood that the artist was a magician."[37]

The early 1890s saw a revival of interest in artists' portraits among poets, as well. Official interest, during the previous decade, had been largely in the historical value the genre was thought to have, as we have seen. Now it took on a new life in independent circles: the portrait of one painter by another painter or by himself – which had been the exception in the iconography of the impressionist movement and the rule in the context of the Salon – became a favorite topos of turn-of-the-century avant-garde painting. An exhibition organized by the literary review *Essais d'art libre* in September of 1893, with the provocative title, *Portraits from the Next Century*,[38] included portraits of symbolist writers (Adam, Beaubourg, Tailhade, Rodenbach, Verlaine, and others) and painters (Ibels, Zuloaga, and others) and a number of self-portraits, as well: of Cézanne ("who possesses all the virtues – including modesty"),[39] of van Gogh ("such a work is as compelling as a confession"),[40] of Angrand, E. Bernard, Filiger, and others. Gauguin's self-portrait was universally reviled: "The portrait of himself, which is outrageous and absurd. . . ."[41] It seems "comical – intentionally so: half-bogeyman, half-buccaneer!"[42] It is hard to know which of Gauguin's self-portraits is meant, here; the description might just as easily refer to the painting in the Pushkin State Museum or – assuming it was among the effects left in Paris by Theo van Gogh's widow – to the *Les Misérables* self-portrait.

This was actually one of the few occasions when a Gauguin self-portrait was exhibited during the artist's lifetime. The critical response is telling: Gauguin is faulted for lacking Cézanne's modesty and van Gogh's genuineness of feeling. As a rule, people found Gauguin on canvas as irritating as he was in real life. They thought of him as a mountebank and poseur, a "barstool theoretician."[43] In truth, Gauguin had made of himself nothing worse than the literal embodiment of the ideas that most of his intellectual friends espoused. It was done with a kind of naive bravery, encouraged by the little circle of poets and painters at Le Pouldu and in Paris. According to the volume that was to have accompanied *Portraits from the Next Century*, the paintings in the exhibition were an attempt to "capture the face of a whole movement that sought to liberate future generations by increasing social and artistic freedom."[44] This was a goal that Gauguin might have claimed for his own self-portraits.

Gauguin's self-portraits were never meant for a large audience nor painted with a view to exhibition or sale. Most were gifts intended for friends and relatives: his wife, his fellow artists, critics, poets. (Ky Dong, the recipient of Gauguin's last self-portrait, was just someone he liked.) It is astonishing how few of Gauguin's self-portraits were destined for anything but private use; each seems to have carried with it a message for the recipient. To Mette, the message in the first self-portrait was, "I want to be a painter." To Laval and Carrière (cat. 29), "I am finally myself and love you well." To Schuffenecker, van Gogh, and Meyer de Haan (cat. 164): "We are brothers in our suffering and our knowledge." To Molard: "I am a

Tahiti 1891

It should be stated right away that as soon as Gauguin landed he drew catcalls and looks of astonishment from the natives, especially the women. He had a tall, straight, powerful build, and managed to preserve an air of profound disdain despite his curiosity about Tahiti and his keen anticipation of the work he would do there. . . . but the thing about Gauguin that especially caught everyone's attention was his long pepper-and-salt hair, which fell to his shoulders from beneath a broad-brimmed, cowboy-style, brown velvet hat.

Jénot 1956, 117.

c. 1894

A magus, my dear fellow, a parlor symbolist; look at his hand! He's wearing a ring, set with a gem, on his index finger! It's bad for one's health to contemplate such a thing. Nobody so outlandish could possibly have a shred of talent; he even talks to himself! He looks like something out of Albrecht Dürer.

Helleu in Blanche 1928, 6.

Paris 1894

He invented everything . . . even his bizarre costume was his own invention. This consisted of an astrakhan hat and an enormous dark blue overcoat with gold buttons, in which he appeared to the Parisians like a sumptuous, gigantic Magyar, or like Rembrandt in 1635. As he made his stately was along the street, he leaned with one white-gloved, silver-ringed hand on a cane that he himself had carved.

Séguin 1903a, 160.

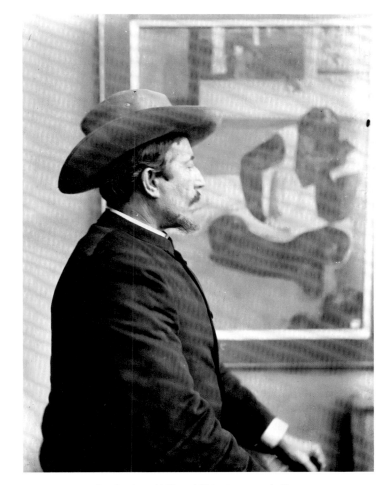

Gauguin in his Studio, late 1893 or 1894, photograph [Larousse Archives, Paris]

great painter and I'm counting on you." To Morice (cat. 159): "I am a *very* great painter – make it known!" To Monfreid, finally, he sent the rather touching portrait in profile, "A l'ami Daniel," accompanied by these plain – and unusually modest – words, "study of myself, an excuse to paint."[45]

In addition to the paintings Gauguin dedicated or gave away to others, nearly all his other self-portraits were eventually acquired by writers and artists. *Bonjour Monsieur Gauguin* (cat. 95) and the tobacco-jar portrait (cat. 65) were both bought by Schuffenecker; the *Self-portrait with Yellow Christ* (cat. 99) by Maurice Denis, the *Christ in the Garden of Olives* (cat. 90) by Octave Mirbeau, and the *Portrait at Golgotha* (cat. 218) by Segalen. It is as though some strong and very specific link were formed between the possessor of a self-portrait and its subject-creator – a link quickly destroyed by Gauguin's death and the intervention of the art market. Outside of the context of the specific individuals they were intended for, many of these self-portraits lose their point; their purpose seems dulled, heavy-handed almost to the point of caricature – as though the painting became

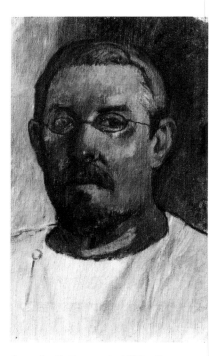

Gauguin, *Self-portrait*, 1903, oil on canvas [Kunstmuseum, Basel]

46. He wrote to Maurice Denis in June 1899: "I fear a little for you the ridicule which has befallen the Rosicrucians. . . . art has no place in this house of Péladan," Malingue 1949, CLXXI.

47. Morice 1903b, 415.

mere masquerade or soliloquy in the absence of any possessor-friend who was capable of answering.

It was at a particularly unhappy moment in Tahiti that Gauguin identified himself with the figure of Christ one last time and in a rather obvious fashion. In *Self-portrait near Golgotha* (cat. 218), one senses the extent to which Gauguin's symbolism had stopped short at a particular point in the history of the Parisian avant garde; and had it been exhibited, it would have fared no better than did the portrait exhibited in 1893. The romantic, archaic quality would have been condemned as "Rosicrucian" – precisely the same quality that he himself had ridiculed.[46] Even in extreme wretchedness – in poor health, luckless and alone – Gauguin could only rouse pity in spite of himself.

In what was undoubtedly one of Gauguin's very last portraits (W 634), the "Incan" face of which he was so proud falls away like a mask. The angle is straightforward, the clothes and hair austere, the glance obscured by a small pair of spectacles giving him the aspect of a wise old man. It is a simple statement – almost off-hand and not particularly kind – recalling the self-portraits of Chardin and Bonnard as old men. The interlocutors are all gone; there is no one left to convince and only death to confront. The other self-portraits all have arguments to frame and speeches to make: this one is still. As the model falls silent, Gauguin's ideas – the provocative theories with which he vainly sought recognition – become lost in the perfume of exotic loves and adventures, material for popular fiction and television docudrama. In death as in life, the artist Gauguin was encumbered by the man Gauguin, as one of his more clear-sighted contemporaries, Jean Dolent, well understood. Hearing of Gauguin's death in 1903 in a far-off land, he declared, "There were two men in Gauguin. . . . I sided with one against the other – often in agreement with Gauguin himself. The theoretician was voluble and imprecise but the artist at his easel was silent. He pleaded his own case. He does it better now than he did when he was alive."[47]

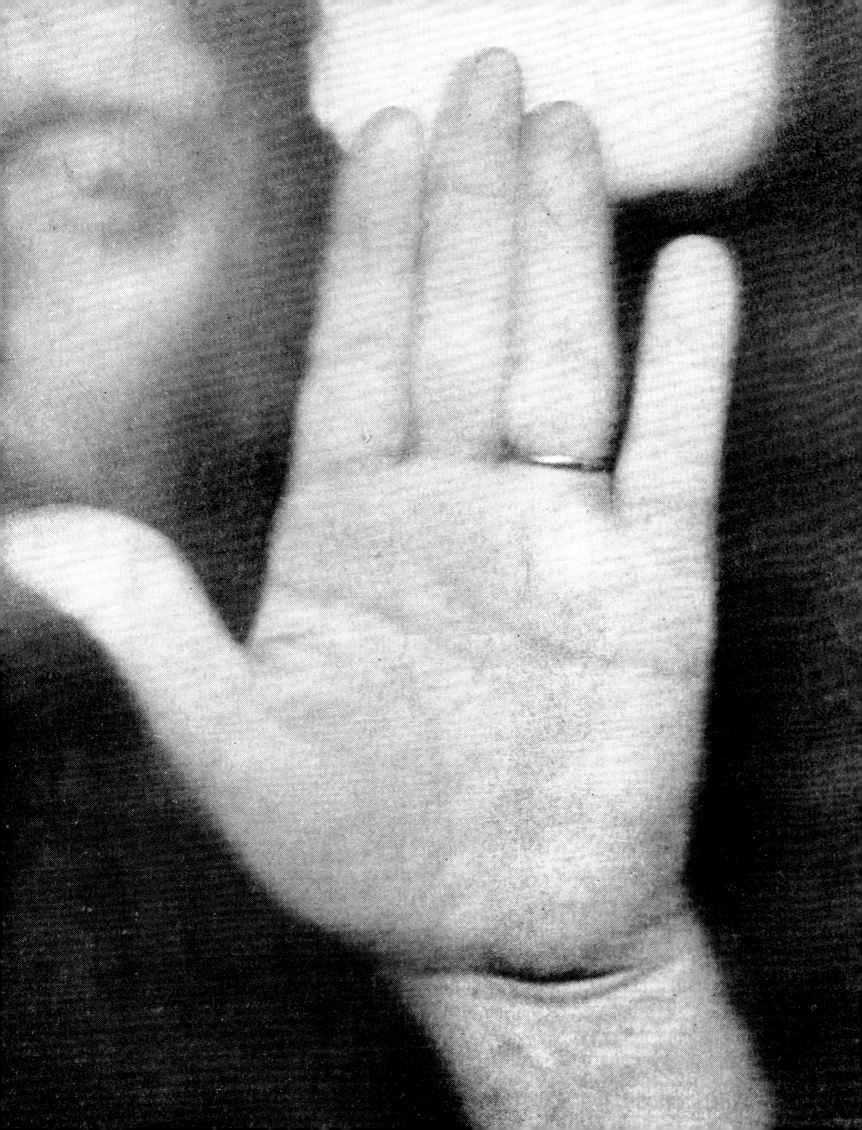

Chronology: June 1848–June 1886

ISABELLE CAHN

1848

JUNE 7

Eugène Henri Paul Gauguin is born at 52 (to-day 56) rue Notre-Dame-de-Lorette in Paris, son of Pierre Guillaume Clovis Gauguin, an editor at the *National*, and Aline Marie Chazal. His maternal grandmother is Flora Tristan (1803-1844) (certificate of birth, Municipal Building of the ninth district, Paris).

Fig. 1. Jules Laure, *Aline Gauguin, The Artist's Mother* [Musée départemental du Prieuré, Saint-Germain-en-Laye]

1849

JULY 19

Baptized at Notre-Dame-de-Lorette. His father, who is absent from the ceremony, is listed as "unemployed." His godfather is his paternal grandfather, Guillaume Gauguin (baptism register, Parish of Notre-Dame-de-Lorette, no. 467).

Fig. 2. Jules Laure, *Paul Gauguin* [Musée départemental du Prieuré, Saint-Germain-en-Laye]

AUGUST 8

The Gauguin family leaves Le Havre for Peru on the *Albert* (Merlhès 1984, 321 n. 4).

OCTOBER 30

Gauguin's father dies of a ruptured aneurism in the Gulf of Port-Famine (Punta Arenas) in the Strait of Magellan, Chile, where he is buried (*Avant et après*, 1923 ed., 134; Rotonchamp 1906, 6; inventory following the death of Aline Gauguin, DA, Hauts-de-Seine). Aline Gauguin and her children, Paul and Marie (b. April 29, 1847), move in with their great-uncle, Don Pio de Tristan Moscoso in Lima *Avant et après*, 1923 ed. 134-135).

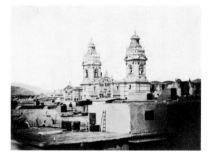

Fig. 3. *The Cathedral in Lima* [Société de Géographie, Paris]

1853

SEPTEMBER 19

In Orléans, France, Guillaume Gauguin agrees to a trust fund, which is to be divided between his two grandchildren (succession papers of Aline Gauguin, DA, Hauts-de-Seine).

END 1854-EARLY 1855

Aline Gauguin returns to France with her children. Her passport is issued in Lima on August 9, 1854 (inventory following the death of Aline Gauguin, DA, Hauts-de-Seine). They move into the family's residence in Orléans where Paul is registered as a day student (*Avant et après*, 1923 ed., 234).

1855

APRIL 9

Guillaume Gauguin dies at 25, quai Tudelle, in Orléans (death certificate, Municipal Building, Orléans).

APRIL 20
Isidore Gauguin (a paternal uncle) is named
guardian for Paul and Marie (inventory after
the death of Aline Gauguin, DA, Hauts-de-
Seine).

1856

Don Pio de Tristan Moscoso, Paul's great-
uncle, dies in Lima (*Avant et après*,
1923 ed., 138).

1859

Paul continues his education at the Junior
Seminary of the Saint-Mesmin Chapel in
Orléans (*Avant et après*, 1923 ed., 235;
Merlhès 1984, 322 n. 4).

1861

Aline moves to 33 rue de la Chaussée d'Antin
in Paris and works as a seamstress (Cadastral
Surveys, D¹ P⁴, 1861, PA; listed at this address
in Didot-Bottin, *Annuaire-Almanach du Com-
merce* from 1861-1865, having become a seam-
stress in 1862). She befriends the Arosa family
(Merlhès 1984, 322 n. 4).

1862

Paul joins his mother in Paris to prepare for
the entrance exam at the Naval Academy. He
is a student at the Loriol Institute, 49 rue
d'Enfer (Marks-Vandenbroucke 1956, 31; Di-
dot-Bottin, *Annuaire-Almanach du Com-
merce*, 1862).

1864

For his final year at school, he boards at the
lycée in Orléans (Rotonchamp 1906, 9).

1865

NOVEMBER 13
Aline draws up a will and names Gustave
Arosa as legal guardian of her children. She
leaves her portraits and paintings to her son
and suggests that he "get on with his career,
since he has made himself so unliked by all
my friends that he will one day find himself
alone." She lives in the village de l'Avenir, at 3
rue de la Paix, on the route to Romainville
(will of Aline Gauguin, DA, Hauts-de-Seine).

Fig. 4. *The Arosa Family* [Musée
départemental du Prieuré, Saint-Germain-
en-Laye]

DECEMBER 6
Too old to take the Naval Academy entrance
exam, Paul enlists as an officer's candidate in
the merchant marines aboard a three-masted
ship, the *Luzitano*, bound for Rio de Janeiro.
The voyage lasts three months, twenty-one
days (*Luzitano* boarding documents, 6P6/282,
DA, Seine-Maritime).

1866

MAY 2
Second voyage to Rio on the *Luzitano*, lasting
three months, twenty-nine days (*Luzitano*
boarding documents, 6P6/290, DA, Seine-
Maritime).

OCTOBER 1
Aline Gauguin moves to 2 rue de l'Hospice in
Saint-Cloud (inventory after the death of Al-
ine Gauguin, DA, Hauts-de-Seine).

OCTOBER 27
Paul leaves Le Havre as second lieutenant
aboard the *Chili*, which travels around the
world (Cardiff, Valparaiso, Iquique [Peru]), for
thirteen-and-a-half months (*Chili* boarding
documents, 6P6/309, DA, Seine-Maritime).

1867

JULY 7
His mother dies in Saint-Cloud (death certifi-
cate, Municipal Building, Saint-Cloud).
Gauguin learns of her death during a stopover
in India (Perruchot 1961, 44).

DECEMBER 14
The *Chili* is laid up in Le Havre (Marks-
Vandenbroucke 1956, 34).

1868

JANUARY 22
Gauguin officially enlists in the military
(6P5/165, DA, Seine-Maritime).

FEBRUARY 26
He is registered in the Cherbourg Division as
a third-class sailor, based in Le Havre. He is
listed as a professional seaman, 1.603 meters
tall, with brown hair and eyes (MR, 47-48).

MARCH 3
He is assigned to the *Jérôme-Napoléon* (MR,
60).

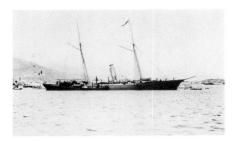

Fig. 5. *The Jérôme-Napoléon* [Musée de la
Marine, Paris]

3

JUNE-JULY

The *Jérôme-Napoléon* cruises the eastern Mediterranean and the Black Sea (Perruchot 1961, 46).

SEPTEMBER

The ship arrives in London (Perruchot 1961, 46).

1869

APRIL-MAY

The *Jérôme-Napoléon* again cruises the Mediterranean, stopping at Bastia, Naples, Corfu, the Dalmation Coast, Trieste, and Venice (Perruchot 1961, 46).

JUNE

Gauguin, now legally an adult, and his sister inherit 32,707.87 francs from their mother and 6,215.84 francs from their paternal grandfather, sums which represent houses and property in Orléans, stocks, and other assets (will of Aline Gauguin, DA, Hauts-de-Seine).

Fig. 6. *Marie Gauguin* [Musée départemental du Prieuré, Saint-Germain-en-Laye]

SEPTEMBER 25-OCTOBER 29

Gauguin is hospitalized (MR, 61).

1870

JULY 1

Promoted to second-class sailor (MR, 62).

JULY 3

The *Jérôme-Napoléon* proceeds toward the North Pole and arrives in Bergen, Norway, five days later (Psichari 1947, 24-25).

JULY 13

The ship crosses the Arctic Circle (letter from Renan to his wife, *Lettres familières*, 1947, 210).

JULY 19

France declares war on Prussia.

JULY 21

Gauguin's ship returns to Calais via Edinburgh and London (Psichari 1947, 29), and leaves for the North Sea four days later (Perruchot 1961, 48).

AUGUST 26-30

Stopover in Copenhagen (Perruchot 1961, 48).

OCTOBER 11-NOVEMBER 1

The *Jérôme-Napoléon*, renamed the *Desaix* after September 19, captures four German boats including the *Franziska*, to which Gauguin is transferred until November 1 (MR, 62).

1871

JANUARY 25

His mother's house at 2 rue de l'Hospice in Saint-Cloud is burned by the Prussians (*Avant et après*, 1923 ed., 174-175).

APRIL 23

Released from military service on six months of renewable leave (MR, 64).

1872

Lives at 15 rue La Bruyère in Paris (electoral lists D¹M², 9th district, 1873, PA; no profession listed). Recommended by Gustave Arosa, he is hired as a broker by Paul Bertin, a stockbroker at 11 rue Laffitte (Rotonchamp 1906, 15; Electoral lists D¹M², ninth district, 1874: listed as stockbroker; Didot-Bottin, *Annuaire-Almanach du Commerce*, 1872). Meets Emile Schuffenecker at the Bertin office (biography

of Schuffenecker sent to Jules Bois, Paris, sale, Hôtel Drouot, April 2, 1987, no. 153).

Fig. 7. *Paul Gauguin* [Harlingue-Viollet, Paris]

Fig. 8. Aimé Morot, *Portrait of Mr. Bertin* [private collection, Paris]

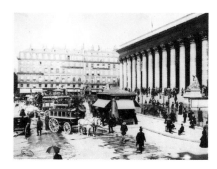

Fig. 9. *The Paris Stock Exchange*, c. 1888 [Bibliothèque Nationale, Paris]

AUTUMN

Mette Gad (b. September 7, 1850) and her friend Marie Heegaard travel from Denmark to Paris on vacation. They stay at the pension, avenue d'Eylau, of Pauline Fouignet, a friend of the Arosa family (Merlhès 1984, 319 n. 1).

1873

JANUARY

Gauguin asks for Mette's hand (Merlhès 1984, no. 1).

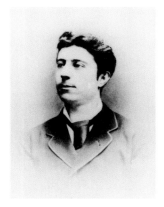

Fig. 10. *Paul Gauguin in 1873* [Musée départemental du Prieuré, Saint-Germain-en-Laye]

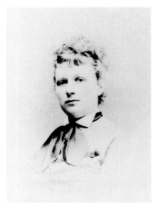

Fig. 11. *Mette Gad in 1873* [Musée départemental du Prieuré, Saint-Germain-en-Laye]

SUMMER

He paints while on vacation (Merlhès 1984, VII-X).

NOVEMBER 22

Marries Mette Gad at the municipal building of the ninth district. Paul Bertin, Gustave Arosa, and Oscar Fahle (Secretary at the Danish Consulate) are witnesses (ninth district marriage register, PA). A church ceremony takes place the same day at the Evangelical Lutheran Church of the Redemption, rue Chauchat. The couple's address is 28 Place St. Georges (marriage register, Church of the Redemption).

1874

AUGUST 31

Emil Gauguin is born at 28 Place St. Georges (ninth district record of births, PA).

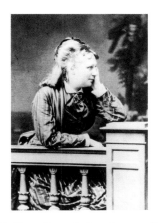

Fig. 12. *Mette Gauguin Leaning on a Railing* [Musée départemental du Prieuré, Saint-Germain-en-Laye]

OCTOBER 14

Mette's sister, Ingeborg Gad, marries the painter Fritz Thaulow (Merlhès 1984, 326 n. 16).

1875

JANUARY

Moves to 54 rue de Chaillot (Cadastral surveys, D¹P⁴, 1875-1877, PA).

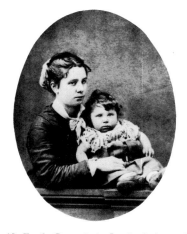

Fig. 13. *Emile Gauguin in Justine's Arms*, 1875 [Musée départemental du Prieuré, Saint-Germain-en-Laye]

MAY 8

Emil is baptized at the Evangelical Lutheran Church of the Redemption. His godfather is Fritz Thaulow, his godmothers Elisabeth Möller and Marie Gauguin, Gauguin's sister (baptism register, Church of the Redemption).

1876

MAY-JUNE

Exhibits a work for the first time at the Salon, *Sous-bois à Viroflay (Seine et Oise)* (W 12?; Yriarte, "Le Salon de 1876," *Gazette des Beaux-Arts*, July 1876, 36).

END 1876 OR BEGINNING 1877

Stops working for Paul Bertin (Merlhès 1984, XII and 327 n. 20).

1877

Moves to 74 rue des Fourneaux (Vaugirard). His landlord is the sculptor Bouillot who introduces him to sculpture techniques (electoral lists, D¹M², fifteenth district, PA: Gauguin is listed as an employee of a stock exchange; cadastral surveys, D¹P⁴, 1876). Meets Danish art critic Karl Madsen and the sculptor Aubé (cat. 10; Rostrup 1956, 63).

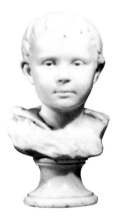

Fig. 14. Gauguin, *Bust of Emil*, marble [The Metropolitan Museum of Art, New York]

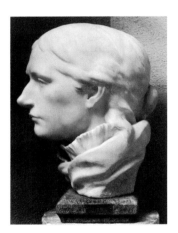

Fig. 15. Gauguin, *Bust of Mette* [Courtauld Institute of Art, London]

DECEMBER 24
Aline Gauguin is born (fifteenth district record of births, 1877, PA).

1878

FEBRUARY 25
Gustave Arosa's art collection is sold at the Hôtel Drouot (Paris 1878).

1879

Gauguin is employed by the banker André Bourdon at 21 rue Le Peletier (see business letterheads in Merlhès 1984, nos. 7, 9, 10-11).

APRIL 10-MAY 11
Gauguin is invited at the last minute by Degas and Pissarro to participate in the fourth impressionist exhibition. His marble portrait head of his eldest son Emil (G 2) is entered too late to be included in the catalogue (Merlhès 1984, no. 6; see San Francisco 1986, 271). Three Pissarros are lent to the exhibition by Gauguin. Becomes a regular at the Café de la Nouvelle-Athènes, where he associates with Manet, Degas, Renoir, Pissarro, and the art critic Duranty (Merlhès 1984, no. 8).

MAY 10
Birth of Clovis Henri Gauguin (fifteenth district record of births, PA).

JULY
Buys a painting by Pissarro (Merlhès 1984, no. 8).

SUMMER
Visits Pissarro in Pontoise for the first time (Merlhès 1984, no. 11).

1880

APRIL 1-30
Participates in the fifth impressionist exhibition with eight works (nos. 55-62, see San Francisco 1986, 304-305, 311).

SUMMER
Moves to 8 rue Carcel (Merlhès 1984, 13); the house is sublet from the painter Félix Jobbé-Duval. One of the doors opened onto the rue Blomet where Haviland later began operating a pottery factory in April 1882 at number 153. Chaplet became the director of the factory in 1883 (see pages 57-59; Cadastral surveys, D^1P^4, 1862, PA; this address appears on the electoral list where Gauguin is still listed as a stockbroker from 1881 to 1894). Works for the Thomereau agency, 93 rue Richelieu, which is involved in the sale and purchase of insurance company stocks (Merlhès 1984, 340-341 n. 39, 352 n. 58, no. 18). Emile is sent to live in Denmark with Mette's friend, Karen Lehmann (Bodelsen 1970, 601 n. 32).

Fig. 16. *The Garden and Studio* (of the house) on rue Carcel [Musée départemental du Prieuré, Saint-Germain-en-Laye]

1881

MARCH 16
Durand-Ruel makes his first purchase from Gauguin – three paintings totaling 1,500 francs (DR).

MARCH 25
Gauguin buys a seascape by Manet from Durand-Ruel (DR).

APRIL 2-MAY 1
Participates in the sixth impressionist exhibition with eight paintings and two sculptures (see Wissman in San Francisco 1986, 342-345, and 354).

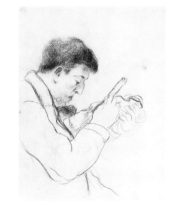

Fig. 17. Pissarro, *Gauguin Sculpting "The Woman Walking"* [Statens Konstmuseer, Stockholm]

APRIL 12
Birth of Jean-René, Gauguin's fourth child (fifteenth district record of births, PA).

6

APRIL 27

Durand-Ruel sells *The Church at Vaugirard* to Baroux and gives Gauguin two Renoirs as payment (DR).

OCTOBER 12

Buys a painting by Brown from Durand-Ruel (DR).

OCTOBER 19

Durand-Ruel buys *Effet de nuit* for 200 francs (DR).

DECEMBER 16 AND 19

Buys two paintings by Jongkind from Durand-Ruel (DR).

1882

JANUARY

L'Union Générale declares bankruptcy, causing the Stock Market to collapse.

MARCH

In spite of rivalries among the artists, participates in the seventh impressionist exhibition with eleven paintings, one pastel, and one sculpture (see San Francisco 1986, 394-395). Gauguin's stocks are in a state of collapse; he hesitates between financial and artistic careers (Merlhès 1984, nos. 23, 24, 28). He often visits Pissarro on Sundays, first in Pontoise, then in Osny (Merlhès 1984, nos. 23, 25, 30).

1883

APRIL 14

Gustave Arosa dies. Gauguin is not present at the burial two days later (Merlhès 1984, no. 33).

MAY 3

Gauguin is not present at Manet's burial (Merlhès 1984, no. 35).

JUNE 15-JULY 5

Spends three weeks with Pissarro in Osny (Merlhès 1984, no. 37; Bailly-Herzberg 1980, nos. 161 and 166). He wants to make designs for impressionist tapestries (Bailly-Herzberg 1980, no. 161).

AUGUST

Goes to Cerbère on the Spanish border, on a mission on behalf of the radical Spanish republicans (Merlhès 1984, no. 39 and 388 n. 119; undated letter from Monfreid to Bausil, LA).

SEPTEMBER

Looks for employment and has someone recommend him to the art dealer Georges Petit (Merlhès 1984, nos. 40-42).

NOVEMBER 1

Arrives at Pissarro's in Rouen where he plans on settling (Merlhès 1984, XXI).

DECEMBER 6

Paul (Pola) Rollon is born. On his son's birth certificate, Gauguin lists himself as artist-painter (fifteenth district record of births, PA).

1884

JANUARY

Moves with his family to an apartment at 5 impasse Malherne in Rouen (Merlhès 1984, nos. 43-44).

APRIL

Travels in the south of France for fifteen days with Emile Armand Bertaux, a brokerage cashier, on behalf of the Spanish republicans. Visits the Fabre Museum in Montpellier where he makes a quick copy of Delacroix's *Aline, the Mulatto Woman* (Merlhès 1984, nos. 47-48, and 394 n. 134).

Fig. 18. *Interior View of the Montpellier Museum at the End of the Nineteenth Century* [Musée Fabre, Montpellier]

APRIL 9

He leaves Durand-Ruel seven pictures on consigment (DR).

SUMMER

Murer holds an exhibition at the Hôtel du Dauphin et d'Espagne in Rouen. He includes a Gauguin from his collection (Merlhès 1984, nos. 49-50).

JULY

Mette leaves for two months in Denmark with Aline and Paul Rollon. In need of money, Gauguin sells his life insurance policy at a 50% loss (Merlhès 1984, no. 50).

AUGUST 12

Opening of the *Exposition municipale des Beaux-Arts* in Rouen where Gauguin, who exhibits one pastel and one sculpture, is listed as a student of Jobbé-Duval (Rouen 1884).

AUTUMN

Exhibits two still lifes and a portrait at the *Kunstudstillingen* in Kristiana [Oslo], Norway.

OCTOBER

Works as a salesman for a canvas manufacturer in Roubaix, A. Dillies and Company, representing Denmark. Also studies graphology (Merlhès 1984, no. 54). At the end of the month, Mette returns to Copenhagen with her children (Merlhès 1984, XXV).

Fig. 19. *Copenhagen, "Lille Rosenborg," Frederiksberg Allé 29* [Bymuseum, Copenhagen]

NOVEMBER

Joins his family in Denmark, bringing with him his art collection, which will ultimately remain in Copenhagen. Stays temporarily with Madame Gad, Mette's mother, "Lille Rosenborg," 29 Frederiksbergallé (Merlhès 1984, nos. XXV, 56; Bodelsen 1970, 601).

The family moves to 105 Gammel Kongevej. Mette gives French lessons (Merlhès 1984, nos. 56-57), and Gauguin is listed as a "traveling salesman" (February 1, 1885 Copenhagen census, Danish National Archives).

Fig. 20. *Copenhagen, rue Gammel Kongevej* [Bymuseum, Copenhagen]

1885

Writes "Notes synthétiques" in a notebook he had bought in Rouen (Cogniat and Rewald 1962; Jirat-Wasiutynski 1978, 16-17). He receives 1300 francs from the sale by Portier of his Manet, *View of Holland,* to Alexander Cassatt (Merlhès 1984, no. 157).

Fig. 21. *Mette and Paul Gauguin in Copenhagen, 1885* [Musée départemental du Prieuré, Saint-Germain-en-Laye]

Fig. 22. Gauguin, pen and ink drawing on Dillies & Co. letterhead, Winter 1885-Copenhagen [Photo by Jean-Pierre Leloir, Musée d'Orsay, Paris, Service de documentation]

APRIL 25
Moves to 51 Nørregade (Merlhès 1984, no. 75).

Fig. 23. *Copenhagen, Norregade 51* [Bymuseum, Copenhagen]

MAY 1-6
Exhibits at the Society of the Friends of Art in Copenhagen (Rostrup 1956, 70).

JUNE
Returns to Paris with his son Clovis (Cogniat and Rewald 1962, 17-18). Nearly broke, asks Durand-Ruel to buy back a Renoir and a Monet from him. He lives with the Schuffeneckers, 29 rue Boulard (Merlhès 1984, 415 n. 179 and no. 80).

Fig. 24. *Site of the Friends of Arts Exhibit Amaliegade 30* [Bymuseum, Copenhagen]

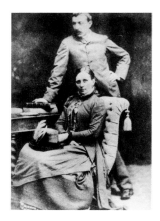

Fig. 25. *Schuffenecker's House, 29 Rue Boulard* [Musée départemental du Prieuré, Saint-Germain-en-Laye]

JULY
Visits a friend in Dieppe where he resides until early October (Merlhès 1984, no. 85).

END AUGUST-MID SEPTEMBER
Goes to London on "Spanish business." When he returns to Dieppe, he encounters Degas, with whom he apparently quarrels (Merlhès 1984, nos. 84-85).

EARLY OCTOBER
Returns to Paris where his son Clovis, who has spent several months with Gauguin's sister, comes to live with him at M. Favre's, 19 rue Perdonnet. Rents an apartment at 10 rue Cail (Merlhès 1984, nos. 86-87). Mette sells several of his paintings left in Copenhagen (Merlhès 1984, no. 90).

DECEMBER

His paintings are rejected at a Danish exhibition (Merlhès 1984, no. 92). Clovis comes down with smallpox. Gauguin takes a job first as a poster hanger, then as an inspector, and finally as an administrative secretary for the train stations (Merlhès 1984, no. 94).

WINTER 1885-1886

Copies a text purportedly by a Turkish poet Vehbi Mohamed Zunbul-Zadé, which he will later include in *Avant et après*. Lends the text to Seurat (Herbert 1958, 151 n. 21).

1886

MAY 6

Attends a dinner organized by Pissarro, in honor of the eighth impressionist exhibition, at the Lac St. Fargeau, a music hall at 296 rue de Belleville (Kahn 1925, 44-45; Bailly-Herzberg 1986, 45-46 n. 1).

MAY 15-JUNE 15

Participates in the eighth impressionist exhibition with nineteen paintings and one wood relief (see San Francisco 1986, 444-445). Clovis is a boarder at Lennuier's in Antony (Merlhès 1984, nos. 97 and 110). Sells a painting for 250 francs to Bracquemond who puts him in contact with the ceramist Ernest Chaplet (Merlhès 1984, 99).

JUNE

First evidence that Gauguin frequents Chaplet's rue Blomet studio (Merlhès 1984, no. 100).

Fig. 26. *Delaherche Cleaning the Kiln (Oven on Rue Blomet)* [Musée départemental de l'Oise, Beauvais]

The Impressionist Years

CHARLES F. STUCKEY

1. Malingue 1949, CLXXIII.

2. Gauguin, *Avant et après*, facs. ed., 193.

3. Merlhès 1984, 319-320 n. 2; and Field 1977, 239ff. n. 50.

4. Merlhès 1984, 401-403 n. 153.

5. Merlhès 1984, 323-324 n. 5.

6. Merlhès 1984, 326 n. 16.

7. Merlhès 1984, 330 n. 20.

8. Bodelsen 1970.

Taken as a group, Gauguin's early works are generally dismissed as a yeomanlike prologue, largely irrelevant, to a brilliant career that began with his first campaign in Brittany in 1886 not long after the eighth and final impressionist exhibition. Gauguin himself discounted them when he wrote to a collector around 1900: "I estimate the number of [my] canvases *since I began to paint* as 300 at most, which is not counting a hundred or so, from the beginning [of my career]."[1] Whereas Gauguin in his various autobiographical writings includes many anecdotes about his childhood and about his career after 1886, he is almost silent when it comes to the works he made and exhibited with the impressionists in the late 1870s and early 1880s.

Considering the competition, which included Degas, Morisot, and Pissarro, it hardly comes as a surprise that his works were, for the most part, overlooked by collectors and critics. What seems truly remarkable is that Gauguin ever became a coexhibitor with these artists. He had begun to paint on a strictly part-time, self-educated basis less than a year before they first pooled their resources in 1874 with Cézanne, Monet, Renoir, and Sisley to present their works in a revolutionary exhibition outside the sanctions of the official art world.

Nothing in Gauguin's early life, except a recollection of how a servant praised a dagger case that he had whittled as a child,[2] suggests that Gauguin would take even an amateur's interest in art. It was only at the age of twenty-two, just after he had completed his military service in 1871, that he started to encounter artists and collectors. His mother, who died four years earlier, had arranged for a neighbor, Gustave Arosa, to become her children's guardian. Arosa, a financier, was also a distinguished photographer specializing in art reproductions, and a collector of contemporary art.[3] Thanks to him, Gauguin began a career in the stock market where he met Emile Schuffenecker, who would likewise become an artist, as well as a selfless supporter of Gauguin's art career.[4] Arosa's younger daughter hoped to become a painter, and at first Gauguin sometimes painted in her company.[5] It was also at Arosa's that Gauguin was introduced to Mette Gad, a Danish woman two years his junior whom he would marry at the end of 1873. Several months later, Mette Gad's sister married a Norwegian painter, Frits Thaulow, and they settled in Paris.[6]

By 1876, Gauguin felt ready to exhibit at the salon, the large, annual, government-sponsored exhibition of contemporary art in Paris. The fact that the conservative jury accepted Gauguin's landscape painting, while it refused works by Manet and Cézanne, helps to explain why the impressionists had initiated a series of independent exhibitions two years before. Since no works by Gauguin are listed in subsequent salon catalogues, either he stopped submitting or he, too, fell victim to the juries. All that is known about this important period is that Gauguin left his job and moved to a larger home in time for the birth of his second child, Aline. His new landlord and neighbor, Jules Bouillot, was a sculptor.[7] Under Bouillot's tutelage, Gauguin took up carving.

Just as important, around this time Gauguin became one of the most active collectors of impressionist art.[8] In early 1878, when Arosa put his distinguished art collection, including three works by Pissarro, up for sale, Gauguin bought nothing. But when the fourth impressionist exhibition opened in April

9. Bodelsen 1970, 590; Merlhès 1984, 333 n. 27.

10. Merlhès 1984, no. 6.

11. Pickvance in San Francisco 1986, 244-250.

12. For Gauguin's business career, see Bodelsen 1970, 598-601, and Merlhès 1984, 332-333 n. 26 and 340-341 n. 39.

13. Merlhès 1984, no. 16, and Malingue 1949, CXXVII.

14. W 46.

15. W 49.

16. W 30.

Gauguin, *The Mandolin,* 1880, oil on canvas [private collection]

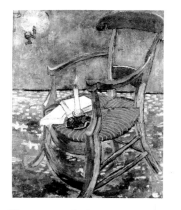

Vincent van Gogh, *Gauguin's Chair,* 1888, oil on canvas [Vincent van Gogh Foundation, National Museum Vincent van Gogh]

1879, he was listed in the catalogue as "Mr. G," lender of two paintings and a decorated fan by Pissarro.[9]

Aware that Gauguin was an ambitious amateur artist, Pissarro and Degas extended a last-minute invitation to exhibit with the group.[10] He accepted, submitting a marble bust of his eldest child, Emil, the only sculpture in the show. Cézanne, Renoir, and Sisley did not participate this time, in protest of Degas' rule that members refrain from exhibiting works at the official salon; this marked the outset of factionalism among the original impressionists.[11] The coincidence of these disputes and Gauguin's debut would have serious implications. Trying to learn from artists in opposing camps during the following years, Gauguin seems to have developed in several different directions all at once. The rather difficult experience of mediating among these ideological adversaries was perhaps the single most significant factor in Gauguin's development, and it seems fitting that he later invented the term "synthetist" to describe his art, encouraging the next generation of maverick artists to embrace the widest variety of aesthetic ideologies in the name of universality.

The experience of collaborating with these talented artists, plus the exhilaration of forming a collection of contemporary art, thanks to his recent gains in the stock market, intensified Gauguin's obsession with the possibility of a career change.[12] By the time the fifth impressionist exhibition opened in April 1880, he had seven new paintings ready to show, as well as a marble bust of his wife. At least three of the new paintings depicted the countryside around Pontoise where Pissarro lived with his wife and four children, both for the sake of economy and to avoid distracting art world debates in Paris. Reviewers of this exhibition correctly pointed out that Gauguin's style was heavily indebted to this tutor. Although it was less apparent in Gauguin's works at first, Degas was also a major influence. Gauguin, for his part, so enjoyed discussions of art theories at the Café Nouvelle Athènes where Degas held court that he came to embrace an attitude that would become anathema for him a decade later: "It's absolutely obligatory to live in Paris to paint," he wrote to Pissarro in 1881, "in order to keep up with the ideas."[13]

In an 1880 still life painting,[14] which Gauguin gave to Degas in exchange for a pastel, he went beyond Pissarro's lessons in composition and brushstroke-by-brushstroke analysis of form, light, and color, adding humorous, ironic details. For example, although movement is of no special concern in still-life painting, Gauguin depicted only fragments of objects in this work, as a satirical commentary on the partial figures that Degas commonly used to record movement across his field of vision. Moreover, the objects that Gauguin included and the way he arranged them stress his art-for-art's sake attitude: the mandolin has no strings with which to function properly, and the chair upon which it is placed functions incorrectly as a table. This painting and a related still life by Gauguin[15] showing flowers on a chair seat should be understood as precedents for the famous still life of a candle and books on a chair that van Gogh painted in 1888 as an abstract portrait of Gauguin.

Listed in the catalogue with the title *Atop a chair* (*Sur une chaise*), this painting, exhibited in 1881, is but one indication of Degas' growing influence. Whereas his colleagues worshipped sunlight, Degas had sought to render artificially illuminated nocturnal scenes, and Gauguin must have painted his *Night in Vaugirard*[16] in direct response. Since they are directly based upon figures in pas-

17. Bodelsen 1970, 593.

18. Copenhagen 1984, no. 10.

19. Merlhès 1984, nos. 13-14; Pickvance 1985, 395, points out that these two excerpts come from the same letter.

20. Bodelsen 1970, 605, no. 4.

21. Merlhès 1984, 350-351 n. 56.

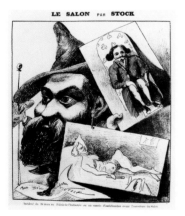

LE SALON PAR STOCK

Stock, *Caricature of Paul Cézanne with Two Paintings Rejected by the Salon Jury of 1870* [from an unidentified Paris newspaper; photo: Rewald 1986]

tels by Degas, however, the two crudely carved wood sculptures (cats. 5 and 6) that Gauguin also exhibited in 1881 are the clearest expression of his debt to the older artist, even if they challenge its premises. These sculptures are deliberately devoid of technical finesse, in blatant contrast to the sort of photographically refined realism exemplified by Degas' controversial *Little Fourteen-Year-Old Dancer*, the centerpiece of the same exhibition. Deliberately rustic in imitation of folk art, Gauguin's wood sculpture heralds the primitivizing mode that would become his most powerful means of pictorial expression.

The large nude (cat. 4) that Gauguin exhibited with the modest title of *Study* was likewise conceived to address art issues inherent in modern realism. Here, Gauguin's mandolin, along with a striped throw rug, hangs on the background wall as if to provide a sort of haremlike setting favored for conventional salon nudes. Gauguin's painting, which depicts a paunchy, round-shouldered woman sewing, at first appears to be an unremittingly realist response to such artificially posed pictures. Yet, since in reality a woman would not undress or turn her back on the light to sew, *Study* also amounts to a parody of realism in art.

Gauguin's professional ambitions were justified when the dealer Durand-Ruel bought three of his landscape paintings shortly before the opening of the 1881 exhibition.[17] That Gauguin had hired a model to pose in the nude is one more indication of these ambitions. But since, with the exception of two much less ambitious pictures of a different nude model,[18] this was his only attempt at this genre until 1887 (cat. 34), perhaps his wife disapproved. Presumably, Gauguin painted all of these pictures in the studio that adjoined the larger home he rented in 1880 to accommodate his growing family as well as his artist's needs.[19] He probably also needed to keep some of the pictures in his growing collection hidden from his family, such as the large satirical nude by Cézanne.[20]

The contentious spirit that guided Gauguin as an artist between 1880 and 1882 is reflected in his pioneering partisanship as a collector of works by Cézanne, whose paintings, such as the nude that had been refused by the jury for the salon of 1870, often outraged even his revolutionary impressionist colleagues. Although it is generally claimed that Gauguin met Cézanne at Pissarro's in Pontoise during the summer of 1881, the two men probably met in Paris,[21] where Cézanne lived from April 1880 until April 1881, an interlude in his self-imposed isolation far away from the capital in his native Provence. If Degas would serve as the role model for Gauguin the ideological gadfly who welcomed young disciples in Brittany, Cézanne would serve as the model for Gauguin the prophet, in Tahiti, removed far from contemporary critical debate, to meditate on ancient values and thus renew art at its source.

The works that Gauguin made in 1881, for the most part records of his own family life in the new rue Carcel home, do not reflect his growing enthusiasm for the art of Degas and Cézanne so much as a dialogue with Degas' protégée, Mary Cassatt, who, like Gauguin, had begun to exhibit with the impressionists in 1879. As if seeking to develop a type of subject matter unexplored by the original members of the group, both these artists now began to paint children, welcoming the challenge raised by such unpredictable models. Although for Gauguin it was surely expedient and economical to use family members as models, these paintings are far from conventional domestic genre portraits of cheerful innocence.

Instead, Gauguin's pictures are subdued emblems of the mysterious private thoughts and dreams of self-absorbed children. The striking originality of this group of pictures has seldom been appreciated, yet they prefigure Gauguin's more openly symbolic images of the private meditations of Tahitians in the innocence of their pre-industrial world.

When Gauguin exhibited these paintings of children at the 1882 impressionist exhibition, he gave them stylized titles, such as *La petite s'amuse*[22] (as in Hugo's controversial play *Le Roi s'amuse*), or *La petite rêve*. The "little one" is his daughter, Aline, who looks boyish with her short hair and has consequently often been mistaken for one of Gauguin's sons. Several of these pictures of Aline document the inception of an important characteristic of Gauguin's mature paintings, the incorporation of studies of individual figures into illogical pictorial contexts (cat. 120). For example, he made two paintings that each show the same child twice (as if in a dialogue with itself), just as he later used the same model for both figures in some of his early Tahitian genre scenes (cat. 130). He apparently used a portrait of Aline reading as the point of departure for a portrait of his neighbor, Aubé, in his ceramist's studio (cat. 10), and the strange discontinuities in the finished pastel are the direct result of incompletely integrating two different settings and moods in proto-surrealist fashion.

As far as is known, it was at the 1882 impressionist exhibition that Gauguin, following the lead of his colleagues, began to use simple white frames for his paintings,[23] as he would continue to do until 1893 (cats. 16 and 111). Unfortunately, these original frames have all been replaced by more conventional gold ones, thus altering Gauguin's apparent intention to set his pictures off in a neutral context, something like the way that prints are set off by their white margins. Whatever precise role such frames were intended to play in terms of overall color harmony, they amounted to symbols of modernity, and Gauguin took a special pride in their innovative character. Writing to his dealer brother in 1888, van Gogh asked, "Do you know that Gauguin was to some extent the inventor of the white frame?"[24]

No less indicative of Gauguin's growing ambitions and self-confidence was the active role that he played as an organizer of this seventh impressionist exhibition. In order eventually to support his family with his art, Gauguin needed to establish a reputation, and such exhibitions were his best chance to do so, but only if their quality remained high. The 1881 exhibition had alarmed many collectors, critics and artists, including Gauguin, because newcomers to the group recruited by Degas were mediocre. Wounded by their criticism, Degas now withdrew from his former colleagues and broke off his friendship with Gauguin until 1886.[25] It seems significant that Gauguin suspended his experiments as a figure painter throughout this rupture with Degas.

The last of Gauguin's experimental figure pieces is a carved wood plaque, closely based on a painting by Corot that had been exhibited in 1881, depicting a naked child brushing its hair.[26] Presenting it as a gift to Pissarro, who considered himself to be a student of Corot, Gauguin assured him that there was no market for such sculpture.[27] Commercial success was an urgent consideration after the stock market crash of January 1882. Considering Gauguin's responsibilities as a father of four, it is surprising, then, that the crash seemed only to increase his

22. W 51 (probably not W 55).

23. Hepp 1882.
24. Merlhès 1984, XCII.

25. Merlhès 1984, nos. 20-22 and no. XXXI.
26. G 7; and see Robaut 1905, no. 1568.
27. Merlhès 1984, no. 29.

28. Merlhès 1984, no. 23

29. Merlhès 1984, no. 29.

30. Merlhès 1984, nos. XVII-XVIII.

31. Merlhès 1984, no. 40.

32. Bailly-Herzberg 1980, no. 164, 224.

33. Kahn 1925, 115.

34. Merlhès 1984, XX.

35. *Avant et après*, facs. ed., 144.

36. Merlhès 1984, no. 65.

37. Merlhès 1984, no. 79.

determination to leave his job as an insurance agent and make his livelihood exclusively from art.[28] His letters from this period contain several references to his interest in decorative art projects, including furniture[29] and tapestry design.[30] Even if such potential money-making schemes remained undeveloped, Gauguin's continuing interest in the decorative arts persisted, as revealed by the stylish furnishings used as props in his paintings (cats. 8, 160, 223). Sales potential probably also guided Gauguin's decision to begin to make decorated fans (cats. 15 and 23). Most important, however, the fact that Gauguin painted virtually nothing except landscapes from 1882 until 1886 reflects his awareness that dealers like Durand-Ruel had more clients for landscapes than for figure paintings.[31]

His artistic license restricted by economic pressures in practice, Gauguin nevertheless became increasingly fascinated with abstract questions of style and theory, sharing Pissarro's reverence for the principles of Egyptian, Persian, Chinese, and Japanese art.[32] Gauguin's advocacy of such unorthodox systems of representation is exemplified by a text that he copied out and circulated among his colleagues, including Seurat.[33] Allegedly a translation of an ancient Persian painter's manual, Gauguin's text is a justification for the sort of emphasis on orchestrated color and silhouette that would characterize most decorative post-impressionist art.

Expecting the birth of his fifth child at the end of 1883, Gauguin nevertheless decided to leave his job and to move his family to Rouen where the cost of living was lower. Pissarro worried that, under such pressures, Gauguin's work would become too commercial.[34] Gauguin consigned seven paintings with Durand-Ruel in April 1884, but only one seems to have sold. Unfortunately, the titles that Gauguin gave to these works make it impossible to identify them and thus to decide whether or not Pissarro's anxieties were justified.

Distressed by the decline in their fortunes, Gauguin's wife insisted that she and the children return to her family in Copenhagen. In early December, Gauguin joined them, hoping to earn money as a sales representative in Scandinavia for a French canvas manufacturer. Although he was determined to continue painting in Denmark, his artist's aspirations were disparaged by his wife's family, and local artists were critical of his impressionist style, which was controversial by Copenhagen standards. In *Avant et après*, looking back on this period, Gauguin declared, "I loathe Denmark."[35]

While he was there, Gauguin continued to formulate a new ideology for his art. Writing to Schuffenecker in January 1885, Gauguin expressed dissatisfaction with impressionist dogma based on the accurate rendition of physical sensations, and he explained the need for artists to search out the invisible underlying verities of life.[36] Singling out Cézanne as a role model for this more mystical approach to art, Gauguin speculated about abstract symbolism inherent in different colors and different types of lines. In May, Gauguin wrote to Pissarro: "More than ever I am convinced that there is no such thing as exaggerated art. And I even believe that there is salvation only in extremes. . . ." What Gauguin perceived as the ultra-conservative mentality of Copenhagen acted as a catalyst for extremism in his temperament as well as in his art theory: "Every day I ask myself if I mustn't go to the attic and put a rope around my neck."[37] He fled Denmark and his family in June, bringing his son Clovis with him to Paris.

38. Merlhès 1984, no. 91.

39. Merlhès 1984, no. 107.

40. Merlhès 1984, no. 92.

41. Mirbeau, 26 April 1886.

Instead of solving his problems, this move only changed them. Unable to find the sort of work he had hoped for as a sculptor's studio assistant or as a runner at the stock exchange, Gauguin earned menial wages pasting posters around a railway station. His irritability sometimes led to outbursts and he barely avoided fighting duels.[38] "Let us hope that next winter will be better," Gauguin wrote to his wife. "In any case I will be less undecided [and] I will kill myself sooner than live like a beggar as [I did] last winter."[39]

Gauguin's greatest hope for the future was to stand out at the next (and what would be the last) impressionist group show, slated to open in May 1886.[40] Realizing that Monet and Renoir would refuse to exhibit with the group, the organizers invited several extraordinary newcomers, whose works, rendered in uniform dots of carefully calculated colors, had greatly impressed Pissarro. It was these artists, Seurat and Signac, who would dominate this exhibition with their scientific approach to impressionism. Gauguin, who had had little time to devote to new works for this exhibition, was upstaged. Opposed to the theories of the neo-impressionists and jealous of their success, Gauguin must have sympathized with another newcomer who had agreed to take part in this same historic exhibition. As one critic remarked of him, "Odilon Redon is nearly the only one to resist the great naturalist movement and to oppose what is dreamed with what is lived, the ideal with the truth."[41] Gauguin's art would take this same direction. Five years later on the eve of Gauguin's departure for Tahiti, the same critic who wrote these remarks, Octave Mirbeau, would become Gauguin's first champion in the press.

1

Portrait of Gauguin by Pissarro Juxtaposed with Portrait of Pissarro by Gauguin

c. 1879–1883

358 x 495 (14 x 19¼), irregular sheet

black chalk and pastel on blue laid paper

Musée du Louvre, Département des Arts Graphiques, Paris

shown in Paris only

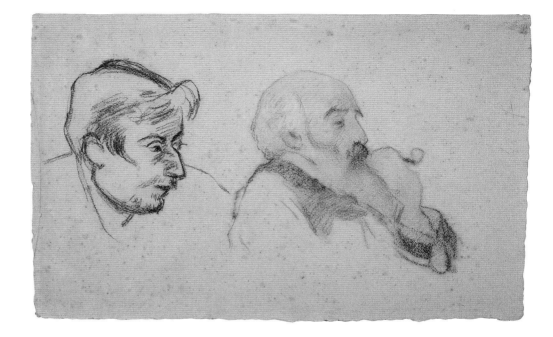

1. Merlhès argued that, in 1879, Gauguin did not actually stay in Pissarro's home. See Merlhès 1984, 334 n. 30, and no. 11.

2. Rostrup 1956, 65; Rewald 1958, no. 5.

3. Rewald 1958, 23 n. 4; Pickvance 1970, 19 n. 1; London 1981, no. 112.

This drawing, one of Gauguin's quick sketches of the late 1870s and early 1880s, was evidently detached from one of his little notebooks as a keepsake for Pissarro, who added his own quick portrait sketch of Gauguin. Pissarro's son, Paul-Emile, presented it to the Louvre in 1947.

Perhaps Gauguin met Pissarro in the early 1870s when Gauguin's guardian, the celebrated collector Gustave Arosa, began to acquire works by Pissarro. It was surely by 1878, for Gauguin lent three works by Pissarro to the fourth impressionist group show early the following year. Pissarro invited Gauguin to Pontoise during the summer of 1879,[1] when the two began to paint together, as they would in the summers of 1881, 1882, and 1883.

It is usually presumed that this collaborative double portrait was executed during one of these summer visits, although it could easily have been done in Paris. Gauguin's drawing of Pissarro is rather close in style to a similar pencil sketch of his mentor in a private collection that has been inscribed *1880*, presumably by one of Gauguin's children or his wife.[2] But although the Louvre drawing has been dated variously from 1880 to 1883,[3] it is virtually impossible to date precisely drawings from this period by either artist on the basis of style.–C.F.S.

2

Apple Trees in the Hermitage Neighborhood of Pontoise

1879

65 x 100 (25⅜ x 39)

oil on canvas

Aargauer Kunsthaus, Aarau

EXHIBITION
Basel 1949, no. 4

CATALOGUE
W 33

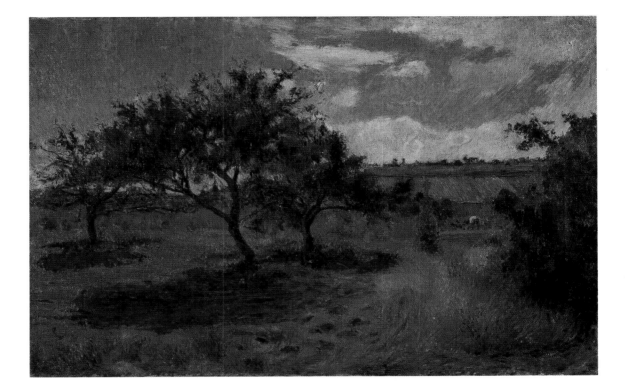

1. W 32.

2. W 31.

3. With the title *Les Pommiers de L'Hermitage*. By mistake all three versions have generally been referred to as *Pommiers en fleurs*, despite the fact that the trees represented in them are not in blossom.

4. W 31, W 34, W 35, and perhaps W 37 and W 38 bis.

5. Pissarro and Venturi 1939, no. 94.

6. Merlhès 1984, nos. 6-11.

7. Merlhès 1984, no. 11.

8. See W 6–7, W 37–38, W 70–71, W 75–80, W 150–152, W 153–154, W 162–163, W 348–349, W 415–415 bis, W 431–432, W 436–437, W 544–545, W 581–582.

Gauguin painted a smaller version[1] of this subject, presumably *en plein air*, and a larger version,[2] signed and dated 1879, which was included in the fifth impressionist group show in April 1880.[3] The exhibition included no fewer than three paintings[4] by Gauguin with motifs from around Pontoise, where Pissarro had lived since early 1866. The small hilltop orchards and gardens in the Hermitage section there were among Pissarro's favorite subjects. The motif of apple trees in Gauguin's painting recalls several landscapes painted by Pissarro in the early 1870s, including one that apparently belonged to Gustave Arosa.[5] After Gauguin had purchased works by Pissarro for his own collection, and had sought to persuade his colleagues on the stock exchange to do likewise, Pissarro invited Gauguin to visit Pontoise and paint with him. Judging from their correspondence[6] and details in the paintings done in Pontoise, Gauguin's 1879 visit probably took place in June.

Although the largest version of *Apple Trees* was probably painted on part of the roll of wide canvas that Gauguin bought at the end of July in Paris,[7] the smaller versions were presumably painted on the spot in Pontoise. The smallest version of *Apple Trees*, in which the clouds are massed differently, may be Gauguin's initial, unedited record of the motif. He apparently decided to silhouette the treetops decoratively against the blue of the sky in the other two versions rather than against a screen of white clouds as in the first. In all but one important detail—the *repoussoir* of foliage in the foreground at its far right edge—the Aarau version corresponds with the large exhibited version of the picture. Gauguin may have added this detail for compositional balance, but ultimately he opted to leave it out of the largest version. The fact that beginning in 1874 Gauguin sometimes repeated a given motif on two canvases[8] suggests that he was inclined to develop

his ideas this way rather than through preliminary drawings. The existence of three versions of *Apple Trees*, however, is probably an indication of the importance of this particular motif for Gauguin as he strove for professional status as an impressionist landscape painter.

Gauguin's own evolving artistic temperament is indicated in the emphasis on decorative arabesques, evident in the profiles of the clouds and trees and in the dense shadows, which amount to symbols of the intense sunlight in this record of farmers at work. His disciple Séguin wrote of the style of Gauguin's Brittany paintings done a decade later: "No one was more able than he to find, without exaggeration, the ever-perfect decoration in all things. By contemplating the emotions he felt, he perceived in rocks, in trees, in all of nature, the arabesque that thrills or charms you, the line that characterizes the undulation of a plain, or fixes the expression of a face."[9]–C.F.S.

9. Séguin 1903b, 230–231.

3
Buildings around a Farmyard

Among the earliest in Gauguin's decade-long series of "portraits" of farm villages (see cats. 12, 59, 109),[1] *Buildings around a Farmyard* exemplifies a modern realist, albeit picturesque, genre of landscape painting developed by Corot around 1830 and subsequently adopted by Pissarro, Cézanne, and van Gogh. Characterized by irregular rooftop silhouettes and alternately bright and dark wall planes registering the fall of light, this genre celebrates the elementary geometry of shelter and workplace. Gauguin bought a landscape of this sort that Cézanne painted in 1880, while he was visiting Zola at his country home.[2]

For his own painting, Gauguin selected a slightly elevated vantage point behind a cluster of buildings, the stark, windowless walls of which can be compared in concept to the figures with their backs turned in the mute genre paintings of Degas. As if he wanted inanimate, mundane objects like the architectonic haystacks and the water tank in the farmyard to play the chief roles in his narrative, Gauguin omitted figures altogether.

A careful study drawing of the large building on the right documents Gauguin's fascination with texture as well as silhouette.[3] Translating such observations into the medium of oil paint, Gauguin applied short, twisted strokes to render both this weathered tile roof and the grass in the foreground. In conjunction with Gauguin's muted palette, this brushwork adds to the tapestrylike character of his picture.

Given the sophisticated brushwork, the dense composition on a relatively ambitious scale, and the mood of privacy, *Buildings around a Farmyard* is among Gauguin's most impressive early exhibition pictures. It has been suggested that this painting might correspond to the work exhibited at the sixth impressionist show of 1881 with the curious title, *My Landlord's Property*. If so, one of the large residences in the background may be, in the spirit of Cézanne's "portrait" of Zola's house in Gauguin's collection, a record of Gauguin's new home in the Vaugirard section of Paris, sublet in the summer of 1880 from the painter Jobbé-Duval. Yet the hilly landscape in Gauguin's painting appears not to record this neighborhood at all but, instead, one of the villages near Pontoise or Osny, where he worked when he visited Pissarro.—C.F.S.

1. W 35, W 36, W 37, W 38, W 87, W 100, W 121, W 196, W 199, W 200, W 271, W 394.

2. Bodelsen 1970, 606, no. 6.

3. Nationalmuseum, Stockholm, NM 1-36/1936, 24 verso.

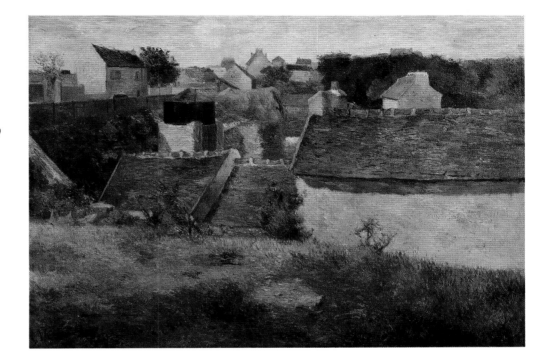

1880

81 x 116 (31⅞ x 45⅝)

oil on canvas

signed at lower left in black, *P. Gauguin 1880*

Sam Spiegel Collection

EXHIBITIONS
(?)Paris 1881, no. 31, *Le terrain de ma pro-
priétaire*; Vienna 1960, no. 3

CATALOGUE
W 44

4
Nude Study, or Suzanne Sewing

1. The left edge, including the "G," has been folded back to serve as the tacking margin.

2. Malingue 1959, 30; for the putative symbolism of *Nude Study*, see Andersen 1971, 30-32.

3. Malingue 1949, CXXVII.

4. Bodelsen January 1966, 34.

5. Merlhès 1984, 342 n. 44.

6. Damiron 1963, n.p.

7. Merlhès 1984, no. 14. Pickvance 1985, 395, points out that nos. 13 and 14 in Merlhès 1984 are extracts from one letter.

8. W 26, misdated 1878; presumably done on the roll of wide canvas mentioned in Merlhès 1984, no. 11.

9. Bodelsen 1962, 208.

10. Huysmans 1883, 240.

Pola Gauguin (born 1883!) claimed that the family nursemaid, Justine, was the model for this painting. Pola also believed that the picture was the "first symptom of the return to primitivism" in Gauguin's art, and that the positive critical reception gave him the determination to leave his financial career to become a full-time artist.[2] Gauguin called the painting "Suzanne" in a letter to his wife in 1892.[3] Bodelsen argued that Gauguin must have hired a professional model by that name,[4] but Merlhès pointed out that "Suzanne" could be a generic name for a model, rather than a specific one,[5] and that, like Degas, Gauguin thought of his modern nudes as a continuation of the traditional Old Master subject of Susanna and the Elders.[6] Bodelsen contended that *Nude Study* was painted from the model mentioned in a letter written after the artist rented a new studio in 1880.[7] In the context of Gauguin's work around 1880, *Nude Study* seems like a reaction against the large conventional genre painting for which his wife had posed at work with needle and thread, albeit fully dressed.[8] It was probably around this same time that Gauguin added a large nude painted by Cézanne to his collection.[9] Now lost, this controversial work depicting a haggard model may have inspired Gauguin to attempt his own unorthodox treatment of the nude subject.

Huysmans singled out *Nude Study* for high praise in his review of the sixth impressionist group show of 1881, describing it as a paradigm of realism that eclipsed the celebrated nudes of Courbet by recalling the genius of Rembrandt.[10]

Nude Study, or Suzanne Sewing

1880

111.4 x 79.5 (43½ x 31)

oil on canvas

signed and dated at upper left, in purple, [G]*auguin*;[1] in dark red, *1880*

Ny Carlsberg Glyptotek, Copenhagen

EXHIBITIONS
Paris 1881, no. 36, *Etude de nu*; Copenhagen 1889; Copenhagen, Udstilling 1893, no. 148, *Studie afen nogen Kvinde, som syer*, misdated 1889; Copenhagen 1984, no. 4; Copenhagen 1985, no. 9

CATALOGUE
W 39

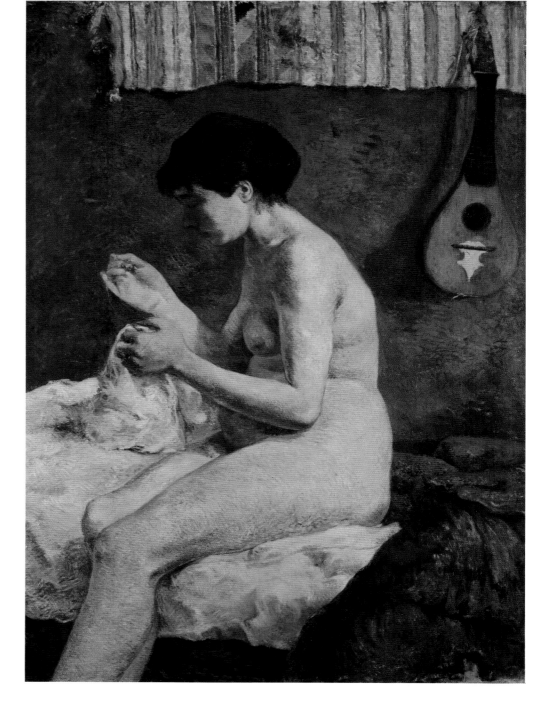

11. Gauguin depicted the same rug or one like it in several still lifes (W 46, W 47, and W 209). Although Huysmans described it as "Algerian," it may be South American in origin.

12. Trianon 1881, 2-3.

Presumably Huysmans was referring specifically to Rembrandt's *Bathsheba with King David's Letter* (Louvre, 1654), since this unidealized treatment of a full-bodied model may well have been a conceptual starting point for Gauguin's modern nude. Moreover, the varied, often rugose way that Gauguin applied his paint has something in common with Rembrandt's vigorous brushwork; it may also be that here Gauguin was seeking an analogy in paint to the coarse texture of the rug that decorates the background wall of the composition.[11]

As another critic observed, however, even by Rembrandt's standards, Gauguin's *Nude Study* is exceptionally ugly.[12] The model's face is bruised with shadow, and her pallid chest is mottled with blues and greens. Worst of all is the graceless profile of her back, which seems to have been reworked several times. It

13. Renoir had entitled the controversial nude that he exhibited in the 1876 impressionist group show *Etude*.

14. Huysmans 1883, 238.

15. Merlhès 1984, no. 36.

can be assumed that Gauguin developed the painting extemporaneously in the fashion of Manet, by wiping out and painting over until he reached a satisfactory rendition of any given detail, as there are no surviving preparatory drawings for *Nude Study*. Perhaps Gauguin used the modest designation "Study" for this ambitious picture to explain the presence of such reworked areas.[13]

The discrepancy between the weak arms of Gauguin's model and her bloated paunch and ample hips suggests that she is not a hardened working woman, but rather a bourgeoise, her ugliness an emblem of modern civilized life. Oblivious to Gauguin's satire, Huysmans described *Nude Study* as " . . . a girl of our own times, a girl who does not pose for spectators, who is neither lewd nor affected, who very nicely busies herself with repairs to her old clothes."[14] Yet whereas Degas and Manet had already painted modern nudes without any apparent artifice in credible everyday situations, Gauguin seems to have posed his model with contempt for conventional realist narrative detail. Women seldom sew in the nude in real life! Indeed, with the exception of the thimble on his model's finger, the limited props in Gauguin's painting are more exotic than domestic; the rug and mandolin do not suggest modern Paris so much as the fantasy world of Near-Eastern odalisques by painters still indebted to Delacroix and Ingres. Apart from Gauguin's discordant treatment of color, it is the incongruity between the model's physique and pose and these props that makes *Nude Study* so ironic and modern. When Huysmans' review appeared in 1883, Gauguin immediately complained in a letter to Pissarro, " . . . in spite of the flattering part, I see that he is attracted only by the literary dimension of my female nude, and not by how it's painted."[15]—C.F.S.

5
The Singer, or Portrait of Valérie Roumi

Degas, *Café Singer*, 1878, pastel and distemper on canvas [Fogg Art Museum, Collection of Maurice Wertheim, Class of 1906, The Harvard University Art Museums, Cambridge]

The Singer, exhibited with the impressionists in 1881, at first suggests a pastiche of a pastel exhibited by Degas with the same group in 1879, the *Café Singer*. Each is a bust-length image with a minimum of props, and it seems that in each the artists wanted to limit themselves to the conventions of portraiture while evoking the spontaneity of a modern-life genre scene observed from close up. Gauguin's bouquet of roses wrapped in paper that an admirer has presented to the performer is also a motif that Degas had used in several other pictures of ballet dancers executed in the late 1870s, and it can be assumed that Gauguin included this bouquet as a reference to his colleague's art. The fact that Gauguin fashioned the bouquet in plaster stained to blend into the reddish color of the mahogany suggests either that the bouquet was a late addition to his original composition or that he was too inexperienced in carving in relief to render the intricate shapes of the petals and folded paper in wood. Yet it is possible that with *The Singer* Gauguin wanted to make a point about the conventions of sculpture by mixing mediums.[1] Whatever the rationale, the mixture fooled critics who reviewed the 1881 exhibition. One of them described *The Singer* as painted plaster, and another as carved pear wood.[2]

With the exception of Huysmans, the critics who deigned to mention *The Singer* in their reviews complained that Gauguin's rendition of the bouquet and the figure was crude. One might assume that the awkward passages are the result

The Singer, or Portrait of Valérie Roumi

1880

diameter 54 x 51, depth 13 (21 x 19⅞ x 5)

mahogany with details added in plaster and touches of polychrome

signed in the plaster bouquet and dated at lower left, *P. Gauguin, 1880.*

Ny Carlsberg Glyptotek, Copenhagen

EXHIBITIONS
Paris 1881, no. 38, *La Chanteuse. Médaillon. Sculpture*; Copenhagen, Udstilling 1893, no. 126, *Valérie Roumi*, misdated 1882; Copenhagen 1948, no. 75; Copenhagen 1984, no. 5

CATALOGUE
G 3

Forain, *Portrait of Valery Roumy-montmartroise*, c. 1880-1883, pastel [The Royal Museum of Fine Arts, Copenhagen, Department of Prints and Drawings]

1. He would do the same in a portrait bust of his son Clovis (G 6), executed in wax and walnut, that he exhibited in 1882.

2. Huysmans 1883, 212; and Trianon 1881, 2–3.

3. See cats. 4, 6.

of inexperience, except that all of Gauguin's subsequent wood reliefs are still more awkward in execution, stylized to achieve the expressive power of folk art or so-called primitive art. In the case of *The Singer* it is possible that Gauguin's style was guided by a satirical impulse that characterizes other works by him from this time.[3] *The Singer* reminded Huysmans of the type of female figure used by the macabre Belgian printmaker, Félicien Rops,[4] for his scathing attacks on the decadent morals of modern-day Europe.

Unfortunately, nothing is known about the model for *The Singer*, Valérie Roumi, whose identity was first recorded in the catalogue for the exhibition in Copenhagen in 1893. Until 1884–1885 Gauguin owned a portrait of the same model in pastel by Forain[5] with the following inscription on its verso: *Valery Roumy (montmartroise) ca. 1880 donné par F. au peintre Paul Gauguin.*

The rather unusual medallion format of *The Singer*, a type associated either with architectural decorations or commemorative art, is usually rendered in stone or bronze. Most of all *The Singer* recalls the great funerary medallion reliefs of David d'Angers and Préault.[6] Préault received considerable attention after his death in early 1879, which may have inspired Gauguin to undertake *The Singer*. Although there is no evidence that his portrait of Valérie Roumi was conceived as an effigy, in their reviews of the 1881 exhibition both Mantz and Trianon found the model to appear thin and sickly.[7] If Gauguin intended his relief with its gilded background accents as an architectural decoration, instead of as a funerary medallion, it would be perhaps the first example of his ambition to bring a decorative dimension to his art. Unfortunately, there is no account of how *The*

4. Huysmans 1883, 212.

5. Bodelsen 1967, 225; in a notebook which dates from 1880–1884, Degas recorded the name *Valerie Romi/104 Quai* [de] *Jemmapes*; Reff 1976b, 1: 141.

6. Millard 1976, 80.

7. Mantz 1881, and Trianon 1881.

Singer was installed at the 1881 impressionist exhibition, whether hung on a wall or placed flat with its back serving as the base. As with *Woman on a Stroll* (cat. 6), Gauguin has here left traces of his original wood block, the shape of which in itself helps to justify the odd medallion format.

Details of *The Singer* relate closely to other wood sculptures by Gauguin from this same period. The red beads in the woman's hair, for example, are comparable to berry motifs on the reliefs that Gauguin incorporated into a cabinet, and to similar motifs on the top of a carved wooden box executed in 1884 (cat. 9). In terms of style, the wooden netsuke heads inlaid into the back of the box ought to be compared to the rendition of the face of *The Singer*.–C.F.S.

6
Woman on a Stroll, or The Little Parisienne

1880

height 25 (9¾)

tropical laurel (Terminalia), stained red and black

Mr. and Mrs. Edward M. M. Warburg

EXHIBITIONS
Paris 1881, no. 39, *Dame en Promenade*; Chicago 1959, no. 116

CATALOGUE
G 4

shown in Washington and Chicago only

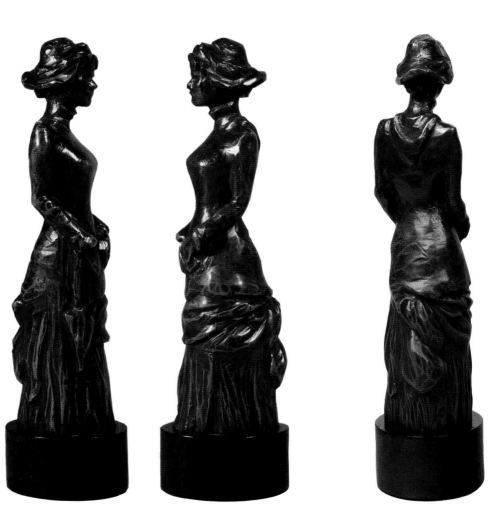

Seurat, *The Woman in Black*, c. 1882-1883, conté crayon [private collection]

25

1. de Mont 1881.

2. See cat. 8.

3. *Avant et après*, ms, 16.

4. Reff 1976a, 257–262.

5. Degas recorded Gauguin's address in one of his notebooks from this period. Reff 1976b, vol. 1, 138.

6. De Hauke 1961, nos. 425, 426, 428, 439, 443, 495–511.

7. Bjurström 1986, no. 1656.

8. Merlhès 1984, nos. 28, 29.

9. In the *Art Lovers Library*, vol. 3 (New York, 1930), the sculpture is illustrated in its present state, showing that the base had been cut away by 1930.

As with *Nude Study* (cat. 4), Gauguin apparently meant to challenge contemporary standards of taste with the crudely carved *Woman on a Stroll* that he exhibited at the impressionist group show in 1881. "I do not speak of the *Woman on a Stroll*, which [Gauguin] has the audacity to show in public," explained one critic. "Where I come from in the country I've known more than one animal herder who carved more interesting figures on the end of a staff than this."[1] Perhaps Gauguin's first attempt at working in wood, this roughly whittled figure, like virtually all of his subsequent wood carvings, indicates such disdain for finesse that it all but welcomes charges of ineptitude. For example, it is impossible to determine what the figure is clutching in her right hand and difficult to make out the purse hanging from her left wrist. Although more sympathetic commentators, such as Huysmans and Trianon, suggested that Gauguin sought to express the simplicity of columnar Gothic sculpture or the archaic and mysterious proportions of Egyptian art (both art forms that Gauguin would eventually adapt to his own uses), *Woman on a Stroll* can better be compared with folk art figurines.

Gauguin, already the father of three children, had sympathy for playthings, to judge from the marionette that he used as a prop for an 1881 painting[2] and from the statement he made later in *Avant et après*: "Sometimes I took myself far back, further back than the horses of the Parthenon . . . to the rocker from my childhood, the good wooden horse."[3] For caricaturists, many of whom parodied the figures in paintings by such artists as Courbet and Manet with wooden dolls in their cartoons, such ill-proportioned toys were a stock symbol for ineptitude in art. Considered as a form of three-dimensional caricature, Gauguin's effigy of a fashionable Parisian woman is one of the first indications in his art of contempt for the artifices of modern urban civilization.

Gauguin seems to have derived this figure of a woman wearing a short, hooded coat over a long, tight-fitting dress from the leftmost figure in a chalk and pastel drawing that Degas exhibited at the 1879 impressionist group show with the title *Project for a Frieze*.[4] The specific interrelationship can hardly be doubted, considering that the other sculpture (cat. 5) that Gauguin exhibited with *Woman on a Stroll* in 1881 also derives from a pastel exhibited in 1879 by Degas, and considering that Degas himself was preoccupied with sculpture during these years, when he apparently visited Gauguin's studio in the rue Carcel.[5] The close similarity between Degas' own wax figurine, *The Schoolgirl* (c. 1881), and Gauguin's *Woman on a Stroll* makes a dialogue between the two artists likely, with Gauguin's little figurine prompting Degas to extend his thinking about modern sculpture or vice versa. In either case, the rigid poses that both artists favored for their statues surely influenced Seurat, whose own drawings of archaically columnar figures from modern life are generally dated around 1882.[6]

In a sketchbook that Gauguin used between the years 1877 and 1887, now in the Nationalmuseet, Stockholm, there is an undistinguished drawing that shows him at work carving *Woman on a Stroll*.[7] This drawing has always been attributed to Pissarro, whose name is lightly inscribed on Gauguin's sleeve. With Gauguin's encouragement, Pissarro, too, had begun in the early 1880s to make sculptures of cows, none of which survives.[8]

At an unknown date, versions of *Woman on a Stroll* were cast in terracotta and bronze, perhaps by Gauguin. In all of the cast versions the shaft continues down below the skirt as a roughly chiseled base, thus incorporating the unfinished end of the stick that Gauguin had whittled as part of his final conception. The signature *P. Gauguin* appears on the front of this base. Such a rustic base can be presumed to have been an important feature of the wood version of *Woman on a Stroll*.[9] The lost base was the prototype for the similar traces of his original log blocks that function as bases for the wood sculptures that Gauguin executed later at Le Pouldu (cat. 94) and in Tahiti (cats. 138–140).—C.F.S.

7
Flowers, Still Life, or The Painter's Home, Rue Carcel

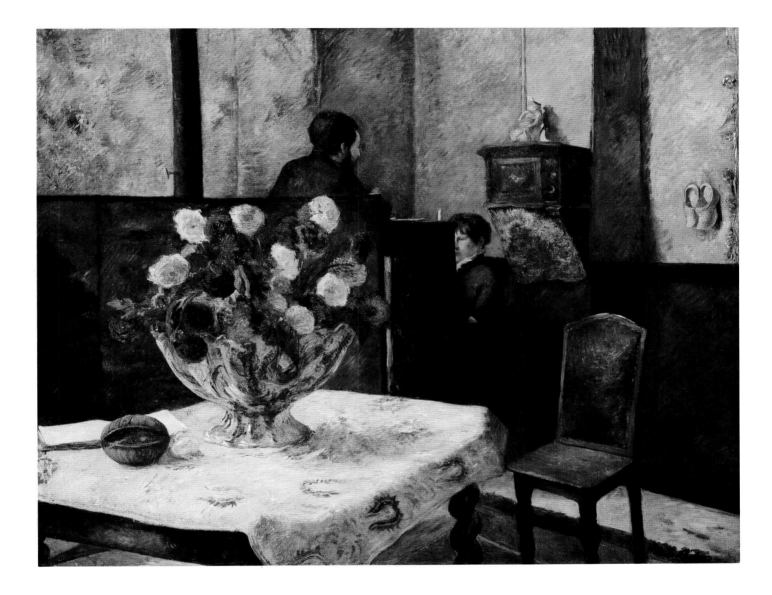

1881

130 x 162 (50¾ x 63⅛)

oil on canvas

signed and dated at lower right, in black on black baseboard, *P. Gauguin 1881*

Nasjonalgalleriet, Oslo

EXHIBITIONS
Paris 1882, no. 18, *Fleurs, nature morte*;
Copenhagen 1985, no. 11

CATALOGUE
W 50

None of the journalists who reviewed the 1882 impressionist group show made any reference to this large picture except for Huysmans, who complained, "As for his studio interior, it has a scurvy, dull color."[1] Three journalists did, however, make the general comment that what Gauguin had chosen to exhibit was perversely dark by the standards of impressionism,[2] and the fact that Gauguin signed his name in black on the black baseboard perhaps indicates an ambition to identify himself as an advocate of muted color. The somber blues and yellows of the decor of the parlor (not, as Huysmans claimed, the studio) and the still mood seem most closely related to the works that Caillebotte had exhibited at these group shows beginning in 1876.

It is rather peculiar that Gauguin decided to entitle this picture simply *Flowers, Still Life*, given the complex background here including two figures, even though the bouquet of zinnias in a ceramic jardiniere[3] is the centerpiece of Gauguin's composition. Gauguin's conflation of the conventional categories of still

1. Huysmans 1883, 288.

2. Hennequin 1882; Rivière 1882; Havard 1882.

3. This very jardiniere, decorated with painted birds and tulips, was borrowed from the artist's descendents as a prop for Henning Carlsen's 1987 film *The Wolf at the Door*.

4. G 6, W 51, W 53, and probably W 67.

5. From "Notes synthétiques," an essay Gauguin copied into a notebook of 1884–1885. See Cogniat and Rewald 1962, 2-3.

6. This reappears in W 174.

7. G 81, G 82, G 83.

life and genre reflects analogous hybridizations in works painted by Degas, Monet, and Renoir as early as the mid-1860s. The figures, for the most part masked by furnishings and thus impossible to identify with certainty, probably represent Mette at the upright piano and Gauguin standing behind it to listen. Simple narrative details relate the tabletop still-life subject in the foreground, silhouetted against an unfolded screen, with the genre elements arranged in the complicated background space beyond the screen. The open sewing basket and the horizontal-format sketchbook on the table are counterparts to the background figures, and suggest that either Gauguin or his wife had been at work prior to abandoning the chair to join the other at the piano. Such details seem calculated to the portrayal of a harmonious bourgeois marriage. That theme evidently preoccupied Gauguin at this time, for no fewer than six of the works[4] (cat. 8) that Gauguin exhibited with the impressionists in 1882 represent members of his immediate family at home.

But, given the fact that Gauguin in 1885 would desert his family to devote himself to art, it seems more appropriate to interpret *Flowers, Still Life* as an allegory of his developing ideas about painting and sculpture. Gauguin wrote, around 1885, "Painting is the most beautiful of all the arts . . . looking at it each one can, through his imagination, create a novel. . . . Like music, it acts on the soul through the intermediary of the senses, harmonious hues correspond to harmonious sounds, but in painting one obtains a unity that is impossible in music, where the chords come one after the other and one's judgment is tried by an incessant fatigue if it wishes to unite the beginning and the end. . . . As in literature, the art of painting tells the story it wants to, but with the advantage that the viewer immediately knows the prologue, the mise en scène, and the denouement."[5] Considered in relation to *Flowers, Still Life*, this passage provides a rationale for Gauguin's apparently literary juxtaposition of the colorful bouquet with the piano played in the background. Furthermore, the sketchbook, the ceramic figurine,[6] and the pair of wooden shoes like those Gauguin himself would sculpt several years later[7] can be understood as prefigurations of the variety of genres and mediums in his subsequent art.–C.F.S.

8
The Little Dreamer, Study

1. Bodelsen 1970, 601.

2. Roskill 1970, 236.

The Little Dreamer, as well as *The Little Girl at Play*, is a genre scene for which his only daughter, Aline (born 24 December 1877), served as the model. Because Aline wore her hair boyishly short, many scholars have identified Emil as the model for these 1881 paintings, but he was taken to Copenhagen by his mother in 1880 and remained there for the rest of his life.[1]

The Little Dreamer, on the background wall of which Gauguin inscribed a bar of music, should be understood as a prefiguration of his symbolist preoccupation with "correspondences" and dreams.[2] This musical inscription is but one detail in an especially rich composition designed to evoke the comfortable bedroom of a well-off child in Paris. The painting is the first of many works by Gauguin with decorative wallpaper in the background. Here the wallpaper is embellished with the silhouettes of leaves and birds whose flight and song can be imagined as

1881

59.5 x 73.5 (23¼ x 28⅝)

oil on canvas

signed and dated (on a diagonal) at upper left in black, *1881 p Gauguin*

The Ordrupgaard Collection, Copenhagen

EXHIBITIONS
Paris 1882, as *La petite rêve, étude*, no. 22; Copenhagen 1948, no. 13

CATALOGUES
W 52, W 54

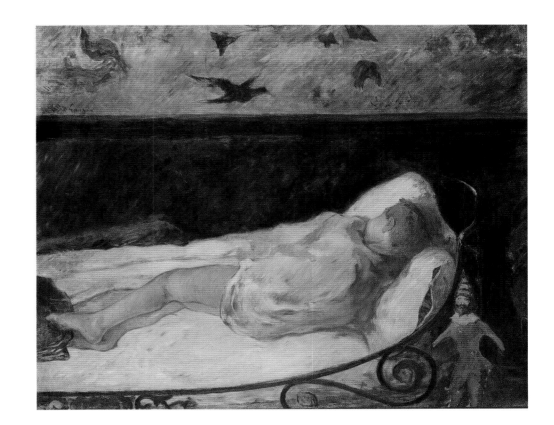

3. See Merlhès 1984, no. 29.

4. Damiron 1963.

fanciful counterparts to the child's dreams, as can the doll dressed like a jester that guards her bed. This wrought-iron boat bed with its scrollwork, along with the wallpaper, is an example of Gauguin's intense interest in modern decorative arts, an interest that would guide his development as an artist in various mediums.[3]

No journalist's account of the 1882 impressionist exhibition made a direct reference to this magical painting. Even though a restrained palette contributes to the success of *The Little Dreamer*, several critics complained that Gauguin's pictures were in general too dark (cat. 7). If anything, the blues and whites of the child's bedclothes and sheets seem too bright for a nocturnal interior, unless Gauguin intended to suggest that light was entering the room through a door or window not indicated within the frame of the picture. Along with his impressionist colleague Cassatt, Gauguin deserves special distinction as an innovator in genre scenes with children.

A dozen years after Gauguin painted *The Little Dreamer*, he made a special album for Aline in which he copied favorite texts by Poe and Wagner to accompany his own thoughts for her.[4] One section of this album bears the title *La Genèse d'un tableau* (*The Genesis of a Painting*) and describes *Manao tupapau* (see cat. 154), one of his most important Tahitian canvases, which in many respects is a reprise of *The Little Dreamer*.–C.F.S.

9
Decorated Wooden Box

1. Pola Gauguin 1937, 67, and caption to illustration on facing page.

2. The exception is a vase with figures of ballet dancers (G 12) executed around 1886.

3. Correcting Gray 1963, 4–5, who suggested Lemoisne 1946-1949, 400, as the source for Gauguin's appropriated figures, Reff 1976a, 267, 336 nn. 103–104, identified it as Lemoisne 340, adding that Gauguin may also have quoted figures from nos. 448, 838, and 841. Amishai-Maisels 1985, 60 n. 7, added no. 186 as a possible source. Of these works only no. 340 had been included in a public exhibition, in 1876. ́

4. G 7.

5. G 58, G 59, G 60, G 71, G 72, G 73, G 74, G 75, G 76.

6. Merlhès 1984, nos. 68 and 78–80.

7. Gray 1963, 5.

8. Bodelsen 1964, 144.

9. Andersen 1971, 33–34.

10. Amishai-Maisels 1985, 13.

The date of execution, the purpose, and the interpretation of this, probably the most bizarre work Gauguin ever made, are all still open to debate. Although a wooden plaque on the back of the bottom section is inscribed 1884, the clumsy execution of the numerals, out of keeping with the careful lettering of the signature on the same plaque, may not be the work of the artist. Pola Gauguin, who evidently inherited the box from his mother, dated it 1881.[1] His rationale for an earlier date remains persuasive: with one exception,[2] it was around 1880 (cats. 5, 6) that Gauguin was most preoccupied with works by Degas, appropriating motifs from his new colleague's art for his own crudely executed sculpture, as he did for the reliefs on this box.[3] If the inscribed date is accurate, however, this little box would be the only wood sculpture that Gauguin made during a rather long hiatus extending from 1882[4] until around 1888.[5]

He spent virtually all of 1884 in Rouen. His wife left in November, taking their children to her native Copenhagen, where Gauguin soon joined them. It seems clear that the move was a symptom of the marital strife that led Gauguin to abandon his family and return to Paris in June 1885.[6] Ever since Gray suggested that this box with a locket and handles on its sides might have been conceived as a sort of macabre case for a woman's jewels,[7] it has been assumed that Gauguin fashioned it as a sardonic present for his wife to symbolize her divisive preoccupation with financial security. This assumption that the box was a strictly personal gesture from Gauguin to his wife helps explain why it was never exhibited in public. Moreover, the theory that Gauguin's decorations for the box were designed as a comment on human vanities was bolstered when Bodelsen suggested that the recumbent figure carved into its interior may have been influenced by the partially mummified remains preserved in a Bronze Age wooden coffin that he could have seen in the Copenhagen National Museum.[8] As Gauguin did not arrive in Denmark until the very end of 1884 and could hardly have completed such a complex work until 1885, Bodelsen's persuasive comparison raises doubt about the inscribed date.

The box's date is crucial to discussions of the genesis of synthetism, primitivism, and symbolism as priorities in Gauguin's art. The little netsuke masks inlaid on the box are an early example of Gauguin's stylistic eclecticism. If he indeed found inspiration for this box in a Bronze Age coffin that he saw in 1885, it was a precedent for his decision in 1889 to appropriate motifs from a variety of medieval and primitive art objects, including a Peruvian mummy (cats. 79, 88, 89). Although Gauguin's first openly symbolic works of art were not undertaken until 1888 (see W 239 and cat. 50), by 1881 he had already begun to juxtapose details in some pictures (cats. 7, 8) in order to make narrative or poetic inferences. Whereas the figures of ballerinas carved on the front of the box seem merely decorative, the female figure and the male head on the top interject the lust and voyeurism that characterize many of Degas' works with theatrical subjects.[9] Understood this way, these moralizing figures can be taken as complements to the larger recumbent figure carved inside the box, which has been interpreted as a tomb effigy.[10] If so, these jewelry box decorations would imply that the wages of sin is death.

Another reasonable interpretation is that the androgynous figure carved inside the box might represent a sleeping youth comparable to figures in other works by Gauguin (see cats. 8, 84).—C.F.S.

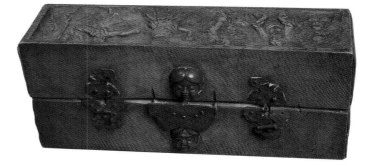

1881–1882 or 1884–1885 (?)

height 21, width 13, length 51 (8¼ x 5 x 19⅞)

pear wood, with iron hinges, leather, red stain, inlaid with two netsuke masks

engraved on wood plaque attached to back, *1884/GAUGUIN*

Uno Wallman

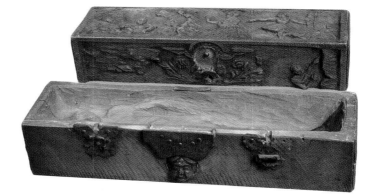

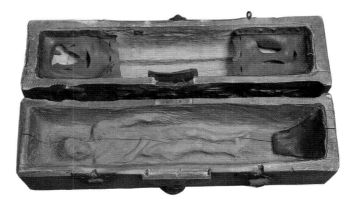

10
The Sculptor Aubé and a Child

1882

538 x 728 (22⅛ x 28⅝)

pastel on wove paper

signed and dated at lower left, in black,
1882/ p. Gauguin; and inscribed on brown
speckled mat,
Ta main pose l'outil bien qu'au labeur ardente
Modelant tour à tour les rires et les pleurs
Elle anime à son gré les femmes et les fleurs
Et courbe le damné sous le talon de Danté.

Pour P. Gauguin
Mette G.[1]

Musée du Petit Palais, Paris

EXHIBITIONS
Paris 1936, no. 7; Munich 1960, no. 78

CATALOGUE
W 66

shown in Paris only

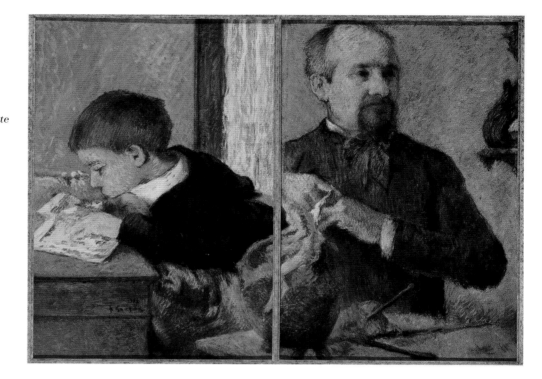

1. "Even though during the hard work, your
 hand puts down the tool,
 Modeling laughter and tears by turns,
 It brings the women and flowers to life
 at its will
 And bends the damned beneath Dante's
 heel.

 On behalf of Mette G., P. Gauguin"

2. Pola Gauguin 1937, 37.

3. Bodelsen 1965, 310 (appendix section 1).

4. Rotonchamp 1925, 18.

5. Merlhès 1984, 330 n. 20.

6. See Longuy 1979.

7. d'Albis 1968, 37.

8. Merlhès 1984, no. 99.

9. Huyghe 1952, 222–228.

Pola Gauguin's claim that his mother stayed at a boarding house run by Aubé's wife when she first came to Paris[2] seems to be altogether unfounded.[3] In fact, the Gauguins first met the sculptor Paul Aubé (1837–1916) in 1877 when they rented a house at 74, rue Fourneaux (today rue Falguière). Their landlord,[4] Jules Bouillot, from whom Gauguin would receive his first instruction in marble carving, rented a studio to Aubé.[5] Aubé, who began to show works at the Salon of 1861, had already received awards and commissions for public sculptures.[6] The quatrain inscribed on the mat of this work seems to refer to Aubé's statue of the poet Dante for the Collège de France, which was exhibited at the Salon of 1879 as a plaster, and at the following Salon as a bronze. During the late 1870s Aubé also began to fashion figurines of naked women in white plaster to decorate vases made by such ceramists as Edouard Lindeneher (d. 1910) for the Haviland company.[7] A vase similar in its general appearance to the one in the foreground of Gauguin's pastel was exhibited at the first Salon des arts décoratifs in 1882. Although the present location of the exact vase represented by Gauguin in the portrait is unknown, the pose seems related to that of the nude in an important painting (cat. 4) exhibited by Gauguin in the 1881 impressionist exhibition and to that of the nude in the wooden relief (G 7) that Gauguin carved in 1882. When Gauguin's colleague, Bracquemond, who had worked with the Haviland company since 1873, saw this last work at the 1886 impressionist exhibition, he urged Gauguin to work in ceramics with Chaplet, thus motivating an extraordinary new direction in his art. Reporting Bracquemond's suggestion in a letter to his wife, Gauguin explained that "Aubé used to work on his [Haviland's] pots to earn a living. . . ."[8]

Gauguin may have given the Petit Palais pastel to Aubé upon its completion, but his name is not listed in the rather complete inventory of collectors who owned his art that Gauguin began to compile around 1887.[9] It is a surprise that

Gauguin apparently never exhibited this unorthodox double portrait, for it is one of his earliest masterpieces in any medium, seemingly a demonstration piece for his innovative ideas about color and composition. Divided in halves, the composition is exceptional for the curious inconsistencies and contrasts between the left and the right. These compositional incongruities suggest that Gauguin changed the left section at some stage of developing the portrait, but never felt inclined to adjust the two sections to make them fit together in a logical fashion. The right side of the composition is a harmony of rich blues with a yellow accent. Aubé wipes his hands clean as he stands behind his worktable, on which there is a completed vase next to a greenish lump of unworked plaster with a spatula stuck into it. The profile of what appears to be another work by Aubé is visible on the far right, as is the profile of its pedestal support.

Although the worktable and vase in the foreground continue beyond the mullion of the mat into the other half of the composition, Aubé's shoulder does not, and everything else on the left suggests an entirely different setting. Here the background wall is a rich orange-yellow, complementary to the blues on the right, and even the level of the floor seems to be different, given the scale of the child.

The child was apparently not included when Gauguin began his picture. Traces of Aubé's right shoulder visible as pentimenti in the left half of the composition suggest the appearance of the earliest stage without the subsequent discontinuity between the sections. Gauguin's bold decision to mismatch them epitomizes his art-for-art's-sake decorative priorities. It is Gauguin's orchestration of color, applied in uniformly vigorous hatched strokes, and the rhythmic repetition of undulating outlines in the figure of the child, the chair, and the vase, that unify the composition of this bizarrely polarized double portrait.—C.F.S.

11
Quarry in the Vicinity of Pontoise

"I've finished a size 50 canvas that I worked on a great deal," wrote Gauguin to Pissarro in November 1882. "It's the duplicate version of the gray weather at the quarry that I had done in Pontoise. Bertaux, to whom I owed a thousand-franc note, bought it from me, and it would greatly please me if you would give your opinion before the painting goes off."[1] Bertaux, who worked at a stock brokerage firm, eventually owned no fewer than five paintings by Gauguin. Merlhès suggested that the quarry painting mentioned in this letter must be this one, whose dimensions conform to a commercially prepared size 50 canvas.[2] If this is so, the first version, which Gauguin presumably had painted *en plein air* when he went to Pontoise to work with Pissarro during the early summer of 1882,[3] is either lost or destroyed. Other dated paintings of quarries by both artists record their campaign that summer in the small canyons of Le Chou.[4]

The complex treatment of space in the Zurich picture is a measure of how much Gauguin had learned about landscape painting from Pissarro, who frequently chose motifs with shifts in space extending beyond his field of vision. In Gauguin's painting, the ground falls off suddenly at the left, where the crest of a hill seems to mask a path along the bottom of another hill on the right. This hill blocks the view into the distance, except for the windswept tops of poplars. The deep cutting into the face of rock on the left leads off in still another direction hidden

1. Merlhès 1984, no. 29.

2. Merlhès 1984, 370 nn. 81–82.

3. Merlhès 1984, no. 23, refers to Gauguin's planned visit; and no. 25 refers to Gauguin's return trip to Paris.

4. W 70 and W 71; and Pissarro and Venturi 1939, no. 559. See Brettell 1977, 94–95.

5. Merlhès 1984, no. 23.

6. Archives of the Galerie Durand-Ruel, Paris, Brouillard, entry for 9 April 1884. This title has not been associated with any extant work by Gauguin.

Quarry in the Vicinity of Pontoise

1882

89 x 116 (34¾ x 45¼)

oil on canvas

signed and dated at lower left, *P. Gauguin 1882*

Kunsthaus Zürich, Vereinigung Zürcher Kunstfreunde

CATALOGUE
W 72

shown in Washington and Chicago only

from sight. Each of these details in this painting functions like an isolated preposition.

In Gauguin's rugged landscape, scale and distance per se become charged with mystery in the spirit of landscapes by Millet and Courbet. These painters and Corot were singled out by Gauguin in a letter to Pissarro around May 1882, when an important retrospective of Courbet's works was presented in Paris.[5] With its studied variety of green grasses in the foreground, Gauguin's painting can be understood as an extension of Courbet's verdant rocky landscapes. Gauguin's uncompromisingly sculptural treatment of this abandoned landscape may also reflect his interest in relief carving in the early 1880s.

Quarry in the Vicinity of Pontoise exemplifies an attempt by Gauguin to develop an identity for himself as a painter of forlorn, poetic landscapes (W 87), and it is worth mentioning that he entitled one of his paintings of the time *Coteaux des malades (Hills of the Sick).*[6]–C.F.S.

12
Snow Scene

Among the largest, most ambitious paintings by Gauguin in the impressionist manner, this sparkling snow scene has always been thought to represent the garden of the house in the rue Carcel that the artist rented from 1880 until the end of 1883.[1] But the background of another painting thought to represent the same garden is significantly different (W 67), without any trace of the factories and smokestacks that set the distinctly modern and urban mood in *Snow Scene*.

Smokestacks, emblems of industrial civilization, appear as ironic counterthrusts in many otherwise idyllic impressionist landscapes by Pissarro and Monet but seldom appear in Gauguin's pictures. The pastel that he exhibited at the seventh impressionist exhibition in 1882 with the title *Usine à gaz* (*Gasworks*) is the most notable exception.[2] Indeed, the three smokestacks represented in this earlier work are possibly the same ones that appear in the background of *Snow Scene*.

Presenting especially difficult challenges to painters committed to working directly from nature, snow scenes, with their many subtle reflections of tone and hue, appealed most of all to daring virtuoso artists such as Courbet and Monet. Perhaps in part from a determination to follow their example, Gauguin at first painted a smaller version of the same scene without figures.[3] Even though this smaller oil remained unsigned, it is not known whether Gauguin had intended to use it as a study for a larger, more complex work. He had not developed any other painting with the help of an oil study since 1879, and on that occasion a snow-covered landscape subject was likewise at issue. In both 1879 and 1883 Gauguin presumably began with the fervor of an orthodox impressionist working on the spot and later opted to transpose the results onto larger canvases in his studio.

The blonde girls in their scarves anticipate perhaps the most frequent theme in all of Gauguin's mature works – idle conversations among women observed, usually from a distance beyond hearing range, in Brittany and later in Tahiti. The figure at the left who steadies herself while adjusting her shoe, in the manner of some of the ballerinas in Degas' pictures, is the direct forerunner of the figure at the far right in Gauguin's first major Brittany "conversation piece."[4]

Snow Scene is apparently the size 50 painting that Gauguin mentioned in a letter to Pissarro in the summer of 1884. If so, Gauguin had established a price of 400 francs when he lent it to an exhibition organized by the restaurant owner Eugène Murer.[5] It was Murer who encouraged Gauguin, who had moved to Rouen at the outset of 1884, to submit the same picture to an exhibition of contemporary art held there in August of that year. However, the jury for this salon refused Gauguin's picture, which was originally in a white frame.[6]

Snow Scene may also be the large painting Gauguin mentioned at the end of 1885 in a letter to his wife: "I thought that Madeleine Adler was supposed to buy the large snow scene from you."[7] The provenance for *Snow Scene*, however, seems to begin with the Gad family, the artist's in-laws, but it is impossible to know whether *Snow Scene* or the smaller version of the composition is the work listed as "Snow" in Gauguin's notebook inventory as a gift to Theodore Gad.

Questions of its early history aside, *Snow Scene* is a tour-de-force, rendered à la Monet with short, interwoven strokes of pale blue and pale pink for the opalescent sky. This rich, uneven light flickers across the thin white snow surface, broken by the protruding blades of grass. The bare saplings seem vulnerable and heroic in the walled-in setting, to all appearances a quiet, natural refuge from the urban world just beyond.—C.F.S.

1. le Pichon 1986, 32.

2. W 62; see Bodelsen 1970, fig. 22.

3. W 75; Roskill 1970, 16.

4. Lemoisne 1946-1949, nos. 343 and 585; Bodelsen 1966, 35.

5. Merlhès 1984, nos. 49, 50.

6. Merlhès 1984, no. 144.

7. Merlhès 1984, no. 91.

Snow Scene

1883

117 x 90 (45½ x 35)

oil on canvas

signed and dated at lower right, *P. Gauguin 83*

EXHIBITIONS
Copenhagen 1948, no. 22; Edinburgh 1955, no. 6; Paris 1960, no. 11; Munich 1960, no. 14

CATALOGUE
W 80, *La Neige Rue Carcel (II)*

13
Sleeping Child

1884

46 x 55.5 (18 x 21⅝)

oil on canvas

signed and dated at upper left, in red, *p Gauguin 84*

Josefowitz Collection

CATALOGUE
W 81

This painting has been identified by its signature and date as one of eight paintings, Gauguin told Pissarro in a letter from Rouen at the end of September 1884, that he sent to Oslo to be included in a group exhibition there.[1] Only three works by Gauguin are listed in the exhibition catalogue, however, which indicates that the organizers were not prepared to accept more than that number of works by any participating artist. *Sleeping Child*, perhaps one of the works excluded, was bought by Hermann Thaulow, whose brother, the painter Frits Thaulow, was Gauguin's brother-in-law and a member of the organizing committee for the exhibition.[2]

The identity of the child is a matter of debate.[3] Any eventual solution must take into account the existence of a painting dated 1883 that shows two views of the head of a blond child who wears the same plaid blouse that appears in *Sleeping Child*.[4] Nothing contributes to the confusion about the child's identity so

much as the bizarre relationship of scale between its head and the oversize tankard. Indeed, since this tankard and the small, oddly insignificant object just next to it appear to be placed on a tabletop, the child's reclining position on the same surface seems awkward and ambivalent. The incongruity may indicate that Gauguin added either the child or the tankard to this composition at a late stage, without bothering to adjust their relative sizes. Several of Gauguin's best pictures of the early 1880s seem to have developed in this same proto-surrealist fashion.[5] In *Sleeping Child*, this juxtaposition is humorous in a fantastical way, for the child, with bold blotches of red, blue, and green on his cheek, appears to have fallen asleep from too much to drink.

Danish Tankard, 18th century, wood
[Trafalgar Galleries, London]

Mette, Paul Rollon, and Jean René Gauguin,
1884, photograph

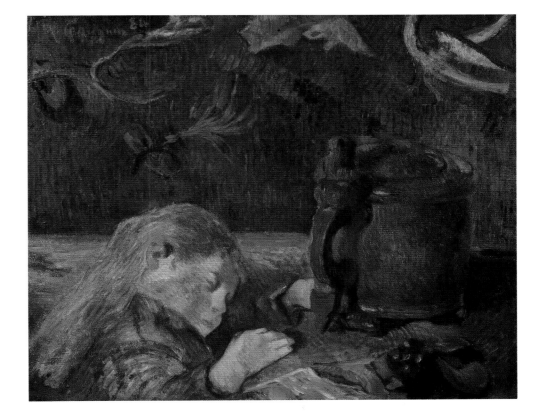

1. Merlhès 1984, no. 53; information supplied to the present owner by the late Douglas Cooper.

2. Information supplied to the present owner by the late Douglas Cooper.

3. Cooper suggested to the present owner that the child may have been Jean-René, but his hair is short in a photo of Mette, Pola, and Jean-René taken at Rouen in 1884.

4. Bodelsen 1967, 225-226 (figs. 65-66); referring to an 1883 letter (Merlhès 1984, no. 39), Bodelsen identified the model as Aline.

5. See W 176.

6. See W 132.

7. See W 49.

These apparently arbitrary patches of color indicate that Gauguin's observations were guided by Chevreul's law of successive contrast, according to which every color modifies its surroundings by imposing an aura of its complementary color. Thus, the reddish tankard imposes a green aura, and the golden hair imposes a blue one on the ruddy cheek. The light falling across the painting from the left to illuminate the hidden side of the tankard and the child's hair, while his face remains in shadow, heightens this effect.

Painters often portray children asleep out of expediency (see cat. 8), given their short attention span. But it seems obvious that Gauguin was seeking to evoke the fancies of the child's dreams here, symbolizing them with the plant and animal motifs in the Japanese wallpaper in the background. The same wallpaper serves as the background for a still life with the same dimensions as *Sleeping Child*, and painted in the same year.[6] Such decorative elements obviously appealed to Gauguin, who began to incorporate their stylized and colorful designs into his compositions around 1880.[7]—C.F.S.

14
Portrait of Clovis and Pola Gauguin

1885

720 x 535 (28⅜ x 21)

charcoal and pastel on wove pastel paper mounted onto wooden stretcher

signed and dated at lower right, in pink pastel, *P. Gauguin/85*

Mr. and Mrs. David Lloyd Kreeger

EXHIBITIONS
Copenhagen, Udstilling 1893, no. 132, *Portraeter*; Copenhagen 1948; Copenhagen 1984, no. 19, *Aline og Pola Gauguin*

CATALOGUE
W 135

shown in Washington only

Aline and Clovis Gauguin, 1884

1. See W 53 and *Gasworks* (*Usine à gaz*). Bodelsen 1970, 591, fig. 22.

2. Rostrup 1960, 161.

3. Merlhès 1984, nos. 87 and 89.

4. Bodelsen 1970, 615 n. 6. It is also possible that the double portrait from the Brandes collection exhibited in 1893 could have been our cat. 10, or W 82, or an 1883 double portrait published by Bodelsen 1967, 225–226, figs. 65–66.

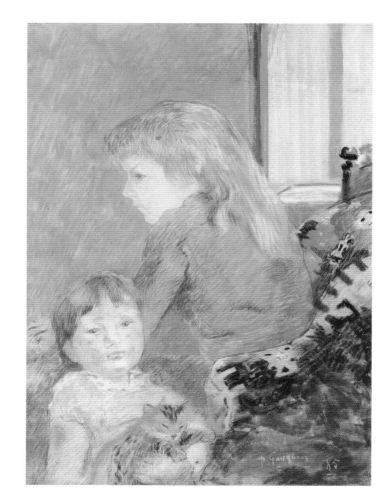

Many of the artists who took part in the impressionist group shows were committed to the revival of the great eighteenth-century tradition of pastel, and by 1879, Caillebotte, Cassatt, Degas, and Pissarro, as well as Monet, Morisot, and Renoir, had begun to exhibit works in this medium in tandem with paintings. Although Gauguin followed suit on only one occasion, exhibiting two pastels[1] at the 1882 show, beginning in 1880 he executed about one portrait in pastels each year until 1885 (cat. 10 and W 40, W 68, W 69, W 81bis, W 98). Afterward his use of the medium became far more complex (cat. 35).

Rostrup identified the children as Aline and Pola,[2] but since the former had short, dark hair, the seated child here can only be Gauguin's son Clovis. It has always been assumed that this double portrait, dated 1885, was completed before Gauguin left Copenhagen in June to return to Paris with Clovis. However, it is worth noting that Gauguin requested that his pastels be sent to him in Paris shortly after his arrival there.[3] The fine pencil grid visible underneath the face of Pola may indicate that Gauguin made the pastel in Paris, transferring Pola's likeness from some drawing that he brought back there with him. Gauguin's wife, with curious disregard for its sentimental value, sold it to her brother-in-law, Edvard Brandes, before 1893, when it seems likely it was exhibited in Copenhagen.[4]

This energetically rendered pastel is ostensibly an exercise in the orchestration of interwoven and juxtaposed complementary blue and yellow tones, repeated in the wall, the upholstery, the kitten, and Clovis' shirt and hair. Yet their blank, joyless faces express the strife that led their parents to separate. With the exception of Gauguin's description of his developing marital conflict in letters that he wrote from Copenhagen to Pissarro and Schuffenecker,[5] this poignant double portrait is perhaps the best document of the turmoil that accompanied his decision to sacrifice everything for his art.—C.F.S.

5. Merlhès 1984, nos. 68, 78, and 79.

15
Fan Decorated with a Portrait of Clovis and a Still Life

1885

325 x 563 (12¹³⁄₁₆ x 22³⁄₁₆)

gouache on fabric

signed and dated at lower right, in black, *P. Gauguin 85*

Dr. Ivo Pitanguy

EXHIBITION
Copenhagen 1948, no. 54

CATALOGUES
W 180; Gerstein 8

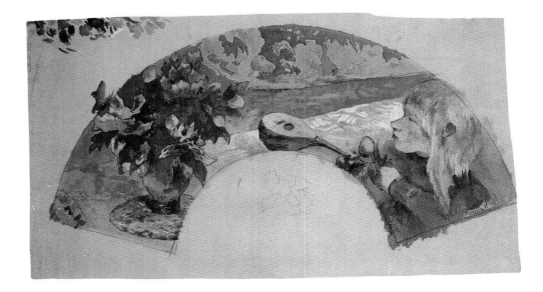

1. Lemoisne 1946-1949, no. 173, and Gerstein 1982.

2. The best accounts of this revival are Gerstein 1978 and Kopplin 1984.

3. Bodelsen 1970, 612 n. 43.

Many of the impressionists created fan-shaped compositions following Degas, who began to paint them by around 1869.[1] In the following years, a variety of eighteenth-century minor arts traditions enjoyed a revival, encouraged by the support of the Empress Eugénie, by the writings of the Goncourt brothers and Philippe Burty, and by the campaign to establish a museum for the decorative arts in Paris.[2] The growing popularity in the 1860s of Japanese fans as collectors' items surely added to the vogue. By the mid-1870s the heightened interest in painted fans was evident from examples on view at Salons, and by 1879 examples were included in the exhibitions of the Société des Aquarellistes Français as well as at the impressionist exhibitions. At the 1879 impressionist show, Degas showed five such paintings, while Forain showed six and Pissarro twelve. One of Pissarro's belonged to Gauguin, according to the catalogue.[3] Although these artists lavished as much inventiveness and care on these fans as they did on their more conventional works, the motivation to make fans was in large part commercial. Durand-Ruel urged

4. Pissarro and Venturi 1939, 2:248.

5. Bjurström 1986, no. 1545 f.12 verso; and Gerstein 1981, 3.

6. See W 116 and W 147.

7. See W 108 and W 147. Rostrup 1960; Bodelsen 1970, 612 nn. 44 and 45; and Gerstein 1981, 4.

8. Huyghe 1952, 222–228; and Gerstein 1981, 6.

Pissarro in 1882 to make more fans, because they "sell well and have had a great deal of success."[4]

Gauguin made a preliminary sketch for a fan painting in a sketchbook that he used around 1880, but he evidently never developed it as a finished work.[5] Apparently it was his pressing need to support his family that prompted him to create such salable objects in 1884, while he was living in Rouen. There are about thirty known fans by Gauguin. With the exception of a few done in 1884 that incorporate motifs from works by Cézanne[6] or Pissarro,[7] all of them repeat elements from his large oil paintings. Later he incorporated his fans into the backgrounds of some of his paintings (cat. 41, W 314). Judging from the inventory of these works recorded in Gauguin's Arles notebook, he often gave them to friends and collectors.[8] In this example, Gauguin repeated his *Still Life with Japanese Peonies* (cat. 16) on the left side, incorporating his beloved mandolin in the center and a likeness of his son Clovis at the right. This integration of different images into the semicircular fan format is closely related to Gauguin's predilection to integrate discontinuous points of view into his rectangular pictures (cats. 10 and 13).–C.F.S.

16
Still Life with Vase of Japanese Peonies and Mandolin

1885

64 x 53 (25 x 20⅝)

oil on canvas

signed and dated at lower right in black, *P Gauguin 85*

Musée d'Orsay, Paris

CATALOGUE
W 173

1. See W 132, W 133.

2. See G 10.

3. Bodelsen 1970, 608.

It is impossible to say whether Gauguin painted this richly colored, carefully composed still life just prior to leaving Copenhagen in June 1885, or just after his arrival in Paris. Gauguin had painted two works with these fragrant flowers[1] the previous year. For the Musée d'Orsay picture he placed them in a vase comparable to those[2] that he began to make in 1886. He chose this particular one because its rich color harmonized with the deep blue of the background wall, just as the shimmering whites, reds, and greens in the bouquet harmonize with the colors in the framed painting visible to the right on the wall. The artist orchestrated shapes as well as colors; the rounded forms of objects in the painting reiterate the scarcely visible perimeter of the round tabletop upon which they are arranged. Gauguin's selection of props served conceptual ends as well as formal ones. The mandolin can be understood as a symbol for musical harmony of the sort that he sought to achieve through the interrelationship of shape and color in his paintings (cat. 7), while the vase and dish attest to his interest in the stylizations in decorative arts designs.

The painting on the wall in the still life, with its rich greens accented by the reds of cows and rooftops, documents a lost work by Gauguin's colleague, Armand Guillaumin. Bodelsen has identified the painting as *The Orchard*, a Guillaumin in Gauguin's collection that was eventually purchased by Edvard Brandes. The painting's broad white frame is typical of works in Brandes' collection that were bought from Gauguin.[3]

Like many of his impressionist colleagues, Gauguin began to use white frames for his paintings around 1881, presumably to heighten the impact of the

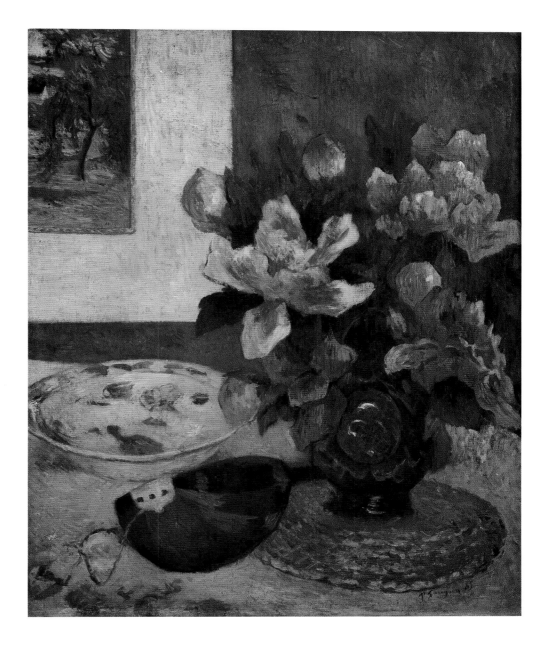

4. Hepp 1882.

5. Merlhès 1984, no. 50.

6. Merlhès 1984, 279.

7. See also W 131, W 211, W 287, W 314.

8. Genthon 1958, 21.

colors as wide white margins heighten the vibrancy of color prints. Indeed, one reviewer of the 1882 group show referred to Gauguin's works there as "hieroglyphics in oil in white frames."[4] Gauguin himself blamed the rejection of the works that he submitted to an exhibition in 1884 on their white frames.[5] Judging from comments in a letter written in early November 1888 by Vincent van Gogh, Gauguin took credit for this innovation in frame design. "Did you know," Vincent asked his brother Theo, "that in a small way Gauguin was the inventor of the white frame?"[6] Beginning in 1884, Gauguin sometimes incorporated paintings in white frames, or unframed color prints with white margins, into the backgrounds of his still lifes and figure compositions (cats. 41, 51, 61, 111).[7] He decided to abandon white frames altogether after his exhibition at the Durand-Ruel gallery in 1893.[8] Presumably his 1880s paintings were often intended for white frames that would become part of the total composition.—C.F.S.

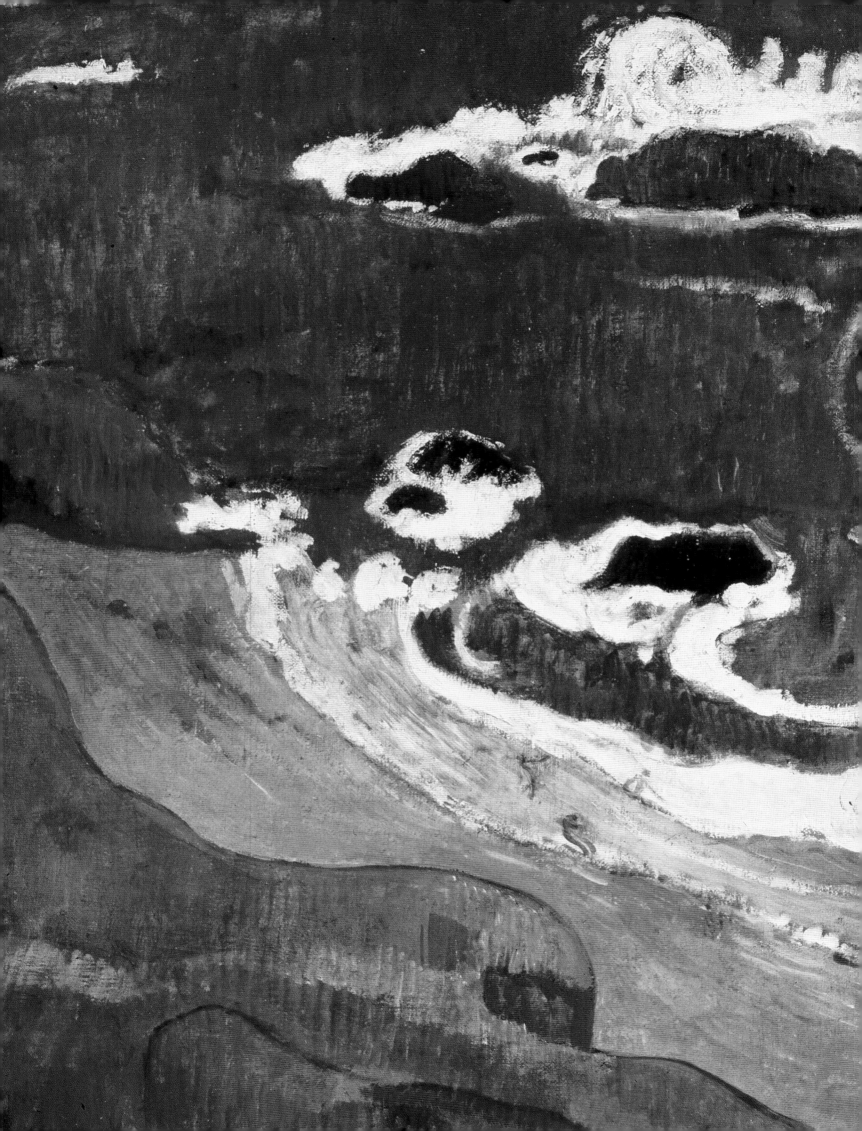

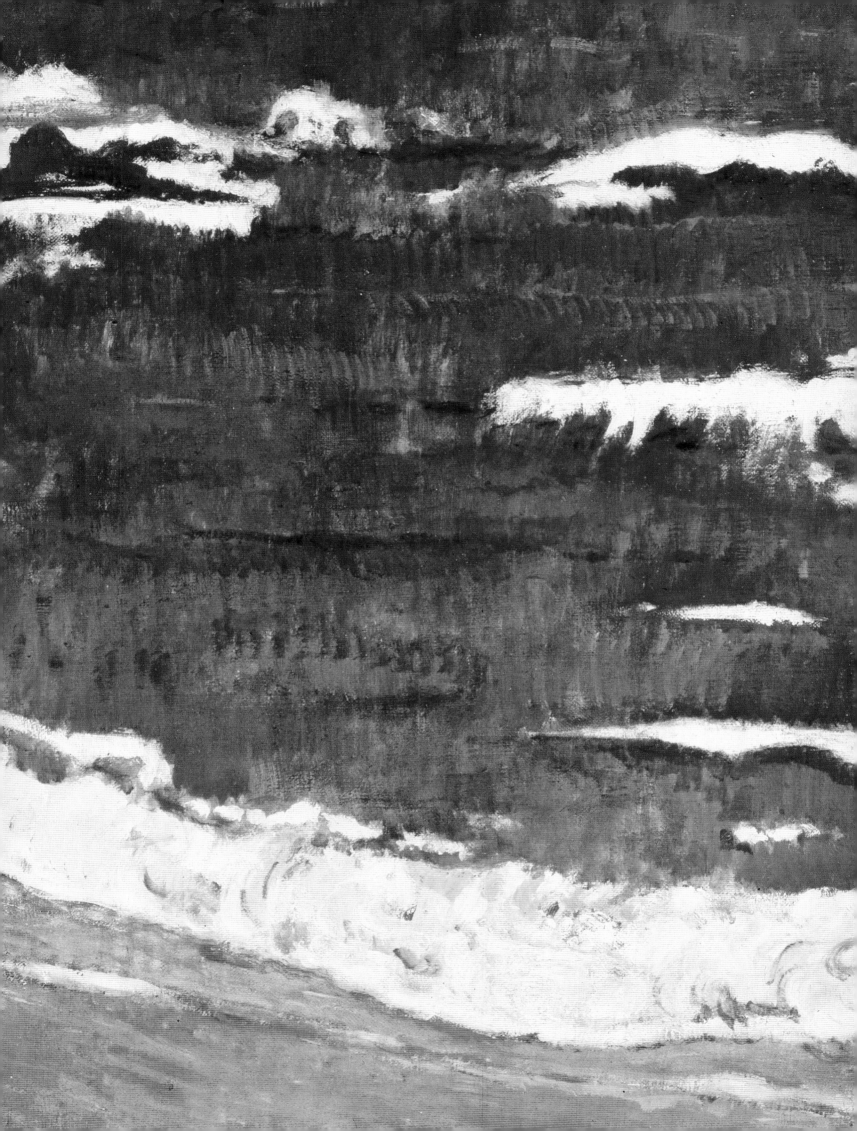

Chronology: July 1886–April 1891

ISABELLE CAHN

1886

JULY

Goes to Pont-Aven in Brittany with a loan from one of his relatives, banker Eugène Mirtil, and moves into the Gloanec inn for three months. During his stay he probably visits Le Pouldu (Merlhès 1984, nos. 105, 107, 110, and 426 n. 195, and 490 n. 264). Meets the painter Charles Laval (Malingue 1949, 94 n. 1). Schuffenecker visits Gauguin and prepares shipment of his paintings for the Nantes exhibition (Bailly-Herzberg 1986, no. 353; Merlhès 1984, no. 110).

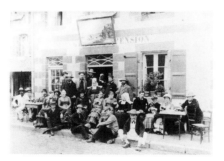

Fig. 27. *The Gloanec Inn, c. 1881* [Harlingue-Viollet, Paris]

AUGUST 15

Meets Emile Bernard but does not work with him until 1888 (Bernard 1895, 333, and 1939, 8).

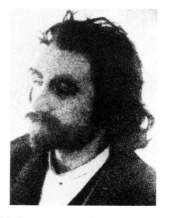

Fig. 28. *Emile Bernard* [Musée d'Orsay, Paris, Service de documentation]

AUGUST 21

Refuses to exhibit in the Independents' exhibition (Bailly-Herzberg 1986, no. 349).

OCTOBER 10-NOVEMBER 30

Participates in the Nantes *Exposition des Beaux-Arts* with two paintings, *Church in Rouen* (W 102 or 103) and *Park—Denmark* (W141 or 142).

MID-OCTOBER

Returns to Paris and moves to 257 rue Lecourbe. Makes pottery in Chaplet's studio (Merlhès 1984, nos. 113-114).

NOVEMBER

First meets Vincent van Gogh (Rewald 1961, 30). Refuses to shake hands with Pissarro and Signac at the Café de la Nouvelle-Athènes. In so doing he breaks with the neo-impressionists (Bailly-Herzberg 1986, no. 361). Sells one of his Jongkinds for 350 francs. He is hospitalized for twenty-seven days due to tonsillitis (Merlhès 1984, no. 115).

1887

JANUARY 6

Gauguin, Degas, and Zandomeneghi are witnesses at Guillaumin's wedding (marriage certificate, Municipal Building, sixth district, Paris). Bracquemond attempts to help Gauguin by trying to sell his paintings and pottery (Bailly-Herzberg 1986, no. 387; Merlhès 1984, nos. 118-119). Gauguin may have visited Saint-Quentin this year to see La Tour's works (Malingue 1949, CLXXII).

APRIL

Mette goes to Paris to get Clovis. She takes several of her husband's works with her when she leaves (Merlhès 1984, nos. 123-124, 136).

APRIL 10

Leaves from Saint-Nazaire for Panama with Charles Laval (Merlhès 1984, no. 122).

Fig. 29. *Colón (Panama), Front Street* [Société de Géographie, Paris]

Arrives in Colón and spends several days in Panama where his brother-in-law, Juan Uribe, lives (Merlhès 1984, no. 124).

Works in Colón for the Society of public works and the construction of the Panama Canal. Following a reduction in staff, he is laid off after fifteen days. He leaves for Martinique with Laval (Merlhès 1984, nos. 125-127).

Lives in a hut on a plantation two kilometers from Saint-Pierre. Shortly after his arrival, he becomes seriously ill with dysentery and malaria (Merlhès 1984, nos. 127, 130). Albert Dauprat buys some of Gauguin's pottery at Chaplet's factory (Merlhès 1984, no. 131; Huyghe 1952, 226).

Fig. 30. *Saint-Pierre, Martinique, in 1889* [Société de Géographie, Paris]

He leaves for France on a schooner and arrives c. November 13 (Merlhès 1984, no. 136, and 469 n. 234).

Stays with Schuffenecker at 29 rue Boulard (Merlhès 1984, no. 135). Meets Daniel de Monfreid at Schuffenecker's (Monfreid 1903, 266). Exchanges a painting with Vincent van Gogh (Cooper 1983, 33 n. 1).

Theo van Gogh presents four of Gauguin's paintings and five ceramics on consignment at the Boussod, Valadon and Company, at 19 Boulevard Montmartre, in Paris. On December 26, he sells *The Bathers* (W 272) to Mr Dupuis for 450 francs (Fénéon, 1888a; see Gallery register in Rewald 1973, appendix I).

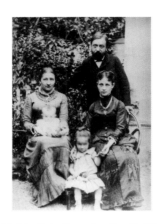

Fig. 31. *The Schuffenecker Family* [Musée départementale du Prieuré, Saint-Germain-en-Laye]

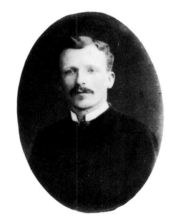

Fig. 32. *Theo van Gogh*, c. 1888 [Vincent van Gogh Foundation, National Museum Vincent van Gogh, Amsterdam]

1888

For several months, Gauguin still suffers from the effects of malaria and dysentery. Theo van Gogh (probably accompanied by his brother) visits Gauguin at Schuffenecker's and buys three paintings for 900 francs, including a large work done in Martinique, *Aux Mangos* (W 224; Merlhès 1984, no. 138, and 472 n. 10; Cooper 1983, 33; Huyghe 1952, 73). Theo exhibits a recent Gauguin, *Two Bathers* (cat. 34), at Boussod and Valadon (Fénéon, 1888b). Gauguin teaches in the open studio of Mr. Rawlins, a London businessman (Rotonchamp 1906, 152).

Leaves for Pont-Aven where he moves into the Gloanec inn (Merlhès 1984, no. 139, and 472 n. 239).

Van Gogh writes to Gauguin of his plans to form an association of painters to facilitate the sale of their works (van Gogh 1960, no. 468 F, and Merlhès 1984, no. 143).

Van Gogh asks Gauguin to come live and work with him in Arles (van Gogh 1960, no. 493 F).

Theo offers Gauguin monthly payments of 150 francs in exchange for one painting a month if he goes to Arles. Gauguin agrees to the arrangement (van Gogh 1960, no. 538 F; Merlhès 1984, nos. L, 156).

Stays in Plestin-les-Greves (Côtes-du-Nord) for several days at the home of Yves-Marie Jacob, head of customs in Pont-Aven (Chassé 1955, 65 n. 1; Merlhès 1984, 490 n. 264).

Emile Bernard joins Gauguin and Laval, who has just returned from Martinique, in Pont-Aven (van Gogh 1960, no. 523 F). Gauguin meets Emile's sister, Madeleine, who is vacationing with her brother and mother (see cat. 51).

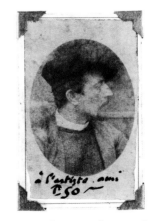

Fig. 33. *Paul Gauguin*, photograph taken by an amateur in Pont-Aven, August 1888 [Musée du Louvre, Département des Arts Graphiques, Paris]

Fig. 34. *Madeleine Bernard in Breton Suit*
[Musée du Louvre, Bibliothèque, Archives
Emile Bernard]

SEPTEMBER

Vincent suggests to Bernard and Gauguin that
they all exchange portraits of one another
(van Gogh 1960, no. 535 F).

OCTOBER

Paul Sérusier paints *The Talisman* (Musée
d'Orsay, Paris), a landscape of the Bois
d'Amour near Pont-Aven, under Gauguin's in-
structions (Denis 1942, 42-44). Vincent re-
ceives Gauguin's self-portrait *Les Misérables*
(W 239) and Bernard's self-portrait (Luthi
1982, no. 133). He sends in exchange his own
portrait (de la Faille 1970, no. 476; van Gogh
1960, no. 545 F). Theo sends Gauguin 300
francs from the sale of some ceramics
(Merlhès 1984, nos. 167-168).

OCTOBER 21

Gauguin settles his debts and leaves Pont-
Aven for Arles where he arrives two days later
(Merlhès 1984, nos. 167, 174).

Fig. 35. *Vincent van Gogh's House in Arles, 2
Lamartine Place* [Foundation, National
Museum Vincent van Gogh, Amsterdam]

OCTOBER 22

Theo sells Dupuis another painting, *Bretonnes*
(W 201), for 600 francs and sends Gauguin 500
(van Gogh 1960, no. 557; Huyghe 1952, 223;
Rewald 1973, appendix I. The sum of 510
francs is listed in the ledger). Gauguin asks
Schuffenecker to send some of his pots to
Arles, including the "horned one" (G 57;
Merlhès 1984, no 174). He sends his Pont-Aven
paintings to Theo where they are admired by
everyone (Merlhès 1984, nos. 175-76, XCIII,
and CI). The banker Mirtil selects a Gauguin,
Le Champ Derout (W 199), at the Boussod and
Valadon gallery as repayment of the 300 franc
loan to Gauguin of July 1886 (Merlhès 1984,
no. 175; Huyghe 1952, 224).

NOVEMBER

Plans to return to Martinique to found a stu-
dio (Merlhès 1984, nos. 177, 180-181, 192-193;
van Gogh 1960, no. 558a). Theo van Gogh ex-
hibits some of Gauguin's recent paintings and
some of his ceramics in two small rooms on
the mezzanine in the Boussod and Valadon
gallery (Rotonchamp 1906, 44-45).

Fig. 36. *Arles, The Alyscamps* [Jean
Dieuzaide]

NOVEMBER 10, 12, AND 13

Theo sells three paintings for a total of 1,200
francs (Rewald 1973, appendix I). Gauguin
sends Theo five more paintings (Merlhès 1984,
no. 183). He is invited to exhibit with the
Belgian group, Les XX, in Brussels. The ship-
ment of paintings will be handled by Theo
(Merlhès 1984, nos. 184-185).

DECEMBER 4

Theo sells *Fishermen in Brittany* (W 262) to
Mr Clapisson for 400 francs. He also sells

some ceramics (Merlhès 1984, no. 187).
Gauguin sends Mette 200 francs (Merlhès
1984, no. 190).

AROUND DECEMBER 17 OR 18

Goes with Vincent to Montpellier to see once
again the Bruyas Collection at the Fabre
Museum (Merlhès 1984, no. CIII; van Gogh
1960, nos. 564 F, 568 F).

DECEMBER 23

In Arles, van Gogh threatens Gauguin during a
sudden outburst and cuts off part of his own
ear (*Avant et après*, 1923 ed., 21). Gauguin is
arrested by the police and then released (let-
ter from Bernard to Albert Aurier, January 1,
1889, sold Hôtel Drouot, Paris, March 29,
1985, no. 48). Gauguin asks Theo to come and
stay with his brother (Merlhès 1984, no. 194).

DECEMBER 26

Gauguin returns to Paris with Theo van Gogh
(Marks-Vandenbroucke, unpub. diss., 1956,
173) and stays with Schuffenecker (Cooper
1983, no. 34).

DECEMBER 28

Attends the execution of a criminal, Prado, in
front of the Petite-Roquette prison (*Avant et
après*, 1923 ed., 179-181).

1889

JANUARY 5

Rents a studio at 16 rue du Saint-Gothard
(rental agreement, sold Hôtel Drouot, Paris,
December 3 and 4, 1948, no. 112). He begins a
series of prints intended for publication (cats.
67-77; Cooper 1983, no. 35; van Gogh 1960, no.
578 F).

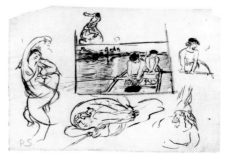

Fig. 37. Sérusier, *Paul Gauguin Rowing*, char-
coal and ink, 1889 [Musée du Louvre, Départe-
ment des Arts Graphiques, Paris]

FEBRUARY

He exhibits twelve works with Les XX in Brussels.

MID-FEBRUARY

Leaves Paris for Pont-Aven (Cooper 1983, 257 n. 3).

MARCH 21

Theo sells *Shepherd and Shepherdess* (W 250) to Anna Boch for 400 francs (Rewald 1973, appendix I). Octave Maus, leader of Les XX, sends Gauguin 400 francs from the sale of the painting during the exhibition (letter from Theo van Gogh to Maus, 22 March 1889, Musées Royaux des Beaux-Arts de Belgique, Archives de l'Art Contemporain, Octave Maus Collection, Van de Linden Donation, inv. 5225.

MID-APRIL

Returns to Paris (Rostrup 1956, 76) to make arrangements for a group exhibition he and Schuffenecker, with whom he is staying, are organizing, and to fire a statue (Malingue 1949, CI).

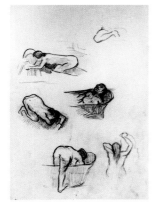

Fig. 38. Gauguin, *Sketch Inspired by Degas,* 1889 [Album Briant, Musée du Louvre, Département des Arts Graphiques, Paris]

Fig. 39. *Poster for the Impressionist/Synthetist Group Exhibition* [Service de Documentation Musée d'Orsay, Paris]

Fig. 40. *Map of the Exposition Universelle of 1889, The Fine Arts Palace and the Café des Arts, across from the Press Pavilion* [Service de Documentation Musée d'Orsay, Paris]

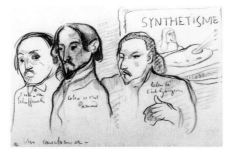

Fig. 41. *Dancers from Java, Exposition Universelle of 1889* [Société de Géographie, Paris]

Fig. 42. *Synthetism, a nightmare* [Musée du Louvre, Département des Arts Graphiques, Paris]

JUNE-OCTOBER

Exhibition of Paintings by the Impressionist and Synthetist Group is held during the Exposition Universelle at the Café des Arts. Schuffenecker had convinced the proprietor, Mr. Volpini, to exhibit paintings in lieu of the costly mirror decorations he had originally intended (Bernard [1939], 14). Gauguin exhibits seventeen works. An album of lithographs by Gauguin and Bernard is available on request (see cats. 67-77).

EARLY JUNE

Returns to Pont-Aven (van Gogh 1952-1954, T.10) and rents a studio in Lezaven (Malingue 1949, LXXXIV).

JUNE 18

Theo sells *Negresses in Martinique* (W 227) to Lerolle (Rewald 1973, appendix I).

END JUNE

Moves into the Destais Auberge in Le Pouldu, then into Marie Henry's inn with Sérusier (Chassé 1955, 63, 65-67).

JULY 4 AND 13

Gauguin's article on the Exposition Universelle appears in two parts in *Le Moderniste illustré* (Gauguin 1889a).

JULY AND AUGUST

He works in Le Pouldu for a month with Meyer de Haan, then returns to Pont-Aven and moves into the Gloanec inn where he lives on credit (Cooper 1983, no. 15; Malingue 1949, LXXXIV, 160 n. 1 and LXXXVII). Rents a room on the first floor of the Furnic farmhouse for use as a studio (Saint-Germain-en-Laye 1985, 77).

SEPTEMBER

Sends a new shipment of paintings to Boussod and Valadon (Cooper 1983, nos. 15, 17). With the exception of *La Belle Angèle* (cat. 89), Theo is disappointed in the new pictures (van Gogh 1952-1954, T. 16).

SEPTEMBER 16

Theo sells *Little Breton Girls Dancing* (see cat. 44) to Montandon for 500 francs (Rewald 1973, appendix I).

SEPTEMBER 21

Gauguin's article, "Qui trompe-t-on ici?" which attacks art criticism and government policies for purchasing works of art is published in *Le Moderniste illustré* (Gauguin, September 1889b).

OCTOBER 2

Returns to Le Pouldu with Meyer de Haan, who helps support him (Cooper 1983, nos. 19, 21). They rent the attic of the Mauduit Villa in Les Grands Sables for a studio (Cooper 1983, no. 37; Chassé 1955, 67). It is probably during this period that Gauguin recopies excerpts from Wagner's writings (*Texte Wagner*, in the Bibliothèque Nationale, Department of Man-

uscripts, Paris; Dorra 1984). Sends more pictures to Theo in Paris (Cooper 1983, no. 21; van Gogh 1952-1954, T. 19). André Gide spends several days in Le Pouldu at the inn of Marie Henry. He would later write about the visit in *Si le grain ne meurt* (Paris 1924, vol. 2, 193-196).

Fig. 43. *Les Grands Sables at Le Pouldu,* 1900 [Musée de Pont-Aven]

OCTOBER 31-NOVEMBER 11
The Friends of Art Association in Copenhagen (Kunstforeningen) puts on an exhibition of French and Scandinavian impressionists, a major part of which consists of Gauguin's early works and paintings from his art collection which had been left in Denmark (Cooper 1983, no. 39; Rostrup 1956, 75).

Fig. 44. *Site of the Friends of Arts Exhibition, Frederiksholms Kanal, Copenhagen* [Bymuseum, Copenhagen]

EARLY NOVEMBER
Sends Theo the wooden relief *Be in Love and You Will be Happy* (G 76; Cooper 1983, no. 37; van Gogh 1952-1954, T. 20). Has himself recommended for a position in Tonkin (Malingue 1949, LXXXII-LXXXIII; Cooper 1983, no. 17).

Fig. 45. *Mette Gauguin and Her Five Children in Copenhagen,* 1889 [Service de Documentation Musée d'Orsay, Paris]

MID-NOVEMBER TO MID-DECEMBER
Gauguin and Meyer de Haan decorate the dining room of Marie Henry's inn (van Gogh 1952-1954, T. 49; Cooper 1983, no. 36).

1890

JANUARY
Still planning on traveling to Tonkin, Gauguin suggests to Vincent that he open a studio in his (Gauguin's) name in Antwerp with Meyer de Haan and later Theo van Gogh (Cooper 1983, nos. 38-39).

FEBRUARY 7
Returns to Paris with money sent to him by Schuffenecker and moves in with him at 12 (now 14) rue Durand-Claye (van Gogh 1952-1954, T. 28; Malingue 1949, XCVII; Rotonchamp 1906, 67; Le Paul and Dudensing 1978, 56). Teaches at the Vitti Academy, a studio in the Montparnasse district (Joly-Segalen 1950, LIV; Perruchot 1961, 204). Gives van Gogh one of his paintings in exchange for two pictures of sunflowers, replicas of those that had decorated Gauguin's room in Arles, and a replica of *La Berceuse* (van Gogh 1960, nos. 576 F, 626 F).

FEBRUARY
Boussod and Valadon exhibits a sculpture and several ceramics by Gauguin along with a selection of Pissarro's recent paintings.

MARCH 20-APRIL 27
The Salon des Indépendants includes works by van Gogh which are admired by Gauguin (Cooper 1983, no. 40; van Gogh 1960, no. 630 F), and he wants to exchange one of his own paintings for one depicting "Alpines" (sic).

APRIL 30
Theo van Gogh buys Gauguin's still life *Oranges in a Vase* (W 401?) for Boussod and Valadon for 225 francs (Rewald 1973, appendix I).

MAY
Gauguin hopes to sell thirty-eight paintings, including fourteen from Boussod and Valadon, to the inventor Dr. Charlopin for 5000 francs. Hopes to use the money to found a "studio of the tropics" in Madagascar with Bernard and Meyer de Haan (Malingue 1949, CII; Cooper 1983, no. 41; letter to Bernard, sale, Hôtel Drouot, June 17, 1987, no. 170).

EARLY JUNE
Leaves for Le Pouldu with Meyer de Haan (Cooper 1983, no. 41).

AROUND JUNE 20
Spends five days in Pont-Aven with Meyer de Haan (Cooper 1983, no. 42).

JULY
Theo van Gogh sells two paintings by Gauguin (van Gogh 1952-1954, T. 40; Rewald 1973, appendix I). Back in Le Pouldu, Gauguin, de Haan, and Filiger are joined by Paul Emile Colin at the Hôtel de la Plage (Chassé 1955, 80).

JULY 29
Vincent van Gogh dies at Auvers-sur-Oise.

Fig. 46. Sérusier, *Paul Gauguin Playing the Accordéon* [Musée du Louvre, Département des Arts Graphiques, Paris]

SUMMER

Gauguin paints the ceiling of Marie Henry's inn. Sérusier and Filiger help decorate the rest of the room (Welsh in Saint-Germain-en-Laye 1985, 124).

AUGUST 19

Theo van Gogh sells *Oranges in a Vase* to Chausson for 300 francs (Rewald 1973, appendix I).

SEPTEMBER

Gauguin wants to return to Paris but remains in Le Pouldu because of his debts (Malingue 1949, 202).

OCTOBER 14

Theo van Gogh is committed to the clinic of Dr. Blanche because of mental illness (Perruchot 1961, 213).

OCTOBER

Gauguin's projected sale to Dr. Charlopin falls through. Eugène Boch pays Gauguin 500 francs from the sale of five of his paintings to five collectors, including Octave Maus. Boch and Bernard had chosen the works from those at Boussod and Valadon. The remaining canvases and ceramics in the gallery are sent to Schuffenecker's (letter from Boch to Maus, cited in Rewald 1973, 69).

NOVEMBER 8

Returns to Paris and stays with Schuffenecker. Eventually quarrels with his host and moves to a furnished hotel at 35 rue Delambre (Rotonchamp 1906, 69; Le Paul and Dudensing 1978, 56; this address appears in Gauguin's letter to the Ministry of Education and Fine Arts, May 15, 1891, NA, F 21 2286, leaflet 20). He uses Monfreid's studio at 55, rue du Château (Loize 1951, 14). Meets Charles Morice for the first time at La Côte d'Or restaurant (Morice 1920, 25-26, 87). Gauguin is a regular at the Gangloff brasserie, 6, rue de la Gaîté, and at the gatherings of symbolist writers at the Café Voltaire (Rotonchamp 1906, 70-71, 74).

AUTUMN

Monfreid introduces him to Juliette Huet, a young seamstress living at 15, rue Bourgeois, who becomes his model and mistress (Germaine Huet's birth certificate; Chassé 1955, 88).

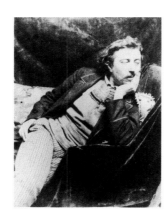

Fig. 47. Boutet de Monvel, *Paul Gauguin Wearing a Breton Jacket,* 1891 [Musée départemental du Prieuré, Saint-Germain-en-Laye]

DECEMBER 31

Gauguin's friend Julien Leclercq engages in a duel with Rodolphe Darzens. Gauguin and Jules Renard are the seconds (Jules Renard *Journal,* entry for 31 December 1890, ed. 1984, 76-77; sale, Hôtel Drouot, November 19-20, 1987, nos. 84-89).

LATE DECEMBER-EARLY JANUARY

Morice introduces Gauguin to Mallarmé (Morice 1920, 88).

1891

Often visits the studio shared by Bonnard, Denis, Vuillard, and Lugné-Poe at 28 rue Pigalle (Lugné-Poe, *Le Sot du tremplin,* 1930, 189-190).

JANUARY

Jean Dolent suggests to the novelist and playwright Rachilde that Gauguin do a drawing for her new drama, *Madame la mort* (Malingue 1949, CXVI; see cat. 114).

JANUARY 5

At the request of Morice, Mallarmé asks Octave Mirbeau to write an article publicizing Gauguin who intends to sell his works in order to finance his trip to Tahiti (Mondor 1973, no. XXXIX).

JANUARY 18 OR 25

Gauguin and Morice visit Mirbeau at his Les Damps property (Mondor 1973, 183 n. 2; letter from Mirbeau to Pissarro, sale, Hôtel Drouot, November 21, 1975, no. 86).

JANUARY 25

Theo van Gogh dies in Holland (death certificate, Utrecht).

FEBRUARY

Gauguin receives authorization to copy Manet's *Olympia* (see cat. 117) in the Musée du Luxembourg (information included in Gauguin's autobiographical manuscript, sale, Hôtel Drouot, April 16, 1974, no. 50). Exhibits two wood reliefs and three ceramics and an enameled statue (cat. 104) in the exhibition of "Les XX" in Brussels.

FEBRUARY 2

Attends the symbolist banquet in honor of Jean Moréas; Mallarmé presides over the event ("Echos divers et communications," *Mercure de France,* March 1891, 189-191).

FEBRUARY 5

Attends dinner of the "Têtes de bois" with Jean Dolent as the master of ceremonies, at the Auberge des Adrets ("Dîners artistiques," *Le Journal des Artistes,* February 11, 1891; "Echos divers et Communications" in *Mercure de France,* March 1891, 191). Sends two drawings to Rachilde to illustrate her dramatic work *Madame la mort* (see cat. 114; Malingue 1949, CXVIII).

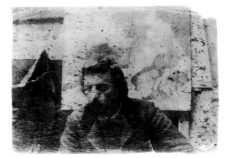

Fig. 48. Boutet de Monvel, *Paul Gauguin, February 13, 1891* [Musée départemental du Prieuré, Saint-Germain-en-Laye]

FEBRUARY 16

Mirbeau publishes an article on Gauguin in *L'Echo de Paris* (Mirbeau 1891).

Roger-Marx's article on Gauguin appears in *Le Voltaire* (Roger-Marx 1891a).

FEBRUARY 22

Exhibition of paintings to be sold at the Hôtel Drouot (Geffroy 1891; Dolent 1891).

FEBRUARY 23

Sale of Gauguin's paintings at the Hôtel Drouot. The article by Mirbeau in *L'Echo de Paris* serves as the catalogue preface (Mirbeau 1891). Revenues from the sale total 9,635 francs for thirty paintings, one of which was bought back by Gauguin himself (for a record of the sale see Paris, Orangerie 1949, 95-96). Jules Huret publishes "Paul Gauguin devant ses tableaux" in *L'Echo de Paris* (Huret 1891).

FEBRUARY 24

Announcement in *L'Echo de Paris* of special presentation at the Théâtre d'art to benefit Verlaine and "the admirable symbolist painter, Paul Gauguin."

MARCH

"Le symbolisme en peinture: Paul Gauguin" is published by Albert Aurier (Aurier 1891).

MARCH 7

Gauguin arrives in Copenhagen where he sees Mette and his children for the last time. Stays at the Dagmar Hotel, Halmtorvet 12 (Rostrup 1956, 78).

Fig. 49. *Mette Gauguin in Copenhagen* [Musée départemental du Prieuré, Saint-Germain-en-Laye]

Fig. 50. *Paul Gauguin, Emil and Aline* [Musée départemental du Prieuré, Saint-Germain-en-Laye]

MARCH 14

Mirbeau purchases *The Red Christ* (cat. 90) for 500 francs (Rewald 1973, appendix I).

MARCH 15

Gauguin writes to the Minister of Public Education and Fine Arts to request a government-sponsored artistic mission to Tahiti (NA, F 21 2286, leaflet 20).

MARCH 18

Gauguin's request is endorsed by Georges Clemenceau (NA, F 21 2286, leaflet 19).

MARCH 23

A banquet honoring Gauguin's departure is held at the Café Voltaire. Mallarmé presides over the forty-odd guests (Malingue 1949, CXIII; Rotonchamp 1906, 78-79; "Dîners artistiques," in *Le Journal des Artistes*, March 29 and April 5, 1891, 94).

MARCH 26

Receives notice that the Ministry of Public Education and Fine Arts has agreed to grant funding to his mission to "study and ultimately paint the customs and landscapes of [Tahiti]" (NA, F 21 2286, leaflet 17).

MARCH 28

At the request of the Director of Fine Arts, the Compagnie des Messageries Maritimes issues Gauguin a second-class ticket at a 30% discount from Marseilles to Noumea (NA, F 21 22 86, leaflet 12).

APRIL 1

The Director of Fine Arts recommends Gauguin to the Under-Secretary of State for the Colonies (NA, F 21, 2286, leaflet 18). Leaves Marseilles on the Océanien (Danielsson 1975, 55).

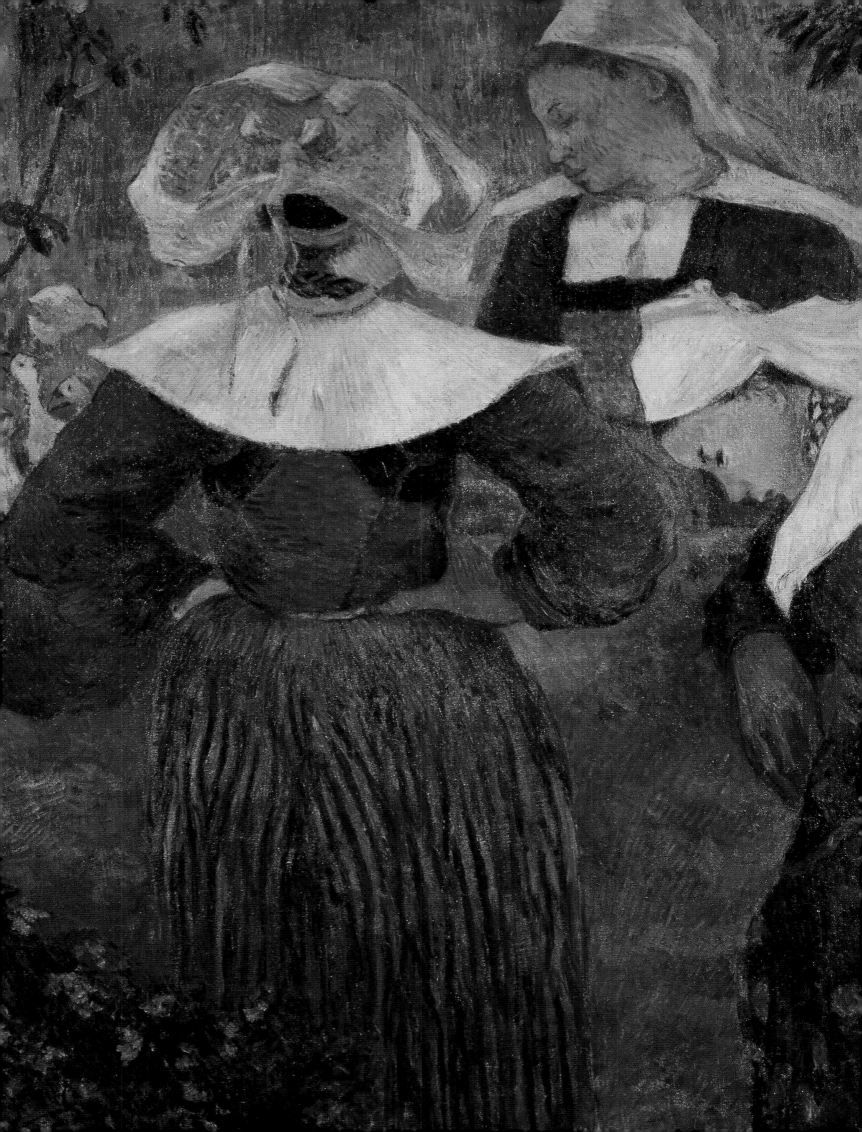

Brittany, 1886-1890

CLAIRE FRECHES-THORY

Dagnan-Bouveret, *The Pardon in Brittany*, 1886 [The Metropolitan Museum of Art, New York, Gift of George F. Baker, 1931]

1. Alexandre Cabanel (1823-1889) and William Bouguereau (1825-1905), both members of the French Academy, were well-known painters of official art.

2. Aurier 1889, 2.

3. Numbers 306, 370, and 198, respectively, *Catalogue Général Officiel de l'Exposition Universelle Internationale de 1889*, vol. I, Paris, Group I, Class 1.

4. "La première manifestation synthétiste," in Bernard [1939], 10.

5. Letter from Gauguin to Schuffenecker; Malingue 1949, LXXVII, dated Arles, December 1888 but redated spring 1889.

6. Léon Fauché (1862-1952)

"During that time, I wanted to try everything, to *liberate* the new generation and work to acquire a bit of talent. The first part of my plan came to fruition; today, anything can be attempted, and no one is surprised" (letter from Gauguin to Maurice Denis, Tahiti; June 1899, Malingue 1949, CLXXI)

"I am happy to learn that individual initiative has attempted what incurable administrative stupidity never would have dared," wrote the critic Albert Aurier in 1889. "A small group of independent artists has forced the gates – not of the Palais des Beaux-Arts, but of the Exposition Universelle itself, and they have set up a small rival exhibition of their own. The layout is somewhat primitive, very bizarre and undoubtedly 'Bohemian'. . . . But what do you expect? If these poor devils had a palace at their disposal, they certainly wouldn't have hung their canvases on the wall of a café. Nevertheless, I hurried to see this little exhibition and found it very unusual. In most of the works shown, especially those by P. Gauguin, Emile Bernard, Anquetin, etc., I noticed a marked trend toward synthetism in sketching, composition, and color; as well as a return to simpler techniques, which I highly appreciated in this era of cleverness and outrageous trickery. . . . Go and see the exhibition, it is a welcome change from all the current 'Cabaneleries' and 'Bouguereaucracies!'"[1] With these words, Aurier enthusiastically invited his readers to spurn the official art of the 1889 Exposition Universelle.[2]

The "official" pictures (by artists such as Bouguereau, Bonnat, and Jules Breton) had been selected by a jury composed of the very men who had painted them. Among the various evocative landscapes, serious portraits, and allegorical paintings were a few pictures that brought the heart of Brittany to Paris. The same realistic, picturesque approach characterized the *Seaweed Burners* by Clairin, *The Pardon* by Dagnan-Bouveret, and *The Woman of Douarnenez* by Breton.[3]

During the Exposition Universelle, there was a new Brittany to be discovered on the red walls of the Café Volpini, an establishment set up by "an Italian who loved paintings, the director of the Café Riche, one of the best-known boulevard establishments."[4] Situated across from the Press Pavilian, the Café Volpini hosted *L'Exposition de Peintures du Groupe Impressioniste et Synthétiste*, a collection of roughly one hundred works by eight artists. Though some of them were not unknown, this was the first time they had exhibited together as a group. It was Schuffenecker who found the location (see cat. 61), but it was Gauguin who carefully selected the participants; in a letter addressed to Schuffenecker, probably in the spring of 1889, he wrote: "Please remember this is not an exhibition for (the) *others*. Let's restrict it to a small group of friends, and bearing this in mind I personally want to be represented as much as possible."[5] He then listed ten of his works and the names of the painters he had chosen: Schuffenecker, Guillaumin, Gauguin, Bernard, Roy, the man from Nancy,[6] and Vincent van Gogh. "That ought to do it. I refuse to exhibit with Pissarro, Seurat, etc. – this is our group!"

The Volpini Exhibition, as it came to be known, was conceived as an act of secession. It was a break with Pissarro and the impressionists; by now the impressionist group had scattered, and some of them were exhibiting at the French Art Centennial, a part of the Exposition Universelle. Cézanne had one painting there, Pissarro two, Monet three, and Manet (who died in 1883) a total of fourteen.

7. Letter from Gauguin to Theo van Gogh, around 1 July 1889, Cooper 1983, 14.3.

8. W 376.

9. Letter from Gauguin to Theo van Gogh, 10 June 1889, Cooper 1983, 13B.1.

10. "La première manifestation synthétiste" in Bernard [1939]. In fact, Toulouse-Lautrec was too independent and did not participate in the show (see letter from Gauguin to Theo van Gogh, cited in n. 7).

11. Chassé 1955, 47.

12. W 201.

Gauguin, *Four Breton Women*, 1886, oil on canvas [Bayerische Staatsgemälde-sammlungen, Munich]

Returning from Brittany in early July 1889, Gauguin wrote: "What I really wanted to do was to show Pissarro and the others that I didn't need their help, and that their speeches about artistic fraternity were pure hypocrisy. Theirs is a blundering exhibition at the centennial; they are lost in the mob, right next to their enemies. If Pissarro and the others don't approve of my show, then that is really good for me."[7] Gauguin also wanted to distance himself from the neo-impressionist leader, Seurat, whose divisionist technique he never stopped ridiculing. He even went so far as to call one of his still-lives *Ripipoint*, having ironically painted it according to pointillist rules.[8]

In choosing the Café Volpini, which was exceptionally well situated beside the Palais des Beaux-Arts, it may be said that Gauguin and his group were blatantly thumbing their noses at both the official art world and the impressionists exhibiting nearby. In the end, Guillaumin, who had recently participated in an exhibition held at the Revue Indépendante,[9] stayed away from Gauguin's show; so did Vincent van Gogh, who had been persuaded by his brother Theo that the enterprise was too risky. The artists present included those Gauguin had listed in his letter; in addition to Charles Laval, who had accompanied Gauguin on his first trip to Brittany in 1886 and to Martinique the following year, there was Louis Anquetin, an acquaintance of Bernard's from the Cormon studio, and Georges Daniel de Monfreid, who became Gauguin's most trusted friend during his stays in Tahiti.

The artists' diversity explains the label "impressionist and synthetist"; ". . . the exhibition was impromptu, so it was somewhat disorganized," wrote Bernard. "For all intents and purposes, Gauguin, Laval, and myself were the only synthetists; the other, Anquetin, Lautrec, Roy, Schuffenecker, Fauché and Daniel de Monfreid, were still impressionists."[10]

This first official use of the term "synthetist" is significant; it was the focal point of discussions among the habitués of Marie-Jeanne Gloanec's inn at Pont-Aven in 1888. According to the painter H. Delavallée,[11] who spoke frequently with Gauguin during his first visit to Pont-Aven in 1886, the artist was already preoccupied with the concept of synthesis at that time. If one takes this term to mean the search for, and the use of, elements characteristic of a motif, or the simplification and ordering of data furnished by observation, then synthetism is especially noticeable in Gauguin's first large canvas depicting women in Brittany; the Munich *Four Breton Women*,[12] of which the preliminary pastels are demonstrably an effort to "synthetize" a picturesque Breton scene.

Among the seventeen works Gauguin chose to exhibit at the Café Volpini, nine canvases and one pastel were of Brittany. Among these, *Young Wrestlers* (cat. 48) and *In the Waves* (cat. 80) illustrate most perfectly the artist's quest for synthesis. In both cases, the subjects are strongly simplified, with colors applied flatly against a Japanese-influenced background, transforming the Brittany motif into the archetype of a primitive way of life.

It was in Brittany that the plastic techniques of synthesis were born, resulting from Gauguin's important meeting with young Emile Bernard at the end of the summer of 1888 (cat. 50). This discovery was in perfect accord with the expression of the basic, primitive aspects of the Breton soul. Thus, during the Brittany

13. Merlhès 1984, 433.

14. Letter from Gauguin to his wife, 19 August 1885; Merlhès 1984, no. 83.

15. Letter from Gauguin to Bracquemond in Merlhès 1984, no. 105, 8-12 July 1886.

16. Chassé 1955, 45.

17. Henry Blackburn, *Breton Folk, an Artistic Tour in Brittany*, London 1880, ill. Randolph Caldecott, 1880, 128-132, cited in Merlhès 1984, 433-435.

18. Thomas Adolphus Trollope, *A Summer in Brittany*, London, 1840, vol. 1, page 4, cited by Denise Delouche in "Gauguin au regard d'autres peintres ses prédécesseurs en Bretagne," in Delouche et. al. 1986, 69.

19. Gustave Flaubert, *Par les champs et par les grèves*, 1886, 199-200.

years, particularly the key years of 1888 and 1889, Gauguin worked out the main elements of the plastic techniques he would develop later in Tahiti.

Gauguin left Paris in early July 1886, traveling to the little town of Pont-Aven, a cantonal center in the *arrondissement* of Quimperlé, with a population of 1,519, six kilometers from the mouth of the Aven river.[13] He was to stay until mid-October. This first "exile" in Brittany was the result of his desire to escape life in the capital, with its intrigues and vicissitudes, and immerse himself in a world that had remained unchanged. There were also economic considerations. As early as 19 August 1885, Gauguin had written to his wife: "One can still live most cheaply in Brittany."[14] The following year, he left to "create art in a backwater,"[15] where his hotel bill came to only sixty francs a month. He moved into the inn run by Joseph and Marie-Jeanne Gloanec, which was the cheapest in Pont-Aven.

But Gauguin's backwater (Pont-Aven) was no desert; it had been attracting painters steadily since the 1860s. These were mostly English or Americans, and they inhabited the town's two hotels, the Villa Julia and the Lion d'Or. At first they came only for the summer season, but gradually, Pont-Aven acquired a permanent artistic community. Delavallée, a painter who was in Pont-Aven during 1886 at the same time as Gauguin, recalled that "the artists living at the Hotel Julia at the time included the Scotsman Donaldson and the Englishmen Morris, Floyd and Wake. . . ."[16] In 1880, the English writer Henry Blackburn praised the charm of this painter's village in his essay "Artistic Voyage in Brittany": "Pont-Aven is a favourite spot for artists, and a *terra incognita* to the majority of travellers in Brittany. Here the art student, who has spent the winter in the Quartier Latin in Paris, comes when the leaves are green, and settles down for the summer to study undisturbed. . . . Pont-Aven has one advantage over other places in Brittany; its inhabitants in their picturesque costume (which remains unaltered) have learned that to sit as a model is a pleasant and lucrative profession, and they do this for a small fee without hesitation or mauvaise honte."[17]

Hence, Gauguin's visits to Pont-Aven in 1886 and 1888 were hardly unique. Since the romantic era, Brittany had been a *finis terrae*. Travelers, artists, and writers had looked to the region's picturesque moors, rocky coasts, primitive churches and statues, and peasant population for inspiration. The English writer Thomas Adolphus Trollope had already been deeply moved by the charm of Brittany in 1840: ". . . there alone can the painter encounter the savage and thrilling majesty of nature, untainted by any trace of modernity and dotted with Druid, religious and feudal ruins, like the scattered pages of a forgotten tale."[18]

Some years later, Flaubert crossed Brittany on foot with his friend the painter Maxime du Camp, noting its picturesque landscapes, religious customs, primitive monuments, and Celtic legends. After this voyage to "the land of the Knights of the Round Table, the land of fairy tales and Merlin's sorcery, and the mythological cradle of forgotten epics,"[19] he wrote of his impressions nearly forty years later in *Par les champs et par les grèves*. This mythical side to Brittany made a similar impression on the pragmatic Ernest Renan, who was of Breton stock. In *La prière sur l'Acropole*, Renan evoked the Brittany of his childhood and of the romantic era: "I saw the primitive world. Before 1830, ancient times were still alive in Brittany. One could observe the fourteenth and fifteenth centuries in the everyday life of the towns. The trained eye could discern traces of the Gaulish

20. Ernest Renan, *Souvenirs d'enfance et de jeunesse, prière sur l'Acropole*, 1883, 87-88.

21. Cachin 1968, 83.

22. Barrès, "L' Art Breton," *Le Voltaire*, 26 August 1886.

23. Letter from Gauguin to Schuffenecker, end of February or early March 1888, in Merlhès 1984, no. 141.

24. Delouche et. al., 1986 n. 17.

Young Breton Girl in Concarneau Dress [photo: Roger-Viollet]

25. Letter from Gauguin to Mette in Merlhès 1984, no. 110, late July 1886.

emigration of the fifth and sixth centuries in the countryside; Paganism lurked behind the people's veneer of Christianity. Blended with all this were vestiges of a world even older than the one I had found in Lapland. . . ."[20]

The Brittany that Gauguin discovered on his first trip to Pont-Aven in 1886 is the one Maurice Barrès described in a series of articles he gave to the *Voltaire* in August of that year.[21] For Barrès, Brittany embodied resistance to cultures imposed from outside, where "the Gallic rooster was never tarnished by Roman dust."[22] It is therefore not surprising that Gauguin's quest for a landscape unscathed by modern civilization took him to this region, where one could still hope to see the vigor of a primitive culture.

Gauguin's taste for the exotic was probably first satisfied in Brittany. "I like Brittany, it is savage and primitive. The flat sound of my wooden clogs on the cobblestones, deep, hollow, and powerful, is the note I seek in my painting."[23] His search for a viable link between his art and the land spurred the wanderings that led him from Pont-Aven to Martinique, Le Pouldu, Tahiti, and finally to the Marquesas Islands; and always his goal was authentic primitivism.

Gauguin's Bretonnes lack all trace of prettiness; his peasant women have rugged, sharp features (cat. 91), and *La Belle Angèle* (cat. 89) may justly be said to resembler a heifer. Infatuated with Breton costumes, which he painted with the utmost attention to detail, Gauguin emphasized the purely decorative aspect; far from stressing the cheap glitter that other painters before him had found in the folklore and customs of Brittany,[24] he concentrated on other features, such as the headdresses in *Vision after the Sermon* and *Yellow Christ* (cats. 50, 80). Elsewhere, he contrasted a peasant woman's smock and bonnet with the green stone of a wayside cross (W 328). *La Belle Angèle's* holiday costume is so painted that her figure resembles a primitive icon. *The Vision after the Sermon* and *Yellow Christ* are probably Gauguin's two most beautiful symbolist works: significantly, both are inspired by Breton statuary and popular religious festivals.

Gauguin chose not to exhibit *The Vision after the Sermon* at Volpini, probably because of the furor it had created in the early winter of 1889 at the Salon of Les XX in Brussels, noted for its partiality to the avant-garde. The Volpini show, which included his Brittany canvases as well as one from Martinique and four from Arles, served as a good indication, though incomplete, of the work undertaken by Gauguin and his group in mid-1889; in fact, it immediately made Gauguin the leader of a movement. Had Gauguin stayed in Paris, such a gathering would have been inconceivable. In Brittany, he assumed the leadership of a whole new school, and realized, at least in part, his dream of an artistic retreat. At the end of July 1886, he wrote to his wife: "I'm working hard here, with a good deal of success; I am considered the best painter in Pont-Aven, though this does not earn me a penny more. But it could in the future. In any case, I am respected and everyone here (Americans, English, Swedish, French) clamors for my advice; I am stupid to give it to them because we are all made use of and then denied proper recognition."[25]

In 1886, Laval alone seems to have been following Gauguin's advice. But by the end of summer 1888, Moret, Chamaillard, Emile Bernard, and Sérusier had all climbed on the bandwagon. It was through Sérusier that Gauguin's influence spread most strongly and unexpectedly. Returning to Paris in the fall of 1888,

Sérusier, *The Talisman* [Musée d'Orsay, Paris]

26. Denis 1890; 1964 ed., 33.

27. Letter from Gauguin to Schuffenecker, 14 August 1888; Merlhès 1984, no. 159.

28. Séguin 1903a, 159.

29. Séguin 1903a, 159.

30. J. M. Cusinberche, "La Buvette de la Plage racontée par..." and R. P. Welsh, "Le plafond peint par Gauguin dans l'auberge de Marie Henry au Pouldu," in Saint-Germain-en-Laye 1985. See also R. P. Welsh's article, to be published in *Revue de l'Art*, in 1988.

31. Chassé 1921, 37.

32. Séguin 1903a, 159.

Sérusier showed his friends at the Académie Julian the small landscape of the Bois d'Amour he had painted in pure colors under Gauguin's direction – the famous *Talisman*, which now hangs in the Musée d'Orsay. This revelation led to the formation of the Nabi group, with Maurice Denis underpinning Gauguin's aesthetic principles with his well-known formula: "One must remember that a painting is primarily a flat surface covered with colors organized in a certain order; its identity as a focus for discussion, a nude woman or an anecdote is firmly subordinate."[26] Two years hence, this definition was echoed in the advice Gauguin gave Schuffenecker in a letter from Brittany dated 14 August 1888: "... don't copy nature too literally. Art is abstraction; draw art from nature as you dream in nature's presence, and think more about the act of creation than about the final result. . . ."[27]

In early June 1889, Gauguin returned to Pont-Aven, where he moved into the Gloanec inn. But the hustle and bustle of the little town, full of "dreadful foreign people" and bad painters, soon proved intolerable. Gauguin moved to the fishing village of Le Pouldu, a few kilometers from the mouth of the river Laïta. Having made several excursions to Le Pouldu with Sérusier and Meyer de Haan during the summer, the artist decided to make it his permanent base and moved into Marie Henry's auberge, which he turned into his dreamed of artistic retreat. Armand Séguin, a painter who spent time in Pont-Aven in 1894, has left a vivid description of the village as it was when Gauguin lived there: "... the place resembled Plato's garden."[28] Over a period of several months, Gauguin and his disciples Meyer de Haan and Sérusier decorated the dining room of the inn from floor to ceiling. The caricatures of Gauguin (cat. 92) and Meyer de Haan (cat. 93), both inspired by the theosophic speculations that obsessed them at the time, were juxtaposed with a portrait of the owner, the beautiful Marie Henry, painted by her lover, Meyer de Haan.

"The talent of Gauguin and his disciples transformed this ordinary tavern into a temple of Apollo: the walls were covered with decorations which shocked the rare visitors to the place, and no surface was left uncovered – noble maxims framed beautiful compositions and the tavern's windows were replaced by fine stained glass. . . ."[29] Numerous descriptions by the painters Maxime Maufra, Jan Verkade, and Paul-Emile Colin, along with accounts by the writers André Gide and Charles Chassé (the latter's mostly based on the memories of Marie Henry's later consort, Henri Mothéré), have enabled experts to recreate the decor of the famous auberge even though it no longer exists.[30] Mothéré's memoir describes the auberge during the summer of 1890: "Meyer de Haan slept in the main bedroom; Gauguin occupied the one overlooking the courtyard, while Sérusier was in the room facing the street and Filiger had the studio."[31] "... here Bernard discussed new theories, Filiger studied primitive religious artists and Sérusier sought to define the nature of the Breton peasants. The gnome's face of Meyer de Haan, absorbing volumes of good counsel, was immortalized in a bizarre sculpture by Gauguin carved from a block of oak [cat. 94], one of the most vivid and beautiful sculptures he ever produced. Here also de Chamaillard made his first experiments, crouching in a corner and painting with an intensity that he never afterward lost. . . ."[32] In Le Pouldu, Gauguin's decorative style was strengthened, and his symbolist bent became more pronounced both in sculpture (cat. 110) and in painting (cats. 92, 93).

Gauguin returned to Paris in October 1890, followed by Sérusier and Meyer de Haan. Filiger stayed on alone at Le Pouldu, where he was soon joined by Maufra and Moret, who arrived too late to profit from Gauguin's advice.

Gauguin had never stopped dreaming of distant lands; his correspondence from 1889 to 1890 reflects his desire to travel farther and farther away, first to Tonkin, then to Madagascar, where he hoped to found his "Tropical Studio – anyone who wishes to visit me there, may do so."[33] In the end, he chose Tahiti, which first appeared to him as a poetic dream: "in the silence of Tahiti's beautiful tropical nights, I will hear the soft, murmurous music of my heart, in perfect harmony with the mysterious beings that inhabit my surroundings. . . ."[34] Later, Tahiti assumed the role of an ideal place to perfect the techniques Gauguin had discovered in Brittany: "My art, which you love, is but a seed – in Tahiti I want to cultivate it for myself, in its primitive and savage state. I need quiet. I care nothing for other peoples' notions of glory! Gauguin is finished here. No work of his will be seen again in this quarter of the globe."[35]

On 23 February 1891, Gauguin's works *were* seen once more, at the Drouot auction that financed his voyage to the Pacific. And in the judgment of posterity, Le Pouldu remains his "French Tahiti."[36]

33. Letter from Gauguin to Bernard, dated April 1890 (though probably from May of that year); Malingue 1949, CII.

34. Letter from Gauguin to Mette; Malingue 1949, C, February or June ? 1890.

35. Letter from Gauguin to Odilon Redon, September 1890; Bacou 1960, 193.

36. Chassé 1921, 28.

The Ceramics

"How can one adequately describe these strange, barbaric, savage ceramic pieces, into which the sublime potter has molded more soul than clay?" (Albert Aurier, "Néo-Traditionnistes: Paul Gauguin," *La Plume*, 1 September 1891)

In June 1886, after the eighth impressionist exhibition, Gauguin was introduced to the ceramist Ernest Chaplet by the engraver Félix Bracquemond.[1] Chaplet (1835-1909) had learned how to paint porcelain during a thirteen-year apprenticeship at the Sèvres factory. After dedicating several years to perfecting and producing slip decoration, which earned him immediate praise in the 1870s, Chaplet worked from 1876 to 1882 with Bracquemond at the Auteuil studio of the Haviland firm before becoming director of Vaugirard at 153 rue Blomet, Paris. From 1882 to January 1886 he worked there on reviving the stoneware technique for Haviland. He made pots, pitchers, and gourds of brown stoneware, thrown on a potter's wheel and decorated with characteristic enameled flowers, the contours often highlighted in gold. In 1886, Chaplet left Haviland and turned his attention again to the rue Blomet studio: it was there that Gauguin (who was living on the neighboring rue Carcel) was able to learn the stoneware technique from a teacher of whom Roger Marx would later write: "With his high principles and his good business sense . . . the man was as unique as his work."[2] Having already tried his hand at sculpture with great success, Gauguin was to find in ceramics a perfect medium for expressing his love of raw materials and his decorative sense. Of an estimated one hundred ceramic objects by the artist, sixty or so remain; numerous

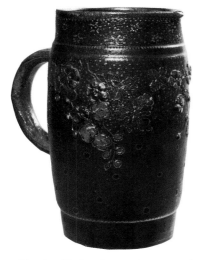

Chaplet, *Pitcher*, brown stoneware decorated in relief with gold highlights [Musée National de la Céramique de Sèvres]

1. See Paris 1976.

2. Roger Marx 1910.

others have disappeared, been lost, or irreparably damaged. This oeuvre was detailed by Gray in 1963 and by Bodelsen in 1964. The highly difficult task of dating Gauguin's ceramic pieces, very few of which were numbered, accounts for the differences in these authors' interpretations, which are often difficult to resolve.

Gauguin began to make ceramics in 1886, though it is uncertain whether he made a few pieces before his first trip to Brittany. He wrote to Bracquemond at the end of 1886 or in early 1887: "If you are anxious to see all the little products of my folly come out of the oven, they are ready – fifty-five pieces which turned out well – you will certainly howl at these monstrosities, but I'm convinced they will interest you."[3] The letter is proof of an intensely productive period, if one takes into account that all ceramists inevitably have a number of failures; this is characteristic of the medium. Gauguin continued to produce ceramics whenever he spent time in Paris, between his trips to Brittany, Martinique, or Tahiti. The last pieces date to the winter of 1894-1895, after which sculpture definitely became his focus.

3. Merlhès 1984, no. 116.

Gauguin's passion for ceramics quickly became a manifesto for an art form, which in his eyes had deteriorated rapidly during the era of triumphant eclecticism. He saw the Sèvres factory as the chief culprit: "Sèvres, in no uncertain terms, has killed ceramics." "Ceramic making is not a futile pursuit. During the earliest periods of history, the American Indians frequently made use of this art. God made man with a bit of clay / with a bit of clay, one can make metal and precious stones, with a little clay and a little genius,"[4] Gauguin wrote at the end of the Exposition Universelle of 1889.

4. Gauguin 1889a, 84.

5. *Avant et après*, 1923 ed., 174-177; Perruchot 1961, 49.

Perhaps Gauguin's taste for the art of earth and fire may be traced to his childhood, for his mother had a collection of Peruvian pottery that was unfortunately destroyed when her house in Saint-Cloud burned in 1871.[5] His guardian Gustave Arosa also owned anthropomorphic Peruvian ceramic pieces, which must have strongly influenced Gauguin's works. Except for a few pieces thrown on the wheel and then decorated, Gauguin's ceramics were modeled by hand, allowing him to create "baroque" forms: pitchers, pots, and vases with one, two, or three openings, adorned with multiple rolled handles added on, decorated either with glazed or mat finish, sometimes inlaid with gold highlights, but most often in relief. The familiar motifs of the Breton paintings reappear: shepherds, shepherdesses, lambs, geese, faces (cats. 62, 64, 65). The last pieces bear no resemblance to utilitarian objects at all and are in fact pure sculpture (cats. 85, 104, 211).

Gauguin's ceramic technique was highly original, and he may be considered one of the great revivers of stoneware art at the end of the nineteenth century. Félix Fénéon wrote in 1888 that "he adores this banished, ill-fated, and hard stoneware." Greatly influenced by Far Eastern art, he systematically searched for material effect, emphasizing firing faults, twists, oxidation, running, so that his pieces had "the feeling of high fire."[6]

6. Fénéon 1888a, reprinted in Fénéon 1970, vol. 1, 91.

Ever the dreamer, Gauguin counted on his ceramics to provide a livelihood when his paintings did not sell. A number of letters to Mette, written from Brittany or Martinique, convey his hopes that his ceramics would rescue him, so much so that he considered associating with Chaplet upon his return from Martinique at the end of 1887. However, buyers were few, and Gauguin's ceramics sold as badly

as his pictures. In January 1888, Félix Fénéon tried to draw the public's attention to "these haggard faces, with large spaces between the eyebrows, tiny slanted eyes, pug noses"[7] shown at Boussod and Valadon. Yet the proceeds of a ceramics sale by Theo van Gogh, three hundred francs, enabled Gauguin to pay for his trip to Arles, where he joined Vincent.

For Gauguin, the art of pottery was inextricably linked with that of painting. The Brittany sketchbooks show numerous motifs common to his paintings and pottery as well as many designs for ceramics. Gauguin also often depicted his ceramics in his paintings. Bodelsen demonstrated how ceramic technique led Gauguin to simplify, to highlight outlines of shapes, which naturally brought him to cloisonnism even before he experimented with this technique in painting.[8] The evolution of his ceramic oeuvre is part of Gauguin's general stylistic development toward an increasingly complex symbolism, which is evident in his last pieces such as *Black Venus* or *Oviri* (cats. 85, 211).

7. Fénéon 1888a.

8. Bodelsen 1959.

Martinique–1887

Gauguin and his friend, the young painter Charles Laval, had landed at the Atlantic port of Colón, Panama, on 30 April 1887 after a brief stopover in Martinique; they were about to discover the isthmus under rather disappointing circumstances. The expected financial help from Gauguin's brother-in-law, J. N. Uribe, the husband of his sister Marie, was not forthcoming, and the cost of the two artists' hotel rooms soon exceeded their means. Gauguin found work with the Panama Canal Construction Company, and Laval earned some income from painting portraits in the academic style. Misfortune soon struck them: Laval came down with yellow fever, and Gauguin lost his job a mere fifteen days after being hired.

By the beginning of June, nonetheless, the two were able to leave for Martinique, where they hoped to live cheaply. They moved into a modest cabin two kilometers from the port of Saint-Pierre, overlooking Mount Pelée. There they found a genuine tropical paradise that caused Gauguin's palette to be transformed by a veritable drunkenness of color. The canvases he brought back from his stay in the Antilles, though few in number, represent an important step in his stylistic development. He also made some very beautiful pastels, numerous sketches, and a few designs for fans.

Gauguin's stay in Martinique may be seen as the first concrete step toward the exoticism and primitivism for which the artist would search during the remainder of his life. Deeply influenced by the paradisaical nature of the island, Gauguin was fascinated more by the black natives than by the whites and Creoles. His impressionist touch, carefully controlled, lent to the paintings of this period a particularly rich texture in accord with the increasingly decorative style of his broadly rhythmic compositions.

1. *Allées et venues* (Comings and Goings), the Thyssen-Bornemyisza Collection, Lugano; not listed in Wildenstein 1964; Fénéon 1888a.

2. W 224.

3. Antoine 1889, 369-371.

4. Octave Mirbeau, 1891a, 1.

5. Letter to Charles Morice at the end of 1890; Rewald 1938, 19.

In January 1888 Félix Fénéon noticed a Martinique canvas at Boussod and Valadon, and referred to its "barbaric and bilious character."[1] One year later at the Café Volpini exhibition, the superb *Under the Mango Trees*,[2] which had been recently acquired by a very enthusiastic Theo van Gogh, caught the attention of Jules Antoine, who referred to it admiringly in his review.[3] However, it was not until February 1891, when the artist's works were sold prior to his departure for Tahiti, that the originality of the Martinique paintings was recognized by Octave Mirbeau, who wrote: "He brought back a series of dazzling and severe canvases, in which he has finally conquered his entire personality; they represent enormous progress, a rapid departure toward idealized art.... Dreams have led him, in the majesty of [his] strokes, to spiritual synthesis, to profound and eloquent expression. Henceforth, Gauguin is his own Master...."[4]

Mirbeau's judgment corresponds to Gauguin's own commentary on his work: "I had a decisive experience in Martinique. It was only there that I felt like my real self, and one must look for me in the works I brought back from there rather than those from Brittany, if one wants to know who I am."[5] This assertion, which may be construed as a confession of sorts, allows the Martinique interval to be viewed as one of the most profound bases for the primitivism which would flourish in Gauguin's Tahitian works.

17
The Breton Shepherdess

1886

60.4 x 73.3 (23¾ x 28⅞)

oil on canvas

signed and dated at lower left, *P. Gauguin 86*

Laing Art Gallery, Newcastle Upon Tyne,
Tyne and Wear Museums Service

EXHIBITIONS
Paris 1906, no. 11; London 1966, no. 3; Zurich
1966, no. 4; London 1979, no. 81; Washington
1980, no. 42

CATALOGUE
W 203

1. Jamot 1906, 467.

2. Cogniat and Rewald 1962, 100-110.

3. Bodelsen 1964, 200.

4. John House emphasized the innovative
aspect of the painting. See House and
Stevens in London 1979, no. 81.

5. Bodelsen 1964, 42; and see fig., cat. 18

Although this canvas has sometimes been dated to 1888 or 1889, it was assigned the date 1886 by Paul Jamot as early as 1906, in the critic's review of the *Salon d'Automne*.[1] This would put it at the time of the artist's first stay in Brittany. The preparatory drawings and the subject, style, and technique of the painting serve to support Jamot's assertion.

There are several preparatory sketches for the work at the end of Gauguin's Brittany sketchbook,[2] in particular a preliminary sketch for the seated shepherdess and various studies in which one can identify the sheep, the little peasant, and the cow on the right with its head turned away. All these have been dated to 1886.[3] This painting, along with *Four Breton Women* (W 201), is one of the first Breton peasant scenes whose landscape is still clearly impressionist in scope and technique. Gauguin would systematically develop this subject matter during his subsequent stays in Brittany. With its dreamy pose, the work is significant as a prototype which, transformed by the exotic, would find its full development in Gauguin's Tahitian period.

While the composition and the already tilted perspective of *The Breton Shepherdess* timidly foreshadow experiments of 1888-1889,[4] the peaceful calm of the canvas is still far from the somber primitivism Gauguin later cultivated. He made a detailed study of the figure of the shepherdess (cat. 18), who appears again on the side of a jardiniere with Breton themes (cat. 25) and in relief on the lid of a vase (G 27) dated to the winter of 1886–1887.[5] The reclining sheep in the foreground at the left and the one in profile in the center reappear respectively on a vase (G 42), on one of the short ends of the previously cited jardiniere, and on the

6. Huyghe 1952, 222.

Brussels vase with Breton scenes (cat. 24). Thus, *The Breton Shepherdess* brings together several of the subjects systematically explored by Gauguin between 1886 and 1887. An entry in his sketchbook of 1888[6] – "Fauché [cow and sheep] 150" – very likely refers to this painting, which Gauguin probably sold for 150 francs to Léon Fauché, a future exhibitor at Volpini's café. For some time the canvas belonged to Gustave Fayet who owned several ceramics by Gauguin (cats. 25, 36, 39, 211).–C.F.-T.

Gauguin, sketches for *The Breton Shepherdess, Brittany Sketchbook*, pages 101, 107 and 110 [The Armand Hammer Collection]

18
Young Breton Woman Seated

1886

305 x 422 (12 x 16⅝)

charcoal and brush and watercolor on laid paper; watermark, *L.BERVILLE*

Musée des Arts Africains et Océaniens, Paris

EXHIBITION
Saint-Germain-en-Laye 1985, no. 154

shown in Paris only

1. Jirat-Wasiutynski 1978, 52-53.

2. C. Lloyd, in London 1981, 157.

Gauguin, *Pot with a Breton Shepherdess on the Cover*, 1886-1887, unglazed stoneware [ex. collection Ulmann, Paris]

This sketch, finely set off with watercolor, is a study for *The Breton Shepherdess* (cat. 17) of 1886. The work seems to have been executed after a model, who probably posed especially for it.[1] Like Degas and Pissarro,[2] Gauguin, by 1886, could call forth a series of poses and gestures, which he used from one work to another and expressed in a variety of techniques. Thus, this figure in the same pose reappears in two ceramic pieces created in Paris during the winter of 1886-1887 (G 27 and cat. 25).—C.F.-T.

19
Seated Breton Woman

1886

328 x 483 (12⅞ x 18⅞)

charcoal and pastel selectively worked with brush and water on laid paper; watermark, *Lalanne*

dedicated and signed at upper right, *à Mr. Laval/Souvenir/PG*; inscribed on the verso, *Ce dessin ci-contre a été utilisé par / Gauguin pour décorer une jardinière en / céramique par Chaplet. / Ce renseignement a été donné à la / Galerie Choiseul par Lenoble gendre de Chaplet/ le 15 avril 28. / Cottereau*[1]

The Art Institute of Chicago, Gift of Mr. and Mrs. Carter H. Harrison

EXHIBITIONS
Chicago 1959, no. 76; Paris 1976, no. 71

shown in Washington and Chicago only

1. "This sketch on the reverse was used by/ Gauguin to decorate a ceramic/jardiniere by Chaplet./ This information was given to the Choiseul Gallery by Lenoble, the son-in-law of Chaplet/15 April 28./ Cottereau."

2. Rewald 1958, no. 6.

While the position of this Breton woman is similar to that of cat. 18 in reverse, this pastel is more audacious both in its composition and in its use of an overhead view. This treatment does not seem to have been employed by Gauguin in his paintings, but it appears again in a vase (cat. 24) on which Gauguin collaborated with the ceramist Ernest Chaplet, and in the right portion of the fan (cat. 23) representing seated Breton women. The position of the head, thrust backward, is repeated on the reverse side of a ceramic of 1889, *Sea Monster and Girl Bathing* (cat. 82). The dedication of this work to Mr. Laval leads one to believe that the sketch was given to him at an early date, before the departure of the two friends for Panama and Martinique in April 1887.[2]—C.F.-T.

20
Breton Woman and Study of Hand

1886

465 x 320 (18¼ x 12⅝)

pastel

signed with initials and dated, *P.G. 1886*; annotated at lower right, *à m Newman souvenir affectueux*

private collection, Switzerland

Like cat. 21, this sketch is a study for a painting now in Munich, *Four Breton Women* (W 201), one of the most important canvases of the artist's first stay in Brittany. The artist's dating of this study provides a valuable reference point and makes it possible, on the basis of technical and stylistic analogies, to reconstitute a group of sketches of the same period (cats. 18, 19, and 21).

In addition, a third preparatory sketch for the Munich painting shows a Breton girl seen from the back, with hands on hips (Pickvance 1970, no. II). In these three equally sized sheets Gauguin used the same pastels and the same solid form of the model. The hatching, which conveys a sense of mass, is reminiscent of Pissarro's technique in his pastels of peasant women of the 1880s. Already evident here is Gauguin's tendency to establish firm outlines. Forcibly impressed by the traditional costume of these Breton women, as he will be by those of Martinique, Gauguin is careful to convey the rusticity of the clothing and to bring out the contrasting delicacy of the headdress.

The repertoire of forms perfected in 1886 was to serve the artist again during his second stay in Brittany in 1888. In *Breton Women and Calf* (W 252) a figure is seen from the back, head in profile, combining the positions of the model exhibited here and of the Breton girl with hands on hips.

Mr. Newman, the person to whom this work is dedicated, remains a mystery. Perhaps he was an American painter working at Pont-Aven at the time, but no trace of him has been found.—C.F.-T.

21
Breton Girl, Head in Profile, Facing Left

1886

440 x 311 (18⅞ x 12⅝)

charcoal and pastel on laid paper

signed at lower left in charcoal, *PEO*

the property of a gentleman

This pastel is a study for the figure at the right in the background of the painting *Four Breton Women* (W 201). While here shown standing in three-quarter view, in the Munich painting she partly disappears, hidden by a low wall. There, too, she has a more thoughtful expression, her eyes almost closed.

The same Breton woman reappears in simplified form on the Brussels vase with Breton scenes (cat. 24).–C.F.-T.

22
Breton Woman Gleaning

1886

460 x 380 (18⅛ x 15)

graphite and pastel squared in graphite and blue pastel on laid paper

from the collection of Mr. and Mrs. Paul Mellon, Upperville, Virginia

EXHIBITION
(?) Paris 1906, no. 124

shown in Washington and Chicago only

1. See Pickvance 1970, 23, pl. 18.

More than a preparatory sketch for the *Breton Shepherd Boy* (cat. 42), this large sheet is a work in its own right, executed in 1886, during Gauguin's first stay in Brittany. Two years later Gauguin used it for his painting.[1] The Breton peasant woman with headdress, picking up a branch, is not necessarily a gleaner; she might be a firewood gatherer. She makes an extended gesture that dates back to the figures of Jean-François Millet, highlighting her big skirt and her immense white headdress whose sinuous design stands out against her velvet bodice. Here one sees, in both subject and execution, what Gauguin owed his master Pissarro and, through him, to Millet, the painter of *The Gleaners* (1857, Musée d'Orsay). One can imagine how, two summers later, sensing the need to heighten the green and the somewhat monotonous harmony of *Breton Shepherd Boy*, Gauguin took this sketch out of a portfolio and, using the same dimensions, painted from it the person on the right. When adding the Breton woman, who is somewhat large and disproportionate in relation to the child, he strengthened the idea of her headdress and made it more precise, more decorative, and the focal point of his painting.

This sketch was exhibited in the *Salon d'Automne* of 1906. In his account of the exhibit, the critic Paul Jamot reported the "unquestionable signs," more than those of Pissarro, "of the influence exercised on Gauguin by the most renowned draftsman of our time, Mr. Degas."[2]—F.C.

2. Jamot 1906, 466.

23
Fan Decorated with Three Seated Breton Women

1886-1887

185 x 410 (7¼ x 16⅛)

watercolor and gouache over graphite

private collection

EXHIBITION
Paris 1960, no. 27

CATALOGUES
W 202; Gerstein 10

This fan again uses various elements of the formal vocabulary Gauguin developed during his first stay at Pont-Aven and draws them together in an essentially decorative composition. The two peasant women seated in the center, the young boy, the trees, and the bush are taken from *Four Breton Women* (W 201). Together with the cow they are all seen again on the ceramic jardiniere of 1886-1887 (G 41). The Breton woman at the left is the principal decorative subject of a vase dated to the same years (G 18), and the Breton woman seated at the right is the same as the one found in a sketch (cat. 19) and on the Brussels vase with Breton scenes (cat. 24).

The semicircular form of the fan inspired the artist to create an unusual composition with subtle symmetry around the central axis of the tree. The fact that the compositional elements of the fan can be pieced together from various other works suggests that this was a souvenir of impressions of Brittany, executed with great freshness after the artist returned to Paris.–C.F.-T.

Gauguin, *Jardiniere with Breton Women*, 1886, glazed stoneware [Musée du Petit Palais, Geneva]

24
Vase Decorated with Breton Scenes

This vase is one of the few authenticated pieces to have emerged from the collaboration between Gauguin and Ernest Chaplet during the winter of 1886–1887. In contrast to other ceramics modeled at this time by Gauguin himself (cats. 27, 28, 36), this vase bears Chaplet's stamp on its underside; hence the basic pot must have been thrown by Chaplet on a wheel, and the glaze subsequently added by Gauguin.[1]

The middle part of the vase is covered with a white slip, to which the incised, glazed decoration has been applied. The base and upper section have been left with the original earth tone. Other examples of this highly individual technique were produced by Chaplet in his workshop in the rue Blomet in Paris before he moved to Choisy-le-Roi at the end of 1887.[2]

1. Berryer 1944, 17.

2. Bodelsen 1964, fig. 154.

winter 1886–1887

height 29.5 (11⅝)

glazed stoneware, with incised decoration and gold highlights

signed in lower section, at base of tree, *P Go*; Chaplet's stamp on underside, along with the number *21*

Musées Royaux d'Art et d'Histoire, Brussels

EXHIBITION
Brussels 1896, no. 77

CATALOGUES
G 45, B 9

shown in Paris only

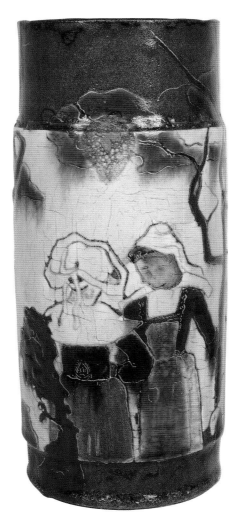

3. Berryer 1944, n. 1.

Gauguin's use of a simplified, incised contour, with gold highlights for his decorative motifs, has led this vase to be dated to 1888–1889,[3] when the artist's interest in cloisonist and synthetist styles was at its height. There is a technical analogy between the vase and a ceramic (G 64) also made by Chaplet and decorated by Gauguin, dated by Gray to about 1889. More convincing, however, is the

Gauguin, *Breton Girl*, 1886, colored chalk [Glasgow Museums & Art Galleries, The Burrell Collection]

4. Bodelsen 1959.

5. Bodelsen 1964, figs. 12, 16, 40a.

hypothesis derived from a comparison between this vase and the paintings, pastels, and sketches of Gauguin's first period in Brittany, dating this ceramic to the winter of 1886–1887. The piece is seen as a key work in the artist's shift toward cloisonism.[4]

The two main figures are based on Gauguin's painting of four Breton women (W 201) now in Munich. The woman seen from the back figures in a pastel (P II) that served as a study for the Munich painting. Likewise, the woman seen in profile may be found in another contemporary pastel (cat. 21). The seated figure viewed from behind is almost identical to a Breton woman featured in a pastel (cat. 19). As for the sheep and geese, these appear several times in Gauguin's Brittany sketchbook,[5] as well as on another ceramic (G 18) from the same period.

A comparison between the drawings and their motifs transposed on the vase shows that the technical considerations raised by working with ceramics – such as the avoidance of any mixing of colors during the firing process by the use of incised decorative outlines – probably led Gauguin to simplify his motifs and to interpret them in a more synthetic style.

Finally, it is intriguing to note that Gauguin left Chaplet to do as he wished with the vase they had made together, as if its fate were not a matter of great personal interest to him. Chaplet later exhibited the piece at the *Troisième Exposition de la Libre Esthétique* in Brussels in 1896, where it was purchased by its present owner.—C.F.-T.

25
Jardiniere Decorated with Motifs from The Breton Shepherdess and The Toilette

Gauguin, sheet of sketches with study for *Jardiniere*, 1889, pencil [The Art Institute of Chicago, Arthur Heun Fund]

1. d'Albis 1976, 91.

2. Gray 1963, 156.

The rectangular form of the jardiniere gave Gauguin the opportunity to use barbotine decoration in simulated bas-relief. There are two known pieces of this type, both decorated with Breton subjects. The first (G 41), probably made somewhat before the one presented here, has fully glazed decoration and repeats motifs from the painting *Four Breton Women* (W 201). The presence of Ernest Chaplet's seal with the initials of the Haviland company[1] on the bottom of this ceramic indicates that it is one of the rare pieces known to have been executed by Gauguin in collaboration with the great ceramist.

Although the jardiniere exhibited here does not have Chaplet's distinctive symbol, a little engraved rosary, it bears sufficient resemblance to the earlier jardiniere to place it among the small group of pieces jointly executed by the two artists during the winter of 1886-1887. Several works from this group, including this jardiniere, belonged to the collection of Gustave Fayet, a great admirer of Gauguin who bought it from Schuffenecker in 1903 for 600 francs.

The body of this jardiniere, decorated with mat barbotine, contrasts with the base, which is covered with a shiny glaze of various shades of red. This difference of treatment well illustrates Gauguin's attempt at this early date to explore the range of technical possibilities of ceramics. In the jardiniere with motifs from *Four Breton Women*, the colors had run and become mixed, which would explain the artist's change in technique for this piece, and offer a reason for dating it a little later, at the beginning of 1887.[2]

1886–1887

27 x 40 x 22 (10⅝ x 15¾ x 8⅝)

stoneware decorated with barbotine, partially glazed

signed on short end, *P. Gauguin*

Mlle Roseline Bacou

EXHIBITION
Paris 1906, no. 54

CATALOGUES
G 44, B 10

shown in Paris only

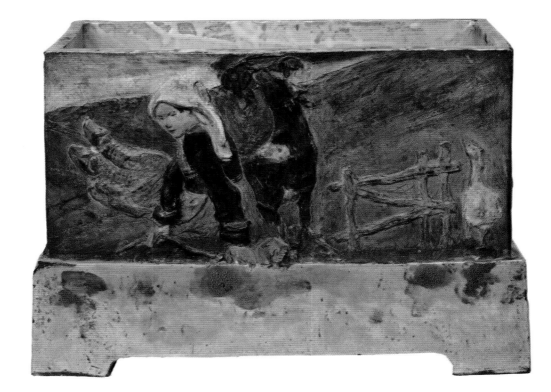

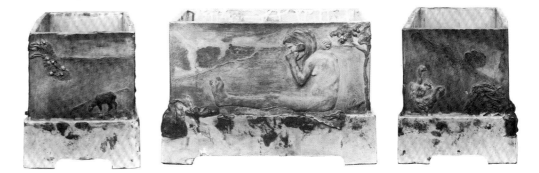

Gauguin, *The Toilette*, 1882, low relief on pear wood [private collection, Paris]

3. Merlhès 1984, no. 99.

4. Bodelsen 1964, 30.

5. Loize 1951, no. 436.

On one of the long sides is the seated figure of *The Breton Shepherdess* (cat. 17) of 1886, while the short ends are decorated with geese and a sheep, familiar subjects of the first Breton paintings. A fragmentary study of the other long side of the jardiniere appears on the back of a drawing at the Art Institute of Chicago. The decoration of this side repeats the motif of the pear-wood bas-relief *La toilette* (G 7), carved in 1882. Exhibited uncatalogued at the eighth impressionist exhibition in 1886, this bas-relief probably attracted Chaplet's attention. A little later Gauguin wrote to his wife: "Delighted with my sculpture, he asked me to do some works with him if I wished, this winter; if sold, the proceeds would be divided equally."[3]

In this jardiniere one can see a point of departure in Gauguin's activity as a ceramist.[4] It is also one of the clearest examples of the close connection between the concerns of the painter, the sculptor, and the ceramist, since the same motifs are found in works executed in each of these techniques. "I acquired a superb ceramic jardiniere from Gauguin," Gustave Fayet wrote to Gauguin's friend, the painter Daniel de Monfreid, on 2 October 1905.[5] Fayet exhibited the piece, together with the numerous Gauguin canvases in his collection, in the retrospective dedicated to the artist at the *Salon d'Automne* of 1906.–C.F.-T.

26
Vase with Figure of a Breton Woman

winter 1886-1887

height 13.6 (5¼)

brownish red unglazed stoneware

signed beneath left handle, *P Go*, and numbered *49*

Museum of Decorative Art, Copenhagen

EXHIBITIONS
Copenhagen, Kleis 1893; Copenhagen 1948, no. 78

CATALOGUES
G 36, B 28

shown in Washington and Chicago only

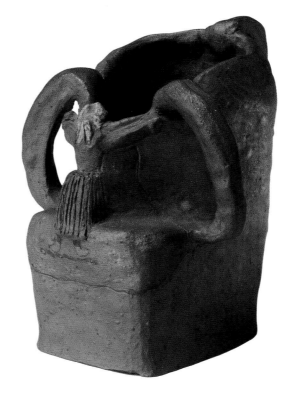

1. Album Briant, Louvre, Département des Arts Graphiques, 25.

2. Cogniat and Rewald 1962, 98.

3. G 31, 32; Bodelsen 1964a, nos. 5 and 27 (?).

This tiny vase, polychromed in slip retouched with gold, is one of the rare ceramics that was numbered by Gauguin. In marked contrast to the vase with Breton motifs in Brussels (cat. 24), it was modeled by hand. Executed during the winter of 1886-1887, it differs from other ceramics from the same period through its more simplified, almost massive form, which is alleviated by three decorative, dark brown handles. Unglazed, it combines decorations in relief – a highly stylized figure of a Breton woman, seen from the back with arms raised – and other motifs that have simply been engraved into the clay, such as the woman's feet and the sun forms on the sides.

The polychromy, made of colored slip retouched with gold, is very subtle, in keeping with the deliberately rustic style Gauguin sought in his early ceramics. The motif of the Breton woman with arms raised appears on a sheet in the Album Briant in the Louvre,[1] among sketches for ceramic projects, and on a page from a Brittany sketchbook.[2] The same motif appears in two vases from the same period,[3] one of which was, like the vase exhibited here, purchased by the Museum of Decorative Art in 1943 after having belonged to Mette Gauguin.—C.F.-T.

27
Vase Decorated with Three Breton Girls

winter 1886–1887

height 21 (8¼)

glazed stoneware

signed, *P GO*; inscribed in relief, *ANNO*

Mr. and Mrs. Herbert D. Schimmel,
New York

EXHIBITION
Tokyo 1987, no. 26

CATALOGUES
G 34, B 24

shown in Chicago and Paris only

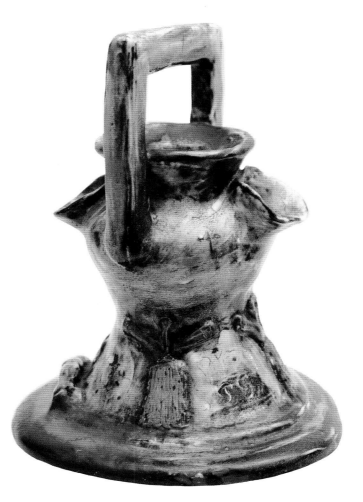

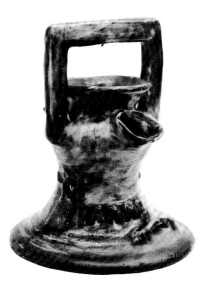

This little piece bears the same decoration of small Breton girls with raised arms as may be seen on its counterpart in Copenhagen (cat. 26). This motif forms the main decorative element in several vases (G 31, G 32, G 33) made in the winter of 1886–1887 and appears in several sketches for ceramics executed by Gauguin during the same period. Here, the frieze of three Breton girls in blue skirts with gold touches is neatly adapted to the base; the belly of the vase, with its three openings, is chiefly ornamented by the heavy rectangular handle. The bulky, symmetrical shape of the piece contrasts with the more fantastical forms of most of Gauguin's other ceramics of this period, which tend to have handles that are slender and rounded.—C.F.-T.

28
Vase with Four Handles Decorated with Breton Peasants

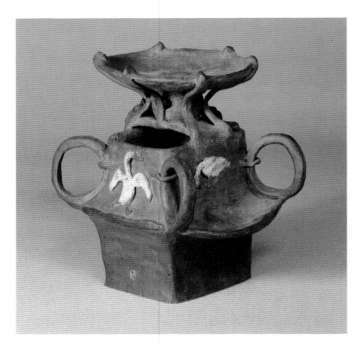 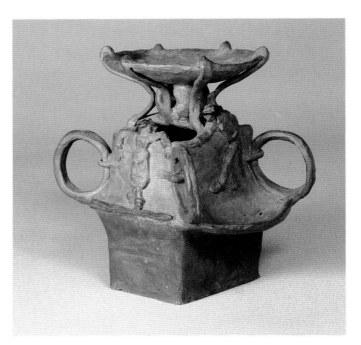

1886-1887

height 17 (6¾)

unglazed stoneware

signed at left of the Breton woman, *P Go*

Musée d'Orsay, Paris, transferred by the Musée des Arts Africains et Oceaniens in 1986, gift of Lucien Vollard, 1943

EXHIBITION
Paris 1976, no. 104

CATALOGUES
G 21, B 26

shown in Paris only

Unlike the Brussels vase with Breton decoration (cat. 24), this pot in the form of a fountain was not thrown on the potter's wheel, but modeled by Gauguin himself. The concept is characteristic of Gauguin's first ceramics executed over the winter of 1886-1887, after the artist's first stay in Brittany. At that time Gauguin liked to experiment with complicated forms having no utilitarian purpose. Handles and decorative elements are expressed in sausagelike shapes or with clay additions to the principal body of the vase, endowing the piece with a whimsical character. This is a first manifestation of the ceramic sculpture that Gauguin would develop later. Here the decoration, applied with great naïveté, consists of Breton peasants like those the artist used in his paintings at this time. An unobtrusive colored slip enlivens this rustic and whimsical vase. Two geese applied to two contiguous faces of the pot are given a white slip. In the upper part of the piece the sun is discernible, its rays carved into the clay body. This naively symbolic motif appears, as does the moon, in several other ceramics of the same period.—C.F.-T.

74

29
Self-Portrait for Carrière

1886?

40.5 x 32.5 (16 x 12¾)

oil on canvas

signed and dedicated at upper left, *A l'ami* Carrière/ P. Gauguin

National Gallery of Art, Washington, Collection of Mr. and Mrs. Paul Mellon

EXHIBITIONS
Paris 1906; Baltimore 1936, no. 20; New York 1951

CATALOGUE
W 384

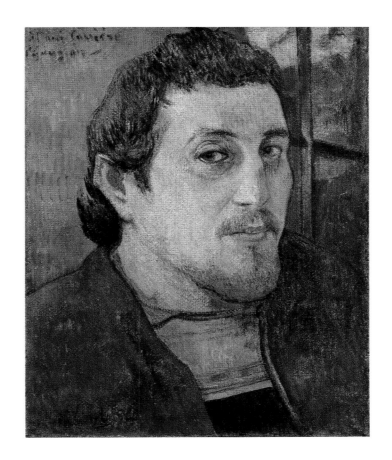

Laval, *Self-portrait*, 1888, oil on canvas [Vincent van Gogh Foundation, National Museum Vincent van Gogh, Amsterdam]

Carrière, *Portrait of Paul Gauguin*, 1891, oil on canvas [Yale University Art Gallery, New Haven, Bequest of Fred T. Murphy]

1. Gustave Geffroy recounted to Charles Chassé a visit he paid to Gauguin at Le Pouldu in the summer of 1890, saying he had already met Gauguin in Paris at Carrière's. Chassé 1921, 37.

Gauguin had met Eugène Carrière (1849-1906) by 1890,[1] and must have seen him quite regularly in 1891 at gatherings of poets and painters linked with the symbolist movement, particularly at the café Voltaire. Carrière began a portrait of Gauguin at this time[2] and, according to the poet Charles Morice, "in exchange . . . Gauguin gave [Carrière] his own portrait, which he had executed some time before."[3] Taking into account this "some time before," as well as the work's earlier dedication to Charles Laval, which can be seen below and to the left of the present one if the painting is examined closely,[4] there are two possible periods to which one might date this work. Rather sober in style, it could have been painted as early as the summer of 1886, at the time of *Still Life with Profile of Laval* (cat. 30); alternatively, it might have been completed in the summer of 1888, at the same time that Laval painted a self-portrait set in front of a window, which he later gave to van Gogh. Gauguin here seems to be placed symetrically in front of the same window. It is not impossible, however, that the Laval self-portrait was painted in 1886, and dated 1888 when it was signed and sent to van Gogh. The earlier date would explain the immense stylistic distance, difficult to credit to just a few weeks, between this self-portrait and *Les Misérables* (W 239), which Gauguin was to send to van Gogh. 1886 does appear to be the most likely date. Laval and Gauguin were, in any case, estranged from one another in 1889, partly because they both courted Madeleine Bernard, who chose Laval. It is quite possible that Laval returned Gauguin's painting to him at this time.

2. A letter from Gauguin to Carrière, excusing himself for interrupting his pose because he was leaving for Copenhagen, makes it possible to date these sittings to the beginning of February 1891. See J. R. Carrière, *De la vie*, 174; cited by Bantens 1983, 93.

3. Morice 1920, 43.

4. Technical report on the painting made for the National Gallery of Art. The inscription is confirmed by a note on page 223 of Gauguin's Brittany sketchbook, which also contains an inventory list: "Gave/Laval/my portrait." Huyghe 1952.

5. The interpretation is from Bantens 1983, 96.

6. For example, the artists' dinner parties of the *Têtes de bois* in 1891, 1893, and 1894, or Pierre Puvis de Chavannes' banquet in 1895. See Bantens 1983, 94.

7. Morice 1920, 43.

8. Laval died in Paris in 1894. See Walter 1978, 290.

9. Morice 1903, 413-414.

Gauguin thus dedicated to Carrière an old, retrieved portrait, which he no doubt reworked a little, particularly at the bottom. He must have presented the work to Carrière either before his departure for Tahiti in 1891 or, more likely, during his last stay in Paris, between 1893 and 1895.[5] The two artists continued to see one another, but always in a relatively official way, at joint exhibits, or at the frequent banquets to honor painters or writers.[6] Their mutual esteem, however – they were almost exact contemporaries – was quite reserved. "Carrière has real regard for Gauguin," wrote Morice, "but only intellectual, I think, and not without reservations: 'His mouth is not pleasant,' he would say."[7] Indeed, it is striking that in Carrière's portrait of Gauguin the mouth is particularly bitter and the face is weary and ill-tempered. In his self-portrait, in which he is wearing the embroidered Breton vest seen in photographs of him, Gauguin looks at himself without displeasure, even with a touch of interest or amusement. It is an intimate, relaxed portrait, which one feels was made for a good friend at a moment of shared closeness. Despite the inscription, this is not a portrait of a friend of Carrière, but of a friend of Laval, during the pioneering years of Pont-Aven and Martinique, long before Gauguin gave the work to Carrière.[8]

In Gauguin Carrière saw only the bitter, unsuccessful, and garrulous person whom he described guardedly in the study Morice carried out after Gauguin's death: "Gauguin represented a form of decorative expression . . . his artistic constitution was subtle, richly nuanced, fresh, flexible, and violent: but he lacked philosophical restraint, and he fell prey to despair too quickly."[9] Probably by this time Carrière had already sold his painting to Gustave Fayet, the greatest collector of Gauguin's work at the beginning of the century.–F.C.

30
Still Life with Profile of Laval

1. For analysis of Laval's work, see his biography in Merlhès 1984, 450-454, n. 219.

2. Merlhès 1984, no. 176.

The physiognomy of the painter Charles Laval (1862-1894), a student of Bonnat before becoming the emulator of Gauguin, is well known to us thanks to his two self-portraits, *Self Portrait in a Landscape* (1888, Rijksmuseum Vincent van Gogh, Amsterdam) dedicated to van Gogh, and *Self Portrait* (1889, Musée d'Orsay). Laval's small body of work, however, still remains little known.[1] By 1886 he had met Gauguin at Pont-Aven and began following in the wake of the master. Sufficient friendship arose between the two painters – "he has a fine and noble nature despite his great failings," wrote Gauguin[2] – for them to decide to go together to Panama and then to Martinique in 1887.

This still life, made up of diverse elements, remains enigmatic in many ways. The strict arrangement of the fruits and the way they are treated with small brushstrokes clearly reveal the influence of Cézanne, one of whose still lifes Gauguin owned and of which he was especially fond (cat. 111). The curious introduction of Laval's profile, however, cut by the right border of the canvas, reflects the influence of the compositions of Degas, whom Gauguin deeply admired. Such a decorative approach anticipates the handling of *Still Life with Fruit* (cat. 55) of 1888 and the celebrated *Portrait of Meyer de Haan* (cat. 93) of 1889. This type of composition, in which a person is only partially introduced into the canvas, would

1886

46 x 38 (18⅛ x 15)

oil on canvas

signed and dated at lower left, *P Gauguin 86*

Josefowitz Collection

EXHIBITION
Toronto 1981, no. 45

CATALOGUE
W 207

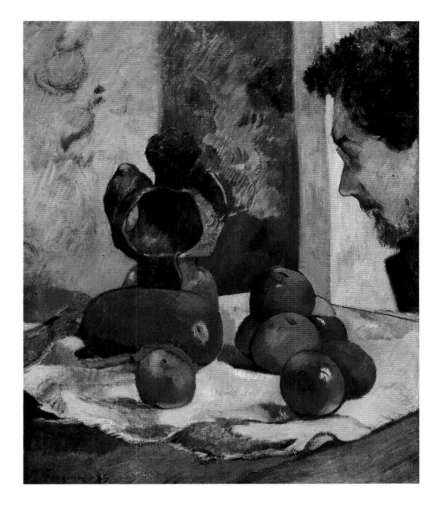

Gauguin, *Study for a Ceramic*, from a letter to Mette, 6 December 1887 [Bibliothèque d'Art et d'Archéologie, Paris; Photo: S.A.B.A.A., Paris]

3. See Welsh-Ovcharov in Toronto 1981-1982, no. 45.

4. Merlhès 1984, no. 137.

5. Bodelsen 1964, 154; Gray 1963, 12, 18.

become a recognizable feature of the work of Pierre Bonnard, who, with his young colleagues, was one of the fervent admirers of Gauguin at Volpini's exhibition of 1889.

The precise dating of this canvas to 1886 still presents problems,[3] as does the identification of the strange ceramic placed in the center. The latter is seen again in the portrait of *Woman with a Chignon* (W 184) dated to the same year. That it is Gauguin's work is attested to by a sketch, in which the piece is clearly recognizable, in a letter of 6 December 1887 from the painter to his wife: "Did you also bring a pot I made; keep it carefully for me, I like it; unless you are able to sell it (for a good price, 100 francs)."[4]

Certain scholars[5] have agreed that this ceramic is the fruit of his collaboration with Ernest Chaplet in the spring of 1886, before his first stay in Brittany. But their finding is based on the conviction that the canvas was painted in Brittany during the summer of 1886, which remains to be proved.

In any case, this painting, with its early date, requires a symbolic reading, since it represents a crisscross of admiration: that of Gauguin for Cézanne and Degas, and that of Laval for Gauguin, whose ceramic the young painter contemplated fixedly.—C.F.-T.

31
Tropical Vegetation

1887

116 x 89 (45⅝ x 35)

oil on canvas

dated and signed at lower right, *1887 P. Gauguin*

The National Galleries of Scotland, Edinburgh

EXHIBITIONS
Brussels 1894, no. 188; Edinburgh 1955, no. 19; London 1979, no. 83; Washington 1980, no. 44

CATALOGUE
W 232

shown in Chicago and Paris only

1. Name given to the island's volcanic peaks.

2. Pope 1981, 125.

This painting is frequently (and with good reason) cited as the masterpiece of Gauguin's brief Martinique period, on account of its exceptional size and iridescent colors. Basically, it is a view of the bay of Saint-Pierre from the Morne d'Orange,[1] which overlooks the bay from the south. In the background looms the cloudy silhouette of Mount Pelée, the volcano that erupted suddenly in 1902 and annihilated the town at its foot.

This idyllic view appears often on postcards and in book illustrations of the epoch. However, an in-depth study of the site has shown that Gauguin deliberately obscured the town of Saint-Pierre, which should appear left of center on the canvas, a zone which the artist has carefully covered over with lush foliage.[2] In the same way he has omitted the striking statue of Notre-Dame-du-Port, erected in 1870, which under normal circumstances should have been well within his field of vision. The result is an unsullied landscape, an Eden still innocent of any human presence, in which the only animal presence is a rooster emerging from behind a

laurel bush in the central background. This misrepresentation of reality assists the painting's highly decorative arrangement, through which Gauguin successfully conveys his wonder at the exuberance of nature in the tropics, translating its colors into paint with a gusto bordering on intoxication.

At that time the town of Saint-Pierre boasted a remarkable botanical garden, laid out at the beginning of the century, which supplied European parks and French colonies with exotic plants. Gauguin was fully aware of Martinique's wealth of natural flora – his Martinique sketchbook contains a small sketch of a papaya tree.[3] The elegant silhouette of a papaya stands out against a cloudy sky in this painting, contrasted with the subtle gradations of green and orange that Gauguin used for the main mass of foliage. While the foreground and sky are executed with broad brushwork, the central area of the canvas is made up of meticulous and delicate touches that produce an overall effect of infinite refinement.

This painting represents the final flicker of Gauguin's impressionist style. It previously belonged to the musician Ernest Chausson, a collector who owned works by Degas, Morisot, and Redon and who was a close friend of Maurice Denis.—C.F.-T.

3. Album Briant, 21.

32
By the Sea

1887

46 x 61 (18⅛ x 24)

oil on canvas

signed and dated at lower left, *P. Gauguin 87*

private collection, Paris

EXHIBITIONS
Paris 1906, no. 214; Basel 1928, no. 26 or 29; Paris, Orangerie 1949, no. 5; Saint-Germain-en-Laye 1985, no. 61

CATALOGUE
W 218

shown in Paris only

Gauguin executed two paintings of the Turin Cove, halfway between Saint-Pierre and the village of Carbet. This is the smaller of the two; the other (W 217) omits the two large figures in the foreground. In this work the red roofs of the town of Saint-Pierre are visible in the distance at the right.

1. Merlhès 1984, no. 129.

"We have been in Martinique, home of the Creole gods, for the last three weeks," wrote Gauguin to Emile Schuffenecker. "The shapes and forms of the people are most appealing to me, and every day there are constant comings and goings of negresses in cheap finery, whose movements are infinitely graceful and varied. For the time being I have restricted myself to making sketch after sketch of them, so as to penetrate their true character, after which I shall have them pose for me. They chatter constantly, even when they have heavy loads on their heads. Their gestures are very unusual and their hands play an important role in harmony with their swaying hips."[1]

Gauguin was fascinated not only by the landscapes of Martinique, but also by the attitudes of the women he saw day after day carring heavy baskets of produce from the interior to the coast. This picturesque sight, indicative of the economic climate of the country, was also noted by the American writer Lafcadio Hearn, whose visit to the island more or less coincided with that of Gauguin. "The erect carriage and steady swift walk of the women who bear burdens is especially likely to impress the artistic observer," he wrote. "It is the sight of such passers-by which gives, above all, the antique tone and color of his first sensations."[2]

Of the sketches Gauguin drew with such relish from the moment of his arrival in Martinique, one, preserved in a sketchbook at the Louvre,[3] shows a seated negress, seen from behind; the figure is very similar to the one in the foreground of this painting, and is also reproduced in the background of *Tropical Conversation* (W 227).

From a picturesque, intimate scene of everyday life in Saint-Pierre, Gauguin has fashioned a hieratic procession of lightly outlined figures moving through a stylized landscape. There is something here of the majestic rhythms of Puvis de Chavannes, and also of the *Thirty-six Views of Mount Fuji*, a series of prints by the Japanese painter, designer, and book illustrator Katsushika Hokusai, with which Gauguin must have been familiar. One of these Hokusai prints depicts travelers against a backdrop of pines, with Mount Fuji in the distance. In this painting Gauguin produced the same effect with the trunks of sea-grapes, broad-leaved trees that grow along the shore by the Turin Cove. Thus, the decorative arrangement of this canvas, along with its frank brushwork (apart from the foreground), is interesting evidence of the artist's attempt to break away from impressionism even at this date. The theme of women with burdens on their heads was later developed more fully in a zincograph (cat. 76), part of a series shown at the Volpini exhibition.

This canvas belonged to a little-known collector, Ernest Cros (1857-1946). Cros was a polytechnician who made a career as a state railway engineer, and who had been a friend of Daniel de Monfreid since childhood. Although he lacked the means to assemble an important collection, Cros quickly came into contact with Gauguin's works through Monfreid, from whom he bought *By the Sea* for the ludicrous price of 130 francs[4] in 1891. In 1889, he had bought another Breton painting entitled *Le Saule* (*The Willow*, W 347) and would have purchased *Te arii vahine* (*Woman with Mangoes*, cat. 215) had Daniel de Monfreid not sold this canvas to Gustave Fayet without his knowledge.—C.F.-T.

Hokusai, *Fuji Seen from the Tokaido at Hodogaya*, from *Thirty-Six Views of Mount Fuji*, c. 1831, woodcut [The Art Institute of Chicago, Clarence Buckingham Collection]

2. Lafcadio Hearn, "Martinique Sketches," in *Two Years in the French West Indies* (New York and London 1890), chap. 1, 103; quoted in Merlhès 1984, 464 n. 227.

3. Album RF 29877, Département des Arts Graphiques, Musée du Louvre, Paris, 31. See Merlhès 1984, 464 n. 227.

4. Unpublished card from Monfreid to E. Cros (dated a Saturday in April 1891). Private collection, Paris.

33
The Pond

1887

90 x 116 (35½ x 43⅜)

oil on canvas

signed and dated at lower right, *Paul Gauguin '87*

Bayerische Staatsgemäldesammlungen, Munich, Neue Pinakothek

EXHIBITION
Copenhagen, Udstilling 1893, no. 142

CATALOGUE
W 226

shown in Washington only

1. Pope 1981, 129-130.

2. Mirbeau 1891, 1.

3. Cooper 1983, 45.1-45.2.

The dimensions of *The Pond* are identical to those of *Tropical Vegetation* (cat. 31), with the difference that it is painted horizontally. The view is of a lush, inviting jungle. The Martinique farmhouse has not been identified with certainty, but Pope believes it could be part of a residence belonging to a Mr. Bouchereau, called "L'Anse Latouche," between the village of Carbet and Saint-Pierre.[1] Gauguin would have walked by many such places on the way from his hut to the town of Saint-Pierre, two kilometers away. With this painting Gauguin returns to the subject of thicket and stream, which he had borrowed from Pissarro. In 1885-1886, he had exploited this theme on a number of occasions using somber color harmonies and thickly applied paint. The palette for *The Pond* is warmer; pinks, mauves, and oranges contrast with deep greens. As in *Tropical Vegetation*, the broad brushwork of the foreground fades into the delicate parallel hatchings of the foliage. This effect occurs again and again in Gauguin's Martinique canvases.

Octave Mirbeau was one of the first to acclaim the originality and charm of such tropical landscapes. "There is an almost religious mystery, . . . a divine, Eden-like abundance in these jungle scenes with their monstrous vegetation and flowers, their hieratic figures, and their tremendous flows of sunlight."[2]

Perhaps *The Pond* is "the big painting . . . of Martinique" alluded to by Gauguin in a letter of 4 May 1894[3] to Jo Bonger, the widow of Theo van Gogh.—C.F.-T.

34
Two Girls Bathing

1887

87.5 x 70 (34½ x 27½)

oil on canvas

signed and dated at lower right, *P. Gauguin 87*

Museo Nacional de Bellas Artes, Buenos Aires

EXHIBITIONS
Paris 1888; Basel 1949, no. 79

CATALOGUE
W 215

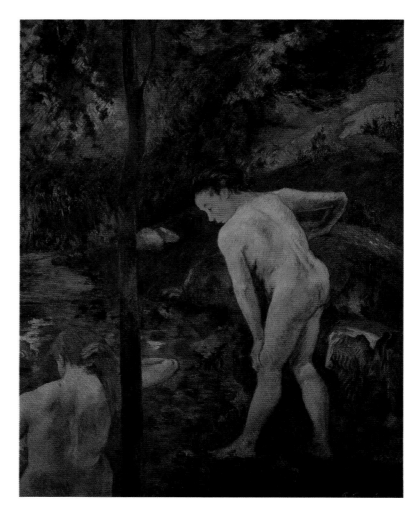

1. Bodelsen 1959, 186–190.

2. Basel 1949, nos. 79, 108.

3. Dated 1888 in Wildenstein 1964.

4. Fénéon 1888, 307–308; reprint 1970, vol. 1, 95.

5. Malingue 1949, XCII.

6. Present whereabouts unknown.

7. Cogniat and Rewald 1962, 90.

8. Rewald 1973, 49.

9. Rotonchamp 1906, 77, no. 18, "sold for 360 francs."

Although it is dated 1887 by Gauguin himself, this painting continues to pose a chronological conundrum.[1] The motif of women bathing is definitely Breton, as is confirmed by the *sabots*, or wooden clogs, that may be seen in the lower right-hand corner of the painting. Gauguin had probably observed the scene in question during his stay in Brittany in the summer of 1886. However, the vegetation, the colors, and the fine brushwork of this canvas are strongly reminiscent of the artist's work in Martinique between June and November 1887, and for this reason the painting was ascribed to the Martinique period when it was shown in Basel in 1949–1950.[2] In our view it is more likely that the artist began the painting in Paris before his departure for Martinique, and completed it on his return in November 1887, when the colors he had seen in the tropics were still fresh in his mind.

Gauguin had already tackled the theme of bathing in 1886, with a canvas of young boys beside the river Aven (W 272).[3] He was to return to the subject on several occasions between 1888 and 1889 (cats. 47, 48), working from studies of nudes whose plastic and decorative qualities rapidly overwhelmed any residue of naturalist interpretation. Thus this painting is one of the earliest manifestations in

Gauguin's art of a theme that was thoroughly developed later, when he reached Tahiti (see cat. 144).

When the work was shown at the Boussod and Valadon gallery in February 1888 (along with some ceramics and paintings executed by Gauguin in Brittany and Martinique), it drew fulsome comments from the critic Félix Fénéon in *La Revue Indépendante*: "A new Gauguin, *Deux baigneuses*, has appeared at the Van Gogh Gallery. . . . One of the women in the picture, severed at the waist by the water, is broad shouldered and opulently bourgeois in build. On the adjoining grass, amazed, stands a little servant girl with stiff, cropped hair; she stares, dumbfounded, at her shivering companion, her left hand on her knee, unable to decide whether or not to take the final step. A tree trunk, slender, rectilinear, and smooth, which we have already observed in a painting by Cézanne, separates the figures, dividing the canvas into two panels. Behind them, the landscape ceases abruptly, cut off by a sharp, almost vertical rise in the ground which is covered in heavy, reddish foliage. Everything within the curve of the painting seems numb with the heat of the day."[4]

This composition is still close to the artistic approach of Degas, which Gauguin was soon to reject as "reeking of the studio sitter."[5] At this time Boussod and Valadon happened to be exhibiting a series of Degas pastels of women bathing and getting dressed, and these cannot have escaped Gauguin's attention. In addition, in the previous year, at the impressionist exhibition of 1886, Degas had shown a group of pastel nudes that are surely echoed in Gauguin's painting.

Again, certain motifs that were to be systematically developed later in Gauguin's career appear for the first time in this work. The most remarkable of these is the girl cut off by the edge of the canvas in the lower left-hand corner. Her bare back, treated here in naturalist style, is the prototype for *Ondine* (cat. 80). The idea was revised in carved wood (cat. 110), before reaching a sumptuous apotheosis in a painting of vibrant colors, *Vahine no te miti* (cat. 144). The figure on the right was also subsequently developed. We come upon her, half-length, on a fan (W 216),[6] also dated 1887, the first rough sketch of which appears in Gauguin's Brittany sketchbook.[7] During the winter of 1887–1888, Gauguin once again singled out this motif in two ceramics, an enamel cup (cat. 38) and a vase (G 51). Finally, the figure appears, reversed, in one of the series of zincographs (cat. 71) shown at the Volpini exhibition. All in all, here is an excellent example of how particular themes recur in every area of Gauguin's work, no matter what technique he used.

The composition of this canvas is very daring. The vertical line of the tree cuts across a diagonal that begins with the outline of a pig seen in profile at upper right and is affirmed by the verticals of the two bathing girls. There is no question that the pig has been deliberately placed in a dominant position; he plays the same part as does a fox in another canvas (cat. 113), though here the effect is more ironical than perverse.

This painting remained on deposit with Boussod and Valadon[8] until 1891, when it was acquired by the collector Roger Marx at the sale of Gauguin's works just before the artist's departure for Tahiti.[9]—c.f.-t.

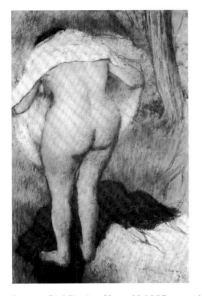

Degas, *Girl Drying Herself*, 1885, pastel [National Gallery of Art, Washington, Gift of the W. Averell Harriman Foundation in memory of Marie N. Harriman]

35
Woman Bathing

1886–1887

588 x 358 (23⅛ x 13¾) irregularly shaped

charcoal and pastel, with brush and brown ink, squared in graphite, on laid paper

signed at lower left, in charcoal, *P. Gauguin*; inscribed at upper right, in charcoal, *Mars 87*

The Art Institute of Chicago. Given by Mrs. Gilbert W. Chapman in memory of Charles B. Goodspeed

shown in Washington and Chicago only

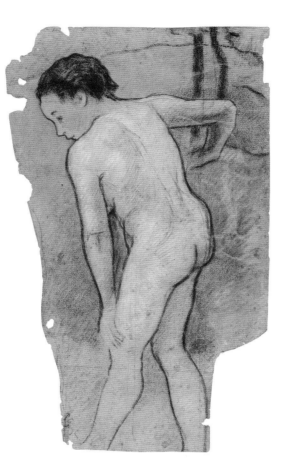

1. Bodelsen 1964, 174–176.

2. Technical comments supplied by Peter Zegers.

Despite the inscription "Mars 87," which can still be deciphered on the upper right-hand side, the date of this large pastel remains uncertain. Its technical complexity would seem to confirm that Gauguin returned to it on several separate occasions; in effect, it is a full-scale study for the figure on the right of the Buenos Aires painting (cat. 34).

A study of this drawing[1] has revealed the hiatus between the vague, somewhat doughy rendering of the model in pastel and the firmness of contour supplied by the charcoal application. The author's deduction is that Gauguin had originally made this drawing in Brittany in 1886 and subsequently reworked it in charcoal in 1887.

In fact, careful examination shows that pastel has been superimposed over the strong charcoal contours. The most logical hypothesis is thus the following: having made his first sketch, probably in Brittany in the summer of 1886, Gauguin squared it and emphasized its contours in charcoal, then transposed its image onto canvas. This he probably did in 1887. He then returned to the drawing at a later date, this time with pastels, and transformed it into a finished work in its own right. The irregular form of the paper, characteristic of Gauguin (see cat. 45), was probably determined during the second or third stage. Finally, the drawing seems to have been wetted at some time; there are thus grounds for supposing that Gauguin later used it to make a counterproof, placing a damp sheet of paper on top of it.[2]

Whatever Gauguin's intentions, this pastel is an excellent example of the artist's penchant for manipulating his work. He makes a drawing, then emphasizes its contours, alters the shape of its surround, and covers it in color. There was definitely, in Gauguin, a tendency to tinker, which shows up to even better advantage in his transfer drawings and woodcuts. After 1889 he was to go back to this figure of a woman bathing in his project for a plate design, which was used on the cover of the Volpini exhibition catalogue and in a zincograph (cat. 77), also part of the series for the Volpini show.

In terms of style, this study shows clearly that Gauguin was moving away from the naturalism inspired by Degas' nudes to a more synthetic approach. This development was to crystallize during Gauguin's second visit to Brittany in 1888.—C.F.-T.

36
Jar with Four Feet

1887–1888

height 18.2 (7⅛)

glazed stoneware

Fondation Dina Vierny, Paris

CATALOGUES
G 23, B 43

shown in Paris only

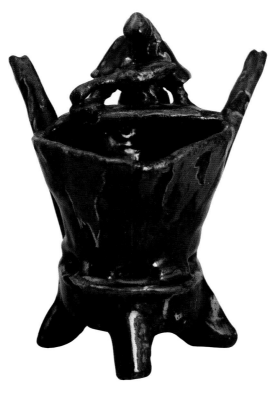

1. Bodelsen 1964, 95.

This curious vase with four feet is part of a series of ceramics that has been dated to the period between Gauguin's return from Martinique in November 1887 and his departure again for Pont-Aven in February 1888.[1] The ceramics of this time are characterized by a renewed search for the exotic. Here the squat form suggests Chinese bronzes, and a growing interest in glaze effects and the systematic pursuit of colors. This last is emphasized by the gold touches in the range of red-browns and ochers. Once again it is a Breton motif that decorates the upper part of the vase: a woman and a goose, as in the artist's very first ceramics. This work was part of the collection of Gustave Fayet.—C.F.-T.

37
Pot Decorated with the Head of a Woman

winter 1887-1888

height 17.5 (6¾)

glazed stoneware

signed, on front, on head, *P. Go.*

Musée du Petit Palais, Geneva

EXHIBITIONS
Paris 1906, no. 178, *Masque au diadème*;
Pont-Aven 1953, no. 42; Saint-Germain-en-
Laye 1985, no. 52

CATALOGUES
G 56, B 33

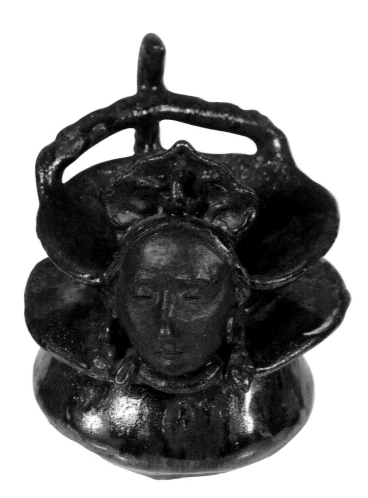

Gauguin, *Study for a Vase, Album Briant*,
page 27 [Musée du Louvre, Paris, Départe-
ment des Arts Graphiques]

1. Album Briant, 27.

2. Bodelsen 1964, 66, fig. 45.

This glazed stoneware vase belongs to a series of anthropomorphic ceramics executed in Paris during the winter of 1887-1888, after Gauguin's return from Martinique. In comparison to Gauguin's Breton vases from the winter of 1886-1887, his technique, as seen in this piece, has evolved greatly. First of all, the form has become full and the decoration is no longer applied, but has become an integral part of the structure of the vase. Second, the form is strikingly original. The double-collared lip topped by a handle creates the effect of an aura around the mask of the woman. The unglazed, mat surface of the mask contrasts with the shiny glaze on the rest of the piece. Finally, the range of oxides, from black to yellow to reddish-browns, shows very great technical skill.

A sketch of a similar vase is found in the Album Briant at the Louvre,[1] along with studies for the vase-portraits of Mme Schuffenecker and of her daughter, Jeanne (cat. 39). The fact that these three studies all appear on the same page, plus the evidence provided by a photograph of the Schuffenecker family, has led Bodelsen to identify the female figure from the Geneva vase as the Schuffeneckers' nurse, whose image appears in the photo.[2] This identification is at best tentative.

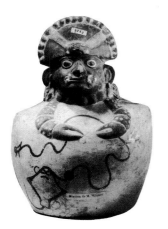

Mochica Culture, Peru, *Devil Crab* [Musée de l'Homme, Paris]

This vase seems to be of Peruvian inspiration, as the tiara is similar to one seen on a vase from the Mochica culture (100 B.C.-A.D. 600) that represents a demon-crab fisherman. Gauguin may have seen the Peruvian vase, which arrived at the Musée d'Ethnographie of the Trocadero (now the Musée de l'Homme) as early as 1878. The comparison shows how deeply Gauguin drew on the early sources of anthropomorphic ceramics.—C.F.-T.

38
Bowl with a Bathing Girl

1887-1888

29 x 29 (11¼ x 11¼)

stoneware

Mrs. Arthur M. Sackler

EXHIBITIONS
Copenhagen, Kleis 1893; Copenhagen 1948, no. 81

CATALOGUES
G 50, B 41

shown in Washington and Chicago only

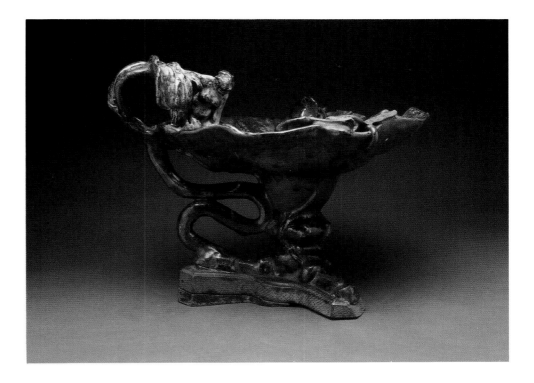

1. Gray 1963, 164.

2. Bodelsen 1964, 91.

3. W 289.

4. Malingue 1949, CXIX, where the name is spelled *Moggens Ballin*.

This wonderfully inventive ceramic vessel has been called both a cup and a bowl. Gray published it as a cup and linked it to an undated letter from Gauguin to Redon in which Gauguin referred to "A *Dish* that I regard as a *rare piece* seeing the difficulty in firing it, as it would probably collapse from the heat."[1] Bodelsen, however, gave the vessel a more sensible title, *Bowl with Bathing Girl*,[2] undoubtedly because it appears in a still life painted by Gauguin in 1888, filled with fruit.[3] It seems to have been sold to Mogens Ballin, a Danish friend of Mette Gauguin, just before Gauguin's departure for Tahiti.[4]

The bowl forms a shallow pool, which a single female bather is about to enter. The figure is related to the standing bather in a painting of 1887 (cat. 34) or to the transfer drawing (cat. 35) begun in preparation for the painting. Yet, in the ceramic medium, Gauguin was able to represent the figure in three dimensions and place her in a setting with immense leaves, tubular vines, and swirling water. Because she is so small, there is a sense of her vulnerability in this vegetative setting.

Gauguin seems to have pushed the ceramic medium to its very limits with his freely "drawn" curves of clay. For this reason, the vessel sustained several early breaks and has been given a wooden support to make it level. All of this suggests that it was made following Gauguin's return from Martinique in November of 1887, during a period devoted to intense experimentation with this medium. The painting to which it relates was shown at Boussod and Valadon's gallery in January of 1888, when Fénéon described it,[5] and it is possible that, moved by Fénéon's evident admiration for his painted bather, Gauguin created a number of variants, including this vessel.—R.B.

5. Fénéon 1888b, reprinted in Fénéon 1970, 94-95.

39
Pot in the Form of a Bust of a Young Girl; Portrait of Jeanne Schuffenecker

1887-1888

height 19 (7½)

unglazed stoneware

signed and dedicated at right in front, *à mon ami Schuff./PGo*

Monsieur Jean-Pierre Bacou

EXHIBITION
(?) Paris 1900, no. 2878

CATALOGUES
G 62, B 32

shown in Paris only

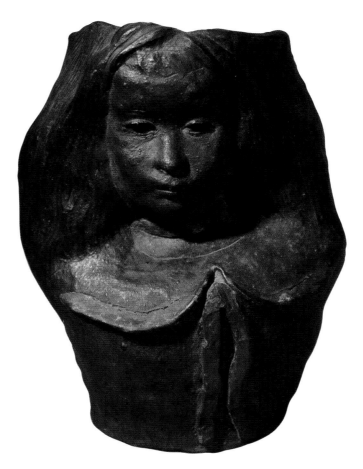

1. Gauguin 1895c, 1.

2. Bodelsen 1964, 58, 63.

3. Album Briant, 27. See fig., cat. 37.

Mochica Culture, Peru, *Portrait Vase*, 100 BC-600 AD, earthenware [Musée de l'Homme, Paris]

This pot well reflects the development of Gauguin's ceramics as sculpture during the winter of 1887-1888. The piece was not conceived as a pot decorated with a head, but as a bust whose interior was probably hollowed out. Moreover, the artist explained his action as aimed at "replacing the thrower by intelligent hands able to endow the vase with the life of a face, while retaining the character of the material."[1]

In this regard, the influence of Peruvian vase-portraits is decisive. Freely taking inspiration from this concept, Gauguin set out to fashion true portraits in clay representing himself or persons close to him, some of whom could be identified (cats. 65, 66). The model for this vase has been recognized[2] at the bottom of a photograph of the family of Emile Schuffenecker, the painter, taken at rue Boulard where Gauguin stayed from November 1887 to the end of January 1888 on his return from Martinique. Jeanne Schuffenecker, daughter of Emile and Louise Schuffenecker, was then six or seven years old. This ceramic should thus be associated with two vase-portraits of Mme Schuffenecker (cat. 62, G 49). A sketch for the portrait of Jeanne Schuffenecker appears in the Martinique sketchbook.[3] This vase belonged to Emile Schuffenecker before becoming part of the collection of Gustave Fayet.–C.F.-T.

40
Early Flowers in Brittany

1. Malingue 1949, LXXVII.

The extraordinary freshness of this painting, which was executed at Pont-Aven in the spring of 1888, is due in part to its unpretentious subject matter and to the absence of any symbolic content. However, its main quality lies in the use Gauguin has made of the impressionist technique, which is here pushed to its outer limits. The artist's intention was clearly to see how far he could use separated brushstrokes within the kind of idyllic context he had exploited during his first stay in Brittany. The result has a fluid charm, of which the only comparable example in Gauguin's work is *Brittany Conversations* (W 250), done at much the same time using a similar technique. That painting was sent to the Volpini exhibition[1] along with this one.

The rare quality of Gauguin's painting caught the eye of Degas, who saw it at the Boussod and Valadon gallery in November 1888. On 13 November Theo van Gogh wrote to Gauguin, who was at Arles with Vincent: "You will doubtless be glad to hear that your paintings are much admired here. . . . Degas is so enthusiastic that he is talking about them all over town. He is going to buy the spring landscape with a field in the foreground and two figures of women, one seated, one standing."[2] In the event, Degas changed his mind and probably bought a Martinique canvas (W 230),[3] which was also included in the Boussod and Valadon exhibition. This appears to have been the only work by Gauguin from the years 1887–1888 that Degas ever owned.

2. Bodelsen 1957, 200; Merlhès 1984, no. XCIII, n. 300.

3. Rewald 1973, n. 76.

4. Bernard 1942, 83.

Gauguin was much encouraged by Theo's good news. "I could not be more satisfied with the results of my studies in Pont-Aven," he wrote to Emile Bernard. "Degas is going to buy the one of two Breton girls. . . . It is most flattering; as you know, I have unshakable confidence in Degas' judgment. Moreover, in commercial terms it is an excellent start. All Degas' friends have the same confidence in him."[4]

Early Flowers in Brittany

1888

70 x 92 (27½ x 36¼)

oil on canvas

signed and dated at lower left, *P Gauguin 88*

on loan at Kunsthaus Zürich

EXHIBITIONS
Paris 1888; Brussels 1889, no. 3; Paris 1889, no. 31

CATALOGUE
W 249

5. Rotonchamp 1906, 77, no. 12; record of sale of Paul Gauguin's paintings, 23 February 1891.

6. Merlhès 1984, no. 159.

As it turned out, this painting was not sold until the auction at the Hôtel Drouot in 1891,[5] when it was acquired by Alexandre Natanson, the editor of *La Revue Blanche* and a shrewd collector, for the sum of two hundred and fifty francs.

A sketch for the standing Breton girl has been identified on the back of a letter from Gauguin to Schuffenecker dated 14 August 1888.[6]–C.F.-T.

41
Still Life with Fan

An X-ray examination of this still life has revealed that it was painted on top of another composition that is unfortunately very difficult to identify. In all probability it was an oil painting, vertically divided in the middle by a curious, long-handled object. Likewise, the handle of the jug in the visible painting seems to be a later addition.

Laboratory tests for this picture, traditionally dated to 1889, have been inconclusive. The mysterious object in the middle ground at right, however, has been positively identified[1] as the ceramic entitled *Rat à cornes* – seen here with horns but without a head – to which Gauguin makes reference in a letter to Emile Schuffenecker.[2] Van Gogh also mentioned this ceramic in a letter to his brother Theo from Arles,[3] in which he declares that "Gauguin has had a magnificent pot with the heads of two rats brought down from Paris." The ceramic is believed to have been made just after Gauguin's return from Martinique, during the winter of 1887–1888.[4] It is also clearly identifiable in a sketch from the Martinique sketchbook.[5]

1. Bodelsen, 1964, 154–155.

2. Cited in Bodelsen 1964, 213 n. 12.

3. Van Gogh 1960, no. 562 F.

4. Bodelsen 1964, 154.

5. Album Briant, 20.

6. Huyghe 1952, 59 n. 1.

c. 1888

50 x 61 (19⅝ x 24)

oil on canvas

signed at lower right, *P Gauguin*

Musée d'Orsay, Paris

EXHIBITIONS
Paris, Orangerie 1949, no. 13; Basel 1949,
no. 38

CATALOGUE
W 377

Gauguin, *Madame Alexandre Kohler*,
1887-1888, oil on canvas [National Gallery
of Art, Washington, Chester Dale Collection]

Gauguin, *Album Briant*, page 20 [Musée
du Louvre, Paris, Département des Arts
Graphiques]

Both the fan (which was probably by Gauguin) and the ceramic appear again in the background of the portrait of Mme Kohler (W 314), the wife of a cashier at the Bon Marché department store in Paris; this portrait is usually dated to 1889. The sober rendering of Gauguin's still life and fan, however, the technique of brushwork, and even the type of fan represented may well place the work slightly earlier in the artist's career, perhaps in 1888.[6]

The canvas was part of the collection of Prince Matsukata of Japan (1865–1950). Matsukata was a celebrated art lover who bought almost a thousand paintings by impressionist, post-impressionist, and School of Paris artists. He was advised in these purchases by Léonce Bénédite, curator of the Musée de l'Etat, Luxembourg, and by the painter Edmond-François Aman-Jean. Part of the prince's collection, which had remained in Europe during the Second World War, was confiscated by the French government following the armistice, and became the subject of protracted negotiations between France and Japan. Finally, in 1959, 371 works of art were returned to Japan and now constitute the bulk of the collection in Tokyo's National Museum of Western Art. Among these works were canvases by Gauguin (cat. 42 and W 340, W 167, W 386). Similarly, a number of Gauguin's paintings (notably this one, and W 313, W 528, W 559) were returned to the Louvre.–C.F.-T.

42
Hilly Landscape with Two Figures

February 1888 (?)

89 x 116 (35 x 45⅝)

oil on canvas

dated and signed at lower left, *88 P. Gauguin*

The National Museum of Western Art, Matsukata Collection, Tokyo

EXHIBITIONS
Paris, Orangerie 1949, no. 9; Quimper 1950, no. 4; Tokyo 1987, no. 24

CATALOGUE
W 256

shown in Washington and Chicago only

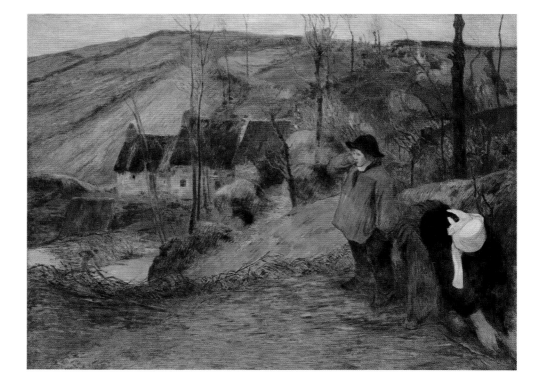

The common title of this painting, *Breton Shepherd Boy*, which was invented at a much later date, is rather surprising. The small boy in his blue smock does not appear to have any sheep, unless of course his flock is out of sight some distance away, maybe to the left. He appears to be more interested in keeping company with the woman in the foreground collecting brushwood, for whom Gauguin used a fine pastel figure of the same dimensions (cat. 22). Gauguin's own title for this painting was *Paysage, coteaux avec garçon blouse bleue* (*Hilly Landscape with Boy in a Blue Smock*), as noted in the list of his paintings left on deposit at the Boussod and Valadon gallery.[1] The same child, with the same round hat, served as a model for another painting (cat. 43); he also appears on a fan (W 257) in a similar pose but this time surrounded by geese. Last, an identical Breton boy is found in the Brittany sketchbook,[2] in which he is seen climbing a ladder and carrying a jug to a spring.

Gauguin's method of work is clearly shown in this canvas. The landscape is painted from nature and the two figures are then "applied" to it, having been selected from earlier drawings kept in portfolios, or from sketchbooks. Hence the slight but noticeable disproportion between the two figures.

The size of the painting is unusual for Gauguin at this time, but it gives him the chance to develop a landscape with a high horizon, using no more than a subtle variety of greens and blues barely set off against the brown winter branches, the pink of the roadway, and the woman's white bonnet. The technique employed is still almost impressionist, and the soft rustic atmosphere testifies to Pissarro's continuing influence. We are inclined to date this work to the very

1. Rewald 1973, 49.

2. Cogniat and Rewald 1962; see Bodelsen 1964, 201.

3. Merlhès 1984, no. 141.

beginning of 1888, well in advance of the great stylistic upheavals of the summer. Gauguin was probably referring to this painting when he wrote to Schuffenecker at the end of February with the news that he had "four paintings in progress, all nearly finished, two of them size fifty."[3]

No one knows quite what happened to this canvas between the time Gauguin left it on deposit with Boussod and Valadon and its appearance in the 1920s in the collection of Prince Matsukata. It remained in France during the Second World War and was returned to Japan in 1959 (see cat. 41).—F.C.

43
Breton Peasant with Pigs

It is rare for Gauguin to represent, as he does here, a well-groomed Breton landscape with a clear sky and lively colors characteristic of fine weather rather than imagined hues like the reds in *The Vision after the Sermon* (cat. 50). In a word, color is recorded "impressionistically." The flowers and the acid green of the grass suggest the end of spring or the beginning of summer. The scene is set in a pasture bordered with granite rocks jutting out over the little town of Pont-Aven, whose whitewashed houses can be seen to the right, shining in the sun. In the background, the hill covered with geometric fields is that of Sainte Marguerite.[1] The child is painted after drawings in a Brittany sketchbook, one of which shows the same little Breton boy perched on a ladder, wearing a big hat and with his hand in front of his mouth.[2] The cow grazing in the flowers to the left comes from the same sketchbook.[3] This confirms a quite traditional working method frequently used by Gauguin (see cat. 42).

The little pigs are certainly the favorites in Gauguin's bestiary, for they are the timeless incarnation of all fleshly pleasures; the color of their skin stands out more against the landscape than does that of the cows; and their jovial, puffy forms end comically with a corkscrew tail. Gauguin made them an important motif of his Arles nude *In the Hay* (W 301) and of his most excellent *The Follies of Love* (cat. 103). In Tahiti he would again, and with evident pleasure, encounter piglets.[4]

At the Salon d'Automne of 1906, among the twenty-five or so Gauguin canvases belonging to the collector Gustave Fayet, who was particularly attracted to the Polynesian Gauguins, there were nevertheless six Breton paintings, including *Ondine* (cat. 80), *The Haystacks* (cat. 107), and this one. This canvas undoubtedly represents a balance between a picturesque vision of local countryside, just

1. Wildenstein 1956, 94.

2. Cogniat and Rewald 1962, 19, 20.

3. Cogniat and Rewald 1962, 23.

4. W 445, W 446, W 447, W 585.

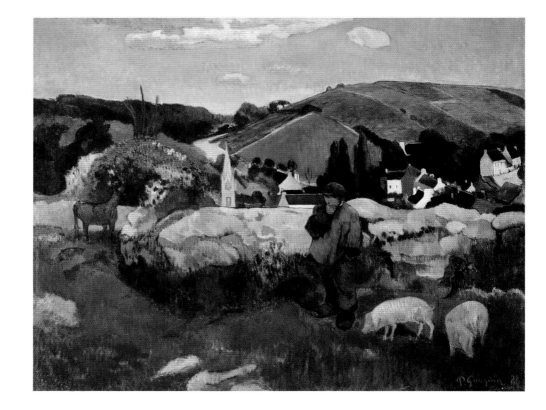

Breton Peasant with Pigs

1888

73 x 93 (28¾ x 36⅝)

oil on canvas

signed and dated in yellow at lower right,
P. Gauguin 88

Lucille Ellis Simon

EXHIBITIONS
Paris 1906, no. 24; Chicago 1959, no. 10

CATALOGUE
W 255

short of commonplace, and elements of pictorial daring to be seen in the months to come. A few traits are Gauguin's alone: the flowered red and pink slope to the left, the pigs, the Aven river winding along in the background, colored a fanciful gold-yellow, and the lively green flat triangle in the center at the top of the canvas.—F.C.

44
Breton Girls Dancing, Pont-Aven

"I'm doing a *gavotte bretonne*, three little girls dancing in a hayfield. I think you'll like it. The painting seems original to me and I'm quite pleased with the composition," wrote Gauguin to Theo van Gogh in mid-June 1888.[1]

 With its classic impressionist treatment, this painting has much the same relaxed feeling as Gauguin's rendering of spring flowers (cat. 40). The site depicted is a field (called the Derout field, after its owners at that time), which covers the side of the hill behind the church of Pont-Aven. The church's bell tower is included in the picture. Gauguin had already painted this place before (see W 199, W 200), during his first visit to Brittany, and he used the same field as a backdrop for several other paintings (W 269, W 270, W 271) in 1888.

1. Merlhès 1984, no. 151.

1888

71.4 x 92.8 (28⅛ x 36½)

oil on canvas

signed and dated at lower right, *P Gauguin 88*

National Gallery of Art, Washington, Collection of Mr. and Mrs. Paul Mellon

EXHIBITIONS
Paris 1888; Paris 1889, no. 36; London 1911, no. 17; Paris 1919, no. 12

CATALOGUE
W 251

shown in Washington only

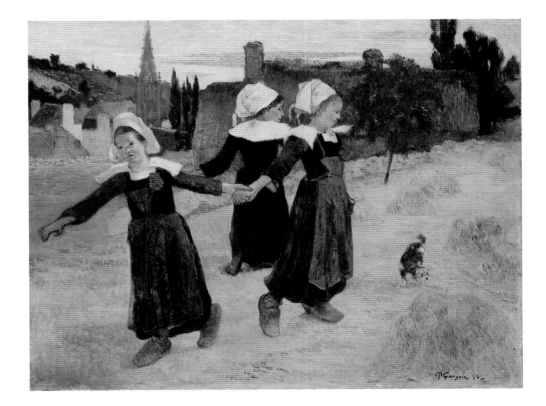

2. Bodelsen 1957, 200; see also Rewald 1973, 32.

3. van Gogh 1978, no. 563.

By comparison with the Munich painting (W 201), a canvas of the same size painted in 1886 in which four figures are seen either from the front, the back, or in profile, this picture is less daring in its handling of space; it might almost be said to be the more conventional of the two. However, a number of decorative pictorial devices, notably the rhythmical positioning of the figures, the harmonious interdependence of lines, and the careful rendering of shapes of bonnets, collars, and clogs, raise this painting above the level of representation. The same decorative concern may be seen in Gauguin's use of color: the dark masses of the clothes, enlivened by two vivid red marks, stand out crisply against the mustard-yellow background.

This canvas was included in the group of Gauguin's paintings that was exhibited at Boussod and Valadon in November 1888. Theo van Gogh had found a buyer for it, on condition that Gauguin make a slight alteration: "I could also sell *la ronde des petites bretonnes* [*Breton Girls Dancing*, cat. 44], but you would have to change it slightly. The hand of the little girl approaching from the edge of the frame somehow has an importance which one does not notice when one sees the picture without the frame. The buyer would like you to alter the form of this hand a little, without in any way modifying the rest of the painting. It does not seem to me to be a difficult request, and I am sending you the canvas accordingly. He will pay five hundred francs for the picture and frame; the frame is worth about one hundred francs. See if you can make him happy and if you want to do this deal."[2]

Theo duly sent the canvas to Gauguin in Arles, and the change was made as requested. "Gauguin's canvas 'Breton Children' has arrived and he has altered it very well. But though I quite like this canvas, it is all to the good that it is sold, and the two he is about to send you from here are thirty times better. I am speaking of '*The Women Gathering Grapes*' and '*The Woman with the Pigs* [W 304, W 301].'"[3]

Despite all this activity, Gauguin's canvas was not sold until the following autumn, when it was recorded in the registers of Boussod and Valadon as having

found a buyer in Montaudon, for five hundred francs, on 16 September 1889.[4] It had been exhibited all that summer under the title *Ronde dans les foins* (*Dancing in the Hayfield*). The price of five hundred francs tallies with the one noted by Gauguin in his 1888 sketchbook;[5] it is also confirmed by a letter he wrote to Emile Bernard.[6]

The theme of Breton peasants dancing was often attempted by the painters of the school of Pont-Aven; examples of it may be found in the work of Emile Bernard, Paul Sérusier, Georges Lacombe, and Maurice Denis.—C.F.-T.

4. Rewald 1973, appendix I.

5. Huyghe 1952, 222.

6. Malingue 1949, no. LXXXIX.

45
Breton Girls Dancing

1888

240 x 410 (8⅝ x 16⅛), irregularly shaped

charcoal and pastel, subsequently worked over with brush and water, on laid paper

Rijksmuseum Vincent van Gogh (Vincent van Gogh Foundation), Amsterdam

EXHIBITION
Toronto 1981, no. 48

shown in Chicago and Paris only

1. Suggested in conversation with Peter Zegers.

2. Merlhès 1984, no. 159.

3. Bodelsen 1964, 72 n. 46; Rewald 1973, 62, 65.

4. Merlhès 1964, no. 182.

This pastel is a study (with some variations) for the painting of Breton girls dancing (cat. 44). Like the study of a woman bathing (cat. 35), this drawing was possibly reworked after it had been used to develop the finished painting.[1] The intense blue background, along with the hint of green on the breast of the girl at the right of the composition, show a strong concern for color; this concern is also evident in the painted canvas, for which the village of Pont-Aven serves as a backdrop. A letter from Gauguin to Emile Schuffenecker of 14 August 1888[2] contains an incisive sketch for the two girls on the right, reducing them to their bare essentials; this sketch reflects the work of Emile Bernard, who arrived in Pont-Aven shortly before it was done.

Gauguin sent his pastel study to Theo van Gogh at the end of 1888,[3] in return for fifty francs Theo had sent him in Brittany that summer. Due to a misunderstanding, the pastel was retained by Emile Bernard's mother, who had been delegated to convey it to Theo. By way of compensation for the removal of the pastel, Gauguin offered Madeleine Bernard one of his ceramics: "Goupil has a small unglazed bowl of mine with a bird motif against a blue-green background. Please take it on my behalf – if you show my letter to van Gogh, he'll give it to you. I bequeath it to Madeleine.... It's a primitive piece, but I think more truly expressive of what I am about than the drawing of the little girls."[4]—C.F.-T.

46
Young Breton Bather (recto); Breton Peasant Woman Knitting (verso)

1888

602 x 415 (23¾ x 16⅜)

red chalk, pastel, and charcoal, squared in graphite, on laid paper

signed (?) at lower right, with initials, *P.G.*

Musée du Louvre, Département des Arts Graphiques, Paris

EXHIBITION
London 1966, no. 45

shown in Paris only

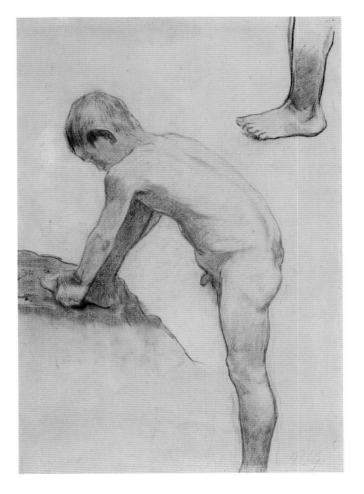

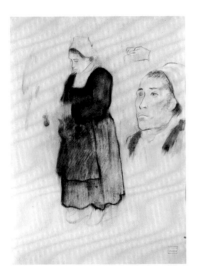

Gauguin, *Breton Peasant Woman Knitting,* 1886, colored chalk, verso of cat. 46

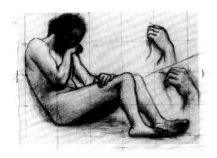

Puvis de Chavannes, *Study for the Prodigal Son,* 1879, black pencil [Musée du Petit Palais, Paris]

1. Bodelsen 1964, 176; Pickvance 1970, 22.

This very beautiful drawing of a young bather served as a study for the figure at the left of the Hamburg painting of Bretons bathing (cat. 47). By a subtle mixture of red chalk and yellow pastel Gauguin has come close to imitating paint tones. The composition itself is unique in its monumental quality and the originality of its arrangement. Both the subject and the experimental approach to relief are reminiscent of Degas, whom Gauguin profoundly admired. Although he never received any kind of academic training, Gauguin uses here, perhaps accidentally, a procedure cherished by the Ecole des Beaux-Arts, the bastion of formal art education in France – namely the repetition, in one corner of the page, of a detail from the figure study. It has been noted[1] that certain parts outlined in red chalk have been drawn again in charcoal (notably the leg, the upper portion of which is detailed). This has led to the suggestion of two dates for the drawing. It could have been initiated during Gauguin's first stay at Pont-Aven in the summer of 1886; the artist might then have reworked the outline of the sketch for the more synthetic oil painting of 1888. This ingenious hypothesis has yet to be proved; in terms of style

there is no reason why this bather should not have been drawn from life in 1888, as a direct study for the painting.

The study of a Breton woman knitting on the reverse side of this sheet has no counterpart in any of Gauguin's known paintings. It was probably executed in 1886, to judge by its technical and stylistic kinship with one or two other Breton women that the artist is known to have produced at this time. By contrast, the head of the Breton woman at the right of the page resembles a ceramic (G 39) completed in the winter of 1886–1887.–C.F.-T.

47
Young Bretons Bathing

summer 1888

92 x 73 (36¼ x 28¾)

oil on canvas

signed and dated at lower left, *P. Gauguin 88*

Hamburger Kunsthalle

EXHIBITION
Toronto 1981, no. 47

CATALOGUE
W 275

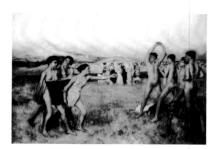

Degas, *Young Spartans*, probably begun about 1860, oil on canvas [Reproduced by courtesy of the Trustees, The National Gallery, London]

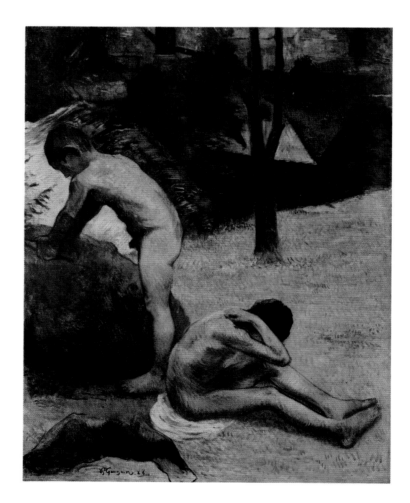

1. Merlhès 1984, no. 156.

Less Japanese in style than Gauguin's depiction of children wrestling (W 273), this painting probably belongs to the series of nudes mentioned by the artist in his letter of 8 July 1888 to Emile Schuffenecker.[1] Although Gauguin pretends to be definitively free of Degas' influence, the fact that he feels obliged to say so is evidence more or less to the contrary. Likewise, this and the painting of children

wrestling contain obvious references to the nudes of Pierre Puvis de Chavannes;[2] and both rely on the same basic composition, namely two figures in a landscape with a still life in the foreground. The impressionist brushwork of the two bathers contrasts strongly with the more synthetic, unrefined treatment of the children wrestling; the bathers are more classical in conception, and hence were probably painted at an earlier date. All the same, the outlines of the two young men are clearly defined, showing that the artist was already moving toward cloisonism at this time. This was one of three canvases bought by Alexandre Natanson, editor of *La Revue Blanche*, when Gauguin's paintings were sold at the Hôtel Drouot auction rooms on 23 February 1891.[3] An advanced study for the left-hand figure exists (cat. 46).–C.F.-T.

2. Welsh-Ovcharov in Toronto 1981, no. 47.

3. Rotonchamp 1906, 77; record of the sale of Paul Gauguin's paintings, 23 February 1891, no. 10, sold 360 francs.

48
Children Wrestling

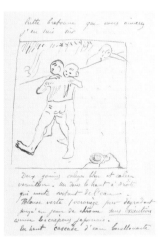

Gauguin, Sketch for *Children Wrestling*, letter to Vincent van Gogh, 24 or 25 July 1888 [Vincent van Gogh Foundation, National Museum Vincent van Gogh, Amsterdam]

Gauguin executed this painting at Pont-Aven in the early summer of 1888, while gradually recovering his strength after an attack of the fever he had contracted during his stay in Martinique. This is one of a small series of canvases depicting young Bretons bathing or wrestling by the river Aven (see cat. 47).

"From time to time I have relapses which force me to take to my bed, but in general I'm getting gradually better, and my strength has returned. Also I have just done some *nudes* which you will be happy with; no Degas about them whatsoever. The latest is of two boys wrestling beside the river, thoroughly Japanese, but seen through the eyes of a Peruvian savage. Upper area white, green sward, very crude," wrote Gauguin to Emile Schuffenecker on 8 July 1888.[1] His letter is illustrated by a rapidly executed sketch of the main motif, the two children, crossed by a diagonal line representing the riverbank.

Shortly afterward, in another letter dated 24 or 25 July 1888,[2] Gauguin described his canvas to van Gogh. This letter, also illustrated, contains an observation that is typical of Gauguin's thinking at this time: "Art is an abstraction, unfortunately we are less and less understood. . . . I've just finished a Breton wrestling scene which I'm sure you'll like. Two boys, one wearing vermilion pants, the other blue ones. Above right, a boy coming up out of the water – green grass – pure Veronese, shading off into chrome yellow: the surface *unrefined*, as in Japanese crépons. Also above, a waterfall in pinkish white, with a rainbow on the edge of the canvas just beside the frame. Below, a white patch, a black hat, and a blue smock."

Gauguin was well aware of the bold, disconcerting nature of his work. The picture's predominant concern is that of space: a rupture with traditional perspective is achieved by the elimination of the line of the horizon, the absence of which is accentuated by the diagonal of the riverbank. This new freedom was to blossom later (see cat. 53). The deliberate distortions used here by Gauguin – for example, the boys' oversize feet – show the artist's willingness to experiment along synthetic, antinaturalist lines, while emphasizing the primitive character ("seen through the eyes of a Peruvian savage") of the painting as a whole. All this, of course, is in harmony with the subject matter, traditional Breton wrestling.

The Japanese origin of this theme – illustrations of wrestlers in Hokusai's *Mangwa* albums (1815) – as well as the subsequent variations on it produced by

Children Wrestling

July 1888

93 x 73 (36⅝ x 28¾)

oil on canvas

signed and dated at lower center, *P Gauguin 88*–

Josefowitz Collection

EXHIBITIONS
Brussels 1889, no. 6, *Lutteurs en herbe*; Paris 1889, no. 40, *Jeunes lutteurs-Bretagne*; Saint-Germain-en-Laye 1985, no. 67; Tokyo 1987, no. 28

CATALOGUE
W 273

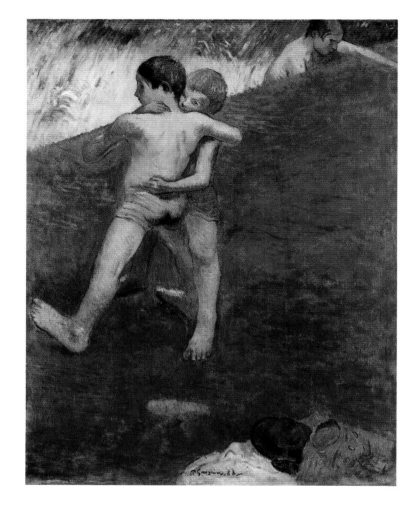

Puvis de Chavannes, detail of *Pleasant Land*, 1882, oil on canvas [Yale University Art Gallery, New Haven, The Mary Gertrude Abbey Fund]

1. Merlhès 1984, no. 156.

2. Merlhès 1984, no. 158.

3. Anquetil in Saint-Germain-en-Laye 1985, 46–49.

4. Malingue 1949, no. LXXVII.

5. Private collection, Neuilly-sur-Seine; probably the one by Gauguin sold to the painter Charles Filiger; see Huyghe 1952, 223: "Filiger Dessin lutteurs 20."

6. Rotonchamp 1906, 77, no. 21.

7. Huyghe 1952, 72, 73.

the painters at Pont-Aven and the Nabis, have recently been exposed.[3] It is probable, however, that Gauguin had in mind a scene by Pierre Puvis de Chavannes of two children wrestling by the sea, entitled *Doux pays* (Gentle Country), part of Puvis' decoration of a Paris town house owned by the painter Léon Bonnat, in the rue de Bassano. Gauguin may well have seen this painting when it was shown at the Durand-Ruel gallery on the occasion of an exhibition of Puvis' work that took place between 20 November and 20 December 1887. It is unlikely that Gauguin, newly returned from his trip to Martinique, would have missed such an exhibition.

This canvas is especially important in that it foreshadows *Vision after the Sermon* (cat. 50), which Gauguin painted about a month later; there the theme of wrestlers is borrowed from the famous Delacroix composition *Jacob Wrestling with the Angel*, in the Chapel of Saints Anges of the Church of Saint-Sulpice in Paris, and used symbolically. In this depiction of children wrestling, moreover, the artist discovers a formula for associating figures in a landscape with a still life in the foreground; he was to use this formula again in several of his Tahiti paintings (W 450, W 451).

Gauguin chose this canvas to represent his work both at the Volpini exhibition and at the Sixième Exposition des XX in Brussels in 1889.[4] The painting, for which a fine preparatory study exists in pastel,[5] was bought for two hundred and fifty francs by the writer Alfred Natanson, brother of the editor of *La Revue Blanche*, when Gauguin's works were auctioned at the Hôtel Drouot in 1891.[6] It later passed into the hands of Ambroise Vollard, and is mentioned twice in the 1888 sketchbook.[7]–C.F.-T.

49
Captain Jacob

summer 1888

31 x 43 (12¼ x 16⅞)

oil on canvas

signed and dated at upper left, *P. Go 88*

private collection

EXHIBITION
Saint-Germain-en-Laye 1985, no. 152

CATALOGUE
W 241 (cited as lost)

shown in Paris only

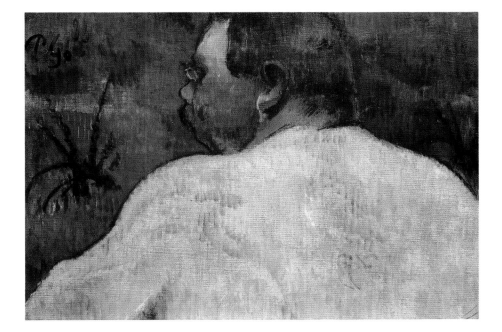

1. Quoted in Chassé 1955, 65.

2. Perruchot 1961, 189.

"To transport our baggage from Pont-Aven to Le Pouldu, we embarked on the salt excise boat, which M. Jacob, the chief customs officer, had kindly laid on for us. Captain Jacob! I can still remember the red face Gauguin gave the man when he painted him in his bathing suit!"[1]

Paul Sérusier's description corresponds perfectly to this droll painting, whose curious setting is a foretaste of the work of Pierre Bonnard and the Nabis. Gauguin has caught the model's cheerful, bon-vivant nature, along with his refinement and originality. One should bear in mind that it must have been unusual for a customs official to consort openly with bohemians like Gauguin and his friends.

Captain Jacob is pictured on the point of jumping into the water, despite the presence on his nose of a pair of small wire-rimmed spectacles. Gauguin probably trimmed the original canvas, since the format is clearly different from that imposed by traditional stretcher sizes. This would also explain why we do not see the "bathing suit" referred to by Sérusier. The captain's job was to prevent the transport of contraband between Pont-Aven and Quimperlé.[2] From time to time he obliged his painter friends by giving them lifts between Pont-Aven (quite some distance upriver) and Le Pouldu on the coast, as he did his rounds of inspection. On other occasions the customs officer took them on scenic or gastronomic trips to Port Manech or Le Pouldu, which Gauguin knew well prior to his move there in the autumn of 1889.

Gauguin gave Captain Jacob a little still life (W 291) painted against a background of flowered wallpaper. In this portrait the blue background, picked out with one or two clumps of plants, probably aquatic, also resembles wallpaper; the reference is obviously to the sea, or to the river Aven.

Curiously enough, Captain Jacob had a famous namesake in the district who was also destined to be acquainted with a great painter. He was the poet Max Jacob, born at Quimper in 1876, who later became one of Picasso's close friends.—F.C.

50
The Vision after the Sermon (Jacob Wrestling with the Angel)

summer 1888

73 x 92 (28¾ x 36¼)

oil on canvas

signed and dated at lower left, *P. Gauguin 1888*

The National Galleries of Scotland, Edinburgh

EXHIBITIONS
Brussels 1889, no. 7; Paris, Drouot 1891; Paris 1906, no. 209; Paris, Orangerie 1949, no. 6

CATALOGUE
W 245

shown in Paris only

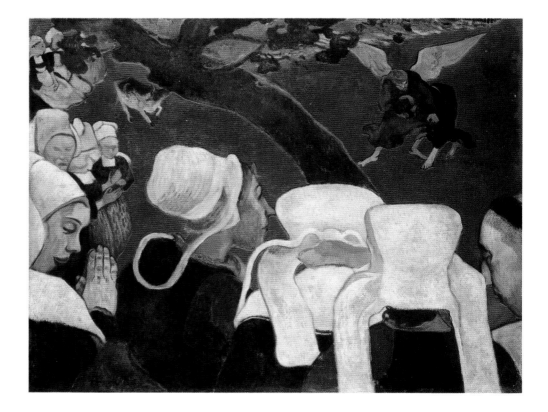

1. Roskill 1970, 132; Jirat-Wasiutynski 1978; Andersen 1971, 60; Viirlaid 1980.

2. Aurier 1891.

3. Herban 1977, 415–419, adds to the list of possible sources the pardon of Saint Nicodemus at Saint-Nicolas-des-Eaux, at which Gauguin may have been present on 5 August 1888. There is no proof, however, that the artist was at Saint-Nicolas-des-Eaux, which is sixty-five miles from Pont-Aven, on that particular day.

4. Genesis 32: 23–31.

5. Merlhès 1984, 501, n. 277.²

6. Merlhès 1984, no. 165; Cooper 1983, no. 32.2.

7. Bernard [1939].

8. Merlhès 1984, no. 167; Cooper 1983, no. 6.2., circa 29 September 1888.

9. Rewald 1973, 49.

10. Rotonchamp 1906, 77; record of sale of Paul Gauguin's paintings, 23 February 1891, no. 6. The painting was sold to Henry Meilheurat des Pruraux.

This painting was probably begun in mid-August 1888 and completed around mid-September. It has provoked all kinds of interpretations, from the symbolic and psychoanalytical to the theosophical,[1] but its most important feature is that it marks a complete change in Gauguin's creative production in the vital year of 1888 and represents a high point in the development of his style. With this, his first painting on a religious theme, Gauguin turned his back on impressionism, which he had not fully mastered; at the same time he created the first accomplished image in a new style, synthetism, of which there are various foretastes in his earlier works but which is here found to be perfectly adapted to a more global, antinaturalist and symbolist approach to art. Not for nothing did the critic Albert Aurier begin his resounding article on symbolism, *Le Symbolisme en peinture*,[2] with an enthusiastic description of this painting: "Far, far away, on a hill out of a legend with turf of gleaming vermilion, Jacob is locked in biblical combat with the Angel." With Aurier's words, Gauguin became the acknowledged leader of a new school of symbolism.

The literary source[3] for the painting is, of course, the famous passage from the Book of Genesis[4] which relates how Jacob spent a whole night wrestling with a mysterious angel after fording the Jabbok with his family. This enigmatic combat has been variously interpreted as man's struggle against God, against Satan, or against himself,[5] and had been illustrated by Eugène Delacroix in a mural executed in 1861 for the Church of Saint-Sulpice in Paris, and also by Gustave Moreau.

Gauguin, *Album Walter*, page 3 [Musée du Louvre, Paris, Département des Arts Graphiques]

Gauguin, sketch for *The Vision after the Sermon*, in a letter to Vincent van Gogh, c. 22 September 1888 [Vincent van Gogh Foundation, National Museum Vincent van Gogh, Amsterdam]

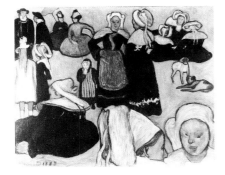

Bernard, *Breton Women in a Prairie*, 1888, oil on canvas [private collection, Saint-Germain-en-Laye; photo: Giraudon]

11. Unpublished letter from Gauguin to Octave Maus, Archives, Brussels [1889], Musées Royaux des Beaux-Arts de Belgique. Archives de l'Art Contemporain, Octave Maus Collection, Van de Linden Donation, Inv. no. 5225.

12. Merlhès 1984, no. 168.

13. Merlhès 1984, no. 165.

"I have just finished a religious painting, wretchedly done, but it interested me to do it and I like it. I wanted to give it to the Church of Pont-Aven. Of course, they will have nothing to do with the thing," wrote Gauguin to van Gogh toward the end of September 1888.[6] Emile Bernard later recalled how he had accompanied Gauguin and Charles Laval to offer the painting to the curé of the neighboring church at Nizon: "A silence filled with suspicion ensued after the artist's lengthy explanation of his painting; and then came a flat refusal."[7] Faced with this wall of incomprehension, Gauguin entrusted the picture to Bernard with a request to pass it on to Theo van Gogh for sale in Paris. "The painting for the church is coming to you, and you can hang it. Unfortunately, it was intended for a church, and what would be all right in surroundings of bare stone and stained glass . . . will scarcely have the same effect in a salon," he wrote to Theo.[8] As a result, the canvas remained on deposit with Boussod and Valadon with a price tag of six hundred francs,[9] according to Gauguin's instructions. No purchaser was found for it until the auction in 1891 at the Hôtel Drouot, at which it made the highest price of the sale, nine hundred francs.[10] This was slightly below the reserve of one thousand francs placed on it by Gauguin two years earlier, when he sent the painting to the *Sixième Exposition des XX* in Brussels in February 1889.[11]

"This year I have sacrificed everything – execution, color – for style, because I wished to force myself into doing something other than what I know how to do. I believe this is a change which has not yet borne fruit, but will one day do so," wrote Gauguin to Emile Schuffenecker on 8 October 1888,[12] announcing the completion of this painting. These words are remarkably enlightening with regard to his motivations; clearly, he viewed the canvas as a real challenge.

In a letter to Vincent van Gogh, he refers to the work once again: "Breton women in a group, praying: very intense black clothes – yellow-white bonnets, very luminous. The two bonnets at right are like monstrous helmets – an *apple tree*, which is dark violet, spreads across the canvas: the foliage is defined in masses, like greenish *emerald* clouds, with greenish yellow interstices of sunlight. The ground is *pure vermilion*. At the church it tones down and becomes a reddish brown.

"The Angel is dressed in violent ultramarine blue, and Jacob in bottle green. The wings of the Angel are pure number 1 chrome yellow. The Angel's hair is number 2 chrome, and the feet are flesh orange – I think I have achieved great simplicity in the figures, very rustic, very *superstitious* – the overall effect is very severe – the cow under the tree is tiny in comparison with reality, and is rearing up – for me in this painting the landscape and the fight only exist in the imagination of the people praying after the sermon, which is why there is a contrast between the people, who are natural, and the struggle going on in a landscape which is non-natural and out of proportion."[13] This letter is accompanied by a sketch of the painting, with one or two annotations of colors.

The dispute between Bernard and Gauguin has caused so much ink to flow[14] that we need only outline it here. Basically, when Bernard arrived in Pont-Aven in the middle of August, he either brought with him or immediately painted the annual pardon at Pont-Aven, which took place on 16 September 1888. His picture, which was entitled *Breton Women in the Fields*, was as disconcerting as it was daring.

"The 'Pardon' had just been held at Pont-Aven," Bernard wrote, "and I, taking this local custom as my theme, had deliberately painted in yellow a sunlit field, illuminated with Breton bonnets and blue-black groups. Taking my painting as his starting point, Gauguin did *The Vision after the Sermon* [cat. 50], a picture in which the bonnets became the main theme, as in mine. He defined his foreground against a deliberately red backdrop, in which two wrestlers, borrowed

14. See Thirion 1956, 98–103; Roskill 1970, 103–105.

15. Bernard 1903, 679–680.

16. See Welsh-Ovcharov in Toronto 1981.

17. For a preparatory sketch, see Gauguin, Album Walter RF 30569, fol. 3r.

18. Thirion 1956.

19. *Le Japon Artistique* 30 (October 1890), 69, and 2 (June 1888), 15.

20. Merlhès 1984, no. 165.

21. Merlhès 1984, no. 172.

from a set of Japanese prints, were deployed to represent a vision. /A new technique/ This flat-tinted painting was so different from the previous work of Paul Gauguin that it amounted to a complete negation of it; and it was so similar to my own *Bretonnes dans la prairie* as to be practically identical."[15]

Bernard squabbled with Gauguin after the appearance of Aurier's article on symbolism in 1891, and after that he never ceased to claim that he was the true father of the new style and that Gauguin had stolen the credit. Recent criticism[16] has acknowledged the role played by Bernard, Louis Anquetin, and Henri de Toulouse-Lautrec between 1886 and 1887 in the development of cloisonism, a style of painting in strongly outlined flat tints, like the enamels and stained glass of the Middle Ages; the importance of Bernard's painting in the genesis of this work by Gauguin should not be underestimated either. Both works contain the same single-color idea in the background, with simplified silhouettes starkly outlined; and both abandon realism in favor of a more decorative, Japanese notion of art.

Bernard later attempted to invest his canvas with religious significance by giving it the title *Breton Women at the Pardon*, under which it was exhibited at the *Salon des Indépendants* in 1892. But still he was unable to match the extraordinary novelty of Gauguin's archetypal symbolist painting, with its combination of tangible reality (the Breton women in the foreground) and interior vision inspired by a sermon. These two ingredients are separated by the diagonal line of the apple tree.[17] In sum, the exceptional power of suggestion inherent in this painting springs directly from the unification of these two levels of reality by the use of appropriate plastic techniques.

Bernard's painting and Japanese sources – for the diagonal tree and for the struggle between Jacob and the angel, which was inspired by illustrations of wrestlers in Hokusai's *Mangwa* prints[18] – appear to have served as a catalyst for Gauguin's poetic imagination. Two other Hokusai prints may also be said to have had an influence: one represents spectators at a wrestling match, the other a group officiating at a religious ceremony. In both cases the figures are arranged on a diagonal, like Gauguin's Breton women. These prints were reproduced in the contemporary review *Le Japon Artistique*,[19] and such images were evidently well-known to Western painters.

"I am unfamiliar with *poetic ideas*; probably I lack this sense. I find EVERYTHING poetic and I glimpse poetry in the corners of my heart. These corners are sometimes mysterious to me," wrote Gauguin to van Gogh on about 7 September 1888.[20] The bonnets of the Breton women in Gauguin's painting are purely decorative, and their faces are masks of meditation. As to color, this has been applied generously in broad masses, but at the same time subtly modulated; Gauguin is already using the evocative potential of color in a manner he was later to develop more fully with his sumptuous Tahiti paintings.

There is no doubt that Gauguin was well aware of the turning point he had reached. He even anticipated, in a letter to Schuffenecker dated 16 October 1888, that his work would be misunderstood: "Clearly the path of symbolism is full of dangers, and I have not yet ventured more than the tip of my toe in that direction: but symbolism is fundamental to my nature, and one should always follow one's temperament. I know quite well that I shall be *less and less* understood. But what does it matter if I set myself apart from other people? For most I shall be an enigma, but for a few I shall be a poet and sooner or later what is good wins recognition. Whatever happens, I tell you that I will manage to do *first rate things*, I can feel it and we shall see. You know very well that where art is concerned I am always basically right."[21]

Soon, Gauguin was to need every ounce of his superb belief in himself to face his critics. In February 1889, the appearance of his painting at the *Sixième Exposition des XX* provoked a scandal: "and it is inferred from his *Vision du*

Sermon, symbolized by Jacob and the Angel wrestling on a vermilion field, that the artist's intention was to make impudent mockery of the visitors," wrote Octave Maus,[22] who for his own part greatly admired Gauguin's painting.

Camille Pissarro was another who refused to recognize the formal innovation of Gauguin's canvas. He waited until shortly after the artist's departure for the Pacific to unleash a broadside against his painting, which he considered foolishly retrograde in subject matter: "I have no quarrel with Gauguin on account of his vermilion backdrop, or his two struggling warriors, or his Breton peasant women in the foreground; but I do quarrel with him because he lifted all this from the Japanese, the Byzantines and the rest, and because he fails to apply his synthesis to our modern philosophy, which is absolutely social, anti-authoritarian and anti-mystical. . . . This is a step backward."[23]—C.F.-T.

22. Maus 1889.

23. Pissarro 1950, 234.

51
Madeleine Bernard (recto); The White River (verso)

1888

72 x 58 (28⅜ x 22⅞)

oil on canvas

signed and dated at upper right, *P. Gauguin 88*

Musée de Grenoble

EXHIBITIONS
Paris 1906, no. 157 (painting on reverse side was shown); Paris, Orangerie 1949, no. 7; Basel 1949, no. 19; Lausanne 1950, no. 9; Edinburgh 1955, no. 125

CATALOGUE
W 240/W 263

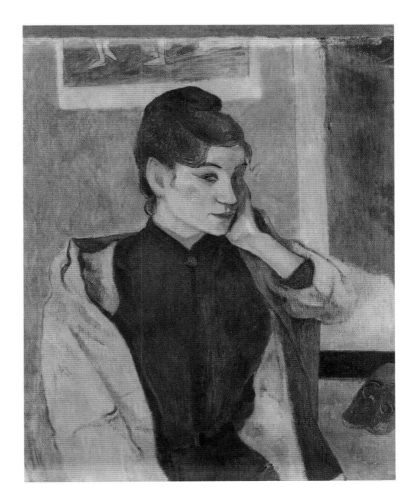

Bernard, *The White River*, 1888 [Musée Toulouse-Lautrec, Albi]

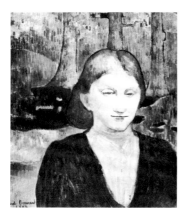

Bernard, *Portrait of the Artist's Sister*, 1888, oil on canvas [Musée Toulouse-Lautrec, Albi]

Forain, illustration [*Le Courrier Français*, 18 March 1888]

Gauguin painted this portrait on the back of a landscape probably executed at Pont-Aven during the summer of 1886. The portrait is vertical, in the traditional fashion, and the landscape is horizontal. With its fresh colors and nervous brushwork, the format of the landscape resembles several other views done by the artist during the same period (W 197, W 198). Gauguin was soon to return to this theme, centering the composition on the bathers close up (cat. 34, W 215).

The reuse of an earlier canvas is evidence of two things; first, obviously, that Gauguin was desperately short of money, and second, that he was nevertheless fully confident of the extent of his progress over the last two years.[1] He was convinced that his recently discovered personal style had made the "impressionism" of his earlier years quite insignificant. Moreover, the model he was painting, Madeleine Bernard, was very closely associated with his new preoccupations and research.

Madeleine (1871–1895) was the younger sister of Emile Bernard. She arrived at Pont-Aven, accompanied by her mother, to spend the months of August and September 1888 with Emile. At this time she was only seventeen years old. "My sister was very beautiful and very mystical," wrote Bernard. "She quickly became captivated by Brittany and had a Pont-Aven costume made for herself. . . . the affection and encouragement that Gauguin offered me as soon as he saw the work I had brought with me from Saint Briac, his colossal talent and his wretched poverty, soon made us both the friends of the 'accursed' painter. . . . Gauguin did a portrait of my sister, and I painted her in the Bois d'Amour reclining, full length, in the attitude of a *gisante* [tomb effigy]. Naturally, neither Gauguin nor I myself attempted anything more than a caricature of my sister, on account of the ideas we had at that time about character; but all the same Gauguin did paint a portrait (not resembling Madeleine, but very interesting from the point of view of style) with a Pont-Aven landscape behind, done in his earlier manner."[2]

It is well known that Gauguin fell in love with Madeleine, who appears to have preferred Laval. Not only was Gauguin seduced by her physical appearance – even though he was old enough to have been the father of both the Bernards – but he also held her in high intellectual esteem. For different reasons both the painter and his model were searching for a direction for their lives and for some kind of justification of their aspirations. Gauguin was torn between the contradictory forces of love for his family and will to obey his higher duty as an artist; he had left his wife with the full material responsibility for their home. This cannot have been achieved without guilt and reflection upon what a woman's true role should be. Madeleine, too, must have been prey to similar doubts, and we may imagine that the portrait sittings were punctuated with impassioned talk. As the painting shows, an ambiguous relationship sprang up between Gauguin and his adolescent model, with her mystical nature, her singularity, and her yearning for independence. As soon as Madeleine returned to Paris the painter wrote to her, encouraging his "dear sister" to "be someone," by which he meant she should be proud and should do whatever she could to earn her own living while "rejecting *vanity*." In other words, she should avoid the traditional fate of woman, not depend upon a man, banish "the doll" within her and "view herself as androgynous, without sex."[3]

The Madeleine of the portrait is not wearing the Breton costume she favored while in Pont-Aven "for artistic reasons!"[4] She is simply clad in a high-necked blouse with a kind of overcoat, which seems too big for her, over her shoulders; this coat probably belonged to Gauguin. She stands out strongly against a blue wall, on which we see the lower area of an engraving or reproduction showing the feet of ballerinas. These were once thought to be possibly part of a work by Degas,[5] but are now known to belong to an engraving by Jean-Louis Forain which was reproduced in the *Courrier Français* on 18 March 1888.[6] Might

1. Bodelsen 1966, 33.

2. Bernard 1939, 7.

3. Merlhès 1984, no. 173. Androgyny was a fashionable theme for the symbolists; Joséphin Péladan, in *Curieuse* (1886), wrote: "les génies et les héros sont androgynes." See also Jirat-Wasiutynski 1978, 147.

4. Bernard [1939], 15.

5. Roskill 1970, 101.

6. Identified by Peter Zegers, who kindly shared this information with me.

7. See Walter 1978, 290, nn. 17, 18, 19.

8. Huyghe 1952, 227.

these dancers be a reference to Madeleine, in contrast to Forain's frivolous "small rats" – whose feet only are seen in Gauguin's painting, but whose elderly protectors and procuresses are not far distant – and the virtuous gravity of the model?

Madeleine Bernard's face is intelligent; it has what the French call *caractère*. The eyes are keen and seem to be made up, doubtless an effect deriving from Gauguin's pursuit of style to the detriment of likeness, of which Emile Bernard disapproved. All the same, the portrait has an intensity, an honesty, even a touch of flirtatiousness, which ring true. Gauguin may have been correct in discerning the *femme fatale* within the saintly Madeleine described by Emile in his memoirs. There is no question that this girl caused much suffering to Gauguin when she chose the youthful Laval, and when she refused to accept the ceramic he offered her (cat. 65), in which he presented himself as both a seducer and a doleful baby, screaming to be consoled. Madeleine cannot have failed to see the resemblance between the Gauguin of this ceramic and the artist's portrait in a wood carving of 1889 (G 76).

As it turned out, Madeleine Bernard's fate was a tragic one. Having become engaged to Laval, she nursed him until his death of tuberculosis in 1894; she then contracted the disease herself, joined her brother in Cairo, and died there the following year aged only twenty-four.[7]

Gauguin gave his portrait of Madeleine to her brother,[8] but Emile had already sold it by the time it was hung at the *Salon d'Automne* in 1906. At this exhibition Madeleine's face was turned to the wall, the organizers having preferred to show the landscape on the reverse side of the canvas.–F.C.

52
Still Life: Fête Gloanec

1. Denis 1942, 59.

2. Probably it was her saint's day, the day of the Virgin Mary (August 15), and not, as maintained by Perruchot, her birthday (Mme Gloanec was born on 8 February 1839, at Pont-Aven).

3. *Still Life with Jug*, Durand-Ruel Collection, Paris; Luthi 1982, no. 156. .

Maurice Denis bought this painting directly from Mme Marie-Jeanne Gloanec, to whom it was given in August 1888 by Gauguin himself. The story of its inception and the anecdote about its signature were told to him by at least two witnesses, Paul Sérusier and Marie-Jeanne Gloanec, and probably also by Emile Bernard: "That year Madeleine Bernard, Emile's sister and Laval's fiancée, was also in Pont-Aven. She had a good deal of charm and Gauguin rather cynically paid court to her. It was to Madeleine that he attributed a very beautiful still life (pears, bouquet of flowers and a cake, on a vermilion pedestal table), the first in his new manner, which Mme Gloanec had refused to accept as a gift and hang in her dining room. She had been influenced by an opposing clique, and notably by a painter Gustave de Maupassant, who was said to be the father of the writer. To make Mme Gloanec accept the painting, Gauguin finally signed it Madeleine B., declaring that it was in fact the work of a débutante. When I bought it, many years later, Mme Gloanec assured me that she had not been taken in for a moment."[1]

The painting is based on real elements, namely the trappings of Mme Gloanec's celebration.[2] These were a bouquet of marigolds with a single outsize cornflower wrapped in a cone of paper, fruit, and a Breton tart. All these objects were arranged on the pedestal table at Mme Gloanec's boarding house (Emile Bernard also made a painting of this table).[3]

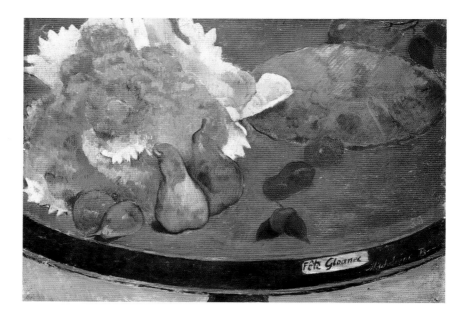

Still Life: Fête Gloanec

1888

38 x 53 (15 x 20⅞)

oil on wood

titled and signed at lower right, on edge of table, *Fête Gloanec Madeleine B.;* dated at right, on table, *88*

Musée des Beaux-Arts d'Orléans

EXHIBITIONS
Paris 1923, no. 10; Basel 1928, no. 31 (or 35); Berlin 1928, no. 21; Paris, Orangerie 1949, no. 8; London 1979, no. 85; Washington 1980, no. 86

CATALOGUE
W 290

shown in Paris only

4. Welsh-Ovcharov in Toronto 1981, no. 51.

5. House and Stevens in London 1979, no. 85.

6. Denis 1890, reprinted Denis 1920, 1.

The bird's-eye view inherited from Degas and the Japanese painters, along with the arbitrary red light that bathes the various objects, combine to lend this still life an imaginary quality that is not unlike Gauguin's painting of Jacob wrestling with an angel (cat. 50). The effect is sumptuous, infused with Gauguin's fresh, partially cloisonist style[4] and new-found liberty. It has been suggested that the bouquet of flowers and the two pears are an emblematic representation of the head and breast of Madeleine Bernard, and hence that the painting is a symbolic portrait of her, but this seems far-fetched.[5] Rather, the work is a perfect illustration of the way the young artists of the time saw Gauguin, namely as the creator of a style of painting that "essentially consisted of a flat surface covered in color and assembled in a certain order,"[6] as the young Maurice Denis, chief theorist of the Nabi movement and future owner of this painting, was to proclaim two years later. Finally, it is hard to resist a comparison with Pierre Bonnard and Henri Matisse, whose still lifes and atelier scenes are bathed in a similar reddish light.–F.C.

53
Seascape with Cow on the Edge of a Cliff

1. Fénéon 1889a; reprint Fénéon 1970, 157–158.

2. Welsh-Ovcharov in Toronto 1981, no. 50.

Did Félix Fénéon have this painting in mind when he wrote the following lines? No proof exists, but they define the work perfectly in the critic's most delectable style: "Reality for him [Gauguin] was no more than a pretext for his faraway creations; he reorganized the raw materials reality provided, and spurned trompe-l'oeil (even the trompe-l'oeil of atmosphere); he accentuated lines, restricted their number and conventionalized them; and in each of the broad spaces between these lines a rich, heavy color was his special bleak pride; it never interfered with the adjacent tints, and never changed one iota because of them."[1]

Despite this bird's-eye view with Japanese overtones,[2] the site at Le Pouldu depicted here is real enough and just as spectacular as Gauguin makes it out to be.

1888

73 x 60 (28¾ x 23⅝)

oil on canvas

signed and dated at lower left, *P. Gauguin, 88*

Musée des Arts Décoratifs, Paris

EXHIBITIONS
Basel 1928, no. 38 or 43; Toronto 1981, no. 50

CATALOGUE
W 282

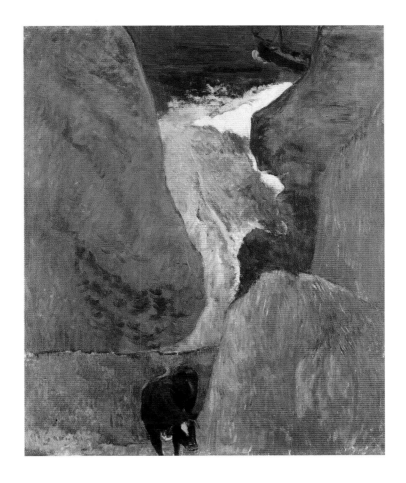

Lacombe, *Cliffs at Camaret*, 1892 [Musée des Beaux-Arts, Brest]

3. Bodelsen 1964, 191.

4. Compare Rewald 1973, 49.

The sheer coastline of Brittany is full of such fields, with yellow haystacks outlined against the sea and cows grazing precariously at the edge of the cliff. By flattening both depth and distance and by placing the cow in the foreground and the boat in the background on exactly the same plane, Gauguin contrives to transmit a feeling of vertigo. There is also a touch of comedy in the contrast between the placid earthbound animal and the little boat racing along at the top of the canvas. The artist was to return several times to this basic composition (see W 360, W 361), but curiously enough his approach to it became more traditional, less experimental with the passing of time. The stark relief of the rocks, along with their blue-violet tones and iridescent gleam, have suggested the theory that Gauguin the painter may have been influenced by Gauguin the daring and innovative ceramist.[3]

The bold cloisonism, and the blocks of vivid, contrasting color connected like the pieces of a jigsaw puzzle, represent a foretaste of the simplified Nabi aesthetic and even of art nouveau. This painting subsequently inspired several canvases by Georges Lacombe (in particular one at the Musée Municipal, Brest).

The title Gauguin put to this painting on the list of his works on deposit with Boussod and Valadon was simply *Seascape with Cow*.[4] The longer title appeared for the first time in 1891, prior to Gauguin's voyage to Tahiti, at the Hôtel Drouot auction. Here the painting was purchased for two hundred and thirty francs (along with cat. 56) by one of the few buyers present who was not an artist or a writer with links to Gauguin. There are several similar instances on record of slight dramatizations of titles; they usually appeared when Gauguin's paintings were on sale. The artist himself tended to give simpler, more precise titles to his works.—F.C.

54
Still Life with Three Puppies

1888

92 x 63 (36¼ x 24¾)

oil on wood

signed and dated at lower left, *P Go/88*

The Museum of Modern Art, New York,
Mrs. Simon Guggenheim Fund, 1952

EXHIBITIONS
Edinburgh 1955, no. 22; Chicago 1959, no. 12;
London 1966, no. 13

CATALOGUE
W 293

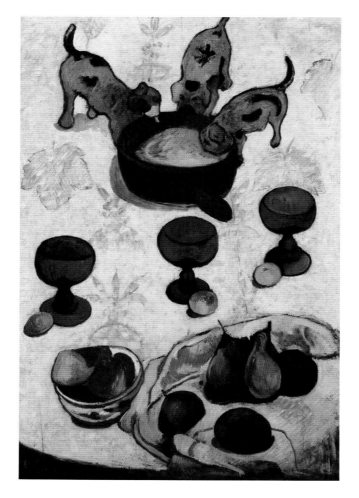

Matisse, *Gourds*, 1916, oil on canvas
[Museum of Modern Art, Mrs. Simon
Guggenheim Fund]

Among the still lifes painted by Gauguin during his stay in Brittany in 1888, this canvas is probably the most daring from a formal standpoint. Here the principles of composition that emerged with the still life at Mme Gloanec's (cat. 52) are developed by being stretched to their logical extremes; indeed, a rounded corner of the same Gloanec table appears in the lower part of the panel. Perspective is completely banished in favor of painting that conforms with the surface to be covered, a formula that anticipates many subsequent still lifes by Pierre Bonnard, Henri Matisse, and the cubists. Matisse, in particular, adopted Gauguin's idea of juxtaposing on a canvas objects without any logical connection to one another, as in *Les Coloquintes* (1912, The Museum of Modern Art, New York). In Gauguin's still life, a deliberately disconcerting subject is handled in flat tints with strong outlines; only the fruits in the lower right-hand corner escape this treatment. The one approximate equivalent to Gauguin's choice here is *Breton Women in a Green Prairie* (see fig., cat. 50) by Emile Bernard. The Japanese source material – probably a print by Kuniyoshi[1] – strengthens the decorative treatment of the painting, which contains three separate registers. Denial of reality on such a scale – with forms that have no shadows and no relief – tallies with the conscious search for naïveté which absorbed Emile Bernard and Gauguin during their time at Pont-

Aven. Three little dogs, three cups, three apples; Gauguin is visibly enjoying himself, as though he were living out a fairy tale. Van Gogh, writing to Theo in August 1888, announced that: "Gauguin and Bernard talk now of 'painting like children.' I would rather have that than 'painting like decadents.'"[2]

In the same month, Gauguin wrote to Emile Schuffenecker in an anti-naturalist vein: "How safe they are on dry land, those academic painters with their trompe-l'oeil of nature. We alone are sailing free on the ghost-ship, with all our fantastical imperfections."[3]—C.F.-T.

1. Thirion 1956, 106.

2. Van Gogh 1978, no. 527.

3. Merlhès 1984, no. 162.

55
Still Life with Fruit

summer 1888

43 x 58 (16⅞ x 22⅞)

oil on canvas

dedicated, signed, and dated at lower right, *à mon ami Laval P Go 88*

Pushkin State Museum of Fine Arts, Moscow

CATALOGUE
W 288

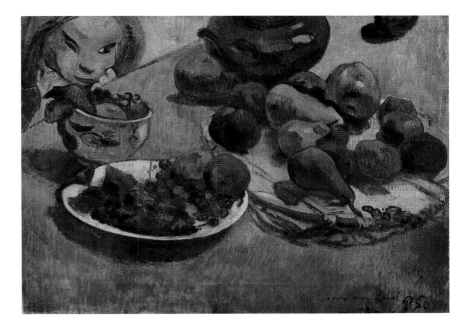

This still life is dedicated to Charles Laval, who returned from Martinique to Pont-Aven in August 1888. The canvas must have been completed in late summer, if the fruit it contains is anything to go by. This is the fourth in a group of pictures (see cats. 52, 54, W 289) in which Gauguin's chief preoccupation seems to be to explore the various ways of representing objects in a given space. Each of these still lifes approaches the problem from a different standpoint, but all are strongly influenced by the handling of space in Japanese prints.

Here, Gauguin chooses to tilt the surface of the table abruptly; the edge of it cuts diagonally across the upper left-hand corner of the canvas and truncates the forms. These seem to quit the observer's field of vision, as do the forms in Pierre Bonnard's later still lifes. Meanwhile, blue shadows stabilize the objects depicted, which without them would float aimlessly in space.

At the upper left of the canvas appears a tragic female figure, with head in hands, slit eyes, and an expression of despair. Her curious cast of features bears a resemblance to that of the Breton woman in the lower right-hand corner of Emile Bernard's *Breton Women in a Green Prairie* (see fig., cat. 50), and her presence here completely alters what might have been a straightforward still life with the usual ambiguous ingredients of symbolism. The figure seems to personify two things: the temptation of worldly things, and the sinister inevitability of the human condition;[1] moreover, her diabolical air recalls the look which Gauguin was shortly to give the painter Meyer de Haan (cat. 93).

This character reemerges at the center of *Human Misery* (W 304), painted at Arles when Gauguin was with van Gogh a few weeks later; and from then on she becomes a recurrent theme in Gauguin's work (see cats. 69, 78, 242).

This painting belonged at one time to the great Russian collector Sergei Shchukin, whose paintings, along with those of Alexander Morosov, later became the nucleus of the former Museum of Modern Western Art in Moscow, now the Pushkin State Museum of Fine Arts.—C.F.-T.

1. See Andersen 1971, 88, and Jirat-Wasiutynski 1978, 160.

56
The Alyscamps

1. Henry James, *A Little Tour in France* (Boston, 1884), cited by Schaefer in Paris 1985, 340.

2. de la Faille 1970, no. 495; Hulsker 1980, no. 1626.

3. Roskill 1970, 137-138.

4. de la Faille 1970, nos. 568, 569, 486, 487.

5. See Pickvance 1984, nos. 115-117.

6. Circa 2 November 1888, cited by Pickvance in New York 1984, 200; Merlhès 1984, no. 177.

7. de la Faille 1970, no. 568.

8. Merlhès 1984, no. 182.

9. Cooper 1983, no. 9.1.

10. Rewald 1973, 49.

11. Rotonchamp 1906, 77, no. 11 (sale record).

The Alyscamps, an ancient necropolis in the old city of Arles, inspired both Gauguin and van Gogh, in November 1888, to paint canvases celebrating the flamboyant colors of autumn. At that time nothing remained of the original Roman burial ground (later used by Christians) save a "melancholy avenue of cypresses, lined with a succession of ancient sarcophagi, all empty, mossy, and mutilated."[1] At the end of this avenue stood the Romanesque church of Saint-Honorat with the lantern tower that is featured in Gauguin's painting.

This canvas seems to be the first of a series of subjects tackled by both artists after Gauguin's arrival in Arles on 23 October 1888. On 4 or 5 November, both men set about painting vine-harvest scenes; the results were the very dissimilar *Red Vineyard*[2] by van Gogh, and Gauguin's depiction of women in a vineyard (W 304). More often than not, however, Gauguin took up subjects that van Gogh had already attempted (cat. 57, W 302, W 303). In the case of this canvas, it is difficult to decide whether the two artists worked together on the same site at the same time, or at different times, as has been suggested.[3]

For his painting Gauguin has chosen to position himself outside the famous avenue of poplars with its sarcophagi, along the banks of the Craponne canal. The sarcophagi, which are not visible in this painting, appear in a later, horizontal version of the same subject (W 306).

Van Gogh has bequeathed us no less than four views of the Alyscamps,[4] two of which were painted in horizontal format on very coarse-grained canvas purchased by Gauguin shortly after his arrival.[5] Both artists used this material, and Gauguin referred to it in a postscript to a letter from van Gogh to Emile Bernard: "Vincent has done two studies of leaves falling in an avenue; they are in my room, and you would like them very much. On very coarse but very good burlap."[6] Gauguin's painting has nothing in common with these two van Goghs.

More similar, at least in terms of its vertical format and general composition, is the van Gogh painting now in a private collection in Switzerland.[7] Yet van

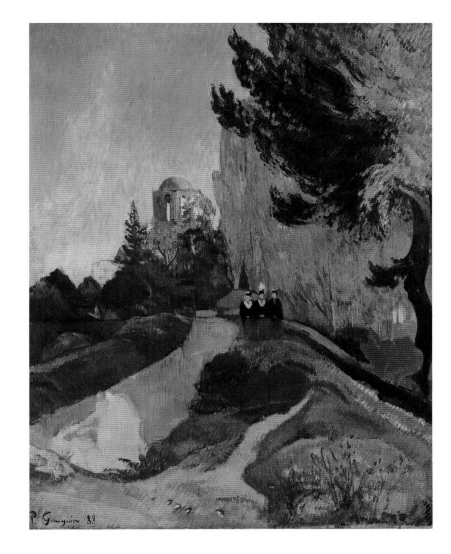

late October 1888

92 x 73 (36¼ x 28¾)

oil on canvas

signed and dated at lower left, *P Gauguin 88*

Musée d'Orsay, Paris

EXHIBITIONS
Paris, Orangerie 1949, no. 11; Paris 1960, no. 174; Los Angeles 1984, no. 133

CATALOGUE
W 307

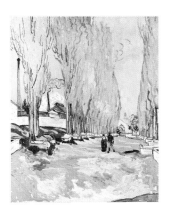

van Gogh, *The Alyscamps*, 1888, oil on canvas [private collection, Lausanne, Switzerland]

Gogh's habit of laying on paint in quantity was always at odds with Gauguin's light, almost scratchy brushwork. Gauguin himself broached this subject in a letter to Bernard in the second half of November: "In general, Vincent and I agree on very few topics, and especially not on painting. . . . He's romantic, and I'm more inclined to a primitive state of things. As to pigment, he appreciates the hazards of thick paint as Monticelli uses it, whereas I detest any form of tampering by brushwork, etc."[8]

Here the brushwork is certainly unextravagant, but the colors are heady, even arbitrary. The blue tree trunk and the vivid red flash in the foreground attest to the dazzling effect of Arles on Gauguin's palette.

On about 4 December, Gauguin sent his painting to Theo van Gogh with the ironic title *The Three Graces at the Temple of Venus*,[9] in a package that included a retouched canvas (cat. 44), and some other works (cat. 57, W 301, W 304). *The Alyscamps* was to remain on deposit with Boussod and Valadon[10] until it was sold at the Hôtel Drouot auction on 23 February 1891[11] for 350 francs. It was bequeathed to the Louvre in 1923 by the Comtesse Vitali, in memory of her brother the Vicomte de Cholet.—C.F.-T.

57
At the Café

early November 1888

72 x 92 (28 x 36¼)

oil on canvas

signed and dated at lower right, *P Gauguin 88*; and at center left, on billiard table, *P Gauguin 88*

Pushkin State Museum of Fine Arts, Moscow

EXHIBITION
Paris 1978, no. 10

CATALOGUE
W 305

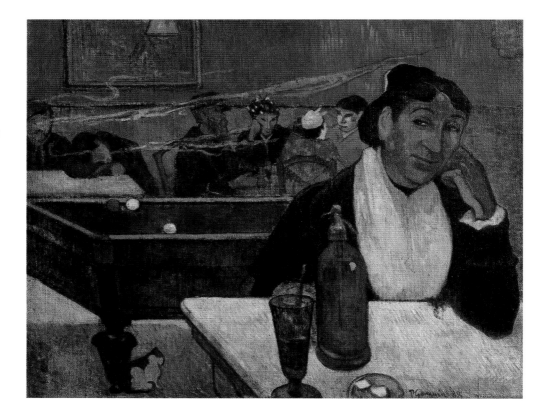

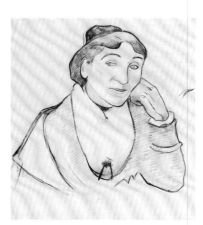

Gauguin, *The Arlesienne, Madame Ginoux*, 1888, colored chalks and charcoal with white chalk heightening [The Fine Arts Museums of San Francisco, Achenbach Foundation for Graphic Arts, memorial gift from Dr. T. Edward & Tullah Hanley, Bradford, Pennsylvania, Achenbach Foundation]

1. de la Faille 1970, no. 463, Hulsker 1980, no. 1575.

2. van Gogh 1978, no. 533.

3. van Gogh 1978, no. 559.

4. Merlhès 1984, no. 177.

5. Merlhès 1984, no. 179.

This canvas represents the interior of the Café de la Gare in Arles, which was run by M. and Mme Ginoux at 30, place Lamartine. Van Gogh occupied a room above the café from May 1888 until mid-September, when he moved to the nearby Yellow House. In his own painting of the café, van Gogh pictures a desolate night interior harshly lit by gas lamps;[1] the work was executed in feverish haste in early September, with the avowed objective of expressing "the terrible passions of humanity by means of red and green."[2]

This painting is Gauguin's response to van Gogh's pathos-filled canvas. The subject is tackled with greater detachment; Gauguin was also working on another canvas (W 304) at the time (early November).[3] "At the moment Gauguin is doing a picture of the same café by night as I painted," wrote van Gogh to Emile Bernard, "but with figures he saw in brothels. It looks like it's turning into something very fine."[4]

A few days later, Gauguin himself described his painting in a letter, which included a rapid sketch, to Bernard: "I've also done a café which Vincent likes very much and I like rather less. Basically it isn't my cup of tea and the coarse local color doesn't suit me. I like it well enough in paintings by other people, but for myself I'm always apprehensive. It's purely a matter of education: one cannot remake oneself. Above, red wallpaper and three whores, one with hair full of bows, the second (back view) in a green shawl, the third in a vermilion shawl. At left, a man asleep. A billiard table. In the foreground, a fairly well-finished figure of an Arlésienne with a black shawl and white [?] in front. Marble table. The picture is crossed by a band of *blue smoke*, but the figure in front is much too neat and stiff. Oh well."[5]

This "figure in front" is none other than Mme Ginoux, the person who has been immortalized in van Gogh's famous Arlésienne portraits.[6] The two painters asked her to pose for them and van Gogh roughed out his first version in a single hour's work; this version is now thought to be the one in the Musée d'Orsay.[7] Meanwhile, Gauguin composed a portrait in charcoal (P 27) that is remarkable for the solidity of its forms; he used it as a study for the foreground figure in this painting before giving it to van Gogh, who in turn referred to it for his own later versions of Mme Ginoux. Here the model is leaning jauntily on a white marble table behind a bottle of seltzer borrowed from the earlier van Gogh painting; she gazes meaningfully at the observer, no doubt in reference to the three prostitutes in the background.

6. de la Faille 1970, nos. 540-543; nos. 488–489; Hulsker 1980, nos. 1624–1625; 1892 to 1895.

7. New York 1984, nos. 120–121.

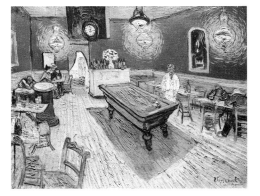

van Gogh, *The Night Café*, 1888, oil on canvas [Yale University Art Gallery, New Haven, Bequest of Stephen Carlton Clark, B.A. 1903]

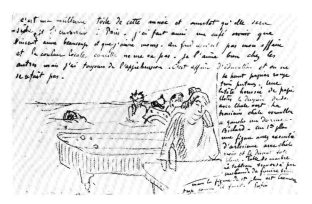

Gauguin, sketch, letter to Emile Bernard, November 1888 [location unknown]

With an ironic nod to Vincent,[8] Gauguin has introduced two other figures, both, like Mme Ginoux, immortalized elsewhere by van Gogh. These are the postman, Joseph Roulin, who is identifiable by his cap, and Paul-Eugène Milliet, the Zouave, on the far left. The two do not appear in the sketch sent to Bernard, and were probably painted in at a later date, which is perhaps the reason for the unusual double signature.

While he uses the same color oppositions as van Gogh (green, red, and ocher), Gauguin offers a much more stylized and decorative view of the subject. The scene is coldly recorded, with none of van Gogh's expressionist vision. A rhythmic insistence on horizontal planes gives Gauguin's version a balance that Vincent's fails to achieve. The individuals in the friezelike group behind Mme Ginoux have the look of marionettes that she dominates and controls, and the general atmosphere of the café is admirably conveyed by the indifferent veil of blue smoke that hangs, stagnant, across the room.

"Also Gauguin has nearly finished his *Café de nuit*," wrote Vincent to Theo in November 1888.[9] Toward the end of the month,[10] Gauguin rolled up the canvas and sent it to Theo in a package that also contained the retouched picture of dancing Breton girls (cat. 44), the painting of the Alyscamps (cat. 56), and two other canvases painted in Arles (W 301, W 304).

The theory has been advanced[11] that this work was shown at the *Sixième Exposition des XX* in Brussels in 1889 under the title *Vous y passerez la belle* (*Your Turn Will Come*). There is no convincing proof of this, and in fact it is more probable that another painting (cat. 60) was referred to and easily identified by contemporary commentaries.

This canvas was purchased by Ambroise Vollard, and later passed into the hands of the great Russian collector Alexander Morosov.—C.F.-T.

8. Roskill 1970, 142.

9. van Gogh 1960, no. 561 F; Merlhès 1984, no. 92.

10. Cooper 1983, no. 9.1; Merlhès 1984, no. 183.

11. Cooper 1983, no. 35.4, n. 10.

58
Old Women at Arles

mid-November 1888

73 x 92 (28¾ x 36¼)

oil on canvas

signed and dated at lower left, *P. Gauguin 88*

The Art Institute of Chicago, Mr. and Mrs. Lewis L. Coburn Memorial Collection

EXHIBITIONS
Basel 1928, no. 39; Chicago 1959, no. 13; London 1979, no. 86; Toronto 1981, no 55; New York 1984, no. 127

CATALOGUE
W 300

van Gogh, *Women of Arles*, 1888, oil on canvas [State Hermitage Museum, Leningrad]

1. de la Faille 1970, nos. 468, 470, 471, 472, 479, 485.

2. House and Stevens in London 1979, no. 86; Pickvance 1984, no. 127.

3. Merlhès 1984, no. 176.

4. Huyghe 1952, 51-52, 56, 60.

5. de la Faille 1970, no. 547.

6. de la Faille 1970, no. 496.

7. Van Gogh 1978, no. 562.

8. Huyghe 1952, 223.

9. Rewald 1973, 35.

This painting, executed in mid-November 1888, casts much light on the artistic give-and-take that occurred between van Gogh and Gauguin during their brief period together. The origins of this work date back to late September and early October 1888, several weeks before Gauguin's arrival in Arles, at which time van Gogh was painting a series of views of public gardens there. One of these gardens lay directly in front of the Yellow House, where Vincent was living.[1] He referred to certain pictures in the series as the Poet's Garden, an allusion to Boccaccio and Petrarch, as he confirms in various letters to Theo. These paintings were intended to decorate the bedroom that Gauguin was soon to occupy.

The evidence suggests that this work is Gauguin's response to van Gogh's series.[2] Although the point of departure – a public garden near the Yellow House – is the same, the painting represents a completely different imaginative concept. Space, for one thing, is handled arbitrarily; there is no horizon, due to a rising perspective that is wedged, in the foreground, against a violently contrasted gate and dense shrubbery. Geometrical forms clearly take precedence over the accurate observation of nature; hence the somber outlines of Arlésiennes wrapped in shawls echo the two strange orange-colored cones (probably shrubs packed in straw against the frost). Van Gogh enlivened his gardens with expressive lovers or people strolling, whereas Gauguin's canvas is frequented by enigmatic silhouettes.

Shortly after his arrival in Arles, Gauguin wrote to Emile Bernard: "It's strange, Vincent sees plenty of Daumier to do here, but I see highly colored Puvis blended with Japanese. The women here with their elegant headdresses, their Grecian beauty, and their shawls with pleats like you see in the early masters, remind one of the processions on Greek urns. At any rate, here is one source for a beautiful *modern style*."[3]

One of Gauguin's sketchbooks[4] shows several studies for the figures – the bench, the fountain, and the cones in this painting. The Arlésienne in the foreground is probably Mme Ginoux (see cat. 57). However, even though certain directly observed elements can be positively identified, this carefully planned composition contrasts in virtually every detail with the spontaneity of van Gogh.

Gauguin exhorted Vincent to paint "from the imagination," and the result was a canvas in which the physical features of the gardens of Arles are blended with memories of the gardens at Nuenen and Etten that Vincent had known in his youth. Together with *The Dance Hall at Arles*,[5] *Memory of the Garden at Etten*[6] is a work in which the influence of Gauguin on van Gogh is at its highest point. Nevertheless, one cannot but notice the obvious effort van Gogh has made to paint against his natural bent. "Gauguin gives me the courage to imagine things, and certainly things from the imagination take on a more mysterious character," explained Vincent to his brother Theo.[7]

Gauguin was to return to the main themes of this painting, in reverse, in one of the zincographs in his series for the Volpini exhibition (cat. 67). Mention of this painting under the title *Arlésiennes (Mistral)* in a list of Gauguin's works in the Brittany sketchbook[8] shows that Theo van Gogh bought the painting for three hundred francs probably in the winter of 1888-1889. Theo subsequently sold it to Emile Schuffenecker.[9]—C.F.-T.

Gauguin, Brittany and Arles Sketchbook, page 51 [The Israel Museum, Jerusalem]

59
Farm at Arles

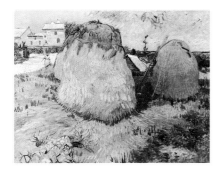

van Gogh, *Haystacks*, 1888, oil on canvas [Rijksmuseum Kröller-Muller, Otterlo]

1. See Pickvance 1984, 93-94.

2. van Gogh 1978, no. 497; quoted in New York 1984, 93.

3. de la Faille 1970, no. 425; see Brettell in Los Angeles 1984, no. 102.

4. de la Faille 1970, nos. 561, 412.

Of the seventeen canvases Gauguin painted at Arles during his time with van Gogh, six are landscapes on large, size 30 canvases (72 x 92 cm, or 28 x 36 in.), in vertical or horizontal format. Van Gogh worked with the same format for most of his harvest and haystacks series, which consisted of ten paintings completed between 13 and 20 June 1888, prior to Gauguin's arrival.[1]

This painting shows Gauguin on the cusp of two influences, those of van Gogh and Cézanne. Van Gogh he saw every day, but the memory of Cézanne haunted him throughout his stay in the south of France. Van Gogh felt the same way. "Instinctively these days I keep remembering what I have seen of Cézanne's, because he has rendered so forcibly – as in the 'Harvest' we saw at Portier's – the harsh side of Provence. . . . The country near Aix where Cézanne works is just the same as this, it is still the Crau,"[2] he wrote to his brother Theo in June 1888.

In this canvas Gauguin tackled one of van Gogh's favorite themes. In van Gogh's *Haystacks*,[3] however, a painting that contains an evident reference to Jean François Millet and that is among the most important works in van Gogh's harvest series, the treatment is radically different from Gauguin's here. Vincent's vibrant brushwork endows his stacked sheaves with powerful presence in a canvas that exudes feverish energy. Other van Gogh versions of the subject[4] are set against a broad horizon that suggests cosmic infinity.

By contrast, Gauguin's solidly structured haystack stands at the center of a landscape that is architecturally and geometrically coherent. Apart from the lower left-hand corner of the canvas, in which van Gogh's influence is evident, the reg-

ular, streaked brushwork harks back to Cézanne and gives this painting a stability that is far removed from van Gogh's passionate view of things.

Interestingly enough, van Gogh had earlier made several pen-and-ink drawings of haystacks and had sent some of these to Emile Bernard in mid-July 1888, shortly before Bernard arrived in Pont-Aven.

This painting was at one time thought to be a Breton landscape executed in 1888, or even 1889.[5] Although the canvas bears no date, this hypothesis has been positively ruled out in view of the Provençal architecture of the houses and the types of vegetation depicted.

The presence of this canvas at the exhibition of Gauguin's work in Copenhagen in 1893[6] remains unproven. It is also not altogether certain that this painting was the one shown at the Volpini café under the title *Landscape at Arles.*—C.F.-T.

5. Roskill 1970, 43.

6. Bodelsen 1966, 36.

Farm at Arles

mid-November 1888

91 x 72 (35⅞ x 28⅜)

oil on canvas

Indianapolis Museum of Art, gift in memory of William Ray Adams

EXHIBITIONS
(?) Copenhagen, Udstilling 1893, no. 156, as *Efteraarslandskab fra Arles*; Houston 1954, no. 11; Edinburgh 1955, no. 27; New York 1956, no. 12; Chicago 1959, no. 14; Paris 1960, no. 39; Munich 1960, no. 38; Vienna 1960, no. 12; Los Angeles 1984, no. 102

CATALOGUE
W 308

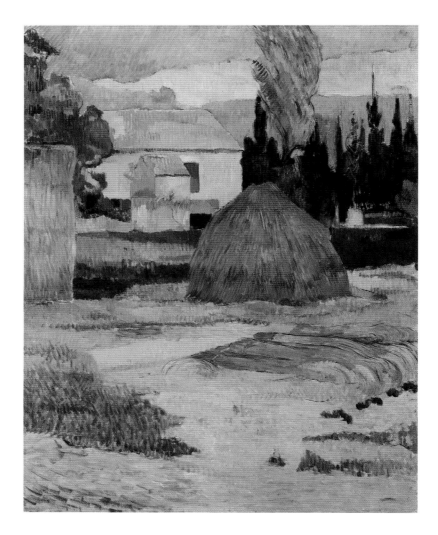

60
Blue Trees

autumn 1888

92 x 73 (36¼ x 28¾)

oil on canvas

signed and dated at lower right, *P Gauguin 88*

The Ordrupgaard Collection, Copenhagen

EXHIBITIONS
(?) Brussels 1889, no. 12, *Vous y passerez la belle*; Copenhagen, Udstilling 1893, no. 157, *Landskab Ved Solnedgang*; Copenhagen 1948, no. 36; Paris 1981, no. 15; Copenhagen 1984, no. 29

CATALOGUE
W 311

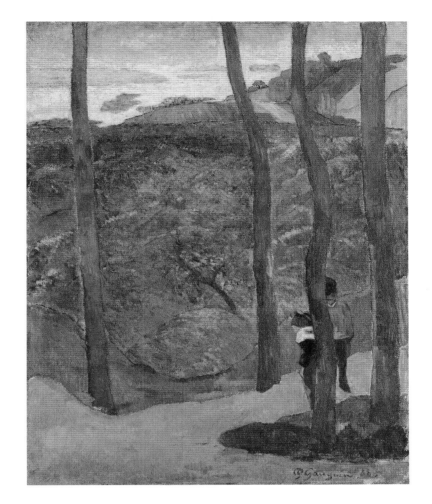

From Octave Maus' enthusiastic description of Gauguin's pictures at the *Sixième Exposition des XX* in Brussels in 1889, we must conclude that this painting was exhibited there. While no work with this title was included in the exhibition catalogue under Gauguin's name, it is hard to see what other canvas the great Belgian critic can have been describing in the following passage: "Insofar as one landscape shows trees with blue trunks and a yellow sky, one might conclude that M. Gauguin lacks the most elementary notion of color. ... I humbly confess my sincere admiration for M. Paul Gauguin, who is not only one of the most refined colorists I know, but also one of the most innocent where the usual tricks of the trade are concerned."[1] This canvas, in which we see a couple through a stand of trees, is most likely the painting that appeared at the Brussels exhibition under the enigmatic title of *Vous y passerez la belle* (Your Turn Will Come), and which has never been positively identified (see cat. 57).

The picture is constructed around boldly contrasting colors: yellow and blue, vermilion and green. It also obeys a decorative pattern in the rhythmical opposition of vertical tree trunks and the exceptionally high horizon line. The layering of the various planes is reinforced by the clear outlining, in blue, of the zones of color in the foreground; the same clarity is applied to the sky, which

1. Maus 1889, cited by Rewald 1979, 249.

contrasts with the central part of the picture in a declining range of orange, blue, and green tones.

Like the painting of Jacob wrestling with an angel (cat. 50), this canvas shows Gauguin putting into practice the famous lesson he had so recently imparted to Paul Sérusier in the Bois d'Amour in Brittany in October 1888. This memorable occasion produced a little picture entitled *The Talisman*,[2] which was painted by Sérusier under Gauguin's guidance and became a veritable manifesto of the painter's freedom in relation to his subject matter.

Gauguin's picture was painted at Arles, on the same burlap as two of his other works (W 239, W 304). We know from a letter of about 10 November 1888, written by Vincent van Gogh to his brother Theo, that Gauguin had purchased "twenty meters of very strong canvas" for a bargain price;[3] and Gauguin himself mentioned this painting, along with the others he did at Arles, in his Brittany sketchbook.[4] The picture was perhaps part of the package sent to Theo at Boussod and Valadon's at the close of 1888, since Emile Schuffenecker wrote on 11 December 1888 to congratulate Gauguin on his latest Arles paintings and to warn him against using any more poor quality canvas. "The paint is falling off in chunks: it's very awkward, and it makes the pictures impossible to sell for the moment."[5] The work was probably one of the paintings listed at three hundred francs in the large inventory left by Gauguin with Boussod and Valadon, probably in 1890.[6]

A simplified version of the lower part of this picture appears in the background of another canvas, a portrait of Mme Roulin (W 298) executed during the artist's Arles period. Mme Roulin was one of van Gogh's most famous sitters.—C.F.-T.

2. 1888, Musée d'Orsay, Paris.

3. Bodelsen 1964, 221 n. 144.

4. Huyghe 1952, 72.

5. Bodelsen 1964, 221 n. 144.

6. Rewald 1973, 49.

61
Schuffenecker's Family

"I'm setting myself to do portraits of the entire Schuffenecker family, him and his wife and the two children in vermilion pinafores," Gauguin wrote to Vincent van Gogh around 15 January 1889.[1] This painting is one of the few that Gauguin undertook during his stay in Paris in 1889, when his primary concern was pottery. It seems to have been done in two stages, the first in January ("It's bitterly cold in Paris now," he informed Vincent),[2] which would explain the overcoat and shawl in which Mme Schuffenecker is wrapped, and the incandescent stove which Gauguin has signed in red. The portrait was probably completed on Gauguin's return to Paris for the Volpini exhibition in May-June, after he had spent the intervening time, the end of February to May, at Pont-Aven; hence the green landscape hinted at beyond the glass windows of the studio that is certainly Schuffenecker's, and which in fact gave on to a cul-de-sac at the back of 29 rue Boulard. Schuffenecker lodged Gauguin in this studio. "A narrow alley, with trellises all along it, had little symmetrical houses on both sides, each one fronted by a tiny garden plot. The dining room and an adjoining room – formerly the sitting room, but now transformed into an atelier – faced directly onto the garden," wrote Gauguin's future biographer,[3] who knew the place well.

This group portrait is a new departure for Gauguin. In it he associates a carefully, even ruthlessly observed reality (the landscape, the likenesses, the attitudes of the figures), with a deliberately arbitrary handling of color. These broad

1. Cooper 1983, no. 35.3; confirming that the letter was received.

2. Cooper 1983, no. 35.3.

3. Rotonchamp 1906, 37.

120

January 1889

73 x 92 (28¾ x 36¼)

oil on canvas

signed at center and at right, on the stove, in red, *P. Go.*; dedicated and dated below and at right, in blue, *Souvenir à ce bon Schuffenecker 1889*

Musée d'Orsay, Paris

EXHIBITIONS
Paris, Orangerie 1949, no. 12; Basel 1949, no. 25; Quimper 1950, no. 5

CATALOGUE
W 313

shown in Paris only

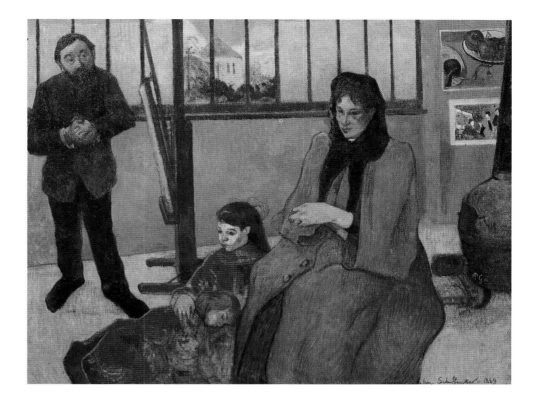

Schuffenecker, *Self-portrait*, pencil and pastel on paper [Collection of Mr. and Mrs. Arthur G. Altschul]

4. The same print appears in a still life (W 287) in a larger frame, probably also done at Schuffenecker's studio the previous year.

5. Confirmed by the laboratory of the Musées Nationaux de France.

6. At the time, Jeanne Schuffenecker was seven and a half years old and her brother Paul was four.

7. Merlhès 1984.

8. Identified by Bodelsen 1964, 66.

9. Bodelsen 1964, 188, quoting Denys Sutton.

zones of contrasted primary tints, yellow and blue, evoke the Arles period and the influence of van Gogh. The figures are immersed in the real volume of the studio, yet rendered in flat colors as in Gauguin's picture of Jacob and the angel (cat. 50) and especially as in the Japanese print on the wall at right, where a group of people are placed against a broad red background.[4] This image provides us with one of the harmonic keys to the ensemble of Gauguin's picture; clearly it was added as an afterthought during the second session, like the painting above it (technical analysis has shown that this was in fact the case).[5]

The main element of the composition is the central triangle, which comprises Mme Schuffenecker and her two children. Gauguin had already done a charming portrait in ceramic of the daughter, Jeanne (cat. 39),[6] and she and her little brother also feature in a comical, somewhat terrifying painting (W 530) reminiscent of the pictures van Gogh did of the Roulin baby in Arles. Here, in their red pinafores, the two young Schuffeneckers are described without affectation but not without a certain tenderness.

One can scarcely say as much for the parents. Mme Schuffenecker, whom Gauguin had already described as a "harpy" and a "limpet"[7] in a letter to Mette, was a very pretty young woman with a somewhat difficult nature. Gauguin did several portraits of her. The first was a plaster bust executed at the time of the Schuffenecker's marriage in 1880 (G 89); then came a vase, sculpted in the winter of 1887-1888, in which her fine features, high cheekbones, and large ear are clearly recognizable (cat. 62);[8] then another vase, in which she wears a snake for a crown (G 49). In the family portrait, however, Gauguin depicts her as a cantankerous, bitter, sad creature, with an ominous black hood; her heavy overcoat and enormous clenched fist evoke some kind of evil power. It has been pointed out[9] that the contrast between the volumetric treatment of the coat, as if molded from heavy material, with the flatness of the background makes a very powerful image. Per-

10. Rotonchamp 1906, 38.

11. Bodelsen 1964, 119.

12. Unpublished letter to Jules Bois, 19 December 1898, sale, Hôtel Drouot, 2 April 1987, no. 153.

13. Rotonchamp 1925, 78.

14. Rotonchamp 1906, 38.

15. Joly-Segalen 1950, 69.

16. See Le Paul and Dudensing 1978; Merlhès 1984, 401–402.

haps Gauguin blamed Louise Schuffenecker for failing to greet him with boundless enthusiasm whenever he was obliged to move into her house and when he proceeded to behave as if he owned the place.[10] Perhaps, as some of his intimates suspected, the painter had tried to seduce his friend's wife and had been rejected. Gauguin himself has left one or two symbolic clues that might confirm this hypothesis: the two ceramic portraits of Louise Schuffenecker both include snakes, and these symbols of temptation may well represent Gauguin himself.[11] Furthermore, the face in caricature and the hand with its ostentatious wedding ring are placed at dead center of the family portrait, which may signify that Gauguin had taken his own kind of revenge by showing Louise's transformation from Eve into a dominating mother and demanding wife. In justice to Gauguin, we may add that only ten years later Schuffenecker himself was referring to his spouse as a "poor, lamentable creature to whom life has cruelly chained me, like a convict to his iron ball."[12]

Here he stands at left, tiny in his big slippers, gazing humbly at his wife; nearby is his easel, and on it is a painting, seen at an angle, which appears to be rubbed out. His hands are crossed in front; he holds no paintbrush, and his pose is that of an obsequious servant or of a cuckold in a comedy. Thus is Gauguin's rendering of "le bon Schuffenecker"; "good" he may have been, but here he is scoffed at as a painter, ridiculed as a husband, and demolished as a friend. Moreover, it appears that Gauguin added a further legend, "je vote pour Boulanggg" – a reference to General Boulanger, who featured in the elections of 27 January 1889 – and that this was effaced later, probably by Schuffenecker, only to be resurrected by Gauguin's biographer.[13]

"Gauguin was always very hard on Schuffenecker," says a witness who knew both men.[14] We can easily believe this, and we know that Gauguin judged him "born to be an ordinary worker, a concierge or a small shopkeeper."[15] This may have been true, but it takes no account of the important role Schuffenecker played in Gauguin's life. The two were fellow employees of Bertin's exchange agency from 1872 onward, and at that time it was Schuffenecker who dragged his friend to museums and encouraged him to paint. Later, it was Schuffenecker who first quit his job to take up painting, subsequently providing Gauguin with material help for the rest of his life. Gauguin's first son was baptized Emile, as a mark of his parents' gratitude; and it was Schuffenecker who continually lodged and fed Gauguin, and who had the idea for the exhibition at the Volpini café, close to the *Exposition Universelle* of 1889, which was to prove a crucial moment in the history of Gauguin's influence on the younger generation of painters. Lastly, it was Schuffenecker who introduced Gauguin to Jean Brouillon, otherwise known as Jean de Rotonchamp, the man who later wrote Gauguin's biography; and above all Schuffenecker brought him to Daniel de Monfreid,[16] the vital friend and supporter of his final years. When, a year after painting this picture, Gauguin dreamed of organizing his "tropical studio" (which was originally planned for Madagascar, not Tahiti), he included "le bon Schuffenecker" in the venture along with Emile Bernard, Jacob Meyer de Haan, and Vincent van Gogh, taking the view that he wasn't too bad as a painter, and anyway his skill at handling practical problems would certainly be useful. But in the end the only thanks poor Schuffenecker got from Gauguin was this eloquent, cruel, derisive family portrait.—F.C.

62

Vase in the Form of a Woman's Head, Mme Schuffenecker

1889

height 24 (9)

glazed stoneware with gold highlights

Dallas Museum of Art, The Wendy and Emery Reeves Collection

EXHIBITIONS
(?) Paris 1906, no. 175; (?) Paris 1917, no. 37; Paris 1923, no. 64; Paris 1928, no. 38; Paris 1936, no. 21

CATALOGUES
G 67, B 50

shown in Washington only

Gauguin?, *Vase in the Form of a Torso of a Woman, Madame Schuffenecker* [private collection]

1. Bodelsen 1964, 119.

2. Bodelsen 1964, 63.

This vase, which was made in the winter of 1889, is assumed to be a portrait of Mme Schuffenecker.[1] The identification is very convincing, when one compares this piece with that lady's despondent face in the painting of the Schuffenecker family (cat. 61). By contrast with the pot that portrays her daughter Jeanne (cat. 39), this ceramic, like the vase with two boys' heads made at the same time (cat. 66), has been completely glazed and colored; in some places the colors have even been accentuated with gold highlights.

Mme Schuffenecker was, it seems, the model for another vase-portrait (G 49)[2] in unglazed stoneware, executed in Paris the previous winter. This consists of a bust, with a necklace around the throat and the waist encircled by a snake. The same snake appears again in this vase, twined like a blue-spotted ribbon in the model's hair. On the back there is a floral decoration, which again includes a long snake coiled in a tree.

Thus the wife of Emile Schuffenecker is twice portrayed in the guise of the temptress Eve, which is in fact a fair illustration of her role in the ambiguous state of affairs that arose in the Schuffenecker household after Gauguin's arrival. Gauguin's repeated advances to Mme Schuffenecker led to a rupture between the two painters in 1891 (see cat. 61). Moreover, Mme Schuffenecker is here given a faun's ear, which further reinforces the symbolic meaning of the portrait.

Picasso, Study for *Seated Woman*,
1901-1902, California Palace of the Legion
of Honor, The Fine Arts Museums of San
Francisco].

With its direct emphasis on the curve of the model's breast, this highly original vase presents an "aspect" of Mme Schuffenecker. It bears no resemblance at all to any traditional bust. For instance, the model's left hand appears at the back of the vase, at the top; and this hand seems to be dismembered and unrelated to the rest of the body.

Gauguin's very modern approach to sculpture, as demonstrated here, was thoroughly disconcerting to his contemporaries. This work can be compared with an early Picasso drawing in the De Young Memorial Museum in San Francisco in which the artist employed the same fragmentary approach to the model (Johnson 1975, 64).

The piece belonged to Emile Schuffenecker and later passed to Amédée, his brother and heir.—C.F.-T.

63
The Ham

1889

50 x 58 (19⅝ x 22⅞)

oil on canvas

signed at right, on the table, *p. go.*

The Phillips Collection, Washington, D.C.

EXHIBITIONS
Houston 1954, no. 10; Chicago 1959, no. 21

CATALOGUE
W 379

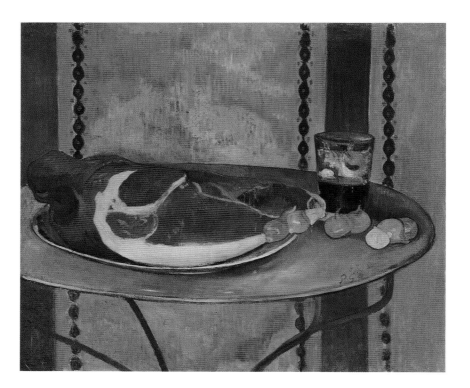

1. Quoted by Chassé 1955, 50.

2. This painting was exhibited at the Manet retrospective in 1884, which Gauguin probably saw.

The space represented here is one of the simplest and most carefully constructed in all of Gauguin's work, with its play on the opposition of the vertical stripes at rear, the concentric forms of the table and plate, and the opulent spiral in the shape of the ham.

The yellow wallpaper in the background of the painting is not confined to flat tints; on the contrary, it is filled with modulated passages, especially in the area above the table. This wallpaper, along with the placement of the pink onions

and the glass of wine, once again testify to Gauguin's reverence for Paul Cézanne. "Let's do a Cézanne!" was his cry, according to Paul Sérusier, particularly when he felt like painting a still life.[1] In spite of his appalling financial straits, Gauguin managed to hold on to a still life by Cézanne until he was literally forced to relinquish it in 1898 (see cat. 111).

Nevertheless, Edouard Manet is the major influence in this painting. Manet's beautiful still life, also entitled *The Ham* (1880, Glasgow Art Gallery and Museum),[2] had recently been bought by Degas at the sale of works in the collection of Eugène Pertuiset, in June 1888. Gauguin must have seen this painting at Degas' house when he visited Paris in January and February 1889, for he was one of the few people whom the misanthrope Degas was willing to admit. Thus he would have painted his own version of the subject on returning to his studio in the avenue de Montsouris, where one may imagine him ensconced with his metal bistro table and his smoked ham, which also enabled him to keep his belly full without cooking or otherwise interrupting his work.

Gauguin's painting closely resembles Manet's; in both the object is centered in the same way, on an oval plate, with wallpaper in the background. Gauguin's debt to both Cézanne and Manet is abundantly clear in this painting; but the exotic, pungent colors, the strangeness and the simplicity, are his alone.–F.C.

Manet, *The Ham*, c. 1875-1878, oil on canvas [Glasgow Museums & Art Galleries, The Burrell Collection]

64
Jug in the Form of a Head, Self-portrait

Of all Gauguin's self-portraits, this is perhaps the most striking and the most unnerving; for in it the artist has succeeded in conveying a forceful, dramatic vision of himself, while the simplicity of the material and the form have spared him the formality inherent in the use of oil on canvas. The piece was executed at the beginning of 1889; it was probably modeled at Schuffenecker's studio, where Gauguin was living at the time, and fired at Chaplet's atelier. However, the image itself seems to have been worked out little by little over the previous year. The interaction between Gauguin's ceramic work and his painting, the way in which, between 1886 and 1887, he was more inventive in the former discipline, have been convincingly described elsewhere.[1] In fact, ceramics led Gauguin to discover a number of new pictorial ideas and formulas at this time. This is borne out by his letter of 8 October 1888 to Schuffenecker, in which he described the famous self-portrait (W 239) that he had sent to Vincent van Gogh: "The color is none too close to nature; a vague memory if you like of my pottery all twisted up in the firing – all the reds and violets seared by bursts of flame, like a furnace glimmering in the eyes, where all a painter's mental struggles take place."[2] The letter was accompanied by a drawing of himself closely resembling this jug, to which he was to give physical form only a few months later. The various areas of Gauguin's work seem to have fed one another constantly; hence the pottery experiments of 1887 led to the self-portrait dedicated to Vincent, which then passed through a drawing phase before playing its part in the creation of this ceramic portrait.

The shape of the piece is not unlike that of the traditional toby jug, or of the Peruvian pots with which Gauguin was familiar from the collections of his mother and of his tutor, Gustave Arosa. Gauguin liked to call himself an "Inca" or an "Indian," which this object most definitely resembles in form and in feature.

1. Bodelsen 1964, 111, has analyzed this piece in masterly fashion.

2. Merlhès 1984, no. 168.

Jug in the Form of a Head, Self-Portrait

January (?) 1889

height 19.3 (7⅝)

stoneware glazed in olive green, gray, and red

Museum of Decorative Art, Copenhagen

EXHIBITIONS
Copenhagen, Udstilling 1893, no. 138;
Copenhagen 1948; Copenhagen 1984, no. 30

CATALOGUES
G 65, B 48

shown in Paris only

Head of Christ, plaster cast from Beauvais Cathedral [Musée de l'Homme, Paris]

3. Merlhès 1984, no. 156.

4. Fénéon 1889b, cited by Bodelsen 1964, 111. Fénéon must have seen the more recent ceramics at Schuffenecker's or at Theo van Gogh's house, since no ceramics were exhibited at Volpini's café.

5. Gérard de Nerval, quoted in Reverseau 1972.

6. *Avant et après*, 1923 ed., 179-181.

Moreover, it corresponds exactly to what the artist was consciously trying to create and express, something "completely Japanese, done by a Peruvian savage."[3]

Contemporary critics were especially struck by the Japanese materials used in the piece. At the end of 1889, Félix Fénéon reproached J. K. Huysmans for his failure to include in *Certains*, a collection of art criticism, "post-1887 Gauguin . . . the Gauguin of vases and statues, who has instilled his wild dreams and innovative forms into the stoneware of sixteenth- and seventeenth-century Takatori potters, using heavy, powerful browns heightened by somber, flickering overflows of color."[4]

In both the romantic and the symbolist movements there was a predilection for "the bloody reveries of severed heads," as is evident in works by Théodore Géricault, Francisco Goya, and Charles Baudelaire, Stéphane Mallarmé, Gustave Moreau, Pierre Puvis de Chavannes, and Odilon Redon.[5] The head might belong to John the Baptist, martyred for his faith, or to Orpheus, martyred for his poetry; it represents the misunderstood artist, tormented by the indifference and hostility of his contemporaries. The image itself had been made horribly real for Gauguin, who on 28 December 1888 attended the execution by guillotine of a convicted murderer.[6] This episode took place only a few weeks before the creation of

7. Bodelsen 1964, 216 n. 61; Roskill 1970, 197.

8. *Avant et après*, 1923 ed., 21-23.

9. Gray 1963, 31, sees in the red marks on the face the image of Christ with his crown of thorns; Amishai-Maisels 1985, 79, sees the source of the head in a Gothic Man of Sorrows at Beauvais Cathedral, which was exhibited at the Trocadéro in 1889.

10. Compare Jirat-Wasiutynski 1978.

11. Malingue 1949, LXVII.

12. Malingue 1949, LXXXVI.

13. Joly-Segalen 1950, V.

14. Compare Bodelsen 1984, 76.

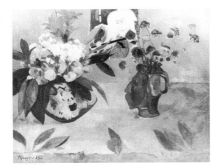

Gauguin, *Still Life with Japanese Print*, 1889, oil on canvas [Museum of Modern Art, Teheran]

Gauguin, *Arii matamoe*, (*Royal End*), 1892, oil on canvas [Archives Durand Ruel]

this jug, with its effect of blood running down the face of a tortured man, or of a severed head.

Another possible analogy is suggested by the jug's lack of ears;[7] the blood-ied places where they should be may refer to van Gogh's famous self-mutilation, which concluded the stormy relationship between the two artists at Arles. Gauguin's feelings of horror and pity on finding van Gogh lying unconscious and covered in gore on the morning of 24 December may well be imagined,[8] and only four days later he was witnessing a public execution in Paris. It is also very likely that soon afterward, at Theo van Gogh's house, Gauguin saw one of the famous self-portraits of van Gogh with his ear cut off. Therefore, this head-jug represents both the continuation and the conclusion of the artistic intimacy between the two men, an intimacy that had proved so fruitful at Arles. Perhaps Gauguin is trying to say that he too is a martyr and a wounded man.

Are there grounds for the supposition that Gauguin is deliberately asso-ciating his own image with that of Christ crowned with thorns, as he did at Pont-Aven a few months later (cat. 99)? Several historians believe so,[9] and the theory can only enrich the choice of interpretations that Gauguin intended for his self-portrait. The Orpheus theme is closer, perhaps, to the symbolic repertoire of contemporary poetry; Edouard Schuré's *Les Grands Initiés* appeared only a few months later and became very popular among Gauguin's new friends,[10] for whom Christ and Orpheus were of the same heroic line.

While the blood and the severed head have symbolic meaning, the fact that Gauguin portrayed himself with eyes closed is no accident either. No doubt there is also a link with Redon, who, in 1889, seems to have replaced Cézanne and Degas in Gauguin's pantheon. Already in the previous year he had painted his Breton women with their eyes closed, imagining a scene described in a sermon (cat. 50), and had himself been represented with lowered eyelids in Bernard's self-portrait. This powerful image expresses Gauguin's new theories; he is now deliber-ately turning his back on nature so as to concentrate on his inner vision. "Art is an abstraction," he wrote. "Draw art out of nature by dreaming in her presence, and think more of the creation that will ensue."[11]

At the end of the summer, Gauguin had Schuffenecker forward the jug to Brittany, where the artist found it "very successful."[12] This would mean that it was fired in his absence by Chaplet, and that he was seeing the finished work for the first time. He immediately included it in one of his most famous still lifes (W 375) in profile, as a vase for flowers; a bunch of daisies is seen sprouting from the painter's brain, an effect intentionally comical and naive. With his usual irony about symbolism and literary interpretations of his art, Gauguin is telling us that the object represents not only the martyred artist, but also a useful object.

He was to return to the theme of the severed head on a table a few years later in Tahiti, only this time he endowed it with legendary overtones. *Arii Matamoe* (W 453) represents "a severed Kanaka head, neatly arranged on a white cushion."[13] It is the image of a barbaric Orpheus whose "royal" skull is placed on a table and used as a utensil, a metaphor for the contemptible nature of all life, whether one is a great leader of men or merely an artist. Behind this image we sense the presence of Gauguin's own head, as he fashioned it in ceramic.

This self-portrait was by far the first of Gauguin's works to enter a public collection. Pietro Krohn, future director of the Museum of Decorative Arts, Copenhagen, bought the jug from Schuffenecker at the Copenhagen exhibition in 1893.[14] He then donated it to the museum in 1897, in Gauguin's lifetime.–F.C.

65
Portrait of Gauguin as a Grotesque Head

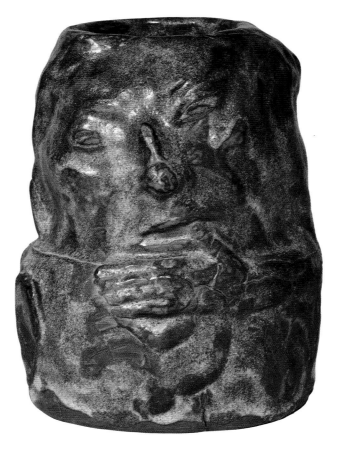

winter 1889

height 28 (11)

glazed stoneware inscribed inside, at base, on a label, *La sincérité d'un songe à l'idéal-iste Schuffenecker. Souvenir Paul Gauguin*[1]

Musée d'Orsay, Paris

EXHIBITIONS
(?) Paris 1891; Paris 1923, no. 66; Paris 1928, no. 34; Paris, Orangerie 1949, no. 86

CATALOGUE
G 66, B 53

Gauguin, *Be in Love and You Will Be Happy*, 1889, painted linden wood [Museum of Fine Arts, Boston, Arthur Tracy Cabot Fund]

1. The sincerity of a dream to Schuffenecker the idealist: A souvenir of Paul Gauguin.

2. Malingue 1949, no. XCVI.

3. Malingue 1949, no. CVI (end of 1889, not June 1890).

"Ask Emile to go round to Schuffenecker's and fetch a big pot he saw me making, which looks vaguely like the head of Gauguin the savage, and you can have it from me," wrote Gauguin to Madeleine Bernard at the end of November 1889.[2] This "big pot" was in fact Gauguin's token of homage to Madeleine: a tragic, grotesque self-portrait, in which tortured matter is made the symbolic vehicle for a poignant autobiographical message.

The piece was executed during the first months of 1889, and was at first dedicated to Emile Schuffenecker, as the inscription on the label glued inside attests. Shortly afterward, probably in November 1889, Gauguin explained the meaning of his strange ceramic in a letter to Emile Bernard. "I was amused at the sight of your sister with my pot. Strictly between ourselves, I did it rather deliberately to probe the strength of her admiration for ceramic work. I wanted also to give her one of my best things, even though the firing isn't entirely right. You've known for a long time, and I wrote it in *Le Moderniste*, that I look for the character of each medium. The character of stoneware is that of a very hot fire, and this figure which has been scorched in the ovens of hell is I think a strong expression of that character. Like an artist glimpsed by Dante on his tour of the Inferno. A poor devil all doubled up to endure his pain."[3]

Thus Gauguin has represented himself as the accursed artist, prey to the torments of creation, which are indeed expressed by the very nature of stoneware, whose cracks and essentially rustic aspect convey the agony of trial by fire. The figure itself is deformed, grotesque, and full of pathos, an image of the artist's

desperate solitude at that time. Gauguin described this in another letter to Bernard written in November 1889, when he was working at Le Pouldu: "In the end, when all the main joys of existence are beyond my reach and intimate satisfaction is lacking, my isolation and my concentration on myself create a kind of hunger, like an empty stomach: and in the end this isolation is an enticement to happiness, unless one is ice-cold and absolutely without feeling. Despite all my efforts to become so, I simply am not: my primary nature keeps welling up, like the Gauguin of the pot, the hand shriveling in the furnace, the cry which longs to escape."[4]

The same desperate mask, with the thumb thrust half into the mouth, reappears in a bas-relief (G 76) that also dates from 1889. A further example of this curious fetal attitude comes much later in a pathetic drawing, one of Gauguin's last self-portraits (cat. 226).

This ceramic, into which Gauguin poured so much of himself, is featured in *Self-portrait with Yellow Christ* (cat. 99), where it is painted from a photograph sent, at Gauguin's request, by Emile Bernard.[5] The piece seems to have been executed in two parts that were subsequently fused together; the mask has its own background, reposing on an irregularly glazed and cracked surface. The joint between the two parts remains visible.—F.C.

4. Malingue 1949, no. XCI.

5. Malingue 1949, no. CVI. Nos. XCI and CVI, the originals of which are lost, each bore a drawing of the pot (Emile Bernard to Jean Schmidt, 5 September 1937, Musée du Louvre, Paris, Département des Arts Graphiques, RF 28895).

66
Vase with Two Boys' Heads

1889

height 20.7 (8)

glazed stoneware

Fondation Dina Vierny, Paris

CATALOGUE
G 68, B 51

shown in Paris only

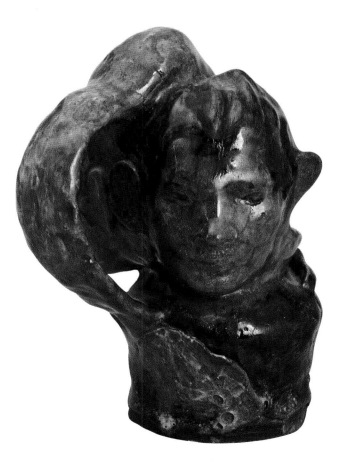

1. Huyghe 1952, 208-210.

2. Pickvance 1970, no. 17.

3. Bodelsen 1964, 128.

Gauguin, *Brittany and Arles Sketchbook*, page 210 [The Israel Museum, Jerusalem]

During his stay in Paris from January to March 1889, and also during May when he was preparing the Volpini exhibition, Gauguin worked in ceramics. The pieces he made at this time are notable for their growing freedom of inspiration, coupled with a more personal symbolism than in his earlier pots. In this regard, Gauguin's ceramics echo the general development of his painting. But with this enigmatic vase, the anthropomorphic Peruvian model is totally reinterpreted to produce an original form; Gauguin has given three-dimensional expression to the twin heads in his painting of children wrestling (cat. 48).

Far from confronting one another as adversaries, the two heads are here united by a handle that turns out to be the neck of a swan, the wings being merely suggested at the base of the vase. This motif occurs elsewhere in a ceramic portrait of a young girl as Leda (G 63), a theme which also appears in one of the zincographs in the Volpini catalogue (cat. 77).

Two sketches of a boy's head in the 1888 sketchbook[1] are probably studies for this vase, which has also been compared to a pastel now in an American collection.[2] But what do the mysterious, contrasting faces actually mean? One is meditative, with closed eyes; the other stares fixedly outward, with an expression that is almost spiteful. These masks have been seen as "an expression of the model's double nature, reflecting the artist's own inner conflict."[3] This ceramic, at one time the property of Gustave Fayet, is also remarkable for its handling of color.—C.F.-T.

67-77
Album of Lithographs, called The Volpini Suite

1. Van Gogh 1978, 73.

2. Cooper 1983, no. 35.3.

3. Van Gogh 1978, no. 578 to Theo van Gogh, 137.

4. Tokyo 1987, 167-168.

5. L'Exposition de peintures du groupe impressionniste et synthétiste, 1889, Café des Arts, Champ-de-Mars, Paris.

6. "Visible sur demande: Album de Lithographies. Par Paul Gauguin et Emile Bernard"; see Paris 1889, unpaginated.

Gauguin's set of ten lithographic drawings of 1889 with a cover is the most important project of its kind realized by a major French artist since Manet's illustrations for Edgar Allan Poe's *The Raven*, 1875. The prints are at once consistent and varied, sustaining a level of technical achievement remarkable for an artist who had never before worked in the medium. Gauguin became a master printmaker almost overnight. No evidence exists to prove that he had worked in lithography before 1888, and a letter to him of 10 October 1888 from Vincent van Gogh makes it clear that Gauguin had considered the medium an expedient to produce cheap images rather than a vehicle for original expression[1] before he began work on the project. Gauguin wrote to van Gogh on 20 January 1889, about having begun "a series of lithographs for publication in order to make myself known . . . according to the advice and under the auspices of your brother,"[2] and, by 20 February, he wrote that he had finished his work on the project.[3] Approximately fifty sets were printed by Ancourt.[4] Several of these were given a cover embellished with a cut-down and hand-colored impression of *Design for a Plate* (cat. 77). The suite was shown in Volpini's café at the Exposition Universelle of 1889.[5] Although it has come to be called the Volpini suite, few visitors to that exhibition saw Gauguin's portfolio because it was only visible on request and shared a place in the exhibition catalogue with another set of prints by Gauguin's friend, Emile Bernard.[6] Bernard was relatively experienced as a lithographer, and he surely must have

worked closely with Gauguin on the project. Unfortunately, the issue of priority has dominated the discussion of these prints in the Bernard-Gauguin literature. The fact that Gauguin probably learned the elements of lithographic technique from Bernard does little to detract from the sheer brilliance of Gauguin's results.

Gauguin's prints spark intense optical excitement. He combined jet-black lithographic lines and delicate gray washes in elegant configurations on enormous sheets of brilliant yellow paper. The margins on the sheets of the few sets that have survived uncut are considerably larger than the images, creating a penumbra of pure color that vibrates against the black. This effect of yellow and black recalls the commercial posters produced by Emile Lévy and others throughout the 1870s and 1880s more than it does the gentle canary yellow found in the Japanese prints to which Gauguin's lithographs have so often been compared.[7] When the prints are compared with the subtly modeled lithographs on pale blue paper in a contemporary album by Edgar Degas and George-William Thornley, also created under the patronage of Theo van Gogh,[8] they seem almost garish. This is the first of three sets of prints made to summarize Gauguin's recent work following the final impressionist exhibition in 1886 (cats. 167-176, 232-245). Unlike the second set, the so-called Noa Noa prints, which has been exhaustively analyzed in the literature, little attention has been focused on the Volpini suite.

Three of these ten prints were made in January and February of 1889, and relate to his recent Arles paintings. Only two of these three can be called reproductive. Gauguin probably began the suite with them, *The Old Women of Arles* and *The Laundresses*, because they faithfully transcribe, in reverse, the major aspects of the painted compositions (W 303 and cat. 58) into the new medium. The third already declares new imaginative territory. This print had traditionally been given the same title as the painting *Human Misery* (W 304), the only one of the three Arles paintings related to the lithographs that was included in the Volpini exhibition with the prints. Yet, whereas *The Old Women of Arles* and *The Laundresses* cling to the painted compositions, this print translates the painted source into another language. The horizontal painting became a vertical print, giving the sulking female figure from the painting a new setting. Beside her a boy seems to intrude into the composition.[9] These two figures fill the lower left corner of a scene dominated by the curve of a fruit tree and closed by a gate at the upper right. The painting does little to help us explain its printed variant, and Gauguin's choice of blood-red rather than black ink for this print further separates it from the group.

If one considers *Human Misery* as crucial in breaking the rules of what had begun as a commercial and reproductive project, the transformations in the remainder of the prints become easier to interpret. For Gauguin, reproduction became translation, and, when translating, the artist chose to alter virtually every variable he could to wring mystery from the new medium. In the case of certain images, like *Breton Women by a Fence*, he even predicted pictorial conventions that he would later make in paint. Except for the blinding yellow of the paper, he eschewed color, usually his greatest source of expression. By limiting himself to the black and gray of crayon and wash, he could reduce an image to an essence and in the process gain even more than he had ever imagined in his letter to Vincent in October 1888.[10]

Of the seven remaining prints, only two are related to specific paintings. They are *Bathers in Brittany*, which borrows the main figure from a painting of 1887 (cat. 34) but transforms the setting, and *The Joys of Brittany*, in which two figures from *Breton Girls Dancing, Pont–Aven* (cat. 44) are almost completely reinterpreted and placed in a new setting. The issue of image transformation would continue to preoccupy Gauguin throughout his life.

7. Boyle-Turner in Amsterdam 1986, 37.

8. Druick and Zegers in Boston 1984, lvii–lviii.

9. The boy is probably Gauguin's son Clovis, who visited Gauguin in France at that time. See also W 187.

10. See n. 1 above.

Bernard, *Breton Woman*, 1889, zincograph [The Art Institute of Chicago, Albert H. Wolff Fund]

Volpini exhibition catalogue cover, 1889

11. See cat. 15.

12. See Pope 1981 for a full discussion of the prints and their relationship to Gauguin's Martinique oeuvre.

None of the remaining five prints is related in any clear way to a painting. Several have sources in Gauguin's drawings; the figures in *Breton Women by a Fence*, for example, derive from chalk figure drawings. Others were evidently invented by Gauguin directly on the zinc plate. The most interesting of these inventions are the two prints called *The Drama of the Sea,* in which Gauguin made active use of lavis wash techniques as well as inventive image shapes derived from fan compositions.[11] These shapes seem to contain the tremendous force of the sea, and the resulting images have an instability that is at once graphic and iconographic.

While *Breton Women by a Fence* and *The Drama of the Sea* are dominated by blacks and curves, their counterparts are two prints with Martinique imagery in which delicate gray washes and rectangular formats give them a pastoral ease. Again, these prints stray rather far from the paintings and drawings that Gauguin actually executed in Martinique.[12] One print, *Martinique Pastorals,* conveys a strong sense of the nurturing quality of a tropical paradise, while *Locusts and Ants* uses the title of a well-known fable to evoke the world of the child and his instruction. Yet the very introduction of the fable undercuts the easy, paradisaical quality of the Martinique prints, introducing concepts of work and sloth and, by extension, good and evil and innocence and guilt, which Gauguin also evoked in the cover of the suite.

The *Design for a Plate* pasted on the cover of several surviving sets is among the most mysterious works in Gauguin's oeuvre. Its primary subject is a young girl, whose shoulders are bare and who turns from us. Although her features are derived from those of the adolescent bather in another print in the suite (cat. 71), the swan superimposed on her body indicates that she is Leda, mother of Castor and Pollux, each of whom is represented as a gosling in the distance. Above her is a serpent with what appears to be an olive branch, and below that are two red flowers. Next to the goslings is an apple, and above that trio of symbols is a reversed inscription, "homis [*sic*] soit qui mal y pense," the motto of the English Order of the Garter. It is generally translated into English as "shamed be he who thinks evil."

Gauguin reversed this text as well as the title for the image, in spite of the fact that all other inscriptions on the other lithographs can be read directly. This reversal can perhaps lead one to the ultimate message of the print. Various layers of civilization – classical, Christian, and contemporary – are all present in the image, and its message has oddly ambivalent moral overtones. Gauguin seems to evoke the English motto in combination with various images to introduce an element of moral doubt. Will the viewer be wrong if he thinks badly of Gauguin? Does one mythological system nullify others?

This cover image can be interpreted as an antiemblem, and the fact that it is a project for a plate, which is at once practical and breakable, lends it even greater significance. Inside the covers of this portfolio are images of transgression, growth, nudity, adolescence, age, prayer, desperate cleanliness, and spoiled paradise. At every level, the represented world is compromised by doubt, and Gauguin's cover manifests that doubt in a self-conscious way.–R.B.

67
Old Women at Arles

1889

180 x 200 (7⅛ x 7⅞)

zincograph on yellow wove paper

The Art Institute of Chicago, The William
McCallin McKee Memorial Collection,
1943.1021

CATALOGUES
Gu 11, K 9

shown in Chicago only

67a Old Women at Arles

1889

180 x 200 (7⅛ x 7⅞)

zincograph on yellow wove paper

Museum of Fine Arts, Boston, Bequest of
W. G. Russell Allen 60.316

CATALOGUES
Gu 11, K 9

shown in Washington only

67b Old Woman at Arles

1889

180 x 200 (7⅛ x 7⅞)

zincograph on yellow wove paper

Bibliothèque d'Art et d'Archéologie,
(Fondation Jacques Doucet), Paris

CATALOGUES
Gu 11, K 9

shown in Paris only

68
The Laundresses

1889

213 x 263 (8⅜ x 10⅜)

zincograph on yellow wove paper

The Art Institute of Chicago, The William McCallin McKee Memorial Collection, 1943.1023

CATALOGUES
Gu 6, K 10

shown in Chicago only

68a The Laundresses

1889

213 x 263 (8⅜ x 10⅜)

zincograph on yellow wove paper

Museum of Fine Arts, Boston, Bequest of W. G. Russell Allen 60.311

CATALOGUES
Gu 6, K 10

shown in Washington only

68b The Laundresses

1889

213 x 263 (8⅜ x 10⅜)

zincograph on yellow wove paper

Bibliothèque d'Art et d'Archéologie, (Fondation Jacques Doucet), Paris

CATALOGUES
Gu 6, K 10

shown in Paris only

69
Human Misery

1889

285 x 230 (11¼ x 9⅛)

zincograph on yellow wove paper

The Art Institute of Chicago, The William McCallin McKee Memorial Collection, 1943.1028

CATALOGUES
Gu 5, K 11

shown in Chicago only

69a Human Misery

1889

285 x 230 (11¼ x 9⅛)

zincograph on yellow wove paper

Museum of Fine Arts, Boston, Bequest of W. G. Russell Allen 60.309

CATALOGUES
Gu 5, K 11

shown in Washington only

69b Human Misery

1889

285 x 230 (11¼ x 9⅛)

zincograph on yellow wove paper

Bibliothèque d'Art et d'Archéologie (Fondation Jacques Doucet), Paris

CATALOGUES
Gu 5, K 11

shown in Paris only

70
Breton Women by a Fence

1889

162 x 216 (6⅜ x 8½)

zincograph on yellow wove paper

The Art Institute of Chicago, The William McCallin McKee Memorial Collection, 1943.1029

CATALOGUES
Gu 4, K 8

shown in Chicago only

70a Breton Women by a Fence

1889

162 x 216 (6⅜ x 8½)

zincograph on yellow wove paper

Museum of Fine Arts, Boston, Bequest of W. G. Russell Allen 60.308

CATALOGUES
Gu 4, K 8

shown in Washington only

70b Breton Women by a Fence

1889

162 x 216 (6⅜ x 8½)

zincograph on yellow wove paper

Bibliothèque d'Art et d'Archéologie, (Fondation Jacques Doucet), Paris

CATALOGUES
Gu 4, K 8

shown in Paris only

71
Bathers in Brittany

1889

235 x 200 (9¼ x 7⅞)

zincograph on yellow wove papers

The Art Institute of Chicago, The William McCallin McKee Memorial Collection, 1943.1030

CATALOGUES
Gu 3, K 4

shown in Chicago only

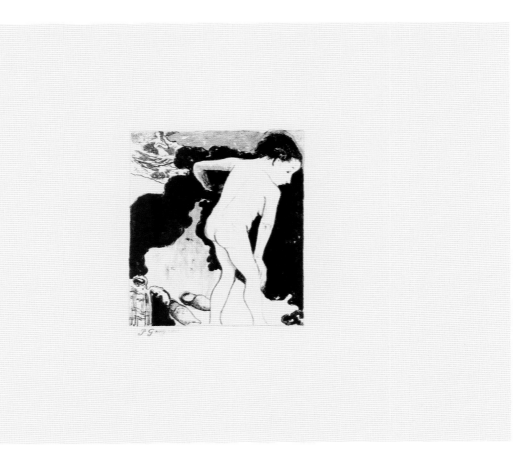

71a Bathers in Brittany

1889

235 x 200 (9¼ x 7⅞)

zincograph on yellow wove paper

Museum of Fine Arts, Boston, Bequest of W. G. Russell Allen 60.307

CATALOGUES
Gu 3, K 4

shown in Washington only

71b Bathers in Brittany

1889

235 x 200 (9¼ x 7⅞)

zincograph on yellow wove paper

Bibliothèque d'Art et d'Archéologie, (Fondation Jacques Doucet), Paris

CATALOGUES
Gu 3, K 4

shown in Paris only

72
The Joys of Brittany

1889

200 x 222 (7⅞ x 8¾)

zincograph on yellow wove paper

The Art Institute of Chicago, The William McCallin McKee Memorial Collection, 1943.1027

CATALOGUES
Gu 2, K 7

shown in Chicago only

72a The Joys of Brittany

1889

200 x 222 (7⅞ x 8¾)

zincograph on yellow wove paper

Museum of Fine Arts, Boston, Bequest of W. G. Russell Allen 60.305

CATALOGUES
Gu 2, K 7

shown in Washington only

72b The Joys of Brittany

1889

200 x 222 (7⅞ x 8¾)

zincograph on yellow wove paper

Bibliothèque d'Art et d'Archéologie, (Fondation Jacques Doucet), Paris

CATALOGUES
Gu 2, K 7

shown in Paris only

73
The Drama of the Sea – Brittany

1889

169 x 227 (6⅝ x 8⅞)

zincograph on yellow wove paper

The Art Institute of Chicago, The William
McCallin McKee Memorial Collection,
1943.1026

CATALOGUES
Gu 7, K 2

shown in Chicago only

73a The Drama of the Sea – Brittany

1889

169 x 227 (6⅝ x 8⅞)

zincograph on yellow wove paper

Museum of Fine Arts, Boston, Bequest of
W. G. Russell Allen 60.312

CATALOGUES
Gu 7, K 2

shown in Washington only

73b The Drama of the Sea – Brittany

1889

169 x 227 (6⅝ x 8⅞)

zincograph on yellow wove paper

Bibliothèque d'Art et d'Archéologie,
(Fondation Jacques Doucet), Paris

CATALOGUES
Gu 7, K 2

shown in Paris only

74
The Drama of the Sea

1889

175 x 276 (6⅞ x 10⅞)

zincograph on yellow wove paper

The Art Institute of Chicago, The William McCallin McKee Memorial Collection, 1943.1024

CATALOGUES
Gu 8, K 3

shown in Chicago only

74a The Drama of the Sea

1889

175 x 276 (6⅞ x 10⅞)

zincograph on yellow wove paper

Museum of Fine Arts, Boston, Bequest of W. G. Russell Allen 60.313

CATALOGUES
Gu 8, K 3

shown in Washington only

74b The Drama of the Sea

1889

175 x 276 (6⅞ x 10⅞)

zincograph on yellow wove paper

Bibliothèque d'Art et d'Archéologie, (Fondation Jacques Doucet), Paris

CATALOGUES
Gu 8, K 3

shown in Paris only

75
Martinique Pastorals

1889

213 x 263 (8⅜ x 10⅜)

zincograph on yellow wove paper

The Art Institute of Chicago, The William McCallin McKee Memorial Collection, 1943.1025

CATALOGUES
Gu 9, K 6

shown in Chicago only

75a Martinique Pastorals

1889

213 x 263 (8⅜ x 10⅜)

zincograph on yellow wove paper

Museum of Fine Arts, Boston, Bequest of W. G. Russell Allen 60.314

CATALOGUES
Gu 9, K 6

shown in Washington only

75b Martinique Pastorals

1889

213 x 263 (8⅜ x 10⅜)

zincograph on yellow wove paper

Bibliothèque d'Art et d'Archéologie, (Fondation Jacques Doucet), Paris

CATALOGUES
Gu 9, K 6

shown in Paris only

76
Locusts and Ants

1889

200 x 262 (7⅞ x 10¼)

zincograph on yellow wove paper

The Art Institute of Chicago, The William McCallin McKee Memorial Collection, 1943.1022

CATALOGUES
Gu 10, K 5

shown in Chicago only

76a Locusts and Ants

1889

200 x 262 (7⅞ x 10¼)

zincograph on yellow wove paper

Museum of Fine Arts, Boston, Bequest of W. G. Russell Allen 60.315

CATALOGUES
Gu 10, K 5

shown in Washington only

76b Locusts and Ants

1889

200 x 262 (7⅞ x 10¼)

zincograph on yellow wove paper

Bibliothèque d'Art et d'Archéologie, (Fondation Jacques Doucet), Paris

CATALOGUES
Gu 10, K 5

shown in Paris only

77
Design for a Plate

1889

205 (8)

zincograph heightened with brush and
water-based colors, on yellow wove paper
mounted on portfolio cover

Josefowitz Collection

CATALOGUES
Gu 1, K 1

shown in Washington only

77a Design for a Plate

1889

205 (8)

zincograph heightened with brush and
water-based colors, on yellow wove paper

Josefowitz Collection

CATALOGUES
Gu, K 1

shown in Chicago only

77b Design for a Plate

1889

205 (8)

zincograph heightened with brush and
water-based colors, on yellow wove paper

Oeffentliche Kunstsammlung Basel,
Kupferstichkabinett

CATALOGUES
Gu, K 1

shown in Paris only

78
Human Misery

winter 1889

205 x 385 (8 x 15)

pen and ink, brush and watercolor on trac-
ing paper mounted on secondary support of
recent manufacture

signed and dated, lower right in brush and
watercolor, pen and ink, *P. Gauguin 89*

Fondation Dina Vierny, Paris

EXHIBITION
Tokyo 1987, no. 31

shown in Paris only

Gauguin, *Human Misery*, 1888, oil on canvas
[The Ordrupgaard Collection, Copenhagen]

Gauguin, *Human Misery*, before conservation

1. Van Gogh 1978, no. 559.

2. Merlhès 1984, no. 179.

3. Andersen 1971, 295, fig. 54.

4. Information furnished by Mme Vierny,
September 1987.

In this watercolor, Gauguin returned to and isolated the main figure in a canvas (W 304) that he painted at Arles in November 1888. The painting was done "completely from memory," as Vincent van Gogh noted in a letter to his brother Theo around 6 November.[1] Gauguin himself described it to Emile Bernard in a letter that included a sketch of his composition: "It's a painting of some vineyards I saw at Arles. I also put in a few Breton women – who cares about exactitude. It's the best oil I've done this year."[2] This remark alone establishes the importance assigned by the artist to it, and invites a symbolic interpretation. The dejected pauper woman is derived from a Peruvian mummy that Gauguin had seen at the Musée d'Ethnographie at the Trocadéro in Paris, known today as the Musée de l'Homme. She embodies all female suffering, with a complex symbolism of fatal

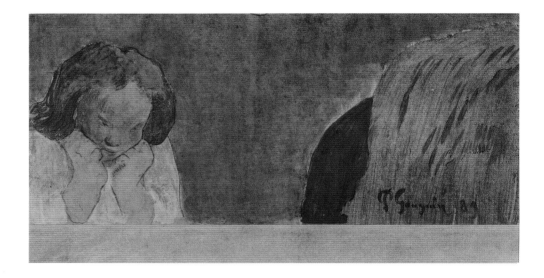

dereliction and hopeless guilt. This figure appears in an earlier canvas (cat. 55). It then became a leitmotif in Gauguin's work; in this watercolor it is reinserted in its original Breton context.

Among the zincographs in the Volpini catalogue that illustrate paintings from the Arles period (cats. 67-77) is a version of *Human Misery* (cat. 69) in a Japanese style. It bears a strong resemblance to this watercolor, especially in the use of a yellow background. Both works were probably done at the same time, between January and February 1889. The expressive power of the composition is strengthened by the off-center placement of the main figure, counterbalanced by the mass of the haystack at right. An early reproduction[3] shows that the original measurements of the work were altered in the course of restoration some forty years ago, and that the lower part, which had deteriorated, was discarded. The restoration has profoundly altered the artist's intention.

The desolate figure of the Breton Eve crops up again in a painting executed at Pont-Aven in 1894 (W 523), and thereafter in a woodcut (cat. 242) dating from Gauguin's second voyage to Tahiti. In the woodcut, the theme is considerably softened.

The sculptor Aristide Maillol received this watercolor as a wedding present from Gauguin in 1896. As the story goes, the gift came wrapped in another drawing of cuckold's horns, which was not at all to Maillol's taste.[4]–C.F.-T.

79
Life and Death

80
In the Waves (Ondine)

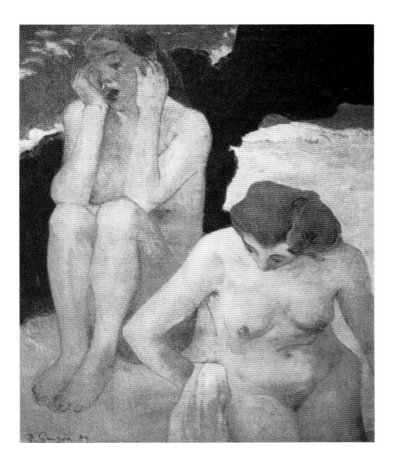

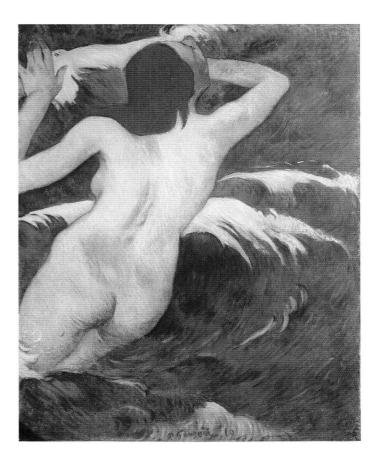

spring 1889

92 x 73 (36¼ x 38⅜)

oil on canvas

signed and dated at lower left, *P. Gauguin 89.*

Mahmoud Khalil Musuem, Cairo

EXHIBITIONS
Copenhagen, Udstilling, 1893, *La vie et la mort*, no. 147; London 1966, no. 18a, *Femmes se baignant*

CATALOGUE
W 335

spring 1889

92 x 72 (36¼ x 28⅜)

oil on canvas

signed and dated at base, in red, *P. Gauguin 89*

Cleveland Museum of Art, Gift of Mr. and Mrs. William Powell Jones

EXHIBITIONS
Paris 1889, no. 44, *Dans les vagues*; Paris 1906, no. 25, *L'Ondine, Bretagne*; Basel 1928, no. 59; Cambridge 1936, no. 11; Houston 1954, no. 14; Chicago 1959, no. 19

CATALOGUE
W 336

1. Rewald 1973, 49.

2. Dorra 1984, 281.

3. Andersen 1971, 117-188; Jirat-Wasiutynski 1978, 171-176.

4. Roskill 1970, 243.

5. Both were exhibited in London 1966, but not together.

6. The drawing for the Cairo Museum nude is known by a Vizzavona photograph, number 7980, location unknown.

7. Gerstein 1978, 325.

8. No. 56. San Francisco 1986, no. 27.

9. Bodelsen 1966, 37.

10. Andersen 1967, 238-246.

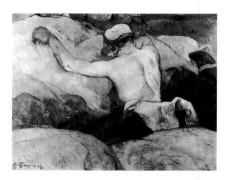

Gauguin, *In the Hay*, 1888, oil on canvas [private collection, Paris]

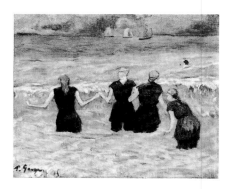

Gauguin, *Women Bathing*, 1885, oil on canvas [The National Museum of Western Art, Tokyo, The Matsuka Collection]

The title of cat. 80 was changed twice, even during Gauguin's lifetime. At the Volpini exhibition in 1889 it was called *Dans les vagues*; it then became *Ondine*, but this title was placed in parentheses after *"un tableau"* in the record of sale of 1891, probably by the auctioneer. In the Boussod and Valadon inventory of 1891, Gauguin entitled it simply *Femme nue dans la vague* (Nude in the Waves);[1] so we should view with considerable suspicion all ingenious interpretations based on the title *Ondine*.

Some observers have seen positive symbolism in the romantic Ondine myth, with Gauguin transcribing Wagner's ideas of the woman "who only achieves the fullness of her individuality in the moment when she gives herself; she is the Ondine who floats murmuring across the waves that are her element." (A part of this text was copied by Gauguin into the visitors' book at Mme Gloanec's pension.)[2] Other experts have discerned the theme of destruction, Ondine being an allegory for the *femme fatale* who lures men to their deaths.[3]

But while we should not place too much emphasis on the Ondine title, there can be no question that Gauguin charged the painting with many different meanings, and that it marks a crucial point in his development as an artist. In his fifteen years as a painter he had done remarkably few nudes (see cats. 4, 34). In every case, these nudes were pictured in highly realistic scenes, somewhat uncomfortable with their nakedness. Even the later painting of a peasant woman leaning bare-backed against a haystack (W 301) shares this slight embarrassment; and we note in passing that her pose is one of the possible sources for the figure of Ondine (cat. 81).[4]

Immediately upon his arrival at Pont-Aven in April 1889, Gauguin painted these two canvases of exactly the same dimensions, which clearly could have been conceived as pendants and which are reunited here for the first time in more than twenty years.[5] The three female nudes in these two paintings are seen close up, placed against a flat, highly colored backdrop. The red-haired, white-skinned, compact woman of the Cairo painting is pictured from the back in the Cleveland picture, plunging into a vivid green wave tinged with white spume. Gauguin may or may not have used a model for this figure, as a classical preparatory study for the nude at the right of the Cairo painting might lead us to suppose.[6] Her back is probably drawn from life, or from the memory of a real nude; she is painted with silken, rounded brushstrokes, her hair is simplified, and her face is completely transformed into a kind of childish mask. The model seems to have been drawn half sitting, half lying, probably leaning on a cushion.

In fact, this nude seems to be a combination of several different elements. It has been convincingly suggested that she was taken from a photograph of a nude by O. G. Rejlander, dating from about 1860, a copy of which Gauguin or one of his friends may have possessed.[7] However, the main source is obviously Degas. Gauguin must have been deeply impressed by Degas' extraordinary *Little Peasant Girls Bathing by the Sea in the Evening*, which appeared at the second impressionist exhibition in 1876.[8] The subject matter and technical daring of that painting had already influenced Gauguin in his picture of girls bathing at Dieppe (W 167). If we look closely at the girl at left with arms outspread, and visualize her naked, we see the idea of the Breton Ondine. Moreover, Gauguin's admiration for Degas must have been revived at the end of 1888, a few months before he undertook the painting exhibited here, by Degas' one-man exhibition, devoted entirely to nudes, at Boussod and Valadon's gallery. Gauguin sketched several of Degas' nudes at this exhibition, as the *Album Briant* shows.

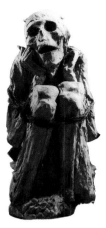

Peruvian Mummy, 12th-15th century [Musée de l'Homme, Paris]

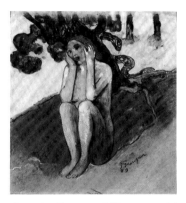

Gauguin, *Eve*, pastel [Courtesy of the Marion Koogler McNay Art Museum, San Antonio, Bequest of Marion Koogler McNay]

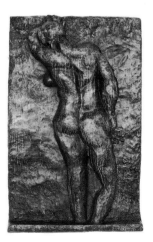

Matisse, *Back I*, 1909, bronze [The Museum of Modern Art, New York, Mrs. Simon Guggenheim Fund]

The wave is strictly Japanese, as in Gauguin's other seascapes of the period (see W 286). The juxtaposition of a nude and of nature decoratively handled is a foretaste of the great Tahiti figures (cats. 143, 144, W 499, W 462); but the arrangement, the simplicity, and the sheer power of the imagery have a flavor that is new to Gauguin's art. It is this special flavor that raises Gauguin's Breton nude, whatever her origin, to a level of mythical ingenuity and innocent wildness that was exactly the artist's intention.

The two paintings from Cleveland and Cairo together constitute a kind of symbolist diptych, *In the Waves* signifying life and the Cairo painting death, or in any case the forces of life and death as embodied in the female nudes. The title of the Cairo picture has been clearly established since 1893 when Gauguin designated it *Life and Death* for the Udstilling exhibition in Copenhagen.[9] It has been proven conclusively that the left-hand figure, completely blue, was borrowed from a Peruvian mummy that Gauguin had seen at the Musée de l'Homme in Paris.[10] The red-headed, snub-nosed Breton woman in the Cleveland picture, who throws herself into the green wave, represents the earliest icon of joyous, primitive animality in Gauguin's universe: the myth of Tahiti born in an aging Europe.

Gauguin seems to have been haunted, almost obsessed, by this creature; she reappears everywhere in his work, in wood carvings, ceramics, on paper, and in details of other oil paintings right through to the end of his life. In the same year, 1889, he painted himself in the foreground of what one might assume was his favorite picture of the time, the *Self-portrait with Yellow Christ* (cat. 99), and the Pushkin Museum self-portrait (W 297), which is usually ascribed to the Arles period, but was clearly painted after the picture exhibited here, the lower half of which we see reversed in a mirror behind the artist's head.

In the Cairo painting, the modern allegory of death and the maiden that was so dear to the German "primitives" he admired, Gauguin replaced the traditional skeleton with a new image of a bather in the crouched position of a mummy. This figure appears throughout Gauguin's work. She is the *Breton Eve* of the pastel in the Marion Koogler McNay Art Institute (W 333). She can also be found in the Hartford painting of Meyer de Haan (fig., see cat. 93, W 320), and in the extreme left of the large frieze in the Boston Museum (W 561) *Where Do We Come From? What Are We? Where Are We Going?*, from late 1897. In the Boston frieze the figure is the incarnation of age and life's end.

If *Life and Death*, which was already in the Brandès Collection in Copenhagen, was not exhibited in 1906 at the Paris Salon d'automne, *In the Waves* was indeed there. Henri Matisse, who was then a great admirer of Gauguin, must have been stricken by it, and his series of *Backs* sculpted in relief from 1907 echoes the Cleveland painting.–F.C.

81
Woman in the Waves (Ondine)

175 x 477 (7⅛ x 18⅞)

pastel selectively worked with brush and water on wove paper, mounted on shaped wooden support

signed and dated at upper right in pastel, *P. Gauguin 89*; and at lower right in graphite, *P. Gauguin 89*

Josefowitz Collection

CATALOGUE
W 337

shown in Paris only

This pastel heightened with gouache was executed after the oil painting of the same subject (see cat. 80). It seems to have been taken from a larger drawing, then cut down and reworked. The focus is on the upper part of the oil composition, with the left arm eliminated. Several differences between the two works are immediately obvious: here the hair is black, and the modeling of the arms and cheek, like the hollow of the shoulders, is highlighted with blue tints for greater emphasis. According to the technical study by Vojtech Jirat-Wasiutynski, kindly communicated by Mr. S. Josefowitz, this pastel was touched up with gouache and then reworked in pastel.—F.C.

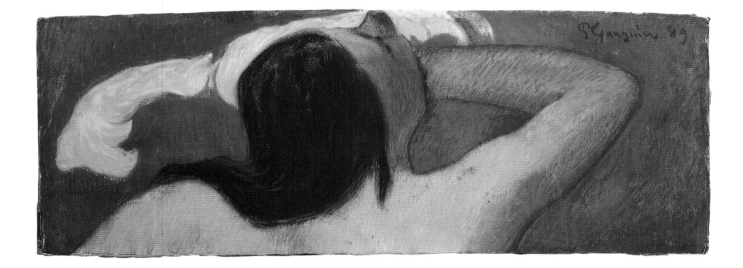

82
Sea Monster and Girl Bathing

This curious piece, with its bather abandoning herself to the waves, its gaping sea monster, and its blue fish for a base, is purely Western in concept. Gauguin has transferred the theme of Ondine, which he had already dealt with in paint (cat. 80) and bas-relief (cat. 110), to sculpture in the round. The association of all three elements in a single vase gives this piece a mannerist style that is unique in the artist's work. Although we cannot possibly know their iconographic source, the subjects of the vase bear a certain resemblance to the sea monsters that enliven sixteenth-century fountains and to mannerist bronzes of naiads and monstrous tritons. This is definitely one of the most curious objects ever made by Gauguin, in which the vase is used as no more than a pretext for modeling expressive forms. This piece belonged to Gustave Fayet.—C.F.-T.

c. 1889

height 26.5 (10⅜)

glazed stoneware

Ex-Collection Gustave Fayet, Igny

EXHIBITION
(?) Paris 1906, no. 58

CATALOGUES
G 69, B 52

shown in Paris only

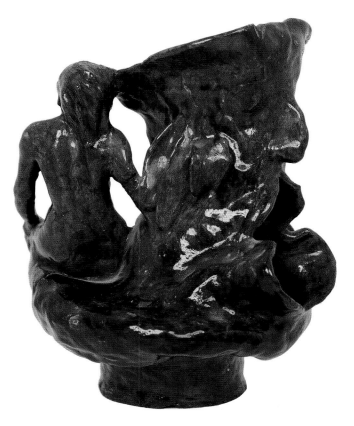

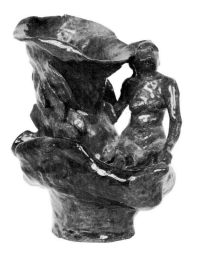

83
Fan with Woman in the Waves (Ondine)

1889-1890

120 x 381 (4¾ x 14⅛)

graphite, brush and gouache, selectively
heightened with pastel, worked with brush
and water on green bristol board

dedicated and signed at left, in green
gouache, *Au Docteur Paulin*; in green
gouache and graphite, *P. Go.*

Mrs. Francisca Santos

EXHIBITIONS
Paris 1960 no. 44; Munich 1960, no. 81;
Vienna 1960, no. 11

CATALOGUE
W 338

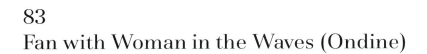

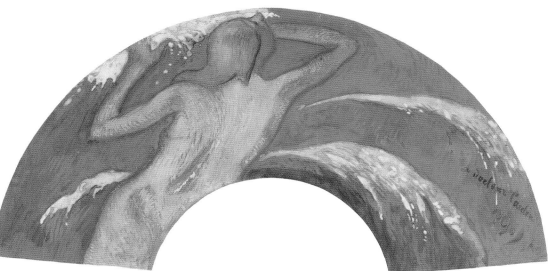

Here Gauguin used the fan design to decentralize his bather, whose arms are more slender than in the oil painting (cat. 80). The foam on the waves is developed more thoroughly to follow the curve of the fan, thus accentuating the Japanese effect.

Dr. Paulin was a Paris dentist and part-time sculptor who owned several other fans, notably by Degas and Pissarro.[1] It is possible that this piece was made specifically for him. At any rate, the doctor received his fan as a present, as Gauguin made clear in his sketchbook.[2]

Gauguin frequently gave people fans made after his paintings to thank them for services rendered or to assure them of his admiration.[3] On the other side of this fan is a pastel and gouache study for a zincograph (see cat. 72).[4]—F.C.

1. Gerstein 1978, 324.

2. Huyghe 1952, 223.

3. W 147, a gift to Pietro Krohn; W 216, a gift to Emile Schuffenecker; W 223, a gift to Paco Durrio; W 228, a gift to Félix Bracquemond.

4. Information kindly contributed by Peter Zegers.

84
Nude Breton Boy

1889

93 x 73.5 (36⅝ x 29)

oil on canvas

signed and dated at lower right, *89 P. Gauguin*

Wallraf-Richartz Museum, Cologne

EXHIBITION
Basel 1928, no. 41 or 46

CATALOGUE
W 339

shown in Washington only

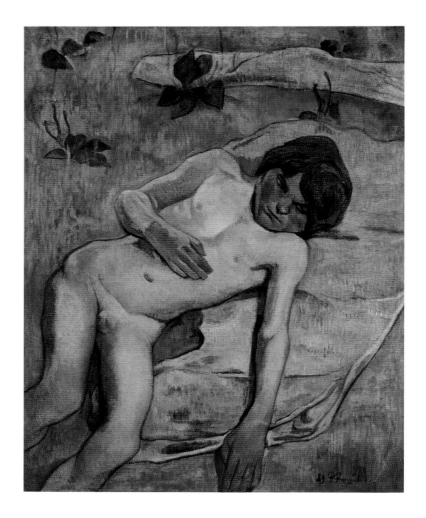

This sickly boy is the last in a series of male nudes executed by Gauguin in Brittany. The other figures are shown in bathing scenes or wrestling matches, which were painted after sketches, then simplified and synthesized (see, in particular, cats. 47, 48); in contrast, the model here actually posed for the painter. He looks both unwilling and uncomfortable. The fact that Gauguin probably worked carefully from straight observation may explain why this nude is so much more realistic than his predecessors. One detail especially strengthens this sense of immediacy: the hands and the face are much more reddened than the body, which in life is never exposed to sunshine. This raw awareness of a person undressed gives the painting an atmosphere of unease. No doubt Gauguin stressed the inaccessible, brutal character of the face and the unattractive body to express a kind of primitive truth that he always sought in his Breton models. The result here is an unsettling image, reminiscent of photographs by Baron van Gloeden (1856–1931) of nude Italian children that date to roughly the same period.

Oddly, Gauguin has refused to paint the boy's genitals, perhaps in an attempt to balance the figure's ruthless naturalism; moreover, the child is seen against the decorative, even naive backdrop of a field of flowers, the effect of which is to make the face look even more perverse and surly.

This canvas appears to have been painted at Le Pouldu in the late summer of 1889. It was then probably sent to Theo van Gogh as part of the second batch of work mentioned in a letter in October.[1]

The subsequent history of the work is not without interest. As one of the few paintings by Gauguin with expressionist features, it quickly attracted the attention of German collectors. In 1917, it passed through the hands of A. Fleishteim[2] in Düsseldorf, before finally coming to rest in a German museum with an especially fine collection of expressionist paintings.–F.C.

1. Cooper 1983, no. 21.1.
2. Bodelsen 1966, 37.

85
The Black Woman, or Black Venus

This ceramic, completed in 1889, is much more elaborate than the Martinique statuette (cat. 86), and it has striking monumentality despite its small size. Like the vase-portraits (cat. 62), it shows that ceramics and sculpture are crucial means by which Gauguin expressed his particular symbolism. This bronzelike, massive, crouching, deliberately nondecorative figure has a primitive aspect resembling that of the main figure in his bas-relief *Be in Love*. At this period of Gauguin's career, his sculptures and ceramics shared a common inspiration.

The complex iconography of this piece blends the images of fertility and death, a double theme that will develop in Gauguin's Tahiti works (see *Oviri*, cats. 211, 212, 213). The head in the lap of Venus is Gauguin's mask, resembling cat. 64. When we remember that Gauguin unhesitatingly identified himself with the suffering Christ, it requires no effort of the imagination to see his Venus as a symbolic Pietà in which the black Virgin is one with Salomé, lover and murderess, a character who had been made fashionable by the works of writers such as Gustave Flaubert and Stéphane Mallarmé.[1] This head, the hair of which seems rooted in the base of the statuette, is attached to a vigorous, upright lotus plant, the Indian

1. Jirat-Wasiutynski 1978, 367-368.

151

Black Venus

1889

height 50 (19⅝)

glazed stoneware

signed on the base, behind the right hand,
P. Gauguin

Nassau County Museum (Museum Services
Division, Department of Recreation and
Parks)

EXHIBITIONS
Paris, Durand-Ruel 1893, no. 45, *Femme
noire*; Paris 1906, no. 227, *Vénus noire*; Paris,
Orangerie 1949, no. 89; Chicago 1959, no. 119

CATALOGUES
G 91, B 49

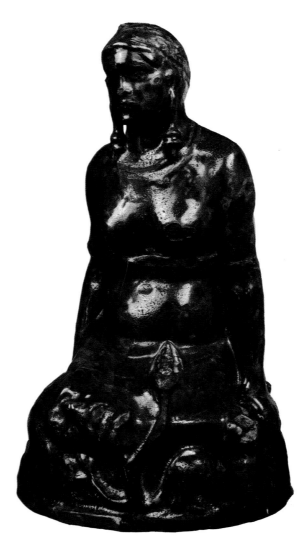

2. Bodelsen 1964, 120.

3. Cooper 1983, 20.2-20.3. See also nos.
14.4, 15.3.

symbol of fertility. No doubt Gauguin's frequent visits to the Exposition Universelle
(where he was fascinated by Buffalo Bill's Indians, watched a troupe of dancers
from Java, and made the acquaintance of a mulatto girl), have something to do with
the idea for this ceramic.[2] This work betrays the artist's growing interest in
exoticism at a time when he was dreaming of a voyage to Tonkin and Madagascar.

Gauguin is probably alluding to this ceramic in one of several letters
written to Theo van Gogh in the summer of 1889. "As for the statue, it is almost
impossible to make it without some kind of fracture, but that is *quite unimportant.*
The firing is what *is* important, much more so than the statuary. I want you to offer
it at 1000 francs: very little for a unique piece made without a mold. I doubt I shall
make another like it, anytime soon, that will be anything as successful."[3]

Black Venus may have been included in the memorable exhibition of
Gauguin's work at the Durand-Ruel gallery in November 1893, under the title *La
Femme noire* (*The Black Woman*). If it was, it attracted no notice or comment. The
traditional title, *Black Venus*, first appeared in 1906, at the posthumous Gauguin
retrospective and was probably not chosen by the artist himself.—C.F.-T.

86
Statuette of a Martinique Woman

c. 1889

height 20 (7⅞)

painted wax, wooden base

Henry and Rose Pearlman Foundation, Inc.

EXHIBITIONS
Paris 1919, no. 28; Paris 1928, no. 54; Paris 1942, no. 109; Toronto 1981-1982, no. 4

CATALOGUE
G 61

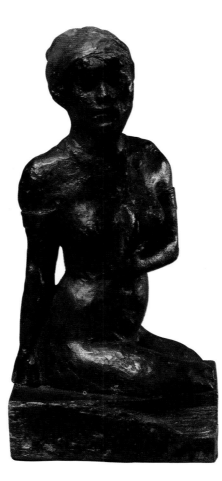

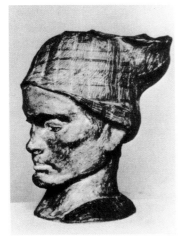

Gauguin, *Pot in the Shape of the Head of a Martinique Woman*, stoneware [ex. collection Ulmann, Paris]

1. Chassé 1921, 48. Wilkinson in Toronto 1981-1982, 26, considers this statutette of a Javanese woman to be a fragment of a dancing figure from the Javanese pavilion at the Exposition Universelle, 1889.

This little statuette once adorned the dining room of Marie Henry's inn at Le Pouldu. Later it was included in the collection of works appropriated by the same lady when Gauguin left the village in 1890. The ensuing court case between the two, which took place in 1894, left Marie Henry in possession of these works as surety for Gauguin's outstanding debt.

Charles Chassé, who has left perhaps the most reliable description of the inn, clearly indicates this work: "On some shelves against the wall on either side of the chimneypiece [on which stood the bust of Meyer de Haan, cat. 94] were the plaster negress and the Javanese statuette."[1]

The piece is in wax on a wooden base, and it is Gauguin's only sculpture in the round of a Martinique subject. The Caribbean voyage otherwise inspired Gauguin to do several reliefs in wood (G 60, G 72, G 73), as well as a fine ceramic head of a Martinique woman (G 52).

As it turns out, the morphology of the statuette is composite in many respects. The general posture of the body is like that of the crouching Martinique woman in one of the wood reliefs (G 72), who also appears in the print *Locusts*

and Ants (cat. 76) done in the early winter of 1889, which was included in the Volpini exhibition. The foulard enveloping the head evokes the madras scarf around the ceramic Martinique woman, but the broad, rounded shoulders, the hieratic attitude, and the conventional position of the left arm and hand reflect the carved figures of the Javanese temple of Borobudur, which Gauguin knew from photographs and which had influenced his whole Breton period. The gesture of the hand is borrowed from the Javanese dancers who had so thrilled him at the Exposition Universelle in June 1889; this gesture was later to become a leitmotif of the Tahiti paintings. The vivacity of the modeling, especially that of the back and the graceful hips, raises the possibility that Gauguin may have been working from a live model, perhaps the mulatto girl he met at the exhibition.[2] In his search for authentic primitivism, Gauguin went to several sources that reinforce the curious character of this piece. However, in the absence of any documentation, the precise dating of this statuette to 1889 remains problematical.

The small size of the piece and its deliberately rough finish invite comparison with Degas' statuettes of the period. Although we cannot be sure of their dates, and although none of them left Degas' atelier before his death in 1917 (with the exception of the famous *Petite danseuse de quatorze ans*), there are grounds for the view that Gauguin was aware of, and admired, his colleague's experiments with wax modeling. A letter from Camille Pissarro to his son Lucien tells us that Gauguin often went to visit Degas: "Gauguin is close to Degas again and goes to see him often."[3]

Gauguin chose to include this statuette, seen from the back, in one of his paintings (cat. 108). No doubt he considered this the best angle from which to show it.—C.F.-T.

2. Malingue 1949, LXXXI (dated March 1889; actual date probably end of April 1889).

3. Bailly-Herzberg 1986, no. 360.

87
Pot Decorated with a Bathing Woman and Trees

All students of Gauguin's ceramics have placed this small vessel rather early in his oeuvre in that medium, dating it to the winter of 1886-1887[1] or of 1887-1888.[2] Its chunky shape, restrictive use of colored slips, and simple applied decoration all bear out this dating. What is problematic about the object, given its apparently early date, is its iconography rather than its style. Indeed, the standing female nude juxtaposed with a small tree has undeniable affinities with the relief sculpture at Borobudur, from which Gauguin borrowed extensively in his later art and which was the specific source for a large group of related work from the early and middle 1890s. The prototype for this figure occurs in a photograph that Gauguin owned of the relief of an effeminate male, Maitrakanyaka, from the Borobudur frieze.[3] However, it has long been thought that Gauguin acquired this and another photograph of Borobudur at the Exposition Universelle of 1889, at which plaster casts from the reliefs were exhibited.

How does one solve the problem of the apparent disparity in date? There is little doubt that Gauguin's surviving ceramics from 1889-1890 are considerably more complex as forms, with extensive use made of slips and glazes. For that reason, style alone seems to mitigate against a later date, and this case has been forcefully argued by Bodelsen. Yet, the source of the figure in this specific Borobudur frieze is undeniable. Even though Gauguin altered both the tree and the costume of the figure, he retained not only the general character of the pose, but

The Arrival of Maitrakanyaka at Nadana, detail of a relief on Borobudur Temple, Java

1. Gray 1963, 128.

2. Bodelsen 1964, 128; Amishai-Maisels 1985, 177.

3. Bodelsen 1964, 79.

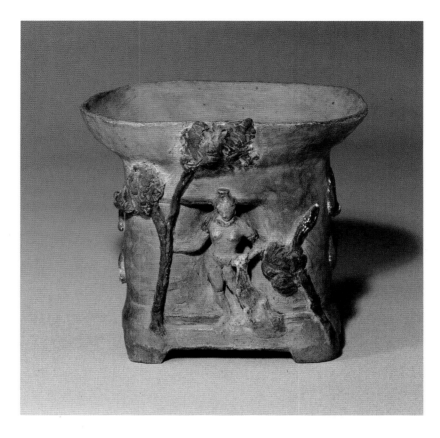

1889-1890

height 13.5 (5¼)

stoneware

signed, *P Go*

Musée d'Orsay, Paris, transferred by the
Musée des Arts Africains et Océaniens

CATALOGUES
G 15, B 39

4. Gray 1963, 128; Bodelsen 1964, 79;
Amishai-Maisels 1985, 177.

5. W 389.

6. "You were wrong not to have come the
other day. In the village of Java there were
Hindu dances. All the art of India can be
found there and the photographs that I have
of Cambodia fit into that context"; Malingue
1949, LXXXI.

7. Bodelsen 1964, 79.

such unique details as the necklace and the arm bracelet. Only two solutions to
the problem are possible. The first is that Gauguin had already acquired the
photograph of Borobudur before the Exposition Universelle. This was already
proposed by Gray and accepted enthusiastically by Bodelsen and Amishai-
Maisels.[4] The second is that the vessel itself is later, in spite of its style. This has
never been adequately argued, but seems the more likely solution to the problem.

To my knowledge, not a single documented case occurs before 1889 in
which Gauguin used the Borobudur reliefs as source material. This observation,
together with the fact that he made a small gouache entitled *Eve Exotique* (see fig.
at cat. 106)[5] from the same source in 1890, suggests that the vessel was indeed
made in 1889 or 1890, perhaps even in connection with the gouache. This argu-
ment can be refuted only if one accepts Bodelsen's reading of Gauguin's letter to
Bernard, written after he saw the Javanese dancers at the Exposition Universelle.
In this letter, Gauguin related the dancers to photographs of Cambodia already in
his possession.[6] Bodelsen assumed that the photographs mentioned in the letter
were those of Borobudur, in spite of the fact that Borobudur is not in Cambodia,[7]
and this rather tenuous link allows her to retain her early date, otherwise based
exclusively on style. If one accepts a later date, Gauguin must have been concerned
less with the form of the vessel, which is derived loosely from that of Chinese
bronzes, than with the figure itself, which he worked in relief like its sculptured
prototype. Gauguin transformed the figure of Maitrakanyaka, whose identity may
not have been known to him, into a female bather revealing herself to the viewer.
She is set in a paradisaical landscape completed on the reverse of the vessel with
either a rising or a setting sun on which there are traces of gold. The trees that
surround her are mysteriously red, and the one to the right of the figure sprouts a
distinctly phallic form. It is likely that this unassuming ceramic vessel was the first
object in which Gauguin translated a Buddhist figure into an ambiguously modern
icon of the temptress.—R.B.

88
Yellow Christ

late 1889

92 x 73 (36¼ x 28¾)

oil on canvas

signed and dated at lower right, *P. Gauguin 89*

Albright-Knox Art Gallery, Buffalo, New York; General Purchase Funds, 1946

EXHIBITIONS
Paris before 1891 (at Boussod and Valadon?); Paris 1906, no. 156; Paris, Orangerie 1949, no. 14; Edinburgh 1955, no. 32; Chicago 1959, no. 16; London 1966, no. 26; Toronto 1981, no. 61

CATALOGUE
W 327

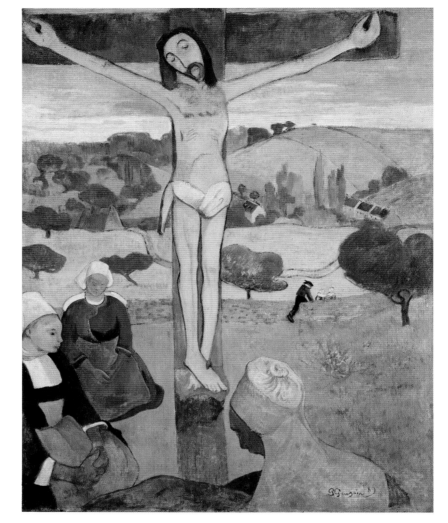

1. Rewald 1978, 474; Rotonchamp 1925, 76.

2. Letter from Daniel de Monfreid to Gauguin, 9 June 1903, in Joly-Segalen 1950, 237.

3. Rewald 1978, 459.

Practically no documentation exists for this canvas, which is nonetheless one of the most important pictures painted by Gauguin in 1889. In both style and subject matter it is one of the most significant examples of the artist's synthetism and primitivism during his Brittany period, yet there is no trace of it in Gauguin's extant correspondence; and it was not included in the great auction of Gauguin's works prior to his departure for Tahiti in February 1891, because by that time it already belonged to Emile Schuffenecker.[1] Subsequently it was bought by the great collector from Béziers, Gustave Fayet, in 1903.[2]

Careful examination of the picture reveals that the upper third of the painting bears indecipherable traces of newsprint, as if the canvas had been rolled up in newspapers before the paint had completely dried.

If the work was exhibited to the public in the artist's lifetime, this can only have been at some indeterminate time at the Boussod and Valadon gallery where, toward the end of 1890, after the departure of the dying Theo van Gogh, it was retrieved from the back of the shop by Maurice Joyant, Theo's successor, who had been a schoolfellow of Toulouse-Lautrec.[3]

Christ, 18th century, polychromed wood [Trémalo Chapel; photo: A.C.L. de Belgique]

Gauguin, *The Green Christ*, 1889, oil on canvas [Musées Royaux des Beaux-Arts de Belgique, Brussels]

4. Welsh-Ovcharov in Toronto 1981, no. 61.

5. Huyghe 1952, 154.

6. Buffalo 1942, 224.

7. Mirbeau 1891, 1.

8. Aurier 1891, 165.

9. Saint-Germain-en-Laye 1985, 94-95.

This painting is generally dated to September 1889, to coincide with Gauguin's stay in Pont-Aven just prior to his move to Le Pouldu with Jacob Meyer de Haan in October. It was probably completed after the move. The autumn landscape in the background depicts the hill of Sainte-Marguerite, which overlooks the village of Pont-Aven and which Gauguin could see from the studio he had rented at Lezaven.[4] The same site appears in another of his oil paintings (cat. 43).

The inspiration for this picture came from a seventeenth-century Christ in polychromed wood, which can still be seen on the left side of the nave in the little chapel of Trémalo, close to Pont-Aven. This ivory-colored figure stands against a bluish wall, harmonious, in its simple rusticity, with the rest of the church; above, the vaulted ceiling is decorated with carved monsters and imaginary creatures, one of which appears in a preparatory drawing (Pickvance 1970, no. 38). Gauguin's 1888 sketchbook[5] contains a study for an oversimplified bonnet such as is worn by the woman seen in profile in the foreground of the painting.

Another more enigmatic image, now in a private collection in New York, is provided by an almost completely faded old photograph, touched up with watercolor. This was long thought to be a drawing by Gauguin (Pickvance 1970, no. 39), but because of its simplicity it can reasonably be considered to be the work of one of his admiring pupils.

The connection between this painting and that of Jacob wrestling with the angel (cat. 50), quite apart from the religious subject matter of both, is clear enough. It has been pointed out, with some justice, that the foregrounds of the two works contain the same truncated Breton woman, reduced to little more than a decorative bonnet. Likewise, the two women kneeling at left in the *Yellow Christ* are variations on the figures in the background to the left of Jacob. Most important of all, both paintings possess the same ambiguity about what is real and what is imaginary. Here the two worlds are in effect united by the cross towering over Golgotha, a Golgotha symbolized by a simple gray mass in the foreground, in contrast to the real landscape behind. Again, the three Breton women lost in meditation can be compared to the three Marys at Calvary[6] who appear in the *Green Christ* (W 328), a painting based on a sandstone crucifixion scene near the church at Nizon, executed at more or less the same time.

The synthetism of *Yellow Christ* resides in its summarily defined shapes, outlined in Prussian blue – a technique that betrays the lingering influence of Emile Bernard. However, the harmony between the naive sculpture of Christ, the superstitious faith of the figures, and the deliberately primitive painting style shows that with this canvas Gauguin has reached full artistic maturity.

The work aroused the enthusiasm of the writer and critic Octave Mirbeau, who heaped it with praise in a long article for the *Echo de Paris* (which was used as the preface to the auction catalogue of Gauguin's paintings at the Hôtel Drouot in 1891): "A rich, disturbing blend of barbaric splendor, Catholic liturgy, Hindu reverie, Gothic imagery, obscure and subtle symbolism."[7] Mirbeau was especially struck by the wistful atmosphere of Gauguin's painting, the dramatic sky reflecting the artist's state of mind at this time of financial and emotional despair. During this period Gauguin was representing himself as the new Christ of painting (cat. 90); he also featured this canvas in the background of a self-portrait (cat. 99), in which appeared a rendering of his ceramic with a grotesque head (cat. 82).

Hailed by Mirbeau and Albert Aurier,[8] the canvas exercised a profound influence over the painters of the Pont-Aven school and the Nabi movement. Charles Filiger, Paul Ranson, and Maurice Denis, among others, later produced their own variations on the same theme.[9]–C.F.-T.

89
La Belle Angèle

summer 1889

92 x 73 (36¼ x 28¾)

oil on canvas

signed and dated at lower left, *P. Gauguin, 89*

inscribed at lower left, *LA BELLE ANGÈLE*

Musée d'Orsay, Paris

EXHIBITIONS
Paris, Orangerie 1949, no. 16; London 1966, no. 23; Zurich 1966, no. 19

CATALOGUE
W 315

shown in Paris only

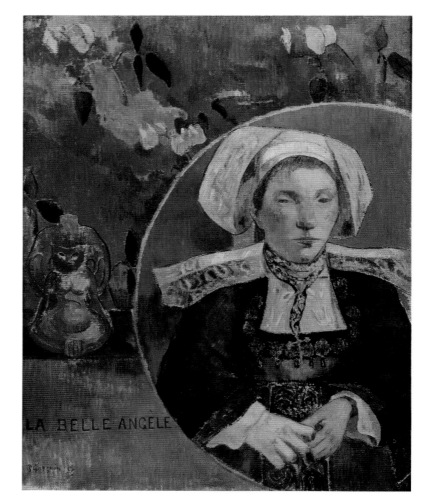

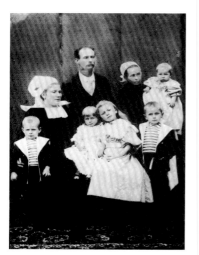

Angélique Satre and her family, photograph [Document of the Musée de Pont-Aven]

1. Rewald 1961, 181.

2. Chassé 1921, 24.

3. Cited by Rewald 1961, 181.

4. Chassé 1921, 24.

5. Cited by Rewald 1961, 181.

6. Roskill 1970, 79 and pl. 55; see also Wichmann 1981, 224.

7. Merlhès 1984, 491 n. 3.

Marie-Angélique Satre (1868-1932), née Cannévet, was born at Pont-Aven, where her mother kept an inn not far from Mme Gloanec's pension. Her father was a sailor. Marie-Angélique was known as one of the most beautiful girls in the neighborhood, and her husband, a builder[1] named Frédéric-Joseph Satre, became mayor of Pont-Aven.

The circumstances under which Gauguin painted this portrait are well known, from the story told by the model herself to Charles Chassé thirty years later, in 1920: "Mme Satre, though unable to give a precise date, told me that this portrait of her had been done prior to Gauguin's departure for Le Pouldu."[2] Given Gauguin's frequent comings and goings between Pont-Aven and Le Pouldu, where he stayed several times for brief periods in the summer of 1889, it is a reasonable guess that the departure to which Mme Satre was referring was that of autumn 1889 (2 October), which marked the beginning of the painter's long stay with Meyer de Haan at Marie Henry's lodging house (2 October 1889 to 7 February 1890). Since Theo van Gogh confirmed having received the picture in a letter to Vincent dated 5 September 1889,[3] the sittings must have taken place in August. "'Gauguin was a pleasant man, very poor,' she told me, 'and we liked him very

Hokusai, *Laughing Female Demon* from *One Hundred Stories*, c. 1830, woodcut [The Art Institute of Chicago, Clarence Buckingham Collection]

X-ray of *La Belle Angèle* [laboratory of the Musées de France]

A. Robida, *Struggle for High Life* [*L'Illustration*, no. 2395, 19 January 1889]

much. He always told my husband he wanted to do my portrait, and one day he started on it. But he never wanted to let me see it when he was working, because he said you could never appreciate a picture while it was still in progress; and he always covered it up after each sitting. When he did finish it, he first of all showed it to other painters, who made fun of it, and I heard about that; so when he brought the picture round for me, I was already ill disposed toward it; and my mother had told me, "It seems some painters got into a fight last night, and all over your portrait. Look at the trouble you've caused!" Well, Gauguin turned up, happy as a lark, and walked around the house looking for the best place to hang his picture. But when he showed it to me, I said "*Quelle horreur!*" and I told him he could take it straight back home, I didn't want that thing in my house. Imagine! At that time, and in a little place like this! Of course, I knew next to nothing about painting. Gauguin was very hurt and disappointed, and he told me he had never done such a good portrait before in his life.'"[4]

Along with the rejection of Gauguin's gift of a painting (cat. 50) to the church of Pont-Aven and the financial failure of the Volpini exhibition, this setback illustrates the climate of total incomprehension with which Gauguin had to cope. Theo van Gogh proved more enlightened than Mme Satre when he received the painting with one or two others at the end of the summer. "Gauguin has sent me some new paintings," he wrote. "He says he hesitated before doing so, because they don't contain as much of what he's looking for as he might have wished. He says he has found this in some other canvases which are not yet dry. Indeed, the batch as a whole is not as good as the one he sent last year, but there's one among them which is, as before, a very fine Gauguin. He calls it 'La belle Angèle.' It's a portrait, arranged on the canvas like those big heads in Japanese *crépons*; the likeness, as a bust, is set directly against the background. It's a Breton woman, seated, with hands clasped, black clothes, lilac-colored apron, white collarette; framed in gray, with a background of beautiful lilac blue with pink and red flowers. The expression of the face and the attitude are very well chosen. The woman looks a bit like a heifer, but there is something here so fresh and (once again) so country, that it is very delightful to look upon."[5] Theo deserved credit for understanding the originality of this portrait, despite the oddity and caricature that made the model herself reject it. The painting, of course, proved to be an important step toward the development of cloisonism and synthetism, Gauguin's major interests at this time.

Using a favorite Japanese procedure that occurs frequently in the prints of Hiroshige and Hokusai,[6] Gauguin separated the portrait of Angélique Satre inside a circle that is set against a mainly decorative background. The rigid pose, fixed expression, and Sunday clothes (usually worn on feast days at Pont-Aven) strengthen the emblematic impact of the ensemble, while the inscription in capital letters, *LA BELLE ANGÈLE*, drives the message home. Earlier portraits by Gauguin have a clearly decorative tendency, but the artist never before achieved so strong a separation between figure and background; in effect the background is underlined by an arc, which seems first to have been left in reserve, then emphasized by a line of ocher. An X-ray of the painting has shown that there is a whole network of such preliminary lines beneath the paint surface – a kind of cloisonism in reverse – on which Gauguin built up his composition.

Another source of inspiration, beside Japanese art, has been suggested[7] in illustrations from Pierre Loti's novel *Madame Chrysanthème*, which appeared in 1888 and which both van Gogh and Gauguin are known to have read. The procedure whereby a detail or a subject is juxtaposed in a circular inset with the main image was often used by illustrators of contemporary magazines: many examples of it can be seen in the various issues of *L'Illustration* published in 1889.

A third source, perhaps closer to home, may have been the headed notepaper of the Villa Julia, the hotel next door to the Gloanec pension, in which the likeness of a Breton woman in a bonnet is set within a circular medallion.[8]

As in so many other Gauguin still lifes and portraits (cats. 30, 99, W 280, W 375), a ceramic is included here, reinforcing the symbolic content of the composition. In this case it is an anthropomorphic, Peruvian-inspired piece. The same strange idol crops up again in another painting (W 316), now in the Ascoli collection in New York.

"Refused even as a gift"[9] by its own model, Gauguin's picture of Angélique Satre was later bought for 450 francs by Degas, through Durand-Ruel, at the auction of Gauguin's works at the Hôtel Drouot in 1891.[10] This was the third highest price paid, with the painting of Jacob wrestling with the angel (cat. 50) topping the list at 900 francs.[11] Degas, a great admirer of Gauguin, held on to the painting until his death, when it was bought by Ambroise Vollard for 3,200 francs at the sale of Degas' collection on 26-27 March 1918. No less than ten works by Gauguin came under the hammer at this memorable sale. Robert Rey, assistant curator of the Musée du Luxembourg, has related how Vollard lent him the painting for one of his courses at the Ecole du Louvre, then "made it known that since *La Belle Angèle* had come as far as the Louvre, he proposed that she should stay there. An elegant and witty gesture."[12] The committee "none too warmly, but nonetheless without visible disgust, decided to accept the offer. And that is how *La Belle Angèle* entered the Louvre"[13] or, to be precise, the Musée du Luxembourg, in 1927.—C.F.-T.

8. Written communication from C. Puget, curator of the Musée de Pont-Aven.

9. Chassé 1921, 24.

10. Journal, Durand-Ruel Archives, 18 October 1889-31 May 1889, 142, 177.

11. Rewald 1973, 78.

12. Rey 1927, 106.

13. Rey 1950, 42.

Letterhead for the *Villa Julia*, Pont-Aven, 1880s

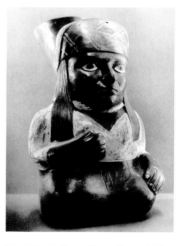

Mochica Culture, Peru, *Seated Figure*, 100 BC-600 AD, pink molded ceramic [Musée de l'Homme, Paris]

90
Christ in the Garden of Olives

summer 1889

73 x 92 (28½ x 35⅞)

oil on canvas

signed and dated at lower right, *P. Gauguin 89*

Norton Gallery of Art, West Palm Beach

EXHIBITION
Chicago 1959, no. 17

CATALOGUE
W 326

This painting was completed in the summer of 1889, one year after Gauguin's *Les Misérables* was sent to van Gogh; in both works he used the same device of including a self-portrait at the left side. Here, perhaps believing himself both a "pariah," or like Jean Valjean, the convict with a heart of gold in Victor Hugo's novel *Les Misérables*, his self-image as an accursed artist and martyr has progressed, allowing him to portray himself as Christ in the garden of olives, alone and wretched before the betrayal. Later, in the interview he gave the journalist Jules Huret for *L'Echo de Paris*, to publicize the Drouot sale, Gauguin explained: "There I have painted my own portrait. . . . But it also represents the crushing of an ideal, and a pain that is both divine and human. Jesus is totally abandoned; his disciples are leaving him, in a setting as sad as his soul." Huret's reaction was: "Yes, that was it! The plebian figure of Christ, iridescent with grandeur; a face drowned by sorrow, lost in boundless distress, grief personified. Indeed, why should Christ be a good-looking young fellow? He has thin, stick-like arms which emerge from his wide sleeves; the landscape is desolate with sorrowing trees under a poignant blue sky, and in the distance the shadows of the cowardly disciples retreat into the darkness. I no longer saw the vermilion of the hood and the beard, the heavy dark features, or the accented lines like window leads. On the contrary, I was moved and delighted by my insight into this powerful synthesis of Sorrow, and felt that I never had experienced a similar emotion except in the Louvre, before some few rare paintings. . . ."[1] We must go back one and a half years in time to see why Gauguin intentionally stationed himself before this canvas for the interview with Jules Huret. "I think I have just done my best thing, a Christ in the garden of olives," he wrote, probably at the end of August 1889, to Schuffenecker.[2] He spoke of it at

1. Huret 1891.

2. Letter to Schuffenecker, late August 1889, no. 161, Hôtel Drouot sale, 18 December 1985, now Getty Archives.

Gauguin, sketch for *Christ in the Garden of Olives*, letter to Vincent van Gogh, November 1889, watercolor [Vincent van Gogh Foundation, National Museum Vincent van Gogh, Amsterdam]

Bernard, *Christ in the Garden of Olives*, 1889, oil on canvas [location unknown]

Gauguin's calling card, with notes [Stedelijk Museum, Amsterdam]

length to Vincent van Gogh: "This year I have made unheard-of efforts in work and in reflection. . . . At the house I have something I have not sent and which would suit you, I believe. It is Christ in the garden of olives. Blue sky, green twilight, trees all bent over in a purple mass, violet earth and Christ wrapped in dark ochre vermilion hair. This canvas is fated to be misunderstood, so I shall keep it for a long time. Included is a sketch to give you a vague idea of it."[3] Van Gogh was far from convinced; he considered that by cutting himself off from observation of reality, like Emile Bernard at the same period, Gauguin was on dangerous ground. Curiously, Bernard, who was in Paris at that time, had also painted a *Christ in the Garden of Olives*. In November he sent a photo of it to Gauguin, who answered, "A strange coincidence: I have done the same subject, but in another way. I am keeping this painting, it's no use my showing it to [Theo] van Gogh, it would be even less understood than the rest. . . ."[4]

The subject probably had been brought up in talks between the two artists and the poet and critic Albert Aurier during the previous winter in Paris. It is not to be ruled out that the idea itself of a Christ with red hair (Bernard's Christ was also a redhead) originally came from the younger man. In the Bernard painting, Judas obviously resembles Gauguin, a fact that did not escape him: "In the photograph there's a face of Judas which looks vaguely like me."[5] This may have been Bernard's way of showing his irritation at the way Gauguin used his ideas. Though he was far away in Paris, Bernard must certainly have heard of Gauguin's painting, which had created a sensation at Pont-Aven.

Gauguin apparently was delighted with this painting; among the works he left on deposit at Boussod and Valadon, he asked the highest price for it – 600 francs, the same as for *The Vision after the Sermon* (cat. 50).[6] Perhaps his attachment to this work can be traced to his obvious desire to lead the movement called, variously, cloisonism, synthetism, or symbolism. At the same time, his "aesthetic program" in Pont-Aven and Le Pouldu was on the point of crystallizing. *Christ in the Garden of Olives* is among his first paintings detached from reality: the landscape is decidedly un-Breton, and the olive trees are more emblematic than real. Moreover, the three trees at right may be derived from the famous engraving by Rembrandt, *The Three Trees*, symbolizing the three crosses. The red hair and beard perhaps have a symbolic meaning: Bogomila Welsh-Ovcharov sees in their bloody tones the transposition of Christ's suffering.[7] But quite clearly the most important element here is the fact that Christ has the face of Gauguin himself.

In this, of course, Gauguin was joining a tradition that harked back to Albrecht Dürer, and which had been popular with the German romantics at the beginning of the nineteenth century. The Resurrection was a fundamental theme of symbolism in France and Belgium;[8] art was viewed as a new religion, with the artist himself playing the role of redeemer. Gauguin had written to Schuffenecker in the previous year, "art is an abstraction; take from nature as you dream, and think more of the creation which will come of it. The only way to rise up to God, is by doing like our divine master, by creating."[9]

In this painting the image is neither that of the triumphant creator, or Jesus amid his disciples, as Parisians imagined Gauguin to be when he was at Le Pouldu with his "students." In a letter to Emile Bernard, he wrote: "I do not know who could have told you I walked along the beach with my disciples. So far as disciples are concerned, there is de Haan who goes off to work by himself, and Filiger who labours at the house. As for me, I pace about like a long-haired beast and do nothing."[10] The image is that of the misunderstood artist, as described in a poem by Aurier entitled *L'Oeuvre Maudit:* "...we are the accursed, the excommunicated, dragging our unrecognized masterpieces like a ball and chain." Aurier addressed artists in general: "...of the tribe of Christ and Homer/ knowing what it

3. Cooper 1983, no. 37.2.

4. Malingue 1949, XCV.

5. Malingue 1949, XCV.

6. Gauguin's inventory of his works on deposit with Boussod and Valadon, published in Rewald 1973.

7. See Welsh-Ovcharov in Toronto 1981, no. 66.

8. See Junod in Lausanne 1985, 59.

9. 14 August 1888, see Merlhès 1984, no. 159.

10. Malingue 1949, CX.

11. Poems of Albert Aurier, 1888 and 1889, in Aurier 1893.

12. See Andersen 1971, 110; also Amishai-Maisels 1985, chapter 2.

13. Letter to Bernard, November 1889, Malingue 1949, XCII.

14. Van Gogh 1960, vol. 3, 407.

15. Van Gogh 1978, no. 643.

16. Mirbeau 1891a.

17. Bought from Gauguin through Boussod and Valadon on 14 March 1891 for 500 francs; Mirbeau sold it back to the same dealer for the same price on 6 November 1903. This is an indication of Gauguin's relative obscurity, even in the years immediately following his death (see Rewald 1973, 78).

is to be spat upon, knowing crucifixion."[11] Thus Gauguin has painted himself as the overwhelmed and betrayed Christ. Clearly, the thin hand clutching the cloth and the humble attitude of resignation intentionally recall *Les Misérables*.[12] The Judases are obviously the Parisian critics and dealers who failed to understand the work Gauguin had exhibited at the Volpini café, which caused him to become irrevocably estranged from the impressionist painters. "Of all my struggles this year, nothing remains save the jeers of Paris; even here I can hear them, and I am so discouraged that I no longer dare to paint, and spend my time dragging my old bones along the beaches of Le Pouldu in the cold North wind. . . . let them look carefully at my recent paintings . . . and they will see how much there is in them of resigned suffering."[13]

Among the Judases, Gauguin particularly resented the fact that Theo had refused to allow Vincent to participate in the Volpini exhibition. Vincent was even more severe: "This month I have worked in the olive groves because they have angered me with their Christs in the garden, where nothing is objectively observed. Of course, there is no question of my doing anything from the Bible, and I have written to Bernard and also to Gauguin to tell them my belief that thoughts, not dreams, are what concern us, and to say I was astonished by their work, that they should have stooped to such stuff. . . . frankly, the English Pre-Raphaelites did this kind of thing much better."[14] However in his last letter to Gauguin (unfinished, unsent, and found among his papers after his death), van Gogh cited his own portrait of Gachet as having "...the heart-broken expression of our time. *If you like*, something like what you said of your "Christ in the garden of olives," not meant to be understood. . . ."[15]

This painting was part of the collection of Octave Mirbeau, the writer, polemicist, and art critic, who wrote about Gauguin in 1891: "When I am confronted by his paintings, I sense a mind that reflects and a heart that suffers deeply, and I am moved."[16] Mirbeau may have met Gauguin during the winter of 1890-1891, when, on the urging of Charles Morice, Mallarmé asked the critic to write an article to "launch" the sale of Gauguin's works; which it was hoped would finance his departure for Tahiti. Mirbeau wrote a resounding piece in *L'Echo de Paris* (16 February 1891), which was used as the preface to the sale a week later. After the auction, at which the painting remained unsold, Mirbeau bought it directly from Gauguin, and only parted with it twelve years later, after the artist's death.[17]—F.C.

91
Breton Girls by the Sea

"This year I'm mostly doing simple farm children strolling beside the sea with their cows," wrote Gauguin to Vincent van Gogh at the end of 1889. "Only, because I don't like *trompe l'oeil* landscapes or *trompe l'oeil* anything else, I try to infuse these desolate figures with the wildness that I see in them, and which is also in me. Here in Brittany the country people have something medieval about them; they don't look for a moment as though they believe that Paris really exists, or that it is really 1889."[1] In this painting, one of a series (W 344, W 345, W 360), Gauguin

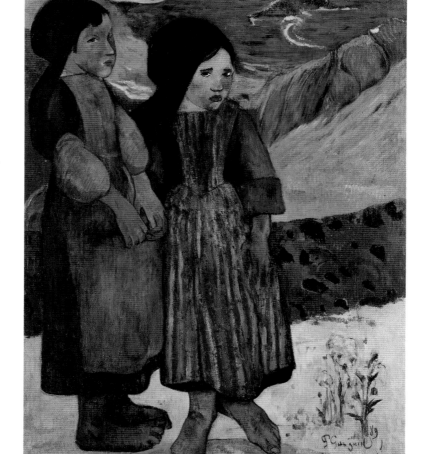

Breton Girls by the Sea

autumn (?) 1889

92 x 73 (36¼ x 28¾)

oil on canvas

signed and dated at lower right, *P. Gauguin 89*

The National Museum of Western Art, Tokyo, Matsukata collection

EXHIBITIONS
Paris, Orangerie 1949, no. 20; Quimper 1950, no. 9; Tokyo 1987, no 32

CATALOGUE
W 340

shown in Paris only

1. Cooper 1983, 36.2-36.3 (date is surely later than that given by Cooper).

2. Cooper 1983, 36.2.

3. Cooper 1983, 36.2.

4. Compare Rewald 1973, 49.

5. Sale, Sotheby's, 2 December 1970, lot 20.

6. Alexandre 1930, 250.

has come closer to the shy, tight group of little girls, giving them a monumental dignity. He has accentuated their awkwardness, turning their outsize bare feet into a deliberately primitive image. He was to use this approach again in Tahiti.

The landscape is described from bottom to top in broad stripes of color up to the line of a Japanese-style sea, similar to that in a painting of the beach at Le Pouldu (cat. 97). All the nuances of modeling in color are concentrated on the children: in their faces and in the striped apron with its delicate, shimmering yellow and light blue. The artist has also lingered over details in the costumes of Le Pouldu, which he thought "symbolic and influenced by Catholic superstition. Note the cross at the back of the bodice, and the head wrapped, like a nun's, in a black headscarf."[2] The faces remind us of Gauguin's remark to Vincent about the Bretons: "The faces are almost Asiatic; they are yellow, triangular, and severe."[3]

The frightened, unhappy look of these children at first prompted Gauguin to call his work *Les Deux Pauvresses* (*Two Pauper Girls*) in his list of paintings on deposit with Boussod and Valadon.[4] One writer has referred to the subjects, which also appear in a preparatory pastel,[5] as "two little Breton girls, almost dwarflike, wearing clothes that are too big for them, seeming already on the brink of widowhood."[6] Prince Matsukata bought the picture, probably from Ambroise Vollard, at some time during the 1930s.—F.C.

92
Self-portrait with Halo

1. Chassé 1921, 48, citing Henri Mothéré; in fact, the portraits were not painted directly onto the wood, without preparation. The analysis of C. Christensen, conservator at the National Gallery of Art, shows that Gauguin painted these panels on a white base, probably casein. His canvases were prepared in a similar fashion at this time.

2. Notably this portrait, in 1919, at the Barbazanges gallery.

3. See Welsh in Saint-Germain-en-Laye 1985, 125. For the entire room, see Welsh 1988, forthcoming.

4. Analysis of C. Christensen, see n. 1.

5. Anonymous 1893a, 167.

6. Photograph published by Welsh in Saint-Germain-en-Laye 1985, 125.

7. Malingue 1959.

8. Paris 1919, no. 1.

9. Norgelet in Paris 1919. Van Hook 1942 was the first to decode the iconographic themes; see also Andersen 1971, 11, 13, 107; Amishai-Maisels 1985.

10. Jirat-Wasiutynski 1987.

This portrait was painted as one of a pair (the other a portrait of Jacob Meyer de Haan, cat. 93) to go in the dining room of Marie Henry's inn at Le Pouldu "on the upper panels of the cupboard doors, Gauguin's portrait on the right, and Meyer de Haan's on the left, painted directly on the wood."[1] This dining room might today be a shrine of turn-of-the-century modern art, had not Marie Henry removed everything in 1893 and sold it piece by piece;[2] nonetheless, a recent study[3] of the room's decoration has shown that both Meyer de Haan and Gauguin worked at tremendous speed to complete it. Most of the job was done between 2 October and 7 November 1889, and the technical analysis of the portraits clearly points to a very rapid execution.[4]

Before we attempt to understand Gauguin's statement about himself in this most provocative of his portraits, we should recall that the work was conceived, as was the picture of his colleague, as a caricature. In short, he was having fun, playing with his own image. In two other works (cats. 90, 218), Gauguin rendered himself convincingly in the guise of the new Christ, the misunderstood artist, the martyr and redeemer; but here the portrait reflects the ribaldry that had made the "dauber" [rapin] so popular in Pont-Aven and Le Pouldu. "He used to laugh and say: 'We're going to be *synthetists*,' but next day he would change his tune and say *symbolists* instead." When he talked, it was usually tongue in cheek, hence the myriad errors and fables that sprang up around him.[5] We should also bear in mind his drawing *Vive la sintaize*, or the decoration of the ceiling at Le Pouldu, on which he wrote *Oni soie que mâle y panse*, which is the motto of the English Order of the Garter, generally translated as "shamed be he who thinks evil."[6] His spelling, full of broad allusions, was later piously corrected by his biographers. His irony, which was sometimes in doubtful taste, is recorded in his posthumous text, *Racontars de Rapin*; it enabled him to take an idea seriously, while at the same time holding it up to ridicule. This was Gauguin's way of affirming his superiority over painters in his entourage like Haan, Sérusier, or Filiger, who were more intellectual and more adept at formulating ideas, but mediocre artists. It is striking that it was the people who knew Gauguin personally, Marie Henry and Henri Mothéré, who dubbed this painting "portrait-charge de l'auteur" (an unkind character sketch of the author);[7] whereas later on, with the posthumous growth of the Gauguin myth, it became *L'alpha et l'omega*.[8] Finally, it was known as *Portrait à l'auréole et au serpent* (*Portrait with Halo and Snake*), a title that appeared in the 1950s when art history was involved more with iconographical issues than with purely formal questions.

Nonetheless, these widely different interpretations reflect a real ambivalence within the portrait itself; suffice it to say that Gauguin has painted himself as an icon, but as an iconoclastic icon.

As the sequence of titles suggests, the interpretation of the work as sacred quickly won out over the "unkind character sketch." In 1919, when the picture was put on sale at the Barbazanges gallery in Paris, along with the rest of the room decoration from Le Pouldu, the catalogue preface set the new tone. Henceforth Gauguin was esoteric, dignified, an "eagle," a "seagull," a "dignitary," an "enormous shadow," a "lay monk of art."[9] Alpha and omega, the Greek letters added to the title in the 1919 sale exhibition, encompass everything: Gauguin is total knowledge, the "master." This he would certainly not have denied.

The pendant, the portrait of Meyer de Haan, contains two books: *Sartor Resartus* by Thomas Carlyle, and John Milton's *Paradise Lost*. These books may give the key to the halo, the apples, and the serpent. In the last fifteen years

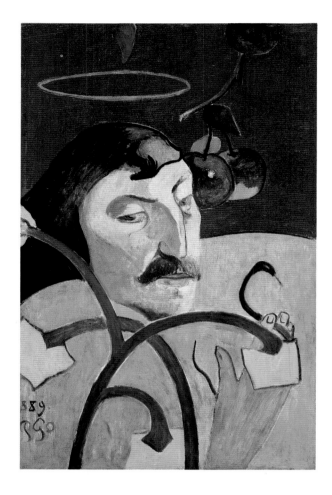

Self-portrait with Halo

late 1889

79.6 x 51.7 (31⅜ x 20⅜)

oil on wood (oak)

dated and signed at lower left, *1889/P. Go*

National Gallery of Art, Washington, Chester Dale Collection

EXHIBITIONS
Paris 1919, no. 1, ∝ *ω: Portrait de Gauguin par lui-même*; Paris 1923, no. 11, *Son portrait par lui-même*

CATALOGUE
W 323

shown in Washington only

especially, a whole series of interpretations has been put forward for the portrait's symbolic hieroglyphs.[10] Briefly they amount to this: Gauguin painted himself as a magus and initiate, in the esoteric tradition of Satan, the fallen angel. The red in the background symbolizes hellfire and the artist's demonic nature, while the yellow, into which the head is weirdly sunk, represents the stylized wings of angels. The apples and the serpent allude to paradise lost, the apples also symbolizing various degrees of temptation, beginning with green and ending, at the fall of man, with mulberry purple.

All this is true enough, and even more can be added. By associating himself with the serpent, Gauguin presents himself in the guise of the tempter. The two apples are no doubt an easy sexual allusion, something to do with Gauguin's acknowledged jealousy of Marie Henry's love affair with his crippled friend Meyer de Haan (see cat. 93). The stylized, papyrus-shaped plants in the foreground are the same as those in the painting of a girl spinning (W 329) – perhaps erroneously referred to as Joan of Arc – on the facing wall, whom an angel is supplying with revelations. This motif may also point to some kind of association between legendary heroes and redeemers. As to the background red, this may refer not to hell, but to the imaginary universe. Gauguin himself postulated this meaning for red in his painting of Jacob wrestling with the angel (cat. 50). Hence he would be representing himself against the symbolic backdrop of a new aesthetic order, of which he obviously claimed the status of hero.

Whatever the truth of the matter, and whether he saw himself as the saint, the prophet, or the magician of the new order in painting, Gauguin has handled

the topic with a fitting irony. The somewhat Japanese face echoes the portraits of popular actors in *ukiyo-e* prints, and the hand might also belong to a marionette. The feeling of casual ease is captured, too, in the little leaf that floats like an exclamation mark above the halo. The pictures adorned panels of double doors that were not part of some church altar, but of a solid cupboard in a rural dining room.

Finally, we should not take too seriously the clues that purport to expose Gauguin as a theosophist or Rosicrucian, given the speed with which the artist absorbed every passing theory at this time in his life. He did not need to read Edouard Shuré, the Cabala, or Hippolyte Taine (who introduced Carlyle's ideas to France) to understand exactly how to generate ideas from symbolism, or where to place himself in its hierarchy. Clearly, Gauguin saw himself as the master, the possessor of innate comprehension, and he knew quite well that from time immemorial the serpent had been the emblem of divination and wisdom. But his was not knowledge as revelation, of the kind transmitted to initiates. It was the knowledge of the art of painting. This is clearly shown in his sarcastic letter to Maurice Denis from Tahiti, in which he refused to take part in an exhibition mounted by his young friends: "My Papuan art has no reason to appear alongside . . . symbolists and the rest . . . I'm afraid you risk appearing as ridiculous as the Rosicrucians, although that would be a marvelous advertisement, although I think that art has no place in that house of Péladan [the Rosicrucian playwright]."[11]

Already, at Le Pouldu, Gauguin knew that he was not the "Sâr Péladan," the leading Rosicrucian among artists, but that he possessed the true power of magic in his talent and genius. By contrast, Meyer de Haan, beside him on the other cupboard door, is seen laboring with a book. "Gauguin was the head," recalled one of his disciples. "He had a whole following of painters, whom he stirred up savagely and encouraged, and to whom, as a friend, he showed the way. . . . envious people said he pontificated."[12]

This painting, despite its irony, is evidence of Gauguin's invincible ego cult, morally underpinned by Carlyle's definition of the artist as hero. The work is a kind of emblem of his phenomenal – and justified – confidence in what he had become in so short a time. Gauguin had always known what he *ought* to do; now he realized what he *could* do. This, no doubt, is what he is telling us so proudly, so humorously, and so ferociously in this portrait.–F.C.

11. Malingue 1949, CLXXI.

12. Anonymous 1893a, 166.

93
Meyer de Haan

Jacob Meyer de Haan (1852–1895) first met Gauguin at the beginning of 1889, through Pissarro and Theo van Gogh, the friend with whom he was staying in Paris. In the following summer, Meyer de Haan joined Gauguin in Brittany. It is no exaggeration to say that the minicommunity of artists this pair created at Le Pouldu between 1889 and 1890 was a key element in both their careers. In their association, Meyer de Haan was of course the pupil of Gauguin and a source of patronage for the entire community, but at the same time he seems to have had considerable intellectual influence over his master. Gauguin was at any rate less cultivated and lacked training in the methods of abstract speculation.

After lodging in several different houses at Pont-Aven and Le Pouldu, on 2 October 1889 the two moved into an inn run by Marie Henry, a young woman

Meyer de Haan

late 1889

80 x 52 (31½ x 20½)

oil on wood

signed and dated at lower right, *P. Go 89*

private collection, New York

EXHIBITIONS
Paris 1919, no. 3, *Le Soir à la lampe, portrait de Meyer de Haan*; Paris 1923, no. 14; Cambridge 1936, no. 14; San Francisco 1936, no. 8; Vienna 1960, no. 20

CATALOGUE
W 317

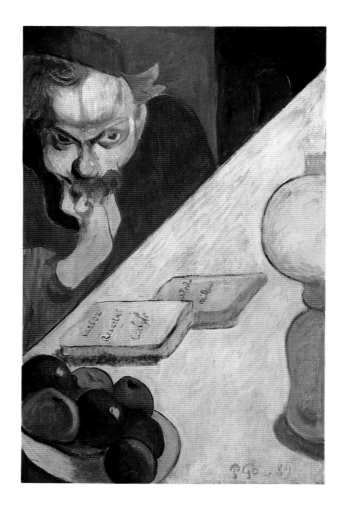

1. For further details, see Guyot and Lefay, in Saint-Germain-en-Laye 1985, 114-115.

2. Chassé 1955, 66.

3. To Schuffenecker, Malingue 1949, XC.

4. Cooper 1983, no. 36.1, dated arbitrarily 20 October; this letter would have been later. See the forthcoming article by Robert Welsh, which reconstitutes the room and identifies its contents.

about thirty years old who was so good looking that she was known locally as "Marie Poupée," or Marie the doll. Before long, Meyer de Haan and she were involved in a love affair that was to lead to the birth of their daughter.[1]

Marie's consort in her later years was Henri Mothéré; he had known the inn as it had been when Gauguin and his friends had moved out. Guided by Marie, Mothéré wrote a memoir of the period, which remains an invaluable source of information for students of modern art: "Meyer de Haan . . . had founded a very prosperous firm which manufactured biscuits. Wishing to take up painting, he had given this firm to his brothers, in exchange for a fixed income of three hundred francs a month. He began with academic, classical work, but after viewing an exhibition of impressionist painters he was won over by the new ideal. He then went to London to seek the advice of Lucien Pissarro, who steered him to Gauguin; and thus he became Gauguin's enthusiastic pupil and patron."[2] The two men found Marie Henry's house too cramped to work in, so they rented a studio together. "There's a view across the sea in front," wrote Gauguin. "It's superb in stormy weather, and I work there with a Dutchman who is my pupil and a fine fellow."[3] Very soon after their arrival, they decided to decorate the dining room of the inn. Gauguin wrote to Vincent van Gogh in the late autumn about "a big job de Haan and I have started: a decoration of the inn where we take our meals. We began with one wall, and now we're doing all four and the window too. De Haan has painted a big panel, about 2 by 1.5 meters [78¾ x 59 inches] tall, straight onto the plaster. I think it's very good and very complete, done just as seriously as if it were a canvas."[4]

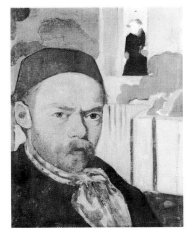

Meyer de Haan, *Self-portrait*, c. 1889-1891, oil on canvas [Collection of Mr. and Mrs. Arthur G. Altschul]

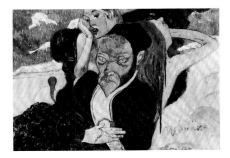

Gauguin, *"Nirvana" Portrait of Meyer de Haan*, c. 1890, essence on silk [Wadsworth Athenum, Hartford, Ella Gallup Sumner and Mary Catlin Sumner Collection]

5. Chassé 1955, 71.

6. Chassé 1955, 71.

7. de la Faille 1970, no. 359.

8. Carlyle's book first came out in London in 1885, while Milton was translated into French and published by Hachette in 1875, then reissued several times between 1877 and 1881. It is probable that Meyer de Haan had read Carlyle in English, and that he had summarized its contents in conversation with Gauguin.

9. *Noa Noa*, Louvre ms, 174.

Gradually the walls were painted over, the places of honor being on the south wall, especially on the chimneypiece, where Gauguin's bust of Meyer de Haan (cat. 94) was later placed, along with an entourage of smaller objects and a sculpture. Gauguin went on to paint the two upper panels of the cupboard door to the left of the fireplace with a pair of portraits: his own on the right (cat. 92) and this work on the left. The two effigies are handled in exactly the same way, in broad expanses of vivid color. The same red is used for Meyer de Haan's clothing and for the background of the self-portrait; likewise the same yellow unites the book in the former and the bust of Gauguin in the latter. There are similar apples in both pictures, and the two faces are equally strongly caricatured.

Unquestionably, these paintings were done at the same time, at great speed, and probably after a discussion between the two painters (this must have been awkward, because Meyer de Haan spoke terrible French). The resulting pair of portraits is clearly intended to seal the close understanding between the two men, for each painting is filled with veiled allusions and shared jokes.

Marie Henry left a description of the painters' daily life, their hours of work, and the evenings when they played lotto or checkers. "Often," she noted, "they would sit up drawing by lamplight."[5]

The portrait of Meyer de Haan commemorates these moments, as *Le Soir à la lampe* (*Evening by Lamplight*), the title given to it no doubt by Marie Henry when it was sold at the Barbazanges gallery in 1919, also indicates. Marie's recollection of Meyer de Haan was of a "slight, rickety, deformed, sickly, almost infirm creature."[6] The description tallies with Gauguin's representation of him in his red sailor's jersey, with a big-nosed face resting on one gnarled hand, tortured alcoholic eyes, and flaming bristly hair and beard.

But this portrait is not merely a caricature. There is also a strong element of explicit symbolism in the presence of the two books, with their clearly legible titles. Van Gogh had used a similar approach in recent paintings such as *Romans parisiens*,[7] which Gauguin had probably seen at Theo's house in Paris. Meyer de Haan's reading matter indicates his preoccupation with metaphysics; the books are *Sartor Resartus* by Thomas Carlyle, in the original English edition, and John Milton's *Paradise Lost* in French.[8] The former is a reflection on the contradictions between culture and nature, as expressed in clothes, and the second is a religious poem about the fall of man and the revolt of Satan and his angels against God.

Knowledge is represented here by the lamp and the apples, which also mean temptation. The serpent is in the other panel, with Gauguin. While Gauguin himself is portrayed there as a kind of Christ, Meyer de Haan here seems satanic, the fallen angel destroyed by his will to acquire knowledge. There is also something about him truer to life, of the traditional rabbi and Jewish sage, the man who knows the Good Book and passes on his knowledge.

Clearly Gauguin had fun painting these hieroglyphic portraits. Nevertheless, the tortured mask of Meyer de Haan seems to have haunted him for the remainder of his life. It first reappears in a small painting on silk done in the same year and titled *Nirvana* (W 320), in which the Dutch painter, slant-eyed, is placed before a composite image of two recent Gauguin paintings (see cats. 79, 80). After Meyer de Haan's premature death at forty-three in 1895, Gauguin included him in a Tahiti wood engraving (Gu 53), which he pasted into *Noa-Noa*.[9] Meyer de Haan reemerged for the last time in one of Gauguin's final canvases (cat. 280), alongside two girls from the Marquesas Islands; one is a beautiful Kanaka redhead and the other is seated like a Buddha. In this painting, it is as if the painter's dead friend has returned, a dreaming, pathetic phantom, to personify Gauguin's Judeo-Christian metaphysics, his syncretic pantheon of mythologies and religions.—F.C.

94
Bust of Meyer de Haan

late 1889

height 57 (22¼)

carved and painted oak

National Gallery of Canada, Ottawa

EXHIBITIONS
Paris 1919, no. 27; Paris 1928, no. 8

CATALOGUE
G 86

shown in Chicago only

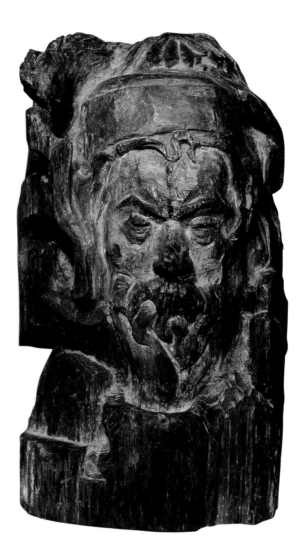

1. R. Welsh in Saint-Germain-en-Laye 1985, 124.

2. Gray 1963, 206; Andersen 1964, 583.

3. Alan G. Wilkinson, in Toronto 1981-1982, no. 6.

This striking, larger-than-life bust occupied a place of honor in Marie Henry's dining room at Le Pouldu, on the chimneypiece. It was carved and painted by Gauguin between October and December 1889.[1]

Gauguin had long been a lover of woodcarving, but until this time he had never approached it with such frankness. The object retains the elemental power and roughness of wood; in fact, most of its lower part consists of a log with practically no finish whatever. Gauguin evidently set out to portray his friend emerging from primeval matter as an allegory of the human mind. Elsewhere, he had represented de Haan as one obsessed with spirituality; here, with his half-closed eyes and concentrated expression, he is a part of nature. We note in passing that the position of the head on the hand is taken from the portrait in oil (cat. 93).

The head is wrapped in a stylized headdress of leaves partly covered in green paint, and on the crown a rooster is perched. There are various opinions about this bird; Gray thought it was roosting, Andersen that it was engrossed in copulation,[2] which might be an allusion to de Haan's love affair with Marie Henry, and Wilkinson that it was a symbol of immortality.[3] Whatever the truth may be, there is an implicit joke, because *haan* is the Dutch word for rooster.

Marie Henry kept this bust for many years; it was still in her collection long after it was exhibited at the Barbazanges gallery in 1919, because she was credited as its owner in the exhibition of Gauguin's sculptures and carvings at the Musée du Luxembourg in 1928.

The piece reminds us of what modern sculpture owes to Gauguin's simplifying, expressive work, and to the primitive sculpture he helped popularize among fin de siècle artists. We think of Matisse's first carved wood pieces, or of those of German expressionists such as Schmidt-Rottluff. A sculpture like this bust of Meyer de Haan, when seen in 1919, must have made an impression on a whole generation of sculptors in the international avant-garde center that was Paris during that period. Paco Durrio, who was a friend of both Gauguin and Picasso, had an equal role in the diffusion of the artwork of the mythical hero of Brittany and Tahiti, in the milieu of the *bateau-lavoir*; and none of it was lost on the painter of *Les Demoiselles d'Avignon.*–F.C.

95
Bonjour Monsieur Gauguin

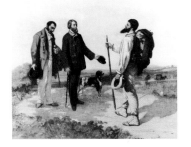

Courbet, *Bonjour Monsieur Courbet*, 1854, oil on canvas [Musée Fabre, Montpellier]

Gauguin, *Bonjour Monsieur Gauguin*, 1889, oil on canvas [The Armand Hammer Collection]

"Vincent sometimes calls me the man who comes from afar, who will go a long way," wrote Gauguin to Schuffenecker,[1] and we must go back to his famous interlude with van Gogh at Arles, less than a year before, to find the sources for this portrait of the artist as a wanderer. Vincent's role in stimulating a series of Gauguin self-portraits was vital; and even the title of the painting evokes the visit the two artists had made together to the museum at Montpellier, which Vincent described at length to Theo.[2] This occasion led to discussions that were "terribly electric"[3] only three days prior to Vincent's famous attack of delirium, leading to Gauguin's departure and Vincent's incarceration in the asylum.

These discussions, which took place both inside the museum and after they left, seem to have turned on the portraits the two artists had seen: notably those of Bruyas by Delacroix, and others by Courbet, Ricard, Couture, and on memories of the Louvre, particularly a painting then attributed to Rembrandt. "You know the strange and magnificent 'Portrait of a Man' by Rembrandt in the Lacaze Gallery. I said to Gauguin that I myself saw in it a certain family or racial resemblance to Delacroix or to Gauguin as well. I do not know why, but I always call this portrait 'The Traveler,' or 'The Man Who Comes from Afar.'"[4]

Although Vincent did not mention it to his brother, one may well imagine that the famous *Bonjour Monsieur Courbet* at the Musée de Montpellier was at the core of the two artists' exchanges on the theme of the wandering artist, and on the way in which an artist could represent himself. Courbet depicted the warm and respectful reception of the artist, a man "on the move" with forward-jutting beard, by Bruyas and his servant.

Gauguin's *Bonjour* is the opposite of ceremonious, being the ordinary passing greeting of a rough farm wife whom the painter has happened to meet. Between the two figures there is a gate, which has momentarily barred the impressionist's progress or his quest for a motif. The darkening sky and stormy light on the house at upper left show that it is just about to rain, or has just stopped

1889

113 x 92 (44 x 35⅞)

oil on canvas

dated and annotated at lower right,
89/Bonjour M. Gauguin

Nàrodní Gallery, Prague

EXHIBITIONS
Paris, Durand-Ruel 1893, no. 42; Paris,
Orangerie 1949, no. 21; Edinburgh 1955,
no. 19; Munich 1960, no. 42

CATALOGUE
W 322

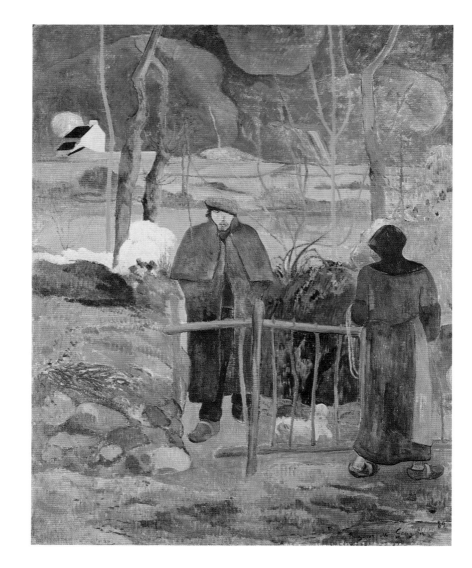

1. E. Schuffenecker, December 1888, cited in
Alexandre 1930, 94.

2. Van Gogh 1978, letter to Theo, no. 564.

3. Van Gogh 1978, no. 564.

4. Van Gogh 1978, no. 564. See also Jirat-
Wasiutynski 1976, 66, 67.

5. W 321, 75 x 55 (29¼ x 21½).

6. See Welsh in Saint-Germain-en-Laye
1985, 124.

7. Some critics have identified the peasant
woman in her black hood as the image of
death. This derives from a poem by Chris-
tina Rossetti of which van Gogh was fond, in
which the wandering poet meets Death (see
Dorra 1978, 15, and Maurer 1985, 942).

raining. Gauguin is muffled in his greatcoat, his blue scarf, and the beret he wore
at that time. The dog from Courbet's painting is also present, very small; he trots
along beside the artist's famous wooden clogs. Gauguin pictured himself full-
length, perhaps following the example of Courbet. The handling of the face is
simplified and impassive. The visible eye is half-closed, and the other is hidden as
in the portrait of Vincent that Gauguin did the previous year. It is a solitary, lonely
face, full of dark thought.

　　There is another, smaller version of this painting in the Hammer collec-
tion[5] known as "the replica, or first translation" of the Prague canvas. It originally
adorned the upper panel of a door in Marie Henry's auberge at Le Pouldu.[6] Several
elements point to the possibility that this was in fact a first draft, and that the
Prague painting came after it; on the other hand, it was Marie Henry herself, a
firsthand witness, who presumably gave directions for the titles. Nonetheless, the
Prague painting is more studied and more intense in every respect. The more
heavily contrasted colors, the stormier sky, the more disturbing light, the larger,
more forbidding figure, and even the peasant woman who is walking away instead
of coming toward the painter[7] are all features that dramatize the subject matter
that seems more humble in the Hammer painting. We are no longer involved in an
ordinary walk near Le Pouldu; this has become "portrait of the artist as a pilgrim,"
and the Courbet-style title merely adds a touch of bitter derision to the image.

Gauguin attached considerable importance to this painting; to his exhibition of forty-one Tahitian paintings at Durand-Ruel in 1893 he insisted on adding three Breton pictures, one of which was this work. "He wanted to show the logical sequence of his development, and he therefore wanted this painting in the Tahiti show: so people would know he could do that too. And yet the gap between this Breton system and the Tahiti work wasn't as huge as it looked. . . ," [8] wrote Charles Morice, with whom Gauguin organized the exhibition, and who probably gave an accurate account of their discussions. At the 1895 sale, the painting found no purchaser, was bought in by Gauguin,[9] and subsequently passed into the hands of Schuffenecker.[10] It probably still belonged to Schuffenecker in 1920 when Charles Morice described it in detail in his book about Gauguin. This work ends in Morice's excessively lyrical style, which was later to damage the published version of *Noa Noa*: "How can we fail to understand the artist's feelings? Do we not discern his anguished soul quivering in the depths of the troubled landscape, whence he comes toward us? And the peasant woman, is she not right to feel uneasy?"[11]–F.C.

8. Morice 1920, 215.

9. 18/2/95, no. 39; bought in at 410 francs.

10. Rotonchamp 1925, 155. The picture was still on deposit with Boussod and Valadon.

11. See also Rewald 1973, 49.

96
Decorated Cask

1889-1890

length 37, diameter 31 (14½ x 12⅛)

carved and painted wood

private collection of Joshua I. Latner

EXHIBITIONS
Munich 1960, no. 144; Toronto 1981-1982, no. 1

CATALOGUE
G 84

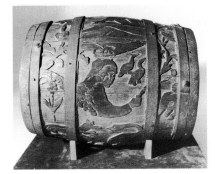

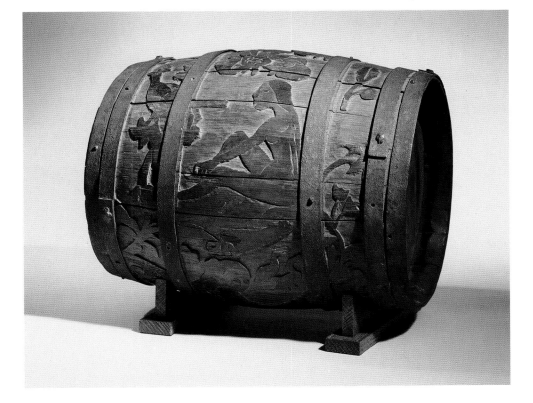

1. Anonymous 1893a, 66a.

2. Quoted by Gray 1963, 68.

Among the various objects in Marie Henry's dining room at Le Pouldu was a wine cask decorated by Gauguin.[1] The iron hoops were gilded (some of the gilt remains), and the wood was carved in flat relief before being painted. The various motifs came from Gauguin's familiar Le Pouldu repertoire: a goose girl, a woman in Breton costume with her poultry, a rooster, a pig with a corkscrew tail, flowers, and a naked girl with long hair, seated in profile. This girl is very much in the style of Gauguin's evocations of exotic women before he visited Tahiti, such as *Be Mysterious* (cat. 110) or *Caribbean Woman* (W 330), who was also painted for Marie Henry's dining room. In addition to these emblematic figures and creatures, the little cask is adorned with floral and vegetable motifs.

The poetess Renée Hamon, a friend of Colette's, traveled to Tahiti in the 1920s to seek out people who had known the artist. Lenore, the man who looked after the cemetery, told her he was amazed by the way Gauguin constantly decorated the things around him: "He carved everything, tree trunks, tin cans, even barrels."[2] No barrel from the Tahiti period has survived.–F.C.

97
Beach at Le Pouldu

Hiroshige, *The Whirlpool at Naruto in the Province of Awa*, from *Famous Sites of More Than Sixty Provinces*, 1853-1856, woodcut [Österreichisches Museum für Angewandte Kunst, Vienna, Exner Collection]

1. Wichmann 1981, 131, 133, 147.

For an artist who spent so much time in Brittany, Gauguin painted very few real seascapes; even pure landscapes are relatively uncommon in his work. Some of his seascapes between 1888 and 1889 (W 284, W 285, W 363) are still heavily influenced by impressionism; others (cats. 53, W 360, W 361) contain bold spatial research; and yet others (W 286) show a strong Japanese influence. To this last group belongs the depiction of the beach at Le Pouldu, a pure seascape and hence a rarity in Gauguin's work.

Between 1880 and 1890, a number of Western artists were inspired not only by the prints of Katsushika Hokusai and Ando Hiroshige, but also by lesser-known plates from Japanese manuals for artists. Vincent van Gogh, Claude Monet – notably in his paintings of Belle-Ile, executed in 1886 – and Georges Lacombe were among the painters for whom Japan was a major influence; the same is true of engravers such as Henri Rivière and Auguste Lepère, and of the ceramist Ernest Chaplet.[1]

One of the effects of Gauguin's stay in Arles was to confirm his admiration of the Japanese, since van Gogh possessed a large collection of prints that Theo sent him regularly from Paris. This painting is heavily influenced by Hiroshige in its decorative treatment of sinuous wave patterns against a horizonless spatial backdrop. It is also remarkable for its bold color contrasts. At one time it belonged to the sculptor Aristide Maillol, who was on good terms with Gauguin and who also received a watercolor from him (cat. 78).–C.F.-T.

1889

73 x 92 (28¾ x 36¼)

oil on canvas

signed and dated at lower left, *P. Gauguin 89*

private collection

EXHIBITIONS
Basel 1928, no. 51 or 58 (according to the edition); London 1979, no. 87

CATALOGUE
W 362

Monet, *Belle-Ile, Effect of the Rain*, 1886, oil on canvas [Bridgestone Museum of Art, Tokyo, Ishibashi Foundation]

98
The Seaweed Gatherers

This superb painting was executed at Le Pouldu in December 1889. It was the subject of one of Gauguin's most moving and fascinating letters to Vincent van Gogh: "At the moment, I'm working on a painting of women gathering seaweed on the beach. I have pictured them like boxes rising by steps at regular distanced intervals, in blue clothes and black coifs despite the biting cold. The seaweed they are collecting to fertilize their land is ocher, with tawny highlights. The sand is *pink*, not yellow, probably because it is wet, and the sea is a dark color. I see this scene every day and it is like a gust of wind, a sudden awareness of the struggle for life, of sadness, and of our obedience to the harsh laws of nature. It is this awareness that I have tried to put on canvas, not haphazardly, but methodically, perhaps by exaggerating the rigidity of some of the women's poses and the darkness of some of the colors etc. All this may be *mannered* to some extent, but on the other hand is there anything about a painting we can really call natural? Since the very earliest times, *everything* about painting has been utterly conventional, intentional, etc."[1]

The Seaweed Gatherers is in fact a highly studied composition. We know of at least one preparatory drawing of the woman in the foreground and the dog;[2] and the little oil on cardboard of the same subject (W 348) is perhaps also a study for this canvas, judging by its simpler, more lifelike approach.

Except for shepherdesses or herdsmen, Gauguin seldom painted peasants or fishermen at their labors. His attention seems suddenly to have been drawn to the theme of physical work (a traditional subject of Western art) while he was at

1. Cooper 1983, no. 36.2-36.3.

2. Private collection, Paris. Pickvance 1970, pl. 44.

3. Cooper 1983, no. 36.2

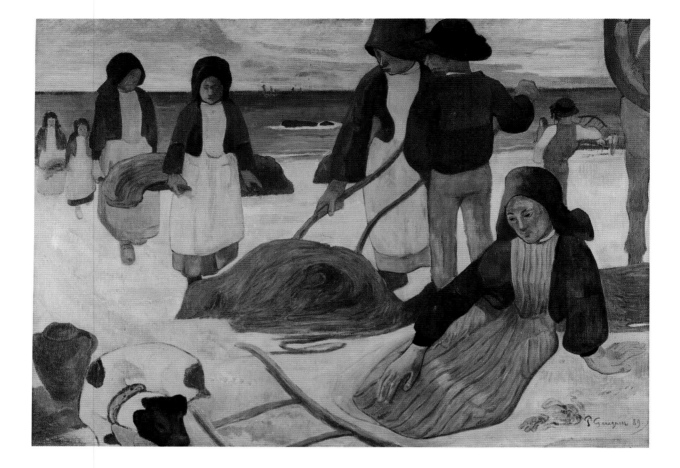

The Seaweed Gatherers

1889

87 x 122.5 (34 x 48¾)

oil on canvas

signed and dated below and at right,
P. Gauguin 89

EXHIBITION
Basel 1949, no. 36

CATALOGUE
W 349

Museum Folkwang, Essen

shown in Paris only

Gauguin, *The Haymakers*, 1889, oil on
canvas [private collection, Basel]

Le Pouldu in the second half of 1889. At this time he painted two harvest scenes, W 351 and W 352. A study of *faneuses* (haymakers), W 350, also dates from this period. The harvesting of seaweed to fertilize vegetables must have captured his imagination because of its strangeness and the beauty of its gestures. In *The Seaweed Gatherers* Gauguin depicts a procession of four women carrying kelp, at left; he aptly describes them as producing a "poupée-gigogne," or Russian doll, effect. The couple at the center gathering the seaweed with pitchforks seem frozen in a kind of trance that is complemented by the dreamy, Asiatic face of the Breton woman in the foreground. At right, with a boldness of construction that is worthy of Manet or Degas, Gauguin has placed the breast of the carthorse who will haul the wagonload of kelp up to the fields. The costumes are the same as those in *Young Girls by the Sea* (cat. 91), with *marmottes*, or headscarves, and the light-colored or striped pinafores.

Gauguin probably painted this canvas in his rented studio at Le Pouldu, with its view across the beach known locally as the "Grands Sables."[3] The most striking thing about the picture is what Gauguin himself made clear in the same letter to Vincent quoted above: that he has consciously blended meticulous observation of nature (note the remark about the color of the sand, showing that his choice of pink is anything but arbitrary), with his unique gift for communicating emotion and a sense of myth. It is no exaggeration to say that this Breton painting is comparable in its way with the later *Where Do We Come From? What Are We? Where Are We Going?* It is a symbolic frieze, perfectly expressing the vital energy and melancholy that belong in equal measure to Brittany, to the people of Brittany, and to Paul Gauguin himself.—F.C.

99
Self-portrait with Yellow Christ

In this portrait, Gauguin attempted to show himself without emotion or irony. He completed the painting during a particularly intense and productive period. It is probably the most serious and moving of his "effigies": the expression of his face is drawn, reserved, and inscrutable, while emotion is conveyed by the pictures behind the figure. This is not the character Gauguin was wont to show the public, but the classical device of the painter in front of his work.

In the background are two of Gauguin's recently completed works. They were two efforts with which he was particularly pleased: *The Yellow Christ* (in reverse, since it is seen through a mirror), finished several weeks earlier, and his tobacco jar self-portrait made early in 1889 (cats. 88, 65). The latter was painted from a photograph,[1] since the original was at Schuffenecker's house in Paris.[2]

1889-1890

38 x 46 (14⅞ x 18)

oil on canvas

private collection

EXHIBITIONS
Paris 1923, no. 21; Cambridge 1936, no. 23; Baltimore 1936, no. 14; Paris, Orangerie 1949, no. 23; Lausanne 1950, no. 14; Munich 1960, no. 56; Saint-Germain-en-Laye 1985, no. 172; Tokyo 1987, no. 30

CATALOGUE
W 324

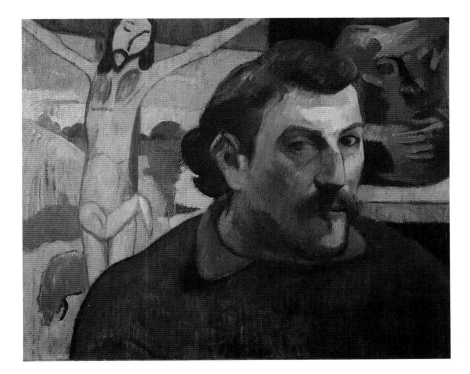

1. Bodelsen 1964, 135.

2. See letter from Gauguin to Madeleine Bernard, Malingue 1949, XCVI, quoted cat. 65.

3. See letter from Gauguin to Theo, 20 October 1889, in Cooper 1983, no. 21.1.

4. Malingue 1949, XCI. The request for the photograph clearly shows the use he intended to make of it: "I would like you to make me a photograph of the pot, well-lighted, with reflections coloring the front standing out against a clear background." Malingue 1949, no. CVI.

Conflicting information has caused some confusion about the date of this portrait. The presence of the *Yellow Christ* could place it in September 1889, because it appears that the *Christ* was no longer in Gauguin's possession after that time, as there is evidence it was included in the second package of paintings Gauguin sent to Theo van Gogh before leaving Pont-Aven for Le Pouldu on 2 October.[3] The fact that the portrait remained in Pont-Aven at Mme Gloanec's until 1903 suggests that Gauguin left it there, as security or as a gift, before he left for Le Pouldu. Yet, Emile Bernard did not send Gauguin the photograph of the pot until January 1890.[4] Hence, there are two possible hypotheses: either the painting was completed in January 1890, and the *Yellow Christ* had not been sent to Theo, or else Gauguin began the painting in September 1889 and added the pot afterward[5] during a subsequent stay at Mme Gloanec's inn. The theory that the picture was

van Gogh, *Self-Portrait,* 1887, oil on canvas
[Oeffentliche Kunstsammlung Basel]

Poussin, *Self-Portrait,* 1650, oil on canvas
[Musée du Louvre, Paris]

Vuillard, *The Dining Room of Maurice Denis*
[private collection]

5. Amishai-Maisels 1985, 132, also put forth this hypothesis.

6. See Mothéré as quoted in Chassé 1921, 30.

7. Malingue 1949, XCI.

8. Denis 1909, 194-195.

painted at two separate times seems the most plausible. Before the addition of the tobacco jar, the composition was very balanced and calm, probably reflecting Gauguin's state of mind in his September letters, when he was less tortured and depressed than at the beginning of winter.

The choice of the two background works was clearly made with a view to developing the central figure. The centered image of *Yellow Christ* seen close up beside the face is the first appearance of a theme Gauguin developed extensively in his later self-portraits, namely the association of the artist with the ideas of Christ and sacrifice. At the same time, the way the body and arm of Christ frame Gauguin's head seems intentional, implying that Gauguin's destiny was both protected and sanctified.

On the other hand, the ceramic tobacco jar with self-portrait symbolizes the grimacing primitive self and its elementary need, tobacco, which Gauguin could not do without.[6] The Christ represents the artist's sacrifice, but the tobacco jar shows his feeling of isolation and abandonment. This is made clear in a letter to Bernard, in which the idea of the jar comes to him by association, while writing of his loneliness.[7] This is in fact a many-sided symbolic portrait, encompassing the "angel" and the "beast," the ideal and the material, the two sources of his art, such as Gauguin postulated during his discussions with Meyer de Haan at Le Pouldu. The face of the portrait reflects discipline and self-control, and the two objects represent everything that this self-control implies: solitude, abandonment, and sacrifice.

By a fortunate twist of fate this self-portrait fell into the hands of a young artist who was capable of loving and understanding it, the painter and Nabi theoretician, Maurice Denis. He bought the picture from Marie-Jeanne Gloanec at Pont-Aven in 1903, and kept it all his life. A painting by Vuillard shows it shortly after its purchase, in situ on the wall of the Denis dining room at Le Prieuré, Saint-Germain-en-Laye. Three years later, Denis bought a self-portrait by Vincent van Gogh (1887, Offentliche Kunstsammlung, Kunstmuseum, Basel). It is intriguing that Denis should have contrasted these two self-portraits to prove that Gauguin was a master in the classic mold, while van Gogh "led the young backward to romanticism. . . . I have before me a fine self-portrait of Vincent. The green eyes, the beard, and the red hair are features of a strongly constructed pale face. The background, with its Japanese print, is of little importance. The painting is a study: but a well-thought-out, premeditated study. I see its faults, . . . but it is also an expression of life, and of intense truth." Of the Gauguin self-portrait, Denis remarked, "it makes no such impression: but it has greater didactic interest, and furthermore it is strongly influenced by the technique of Cézanne. Firstly, it is a balanced composition: the distribution of the shadows, the colors, and the chiaroscuro convince me that the painter did not intend to make a fragmentary study, but a painting. Instead of the harsh angles of van Gogh, there is a nose, an ear, and features that submit to the requirements of the composition and which are stylized in the manner of Italian decorators. . . . Like Cézanne, and through Cézanne, Gauguin seeks style. . . . Gauguin, who had so much disorder and incoherence in his life, would stand for neither of these things in his painting. He loved clarity, which is a sign of intelligence."[8]–F.C.

100
Cattle and Peasant Woman in a Landscape

1889–1890

26.4 x 31.9 (10¼ x 12½)

watercolor and gouache on cardboard with gesso preparation

signed below and at left, *P. Go.*

private collection

CATALOGUE
W 343 *bis*

1. Malingue 1959, 38.

2. Welsh in Saint-Germain-en-Laye 1985, 124.

3. Welsh 1988.

4. See cats. 67-77. Chassé 1955, 73.

This gouache is without question no. 18 on the 1895 list of photographs of works by Gauguin in the possession of Marie Henry.[1] We know that Gauguin and Meyer de Haan, and later Filiger and Sérusier, gradually covered Marie Henry's dining room at Le Pouldu with a variety of decorations between the autumn of 1889 and the summer of 1890.[2] The placement of each object and its identity was later carefully recorded and published in 1920,[3] but even before this time Henri Motheré, the husband of Marie Henry, had confirmed the presence of a series of gouaches and their exact position on the wall: ". . . to the left, all along the wall, were painted cardboard panels, two lithographs on yellow paper, . . . a little canvas. . . ."[4]

Of these "painted cardboard panels," some, including this work, were certainly by Gauguin. The fantastical, rhythmical gaiety is pure Gauguin, as is the combination of colors; for instance the pink of the low wall against the yellow ocher of the ground, or the varied greens of the flowery bank at left. Similar willows had already appeared in paintings of the previous year (*La Femme à la cruche*, W 254, and *Les Saules*, W 357) as well as in *Le Saule* (W 347), painted in 1890.

The sunken track is a common feature of the Breton countryside. The sides of such tracks are built up with stones, and they are rimmed with trees, allowing human beings and animals to pass more or less protected from the stormy weather of the Breton coast.

Gauguin used angular or curving shapes in as many rhythmical and humorous notes as possible: the cattle standing stubbornly athwart the track, the bare, slightly comical willows, the complicated motif of the woman's costume. Here we are on the brink of art nouveau, as in *The Kelp Gatherers* (cat. 101), which originally hung beside this gouache on the wall of the dining room at Le Pouldu. Both share an obvious delight in the dancing play of curves, a feature then unique to Gauguin.–F.C.

101
The Kelp Gatherers

autumn 1889

280 x 320 (11 x 12⅝)

graphite and gouache on gray millboard
coated with white primer

Fujikawa Gallery, Japan

EXHIBITIONS
Paris 1919, no. 22; Tokyo 1987, no. 51

CATALOGUE
W 392

Gauguin clearly defined the synthetist, decorative style of this gouache in a preparatory drawing (P 45). He stressed the broad, dancing movements of the women, and the undulating, rolling waves behind them, which in reality would be much farther off and smaller than they appear here. The artist has simply brought them forward to frame his two figures. With complete self-assurance he contrasts the vivid blue of the bodice of the left figure with the grays and greens of the scene around her. The hoods, the warm clothes, and the waves suggest September or October weather.

This gouache, with the title *Les Pêcheuses de goëmon*, was almost certainly one of the works by Gauguin that decorated Marie Henry's inn at Le Pouldu. According to contemporary descriptions, a series of painted cardboard panels hung on the left-hand wall of the dining room (see cats. 92-96). A published list[1] of photographs of works by Gauguin that were once in the hands of Marie Henry's heirs includes this gouache, as no. 17.

Gauguin always paid special attention to the specific details of costumes worn at Pont-Aven and Le Pouldu, and studies for the same low-cut bodices and ample bonnets exist in his 1888 sketchbook.[2]–F.C.

1. Malingue 1959, 38.

2. Huyghe 1952, 89, 91.

102
In Brittany

1889

379 x 270 (14¾ x 10½)

gouache, metallic gold paint, and india ink, selectively heightened with gum arabic, on gray millboard covered with wove facing paper

titled, dated, and signed at lower left in india ink, *En Bretagne 89 P. Go*

The Whitworth Art Gallery, University of Manchester, England

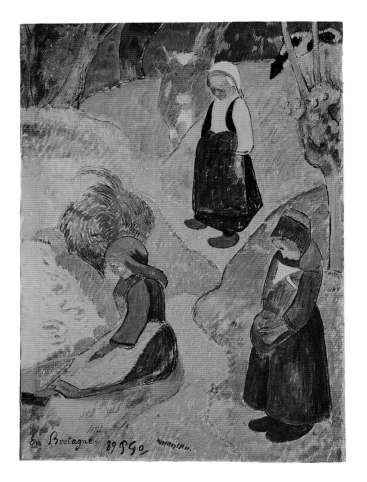

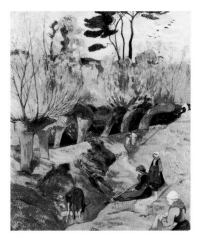

Gauguin, *The Willow Trees*, 1889, oil on canvas [National Gallery, Oslo]

1. Most specialists, including Ronald Pickvance and Peter Zegers (who has made a technical analysis of the work), accept the attribution of this watercolor to Gauguin. This has, however, been contested, notably by Douglas Cooper.

This watercolor poses certain problems.[1] The hatching technique is most uncommon, though not inconceivable, in Gauguin's work at this time, while the surprising touches of gold paint definitely look like something Gauguin might have done during this experimental phase of his career. The children's bonnets, called *marmottes*, are repeated in several other paintings (see cat. 92, W 345), and there is a fine Gauguin pencil study of this type of headwear in the Fogg Art Museum, Cambridge (P 43).

 The main theme of the work is contained in the center of an oil painting now in Oslo (W 357). It is difficult to know for certain whether this watercolor is a preparatory study for the oil, or whether it was executed shortly after the Oslo picture; both are dated 1889. In the oil painting the two little girls in the foreground are placed one against the other, but the path winding upward is the same. Both works include the cow at the top of the path, which also appears in another painting (cat. 100). The willow tree at upper right is also present, but on the left, in the oil.—F.C.

103
The Follies of Love

1890

diameter 273 (10⅝)

graphite and gouache on gray millboard
coated with white primer

inscribed at top center, in gouache, *les Folies
de l'*[Amour]; signed and dated at lower left,
in gouache, *PGO 1890*

private collection

EXHIBITION
Paris 1919, no. 20

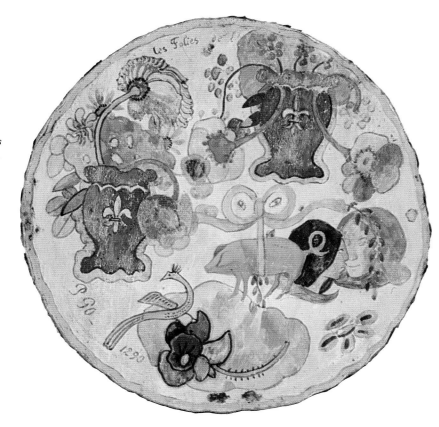

1. Malingue 1959, 38.

2. Hôtel Drouot sale, 16 March 1959, no. 106
(reproduction). The author has not seen this
object and can only say the attribution is a
probable one.

3. Rewald 1978, 276.

4. Pickvance 1970, 28.

During the winter of 1889-1890, while he was staying at Marie Henry's lodging
house, Gauguin painted a series of round gouaches on cardboard. These have
sometimes been identified as tablemats,[1] but actually they are designs for plates.
Four are known to have survived. One of these is little known, with flowers, fruits
and a cow's head.[2] The other three, *Long Live the Joys of Love*, which, like *The
Follies of Love*, used to be in the Thannhauser collection; *Homis* [*sic*] *soit qui mal y
pense*, of which only the zincograph survives (see cat. 77); and this work, have
been published together by Rewald.[3]

The "joys" design is a Breton woman in costume beneath a large beaker
filled with fruits and flowers; its twin, "the follies," is altogether more interesting
and amusing. It has been noted, with some justice, that this is a light, humorous
version of Gauguin's feelings about love, halfway between the creation of his relief
sculptures *Be in Love* and *Be Mysterious* (see cat. 110). Using vivid tints and
deliberately naive graphics, Gauguin arranged various objects against a white
background. The relationship between these objects and the title of the gouache is
sometimes clear, and sometimes less so. For example, there are two vases with
fleurs-de-lis, these flowers being not only the emblem of the French royal house,
but also that of Brittany since the accession of Queen Anne of Brittany. But why do
the vases contain wilting flowers? The intention of the little peacock must be to
show the vanity of love, or the need to show one's best colors when engaged in
love's endeavors. The two heads of exotic women (the one on the left an Inca type,
the one on the right a composite Breton-Asiatic) are no doubt whispering am-

orous confidences to one another. The animals in the middle of the composition were favorites in Gauguin's repertoire at the time (see cat. 43), just as they were later in Tahiti, where he described them as "adorable little black pigs, snuffling with their snouts the good things we will later eat, and indicating their interest with a jiggle of their tails."[5] Nor should we forget the hoary French proverb, which Gauguin certainly had in mind: "En tout homme il y a un cochon qui sommeille" (there's a sleeping pig somewhere in every man), which awakens in the company of women.

Gauguin decorated his little pig with a ribbon, like a gift, which gives it a toylike, piggy-bank air. Perhaps the eyes, open wide behind the rippling ribbon, are meant to express Gauguin's enduring amazement at the follies lovers commit.–F.C.

104
Eve

In 1929 this work was called a statuette of a Maori woman, and it was dated after Gauguin's return from his first voyage to Tahiti.[1] The subject is actually Eve, and has since been more correctly dated winter 1890, when Gauguin was in Paris.[2] Jean de Rotonchamp described it during a visit to Schuffenecker's studio in rue Durand-Claye, where Gauguin was staying. He wrote: "On a turntable, swaddled in wet cloth, in front of a sheet thrown over a folding screen, was a maquette in red clay which the artist was infusing with life, a standing Eve richly draped in her own loose tresses."[3]

The bodily structure of the model is very different from that of the two Gauguin ceramics dated immediately after the artist's return from his first voyage to Tahiti (cat. 211, G 115). Indeed, the statuette as a whole answers to European rather than Tahitian criteria. Thus the date of 1890 is more likely correct.

The "glazed statue in stoneware" shown in 1891 in Brussels, along with "three vases (pottery)" and the carved wooden figures represented in the *Be in Love* (G 76) and *Be Mysterious* (cat. 110) reliefs, was Gauguin's *Eve*.[4] It belonged to Schuffenecker at the time. The wooden pieces drew much critical sarcasm, being dubbed "Gauguinism"[5] among other things. However, *Eve* should be counted among the "one or two marvels of glazed pottery that complete Paul Gauguin's contribution to the exhibition,"[6] as mentioned by P. M. Olin in the *Mercure de France*. The critic A. J. Wauters was similarly indulgent: "I prefer the glazed statuette of a woman … which Gauguin has placed in the first room at the XX Exhibition"; elsewhere he calls it "that one-armed statue."[7] Clearly, he is talking about *Eve*, which lacks a right arm. C. Gray observed that the left arm was fired separately, to be stuck on to the torso later,[8] which was a frequent practice in modeling a delicate piece.

This ceramic was left on deposit at Boussod and Valadon's gallery toward the end of 1890, along with many other works by Gauguin. It was valued at 700 francs, minus the 300 francs already paid for it by Manzi, Joyant's associate at the gallery.[9] In his Brittany sketchbook, Gauguin noted, "Manzy advanced 300F on statue."[10]

Contrary to Bodelsen's hypothesis,[11] Gauguin probably referred not to *Eve* but to *Black Venus* in his letter to Mette (erroneously dated April 1890, instead of April 1889), in which he said he must return to Paris on the 20th of April ". . . to fire some statues."[12]

5. Guérin 1974, 166.

1. Barth 1929.

2. Gray 1963, 214; Bodelsen 1964, 138.

3. Rotonchamp 1925, 77.

4. Ahladeff 1979.

5. Anonymous, *La Chronique*, 23 February 1891. See Alhadeff 1979.

6. Olin 1891, 237.

7. Wauters 1891.

8. Gray 1963, 215.

9. Rewald 1973, 49 and 72.

10. Huyghe 1952, 222.

11. Bodelsen 1964, 138.

12. Malingue 1949, CI, 185. For the dating of this letter, see Cooper 1983, no. 14.4, n. 9, 107.

Eve

winter 1890

height 60, width 28, depth 27 (23⅝ x 11 x 10⅝)

glazed stoneware

signed in relief on the base, *P. Gauguin*

National Gallery of Art, Washington, Ailsa Mellon Bruce Fund

EXHIBITIONS
Brussels 1891, no. 3; Paris 1928, no. 32

CATALOGUES
B 55, G 92

shown in Washington only

Botticelli, *The Birth of Venus*, detail, 1480 [Uffizi Galleries, Florence]

13. Chassé 1955, 72, after Bidou 1903.

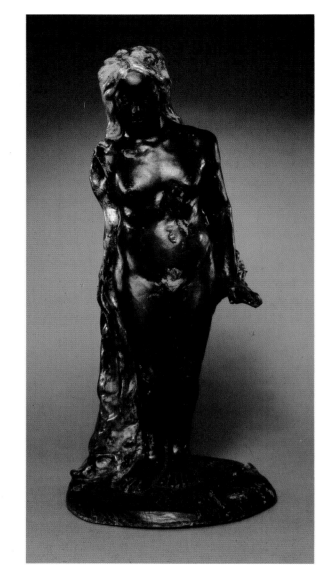

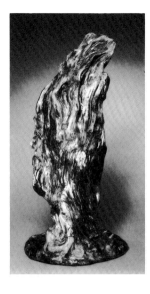

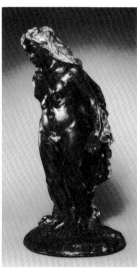

Eve's abundant tresses are glazed in ivory, verging on blue-gray in certain areas. She leans forward slightly in a dynamic pose. Her left hand rests on a shrub sprouting from the base on which she stands. This base is incised with leaves and sinuous shapes that invoke the surface of water.

The figure has a harmony of form that is exceptional in Gauguin's sculpture. Bodelsen saw it as one of many variants on the theme of standing women drawn from the frieze of the Temple of Borobudur. The *Black Venus* was one of the avatars of the crouching figures in the same bas-relief. No doubt there are also echoes of Botticelli's *Birth of Venus* in this graceful girl so atypical of the work of Gauguin, for a photograph of Botticelli's goddess was a feature of his room at Le Pouldu in 1890.[13] *Eve* is the antithesis of *Black Venus* of 1889; it is also a significant example of Gauguin's ability to transcribe the great figures of Western myth into his own exotic frame of reference.—C.F.-T.

105

Withdrawn from the exhibition

106
Portrait of the Artist's Mother

1890

41 x 33 (16⅛ x 13)

oil on canvas

Staatsgalerie Stuttgart

EXHIBITIONS
Paris 1906, no. 94, *Portrait de la mère*; Paris 1923, no. 23 (dated 1895); Basel 1928, no. 78; London 1931, no. 71; Paris 1936, no. 1; Paris, Orangerie 1949, no. 4 (dated c. 1893); Basel 1949, no. 52

CATALOGUE
W 385

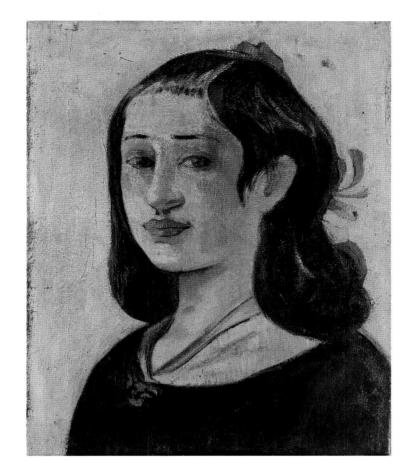

Aline Gauguin, the artist's mother, photograph [private collection]

1. Marks-Vandenbroucke 1956, 9.

2. *Avant et après*, 1923 ed., 132.

3. Marks-Vandenbroucke 1956, 12-13.

4. *Avant et après*, 1923 ed., 135-136.

Aline Chazal, who was born in 1825, married Guillaume Clovis Gauguin in 1846; Paul, born in 1848, was their second child.

Aline's parents were both strong, indeed violent personalities. André Chazal, her father, was an engraver and lithographer who is remembered chiefly for the trial that followed his attempt to murder his wife,[1] the famous and very beautiful militant socialist, Flora Tristan. Of his grandmother, the author of *Pérégrination d'une paria* (*Wanderings of an Outcast*), Gauguin spoke with a mixture of pride and mockery. He was no great advocate of feminism. "Proudhon said she had a touch of genius; I have no way of knowing if this was so, but I'm willing to go along with Proudhon. Probably she couldn't cook. She may have been a socialist blue-stocking and an anarchist . . . but one thing I'm sure of is that Flora Tristan was a very pretty, very noble woman."[2]

Aline had a restless childhood,[3] but was remembered by her son just as she appears in a photograph he possessed of her. She was apparently a sweet and timid young woman, and yet, "although she had a noble, Spanish quality, my mother was of a violent nature, and I remember some slaps from that small hand, as supple as rubber. Straight afterward though, in tears, she would kiss me and comfort me."[4] Aline lost her husband at the age of twenty-four, and went to live with her mother's family in Lima, Peru, between 1849 and 1854. "How gracious

5. *Avant et après*, 1923 ed., 138.

6. Cited by Marks-Vandenbroucke 1956, 26.

7. Dorra 1967, 109-111.

Gauguin, *Eve Exotique*, 1890, gouache (?) on millboard transferred to fabric [private collection, Paris]

and pretty she was when she put on the costume of Lima, with the silk mantilla all but covering her face, revealing one eye only; her gaze was as sweet as it was commanding, and so pure and caressive."[5]

George Sand has left a description of Aline at nineteen, in 1845, which corroborates Gauguin's memory of her: "a young girl . . . seemingly as tender and even tempered as her mother was domineering and irascible. The child is like an angel; her sadness and grief, her fine eyes, her solitude, and her affectionate modesty touch my heart."[6]

Gauguin painted this little picture from a photograph of his mother, but we do not know precisely when. Aline had died in 1867; Gauguin learned of her death when the merchant ship of which he was second lieutenant stopped off in India. Hence, both his saddest and most delightful memories of his mother were always linked to exotic countries. The disturbing resemblance between the face in his painting of Eve (W 389) and that of Aline may well justify the choice of 1890 as the date of this portrait.[7]

In the Eve painting, Gauguin seems to have performed a kind of sentimental rearrangement of his subject matter based on the photograph of his mother. The dark-skinned figure, a forerunner of the Tahitian Eves, is a composite. Her body comes from the Borobudur temple reliefs that Gauguin had seen at the Exposition Universelle, her surroundings are taken from his memories of Martinique, and her face is borrowed from that of his mother in the old photograph. This must have given him the idea of painting the portrait of Aline, but in it she is transformed by him into an island girl. The white lace collar is replaced by a simple ribbon, the skin is less white than it appears in the photograph, and the mouth is thicker. In other words, the romantic schoolgirl has become a young, exotic beauty, a synthesis of Gauguin's memories of his mother in Peru and of the associations he made, as a boy, between her and his Indian nannies.

Traditionally, artists have waited until they themselves have reached maturity before painting their mothers as old women. This is the case with Rembrandt, Whistler, and Vuillard. Here Gauguin, in his forties, has painted a tenderly discreet portrait of Aline, unsigned and undated, and which he never put up for sale. He has given her the form of his own exotic feminine ideal, and yet he has immortalized her just as she was as a young girl.—F.C.

107
The Haystacks, or The Potato Field

1890

73 x 92 (28⅞ x 36)

oil on canvas

signed and dated at lower right, *P. Gauguin 90*

National Gallery of Art, Washington. Gift of
W. Averell Harriman Foundation in memory
of Marie N. Harriman

EXHIBITIONS
Paris 1906, no. 16; New York 1936, no. 15; San
Francisco 1936, no. 10; New York 1946, no. 11;
New York 1956, no. 19

CATALOGUE
W 397

1. Cat. 108 and W 394, W 395, W 396,
W 398, W 399, W 400.

2. W 395 and W 396.

Along with *Landscape at Le Pouldu* (cat. 109), this painting is one of a series of landscapes executed by Gauguin during his stay at Marie Henry's auberge in 1890.[1] The sites represented are either the gentle hills of the Breton hinterland or the picturesque coastline.[2]

These landscapes are characterized by a rhythmical conception of space powerfully organized in layers. This is especially true in this picture, where the various alternating bands of color, from the foreground that is handled as a decorative frieze to the sky with its raised horizon, are strongly differentiated. The peasant woman and her cattle moving across the foreground are reduced to flat, heavily contoured silhouettes with powerful contrasts of dark and light values; these in turn throw the variety of the middle ground into stark relief.

At the center of the canvas stands the massive shape of the haystack, which has the same solid quality as its predecessor in *Farm at Arles* (cat. 59). Overtones of the broad spaces painted by van Gogh in 1888 are also present, with tiers of colors playing an important role in the front of the composition.

This accomplished landscape originally belonged to the great collector Gustave Fayet. It is painted in the classic Pont-Aven style, which so strongly influenced the painters who gravitated around Gauguin, a style that reappears in many pictures by Emile Bernard, Meyer de Haan, Séguin, Filiger, and Verkade.—C.F.-T.

108
Roses and Statuette

c. 1890

73 x 54 (28½ x 21)

oil on canvas

signed at lower right, *P. Go.*

Musée Saint-Denis, Reims

EXHIBITIONS
Paris 1906, no. 217; Paris, Orangerie 1949,
no. 19; Tokyo 1987, no. 52

CATALOGUE
W 407

Matisse, *The Goldfish*, 1912 [Staten Museum for Kunst, Copenhagen]

1. W 329.

In this simply constructed still life, Gauguin represented his statuette of a Martinican woman (cat. 86) viewed from the back: no doubt this was the angle the artist preferred. The painter made a habit of including earlier ceramics or paintings in his canvases (cat. 164).

Contrary to Gauguin's other 1890 still lifes painted in a rather traditional style, *Roses and Statuette* lays special emphasis on the tabletop, which occupies almost half of the composition. It consists of a broad pink mass, strongly outlined, that stands out against a backdrop with two distinct zones: a beige wall and what appears to be a painting with a blue background. The stylized motif of yellow flowers with long stems crossing one another is the same as that in *Self-portrait with Halo* (cat. 92), and is also found in another decoration from the Le Pouldu dining room entitled *Jeanne d'Arc* or *The Shepherdess*.[1] These similarities, along with the presence of the Martinican who was also a part of the Le Pouldu décor, suggest that this still life was painted at Marie Henry's house in 1890.

The pitcher seen from above in the foreground reminds us of later still-life arrangements by Bonnard; the painting in general also prefigures several of Matisse's compositions, notably *Goldfish*, 1912, which has the same association of flowers, statuette, and pitcher. *Roses and Statuette* was exhibited at the Gauguin

retrospective at the Salon d'Automne in 1906, where Bonnard, Matisse, and other modern artists apparently found new inspiration in works such as this.

Roses and Statuette first belonged to Gauguin's friend Jean Brouillon, who wrote an important monograph on the artist under the name of Jean de Rotonchamp in 1906. He bequeathed this painting to the Musée de Reims in 1945, along with a large collection of Gauguin's prints.—C.F.-T.

109
Landscape at Le Pouldu

summer 1890

73 x 92 (28½ x 35⅞)

oil on canvas

signed and dated at lower right, *P. Gauguin 90*

National Gallery of Art, Washington, Collection of Mr. and Mrs. Paul Mellon

EXHIBITIONS
Brussels 1904, no. 49; Basel 1928, no. 59 or 69 (according to the catalogue edition); Paris, Orangerie 1949, no. 22

CATALOGUE
W 398

Meyer de Haan, *Landscape at Le Pouldu*, c. 1889-1890 [Collection of Mr. and Mrs. Arthur G. Altschul]

1. W 394; Meyer de Haan, *La Ferme au Pouldu*, Otterlo, Rijksmuseum Kröller Müller.

2. Rewald 1973, 69.

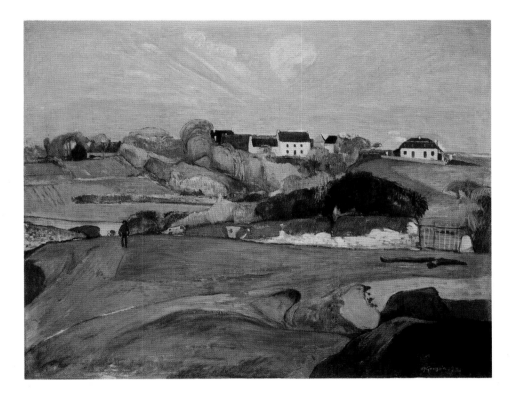

Like its contemporary, *The Haystacks* (cat. 107), *Landscape at Le Pouldu* is a good example of the synthetist style that Gauguin used in his landscapes in 1890. The site depicted, fields studded with small stretches of woodland, is the valley of Kerzellec, just behind the hamlet of the same name near Le Pouldu. The buildings against the sky at the center are those of the farm at Porsguern, which still exists today. Gauguin and Meyer de Haan, as master and pupil, sometimes painted the same subjects simultaneously; hence the essential elements of this landscape also occur in a work by the Dutch painter from the Altschul collection. The two artists also painted another farm at Kerzellec,[1] the buildings and courtyard of which are also still intact today.

Landscape at Le Pouldu was in the collection of Octave Maus, the Belgian organizer of the XX Exhibitions in Brussels. It was chosen for him in 1890 by a Belgian painter, Eugène Boch, who was a friend of Vincent and Theo van Gogh and whose sister Anna was also an exhibitor.[2]—C.F.-T.

110
Be Mysterious

September 1890

73 x 95 x 0.5 (29 x 37½ x 1/16)

lime wood, polychrome

carved signature at lower right, *Paul Gauguin 90*; carved inscription on a banderole at upper left, *soyez mystérieuses*

Musée d'Orsay, Paris

CATALOGUE
G 87

EXHIBITIONS
Brussels 1891, no. 2; Paris 1906, no. 53

shown in Paris only

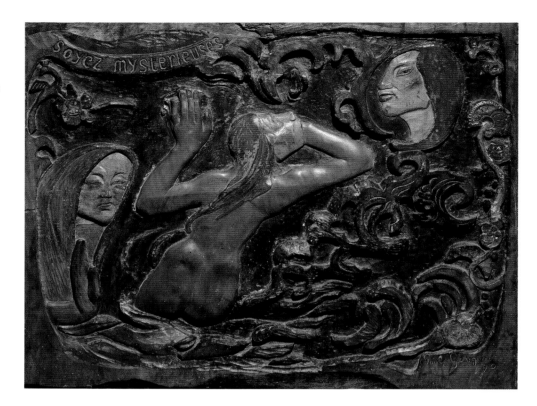

1. Malingue 1949, CXII.

2. Cooper 1983, no. 27.1.

3. Based on a mixture of chalk and animal glue, according to an analysis carried out by the laboratory of the Musées Nationaux. See Cachin 1979, 215.

4. See Gray 1980, 42-47.

5. Aurier 1891, 165.

By September 1890, Gauguin, still in Le Pouldu, was already dreaming of Tahiti. "I've been working hard lately," he wrote to Bernard, "and I've given birth to a woodcarving, a pair to my first: it's called *Soyez mystérieuses*, and I'm very pleased with it. In fact I don't think I've ever done anything as good before."[1] He even wrote to Theo van Gogh: "I'm just finishing a woodcarving that I think is much better than the first."[2]

The "first" woodcarving Gauguin referred to is the famous *Be in Love and You Will Be Happy* (fig., see cat. 65), which is much the same size as this one, but arranged vertically rather than horizontally. The principle and the technique are the same: the woman's body (and, in the case of *Be in Love*, the mask of Gauguin) is sculpted and left in natural, patined wood, the remainder of the relief being prepared with a wash and painted over.[3] Nonetheless, the styles of the two pieces differ considerably. The 1889 relief was charged with somewhat strident symbolism, such as the fox representing perversity,[4] in which desire and derision are mingled. The fulsome symbolist critic Albert Aurier compared the two carvings in an interpretation that bears the trademark of Gauguin himself: "How may we define the philosophy contained in this ironically titled bas-relief, *Soyez amoureuses et vous serez heureuses*, in which all lechery, all the struggles of mind and flesh, and all the pain of sensual delight seem to writhe and gnash their teeth? And how are we to describe this other carving, *Soyez mystérieuses*, which by contrast celebrates the pure joys of esotericism? Are they symbols of mystery, or are they fantastic shadows in the forests of enigma?"[5] This passage unquestionably contains something of what the artist wished to communicate at that time.

Why was Gauguin so happy with *Be Mysterious*? Perhaps because the piece was directly inspired by *In the Waves* (*Ondine*) (cat. 80), in which he felt he was achieving greater simplicity and expressive power after the feverish experiences of the previous year.

In this sculpture, Gauguin's Tahitian model emerges in his work for the first time, even before his departure for Tahiti. The body of the Breton Ondine is darkened and hardened by the patina of the wood; the face and the hand are those of the native sculpture of Java that Gauguin had seen at the Exposition Universelle in Paris in 1889, and which had set him dreaming. We know that he was preparing to leave for Tahiti when the carving was done, and he was probably devouring popular literature about the Pacific.[6] The faces on either side each represent something: the one on the right is definitely the moon (with the same red hair as Ondine), which regulates all the mysterious links between women and nature. By contrast, the malevolent face of the little Breton girl at right is more enigmatic; she has an expression that is more menacing than spiritual.

It has been noted that the carved and painted decor surrounding this nude, which symbolizes waves and foam, is based on a polychrome Japanese woodcarving of a legendary hero in turbulent waters. Gauguin must have seen this piece reproduced in *Le Japon artistique*, Bing's revue, in April 1889.[7] The text illustrated by this image would have intrigued him: "Polychrome woodcarvings such as this are one of the earliest forms of art, not only in Japan but also in Western countries; they date from the times before technical progress made it possible to work with stone or metal, when the wood was better suited to the rough implements available, and when colors satisfied the still-primitive tastes of mankind."[8] Thus Japanese art was not only a plastic, but also an intellectual model, the perfect vehicle for Gauguin's search for a more authentic primitive art.

There is a possibility that this woodcarving may originally have been two-sided,[9] and that the other side was also worked; this theory is supported by the list of Gauguin's works on deposit at Goupil's, which Joyant gave to Monfreid. In this list the two woodcarvings are described as follows: "One double-sided woodcarving; a woodcarving entitled *Be in Love*."[10] If this is the case, the two reliefs must have been separated at a later date.

One thing is certain: Gauguin gave high value to the carvings. In his 1891 letter to Theo van Gogh, Gauguin detailed the works he left on deposit, along with their prices;[11] most of the paintings are evaluated at between 300 and 500 francs, only a few of them attaining 500 to 600 francs. But the two reliefs, *Be in Love* and *Be Mysterious*, were valued at no less than 1,500 francs each.

Gauguin returned to the theme of *Be Mysterious* at the end of his life, on the left-hand horizontal panel surrounding the portal of the *House of Pleasure*, which he carved for the upper level of his last abode at Hivaoa (see cat. 257). The right-hand panel was based on *Be in Love*.

For a long time this relief was among the many Gauguin masterpieces in the collection of Gustave Fayet. The artist sent it to Paris in May 1901, where it remained on deposit for ten years, as a letter he wrote to Fayet attests.[12]

Like a number of the other works by Gauguin exhibited at the Salon d'Automne in 1906, this carving had a strong effect on those of his colleagues who saw it. Maillol, who knew Fayet well, must have been familiar with *Be Mysterious* before 1906; and Matisse's series of backs sculpted in relief[13] are clearly influenced by it. The first of this series was completed in 1908; the manner of its execution, as well as the gesture of the figure's arm, is nothing short of homage to Gauguin.–F.C.

6. Notably Le Chantier, *Tahiti et les colonies françaises de la Pacifique*, 1887, which gives a résumé of the contents of Moerenhout's book on the Polynesian religion, on which *Noa Noa* was later based. See Gray 1980, 49.

Japanese woodcut [*Le Japon artistique*, April 1889]

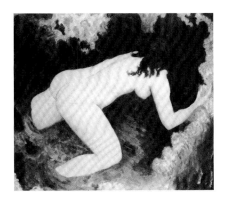

Maillol, *The Wave*, 1898, oil on canvas [Musée du Petit Palais, Paris]

7. Gray 1980, 51.

8. *Le Japon artistique*, April 1889, 156.

9. See Gray 1980, 207.

10. Loize 1951, 94.

11. Rewald 1973, 49.

12. Cachin 1979, 215, n. 1.

13. See fig., cat. 80.

111
Portrait of a Woman, with Still Life by Cézanne

late 1890 (?)

65.3 x 54.9 (25¾ x 21⅝)

oil on canvas

signed and dated at lower right, *P. Go. 90/*

The Art Institute of Chicago, The Joseph Winterbotham Collection

EXHIBITIONS
London 1924, no. 45, *L'Arlesienne*; Houston 1954, no. 18, *Marie Henry*; Edinburgh 1955, no. 35, *Marie Henry*; Chicago 1959, no. 24, *Marie Derrien*; London 1966, no. 33, *Marie Derrien*

CATALOGUE
W 387

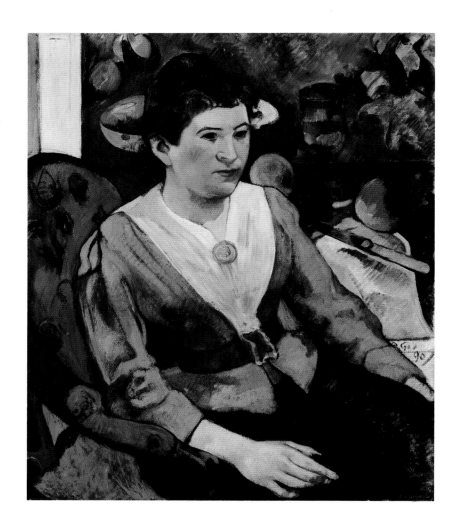

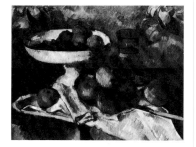

Cézanne, *Fruit Bowl, Glass, and Apples*, 1885-1887, oil on canvas [private collection]

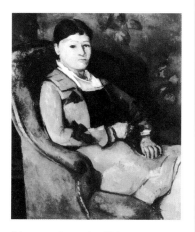

Cézanne, *Portrait of Madame Cézanne*, 1881-1882, oil on canvas [Foundation E.G. Bührle Collection]

It is difficult to date precisely Gauguin's meeting with Cézanne. The impressionist Pissarro, who inspired both artists, probably introduced them in the late 1870s. While there is no account of direct contact with Cézanne in Gauguin's writings, for many years the Aix master provided a point of reference for Gauguin.

When Gauguin was still a bank employee, he gathered a large collection of impressionist works, including five or six canvases by Cézanne.[1] Among these was the still life *Fruit Bowl, Glass, and Apples*,[2] which appears in the background of this portrait. In 1884 Gauguin took this painting with him to Denmark, with the rest of his collection. This is confirmed in Gauguin's list of works that went to Copenhagen – *10 (toile de dix) Nature Morte* – in the *Album Briant* at the Louvre. Apparently Gauguin prized this work more highly than the rest of the paintings in his collection, which he sold one by one to augment his ever-disastrous finances. He probably referred to Cézanne's still life in a letter to Schuffenecker, from early June 1888: "The Cézanne you ask for is an exceptional gem and I have already refused 300 francs for it. It's the apple of my eye and I shall never part with it except in a case of direst necessity. I would rather sell the last shirt off my back – and whoever would be fool enough to buy that?"[3] Despite Gauguin's apparent

1. On the five or six Cézannes in Gauguin's collection, see Bodelsen 1962, 204-211, and Merlhès 1984, n. 115.

2. Venturi 1936, no. 341.

3. Merlhès 1984, no. 147.

4. Mirbeau 1914, preface, and Geffroy 1924, vol. 2, 68.

5. Bodelsen 1970, 606; Rewald 1961, 182. Douglas Cooper letter, 1983, which dates the painting from Le Pouldu in 1889 (curatorial file, The Art Institute of Chicago).

6. Purchased as such by the Art Institute in 1925; see *Bulletin of the Art Institute of Chicago*, vol. 20, no. 1 (January 1926), 2.

7. Alexandre 1930, 29. This identification was formally denied by the daughter of Marie Henry and Meyer de Haan, Mme. Cochennec (curatorial file, The Art Institute of Chicago).

8. Rewald 1961, 183; this identification was refused by Père Pierre Tuarze, who knew Marie Derrien as a child (letter in the curatorial file, The Art Institute of Chicago). Also refused by Douglas Cooper (letter in the curatorial file, The Art Institute of Chicago, 1980).

9. Vollard 1937, 184.

10. Joly-Segalen 1950, XXXV, August 1897; XLVII, October 1898; LIII, 12 March 1899.

11. Joly-Segalen 1950, LXII, March 1900.

12. Cited in Bodelsen 1970, 606.

13. Musée d'Orsay, Paris.

14. Brettell 1987, 30.

admiration for Cézanne, the two were frequently at odds, as, for example, during the organization of the 1882 impressionist exhibition when Cézanne referred to Gauguin's art as "Chinese images," and blamed Gauguin for having stolen his (Cézanne's) "little sensation."[4]

The history of this still life is tantalizingly uncertain. And who was the model? Did she pose for Gauguin in Paris or in Brittany? If the latter, did Gauguin really bring the Cézanne still life there, as is generally claimed?[5] Many experts have been intrigued by this question, but none has produced a convincing identification. At one time, the painting was presumed to be a portrait of Mette.[6] A resemblance has been suggested between the mysterious model and the beautiful Marie Henry,[7] owner of the inn at Le Pouldu where Gauguin and Meyer de Haan settled in the autumn of 1889. Finally, Marie Derrien, nicknamed Marie Lagadu, a young servant of Marie-Jeanne Gloanec at Pont-Aven, was proposed,[8] but still the matter remains unresolved. Who can even say this woman is really a Breton? She has fine hands, and her bourgeois appearance has nothing in common with Gauguin's rustic Breton women. Hence the theory that this portrait could have been made on Gauguin's return to Paris in November 1890, using a Parisian model and with the framed Cézanne still life as background. In this case, as the Cézanne would need never have left the capital, the idea deserves consideration.

According to Vollard[9] Cézanne's still life occupied a prominent place in the studio on rue Vercingétorix in 1893. Gauguin, back from Tahiti and hard-pressed for money, was finally reduced to giving up his beloved painting. As several of his letters to Monfreid[10] attest, he entrusted the sale to the painter and dealer Chaudet. It was eventually sold in 1898 for 600 francs; Gauguin only received 400 francs, since Chaudet died in 1900 still owing him 200 francs.[11]

Even while Gauguin still owned the still life, Cézanne had acquired the status of master in artistic circles and was generally considered admirable, though fierce. The Polish painter Maszkonoski recounted in his memoirs of 1894[12] how Gauguin would show his picture to the young painters who frequented his neighborhood restaurant, *Chez Madame Charlotte*, and "explain" Cézanne to them. The impact of this work on the new generation of painters is obvious; it was featured in Maurice Denis' famous *Homage to Cézanne*[13] along with the likenesses of the major Nabi artists.

Nor does Gauguin's homage stop at the spectacular inclusion of the still life, in which he uses brushwork that mirrors Cézanne's. The model's pose and her pensive, noble look recall more than one portrait of Mme Cézanne by the Aix master. An X ray of the painting[14] has shown that Gauguin hesitated before settling on the pose for his model; he began by painting her with crossed hands, a pose similar to that of Mme Cézanne in several portraits by her husband. Coming one or two years before the richly colored paintings of Tahitian women, this canvas shows an admiration for Cézanne that in no way diminishes a decorative power and individuality that was all Gauguin's own. —C.F.-T.

112
Bust of a Young Girl with a Fox

This charcoal drawing, with its remarkable simplicity of line, is a preparatory study for *The Loss of Virginity* (cat. 113). It originally belonged to Octave Mirbeau, the writer, pamphleteer, and art critic, who, over the years, assembled a body of works by the artists he championed in his writing, such as Cézanne, Monet, Pissarro, van Gogh, Signac, Vuillard, Bonnard, and Vallotton. As the future author of *Journal d'une femme de chambre* (*Journal of a Chambermaid*, 1900), Mirbeau would scarcely have been alarmed by the subject of Gauguin's drawing.

In an article that appeared in *Le Figaro* on 18 February 1891, Mirbeau referred to Gauguin's work as follows: "I see . . . a hand that has mastered all the secrets of drawing and all the syntheses of line, and this delights me."

When Mirbeau died, this drawing was sold with the rest of his collection at the Galerie Durand-Ruel on 24 February 1919 under the title *La Fille au chien (Girl with a Dog)*. At this time, the painting for which it is a study was thought to be lost. Another fine Gauguin that Octave Mirbeau owned was the famous self-portrait *Christ in the Garden of Olives* (cat. 90).–C.F.-T.

c. 1890-1891

316 x 332 (12¼ x 13), irregularly shaped

charcoal selectively heightened with white chalk, on yellow wove paper

signed at top left, *P. Gauguin*

Marcia Riklis Hirschfeld, New York

shown in Washington only

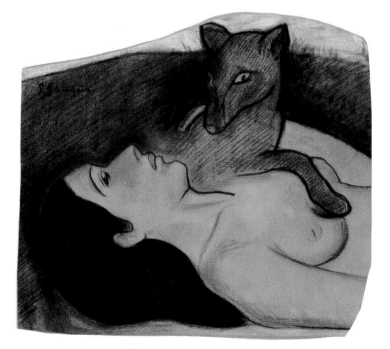

113
The Loss of Virginity

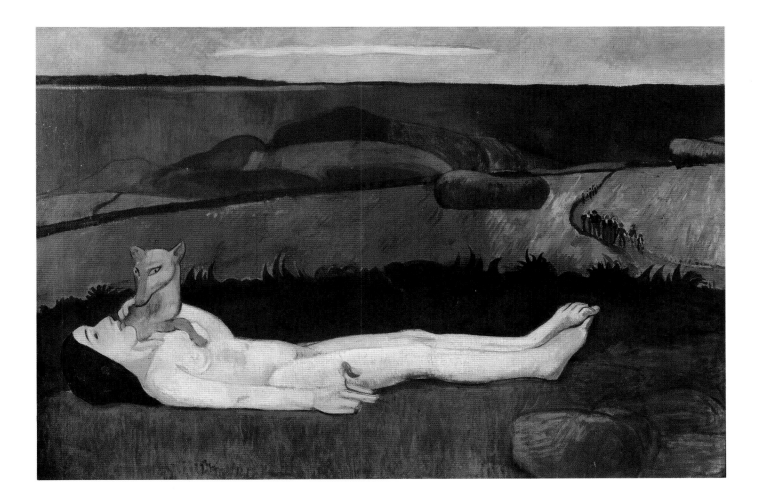

late 1890-early 1891

90 x 130 (35 x 50¾)

oil on canvas

The Chrysler Museum, Norfolk, Virginia.
Gift of Walter P. Chrysler, Jr.

CATALOGUE
W 412

EXHIBITIONS
Paris, Orangerie 1949, no. 24, *L'eveil du printemps*; Basel 1949, no. 41; Lausanne 1950, no. 40; Houston 1954, no. 23; Edinburgh 1955, no. 37; Chicago 1959, no. 26

shown in Washington only

1. Rotonchamp 1906, 71-72.

2. Sutton 1949, 104.

3. Sutton 1949, 104.

At the time that Jean de Rotonchamp described this painting in his important monograph on Gauguin,[1] he had no idea of its whereabouts. It was thought to be lost, stacked away "in some attic"; but in fact it had simply been bought by Comte Antoine de La Rochefoucauld, a painter and close friend of the neo-impressionists Seurat and Signac. La Rochefoucauld was also the protector of the Pont-Aven painter Charles Filiger, and we note without surprise that several of Filiger's gouaches contain almost exact copies of the background to Gauguin's masterpiece.

"As I recall," wrote La Rochefoucauld in 1944, "I purchased *La Perte du Pucelage* around 1896, at a sale of this master's paintings that took place just before his final departure for Tahiti."[2] Actually, in the sale in question, that of 18 February 1895, no painting of that title can be found; but lot 42, a nude, that did not figure in the auction record, probably was bought in by Gauguin and sold to La Rochefoucauld.[3] There can be little doubt that Henri Rousseau thought of Gauguin's unusual nude when he painted *The Sleeping Gypsy* in 1897. At the earlier sale of Gauguin's works in February 1891, La Rochefoucauld had purchased *La Couture* (W 358). *The Loss of Virginity* did not reappear on the Paris market until 1947,[4] after which it figured in the 1949 Gauguin retrospective at the Orangerie with the title *L'éveil du printemps* (*The Awakening of Spring*). It is hard to pinpoint the exact timing of the change of title from the frankly crude to the

Filiger, *The House of the Pan-Du*, pen and gouache [private collection]

Bernard, *Madeleine in the Bois d'Amour*, 1888, oil on canvas [Musée d'Orsay, Paris]

Gauguin, detail of *Be in Love and You Will Be Happy*, 1889, painted linden wood [Museum of Fine Arts, Boston, Arthur Tracey Cabot Fund]

4. Malingue 1959, 34. The work exhibited in 1923 at the Galerie Dru, no. 20, entitled *L'éveil de la pudeur*, dated 1892, and classified among Gauguin's Tahiti works, is probably not *The Loss of Virginity*; had the painting been exhibited at this time it would certainly not have escaped the notice of Rotonchamp.

5. Alias Gauguin, who served on the warship 'Desaix' during the war of 1870.

6. Rotonchamp 1906, 71.

7. Rotonchamp 1906, 72.

8. Chassé 1955, 87-88. The author rests his theory on evidence provided by Mme Bizet, the natural daughter of Juliette Huet and Gauguin.

chastely metaphorical: Rotonchamp said, "at the beginning of 1891, Gauguin . . . started a large composition which he considered symbolic, and to which the former helmsman of the 'Desaix'[5] gave the provisional title of *La Perte du Pucelage (The Loss of Virginity)*."[6]

The Loss of Virginity was painted in Paris, sometime after Gauguin's return from Le Pouldu, between November 1890 and his departure for Tahiti on 4 April 1891. According to Rotonchamp, it was completed at the beginning of winter. The scene is set in a Le Pouldu landscape, all the more synthetic in character because painted from memory. The same site reoccurs in several other canvases executed in Brittany between 1889-1890, notably W 344, W 364, W 395, W 396.

Rotonchamp reported, "Gauguin, who had only done nudes in the academies, had difficulty finding himself a model in Paris. Having no interest whatever in the ordinary pretty but characterless model, the painter chose instead a dark, skinny girl who cannot have had many suitors. He had a lot of trouble persuading her to pose – and when she finally did, how great was the disappointment!"[7] The model, according to Chassé,[8] was a twenty-year-old seamstress named Juliette Huet, whom Gauguin had met through his friend Daniel de Monfreid, and whom he mentioned several times in his letters.[9] Gauguin left her pregnant when he sailed for Tahiti, and she subsequently consigned all his letters and souvenirs to the fire. Juliette Huet died in about 1935, at age eighty-nine.[10]

The painting itself is ambitiously large, with vigorous and flat planes of colors, with strident contrasts. Gauguin was in close association with the symbolist literary milieu during the winter of 1890-1891. Among his friends at this time were Charles Morice, the poets Jean Moréas and Mallarmé, the critic Albert Aurier, the writers Jean Dolent, Julien Leclercq, Jean Brouillon (alias Rotonchamp) and Alfred Valette, the director of the *Mercure de France*.

The symbolism of this painting is much more primal than that of *The Vision after the Sermon* (cat. 50) or *Yellow Christ* (cat. 88). It is really a distillation of Gauguin's idealist and synthetist concepts just after the conclusion of his experience in Brittany and just prior to his departure for Tahiti.

The model lies full-length in the foreground, with her back to an autumn landscape summarized by horizontal bands of color. Her features are harsh, and her roughly contoured body is immobilized in the same attitude as Emile Bernard's *Madeleine in the Bois d'Amour*. To the chaste Madeleine, Gauguin has contrasted the naked, cadaverous body of Juliette, with her feet pressed one on top of the other like those of Christ nailed to the cross. This may be a reference to Holbein's famous *Dead Christ*, for which Charles Filiger, who had been with Gauguin at Pont-Aven and Le Pouldu since 1888, professed a fervent admiration.[11] There may also be something in the girl's pose of the Breton calvaries Gauguin knew so well.[12] In any event, the image combines the theme of the fall of woman, in the loss of her virginity, with the sacrifice of Christ.

During the same period, Gauguin copied Manet's celebrated Olympia (cat. 117), which had recently entered the Musée du Luxembourg. There is a sort of challenge in his provocative reprise of Manet's theme, which had caused such a scandal at the 1865 Salon. For example, Manet's black cat is replaced by a fox, whose foot rests proudly on the breast of the young girl; Gauguin defines this fox in a letter to Emile Bernard[13] as the "Indian symbol of perversity." He had already linked the creature to the theme of lewdness in his 1889 woodcarving *Be in Love*. Several sketches of foxes occur in one of his Brittany sketchbooks,[14] and in Brittany the fox was considered a symbol of sexual power and renewal.[15] A cut flower emerges from the hand of the model – no longer the traditional lily, but an iris (?) spotted with red – and in the background, at right, a group of peasants is seen in procession. This group is interpreted by Rotonchamp as a country wedding party

9. Letters from Gauguin to Daniel de Monfreid, 7 November 1891, and 4 September 1893, Joly-Segalen 1950, II and XV.

10. Chassé 1955, 88.

11. Maxime Maufra, in Saint-Germain-en-Laye 1981, 63.

12. On the various possible sources of *The Loss of Virginity*, see Andersen 1971, 100-108.

13. Letter from Gauguin to Emile Bernard (early September 1889), Malingue 1949, LXXXVII.

14. Huyghe 1952, 194, 195, 197.

15. On agrarian rituals and the symbolism of the harvest, see Andersen 1971, 100-108.

on its way to meet the girl, thereby completing the heavy symbolism of the painting.

This is the last of Gauguin's Breton Eves; from henceforth this model was replaced in his work by richly symbolical and diverse Tahitian figures such as those of *Manao tupapau* (cat. 154), *Nativity* (cats. 262, 263), or *Nevermore* (cat. 222).—C.F.-T.

Holbein, *Dead Christ*, 1521, tempera on wood panel [Oeffentliche Kunstsammlung, Basel]

114
Madame Death

February 1891

235 x 293 (9⅜ x 11½)

charcoal selectively worked with brush and water on laid paper

signed at lower left, *P. Gauguin*

Musée du Louvre, Paris, Département des Arts Graphiques

EXHIBITION
Paris, Le Barc de Boutteville, June 1893

shown in Paris only

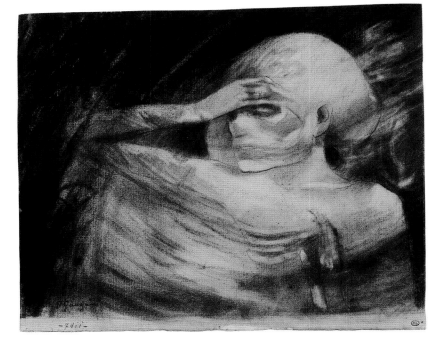

1. Rachilde 1891.

2. Letter from Gauguin to Jean Dolent, January 1891, Malingue 1949, CXVI.

3. Letter from Jarry to A. Vallette, 18 June 1874. Jarry 1972, 1038.

4. Letter from Gauguin to Rachilde, 5 February 1891, Malingue 1949, CXVIII.

5. Rachilde 1891, 292.

6. F 84.

7. Letter from Rachilde-Vallette to Yvonne Manceron, 20 December 1945, Département des Arts Graphiques, Louvre, Paris.

Gauguin clearly borrowed the symbolist iconography and style for this drawing from an illustration for a play entitled *Mme la Mort*, which appeared as the frontispiece to the edition of Mme Rachilde's *Le Théâtre*, published by Savin in 1891.[1]

The playwright Marguerite Eymery, known as Rachilde (1860-1953), was married to Alfred Vallette, the founder of the *Mercure de France*. Gauguin received the commission to illustrate Rachilde's play through the writer Jean Dolent, who was deeply involved in the symbolist milieu.[2] *Mme la Mort, drame cérébral*, consisted of three prose tableaux, and was first performed at the Salle Duprey on 18 November 1890. It was later shown at the Théâtre d'Art (Théâtre Montparnasse) on 27 February 1891, along with several other short plays, among them Mallarmé's *L'Aprés-midi d'un faune*. Not long after, on 19 and 20 March 1891, Rachilde's play was recited at the Théâtre Modern by Georgette Camée. This now-forgotten work was an excellent example of the symbolist aesthetic, with a veiled woman playing the role of Death. It especially pleased Alfred Jarry, who wrote to Vallette in 1894 to express his delight with the play.[3]

Gauguin made so many concessions to the symbolist style of Carrière that this is not his most successful effort. He had been sufficiently impressed by the play to write to Rachilde on 5 February 1891: "When I heard your play, 'Madame la Mort,' I was truly perplexed. How am I to express your thoughts with a mere pencil, when you designed them for the stage, with the powerful attributes of the stage: an actress, words, gestures. I hope you will forgive me if my feeble attempt at translating your work is far short of what you may have wished: if I send you two drawings instead of one, it is because I feel they could perhaps be put together (why not?) and each would explain the other."[4] The Louvre drawing was also published in the review *La Plume* in September 1891.[5] The location of the second drawing mentioned by Gauguin is unknown.

Ten years later, Gauguin used the same skeletal figure, with raised arm and hand on brow, in a 1902 transfer drawing of the Nativity.[6]

This drawing was acquired from Madame A. Vallette by the Louvre in 1946. At that time, the writer (who was then eighty-five years of age) also donated a copy of her *Théâtre*, " . . . in which *Madame la Mort* was reproduced; a beautiful rendering of a macabre dream, which would have been hideous had it not been by the genius of Paul Gauguin."[7]—C.F.-T.

115
Portrait of Stéphane Mallarmé

January 1891

150 x 117 (5⅞ x 4½)

etching heightened with pen and ink, brush and gray wash, on wove paper

Dr. and Mrs. Martin L. Gecht Collection

CATALOGUES
Gu 13, K 12 I

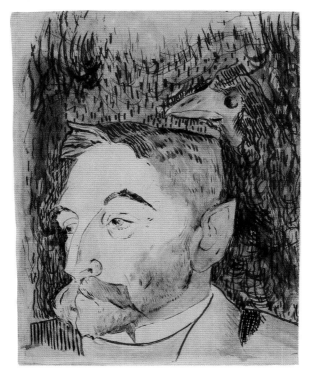

116
Portrait of Stéphane Mallarmé

January 1891

183 x 143 (7¼ x 5⅝)

etching on vellum

signed and dated in plate, *PG/91*

dedicated, signed, and dated below composition, in pen and ink, *au poète Mallarmé/ Témoignage d'un très grande admiration/ Paul Gauguin/ Jer 1891*

Annick and Pierre Berès Collection, Paris

CATALOGUES
Gu 14; K 12 IIA

shown in Paris only

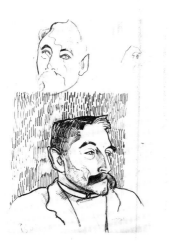

Gauguin, *Portrait of Stéphane Mallarmé*, 1891 [ex. collection Vollard]

Manet, *Bust of the Raven*, illustration for Mallarmé's translation of *The Raven*, 1875 [Bibliothèque Nationale, Paris, Fondation Moreau-Nélaton]

Manet, *Raven*, poster, 1875, lithograph [Bibliothèque Nationale, Paris, Fondation Moreau-Nélaton]

In a letter to Mallarmé of 23 July 1892, Charles Morice wrote, "Dear Master and friend, I have undertaken to prepare an issue of *La Plume* devoted to you. We must confer together about it. I have a plan for your consideration: it involves something of yours not yet published. . . . we are also including your portrait by Gauguin."[1] Although this project eventually materialized in March 1896, with number 166 of *La Plume*, the Gauguin portrait was rejected in favor of a photograph. Several posthumous editions of this etching were also printed, including one that served to illustrate the sixty deluxe copies of Morice's book on Gauguin published by H. Floury, Paris, 1919.

The portrait of Stéphane Mallarmé, finished in January 1891, represents Gauguin's only known attempt to use the etching technique. A preparatory sketch in graphite, traced over in pen (Gu 12), served as a base for the preparation of the print. Clearly, Gauguin made a first attempt – crossed out – to portray Mallarmé frontally, on the same sheet with little sketches of a raven's head and the head of a faun, alluding to Mallarmé's translation of Edgar Allen Poe's famous poem *The Raven* and Mallarmé's own poem, *L'Après-midi d'un faune*, published in 1876. In the two states of the print that followed, Gauguin retained only the pointed ears of the faun, while the raven was moved so close to the head of Mallarmé that his beak practically rested on it. This intimate association of the face and the bird acknowledges Mallarmé as the man who introduced to France the pre-symbolist poetry of Poe, a writer whom he considered to be his master, along with Charles Baudelaire. The publication of *The Raven* in 1845 had brought Poe recognition that had previously been denied him, and the appearance in 1875 of Mallarmé's French translation was an event of great significance. The poem was illustrated with lithographs by Manet, which were especially suggestive of its somber and fantastic atmosphere. A raven's head appeared on Manet's poster for the book. Oddly, it was at exactly this time that Gauguin became interested in copying Manet's *Olympia*, which had recently been installed in the Musée du Luxembourg (cat. 117).

In his biography of Gauguin[2] Rotonchamp relates how Gauguin, "not having the necessary equipment, asked the painter Léon Fauché, a fellow Volpini exhibitor, to help him: and Fauché provided everything he needed. Working from a simple sketch, Gauguin attacked the copperplate with great boldness. He used all the instruments – point, pen, burin, and scraper. Working feverishly, he reversed the image and sponged over it with whatever materials he could lay his hands on." Charles Chassé[3] repeats an account by Sérusier, which has it that another painter, Carrière, may have introduced Gauguin to the etching technique, and may himself have varnished the plate Gauguin used.

In addition to this impression, which was presented to Mallarmé, Gauguin gave several others to his close friends Charles Morice, Filiger, and Daniel de Monfreid. By doing so, he indicated that the image was intended for a small group of initiates within the symbolist milieu.

In 1891, at the age of forty-nine, Mallarmé was the undisputed leader of the symbolist school in French literature, a title to which Charles Morice had long pretended. In 1893, Mallarmé finally gave up his job teaching English at the Lycée Fontane in Paris, and from then on, no aspect of contemporary culture escaped him. Everyone who counted in the Paris intelligentsia attended the famous Tuesdays at Mallarmé's house on rue de Rome. Charles Morice introduced Gauguin and Mallarmé during the winter of 1890-1891 when Gauguin needed widespread publicity for his auction, and Morice asked the help of his old friend Mallarmé. "I brought Gauguin to the home of Mallarmé. A spiritual intimacy soon developed between the great poet and the great painter. Each had appreciated the other from afar, and held his work in high esteem. I was sure Mallarmé would provide what we needed. He said to me without hesitating: 'See Mirbeau.' I nodded yes, then on reflection, no. Mallarmé smiled, 'All right,' he agreed, 'I'll see him.'" On 5 January

1891 Mallarmé wrote a detailed letter to Mirbeau to ask him to receive "this rare artist, who is spared few tortures in Paris. . . ."[4] He also asked Mirbeau to write an article in *Le Figaro* on Gauguin's behalf. Mirbeau agreed, and in fact wrote two articles, one of which served as a preface to the sale catalogue (see cat. 90).

The friendship and mutual regard between Mallarmé and Gauguin continued for many years, despite Gauguin's long absences abroad. There was a deep creative affinity between the painter of exile and the author of *Brise marine*, by whose verses *Fuir! Là-bas Fuir!* Gauguin had been (according to Morice) deeply moved.[5] Also according to Morice, the pair engaged in a certain friendly rivalry, as befitted the two great masters of symbolism.[6] Mallarmé, presiding at a farewell banquet organized for Gauguin by the symbolists on 25 March 1891, made the following toast: "Gentlemen, our most urgent task is to drink to Paul Gauguin's return; but we should do so in admiration of that superb conscience of his, which, in the full flood of his talent, leads him to seek exile and renewal within himself, in faraway places."[7]

Later, during Gauguin's stays in Paris in 1893-1895 between his two trips to Tahiti, Mallarmé gave him consistent support, always at the instigation of Charles Morice. While Mallarmé appeared to have been a little hesitant about writing a new article on Gauguin in *Le Figaro* in November 1893,[8] he did recommend that the Belgian editor Deman publish *Noa-Noa*.[9] Subsequently, he reacted enthusiastically to the two partial publications of the work in *La Revue Blanche*.

Whenever he came back to Paris, Gauguin was a faithful participant in the "Tuesdays" at the rue de Rome, as is shown by a letter of 3 November 1893: "Dear Sir, I learned you were back in Paris but do not know if you have yet resumed your 'Tuesdays.' In any event, I am most eager to see you again, so I shall drop in next Tuesday to tell you a little about my trip.'"[10]

On 21 November 1894 Mallarmé attended a dinner organized by Charles Morice at the Café des Variétés in honor of Gauguin; a little later he was approached by Morice in connection with *Oviri* (cat. 213). On 18 February 1895, an attack of influenza prevented the poet from attending the sale of Gauguin's works before his second departure for Tahiti. Mallarmé presented his excuses in the only letter he is known to have written to the artist, in which, incidentally, he congratulates him on his plans for the future. "This winter I have often meditated on the wisdom of your decision."[11] Gauguin, depressed by the poor result of his sale, replied appreciatively in a short letter dated 23 February 1895: "Dear M. Mallarmé, the sale turned out to be nothing for me. In this difficult time, the cordially extended royal hand of Stéphane Mallarmé has filled me with new joy and strength."[12]

The news of Mallarmé's death in 1898 reached Gauguin in Tahiti through the *Mercure de France*. He was deeply affected by this, to a much greater extent, indeed, than by the death of his friend van Gogh in 1890. "I read of the death of Stéphane Mallarmé in the *Mercure* and I am profoundly grieved. He is another who has died a martyr to art; and his life was at least as beautiful as his work," he told Daniel de Monfreid shortly afterward.[13] In 1899 Gauguin again referred to Mallarmé in his response to an article by André Fontainas, the critic, on the Vollard exhibition of his most recent Tahitian works (including the large panel *Where Do We Come From?*).[14] Fontainas had gone to great lengths to make the image in the painting coincide with the title, and Gauguin was roused to anger. "My dream cannot be grasped," he wrote. "It involves no allegory; it is a musical poem without a libretto." He went on to quote Mallarmé, for whom the essence of any creative work consisted of "that which is not expressed."[15] Mallarmé, when confronted by Gauguin's Tahitian canvases, is reported to have said: "It is extraordinary to infuse so much brilliance with so much mystery!" For Gauguin, Mallarmé was one of the few who had understood him.

1. Mondor 1981, vol. 6, 99.

2. Rotonchamp 1906, 73.

3. Chassé 1922, 246 n. 1.

4. Mondor 1973, vol. 4, 1, 176, and 183, letter from Mallarmé to Octave Mirbeau, 17 January 1895.

5. Morice 1920, 72.

6. Morice 1920, 53.

7. Mondor 1973, vol. 4, 1, 10. See also Malingue 1949, CXXIII.

8. Mondor 1981, vol. 6, 184.

9. Mondor 1983, vol. 8, 10, 158.

10. Letter to Stéphane Mallarmé, 3 November 1893, Malingue 1949, CXLIV.

11. Mondor 1982, vol. 7, 161 [19 February 1895].

12. Letter to Stéphane Mallarmé, 23 February 1895, Malingue 1949, CLVI.

13. Dated 12 December 1898, Joly-Segalen 1950, XLIX.

14. Fontainas 1899.

15. Letter to André Fontainas, March 1899, Malingue 1949, CLXX.

Only two proofs of the first state are known. The Gecht proof previously belonged to the Swedish composer William Molard, a friend and neighbor of Gauguin in Paris after his return from Tahiti in 1893 (see cat. 164). The other proof was part of the important H. M. Petiet collection.

About ten impressions of the second state, printed on different papers, are known. This second state differs from the first in a number of details: emphasis on the wrinkled brow and the bridge of the nose, and the reworking of the beard, mustache, and hair. The background and the raven have also been radically reworked. The Berès print is especially precious since it is dedicated to the poet Stéphane Mallarmé, who posed for it.—C.F.-T.

117
Copy of Manet's Olympia

Manet, *Olympia*, 1863, oil on canvas [Musée d'Orsay, Paris]

1. Morice 1903a, 123.

2. Paris 1895, lot no. 49, sold for 230 francs.

3. Lemoisne 1946–1949, vol. 1, 177.

4. See Merlhès 1984.

5. Gauguin 1889a, 91.

6. See New York 1983, 183, list of subscribers and history of the work.

7. Malingue 1949, CVI.

8. Gauguin's answer to a question on this subject, probably in 1895: "I had trouble getting permission to copy *Olympia* in February 1891, because I had no recommendation from a professor" (sale of writings, Hôtel Drouot, 16 April 1974, no. 51).

9. Rotonchamp 1925, 82-83.

10. Loize 1966, 24.

In 1903, shortly after Gauguin's death, Charles Morice wrote of "...Manet, the painter whom Gauguin valued the most, after Corot, Ingres, and Raphael. Gauguin once made a copy of 'La Belle Olympia' - a masterpiece to go with a masterpiece. I wonder where it is now. . . ."[1] Morice might have added "...among other masterpieces!" His ignorance of the copy's whereabouts is interesting, because it shows how hermetic the worlds of literature and painting were. The painting in question had been bought by Degas at public auction in 1895[2] and was hanging in the painter's antechamber[3] where it remained until Degas' death in 1917, in the company of other canvases by Ingres, Manet, Corot, Delacroix, and others by Gauguin himself.

We know that Gauguin missed the Manet retrospective in 1883,[4] but he definitely saw *La Belle Olympia* among the fourteen Manet paintings exhibited at the centennial of French art during the 1889 *Exposition Universelle*, because he mentions it in his postscript to an article about the show. "La Belle Olympia," he writes, "who once caused such a scandal, is ensconced there like the pretty woman she is, and draws not a few appreciative glances."[5]

In 1890, seven years after Manet's death, *Olympia* was purchased from his widow by public subscription organized by Monet. It was presented that same year to the French state,[6] and hung in the Musée d'Art Contemporain (Musée du Luxembourg), because an artist's work could not enter the Louvre until ten years after his death. Gauguin was at Le Pouldu when he heard the news. He wrote to Emile Bernard, "It's hilarious that they've bought 'Olympia,' now that the artist is dead. Will it go on to the Louvre? I doubt it, but *hope* so." In the same letter, Gauguin rejected Bernard's proposal that he write an article on the topic.[7]

Instead, Gauguin took up his brush. Back in Paris in February 1891,[8] and "....overcoming his horror of bureaucratic formalities, he made the necessary arrangements for permission to work in the Luxembourg gallery. The copy of *Olympia,* on which he worked from the original for eight days, was completed later in his studio. (This perhaps explains why he reproduced Manet's work with only

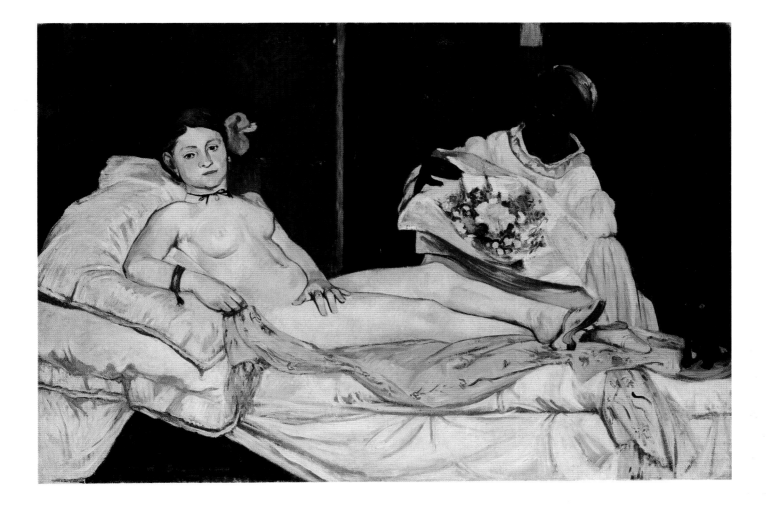

1891

89 x 130 (35 x 50¾)

oil on canvas

inscribed and signed at lower left, *after Manet, P. Gauguin*

private collection

EXHIBITIONS
Paris, Le Barc de Boutteville 1893, no. 188 (supplement); Oslo 1926, no. 67; Oslo 1955, no. 21; Paris 1960, no. 20; Munich 1960, no. 22

CATALOGUE
W 413

shown in Paris only

approximate fidelity.) In any case, the famous creator of *The Yellow Christ* readily admitted that he was constitutionally incapable of copying another painter. One day, when he had to take one or two notes from a photograph, he gave up the attempt and passed his pencil to someone else.[9]

Copies of masterpieces by experienced painters are often made too simply and with lack of deference to the master. But in this case the result – which is two-thirds the size of the original – shows Gauguin's considerable respect for Manet, despite his legendary reputation for insolence. It is true that the act of copying this painting, which was still controversial even twenty-five years after the scandal of the 1865 salon, was in itself a provocative gesture; as was Gauguin's decision to exhibit his copy at Le Barc de Boutteville's gallery in 1893, the year in which *Olympia* should have entered the Louvre, but was refused by the administration of the Beaux-Arts.

Gauguin kept a photograph of *Olympia* with him at Le Pouldu, and also later, in Tahiti. In *Noa Noa*, he wrote that Tehura-Tehamana discovered this photograph in a pile of other reproductions of paintings. "She told me that this Olympia was very lovely; I smiled at her remark, and was much moved. She had a sense of what was beautiful (the Ecole des Beaux-Arts thinks the picture's horrible). Then she suddenly spoke again, breaking the silence brought on by these thoughts. 'Is she your wife?' she asked. 'Yes,' I lied. Me! The lover of Olympia!"[10]

It is undeniable that *Olympia*, the modern equivalent of Titian's *Venus of Urbino*, is a constant presence in Gauguin's great South Pacific nudes of the nineties, notably *Manao tupapau* (cat. 154), *Te arii vahine* (cat. 215), and *Nevermore* (cat. 222).–F.C.

Patata te Moua

Chronology: April 1891–July 1893

GLORIA GROOM

1891

APRIL 7-11

Crosses the Suez Canal and docks in Aden (Danielsson 1975, 55).

APRIL 16-17

Disembarks at Mahé in the Seychelles Islands (Danielsson 1975, 55).

APRIL 17-MAY 12

Stops in the Australian cities of Adelaide, Melbourne, and Sydney (Danielsson 1975, 56).

MAY 6

Sale, Achille Arosa collection, Hôtel Drouot, Paris.

MAY 12

Arrives in Noumea, New Caledonia, for nine days before departing for Tahiti aboard the war transport *La Vire* (Malingue 1949, CXXIV; Danielsson 1975, 56).

Fig. 51. *Port of Papeete*, c. 1890s [Musée de l'Homme, Paris]

MAY 15

Opening in Paris of the Salon of the Société Nationale des Beaux-Arts. Includes four objects by Gauguin (nos. 49-52; see Cooper 1983, no. 16 n11). Mette visits Paris. She discusses with Schuffenecker her plans to sell Gauguin's paintings in Copenhagen (Bodelsen in Copenhagen 1984, 26).

MAY 21

At the Vaudeville Theater's benefit matinée for Gauguin and Paul Verlaine, several ceramics and paintings by Gauguin are exhibited in the foyer (Fouquier 1891; Joly-Segalen 1950, II). The benefit raises a mere 100 francs (Joly-Segalen 1950, II).

Fig. 52. *Théâtre du Vaudeville, 7-9 Blvd. Montparnasse, where the benefit matinée for Gauguin and Verlaine was held* [postcard, c. 1903]

JUNE 9

Arrives in Papeete (*Messager de Tahiti*, no. 361, 12 June 1891). The islanders, surprised by his long hair, nickname him *taata-vahine* (man-woman). Gauguin is greeted by Lieutenant Jénot, who helps find him a room (Jénot 1956, 117-118).

AROUND JUNE 11

Writes to Mette of his hopes for "some well-paid [portrait] commissions" (Malingue 1949, CXXV). Receives only known portrait commission in Tahiti for 200 francs (W 423).

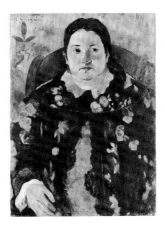

Fig. 53. *Gauguin's only known portrait commission in Tahiti, Portrait of Suzanne Bambridge* (W 423) [Musée Royaux des Beaux-Arts, Brussels]

JUNE 16

Makes sketches at the funeral of King Pomare V, who had died in Papeete four days earlier (Jénot 1956, 124-125).

Cuts hair and buys white colonial suit. Mingles with colonists and at the officer's club where Jénot had introduced him. Carves stylized decorations into native wooden bowls (Jénot 1956, 120-121; see cat. 137). Paints portraits of neighbors' children (Field 1977, nos. 59-62, 333).

Fig. 54. *Governor Lacascade and members of the prestigious "Military Circle," which Gauguin frequented upon arriving in Tahiti* [Danielsson Archives, Papeete]

AUGUST 13
Birth of a daughter, Germaine, to his former mistress, Juliette Huet, in Paris (Joly-Segalen 1950, II).

AUGUST-SEPTEMBER
Tries unsuccessfully to learn Tahitian while staying with Gaston Pia, a drawing instructor, at Paea, thirteen miles south of Papeete (Danielsson 1975, 69, 87). Photographs of works by Gauguin shown at the Champ de Mars exhibition are published (Roger-Marx 1891b).

SEPTEMBER-OCTOBER
Accompanied by Titi, an Anglo-Tahitian woman from Papeete, visits Mataiea, a small village forty miles south of Papeete, and decides to rent a native house (*Noa Noa*, Louvre ms, 40-41). Returns to Papeete for supplies and leaves Titi (*Noa Noa*, Louvre ms, 35; Danielsson 1975, 89). Fined for public indecency when caught bathing in the nude in Mataiea (Danielsson 1965, 89-92).

Fig. 55. *The coast of Mataiea, where Gauguin settled in the fall of 1891* [Gillot, in *Autour du Monde*, c. 1899, CCLXVII]

NOVEMBER
Writes to Monfreid that he has yet to do a major work, but that he is accumulating "documents" (drawings) for paintings he will do when he returns to Paris (Joly-Segalen 1950, II). Sends for Titi, who leaves Mataiea after a short time (unpublished letter to Jénot, LA). Probably meets Tehamana, who becomes his *vahine* and model.

Fig. 56. *The Burao Tree (I) depicting a scene of daily life in Mateaia*, 1891 [The Art Institute of Chicago, Gift of Kate L. Brewster]

DECEMBER
Without Gauguin's consent, one of his Arles landscape paintings is included in the first exhibition of modern art at Le Barc de Boutteville gallery (Sérusier 1950, 59; Passe 1891). By Christmas, Gauguin has painted twenty scenes of life in Tahiti (cats. 120, 127, 130).

1892

EARLY 1892
Gauguin begins hemorrhaging and is hospitalized in Papeete. Leaves against doctor's orders because of the expense (Malingue 1949,

CXVII). Recovered by March, writes to Monfreid that he was coughing blood, "a quarter liter per day" (Joly-Segalen 1950, III).

Fig. 57. *Study for the painting Te fare hymennee* (The House of Hymns) by Gauguin, 1892 [Josefowitz Collection]

JANUARY
Gallery owner and art publisher Maurice Joyant accepts five ceramics and ten paintings by Gauguin on consignment from Monfreid (Loize 1951, 94 n138).

FEBRUARY
Gauguin's application for a vacant civil service post in the Marquesas Islands is refused by Governor Lacascade (unpublished letter to Jénot, LA; Danielsson 1975, 93-94).

MARCH 5
Death of the eighteen-month-old son of Gauguin's friend, the pharmacist Suhas. Gauguin paints a deathbed portrait, which the mother immediately rejects (W 419; Field 1977, 336; Danielsson 1975, 99).

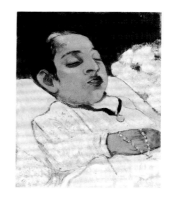

Fig. 58. *Deathbed portrait of Atiti, the eighteen-month-old child of Gauguin's neighbor in Mataiea* [Rijksmuseum Kröller-Müller, Otterlo]

MARCH 11

Writes to Monfreid that he is working more and more, primarily on studies or "documents" to be used later, if not by him then by others (Joly-Segalen 1950, III; see cats. 118, 119).

MID-MARCH

Instructs Monfreid to take *Vahine no te tiare* (W 420), the first Tahitian work sent to Paris, to the Goupil gallery; hopes it will sell because it is "new and different" (Joly-Segalen 1950, IV).

MARCH 22

In Copenhagen, Mette receives a group of pre-Tahitian paintings sent by Schuffenecker (unpublished letter, Musée Gauguin, Papeete).

MARCH 25

Gauguin announces to Sérusier that he is penniless and needs to return to France (Sérusier 1950, 12). Has evidently seen J.A. Moerenhout's *Voyage aux îles du Grand Océan* (1837), an account of the islanders' beliefs, customs, language, and politics, lent to him by a lawyer and coconut magnate, Auguste Goupil. It will be the basis for Gauguin's own illustrated manuscript, *Ancien Culte Mahorie* (Huyghe 1951, 26).

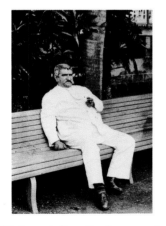

Fig. 59. *Auguste Goupil, a lawyer and wealthy plantation owner, seated in front of his house at Outumaoro near Mateaia* [O'Reilly and Danielsson 1966, VII]

APRIL 1

Important article published in Paris designates Gauguin the "prime initiator of the [symbolist] movement" (Aurier 1892a, 482).

APRIL

Emile Bernard organizes a van Gogh retrospective of sixteen paintings at Le Barc de Boutteville gallery. Gauguin seeks local patronage for money to return to France. Writes to Mette of the possibility of painting a portrait of Captain Arnaud's wife for 2,000 francs, and that he has finished a total of thirty-two canvases (Malingue 1949, CXXX; redated by Field 1977, 361). Compiles inventory of Tahitian paintings in the *Carnet de Tahiti* (Dorival 1954; see Field 1977, 304-306).

Fig. 60. *Catalogue for the van Gogh exhibition organized by Emile Bernard, April 1892*, woodcut [Teist-Rohde Collection, Copenhagen (Rewald 1962, 536)]

JUNE 1?

Desperate to obtain the funds necessary to return to France, Gauguin goes to Papeete to appeal to Governor Lacascade (Malingue 1949, CXXIX).

Fig. 61. *Gauguin's letter requesting permission to repatriate*, June 12, 1892 [The National Archives, Paris]

JUNE 12

Still anxious about his financial situation, Gauguin writes to Henry Roujon, Director of Fine Arts in Paris, for permission to repatriate (NA, Dossier Gauguin F21 2286).

JULY

A fan by Gauguin is included in the second exhibition of modern art at Le Barc de Boutteville gallery (Aurier 1892b, 262).

Fig. 62. Gauguin, *The Little Peasant Boy*, in *Livre d'Art*, June-July 1892, [Bibliothèque Nationale, Paris]

AUGUST

Gauguin boasts in a letter to Mette that after eleven months, he has completed forty-four "fairly important" paintings, worth 15,000 francs, and that he will go to the Marquesas if he can afford the 1,000 franc ticket (Malingue 1949, CXXVIII; redated by Field 1977, 364). His *vahine*, Tehamana, is pregnant (Joly-Segalen 1950, XII; redated by Rewald 1978, 499 n.44).

SEPTEMBER

Gauguin's first Tahitian painting, *Vahine no te tiare* (W 420), is exhibited at the Boussod and Valadon gallery in Paris (Aurier, 1892c, 92).

OCTOBER 5

Death of Albert Aurier, at 27, of typhoid fever (Leclercq 1892, 201). Gauguin does not learn of this until the following year.

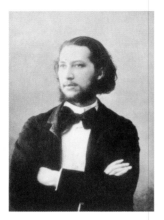

Fig. 63. *G. Albert Aurier in c. 1890*, [Rewald 1962, 367]

OCTOBER

Complains in a letter to Monfreid that he has run out of canvas and that he has not painted for a month. Instead he is carving wood statuettes and cylinders, two of which he has managed to sell (Joly-Segalen 1950, VI; redated by Field 1977, 364).

EARLY NOVEMBER

Learns that his request for repatriation has been granted by the French government. Abandons plan to go to the Marquesas so he may return to France in January (Joly-Segalen 1950, VII).

NOVEMBER-DECEMBER

Third exhibition of modern art at Le Barc de Boutteville gallery includes an *Etude* (no. 40) by Gauguin.

EARLY DECEMBER

Gauguin sends eight canvases back to Europe with Audoye, a friend of Jénot, for an exhibition to be held in Copenhagen in 1893 (Malingue 1949, CXXXIV).

DECEMBER

Portier returns to Monfreid the seven unsold Gauguin canvases remaining in his gallery (Loize 1951, 94-95, no. 145). Governor Lacascade refuses to provide passage for Gauguin to return to France (Danielsson 1975, 123), forcing him to reapply for repatriation (Joly-Segalen 1950, VIII). Begins to write *Cahier pour Aline*, a notebook dedicated to his daughter (Damiron 1963). Finishes three can-

vases (W 467, W 468, and cat. 155), which he considers to be his best work (Joly-Segalen 1950, IX).

Fig. 64. *Palace of Governor Lacascade in Papeete, where Gauguin was forced to go in order to reapply for repatriation* [Gleizal/ Encyclopédie Polynésie, Papeari]

1893

JANUARY 21

Mette receives 700 francs in Copenhagen from the sale of her husband's paintings (unpublished letter to Schuffenecker, LA).

FEBRUARY

Gauguin is furious to learn that Morice sold several of his paintings in May to Joyant in Paris, without sending him the proceeds (Joly-Segalen 1950, X). Asks Mette to help him obtain recommendations for a drawings inspector position in Paris (Malingue 1949, CXXXV; redated by Field 1977, 366).

MARCH 13

Mette receives ten of her husband's paintings from Monfreid for the *Free Exhibition of Modern Art (Frie Udstilling)* in Copenhagen (unpublished letter to Schuffenecker, LA).

Fig. 65. *Frie Udstilling in the Old Haymarket Square in Copenhagen*, c. 1896 [Copenhagen City Museum]

MARCH 24

Joyant returns twenty-six works of art to Monfreid's studio in Paris (Loize 1951, 94, no. 138).

MARCH 26

Opening of the *Free Exhibition of Modern Art* in Copenhagen, with a room devoted to the art of Gauguin and van Gogh. Gauguin exhibits fifty paintings, ceramics, and sculptures from his impressionist, Brittany, and early Tahiti periods (Bodelsen in Copenhagen 1984, 24). The same day, the Kleis Gallery in Copenhagen opens its March exhibition of Nabi and Symbolist art with seven paintings and six ceramics by Gauguin (Rostrup 1956, 79).

AROUND LATE MARCH

Gauguin writes to Monfreid that he will have finished several sculptures and sixty-six canvases by the end of his stay in Tahiti (Joly-Segalen 1950, XIII; redated Field 1977, 367). Returns to Papeete with Tehamana and rents a room in the suburb of Paofai near his friends Jénot, Drollet, and Suhas (Danielsson 1975, 133).

EARLY MAY?

Paints the four glass window panes above his doorway (W 509) to prevent his landlady, Mme. Charbonnier, from spying on his work with native models (O'Brien 1920, 226).

MAY 25

Receives letter from the Minister of the Interior authorizing him to return "last class" to France (Loize 1966, 49-50).

JUNE 1893

Several works on exhibit at Le Barc de Boutteville (cats. 50, 114; Merki 1893, 147-149).

JUNE 4

Leaves Tahiti for Noumea on board the cruiser *Duchauffault* with sixty-six paintings and several sculptures (Danielsson 1975, 134 n69).

JUNE 21

The *Duchauffault* docks at Noumea where Gauguin is forced to stay at a hotel for twenty-five days, spending almost all of the 650 francs he brought with him (Joly-Segalen 1950, XIV).

JULY 16

Leaves on the *Armand Béhic* for Marseilles, paying a surcharge for second-class passage (Danielsson 1975, 135).

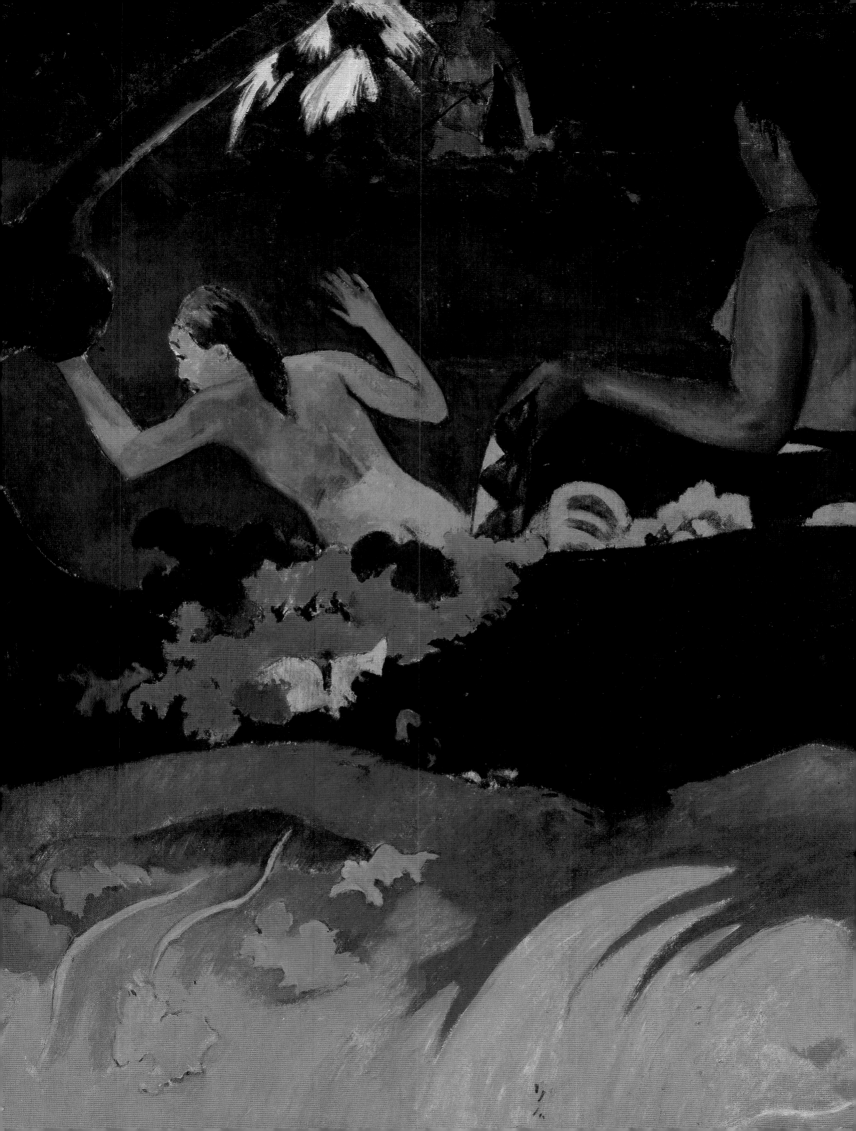

The First Tahitian Years

CHARLES F. STUCKEY

1. Danielsson 1975, 17-36; and Rewald 1978, 410-418.

2. Malingue 1949, CV.

3. Bernard 1954, 45; and Merlhès 1984, LVII.

4. Bacou, Paris 1960, III.

5. Malingue 1949, C.

In concept, there was nothing new about Gauguin's journey to paint in Tahiti. Beginning with the so-called Orientalist painters, such as Horace Vernet and Eugène Delacroix, nineteenth-century adventurer artists of every nationality had sought pre-industrial non-Western societies and landscapes to record from Morocco to Ecuador. Gauguin's trip to Martinique in 1887 was part of this trend. When he saw displays of exotic Eastern and Pacific cultures at the 1889 World's Fair in Paris, his wanderlust returned anew.

Before choosing Tahiti as his destination, Gauguin, true to character, studied a variety of other possibilities, including Java, Tonkin, and Madagascar, as headquarters for the "studio of the Tropics" that he hoped to establish with close colleagues.[1] As he wrote to Emile Bernard in June 1890, "With the money I'll have, I can buy a native house like those you saw at the World's Fair. Made of wood and dirt, with a thatched roof, near the city, but off in the countryside, that costs almost nothing, and I will enlarge it by cutting down wood to make a comfortable abode for us."[2] A few months later, perhaps influenced by the popular novel *Le Mariage de Loti*, 1880, Gauguin opted for Tahiti.[3] "Madagascar is still too close to the civilized world," he wrote to Odilon Redon. "I will go to Tahiti and I hope to finish out my life there."[4] He envisioned a life of "ecstasy, calm, and art," as he wrote to his wife, Mette. "Surrounded by a new family, far from the European struggle for money, there in Tahiti I will be able to listen in the silence of beautiful tropical nights to the soft murmuring music of my heartbeats in loving harmony with the mysterious beings in my entourage."[5]

Closer in spirit to such fantastic anticipations than to the realities that he found there, the paintings that Gauguin made in Tahiti portray an imaginary voluptuous world. Somehow they failed to appeal at first to collectors in Europe. Within a decade of Gauguin's premature death, however, these same early Tahitian works had become icons for a realm of psychic happiness and freedom, and they were treasured as such everywhere from Russia to the United States, inspiring artists from Matisse to de Kooning. But while Gauguin's mythical image of Tahiti has come to have such a strong hold on twentieth-century admirers of his art, most of the everyday realities about Gauguin's first trip to the South Seas will probably never be known.

Quite understandably, Gauguin's own account of his 1891-1893 trip to Tahiti, entitled *Noa Noa*, which means "fragrant" or "perfumed," has been the basis for every subsequent biography. Yet, despite its diaristic style, *Noa Noa* was apparently written after the fact in collaboration with Charles Morice, an irresponsible would-be modern poet, as part of a public relations campaign. Moreover, the account in *Noa Noa* is different in almost every respect from the account contained in the letters that Gauguin wrote while he was in Tahiti. Except for references to health and fiscal crises and to his frustrated attempts to obtain subsidized return fare passage to France with the help of local government officials, Gauguin's letters contain little information about his private life in Tahiti. *Noa Noa*, on the contrary, is a sensationalist account of Gauguin's bigamy with a Polynesian child bride, who is never once mentioned in his letters. Gauguin omits references to workaday worries in *Noa Noa*. Instead, he chronicles his gradual evolution from a civilized state into a primitive one characterized by intuitive contact with the deepest spiritual dimensions of nature. Probing just such incon-

6. *Noa Noa*, Louvre ms, 33-35.

7. *Noa Noa*, Louvre ms, 46-47.

8. *Noa Noa*, Louvre ms, 97.

9. *Noa Noa*, Louvre ms, 100-101.

10. *Noa Noa*, Louvre ms, 57.

11. Loize, 1966, opp. p. 34, published a photograph of a woman who resembles the one in Gauguin's paintings, but since he provided no documentation, Danielsson 1975, 299 n. 57, disputed the photograph's relevance.

Tehamana, c. 1894, photograph [Loize]

12. *Noa Noa*, Louvre ms, 108-110.

13. *Noa Noa*, Louvre ms, 129-130, and 151. Danielsson 1975, 160, doubts whether this could be true.

14. *Noa Noa*, Louvre ms, 110-112.

15. *Noa Noa*, Louvre ms, 112-116.

16. *Noa Noa*, Louvre ms, 196-202.

17. *Noa Noa*, Louvre ms, 203-204.

sistencies between Gauguin's official record in *Noa Noa* and other documentary sources may not lead to a bedrock of fact, but it does justify the skepticism necessary for a reconsideration of this crucial period.

It seems best to begin this reconsideration with a summary of the autobiographical details in *Noa Noa*, adding brief comments to indicate the issues that will need more detailed discussion afterward. Unimpressed with the Europeanized capital city of Papeete where he disembarked in June 1891, Gauguin sought to find the unspoiled Tahiti, taking a French-speaking, half-breed woman named Titi with him on a trip to search for a suitable house to rent in rural Mataiea, forty-five kilometers south along the coast road. Although Titi wanted to settle there with him, Gauguin preferred to be on his own at first.[6] Gauguin's ignorance of the Tahitian language prevented him from starting a liaison with one of the local women as he wished, so he eventually sent for Titi. Unsuited to the rural life style, she stayed in Mataiea for only a few weeks.[7] The relatively prominent role that Gauguin gives to Titi in *Noa Noa* notwithstanding, he does not say whether she ever posed as a model.

Several months after Titi's departure, loneliness began to depress Gauguin. "My work suffered from it. It is true that I lacked many documents, but mostly it was happiness that I missed."[8] As we shall see, "documents" was Gauguin's term for his drawings, and the implication here is that his progress as an artist had been stalled until this point. As a remedy, Gauguin made a journey beyond Mataiea around to Faone on the east coast of the island, and there he met a native family who offered him Tehamana, around thirteen years old, as a *vahine*, on condition that she had no objections after an eight-day trial period living with him. According to *Noa Noa*, Tehamana was tall, Tongan in origin, consequently lacking typical Tahitian features, and her hair was bushy and kinky.[9] Although the woman in a photograph pasted into Gauguin's copy of *Noa Noa* could be a thirteen-year-old and her kinky hair corresponds to Gauguin's verbal description of Tehamana in *Noa Noa*,[10] neither this photograph nor the description in *Noa Noa* corresponds to the woman portrayed most frequently in Gauguin's paintings, including the one that he inscribed with Tehamana's name (cat. 158).[11] In the one painting that corresponds to an episode in the *Noa Noa* account of Gauguin's life with Tehamana, *Manao tupapau* (see cat. 154), the model has relatively straight hair.[12]

While Tehamana's model's role goes undiscussed in *Noa Noa*, Gauguin describes how she explained Polynesian customs and ancient religious history to him while they lay together in bed.[13] On the whole, there are far more details about the first month or so of Gauguin's relationship to Tehamana in *Noa Noa* than there are about the remaining year and a half that they are presumed to have spent together. Just three anecdotes from this entire latter period are included in Gauguin's book: how Tehamana coveted earrings shown to her by a traveling salesman,[14] how she and Gauguin were guests at a Polynesian wedding with the bride already four months pregnant,[15] and how Gauguin accused Tehamana of infidelity.[16] Yet at the end of *Noa Noa* she was at the dock, stoic but sad, because "pressing family duties" obliged Gauguin to return to France.[17]

Of course, family duties had nothing whatsoever to do with Gauguin's departure after months of ineffective efforts to leave even earlier. A purely literary

18. Danielsson 1975, 142. It should be pointed out, too, that Gauguin's maternal grandmother and his father were both writers, and that his wife considered literature to be the highest form of art (see Merlhès 1984, 130 (no. 102)).

19. Delacroix's notebook was acquired by the Louvre in 1891.

20. W 27.

21. That Gauguin waited until he returned to Paris to describe his Tahitian mistress suggests that until then he had felt vulnerable to retaliations from his wife, Mette.

22. Danielsson 1975, 160.

23. Archives, Musée Gauguin, Papeari.

24. Jénot 1956, 419.

25. See Handy 1927, 217-218; according to Menard 1981, 117, a bartender in Papeete told Somerset Maugham that Gauguin's mistress was named Teha'amana a Tahura. Danielsson 1975, 298 n. 57, interviewed a Tahitian who claimed to have married Tehamana after Gauguin abandoned her.

26. Jénot 1956, 125.

27. Sérusier 1950, 52-55.

28. Joly-Segalen 1950, XII. Field 1977, 363, no. 17, dates this letter to September 1892, but it may be earlier. An unpublished letter from Gauguin's wife to Schuffenecker, dated 5 September 1892 (copy in Fonds Loize, Musée Gauguin, Papeari), includes similar information, suggesting that she had already received a closely related letter (Malingue 1949, CXXVIII). While the length of time for a letter to cross from Tahiti varied, on average it seems to have taken two months.

device, the final scene in *Noa Noa* was evidently modeled on a similar incident in Julien Viaud's autobiographical novel, *Le Mariage de Loti*, about the love affair between a fourteen-year-old Polynesian named Rarahu and a French sailor. Gauguin's claim that Tehamana was thirteen makes *Noa Noa* slightly more shocking to European readers. Other parallels between this novel and *Noa Noa* (cat. 157) have led modern scholars to suggest that Gauguin's motivation to write his autobiography must have been largely commercial.[18]

In a more general way, Delacroix's diary, published between 1893 and 1895, while Gauguin was back in France, was probably another literary prototype for *Noa Noa*. What seems certain is that the illustrated draft of *Noa Noa* that Gauguin took back with him to Tahiti owes its illuminated manuscript format to the example of Delacroix's magnificent album of notes and watercolors, compiled during a visit to North Africa in 1832.[19] Indeed, Gauguin's fantasies about non-European women were first expressed in a copy[20] that he made around 1884 after one of Delacroix's portraits of a North African model.

For the most part, Tehamana as described in *Noa Noa* may also be a mere fantasy based upon the young Javanese woman (cat. 160) with whom Gauguin shared an openly adulterous life-style while he was back in France and at work on this text.[21] The real Tehamana was Gauguin's favorite model (cat. 158), a woman without kinky hair, older-looking than a teenager, who had begun to pose for him by the end of 1891 (see cats. 127, 130, 135).

Although Gauguin used her name for that of his young mistress in the first draft of *Noa Noa*, for some unknown reason he used the name Tehura instead in later versions of the text.[22] Perhaps only coincidentally, Gauguin included his regards for one "Tehora" at the end of an unpublished letter to his friend, P. Jénot, in Papeete.[23] In this letter, written about a month after Gauguin had settled in Mataiea (presumably around October 1891), he reported Titi's departure as good riddance and swore that he would do without the expense of a woman in the future. Since Jénot helped find models for Gauguin,[24] it is tempting to make a connection between the Tehora in this letter, the Tehura in the late versions of *Noa Noa*, and Tehamana the model, especially in light of the fact that Polynesians often receive a second name at birth.[25]

Aside from her name and the fact that she began to pose for Gauguin before the close of 1891, all that is known about the real Tehamana is that she had seven toes on her left foot (cat. 148) and that she became pregnant (cat. 143). When exactly she began to pose is difficult to calculate. According to Jénot's memoirs, Gauguin, who arrived in Tahiti on 9 June 1891, spent several months in Papeete and then several more months in Paea before settling in Mataiea.[26] Add to that the period before he sent for Titi, as well as the weeks that she stayed, and it would seem that Gauguin could not have begun to paint pictures of Tehamana until October or November at the earliest. In a letter to Paul Sérusier that has been assigned a date of November 1891, Gauguin claimed that he was living by himself in Mataiea and that he had still not made any paintings, although he had accumulated many "documents" or drawings.[27] An earlier date would seem likely for this letter, however, considering that more than twenty paintings by Gauguin are inscribed with 1891 dates. That much work would generally take a good deal more than a month or two.

29. The April date is a deduction from the fact that *Vahine no te vi* is listed in Gauguin's inventory of early Tahitian paintings shortly after *Vairoumati tei oa* (W 450), which he referred to in a letter dated March 25.

30. Danielsson 1975, 107.

31. *Ancien Culte Mahorie*, ms, 28, and *Noa Noa*, Louvre ms, 157. In the latter the woman wears an earring, perhaps an allusion to the episode in *Noa Noa*, Louvre ms, 110-112. The figure in *Ea haere ia oe* (W 501) also wears an earring.

32. Joly-Segalen 1950, VI and VIII. See Field 1977, 364, no. 19 for the date of the former.

33. Malingue 1949, CXXXV; see Field 1977, 366, no. 26 for the date.

34. Danielsson 1975, 121, proposed the abortion theory.

35. W 467, W 468, and W 501.

36. Sérusier 1950, 53. In *Noa Noa*, Louvre ms, 44-46, Gauguin describes how one of these portrait drawings was made. According to Jénot, 1956, 124, Gauguin did not make any large paintings while he was in Papeete in the summer of 1891.

37. W 431 and W 432; W 434 and W 466; W 436 and W 437.

38. Gauguin must also have used a lost working drawing for the bending woman repeated in W 429 and W 430.

Paul Gauguin, *Cover of Documents Tahiti-1891/1892/1893* [Whereabouts unknown, photo: Malingue]

Tehamana's pregnancy is revealed in one of Gauguin's undated letters to Daniel de Monfreid: "I will soon be a father anew in Oceania."[28] This letter was probably written around August 1892, if, as it appears, Tehamana was already about five months pregnant when she posed for *Vahine no te vi* (cat. 143) the previous April.[29] Gauguin's hope to move to the remote Marquesas Islands, expressed in the same letter, comes as a surprise under the circumstances. No less telling about Gauguin's lack of fatherly dedication is his request for repatriation, sent off to authorities in Paris on 12 June 1892.[30] Gauguin apparently recorded an early stage of this same pregnancy in one of the watercolors that he used to illustrate both *Ancien Culte Mahorie* and *Noa Noa*.[31] The new model that Gauguin found (Pickvance 1970, pl. X and cat. W 147), now that Tehamana had become unsuitable, except when observed from the back (cat. 144), obviously failed to satisfy his needs (cat. 148). By around October 1892, Gauguin started to point out in his letters that he was working without a model (see cats. 153 and 154).[32] And by February 1893, he complained that he was living by himself.[33]

What happened to the mother and the child is not known. She cannot have had an abortion at such at late stage of pregnancy.[34] He may have chased her away, or she may have abandoned him, taking her child. But details in several of Gauguin's paintings (cats. 154 and 155) suggest the possibility that Tehamana died. Gauguin began to include figures in white costumes in his paintings toward the end of 1892, and white symbolizes death and mourning in Polynesia.[35] The absence of any explanation in *Noa Noa* or in Gauguin's letters may suggest that the artist was nonchalant about his model. He repainted one of his allegorical nudes, however, for which a different woman had posed, tranforming it into a sort of portrait of Tehamana (cat. 148), and we know he painted a conventional portrait of her in 1893 (cat. 158), in both cases working from drawings (cats. 124 and 149) as if she were no longer available in person as a model, suggesting instead that Gauguin was obsessed with her memory.

The drawings in question, part of a group of careful portrait studies of his Tahitian neighbors, must belong to what Gauguin referred to in his letters as "documents." "Still not one painting," he wrote to Sérusier shortly after his arrival in Mataiea, "but a lot of research which can bear fruit, many documents that I hope will be useful for a long time in France."[36] In fact, Gauguin did make use of many of his early Tahitian drawings when he returned to France, just as he developed most of the paintings that he made in Tahiti from drawings.

Nothing reveals the studio character of Gauguin's art so much as his making second versions - nearly copies at the same scale - of three of his earliest Tahitian paintings.[37] Although "documents" for the figures in these particular pictures have not survived, it seems highly likely that Gauguin would have used them, both for the development of his ideas at an initial stage and then later for transfer. The use of working drawings seems to be the only possible explanation for the fact that the same model posed for both figures in one of these compositions (cat. 130).[38]

To file his precious early Tahitian drawings, Gauguin later made a portfolio, which he inscribed in large characters: *Documents Tahiti - 1891/1892/1893*. Unfortunately, when this portfolio was found after Gauguin's death, it no longer served its original, strictly limited purpose, since both earlier and later drawings

39. The portfolio was exhibited with both the earlier and later drawings in Paris 1942.

40. One of Gauguin's early Tahitian notebooks survives intact (Dorival 1954). Jénot 1956, 125, describes a different one used to sketch the ceremonies for Pomare V's funeral and Bastille Day, 1891.

41. *Avant et après*, facsimile, 115-117.

42. Aurier 1891, 165.

43. Field 1977, 77, and 317-319, no. 23.

44. Malingue 1949, CXXX; for the date see Field 1977, 361, no. 11. In the opinion of Field, this painting is identical with *Come Eat with Us* (see above n. 43). That Gauguin was working on a larger scale helps to explain the decline in his productivity in early 1892 although health problems (Joly-Segalen 1950, III) and efforts to obtain a civil service post in the Marquesas (Danielsson 1975, 93-94; and unpublished letter, Gauguin to Jénot, Archives, Musée Gauguin, Papeari) were also factors.

45. W 561.

46. Dorival 1951; Field 1960; Field 1977, 238-242 (nn. 41-53); and Kane 1966.

47. Bacou 1960, III.

48. Jénot 1956, 121 and 124; and *Noa Noa*, Louvre ms, 44. Leclercq 1895, 121-122, points out that Gauguin displayed similar photographic reproductions at his private studio exhibition in 1844.

had been added.[39] As a result, there is no way to know with certainty whether Gauguin would have applied the term "documents," a neologism borrowed from the vocabulary of photographers, to small sketchbook drawings or only to larger works on paper.[40] Gauguin's elaborate decoration of this portfolio would seem to imply that he showed his drawings to admirers while he was back in France. But in *Avant et après*, referring to one of his early Tahitian portrait drawings, Gauguin insisted that such works were strictly private, like his letters or secrets.[41]

In this same revealing passage, Gauguin points out that working drawings of figures are totally different from the same figures incorporated into the composition of a painting. He also debates the propriety of exhibiting working drawings as Pierre Puvis de Chavannes had done, because these drawings are generally undeveloped as far as color is concerned. Yet, at some point, probably during his return visit to France, Gauguin quite obviously considered the possibility of developing some of his own early Tahitian cartoons as exhibition pieces by coloring them. The most extraordinary are those that Gauguin tore carefully around the edges (cats. 35, 45, 112, 126 and 149), evidently to approximate the look of ancient art objects in partially ruined condition. These drawings seem to fulfill in literal fashion Aurier's claim that Gauguin was fundamentally a decorative artist, whose works could be taken "as fragments of immense frescoes."[42]

Indeed, some of Gauguin's early Tahitian paintings may be salvaged fragments from one of the nearly mural-scaled pictures that Gauguin attempted to paint during the first months of 1892, just as some of his surviving drawings may be directly related to parts of them that were destroyed. In the inventory that Gauguin compiled in his sketchbook around April 1892, one of these large works, entitled *Come Eat with Us,* is listed as a size 100 format, that is, 1.60 by 1.30 meters.[43] Gauguin mentioned a still larger picture, measuring 3 by 1.30 meters, in a letter to his wife written not long afterward.[44] Never described in Gauguin's letters nor in *Noa Noa*, and thus ignored by all of his biographers, this expensive, time-consuming work, presumably destroyed by the artist out of dissatisfaction, was nearly as large as *Where Do We Come from?*,[45] the masterpiece of Gauguin's second trip to Tahiti.

If Gauguin's biographers have all so far neglected the role of life models and drawings in the art that he made during his first trip to Tahiti, Dorival and Field in particular have emphasized how he used photographs of works of art, including ancient Egyptian wall paintings, for reference.[46] "I am bringing a whole little world of friends with me in the form of photographs [and] drawings who will talk with me every day," Gauguin had explained to Redon by 1890.[47] Jénot recalled that Gauguin's collection included photographs of Marquesans with tattoos covering their bodies, and in *Noa Noa* Gauguin himself described the curiosity with which one of his Polynesian neighbors examined his photographs of Manet's *Olympia* and several so-called primitive Italian religious paintings.[48] Examining the remnants of this photograph collection that had been salvaged by Victor Segalen at the auction of Gauguin's estate in Papeete in 1903, Dorival realized how Gauguin had appropriated poses and gestures from the Buddhist temple in Borobudur in Java and the Parthenon in Athens for his own art. This discovery led to a revolution in the interpretation of Gauguin's early Tahitian art. Now that some of its essential elements could finally be understood as specific allusions to stylistic

49. Mirbeau 1891, 1.

50. W 430, W 443, W 450, W 451, W 455, W 458, W 461, W 464, W 476, W 498.

51. Malingue 1949, CXXVII.

52. Merlhès 1984, no. 193; and *Avant et après*, facsimile, 187.

53. Rosenblum, *Transformations in late Eighteenth Century Art* (Princeton, 1967), 176.

54. The best recent studies of the "primitivism" of Gauguin's sculptures are Varnedoe, "Gauguin" in New York 1984-1985, 179-209; and Rocquebert, *La Sculpture française au XIXᵉ siècle*, (Paris, 1906), 395-405.

55. G 71, G 74, G 76, G 88.

56. Joly-Segalen 1950, LXVIII, and unpublished letter, Monfreid to Vollard, 27 Dec. 1900 (copy in Rewald Archives).

57. Jénot 1956, 122.

58. Jénot 1956, 122-123.

59. A unique manuscript issue of *Le Sourire*, inscribed August 1891, in the Musée du Louvre, Département des Arts Graphiques (R.F. 28:844) is illustrated with an image of *Oviri*. Danielsson 1975, 226, contends that this was made in 1899, but without explaining why Gauguin inscribed an earlier date, nor how this issue came into the possession of Schuffenecker, with whom Gauguin had broken off relations by 1895.

60. *Noa Noa*, Louvre ms, 76-83; Jénot 1956, 122, describes a similar earlier expedition.

61. For references to the sculpture in Gauguin's letters, see Joly-Segalen 1950, VI and XIII; see Field 1977, 361-367, for dates.

and symbolic religious ideas embodied in earlier works of art, it was possible to understand Mirbeau's claim, published in February 1891, that in Gauguin's art there is "an unsettling and savory mingling of barbarian splendor, Catholic liturgy, Hindu meditation, Gothic imagery, and obscure and subtle symbolism."[49]

But since appropriations of this sort have so far been identified in only about a dozen (cats. 132, 133, 135, 143) of the nearly seventy paintings that Gauguin made during his first trip to Tahiti,[50] the significance as well as the scope of these photographic sources needs further study. It seems perverse that Gauguin traveled all the way to Tahiti only to consult photographs of art made by other cultures. After all, he had justified his South Pacific odyssey by the isolation he would enjoy there, like the deaf Beethoven, he wrote to Mette, "living on his own planet."[51] Presumably, his references to art of the past were intended to stress that his modern art shared the same timeless values, the way that Corot's paintings of arcadian nymphs, so deeply admired by Gauguin, shared a pagan spirit that transcended modern everyday reality.[52] But such a rationale hardly explains why Gauguin would portray Tehamana in the pose of Joseph in Pierre Joseph Proudhon's *Joseph and Potiphar's Wife* (cat. 143); or why he would appropriate the fantastical homoerotic details of David Pierre Humbert de Superville's 1801 *Allegory* for *Manao tupapau* (cat. 154);[53] or why, finally, Gauguin would base a painting of a woman (cat. 157) on a photograph of a man standing by a waterfall.

What Gauguin's collection of photographs most clearly reveals is his special interest in sculpture of every culture and period. Recently, scholars have explained how his own Tahitian sculptures—the earliest examples of the primitivizing mode of expression characteristic of so much early twentieth-century art[54]—are fundamentally hybrids that reflect his wide range of knowledge. But if Gauguin's sculpture is indebted to a variety of precedents, it is only in a most general way. For example, the decorative compositions circumscribing most of Gauguin's wooden idols are more in keeping with conventional ceramic design than with non-Western sacred art with its emphasis on frontality. Extensions of the exotic sculpture (see cats. 85, 96, 110)[55] that he began to make in response to non-Western art that he studied at the 1889 Paris World's Fair, these are the most daringly original works that Gauguin made during his first trip to Tahiti. Aware of this, Gauguin excluded them from the auction of his works in 1895, and later he asked Monfreid to take them off the art market and keep them forever together as a group.[56]

According to Jénot, although Gauguin was disappointed to learn upon arriving in Tahiti that there was no indigenous sculptural heritage to study, he immediately began to carve "bizarre gods."[57] His own idols would apparently compensate for what was missing in reality. Unfortunately, Gauguin carved most, if not all, of his earliest sculpture from guava wood that quickly crumbled to dust.[58] His surviving hardwood sculptures may be copies of some of these early lost works; and still more intriguing is the possibility that *Oviri* (cat. 211) was first conceived as one of these lost idols.[59] His successful quest to find more durable wood, recorded in *Noa Noa*,[60] evidently took place before April 1892, when he began to refer to his "sculpted knickknacks" in some of his letters.[61]

By that time, Gauguin had already used one of his pseudo-idols as a prop for the imaginary monumental shrine depicted in *Vairumati tei oa* (*The Name is*

62. W 450. Gauguin included a sketch of the painting in a letter of 25 March 1892, see Sérusier 1950, opp. 144.

63. For Gauguin's plagiarism of Moerenhout, see Huyghe 1951. For Gauguin's earliest expressed interested in the subject see Malingue 1949, CVI and CIX.

64. *Noa Noa*, Louvre ms, 16-21 and 129-167. Most of this material was probably first used for *Ancien Culte Mahorie*, which Gauguin had begun by November 1893 (see Malingue 1949, CXLIII).

65. W 450, W 451, W 453, W 460, W 467, W 468, W 470, W 483, W 499, W 500.

66. In *Avant et après*, facsimile 188, Gauguin categorized all works of art as self-portraits.

67. Joly-Segalen 1950, VI.

68. Joly-Segalen 1950, XIII.

Vairumati, W 450), a painting about an episode from ancient Tahitian religious history.[62] Gauguin took an earnest interest in the ancient Tahitian gods described in Jacques Moerenhout's *Voyages aux îles du grand océan*, 1837,[63] and his decision to incorporate these forgotten divinities into his art in the spirit of Richard Wagner reviving Nordic legends amounted to a return to academic history painting. But a Jarryesque humor seems sometimes to have guided him. His decision to inscribe paintings with Tahitian titles, thus supplying explanations, but in a language unknown to his Western audience, is charged with irony; and his use of visual language can be sardonic. For example, in *Vairoumati tei oa*, the legendary beauty who inspired the founding of the Ariois society holds a lighted cigarette, like a modern Parisian tart. Given the number of pages in *Noa Noa* devoted to a detailed account of Polynesian polytheism,[64] it comes as a surprise that, besides Gauguin's wooden idols, only about a dozen (cat. 158) of the sixty-six paintings that he claimed to have executed during his first trip to Tahiti deal with ancient Polynesian mythology.[65] Several of these (cat. 155) do so in the general way that Poussin's landscapes allude to a long-ago golden age. That nearly twice as many works, including several watercolors, depict the house with a thatched roof (cat. 132) where he lived in Mataiea suggests that Gauguin was more interested in self-portraiture by proxy than he was in arcane gods.[66]

Of those sixty-six paintings, thirty had already been painted by April 1892, judging from the inventory in Gauguin's notebook. This means that, after painting about five pictures a month at the outset of his stay in Tahiti, during his last twelve months there, his production declined to around two paintings a month on the average. The scarcity of canvas was a factor;[67] but something more was probably also involved, like the onset of self-doubt. "We'll see," Gauguin wrote at the conclusion of his final letter to Monfreid before his departure from Tahiti. He was referring to his future plans as an artist: "unless I give up painting, which is quite likely as I told you in my previous [lost] letter."[68] When Gauguin wrote *Noa Noa*, this doubt was something that he had evidently chosen to forget.

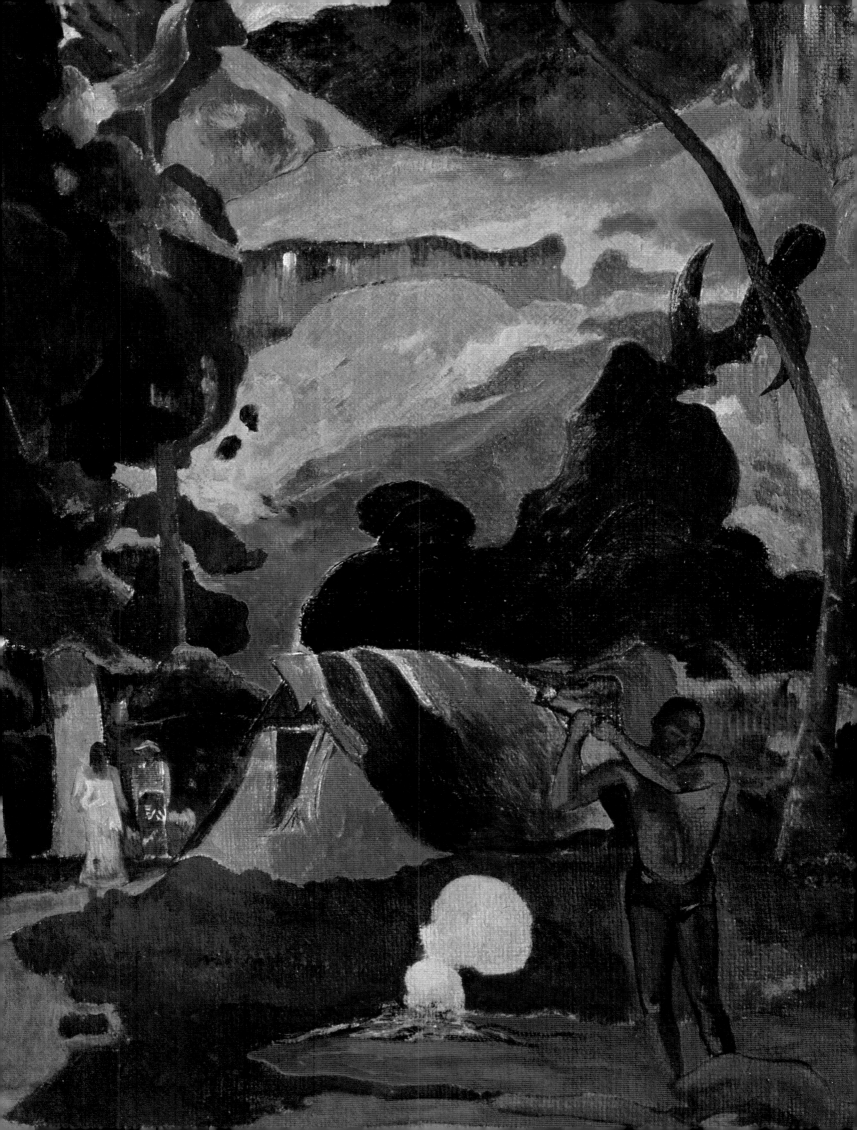

118
Head of a Tahitian Woman

1891

306 x 243 (12 x 9½)

graphite, selectively stumped, and gray brush and wash on vellum

The Cleveland Museum of Art, Mr. and Mrs. Lewis B. Williams Collection

EXHIBITIONS
Chicago 1959, no. 82; Toronto 1981-1982, no. 18

shown in Washington and Chicago only

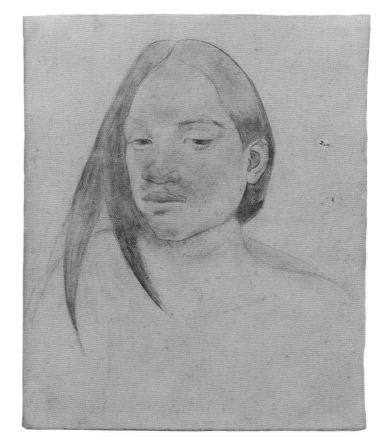

1. See Field 1977, 304 n. 2, and 310 n. 4.

2. For the debate about the early history of this painting, see Bodelsen in Copenhagen 1984, no. 48; and Motoe in Tokyo 1987, no. 57.

3. Now in the Musée Gauguin, Tahiti.

4. *Noa Noa*, Louvre ms, 173.

5. Philadelphia 1973, 16.

6. In the files of the Cleveland Museum of Art, Department of Prints and Drawings.

This stately head belongs to a group of drawings (see cat. 119) related to one of the first paintings that Gauguin undertook in Tahiti, *Les parau parau* (W 435),[1] a work that may have been among the eight (see cat. 127) that Gauguin sent back to Paris in December 1892.[2] The stylized way strands of her straight hair fall over her shoulder leave no doubt that this woman is the same one who appears as a full figure seated to the left of three others (likewise related to *Les parau parau*) in a quickly sketched watercolor[3] that must have been the "document" upon which Gauguin based the painting. Gauguin was so fond of this particular figure, which he placed at the very center of *Les parau parau*, that he repeated it later in a transfer drawing (F 36) and in another watercolor executed on a page of his *Noa Noa* manuscript.[4]

Given Gauguin's masterful rendition of the woman's guarded mood, in no way apparent in the painting, the Cleveland drawing can hardly be considered a preparatory study. Instead, it may be the very first of a brilliant group of portrait drawings of Tahitians (see cats. 119, 122, 123, 124, 125) that Gauguin executed as independent works during his first stay in the South Seas. On its back are remnants of the type of cardboard mount to which Gauguin affixed many of his finest works on paper, evidently for presentation at the private exhibition that he held in his Montparnasse studio in late 1894.[5] A relatively early photograph of this drawing[6] shows how it was once framed with a French mat, perhaps chosen by Gauguin, given how closely it compares to the distinctive frames visible in photographs taken in Gauguin's studio around the same time.–C.F.S.

119
Head of a Tahitian Woman, Related to
Les parau parau

1891 or later

318 x 242 (12½ x 9⅞)

pen and ink; brush and ink and watercolor over preliminary drawing in graphite on vellum

signed at lower right, in brown writing ink, *Gauguin*

inscribed [probably by Bernard] in pen and brown ink, *Reconnu de Paul Gauguin. Emile Bernard. 29*

Mr. and Mrs. Marshall Field

CATALOGUE
FM 64

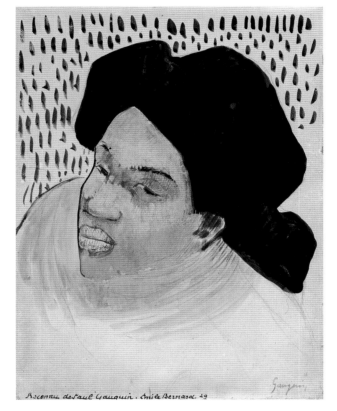

Gauguin, *Les parau parau*, 1891, oil on canvas [State Hermitage Museum, Leningrad]

van Gogh, *Portrait of Patience Escalier*, 1888, reed pen and ink [private collection, Switzerland]

1. Danielsson 1967, 231 n. 22.

2. de la Faille 1970, no. 1461; see Pickvance 1984, 167 n. 97.

3. See W 419.

The head in this drawing corresponds to a head in one of Gauguin's earliest Tahitian paintings, *Les parau parau* (*Words, Words*).[1] But since the drawing is not squared for transfer, and since it is so extensively reworked, it seems likely that Gauguin made it after the painting as an independent work. He made a number of changes as the drawing developed, as can be seen from traces of the figure's left arm, rendered lightly in graphite, as the entire figure was at first. Otherwise, Gauguin strengthened the rest of the contours in this drawing with pen and ink, adding shading with energetically hatched strokes.

His decorative use of similar strokes of india ink applied uniformly for the background is like a parody of the regular little dots of paint championed by his pointillist rivals, Seurat and Signac. Van Gogh's similar transformation of their technique, especially in a pen and ink drawing after his portrait of Escalier, could have provided an example for the Field head, since van Gogh may have sent this drawing to Pont-Aven while Gauguin was in residence there.[2] The unprecedented way that Gauguin brushed an unmodulated coat of shiny india ink for the figure's hair, however, makes it look like a broad-brimmed hat in another of his early Tahitian paintings.[3]

Most extraordinary of all, of course, is Gauguin's proto-expressionist use of color, the overlapping areas of pistachio, turquoise, and lime green gouache,

accented with touches of complementary dark red for the lips and eye socket. Altogether different from the naturalistic tones in the painting, these jarring greens transform this Tahitian into an emblem of theatrical artifice analogous to the modern Parisians in works by Degas and Toulouse-Lautrec, whose faces are turned into wicked masks by the flicker of gaslight. The work most closely related to the Field drawing is perhaps Lautrec's *At the Moulin Rouge*.[4] Although Lautrec's painting was apparently executed around 1894 or 1895, while Gauguin was in Paris, it was evidently never exhibited in public. The presentation mount once affixed to Gauguin's drawing seems to indicate that it was among the works that he exhibited in his Montparnasse studio at the end of 1894;[5] if so, Lautrec could have seen it there.—C.F.S.

4. Dortu 1971, no. P 427. For the dating of *At the Moulin Rouge*, see Stuckey and Maurer 1979, no. 52, and Heller 1985, 129.

5. Philadelphia 1973, 16.

120
Te tiare farani

1891

72 x 92 (28 x 35⅞)

oil on coarse canvas

signed and dated at lower left, in purple, *P Gauguin 91*

inscribed at lower right, on side of table, in purple, *TE TIARE FARANI*

Pushkin State Museum of Fine Arts, Moscow

EXHIBITIONS
Paris, Durand-Ruel 1893, no. 40, *A l'écart*, or no. 41, *Bouquet de fleurs*; Paris, Drouot 1895, no. 24, *Tiare farani*, or no. 31, *Tiare forani*; Paris 1906, no. 62, *Bouquet*; Moscow 1926, no. 4

CATALOGUES
Dorival 1954, inv., no. 5, as *nature morte fleurs*; Field 1977, no. 67; W 426; FM 13.

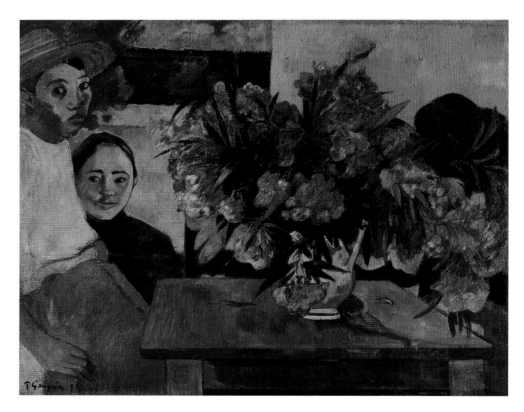

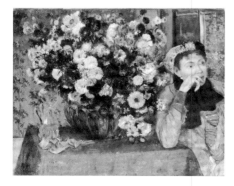

Degas, *Woman with Chrysanthemums*, 1858 and 1865, oil on canvas [The Metropolitan Museum of Art, New York, Bequest of Mrs. H.O. Havemeyer 1929, The H.O. Havemeyer Collection]

Scholars have compared *Te tiare farani* (*The Flowers of France*) to works by Cézanne, Degas, and Manet,[1] and the title, referring to the massive bouquet of poisonous oleander placed in a vase of European design set on a European table, does seem to indicate a sardonic nostalgia for his own culture. Yet the European still-life arrangement functions foremost as the West in the East-meets-West images (see cats. 126, 135, 147, 148) that form a group apart in Gauguin's early Tahitian paintings.

The Tahitian elements in *Te tiare farani* appear somewhat disconnected from the European still life, as well as from one another, and as a result this ostensibly simple genre painting has a mysterious mood. For example, the setting

is a patchwork of ambiguous rectangular zones. What appear to be clouds in the upper left zone suggest an outdoor setting at odds with the interior indicated by the background to the right. The clouds are possibly remnants from some early phase in the painting's development, like the woman in a high-necked black dress. The shape of her long dark hair is visible as a pentimento beneath the white shirt of the Tahitian boy next to her, indicating that Gauguin began his composition with the woman alone. Her leftward glance, apparently directed at someone outside the picture, seems strange in the context of the final composition.

The boy, for whose head there is a thumbnail sketch in one of Gauguin's notebooks,[2] turns his eyes toward the spectator, and the divergence of his glance from the woman's is left unresolved. Silhouetted against a rectangular field of blue similar to the backgrounds Cézanne used for several portraits of his wife,[3] the woman appears like a picture within a picture. The thick black shapes above her and to her left suggest a frame. Although the significance of these black rectangular zones in *Te tiare farani* is unclear, this odd detail anticipates the woman observed through a window in a still life of 1901 (cat. 253). What seems clear, however, is that Gauguin eventually came to appreciate the interplay between the blue area behind the woman, the blue pants of the male figure that he added next to her, and the complementary golden yellow wall that serves as the background at the right side of *Te tiare farani*.

The lower section of this wall is masked by a dark blue and yellow floral print *pareu* that recalls the crumpled patterned curtains in many still lifes by Cézanne.[4] The decorative flowers printed on it, evidently draped over a piece of furniture, intermingle with the real flowers in the adjacent vase. This same garment, which appears tossed onto the floor in a watercolor illustration to *Ancien Culte Mahorie*,[5] is worn by one of the female attendants in the background of *Ia orana Maria* (*Hail Mary*) (cat. 135).

Given the discontinuities between its constituent parts, *Te tiare farani* might be understood as a statement of Gauguin's priority of relationships of color and form over logical subject matter. Several early still lifes (see cat. 13) by Gauguin are charged with similar lapses in logic, and the resulting mood of mystery in all of these paintings was among Gauguin's foremost goals.

Te tiare farani was apparently among eight early Tahitian paintings that the artist consigned to the dealer Durand-Ruel just prior to the opening of his exhibition of forty-four paintings and several sculptures at the gallery in November 1893. Of these eight, it was assigned the lowest value in the gallery records, 800 francs, compared to 1,500 francs for the most expensive (see cat. 145).[6]–C.F.S.

1. Distel, in Paris 1978, 30 n. 11; Kostenevich and Bessonova 1983, no. 60.

2. Dorival 1954, 28.

3. For example, see Venturi 1936, nos. 521, 526, 573.

4. Venturi 1936, nos. 499, 597, 598, 625, 734, 741, 742.

5. Huyghe 1951, 25.

6. Archives Durand-Ruel, Paris, Brouillard (Juin 1893–Novembre-Décembre 1897), entry for 28 November 1893, received on deposit and assigned stock number 8324; entry for 29 January 1895, returned to Gauguin, c/o M. Bernheim.

121
Upaupa

Gauguin listed this infernolike nocturnal scene as *Upaupa* (Fires of Joy) near the very beginning of the 1892 inventory of his Tahitian works.[1] The fact that the artist decided not to include it in the exhibition that he staged in Paris in 1893 might suggest that he was not completely satisfied with this painting, which purports to record a festival of native dancing, characterized by frenetic, lewd gestures, accompanied by drumming. But Gauguin repeated the whole composition in a

Upaupa

1891

73 x 92 (28½ x 35⅞)

oil on coarse canvas

signed and dated at lower right, in light blue,
P Gauguin 91

The Israel Museum, Jerusalem, gift of the
"Hanadiv" Foundation, London

EXHIBITIONS
Paris, Drouot 1895, no. 36, *Feux de joie*;
Tokyo 1987, no. 56

CATALOGUES
Dorival 1954, inv. no. 6, as *Upa Upa*;
FM 129n; Field 1970, no. 9; W 433

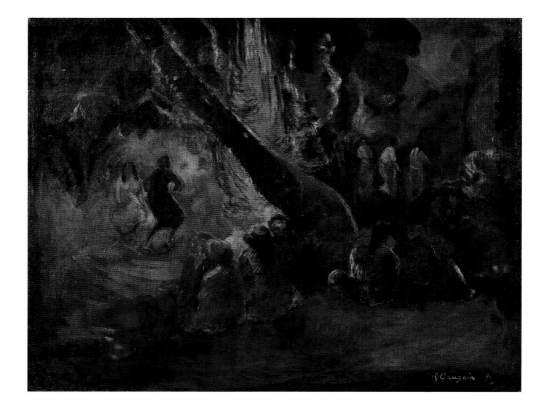

1. Field 1977, 304, no. 6.

2. Danielsson 1967, 231, no. 26, and 233,
no. 68.

3. Dorival 1954, inv., 1892, 15, 16v and 22v;
and perhaps a separate pen and ink study
(see Saint-Germain-en-Laye, no. 383, and
Tokyo 1987, no. 150). Several of the spectator
figures are repeated in a watercolor in the
shape of one side of a fan with which
Gauguin illustrated his copy of *Noa Noa*
(Louvre ms, 173).

4. Field 1977, 312, no. 9.

5. O'Reilly [n.d.], 11-18.

6. Loti 1879, chapter 13.

7. Roskill 1969, 204.

woodblock print (cat. 175) around 1894, adding the misspelled legend *Mahna no varua ino* (*The Day of the Evil Spirit*). And for another woodblock print (cats. 171, 207) he enlarged the pair of lovers seated in an embrace at the far right of *Upaupa*, adding the winged head of a specter above them. Gauguin inscribed this print with the legend, again misspelled, *Te faruru*, meaning literally "to tremble," or metaphorically "to make love."[2] Like many of Gauguin's woodblock prints, impressions of both of these were in luridly colored inks to convey the mysterious flicker of the sort of fiery nocturnal spectacle that he sought to render in oils with *Upaupa*.

Yet since Gauguin neglected to describe any *upaupa* festival in *Noa Noa*, there is no way to know whether he ever attended such a rite or whether he created this scene in imagination with the help of little sketches of seated figures and dancers jotted into his notebooks.[3] Field's suggestion that the painting might be based on a photograph has never been substantiated.[4] With the arrival of European missionaries in Tahiti, heathen dancing had been repressed, although the natives maintained their heritage by dancing the *upaupa* in clandestine houses throughout the early nineteenth century.[5] In the best-selling novel recording his experiences in Tahiti in 1872, Loti included a rare account of these dances, for at that time the princess Pomare presided over rituals every night outside her palace in Papeete, and, in a spirit of competition, the women from outlying villages held still more savage dances.[6] The dance recorded in Gauguin's painting, however, with its enormous bonfire, differs considerably from those described in Loti's novel.

Gauguin based the composition of *Upaupa* on his 1888 masterpiece, *Vision after the Sermon* (cat. 50), the intense red background of which is crossed in similar fashion by the inclined trunk of a tree.[7] Since the Tahitian dance amounts

to a cathartic form of pagan devotion, Gauguin's decision to repeat his earlier composition seems significant, as if he associated the two dancing figures at the left of *Upaupa* with the wrestling figures of Jacob and the angel in the earlier work. Moreover, the allegorical titles that Gauguin inscribed on the woodblock prints related to *Upaupa* suggest that he may have conceived the painting in visionary rather than realistic terms. The women in the background at the right anticipate the tiny celebrants in outdoor sanctuaries included in the imaginary history paintings, such as *Arearea* (W 469),[8] that Gauguin undertook at the end of 1892. An elaborate undated pencil drawing likewise reconstructs an imaginary past with native dancers around an idol.[9]—C.F.S.

8. See W 467, W 468.

9. Rewald 1958, no. 41. Teilhet-Fisk 1985, 65.

122
Head of a Tahitian with Profile of Second Head to His Right (recto); Two Figures Related to Tahitian Landscape[1] and Head (verso)

1891 or 1892 (?)

352 x 369 (13⅞ x 14½)

recto, black and red chalk selectively stumped and fixed; verso, black chalk with accidental touches of watercolor, on wove paper

inscribed on recto at lower left, faintly in pencil, *HAUTEUR*

The Art Institute of Chicago, Gift of Mrs. Emily Crane Chadbourne

EXHIBITIONS
New York 1913, no. 177, *Tête d'homme*; Chicago 1913, no. 140; Boston 1913, no. 57, *Head of a Tahitian Man*; Chicago 1959, no. 98; Munich 1960, no. 108

shown in Washington and Chicago only

1. W 442.

A group of powerful portraits of individual Tahitians' heads (cats. 118, 119, 123, 124, 125), for the most part in charcoal, forms a significant part of Gauguin's artistic output during his first trip to Tahiti. Although Gauguin may have considered them among the "documents" to which he referred in many of his letters back to France, the scale and careful execution of these stately portrait heads set them apart from his other early Tahitian drawings. Moreover, since many of these heads were never used as working drawings for paintings, it seems quite possible that Gauguin conceived them as independent exhibition drawings. It is impossible to identify any of them with works in the private exhibition at his studio in Paris at the end of 1894 or with the drawings in the auction the following February.

2. W 422.

3. Danielsson 1975, 88–89; Anani is mentioned by name in *Noa Noa*, Louvre ms, 97.

4. *Noa Noa*, Louvre ms, 74–83.

The Art Institute drawing, the only one of this group to portray a male, was probably done relatively early, judging from the figures on the verso of the sheet (working studies for a painting dated 1891) and the similarity of the man's features to those of the sitter in an undated portrait in oils that appears to be relatively early in terms of style.[2] These works perhaps portray Anani, Gauguin's landlord and neighbor in Mataiea,[3] or Jotépha, who led Gauguin into the mountains to find wood to make sculpture.[4] Since the sitter turns to the left in the oil portrait, his face lacks the intensity evident in the Art Institute drawing. Gauguin adjusted the contours, especially around the chin, to give the man's likeness a masklike regularity. This quality is accentuated by Gauguin's decision to leave the eyes unworked, as he did in most of the portrait drawings from his first trip to Tahiti.

Curiously, the profile to the right of the man's head in the Art Institute's drawing corresponds exactly to the profile, facing in the opposite direction, of a seated woman in *Te rerioa* (cat. 223), a major oil painting executed in 1897. This correspondence suggests that Gauguin had the Art Institute drawing with him when he returned to Tahiti in 1895. But it is impossible to determine whether the female profile was part of the original early drawing used as a point of reference some six years later or whether Gauguin added the profile to the early drawing at the later date.–C.F.S.

123
Heads of Tahitian Women, Frontal and Profile Views (recto); Portrait of Tehamana (verso)

1891 or 1892 (?)

414 x 326 (16¼ x 12¾)

charcoal, selectively stumped and worked with brush and water, fixed, on wove paper

The Art Institute of Chicago. Gift of David Adler and His Friends. 1956.1215

shown in Washington and Chicago only

Although one side of this drawing has here been designated the recto, both sides are equally worked portraits belonging to the impressive group of masklike heads (see cats. 118, 119, 122, 123, 125) executed during Gauguin's first stay in Tahiti.

The portrait of Tehamana on the so-called verso apparently served the artist as a guide for an oil painting dated 1893 (see cat. 158). This does not necessarily imply that it postdates the drawing of another model on the recto. This other drawing, unrelated to any work in oils by Gauguin, is one of several to include a faint profile of an ancillary figure in the background (see cats. 122, 123).

The fainter profile heads seem to suggest a dialogue similar in spirit to that in several of Gauguin's most ambitious early Tahitian paintings (see cats. 136, 145, 147). The contrast between the sculptural primary heads in these drawings and the more tentative, exclusively linear profiles suggests that the latter might have been intended to represent immaterial spirits, or internal psychic states projected as alter egos. Just such a dialogue between a woman and a spirit is represented in one of Gauguin's late transfer drawings (see cat. 260). In many of the paintings made during his first stay in Tahiti, Gauguin explored different ways to visualize similar encounters between his Polynesian models and the spiritual world (see cats. 147, 148, 154). Indeed, in the painting based on the verso of this drawing, the disembodied heads of *tupapaus* over each of Tehamana's shoulders seem to be an elaboration of the idea that Gauguin sought to express in the drawing on the recto.–C.F.S.

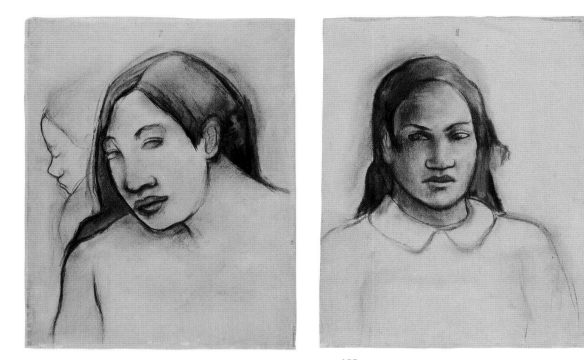

cat. 123, recto cat. 123, verso

124
Head of a Young Tahitian Woman with a Second Figure in Profile to Her Right

This drawing is another one of the group of charcoal drawings of heads of Tahitians (cats. 118, 119, 122, 124, 125) that Gauguin may have included in what he referred to as the "documents" he assembled in Tahiti before he felt he could begin to paint in earnest. It seems to portray the artist's favorite model, Tehamana. Since Gauguin did not indicate pupils in the eyes in any of these portrait drawings, her face seems like a mask. Although all of the drawings in this group amount to independent exhibition pieces, this is one of only two (see cat. 125) that he signed, which suggests that the artist sold them during his return visit to France.

 Like cat. 122, the head in this drawing is embellished by the addition of a faintly indicated profile of a second face at the left. Perhaps another rendition of Tehamana's features, this profile corresponds to the head of the standing figure at the right in an unfinished oil painting.[1] Although the principal head on this sheet does not correspond exactly to any painting by Gauguin, it is remarkably similar, albeit facing in the opposite direction, to the head of the figure at the left of this same unfinished work, for which Gauguin apparently also made an oil study.[2]—C.F.S.

1. W 456.

2. W 448.

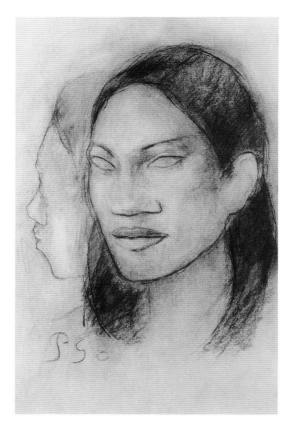

Head of a Young Tahitian Woman with a Second Figure in Profile to Her Right

1891 or 1892 (?)

590 x 440 (23 x 17⅛)

charcoal on wove paper

signed at lower left, *P Go*

private collection

1. *Noa Noa*, Louvre ms, 45.

2. *Noa Noa*, Louvre ms, 45.

3. W 27. For references to this trip to Montpellier as well as one in 1888 with van Gogh, see *Avant et après*, 1923 ed., 220–222; and Roskill 1970, 262.

4. Malingue 1949, CLXXII.

5. See W 391, W 424 bis, and Pickvance 1970, pl. X.

125
Head of a Tahitian Woman

This drawing belongs to a special group of similar portrait heads (cats. 118, 119, 122, 123, 124) characterized by a masklike quality, since Gauguin decided not to indicate pupils in the eyes and since he generalized the features in the classicizing spirit of Raphael. Indeed, in *Noa Noa*, recounting how he persuaded one of his Tahitian neighbors in Mataiea to pose for him, Gauguin noted: "All of her features afforded a Raphaelesque harmony in the conjuncture of curves. . . ."[1] According to *Noa Noa*, what Gauguin most wanted to capture in his portrait drawings was the "enigmatic smile."[2] Although there are no direct precedents in nineteenth-century art for such portrait drawings, the Lande head recalls in a general way Delacroix's oil studies of an exotic model referred to as Aspasie, one of which Gauguin had copied when he visited the Musée Fabre in Montpellier in the late 1870s or 1880s.[3]

Gauguin's economical treatment of color in the Lande drawing adds to its mood of mystery. Using only two dark pigments, Gauguin varied his touch, drag-

ging his crayons to suggest a flicker of shadows, while stumping and wetting different areas to obtain rich, shimmering textures. Gauguin's own admiration for such finesse is clear from a letter he wrote to the critic Fontainas in 1899, comparing Maurice Quentin de la Tour's mastery of the pastel medium to the deftness of a fencer.[4]

Although in the Lande drawing the head nearly fills the entire sheet, Gauguin left the upper corners blank, and the resulting arched vignette shape should perhaps be compared to the irregularly curved shapes of a group of preparatory drawings (cats. 112, 149)[5] that Gauguin reworked, presumably to make them more suitable for exhibition or sale.—C.F.S.

1891 or 1892 (?)

310 x 240 (12¼ x 9⅜)

charcoal and black chalk, selectively stumped and worked with brush and water on laid paper

Mr. and Mrs. Bernard Lande

shown in Washington and Chicago only

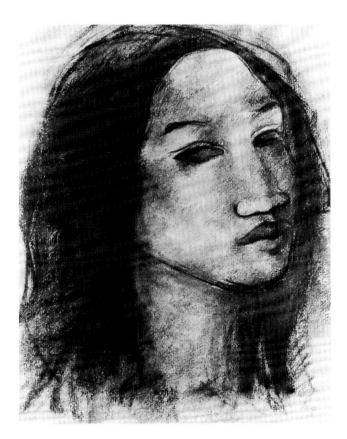

126
Faaturuma

1891

94.6 x 68.6 (36⅞ x 26¾)

oil on canvas

signed and dated at lower right, in orange,
P Gauguin 91

inscribed at lower right corner of frame of
painting represented in the background, in
red orange, *Faaturuma*

The Nelson-Atkins Museum of Art, Kansas
City, Missouri (Nelson Fund)

EXHIBITIONS
Paris, Durand-Ruel 1893, no. 27, *Faturuma
(Boudeuse)*, or no. 28, *Mélancolique*; Paris,
Drouot 1895, no. 30, *Faturuma*; ? Paris,
Vollard 1896; Béziers 1901, no. 52, *Tahi-
tienne au rocking-chair*; Paris 1903, no. 31,
Rêverie; Paris 1906, no. 72, *Rêveuse*; London
1910, no. 45, *Rêverie*; Paris, Orangerie 1949,
no. 26; Chicago 1959, no. 29

CATALOGUES
Dorival 1954, inv., no. 7, *Faturuma*; Field
1977, no. 64; W 424; FM 11

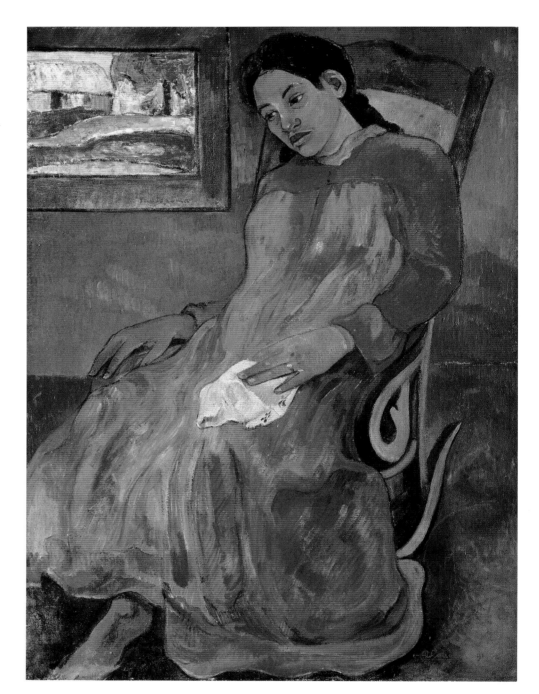

The inscribed title is so similar to the title *Te faaturuma* inscribed on another
painting of the same year (cat. 127) that details in their histories may have been
confused by early writers. Taking into account the likelihood that Degas bought
the latter work out of the 1893 exhibition at the Durand-Ruel gallery, it would
seem that the Kansas City painting was the one included in the 1895 auction and
bought in by Gauguin. Moreover, the Kansas City picture probably corresponds to
the work listed as "Faturuma" near the beginning of Gauguin's inventory of his first
thirty Tahitian paintings.[1]

Corot, *Reverie*, 1878, oil on wood [The Metropolitan Museum of Art, New York, Bequest of Mrs. H.O. Havemeyer 1929, The H.O. Havemeyer Collection]

1. Dorival 1954, 2; Field 1977, 304, no. 7.

2. Danielsson 1975, 89.

3. W 423.

4. Field 1977, 334.

5. Maurer 1985, 967–969.

6. Dorival 1954, 31, 73.

7. Jénot 1956, 120, 124, refers to Gauguin's use of "blanc d'Espagne."

8. For Gauguin on symbolic color see, for example, Merlhès 1984, no. 163, or Joly-Segalen 1950, XXVIII.

9. Rewald 1978, 466.

Faaturuma (Melancholic or Reverie) is probably among the nearly twenty exhibition paintings that Gauguin painted during the last three months of 1891 after he settled in Mataiea. The small painting in a simple wood frame on the background wall of *Faaturuma*, presumably a lost work by Gauguin, may record the bamboo hut that Gauguin rented there (cat. 132, W 438).[2] He must have brought the rocking chair with him from Papeete, for it appears in a portrait that he painted shortly after his disembarkation.[3]

In terms of style, *Faaturuma* appears to be relatively early. Its colors are restrained compared with those in most of the other paintings dated 1891, and it is less elaborate in terms of composition. Field suggested that Gauguin may have based his composition on a figure painting by Corot that belonged to Arosa.[4] Indeed, this pensive native woman wearing a missionary dress is a hybrid between traditional European portraiture and the decorative style that Gauguin would develop in the South Pacific. It is both a reprise of Gauguin's first attempt to render a woman lost in her thoughts, executed in 1889 (cat. 61), and a prologue to a group of nine extraordinary pictures with the same theme (including cats. 127, 130, 145, 147, 148, 153, 154) that preoccupied him throughout his first stay in Tahiti.[5]

Although there is a large drawing (cat. 146) that may record Gauguin's first idea for this composition, and although he made pencil sketches in a small note-book,[6] most preliminary drawing was done in charcoal on the canvas. Traces of his initial attempts to outline her skirt are visible today as pentimenti. The lack of definition in her foot is particularly noteworthy, given the care with which Gauguin defined feet in his other Tahitian paintings. Much of Gauguin's ultimate drawing was done with color, especially the woman's body underneath her dress, rendered in long strokes of white.[7] For the most part, the paint is applied thickly with a brush or palette knife, and large areas of color, such as that of the dress, are enlivened with varied hues. It is the treatment of color in *Faaturuma* as much as gesture, pose, and facial expression that conveys the mood of quiet sadness with such assurance.[8]

The identity of the model is open to question. The same woman wearing the same dress but without a ring appears in *Tahitian Women* (cat. 130), and her features have been identified as those of Tehamana.[9]–C.F.S.

127
Te faaturuma[1]

1891

91 x 68 (35½ x 26½)

oil on fine-weave canvas

signed and dated at lower left on hat brim, in blue, *P Gauguin 91*

inscribed at upper left, probably by Daniel de Monfreid,[2] in red orange, *Te Faaturuma*

Worcester Art Museum

EXHIBITIONS
Copenhagen Udstilling 1893, no. 162, *Te Faaturuma*; Paris, Durand-Ruel 1893, no. 27, *Faturuma* (*Boudeuse*), or no. 28, *Mélancolique*; Paris, Drouot 1895, no. 30, *Faturuma*; Paris 1918, Degas sale, no. 41; Chicago 1959, no. 30; Copenhagen 1984, no. 43

CATALOGUES
Dorival 1954, inv., 1892, no. 7, *faturuma*, or no. 8, *idole du foyer*, or no. 16, *femme faisant chapeau*; Field 1977, no. 13; W 440; FM 119

1. See Danielsson 1967, 232–233, no. 63.

2. Joly-Segalen 1950, VIII, and Field 1977, 279 n. 24.

3. Danielsson 1975, 125; Joly-Segalen 1950, VIII.

This was one of eight unstretched and unframed pictures that Gauguin sent in early December 1892 to Monfreid in Paris,[3] who was to send them on to Copenhagen for an exhibition that opened around 25 March 1893. Gauguin pointed out to Monfreid that four of them remained uninscribed with the Tahitian titles he had invented for them, and he asked him to add these, describing the Worcester painting as "La femme en chemise," which should be inscribed *Te faaturuma*. Gauguin explained in a letter to his wife that he wanted his works to be listed in the catalogues with only their Tahitian titles, which he translated in

Degas, *Dancers Resting*, 1881-1885, pastel on paper mounted on cardboard [Museum of Fine Arts, Boston, Juliana Cheney Edwards Collection]

Gauguin, *Seated Woman*, pastel (?) [location unknown]

4. Malingue 1949, CXXXIV.

5. Bodelsen in Copenhagen 1984, no. 43, incorrectly implied that *Te faaturuma* was not one of the two works bought by Degas from the 1893 exhibition.

6. First published in Roger-Marx 1894, 33.

7. In particular see Lemoisne 1946-1949, no. 661.

8. Gauguin captured her in the same head-to-hand pose in a quick sketch in Dorival 1954, inv., 1892, 64; another sketch in the notebook (17v) may also be related to this painting.

9. Danielsson 1975, 88–89; more detail was given in the 1966 edition, 94.

10. Reproduced in Munich 1960, no. 123, pl. 47. Gauguin inscribed this pastel as a gift to the critic Arsène Alexandre.

11. Maurer 1985, 969.

12. Malingue 1949, CXXVI.

case she needed to explain them to a potential buyer. For *Te faaturuma* he gave the equivalents "Le Silence" or "Etre Morne" (Silence, or To Be Dejected), and he allowed her to set the price.[4]

Apparently in an attempt to avoid confusion with another of his early Tahitian paintings, *Faaturuma* (cat. 126), the Worcester painting was entitled *Mélancolique* in the catalogue for the Paris exhibition of Gauguin's work in November 1893. After this exhibition the painting was purchased by Degas,[5] which explains why *Te faaturuma* was not listed among the works that Gauguin was compelled to sell at auction in 1895.

This sale must have seemed extremely important to Gauguin for its potential to set an influential example to others, because Degas was generally acknowledged to be one of the most discriminating collectors in Paris. Indeed, Gauguin had a publicity photograph taken of himself in profile next to this picture.[6] No less important, this sale must have seemed like an act of recognition to Gauguin, whose art often developed ideas that Degas had originated. *Te faaturuma* is one of three early Tahitian pictures (cats. 144, 156) with direct counterparts in works by Degas, in this case his many images of weary dancers, heads propped on hands, seated in empty rehearsal rooms.[7] The pose of the figure and also Gauguin's treatment of space observed from above should be understood as homage to his distinguished older colleague.

There are many open questions about *Te faaturuma*, starting with the identity of the model. Presumably, it was Tehamana.[8] The setting with the veranda in the background does not correspond to the hut that Gauguin rented in Mataiea, but, if not altogether imaginary, it may represent the interior of his landlord's colonial-style house.[9] Although it is clear from Gauguin's title that she is pouting (motivated, perhaps, by the man on the horse waiting outside), it is unclear whether she is doing anything else. No one has been able to identify or explain the smoking cigarlike object in a simple wooden bowl placed before her, which could be insect repellent or incense. If the latter, *Te faaturuma* may correspond to the work that Gauguin inventoried in 1892 as "idole du foyer," the term "idol" a metaphor for the woman's Buddha-like pose. The other props, no more pertinent to the overall context of the scene, seem to be accents of color devoid of any specific narrative functions. None of them is included in Gauguin's full-scale preparatory pastel.[10]

It has been suggested that this figure symbolizes Gauguin's earliest and most abiding response to the haunting silence of the island and its natives, described in a letter to his wife written shortly after his arrival in Tahiti.[11] "Always this silence. I understand why these individuals can rest seated for hours and days without saying a word and look at the sky with melancholy."[12]

Gauguin also incorporated this figure into a large landscape (see cat. 131).—C.F.S.

128
The Siesta

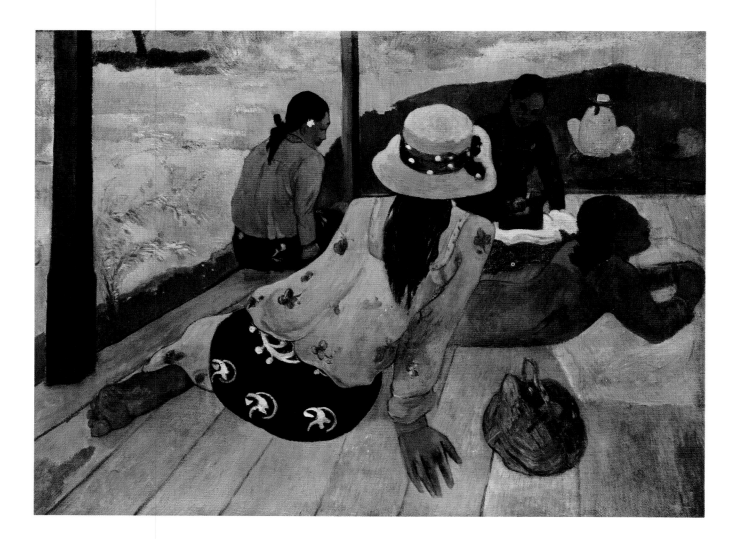

probably 1891–1892

87 x 116 (34 x 45¼)

oil on canvas

Mr. Walter H. Annenberg

EXHIBITIONS
Zurich 1917, no. 103; New York 1956, no. 38;
Chicago 1959, no. 50

CATALOGUE
W 515

shown in Washington and Chicago only

The absence of a signature, date, and title on this superb canvas has long puzzled scholars, some placing this picture in Gauguin's first Tahitian visit, and others concluding that it was among the canvases painted after Gauguin's return to France.[1] The latter notion prevailed in the most recent catalogue raisonné of Gauguin's paintings.[2] Because there is no evidence that the painting was exhibited during Gauguin's lifetime, a judgment about the date and the degree of finish must rely on stylistic and technical evidence.

The painting represents women seated on a veranda during the intense heat of the day, and other figures occupying the shady portion of the lawn. The veranda itself is unusual; lacking cutout balusters, it is clear that it is not part of a colonial house like that represented in *Ta faaturuma*.[3] Rather, it seems to be the side porch of a low, native house built not in the traditional manner, but in imitation of colonial dwellings. Similar covered spaces can be found in other paintings by Gauguin, especially two landscapes also from 1891, *Street in Tahiti* (cat. 131) and *Les Porceaux Noirs*.[4]

The Siesta is a genre study of domestic work and leisure in a colonial setting. The fact that one figure is ironing tells us immediately that it has no

ethnographic ambitions. Women wear both Western missionary dresses and *pareus* made not with native tapa, but English printed fabric. Both need to be washed and ironed along with the household linen present in the painting. Yet, despite the colonial origins of the costumes, there are no Europeans present.

The position of the viewer in this painting is at once encouraged by the clearly legible pictorial space and discouraged by the poses and psychological distance among the figures. Gauguin has observed the patterning and construction of the superb principal figure's garment in as detailed a way as any painter of *la mode* in Paris. Like the fashionable Parisienne, she is nothing other than her costume; we see one hand, one foot, and her hair, but we have no sense of her age, her mood, or her purpose.

For all its mysteries, the painting is among the most satisfying of Gauguin's Tahitian genre scenes. It was executed on a size 50 canvas, the largest he used on his first Tahitian trip, and one that he never used after his return to Tahiti in 1895. Its companions in size include such masterpieces as *Ia orana Maria*,[5] *Street in Tahiti, Tahitian Pastorals*,[6] *Matamoe*,[7] and the great *Aita tamari vahine Judith te parari*,[8] ranging in date from 1891 to 1894. It is impossible to date this unfinished painting with precision in terms of its palette, because analogous works can be found throughout the period. It was most likely begun in 1891–1892, when Gauguin seemed most interested in genre scenes and in varieties of Tahitian colonial costume.–R.B.

1. Huyghe 1967, 64, dates it 1894; Van Dovski 1950, no. 302, places it in the 1893 period, but offers no explanation for his redating of the Wildenstein 1964, in which it is dated 1894.

2. W 515.

3. Cat. 127.

4. W 446. See, for example, contemporary photographs of colonial homes by Gauguin's friend Charles Spitz, an amateur who photographed Tahiti.

5. Cat. 135.

6. Cat. 155.

7. Cat. 132.

8. Cat. 160.

129
The Meal, or The Bananas

Listed with the earliest Tahitian paintings in the inventory that Gauguin compiled in 1892, this stunning picture, a work that is half still life and half genre and without any apparent precedent among his own works or those by colleagues, was apparently not included in any exhibition until after the artist's death, perhaps because its support is paper. The only other early Tahitian painting on paper by Gauguin[1] was never brought to completion. Although *The Meal* was mounted on canvas at an early date, exactly when and by whom are unknown.[2] Whereas large working drawings for several other early Tahitian paintings (cats. 127, 145, 147, 148) have survived, in this case Gauguin's working drawing quite literally became his finished composition in oils. Infrared photography of the painting has revealed several details in the original underdrawing that Gauguin altered as the work developed; for example, the child at the right in a high-collared shirt was originally a girl with long hair, and the ear of the girl in the center of the composition was visible at first.

As Bodelsen pointed out, Gauguin seems to have donated this picture to the auction held in Paris on 2 June 1894 for the benefit of the widow of the art-supply dealer Julien Tanguy, who had been a staunch supporter of several generations of avant-garde artists.[3] Although it is unclear whether it was bought at this sale, it was acquired by Degas' friend Alexis Rouart soon thereafter.

1. W 516.

2. Distel in Paris 1978, no. 12.

3. Bodelsen 1957, 346–348.

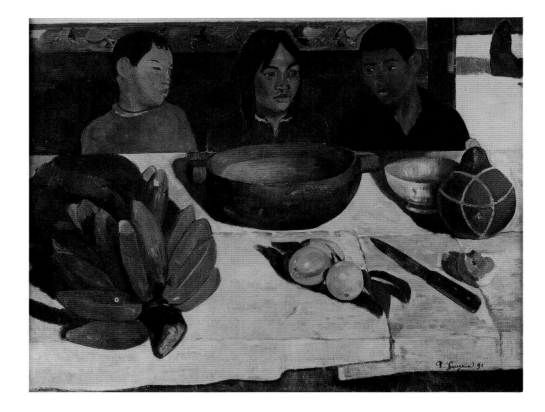

The Meal, or The Bananas

1891

73 x 92 (28½ x 35⅞)

oil on paper mounted on canvas

signed and dated at lower right in dark blue,
P Gauguin 91

Musée d'Orsay, Paris

EXHIBITIONS
Paris 1894, Mme Vve Tanguy sale, no. 27;
Paris 1906, no. 219, *Les Bananes*; Paris,
Orangerie 1949, no. 27; Chicago 1959, no. 27

CATALOGUES
Dorival 1954, inv., 1892, no. 12, *nature morte
fei*; Field 1977, no. 65; W 427; FM 18

4. This figure also appears in W 435.

5. Maurer 1985, 960–962.

Almost everything about the painting contributes to an air of mystery, most of all the seated adult figure casting a long shadow in the background.[4] Characterizing this dark figure as an image of foreboding, Maurer suggested that the gazes of the two boys directed to the girl between them, taken together with the phallic and uterine shapes of the bananas and bowl, are evidence of the awakening of sexual awareness.[5] Although such an interpretation cannot be dismissed altogether, the boys' somewhat anxious facial expressions might also be a response to the presence of the French artist who has asked them to pose, or to the unusual elements in the still life before them. The still-life elements all seem to have been chosen by Gauguin primarily for their decorative shapes and colors rather than as documents of a typical native meal. To begin with, Gauguin's table, used as a prop in only one other painting (cat. 120) during his first trip to Tahiti, seems out of place in a native hut. All the children keep their hands off the tablecloth, which must have struck them as no less peculiar than the table. The artist apparently fashioned it by overlapping large scraps of heavy paper or canvas. The *fei* (red bananas) on the table are considered to be a great delicacy that grows only in the mountains of Tahiti, but they are inedible in the uncooked form shown here. The wooden bowl filled with seawater should contain a fish and savory sauce to eat. Like these objects, the half-eaten guava placed away from the children, the knife, and three wild lemons still on a branch seem only decorative. Whereas all of these props are brightly illuminated and cast long shadows, by contrast the children in their drab costumes seem immune from the same play of light, suggesting that Gauguin may have added them to his still-life composition at a late phase of its development.

The painted frieze behind the children, composed of stylized pieces of fruit, is probably Gauguin's invention. It reflects his abiding interest in the decorative arts and it prefigures the fanciful friezes and murals in two of his most ambitious late Tahitian paintings (cats. 222, 223).–C.F.S.

130
Tahitian Women, or On the Beach

1. Danielsson 1975, 99–100, 106.

2. W 466.

3. Danielsson 1967, 232, no. 45.

4. Bodelsen in Copenhagen 1984, no. 46.

5. Malingue 1949, CXLIII.

6. It is the same dress that is worn by the same model in another painting from 1891 (W 424).

Needing to raise money to return to France in the spring of 1892, Gauguin increased his efforts to find local patronage, and apparently around early June he was able to sell *Tahitian Women* to Charles Arnaud, who had come to Tahiti for his military duty and remained there as a trader.[1] This extraordinary work, evidently executed before Gauguin decided to inscribe Tahitian titles on his paintings, was not known in France until 1920. But the fact that Gauguin immediately made a revised replica[2] of the composition gives some idea of the importance that Gauguin attached to it. Moreover, though the surviving correspondence between Gauguin and Monfreid makes no reference to when Gauguin sent the second version inscribed *Parau api* (News)[3] to France, it was among the ten paintings that arrived in Copenhagen on 13 March 1893, to be exhibited there. On its arrival *Parau api* was immediately purchased by Edvard Brandes.[4] The sale upset Gauguin, who had counted on including the work in his exhibition in Paris in November of that year.[5]

1891

69 x 91 (26⅞ x 35½)

oil on fine-weave canvas

signed and dated at lower right, in brown, *P Gauguin 91*

Musée d'Orsay, Paris

EXHIBITION
Paris, Orangerie 1949, no. 31

CATALOGUES
Dorival 1954, inv., 1892, no. 16, *femme faisant chapeau*; Adhémar 1958, no. 135; Field 1977, no. 14; W 434; FM 135

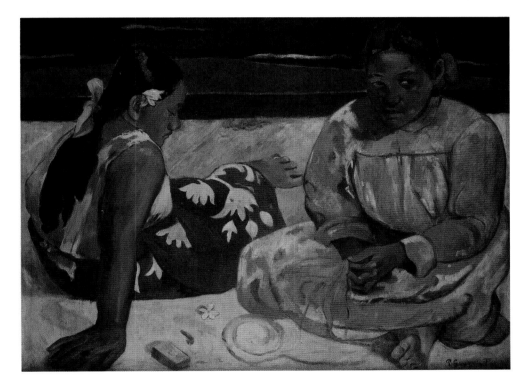

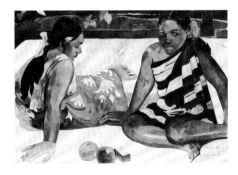

Gauguin, *Parau api* (*What News?*), 1892, oil on canvas [Staatliche Kunstsammlungen, Dresden]

Parau api differs significantly from *Tahitian Women* in only a few respects: whereas the floor in the earlier version is a relatively subdued ocher, in the later version it is intense chrome yellow; and, the woman seated on the right in the later version wears a striped *pareu*, instead of the missionary dress that she wears in *Tahitian Women*.[6] Perhaps the most intriguing difference, however, is the addition of the bottom of a post for a balustrade of the sort commonly constructed around the verandas of colonial houses in Tahiti. This post, together with the faint diagonal lines visible in the corresponding ocher and yellow zones of both versions, suggests that neither picture represents a scene on the beach, despite the title

traditionally given to the Musée d'Orsay picture. Presumably Gauguin's setting is ambiguous by design. Although the lines of white against the dark background suggest breaking waves in the distance, the squared outlines of the adjacent horizontal zones of color in this picture instead suggest architecture.

Since the same woman obviously posed for both figures, the term "women" in the traditional title is as problematic as "beach." The inertly posed figure on the left wears the same floral pattern *pareu* that the Virgin Mary wears in *Ia orana Maria* (cat. 135) and a *tiare* behind her right ear.[7] In spirit, the decidedly graceless profiles of her back and face (this latter one repeated by Gauguin in reverse on a drawing, cat. 124) recall those in the large nude (cat. 4) that Gauguin had exhibited with the impressionists in 1881. Although the stolid pose of the figure on the right is quite similar to one captured in a quick watercolor sketch in a notebook that Gauguin used in Tahiti,[8] in the painting the artist sought to capture a faint revelation of mood by indicating a shift in Tehamana's eyes to the right in reaction to something (perhaps the "news" in the title Gauguin gave to the second version) outside the picture.

Since the figure seated with her legs crossed is braiding strips of palm leaf, this picture may be related to the otherwise unidentifiable work listed in Gauguin's 1892 inventory as "woman making hat."[9] But indolence is more at issue here than work, and Gauguin's uppermost artistic goal was the orchestration of a decorative color harmony, with the palm fronds, the matchbox, the dresses and the hair ribbons included as interacting tones of yellow and red, streaked with white highlights.

What is most remarkable about *Tahitian Women*, however, is its composition. By the conventional standards for nineteenth-century pictures the two slightly overlapped figures are crowded in Gauguin's painting, as if observed close up, with almost total disregard for the spatial setting. Whereas other artists might have included such a tightly interlocked figural group as a detail in a more populated composition, there is no direct precedent for the way Gauguin has monumentalized their arbitrary activity by isolating them in this way. The painting that most closely prefigures Gauguin's *Tahitian Women* in this respect is probably Manet's *On the Beach*,[10] which Gauguin may have seen when it was exhibited in Paris at the beginning of 1884.–C.F.S.

7. This same figure appears in reduced scale in W 437 and W 477.

8. Dorival 1954, inv., 1892, 19. Le Pichon 1986, 154, compares the figure on the right to C. Chaplin's *Petit Moissoneuse endormie* (Gustave Arosa Collection), of which Gauguin owned a photograph.

9. Dorival 1954, inv., 1892, 2.

10. Rouart and Wildenstein 1975, no. 188.

131
Street in Tahiti

This majestic landscape must correspond to the work listed by Gauguin as a size 50 canvas entitled "Paysage Papeete" in the inventory he compiled in early 1892.[1] Thus it records some otherwise undocumented trip back to the capital, perhaps for medical treatment, from Mataiea, where he had installed himself in the fall of 1891 to begin painting in earnest.[2] Judging from the barren mountains in the background, this picture was painted during the dry season, which typically extends from November to March. While the little dirt road bordered by a low wall is characteristic of the outskirts of the capital, the feathery brushwork in this

1. Field 1977, 306, no. 26.

2. Field 1977, 251, no. 99.

1891

115.5 x 88.5 (45 x 34½)

oil on canvas

signed and dated at lower right, in black,
PGo 91

The Toledo Museum of Art, gift of Edward
Drummond Libbey

EXHIBITIONS
Paris, Durand-Ruel 1893, no. 34, *Paysage*;
Frankfurt 1913, no. 25; Edinburgh 1955,
no. 27; Chicago 1959, no. 31

CATALOGUES
Dorival 1954, inv., 1892, no. 26, *Paysage
papeete*; Field 1977, no. 19; W 441; FM 111

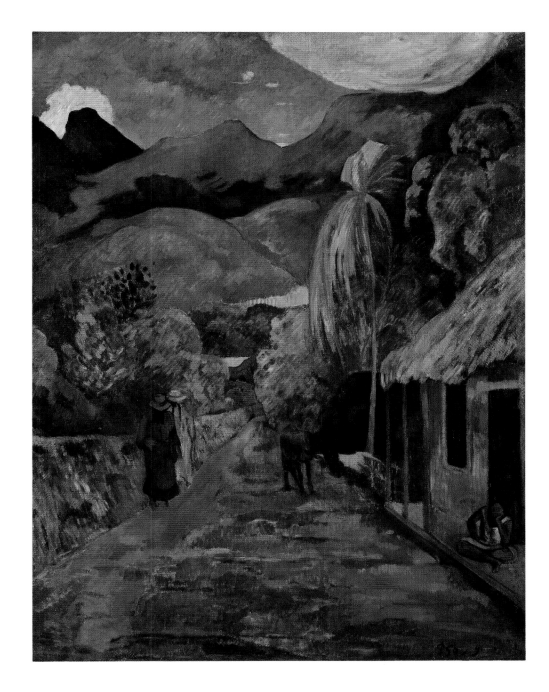

Gauguin, *Carnet de Tahiti*, page 18

3. Field 1977, 70–72.

4. W 70, W 84, W 88, W 127.

5. Dorival 1954, inv., 1892, 9, 12, 13v; the
house appears on a sheet of studies (77), ele-
ments of which Gauguin later repeated in a
monotype (F 78).

painting and the richly varied green palette recall the most ambitious landscapes
that Gauguin had painted in Martinique in 1887 (cat. 31). Indeed, as Field stressed,
the treatment of space here, with orthogonals plunging to where a flowering red
shrub is growing in a garden, is completely atypical of Gauguin's mature work,[3]
although he had organized several early compositions in similar fashion.[4]

The horse, the thatched bamboo house, and the two figures walking down
the road were all based on little sketches in Gauguin's notebooks,[5] although the
pink dress of one of the figures in a sketch was changed to blue to enhance the
color harmony in the painting. The seated figure in the shadowy doorway of the
house repeats the pose taken by Tehamana in *Te faaturuma* (cat. 127), and her
brooding mood accords with the drooping crown of the coconut palm, the grazing
horse, and the extraordinary low-hanging cloud.

Because Gauguin incorporated a figure from another genre painting into a second landscape (cat. 132) on the same scale as *Street in Tahiti*, it seems likely that these pictures were conceived as pendants. Since the second landscape, which also represents the interior mountains rising beyond a plunging path, probably represents the artist's house in Mataiea, *Street in Tahiti* might represent the house he had rented on the outskirts of Papeete.[6] Alternatively, the little figure of Tehamana in *Street in Tahiti* may indicate that the house was her home in the capital.

The early history of this important work is unknown. While it may correspond to the work entitled simply *Paysage* in Gauguin's 1893 exhibition in Paris, it does not correspond to any of the works included in the auction organized in February 1895. This suggests that it may have been sold, perhaps through the artist's wife, at a relatively early date.—C.F.S.

132
Matamoe[1]

This landscape view is among the most richly colored of all Gauguin's early Tahitian pictures. It seems to be a depiction of the hibiscus-wood house that the artist rented in Mataiea in the autumn of 1891. He gave a poetic account of his new surroundings in *Noa Noa*, describing both the view out to sea and the opposite view back toward the interior mountains. At the seashore he observed a woodcutter whom he would portray in *Man with an Ax* (W 430) and contemplated how the dead tree being cut would, in a sense, come back to life when it was used as firewood.[2] In *Matamoe* (*Death*), Gauguin represented this transformation quite literally, even adding a diminutive version of the same woodcutter figure to this view eastward to the many trees that masked a large cavern at the foot of the mountains (see also cat. 136).

Matamoe is one of three large, size 50 canvases that Gauguin listed near the end of his inventory of Tahitian paintings in a notebook in the spring of 1892.[3] Perhaps *Matamoe* was conceived as a pendant to *Street in Tahiti* (see cat. 131), of similar size and subject, also listed near the end of the inventory. Since *Street in Tahiti* represents the outskirts of Papeete near the interior mountains where Gauguin lived,[4] it may portray the house that he rented there, while *Matamoe* may represent his second house in the countryside south of the capital.

The actual site depicted in *Matamoe* is uncertain, however, since Gauguin listed this painting as "The woodcutter of Pia" *(Le bucheron de Pia)* in his inventory. Gaston Pia, a French schoolmaster and amateur painter, invited Gauguin to stay with him in the village of Paea in late summer 1891, before he settled in Mataiea. Danielsson has suggested that *Matamoe* and another, smaller landscape, listed at the beginning of the inventory as "Landscape Paia Evening"*(Paysage Paia Soir)*, were painted during that visit.[5] Gauguin only began seriously to paint in oils after he established himself in Mataiea, however, and it seems unlikely that this large, highly developed landscape could have been executed before that time. Given the fact that Gauguin inscribed *Matamoe* with the date 1892, Pia's name in the inventory might indicate instead that Gauguin had given it to his friend as a keepsake, but later reclaimed it.

6. Jénot 1956, 119, reported that Gauguin's house in Papeete was near the foot of the mountains.

1. Danielsson 1967, 230-231, nos. 6, 29.

2. *Noa Noa*, Louvre ms, 38.

3. Field 1977, 300-308, analyzes this inventory.

4. Jénot 1956, 119.

5. Danielsson 1975, 85-87, 297, no. 37 (where he misidentifies the large painting listed in the inventory as W 430). An alternative explanation for the word "pia" in the title can be found in Moerenhout 1837, 97-98, who describes the arrowroot as a tree in his detailed account of the plant's processing.

1892

115 x 86 (45¼ x 33⅞)

oil on fine canvas

signed and dated at lower right, in purple,
P. Gauguin 92

inscribed at lower right, in purple,
MATAMOE

Pushkin State Museum of Fine Arts,
Moscow

EXHIBITIONS
Paris, Durand-Ruel 1893, no. 2, *Matamoe.
(Mort.)*; Paris, Drouot 1895, no. 4, *Matamoe*;
Paris 1906, no. 76, *Les Paons*; Moscow 1926,
no. 8

CATALOGUES
Dorival 1954, inv., 1892, no. 23, *Le bucheron
de Pia*; Field 1977, no. 27; W 484; FM 181

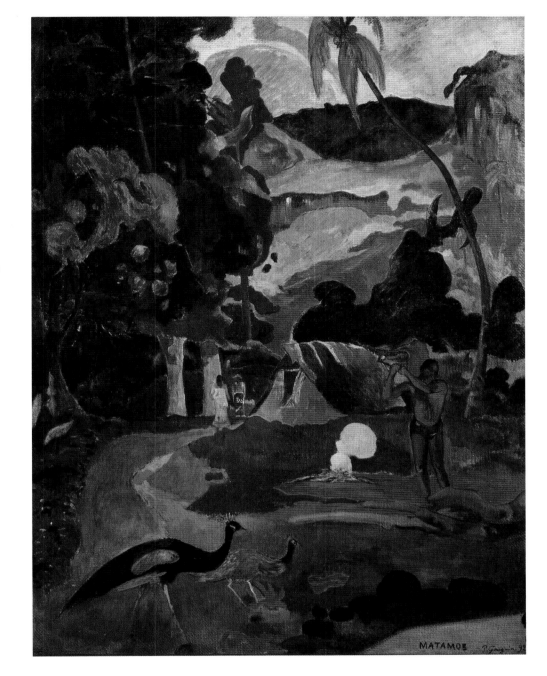

6. Sérusier 1950, 60, and ill. opp. 144.

7. *Noa Noa*, Louvre ms, 65, 71, 181.

8. W 436, W 437, W 467, W 471, W 472,
W 473, W 474, W 478, W 491, W 500,
W 501.

9. Field 1977, 97-107.

10. *Noa Noa*, Louvre ms, 43 (see cat. 136).

The same view of the house recorded in *Matamoe* appears in the background of a mythological painting (W 450) that Gauguin had underway by March of 1892.[6] This painting is also listed near the end of Gauguin's inventory, shortly after the entry for *Matamoe*. Several watercolors pasted into Gauguin's *Noa Noa* manuscript seem to show the same house, observed from different sides,[7] and the many versions suggest that the house was his own (see cats. 126, 136, 203).[8]

Field realized that the importance of *Matamoe* lies in Gauguin's unprecedented richness of color and linear arabesque.[9] In *Noa Noa* Gauguin pointed out that the colors in the landscape in Mataiea at first seemed incredible to his European eyes.[10] Gauguin's Tahitian title, which means "sleeping eyes," may refer to the shocking appearance of the Tahitian landscape to Gauguin's Western eyes. It may also refer to the peacock's feathers with eye-like markings at their tips.

Most accounts of the painting by scholars, including Field's, have stressed the possible symbolism of the woodcutter: in an episode in *Noa Noa*, Gauguin realizes that he has escaped from his European consciousness and attained an insight into the savage mentality after helping to cut down a tree.[11] The relationship between this episode and *Matamoe* is the only apparent explanation for Gauguin's decision to mistranslate his Tahitian title as "Death" *(Mort)* in the catalogue to his 1893 exhibition at the Galerie Durand-Ruel.–C.F.S.

11. For example, Field 1977, 101-102; and Danielsson 1967, 231 (no. 29). For this episode, see *Noa Noa*, Louvre ms, 82-83.

133
Fan Decorated with Motifs from Ta matete

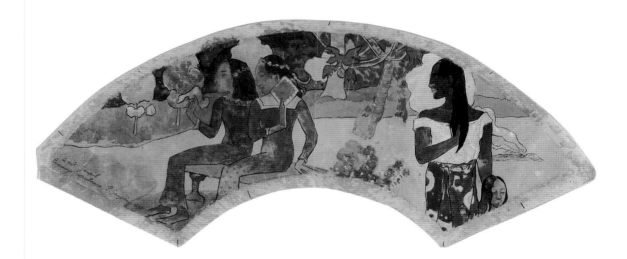

1892

145 x 460 (5⅞ x 18⅛)

brush and watercolor over preliminary design in graphite, strengthened with pen and ink and graphite, on wove paper

dedicated, signed, and dated at lower left, *à Mde Goupil/hommage respectueux— P. Gauguin 1892*

John C. Whitehead

1. Jénot 1956, 120. Information about Madeleine Goupil communicated by Mme D. Touze in a letter of 4 July 1987.

2. Danielsson 1975, 69, 101, 104.

3. *Noa Noa*, Louvre ms, 131; Rotonchamp 1925, 114.

4. See Huyghe 1951.

As is evident from its inscription, this watercolor was presented to Madeleine, one of the daughters of Auguste Goupil, a lawyer and self-made coconut magnate. Jénot introduced Gauguin to this potential art collector shortly after the artist's arrival in Papeete.[1] Although Goupil did not purchase any works by Gauguin until 1896 (see cat. 216), when the artist made excursions from his home in Mataiea to the capital, Goupil did hire him for odd jobs.[2] Most important, he lent Gauguin a copy of Jacques-Antoine Moerenhout's anthropological account of ancient Polynesian religions, *Voyage aux îles du Grand Océan* (1837).[3] This text became a sourcebook for the subject matter of many of the exhibition pictures that Gauguin executed in 1892 and 1893, and during these same years the artist copied out long sections from it for his own illustrated manuscript on the same subject, which he entitled *Ancien Culte Mahorie*.[4]

Despite Gauguin's later comments about the sacred place held by prostitution in ancient Tahitian religious rites and the modern Tahitian's inability to understand the European concept of it,[5] according to Danielsson, *Ta matete* (W 476), which means "marketplace," depicts a group of prostitutes awaiting customers.[6] His interpretation seems at odds with his own further suggestion that *Ta matete* resembles a photograph taken by Charles Gustave Spitz of Tahitian women performing a mime dance called *aparima*.[7] If the women in the painting, all wearing

5. *Noa Noa*, Louvre ms, 163; *Avant et après*, ms, 117; and *Diverses choses*, ms, 323.

6. Danielsson 1975, 73.

7. Danielsson 1975, 73, fig. 9 opp. 81.

8. Dorival 1951, 118, 121–122.

9. Maurer 1985, 967.

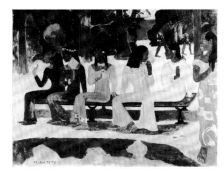

Gauguin, *Ta Matete*, 1892, oil on canvas [Oeffentliche Kunstsammlung, Basel]

1. The police officer Charpillet, cited in Chassé 1938, 7.

2. Maugham 1949, 130.

modest missionary dresses, can indeed be recognized as prostitutes, the subject matter of this fan would hardly seem to be appropriate as a token for Madeleine Goupil!

Whatever commonplace genre scene Gauguin intended to represent, he conspicuously stylized every detail of *Ta matete*, as if to transcend conventional realism. Indeed, Gauguin based the five figures of the seated women quite closely on figures in an Egyptian wall painting from the Eighteenth Dynasty, which he knew through a photograph he purchased in France.[8] The gestures of the Tahitians – each holds something, a handkerchief, fan, letter, or perhaps a cigarette – appear even more hieratic than those in his Egyptian prototype and may reflect Gauguin's knowledge of Buddhist art.[9]

The details of the scene represented on the fan are more refined than in the painting, and the scene has been abbreviated, perhaps to suit the rounded format. To compensate for the omission of the three seated women and the native men carrying fish on a pole, all of which appear only in the oil painting, Gauguin added the branch of a breadfruit tree with its large, decoratively shaped leaf, and the head of a little girl at the far right. Unlike the woman (partly visible in *Ta matete*) who accompanies her, the child shows no interest in the other seated women nearby. Finally, behind the child and her escort Gauguin added the smoldering remains of a small cooking fire on the ground.–C.F.S.

134
Bare-Breasted Tahitian Woman Holding a Breadfruit

Limiting himself to simplified silhouettes outlining unmodulated colors, Gauguin painted this window in synthetist fashion to evoke medieval church windows with their irregular webs of lead tracery and shaped pieces of colored glass. Although Matisse never had an opportunity to see it, it is perhaps the most extraordinary harbinger of twentieth-century stylization to be found in Gauguin's oeuvre.

In search of background material for *The Moon and Sixpence*, the novel based on Gauguin's life, Somerset Maugham went to Tahiti in 1916. He subsequently claimed to have found the window in situ at the house of Anani, the painter's landlord in Mataiea. Although an elaborate decorative scheme designed by Gauguin for one of the rooms there is mentioned by an earlier visitor to Tahiti,[1] Maugham's sparse account of it supplies the only details: "In one of the two rooms of which the bungalow consisted, there were three doors, the upper part of which was of glass, divided into panels, and on each of them, he painted a picture. The children had picked away two of them; on one of them hardly anything was left but a faint head in one corner, while on the other could still be seen the traces of a woman's torso thrown back in an attitude of passionate grace."[2]

Whereas Maugham's prompt decision to purchase the window saved it from inevitable ruin, the writer failed to document the decorative ensemble as a whole. With no photographs or sketches of the room as Maugham found it, the position and significance of the surviving window in relation to its original surroundings are lost to us. For the sake of expediency in handling, Maugham cut off the lower portion of the door into which the window was originally set. The sea-

Bare-Breasted Tahitian Woman Holding a Breadfruit

probably early 1892

100 x 54 (39 x 21)

oil on glass panes backed with white paper and inserted into a wooden window frame

Mr. and Mrs. Philip Berman

signed at lower right in black and light blue, *P.GO*

CATALOGUE
W 552
shown in Washington and Chicago only

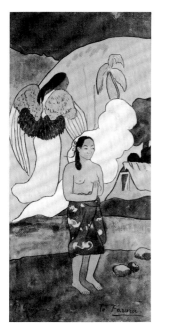

Gauguin, *Te Faruru* (*To Make Love*), 1892, gouache [Museum of Fine Arts, Springfield, The James Philip Gray Collection]

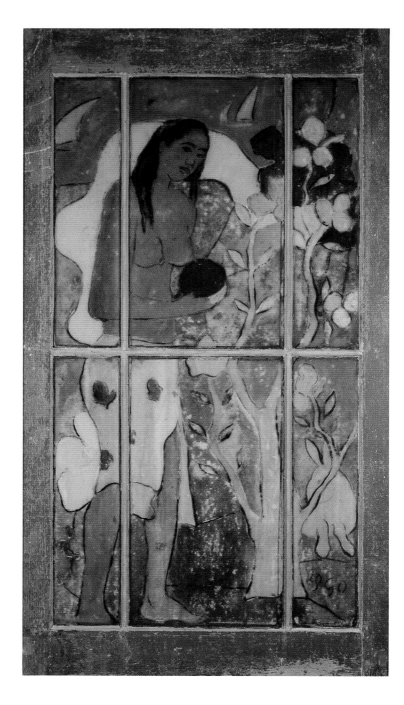

3. See Tokyo 1987, no. 69. The figure should also be compared with that in W 464.

green color of the surviving framing elements was apparently chosen by Gauguin to harmonize with the blue and pea-green tones that predominate in the panels.

Although the presence of the artist's monogram suggests that the window is a complete composition in its own terms, the placement of the figure at the left of the composition and the fact that she faces right raises the possibility that this panel was the leftmost member of an integrated tripartite decoration. If so, the role of the figure might be understood as a subsidiary one, comparable to that of one of the attendants in *Ia orana Maria* (cat. 135). Indeed, the close stylistic similarity of the window and a watercolor of a single attendant figure inscribed *Te faruru* (To Make Love)[3] to *Ia orana Maria*, on which he was still at work in the early part of 1892, suggests that Gauguin executed these two objects at this time as well. Maugham's claim that Gauguin began the windows after he had recuperated

4. Maugham 1949, 130. But in Ménard 1981, 116, Maugham confused the issue by referring to Anani's house in connection with Gauguin's convalescence in 1898 after his suicide attempt. See, too, Danielsson 1975, 105.

5. Joly-Segalen 1950, VI, dates this letter to August 1892; but Field 1977, no. 19, 365, redates this letter to October of that year.

6. W 501.

7. Danielsson 1975, 133, and W 509. See also chronology. O'Brien 1920, 227, confuses these two stained glass window projects.

from an illness is consistent with that relatively early date.[4] However, in a letter written later in 1892, Gauguin complained to Monfreid that he had run out of canvas and praised the simplicity of stained glass windows, concluding that he may have been born to specialize in such decorative art enterprises.[5] Moreover, a still later date for the window is not out of the question, for the figure represented holding a breadfruit corresponds very closely to a female figure holding the same fruit in a painting dated 1893.[6] The ensemble was possibly carried out shortly before Gauguin's repatriation to France and intended as a keepsake for his neighbor, Anani. Gauguin evidently executed another ensemble of painted windows in Papeete, just before his departure in May.[7]

Questions of dating aside, there remain several distinctive details in the window that deserve further study: the sailboats in the background, the little tree (probably a frangipani or *tiare*), and the rabbit, generally an emblem of fertility. All of these are white, suggesting some funereal significance. The white banderole looped around the figure's shoulders—reminiscent of medieval art, where one finds such banners carrying inscriptions—is left curiously blank.—C.F.S.

135
Ia orana Maria

1. Joly-Segalen 1950, no. III.

Gauguin did not refer to any of his Tahitian paintings in his letters back to France until he wrote to Monfreid on 11 March 1892: "I am working more and more, but until now [I have only made] studies or rather documents, which are piling up. If they are of no use to me later, they will be of use to others. I have nevertheless made a painting, size 50 canvas. An angel with yellow wings reveals Mary and Jesus, Tahitians just the same, to two Tahitian women—nudes dressed in *pareus*, a sort of cotton cloth printed with flowers that can be draped as one likes from the waist. Very somber mountainous background and flowering trees. Dark violet path and emerald green foreground, with bananas at the left.—I'm rather happy with it."[1] Gauguin inscribed this most ambitious of his early Tahitian pictures with the date [18]91, although, according to the letter, he had finished it (and about twenty other exhibition paintings!) at least two months earlier. Any attempt to establish the date of *Ia orana Maria* (Hail Mary) is further confused by Gauguin's small sketch of the composition illustrating the letter. This differs significantly from the final painting; the sketch is horizontal, while the "size 50" painting (116 x 89 cm) is vertical. The discrepancy suggests that Gauguin eventually repainted the entire picture, and the delay perhaps helps to explain why *Ia orana Maria* was not among the paintings that he sent back to France before his return in 1893, and why none of the figures resembles his usual model, Tehamana. (The absence in the Virgin's face of the emotional charge characteristic of Gauguin's paintings of Tehamana makes *Ia orana Maria* less powerful in comparison.)

Technical examination bolsters this hypothetical account of the picture's early history. Small losses on the upper paint surface reveal the presence of a white ground painted over an earlier composition, and the colors correspond to a horizontal format picture. Specifically, the green paint at the upper right corresponds to the grassy zone of the original version. Apparently, Gauguin covered the

2. Amishai-Maisels 1985, 294, points out that the angel holds no palm branch in the sketch.

3. A similar altar appears in W 450 and W 451, as well as in Huyghe 1951, 24 (copied in *Noa Noa*, Louvre ms, 77).

4. Sérusier 1950, 60.

5. W 450, W 451, W 453, W 459, W 460, W 467, W 468, W 499, W 500, W 512.

6. Pola Gauguin 1937, 171; and Amishai-Maisels 1985, 288-289. Gauguin referred to the child's birth; see Joly-Segalen 1950, II.

7. Field 1977, 74, dates this illness to late 1891 or early 1892, whereas Danielsson 1975, 84, dates it to the summer of 1891.

entire early composition with white ground and turned the canvas ninety degrees before starting all over again.

Why Gauguin made such a drastic change is not known, though the vertical format is more in keeping with the traditions of devotional images such as altarpieces. Since the final painting repeats all of the details in the March 1892 drawing,[2] it seems most likely that Gauguin became dissatisfied with the quality of the execution of the first version, rather than with his original ideas for the poses or the setting. His thumbnail sketch even includes the plaque-like rectangular insert in the lower corner, where he has inscribed the title in Tahitian.

The opulently colored setting fulfills any Westerner's fantasy of paradise on earth: thatched boathouses in the distance range along pink-tinted sands; coconut palms, a breadfruit tree, hibiscus plants dotted with red flowers and, in the foreground at left, a *tiare moorea* with sweet-scented white blossoms. To stress further the natural bounty of Tahiti, Gauguin added an exotic still life in the foreground. A little wooden altar, or *fata*,[3] is overladen with a bunch of *fei*, or wild red bananas, a great delicacy, as well as two globes of breadfruit and a native bowl filled with *maia*, or yellow bananas. As if the intensely colored *pareus* worn by the women did not fully satisfy Gauguin's rapacity for color, he imagined how an angel might dress in this faraway land and added a figure in a deep lavender gown with yellow, blue, and purple wing feathers. Ultimately, *Ia orana Maria* is a hymn to the diversity and richness of color.

Why Gauguin decided to paint a Christian theme at this time is unknown. In a letter to Sérusier on 25 March 1892, only two weeks after he wrote the letter to Monfreid with the little sketch, Gauguin confided that he was intrigued with the prospect of painting pictures based upon ancient Polynesian religious beliefs.[4] He promptly began to paint such themes (see cats. 138, 139, 140, 151, 204, 205).[5] Although he was preoccupied with questions of Catholic theology during his second stay in the South Seas and painted several pictures with obvious Christian overtones in 1896 (see cat. 221) and again in 1902 (see cats. 260-263, 266), *Ia orana Maria* is the only explicitly Christian painting from his first trip to Tahiti. According to a preposterous theory initiated by his son Pola,[6] *Ia orana Maria* commemorates news that Gauguin's mistress in Paris had given birth to his illegitimate son. Far more likely is the possibility that the painting celebrates his recovery from a nearly fatal illness for which he had been hospitalized.[7] Recalling how, in 1888, Gauguin had hoped to donate his ultra-modern picture of visionary religious expe-

Gauguin, letter to Daniel de Monfreid, 11 March 1892 [private collection]

Gauguin, *Noa Noa*, page 125 [Musée du Louvre, Paris, Département des Arts Graphiques]

Ia orana Maria

around 1891-1892

113.7 x 87.7 (44¾ x 34½)

oil on canvas

signed and dated at lower right, in black or dark blue, *P. Gauguin 91*

inscribed at lower left, in black or dark blue, *IA ORANA MARIA*

The Metropolitan Museum of Art, Bequest of Sam A. Lewisohn, 1951

EXHIBITIONS
Paris, Durand-Ruel 1893, no. 1, *Ia Orana Maria (Ave Maria)*; Paris, Orangerie 1949, no. 25; Chicago 1959, no. 28; New York 1984-1985, no. 28

CATALOGUES
Dorival 1954, inv., 1892, no. 24; Field 1977, no. 17; W 428; FM 136

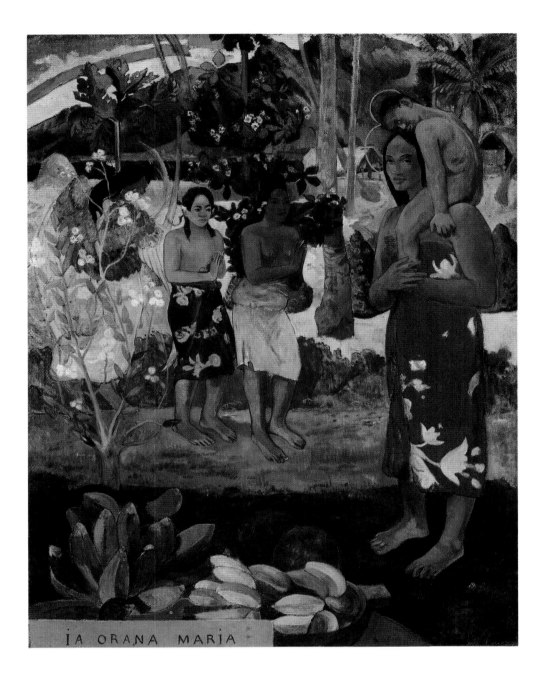

8. Danielsson 1975, 88-89, 91.

9. Amishai-Maisels 1985, 289.

10. Maurer 1985, 983, has contended the anti-missionary interpretation of Andersen 1971, 192. Shortly after his arrival in Tahiti Gauguin wrote to his wife that Protestant missionaries had had a negative impact on the natives (see Malingue 1949, CXXVI).

11. For Gauguin's anticipation that his recent works will startle Parisians, see Sérusier 1950, 60. Amishai-Maisels 1985, 357, dates Gauguin's *Crucifixion Cylinder* (G 125) to 1891, which would relate it in concept to *Ia orana Maria*.

12. Dorival 1951, 118-119. See figs. p. 390.

rience, *Jacob Wrestling with the Angel* (cat. 50), to the church in Nizon, there is also the possibility that he intended to present *Ia orana Maria* to the Catholic missionary church near his new home in Mataiea.[8] However, it was only in 1951 that a papal encyclical sanctioned images with non-Western types in sacred roles.[9,10] It seems most likely that Gauguin was contemplating the shock value of such a non-Western substitute for the Holy Family.[11] When he eventually exhibited the painting in Paris in 1893, he placed it at the very head of the catalogue list.

Gauguin undoubtedly referred to a photograph of part of the frieze of the Buddhist temple at Borobudur, for the poses of the figures of the two worshippers in *Ia orana Maria* and perhaps for the stylized tree behind them as well.[12] During his first trip to the South Seas, Gauguin sketched a similar figure in a notebook,

13. Dorival 1954, inv., 1892, 72 v.

14. Dorra 1953, 196.

15. For a discussion of Gauguin's syncretism, see Amishai-Maisels, 1985, chap. VIII.

16. Mirbeau 1891a.

17. See Dorival 1951, 118; Field 1977, 64; Amishai-Maisels, 1985, 293-294.

18. See Field 1977, 248, no. 87; Amishai-Maisels 1985, 293; Thomson 1987, 145.

19. Sterling and Salinger 1967, 172.

20. Maurer 1985, 962.

21. See Field 1977, 65; Amishai-Maisels 1985, 294-296; and Andersen 1971, 193.

22. See Motoe in Tokyo 1987, 172, cat. 69.

23. Anonymous 1893b.

24. Gauguin mentions the price in a September 1900 letter to Vollard published by Rewald 1943, 39. Perruchot 1961 claims that Manzi only paid 300 francs at first, and that Gauguin had tried unsuccessfully to present *Ia orana Maria* to the Musée du Luxembourg.

25. Dayot 1894, 111. In an unpublished letter written in February 1895, Gauguin suggests that different photographs be used for another publication (Roger-Marx 1894); sold Tausky, summer 1952, also Paris, Orangerie 1949, no. 110. Gauguin pasted the colored version of this photograph on page 125 of the Louvre *Noa Noa* ms. Moreover, Gauguin executed a zincograph (Gu 51) of the detail of the Virgin and Child for publication in *Epreuve* in February 1895. Two printed drawings by Gauguin, one early (F 1) and one late (F 65), repeat this same detail, while another early printed drawing (F 2) and a charcoal drawing (Rewald 1958, no. 54) repeat the composition as a whole with minor variations. What appears to be an example of this zincograph heightened in watercolor was published in the *Bulletin of The Art Institute of Chicago*, 1925, 85.

26. Joly-Segalen 1950, LV.

apparently from life.[13] Prior to his departure for Tahiti,[14] Gauguin had been obsessed with this source, encouraging speculation that Gauguin designed *Ia orana Maria* to express a syncretistic attitude embracing both Eastern and Western religious symbols.[15] The painting fulfills Mirbeau's characterization of Gauguin's art, written in early 1891, as "a disquieting and spicy mixture of barbaric splendor, Catholic liturgy, Hindu reverie, Gothic imagery, and obscure, subtle symbolism."[16] Modern scholars have suggested a variety of possible sources in medieval and Japanese art, as well as in the Javanese frieze, for the figures of the angel and those of the Virgin and Child in *Ia orana Maria*.[17] The observation that a Tahitian mother probably would not carry a child on her shoulder as the Virgin does in this work has stimulated this search for precedents.[18]

Discrepancies between details in *Ia orana Maria* and conventional Christian pictures have also been investigated as clues to the ultimate meaning of the painting. It has been interpreted as a representation of the Annunciation,[19] despite the presence of Christ, and as a representation of the Adoration of the Shepherds,[20] despite the absence of sheep. Most of all, the palm branch that Gauguin's angel holds, traditionally a symbol of martyrdom and death, has been understood as an ironical accent, added to undercut the otherwise joyfully innocent image of heaven on earth.[21]

A curious and related detail, the tip of a yellowed palm branch entering the composition at the top, above the angel, has never been explained. Neither has the close relationship between *Ia orana Maria* and a watercolor that Gauguin inscribed *Te faruru* ("To Make Love")—perhaps an ironic reference to the virgin birth—as a gift to Jénot.[22] With the forms all simplified like sections of a stained-glass window (cat. 134), this watercolor depicts one of the worshipers in *Ia orana Maria*, her back turned to a cloud of smoke above which the angel hovers.

Although the majority of journalists who reviewed Gauguin's 1893 exhibition in Paris praised *Ia orana Maria* as a modern masterpiece, one unsigned review described it as a "Tahitian Bastien-Lepage,"[23] probably an allusion to that popular painter's *Joan of Arc*, with its hovering archangel (Salon of 1880). Even so, *Ia orana Maria* was among the few works that Gauguin was able to sell as a result of the exhibition and at a price—2,000 francs—far beyond what he was able to obtain from any other sale. It was bought by Michel Manzi, a major collector, who was a close friend of Degas and a pioneer in the development of art reproduction techniques.[24] Shortly after the close of the exhibition, a photograph of *Ia orana Maria* was published in *Figaro Illustré*, and Gauguin later hand-colored a copy of this reproduction to insert into the *Noa Noa* manuscript that he embellished during his second trip to the South Seas.[25]

The intense pride that Gauguin took in *Ia orana Maria* is further apparent in a letter that he wrote to Monfreid in 1899, expressing the hope that Manzi might agree to lend it to an exhibition that Gauguin hoped to have at Vollard's gallery the following year.[26] These plans never materialized.—C.F.S.

136
Fatata te mouà[1]

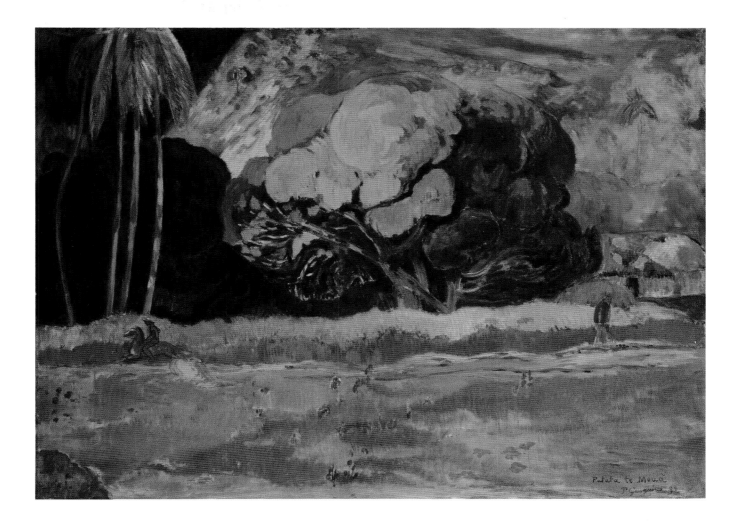

1892

68 x 92 (26½ x 35⅞)

oil on fine canvas

signed at lower right, in purple,
P. Gauguin 92

inscribed at lower right, in purple, *Fatata
te Mouà*

State Hermitage Museum, Leningrad

EXHIBITIONS
Paris, Durand-Ruel 1893, no. 26, *Fatata te
mouà (Adossé à la montagne)*; Paris, Drouot
1895, no. 29, *Fatata te Mouà*; Moscow 1926,
no. 10; Tokyo 1987, no. 66

CATALOGUES
Dorival 1954, inv., 1892, no. 10, *Paysage
Matia*; Field 1977, no. 49; W 481; FM 273

The French title that Gauguin used for *Fatata te mouà* in the catalogue to his 1893 Paris exhibition – *Adossé à la montagne* ("Against the mountain") – corresponds exactly to a passage in *Noa Noa* in which Gauguin described the setting of his new home in Mataiea. He may have been referring to two of the earliest paintings that he made there, this one and *The Man with an Ax* (W 430): "Landscape description - Alongside the sea - Picture of woodcutter - On the other side - The mango with its back to the mountain blocking the formidable cavern. My house made of hibiscus wood stands between the mountain and the sea, and next to my house there was another small one - *Fare amu* (house for dining)."[2] Elements of this same landscape with the interior mountains to the east appear in several other early Tahitian paintings and in a series of imaginary history pictures (W 512) that Gauguin undertook at the end of 1892.[3] Since Gauguin added an idol to the moon goddess Hina (see cat. 139) in the pictures in this series, he may have come to attribute some special symbolic significance to the site, or at least to the large tree, which could easily be understood as an emblem for the sweet, nourishing bounty of nature in Tahiti.[4]

1. Danielsson 1967, 230, nos. 14, 15.

2. *Noa Noa*, Getty ms, 7; the text is slightly different in *Noa Noa*, Louvre ms, 38 (following the first page numbered 39). Bouge 1956, 163, no. 49, explained that Gauguin misspelled the Tahitian word for "hibiscus" in his manuscript.

3. See W 482, W 504, W 467, W 500. Field 1975, 165–167, dates *Fatata te mouà* to the latter part of 1892 when Gauguin was at work on this series.

4. Bessonova et al. 1985, 361, no. 123.

5. *Noa Noa*, Louvre ms, 43.

6. Paris, Orangerie 1949, no. 109, transcription, 100.

Gauguin, *Women by the River*, 1892, oil on canvas [Vincent van Gogh Foundation, National Museum Vincent van Gogh, Amsterdam]

The sky in *Fatata te mouà*, visible beyond the crowns of the coconut palms to the left, is a deep blue-black. The mysterious mood is heightened by two tiny figures, one on horseback, who move off away from one another. They travel along the coastal road, indicated only by a broken line of green at its edge, that continues across the entire canvas. Where they are going is left unexplained. The vermilion foreground seems to glow from the light of the setting sun, which also illuminates the leaves of the large mango tree. Although Gauguin may have been primarily concerned with the decorative harmony of these intense reds and yellows interspersed with shadowy greens, his use of color can also be understood in symbolic terms. With its brilliantly colored leaves, this mango tree is a synecdoche for the large orange-, red-, and green-skinned fruits that it yields. Gauguin used these fruits as emblematic props in some of his early Tahitian figure paintings (see cats. 143, 158).

Yet Gauguin apparently did not intend to exaggerate reality with the intensity of his colors in *Fatata te mouà*. In *Noa Noa* he gave an account of how he needed to reconsider his ideas about color when he arrived in Mataiea. "I began to work: notes and sketches of every sort. But the landscape, with its pure, intense colors, dazzled and blinded me. Previously always in doubt, I searched from noon until two o'clock. . . . It was so simple, however, to paint what I saw, to put a red or a blue on my canvas without so much calculation! Golden forms in the streams enchanted me; why did I hesitate to make all of that gold and all of that sunny joy flow on my canvas? Old European habits, expressive limitations of degenerate races!"[5] No other painting exemplifies this conversion in Gauguin's attitude toward color better than *Fatata te mouà*.

In a letter written to a potential collector shortly after the auction that Gauguin organized in February 1895, the artist offered *Fatata te mouà*, along with five other paintings that had gone unsold.[6] Although he priced this luminous landscape slightly lower than the early Tahitian figure paintings in this group – only 400 francs, compared to 550 francs for the most expensive (see cat. 156) – the fact that Gauguin repeated the basic elements of *Fatata te mouà*, including Jthe diminutive figures, in watercolor transfers (see cats. 200, 201), suggests that the image had exceptional significance for him.–C.F.S.

137
Umete (Dish for Popoi Decorated with Polychromed Relief Carvings)

1. Jénot 1956, 120–121.

2. Joly-Segalen 1950, VI, 59.

3. Gray 1963, 234, incorrectly describes a deep indentation at one end of the bowl as a drainage hole typical of functional *umete*.

4. Huyghe 1951, 18.

Unable during his early months in Papeete to procure suitable wood to make wooden bowls comparable to those made by the natives, according to Jénot,[1] Gauguin was content to carve decorations into bowls that belonged to friends or that he acquired in the market. His magnificent relief carvings on this elongated dish recall the Japanese-inspired motifs on French china, popularized by the firm of Eugène Rousseau beginning in the late 1860s, when Bracquemond designed a dinner service for them. It should not be forgotten that Gauguin often chose to see himself as, above all, a decorative artist. As he told Monfreid in a letter written

around October 1892, "To think that I was born to make an industry of art and that I am unable to carry it off. Stained glass windows, furniture or faïence, etc., whatever . . . those are my basic aptitudes much more than painting properly speaking."[2]

As a functional object, this sort of *umete* was used for preparing *popoi*, a paste made from breadfruit.[3] The simplicity of the carving here and the thick application of paint suggest a relatively early date. Moreover, the motif of two tropical fish facing one another while ingesting opposite ends of the same worm or plant is closely related to a watercolor that Gauguin pasted into his manuscript *Cahier pour Aline* (1893) as a frontispiece decoration. One of these feeding fish also appears in a watercolor illustration to his *Ancien Culte Mahorie* manuscript, superimposed over a hieroglyphic figure of a man.[4] This same motif in reverse appears in the visionary context of a woodblock print (see cat. 174) that Gauguin inscribed with the title *l'Univers est créé* (The Universe is Created).

At an unknown later date, a unique bronze copy of this dish was cast from a plaster (destroyed) taken from Gauguin's original in wood.—C.F.S.

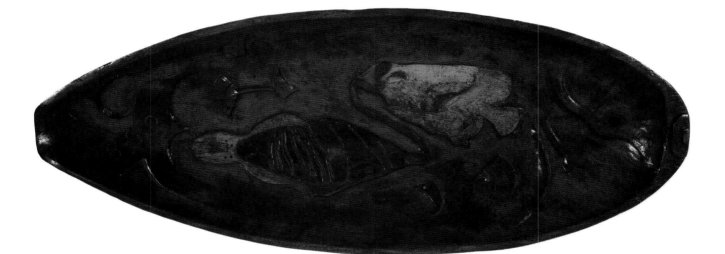

probably 1892

length 90 (35⅜); width 36 (14⅛)

tamanu wood polychromed with paint

incised at left, *PGO*; inscribed on the reverse with Monfreid's address, *P. Gauguin 55 rue du Château, Paris*

private collection; on loan to the Musée Gauguin, Tahiti

EXHIBITIONS
Paris 1960, no. 119; Saint-Germain-en-Laye 1985, no. 318

CATALOGUES
G 103; FM 27

Gauguin, *Cahier pour Aline*, front inside cover [Bibliothèque d'Art et d'Archéologie, Paris, Fondation Jacques Doucet]

Gauguin, *L'Ancien Culte Mahorie*, page 18 [Musée du Louvre, Paris, Département des Arts Graphiques]

138
Idol with a Pearl

probably 1892

height 25, diameter 12 (9¾ x 4⅝)

tamanu wood polychromed with stain and gilding; seated figure in half lotus position decorated with a pearl and a gold chain necklace with a star pendant[1]

incised at top, *P Go*

Musée d'Orsay, Paris

EXHIBITIONS
Paris, Durand-Ruel 1893, probably one of a group catalogued as no. 46, *Les Tiis*; Paris 1906, unnumbered, listed after no. 191, *Six Bois Sculptés*; Edinburgh 1955, no. 76; Paris 1960, no. 111; Munich 1960, no. 149; Saint-Germain-en-Laye 1985, no. 293

CATALOGUES
G 94; FM 182

Idol with a Pearl, photograph by Georges Chaudet, c. 1895

1. Although the star pendant has been lost, it is visible in a photograph first published in Roger-Marx 1894, 33.

2. Roger-Marx 1894, 33.

3. Joly-Segalen 1950, XII; Field 1977, 363 n. 17. See cat. 151, n. 3.

4. Malingue 1949, CXXX.

5. Jénot 1956, 120.

6. Sérusier 1950, 60.

7. G 88. Gray 1963, 56.

Although this *Idol with a Pearl* was one of the few works that Gauguin chose to photograph for publicity purposes,[2] its date and hence its place in the evolution of his art is open to debate. It may well be one of the tree-trunk sculptures that he mentioned in a letter to Monfreid written around August 1892,[3] or it could be an earlier work. Gauguin clearly intended to make sculptures as soon as he arrived in Tahiti, and he had brought carving tools with him from France in order to do so. The first references to sculptures in Gauguin's letters, around April 1892,[4] may have to do with durable new versions to replace works conceived the previous year that had already deteriorated.[5]

Gauguin had hoped to find examples of indigenous sacred art in Tahiti, objects comparable to the Far Eastern sculptures collected by the Musée Trocadero or to those presented at the Exposition Universelle in Paris in 1889. Learn-

8. Amishai-Maisels 1985, 361; and Teilhet-Fisk 1985, 54-55.

9. W 629 and W 630. Amishai-Maisels 1985, 363.

10. Gray 1963, 57-58; Amishai-Maisels 1985, 393 n. 55, took exception to this interpretation.

11. Amishai-Maisels 1985, 360-361.

12. G 76. Malingue 1949, LXXXVII; and Cooper 1983, nos. 22, 35.

13. W 320. Gray 1963, 57 n. 15. Gauguin made a drawing of a figure in a half lotus position in one of his notebooks; see Huyghe 1952, 12.

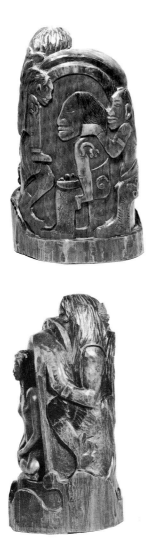

14. Gray 1963, 57 n. 15; and Amishai-Maisels 1985, 360–361.

15. Teilhet-Fisk 1985, 49–51.

16. Teilhet-Fisk 1985, 186 n. 52.

17. Gray 1963, 57–58.

18. Teilhet-Fisk 1985, 53.

ing shortly after he arrived that few such objects could be found in Polynesia, Gauguin, who was convinced that a native art had flourished at some earlier period, sought to re-create his own versions of this lost art. By March 1892,[6] Gauguin had already begun to study ancient Polynesian theology as a basis for such reconstructions. For the most part, his understanding of this subject, based upon Moerenhout's *Voyage aux îles du grand océan* (1837) and interviews with local residents, is documented in the illustrated manuscripts that Gauguin made, in particular *Ancien Culte Mahorie* and *Noa Noa*. Judging from Gauguin's decision to leave the bases of the blocks for his sculptures unfinished (cat. 6), the artist conceived these ancient divinities to have been fundamentally animistic, their spirits dwelling within the limb of the tree he carved in their honor.

Pointing out that *Idol with a Pearl* is the only one of Gauguin's Tahitian objects with a separate piece (the principal seated figure) pinned on to the block, Gray argued for an early date, relating it to a sculpture that Gauguin made this same way in 1890.[7] Gray bolstered this argument by stressing the fact that Gauguin expressed the identity of this seated figure, and the other figures carved in relief on the back, with slightly different details than he used for the figures in his other, presumably later, Tahitian sculptures. But these differences suggest the opposite sequence to Amishai-Maisels. As she observed, in *Idol with a Shell* (cat. 151), the principal figure is male and the shell attribute identifies him as Taaroa, the primary god in the Polynesian pantheon, whereas the similar primary figure in Gauguin's *Idol with a Pearl* has long hair and breasts. These female characteristics probably constitute refinements in the artist's conception of this deity with androgynous creative powers.[8] The central divinity (presumably Taaroa) in Gauguin's subsequent woodblock print *Te atua* (cat. 169) has long hair and breasts, as does Gauguin's late lost idol, which appears in two still-life paintings.[9] Thus, *Idol with a Pearl* was apparently developed after *Idol with a Shell*.

Except for the facial features, which are Polynesian, Gauguin based the principal figure in *Idol with a Pearl* on Far Eastern sculptures of Prince Siddhartha,[10] the Buddha, or Siva.[11] Examples of such sculptures were included in the Exposition Universelle, and Gauguin evidently studied the symbolism inherent in such works. He referred to the figure of a fox that he incorporated into a relief executed in the latter part of 1889 as the Indian symbol of perversity,[12] and inscribed the word "nirvana" on a painting from that same year.[13] He brought at least two photographs of statues of Buddha in the half-lotus pose with him to Tahiti as reference material.[14]

The gilded niche with a border of stylized plant shapes in *Idol with a Pearl* corresponds to the mandorla around Buddha, often with a comparable border that alludes to the Bodhi tree under which he arrived at his enlightenment. In representations of the Buddha, closed eyes are symbolic of meditation, and the gesture of a lowered hand, like the one Gauguin adopted for this idol, symbolizes enlightenment.[15] The pearl inserted into the forehead of Gauguin's idol may correspond to the tuft of hair on some images of the Buddha and may allude to the inner vision of a third eye.[16] Although it has been suggested that this pearl should be understood as the shell of Taaroa, the gold star pendant with which Gauguin adorned his figure has no apparent symbolic connection whatsoever to this god, nor to the Buddha.

The identity of the incomplete figure whose head emerges from the block above the niche is puzzling. Gray interpreted this long-haired figure with a closed eye as the Buddha's adversary, Mara, the lord of death and desire,[17] but Teilhet-Fisk suggested instead that it represents some aspect of Taaroa's union with the moon goddess Hina (cat. 139).[18]

The three apparently female figures carved in low relief at the back of *Idol with a Pearl* have no connection with Buddhist art. Scholars have interpreted the

standing figure as a ritual dancer, whereas the seated pair, derived from Marquesan tiki figures, may represent some manifestation of Taaroa, Hina, and/or Fatu.[19] The fact that Gauguin chose to contrast these three figures with the primary Buddha-like figure, the latter distinctly refined in execution in comparison to the crudely carved images on the opposite side, may have as much significance as the putative identities of any of these imaginary gods.

Around 1900, Monfreid cast copies of this idol and cat. 151, and in 1959, one of his heirs authorized an edition of six in bronze.[20]–C.F.S.

19. Amishai-Maisels 1985, 352; and Teilhet-Fisk 1985, 53.

20. Gray 1963, 218.

139
Cylinder Decorated with the Figure of Hina

probably 1892

height 37.1, diameter 13.4, depth 10.8 (14½ x 5¼ x 4¼)

tamanu wood polychromed with stain and gilding

incised at top, *PGO*

Hirshhorn Museum and Sculpture Garden, Smithsonian Institution, Washington. Museum purchase, 1981

EXHIBITIONS
Paris, Durand-Ruel 1893, probably one of a group catalogued as no. 46, *Les Tiis*; Paris 1906, unnumbered, listed after no. 191 as *Six Bois Sculptés*; Paris 1960, no. 112; Toronto 1981, no. 14

CATALOGUES
G 95; FM 250

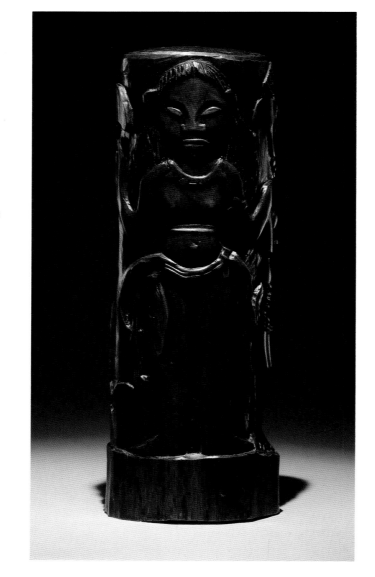

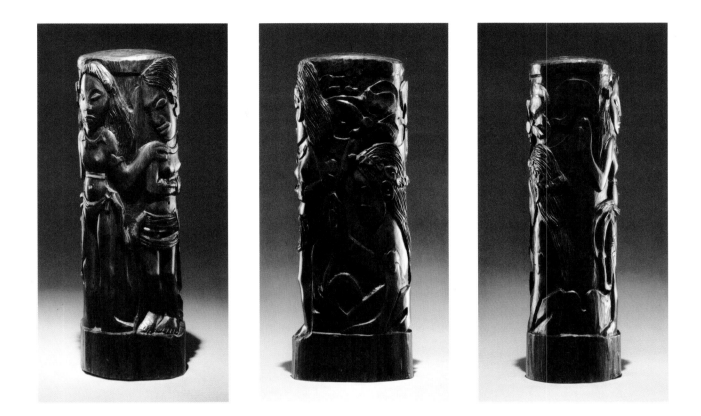

1. *Noa Noa*, Louvre ms, 130-131. He referred to his interest in the subject in a letter to Sérusier. Sérusier 1950, 60.

2. Moerenhout 1837, I: 563-567; corresponding to Huyghe 1951, *Ancien Culte Mahorie*, 32-35.

3. Field 1977, 284 n. 12. See also *Noa Noa*, Louvre ms, 146-148.

4. G 97, G 102, W 500.

5. This drawing is reproduced in Guérin 1927, xv.

6. Also W 460, W 514, W 561.

7. Teilhet-Fisk 1985, 78.

8. Amishai-Maisels 1985, 374.

9. Gray 1963, 220 n. 95.

Gauguin undertook a systematic study of ancient Polynesian theology with the help of Tehamana and, more significantly, with the help of the book by Moerenhout lent to him by the lawyer Goupil (cat. 134).[1] According to it, the Polynesian universe was created by the union of the spiritual male principle, Taaroa, and the material female principle, Hina.[2] Copying and paraphrasing passages from Moerenhout's book into his *Ancien Culte Mahorie* manuscript and again into *Noa Noa*, Gauguin endowed Hina with an importance that seems disproportionately large by the standards of modern studies on the subject.[3]

Three or four of Gauguin's carved idols (cat. 140) embody Hina and her attendants, as does the large seated idol represented in one of his early Tahitian paintings.[4] But since Gauguin repeated the pose of the dominant figure on the Hirshhorn cylinder in a drawing[5] and several allegorical paintings (cat. 158 and 205),[6] this particular image of the goddess seems to have had a special significance for him. Although Gauguin apparently derived the figure's masklike face from Maori art,[7] he evidently derived the necklace, arm bands, girdle, and life-giving gesture from Hindu sculptures representing Siva's consort, Pavati.[8] The pose of a secondary figure with a flower decorating her ear at Hina's left is apparently based on a figure from the Buddhist temple at Borobudur.[9] Holding a dish with an offering to her breast, she appears on the reverse of another of Gauguin's Hina idols (G 97), and again in a painting (cat. 230) executed during his second trip to Tahiti. A third figure kneels and raises her right hand as if to signify speech, a gesture repeated in *Parau hanohano* (Frightening Talk, W 460), painted in 1892.

10. Amishai-Maisels 1985, 374; Teilhet-Fisk 1985, 78.

Gauguin may have intended the kneeling figure on the Hirshhorn cylinder to represent another manifestation of Hina, given its similarity to the figure of Hina in Gauguin's drawing of her dialogue with Fatu (cat. 140).[10]

Whereas Gauguin decorated all of his early Tahitian sculptures with interrelated motifs on the front and the back, this three-figured Hirshhorn cylinder is the most sophisticated of his compositions in the round. He favored the cylindrical format because it respected the integrity of the material he used for these idols, tree trunks or branches (see cats. 6, 94). He always left one end unworked as a rustic base to imply that the ancient Polynesian deities were animistic. The natural phallic shapes of Gauguin's early Tahitian sculptures may have as much significance as the images with which he decorated them. If Gauguin were familiar with linga, the sacred statues of Buddhist fertility cults, his Hina cylinders could be understood to express the fundamental interdependence of male and female powers in Polynesian deism.—C.F.S.

140
Hina and Fatu[1]

1. See Danielsson 1967, 231 n. 19.

2. Entry for 9 November 1893 in the daily ledger (*brouillard*) of Galerie Durand-Ruel, Paris. Amishai-Maisels 1985, 368, discusses this drawing. A closely related drawing (Rewald 1958, no. 95) may have been executed at this same time.

3. Huyghe 1951, 13; based on Moerenhout 1837, 1:428–429. Another version of the dialogue appears in *Noa Noa*, Louvre ms 88-89.

4. Guérin 1927, xvii.

Stylized in the spirit of Marquesan tikis with large heads and clawlike hands, the figures on this idol were among the most crudely savage ones that Gauguin exhibited in Paris in November 1893. The special significance this particular idol had for the artist is suggested by the fact that he made a drawing (now lost) of the upper section of one of its sides, added the legend *Parau Hina tefatou* (Hina Addressing Fatu), and had this reproduced as the frontispiece for the catalogue to his exhibition.[2] According to the Polynesian account of the creation, Hina (cat. 139), goddess of the air, coupled with Taaroa (cats. 138, 151), supreme god of the universe, to beget Fatu, the genie who animated the earth. Hina's dialogue with her son appears in Gauguin's manuscript *Ancien Culte Mahorie* as follows:

"Hina said to Fatu: 'Bring man back to life or resuscitate him after his death.'

"Fatu replies: 'No, I will not bring him back to life. The earth will die; the plants will die; they will die just like the men that they nourish; the soil that makes them will die. The earth will die; the earth will come to an end; it will come to an end never to be reborn.'

"Hina replies: 'Do as you wish: for my part I will bring the moon back to life. And that which belonged to Hina will continue to exist: that which belonged to Fatu perishes, and man must die.'"[3]

Gauguin's watercolor illustration to accompany this text in *Ancien Culte Mahorie* shows two tiki-like figures with long hair, their hands raised in conversation as they sit facing one another. But whether or not this watercolor predates the Toronto cylinder is unclear. In an unlocated pencil drawing[4] Gauguin rendered the figures closer together, knee to knee, leaving only Hina's hand raised between them in a gesture of speech. For the relief on the Toronto cylinder, Gauguin interrelated the figures still more closely, forehead to forehead, and he rendered Hina's breast as a gourd-shaped arabesque, adding scarification patterns around her eye and a tattoo on her buttocks. This same pair, with minor variations, appears in the leftmost of three niches in Gauguin's woodblock print entitled *Te atua* (The Gods, cat. 169), with Taaroa in the central niche and Hina on the right,

probably 1892

height 32.7, diameter 14.2 (12¾ x 5½)

tamanu wood

incised at top, *PGO*

Collection of the Art Gallery of Ontario, gift from the Volunteer Committee Fund

EXHIBITIONS
Paris, Durand-Ruel 1893, probably one of a group catalogued as no. 46, *Les Tiis*; Paris 1906, unnumbered, listed after no. 191 as *Six Bois Sculptés*; Paris 1960, no. 120; Toronto 1981-1982, no. 12; New York 1984-1985, no. 32

CATALOGUES
G 96; FM 200

shown in Washington and Chicago only

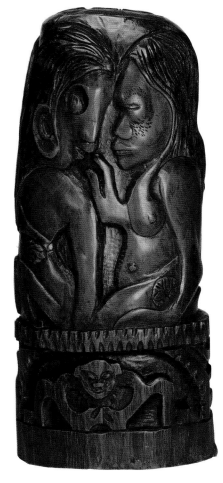
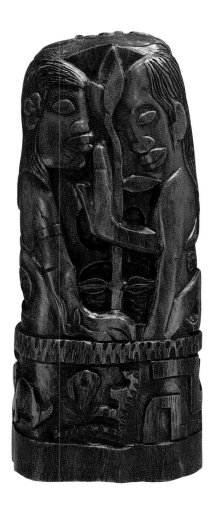

5. *Noa Noa*, Louvre ms, 57.

6. Private collection, France.

7. Wilkinson in Toronto 1981-1982, 48.

8. Teilhet-Fisk 1985, 80-81.

forming a sort of trinity of Polynesian supernatural powers. Gauguin cut out this leftmost vignette from a colored impression of *Te atua* and pasted it into his *Noa Noa* manuscript.[5] Although the same figures appear in a vignette on a watercolor after *Pape moe* (cat. 157) dated 1894, the relationship between the two themes is unclear.[6] Finally, Gauguin adopted the motif to decorate a square terracotta vase (G 115), of which three versions have survived. One of these late versions, if not the Toronto cylinder itself when exhibited in 1906, may well have helped to inspire the "kiss" motif that Brancusi began to develop around 1907.[7] Gauguin treated the same encounter between Hina and Fatu in an 1893 oil painting (W 499) in different, less emblematic fashion.

There is a corresponding pair of figures in dialogue on the opposite side of the Toronto cylinder. Teilhet-Fisk identified this pair as Hina and Taaroa and suggested that the stalk of a plant in the background between them may allude to their offspring, Fatu.[8] If she is correct, the sides of the Toronto cylinder contrast the fundamental dialogues mandating life and death.

The similar shapes used by Gauguin to render the eyes of these figures and the leaves of the plant suggest that they are animistic spirits, as does his decision to leave the block unfinished at the base. Like several of Gauguin's other early Tahitian sculptures with rustic bases (cat. 139),[9] the Toronto cylinder may be related to the Hindu linga.

A frieze supporting the figures decorates the lower third of Gauguin's cylinder. Comparable to the decorative motifs on the handles for Marquesan fans, it incorporates two or more curious animallike figures, one of which is a rabbit.[10]

A plaster cast of the Toronto idol was made around 1900 by Monfreid, and was copied in bronze in 1959.[11]—C.F.S.

9. Others are G 97, G 100, and G 102.

10. Gray 1963, 222; and Teilhet-Fisk 1985, 80.

11. Gray 1963, 218, 222.

141
Two Marquesan Women and Design of an Earplug

probably 1892

240 x 317 (9½ x 12⅜)

pen and brown ink and graphite on vellum

The Art Institute of Chicago. The David Adler Collection. 1950.1413

EXHIBITIONS
Chicago 1959, no. 97; Toronto 1981-1982, no. 19

shown in Paris only

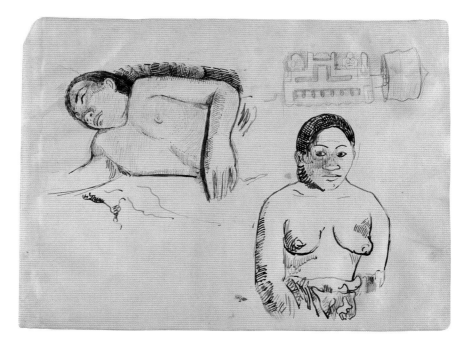

1. The contents of this portfolio were exhibited at the Galerie Marcel Guiot, Paris 1942; see especially nos. 26, 38, 39 (F 43); the latter served as the basis for the monotype printed on page 179 of Gauguin's *Avant et après*, facsimile (F 119).

The appearance of the model and the crude hatching lines to indicate shading relate this sheet to a group of studies of which several were eventually filed away in a portfolio inscribed *Documents Tahiti – 1891/1892/1893*.[1] The model should probably be identified as Tehamana. Although Gauguin chose not to use either of these two little sketches of Tehamana to develop an exhibition work, the one that shows her asleep should probably be understood as a harbinger of his goal to express the Tahitians' experience of their dream world. This ambition culminated in *Manao tupapao* (see cat. 154), painted in late 1892. Even so, the Chicago sheet

can hardly be categorized as a mere page of sketches jotted down at random, since Gauguin must have calculated the poetic juxtaposition of the image of Tehamana oblivious to the fact that she is being observed with the second image showing her wide-eyed awareness of her model's role.

Since the drawing of the Marquesan ear ornament in the upper right-hand corner of this sheet is rendered in pencil, Gauguin may have added it at a later date to record a rare example of the sort of native art that seems to have begun to intrigue him even before his arrival in the South Seas. Jénot recorded Gauguin's intense interest in learning about Polynesian art and his disappointment upon hearing that almost nothing of the sort existed in Tahiti.[2] No later than January 1892, Gauguin had expressed a desire to leave Tahiti and settle himself in the Marquesas Islands. Not only was this a less expensive and less civilized locale, but Gauguin hoped that he could learn more about Polynesian art there.[3] Another especially beautiful sheet of sketches of Tehamana (cat. 142), which Gauguin dated 1892 and presented as a gift to one M. Marolles, carries an inscription that suggests that the two men may have studied examples of Maori art together: "As a fond souvenir of our glimpse of Maori life" (*Comme un Bon Souvenir de notre entrevue chez les Maories*). The present location of the particular ear ornament that Gauguin recorded here and again, from the other side, on another drawing,[4] is not known, but such objects, called *taiana*, were family heirlooms carved from the arm or leg bone of an ancestor and worn exclusively by females.[5] In a fanciful attempt to reconstruct the appearance of ancient Polynesian sacred architecture, Gauguin adapted the post and lintel motif decorated with skulls on this ornament for the fence surrounding a shrine precinct in his 1892 painting, *Parahi te marae*.[6]–C.F.S.

2. Jénot 1956, 121.

3. Danielsson 1975, 93–94; Malingue 1949, CXXVIII, CXXX; Joly-Segalen 1950, no. XII.

4. Départements des Arts Graphiques, Louvre; see A. G. Wilkinson in Toronto 1981-1982, 60.

5. Teilhet-Fisk 1985, 62.

6. W 483. First pointed out by Virch and Wagstaff in Chicago 1959, nos. 44 and 97. For a drawing that seems to incorporate this same motif see Amishai-Maisels 1985, 353, 364, and fig. 183, who contends that the heads on the earplug constitute Gauguin's interpretation of the *tiis* that, according to Moerenhout (1837, 461), guarded the temples.

142
Little Tahitian Trinkets

Nothing whatsoever is known about the man to whom Gauguin inscribed this exquisite sheet of drawings as a gift. Jénot's memoirs make it clear, however, that when Gauguin first arrived in Tahiti, he was already eager to study examples of Maori art,[1] and this is presumably what the interview referred to in the inscription was about.

The word "trinkets" (*babioles*) in the sheet's facetious title seems to describe the little drawings as trifles rather than to characterize the women represented in them as toys, yet the double entendre is hard to ignore.

Whereas the disparate little sketches on this sheet at first appear to be ideas collected informally in an artist's notebook, the care with which Gauguin has colored and arranged them on the page sets *Little Tahitian Trinkets* apart from any routine documentary exercise. In spirit, this illusion of sketchbooklike spontaneity prefigures Gauguin's illuminated manuscripts, especially *Noa Noa*. Indeed, the way that Gauguin pasted a separate little drawing onto this sheet anticipates his frequent use of collage in subsequent book projects.

Ostensibly a sketchbook page within a sketchbook page, this separate drawing portrays a bare-breasted woman with eyes lowered, the soft flesh of her stomach bunched over the top of her skirt as she sits before the artist. It is among

1. Jénot 1956, 120–121.

2. W 462.

3. Joly-Segalen 1950, no. XII; redated to September 1892 by Field 1977, 363, no. 17. We have dated this letter to around August because a letter containing similar information reached his wife before September, when she passed it along in an unpublished letter to Schuffenecker (copy in Fonds Loize, Musée Gauguin, Tahiti).

the most carefully observed and delicately rendered drawings from Gauguin's first trip to Tahiti, the majority of which are closer in style to the smaller, more schematic, even slightly caricatural sketches on the right side of this sheet.

The uppermost of these records the leaf of a breadfruit tree, its twisted form registering the play of light and shade and decorating the top of the sheet like an emblem. Directly below is a most curious rendition of a supine model observed in abrupt perspective. Although only her upraised forearm, the tops of her head and shoulders, the tip of her nose, and her erect nipples are visible from this point of view, she is apparently nude, lying on what appears to be a mattress covered with a white European sheet. The sheet is inscribed with the Tahitian word, *Taota*, which means "to sleep" or "to sleep with." Just below this word is an unusual sketch of a woman's face observed from above, an intimate if unflattering point of view, her head extended backward, her lips parted as if in a gasp. The bottom-most of these studies, and the most conventional of all, depicts the back of a seated woman wearing a *pareu*. This figure corresponds exactly to a figure in an untitled oil painting[2] executed in 1892, probably after May. In *Little Tahitian Trinkets*, Gauguin inscribed the words *OpuOpu*, meaning "belly," just next to this figure. This could be a reference to the pregnancy of the artist's *vahine*, to which Gauguin refers in a letter to Monfreid of around March 1892.[3]—C.F.S.

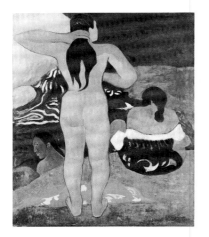

Gauguin, *Tahitian Women Bathing*, 1892, oil on canvas [The Metropolitan Museum of Art, New York, Robert Lehman Collection]

Little Tahitian Trinkets

1st support: 440 x 325 (17⅜ x 12¾) (approx.); 2nd support: 175 x 300 (6⅞ x 11⅝)

pen and ink, brush and ink, heightened with watercolor and pastel, selectively worked with brush and water, over preliminary drawing in graphite, on support composed of two sheets of different types of wove paper

inscribed, dedicated, signed, and dated, along top, in graphite, *Petites Babioles Tahitiennes; a Monsieur de Marolles/Comme un Bon Souvenir de notre entrevue/chez les Maories/Paul Gauguin/1892*; in composition, at center right, *Taota*; at lower right: *Opu Opu*.

Anne Desloge Bates

EXHIBITION
San Diego 1973, no. XII. 24

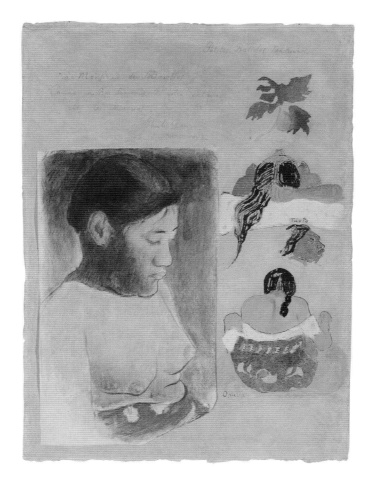

143
Vahine no te vi

1892

72.7 x 44.5 (28⅝ x 17½)

oil on standard canvas

signed and dated at upper left, in faded purple, the result of blue superimposed over green, *P Gauguin · 92*

inscribed at upper left, in black superimposed over blue, *Vahine no te Vi*

The Baltimore Museum of Art, The Cone Collection, formed by Dr. Claribel Cone and Miss Etta Cone of Baltimore, Maryland

EXHIBITIONS
Paris, Durand-Ruel 1893, no. 32, *Vahine no te vi* (*Femme au mango.*); Paris, Drouot 1895, no. 2, *Vahine no te vi*; Chicago 1959, no. 40

CATALOGUES
Dorival 1954, inv., 1892, no. 27, *Vahine no te vi*; Field 1977, no. 69; W 449; FM 171

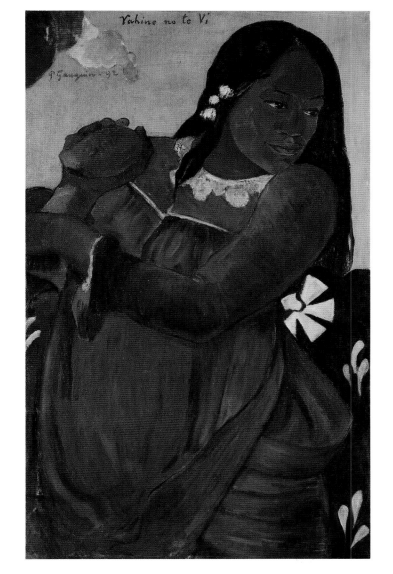

1. The literal translation of the Tahitian is *Woman of the Mango*; Danielsson 1967, 233, no. 82. Compare also W 445, W 447.

2. Sérusier 1950, 60.

3. Joly-Segalen 1950, XII; redated to around August. See cat. 142, n. 3.

4. Leclercq 1895, 121.

A portrait of Tehamana (see cats. 126, 127, 130) in a Sunday missionary dress, *Vahine no te vi* (*Woman with a Mango*)[1] is listed near the end of the inventory of his first thirty Tahitian paintings that Gauguin compiled toward the beginning of 1892. Given its salient similarities to an earlier portrait of Tehamana (W 420) with the same dimensions, which Gauguin had sent to France prior to 25 March of that year,[2] he may have begun *Vahine no te vi* as a sort of replacement. Indeed, when he finally received word from Monfreid that the first version had reached France, Gauguin replied, "That study was a starting point for other better works."[3]

Like the early portrait, *Vahine no te vi* is a carefully orchestrated color harmony keyed to the intense chrome yellow background wall, presumably the shade that Gauguin later painted the walls of the studio that he rented on the rue Vercingétorix when he returned to Paris and where he held a private exhibition of his works in late 1894.[4] Whereas in the early portrait this yellow functioned as

5. *Noa Noa*, Louvre ms, 63.

6. *Diverses Choses* ms, 228. This same portrait appears in a drawing (Rewald 1958, no. 45) which may have served as the matrix for a monotype from 1894 (F 19-20).

7. Danielsson 1975, 190.

8. Field 1977, 336, no. 69.

9. Thomson 1987, 149–150.

part of a triad of primary colors with the blue of Tehamana's dress and the red of her chair, in *Vahine no te vi* the yellow functions as the vibrant complementary to the rich purple of her dress.

Examination of the picture under a microscope has revealed that Gauguin obtained this purple hue by feathering a coat of blue paint over various shades of green. Likewise, for the hair of the model Gauguin sought a special vibrancy by layering blue and black paint over a green undercoat. Gauguin even painted his signature with similar care for the color system, painstakingly strengthening the letters in blue over green to achieve a faded purple tone.

The evolution of Gauguin's calculated treatment of color in *Vahine no te vi* can be traced from a watercolor study for the painting (R 84), which the artist copied into his manuscript of *Noa Noa* some half a dozen years later.[5] Since the background in these watercolors is a vivid coral pink and Tehamana's dress is blue, it seems that Gauguin decided to transform them in the oil version to achieve a particular abstract resonance.

The crude outline portrait of Gauguin in profile in the upper left corner of the original watercolor study was evidently added at a later date. When Gauguin copied this same profile into his *Diverses Choses* manuscript[6] he added the inscription "My portrait by my vahiné Pahura" (*Mon portrait par ma vahiné Pahura*). Thus the mistress kept by Gauguin during his final stay in Tahiti[7] doodled on a drawing of her predecessor.

In the watercolor studies, Tehamana, shown in half length, seems to hold a mango in her raised right hand. For the oil version, Gauguin changed the gesture, basing what had developed into a three-quarter length portrait on the figure of Joseph in a photographic reproduction of Prudhon's drawing of *Joseph and Potiphar's Wife*, which his guardian Arosa had published in a monograph in 1872.[8] Gauguin's decision to base *Vahine no te vi* on a detail from this biblical scene has been interpreted as an attempt to make a more salable work than his other, stiffer, more primitive early Tahitian paintings.[9] But, if so, no one bought it until the auction organized by the artist in February 1895, when Degas acquired it.

Gauguin, *Tahitian Girl*, 1891-1893, watercolor [location unknown]

Gauguin, *Noa Noa*, page 63 [Musée du Louvre, Paris, Département des Arts Graphiques]

Gauguin, *Noa Noa*, page 157 [Musée du Louvre, Paris, Département des Arts Graphiques]

10. The significance of these colors might have something to do with the mask in cat. 147 or the apples in cat. 92.

11. Joly-Segalen 1950, XII (see cat. 142, n. 3).

12. Huyghe 1951, 28; *Noa Noa*, Louvre ms, 157.

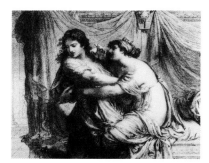

Prudhon, *Joseph and Potiphar's Wife* [Bibliothèque Nationale, Paris]

The essential significance of *Vahine no te vi* may go well beyond Gauguin's virtuoso treatment of color and arabesque. Although Tehamana seems to be standing in an interior before a piece of furniture covered with a dark blue *pareu* decorated with white floral patterns, the setting is ambiguous. The cluster of white flowers that appears next to two fruitlike shapes, one green, the other red,[10] in the upper left corner, gives the impression that she has picked the mango from a nearby tree. The loosened hair, adorned with three white *tiare* blossoms, gives an especially sensuous character to this portrait of a woman holding a ripe fruit, relating it in spirit to *Te nave nave fenua* (see cat. 148), Gauguin's explicitly symbolic rendition of the Temptation of Eve painted later in the same year. Although Tehamana's facial expression is anxious in *Te nave nave fenua*, while in *Vahine no te vi* it is serene, in both works she looks away from what she has just grasped. The possibility that *Vahine no te vi* refers to sexual temptation would help to explain why Gauguin imparted a pronounced fullness to Tehamana's body underneath the missionary dress, as if she were pregnant. In a letter to Monfreid from around August 1892, Gauguin announced, "I am soon going to be a father again in Oceania."[11] A watercolor depicting a woman several months pregnant, which Gauguin included in his manuscript *Ancien Culte Mahorie* and which he subsequently copied into *Noa Noa*, is perhaps another record of this pregnancy.[12]—C.F.S.

144
Vahine no te miti

1. Field 1977, 306.

2. Dorival 1954, 1892, 81 recto.

3. Field 1977, 85-86.

This was the last work in the inventory that Gauguin compiled in his Tahitian sketchbook around April 1892.[1] It was also the first of several paintings of bathers (see cat. 152) that Gauguin made in Mataiea, returning to an idyllic theme that had obsessed him in 1888 (see cat. 80). He developed *Vahine no te miti* (Woman at the Sea) from an especially careful colored "document" drawing made in the same sketchbook,[2] perhaps from a model. This study, faintly squared for transfer in a much larger scale onto the canvas, indicates that Gauguin's initial priorities were the sharp contrast of light and shadow and the curious silhouette. The deep shadow across all but the left edge of the figure's back does not seem remarkable in the context of the sketchbook, but, transposed to a beach setting in the painting, the shadow seems at odds with both the light conditions and the mood implied by the sun-drenched sand. The silhouette, outlined as forcefully in the painting as in the drawing, seems deliberately awkward, with the model's arms and legs bent and pulled in close to the torso. The short hair, the arms indicated only from the shoulders to the elbows, and the right leg drawn in only above the knee emphasize the model's torso, recalling a fragment of antique sculpture, such as the famous Belvedere Torso, with its limbs broken off. In the painting the figure appears at once daringly flattened and palpably sculptural.[3] Moreover, the rich variety of scumbled brown skin tones are comparable to the luminous, unevenly applied glazes that Gauguin used for many of his ceramics or to the patina on a statue of wood or bronze.

Vahine no te miti

1892

93 x 74.5 (36¼ x 29)

oil on coarse canvas

signed at lower right, in orange, *P Gauguin 92*

inscribed at lower left, on yellowed leaf, in dark blue, *Vahine no te /Miti*

Museo Nacional de Bellas Artes, Buenos Aires

EXHIBITIONS

Paris, Durand-Ruel 1893, no. 30, *Vahine no te miti (Femme de la mer)*; Brussels 1894, no. 190; Paris, Drouot 1895, no. 25, *Vahine' no te' miti (Femme de la mer)*; Tokyo 1987, no. 63

CATALOGUES

Dorival 1954, inv., 1892 no. 30, *Etude de dos nu*; Field 1977, no. 21; W 465; FM 228

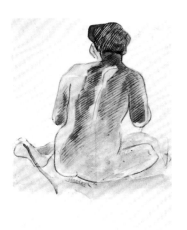

Ingres, *The Bather of Valpinçon*, 1808, oil on canvas [Musée du Louvre, Paris]

Gauguin, *Carnet de Tahiti*, page 81

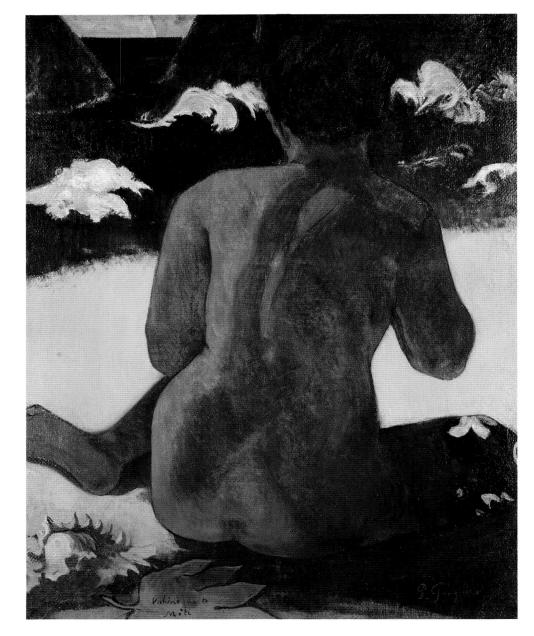

In *The New Painting*, 1876, Duranty advocated the idea that modern painters should ignore the conventions, especially frontality, of traditional genre painting and portraiture, and find some way to express psychological mood, age, and social class by rendering figures from the back.[4] Duranty was a strong admirer of Degas. Gauguin's nude, like Degas' many variations on the theme,[5] is turned away from the spectator, evoking a private dialogue with her own thoughts. The model's visible ear draws attention to her solitude, broken only by the gentle sound of the surf over the coral reef. Of course, the peaking crests of water are also decorative accents in Gauguin's composition, harmonizing with the white floral pattern on the *pareu* draping the model's right leg and with the silhouettes of the flowers and leaves washed onto the beach. All these are absent in the sketchbook drawing.

Both this little still life of writhing organic forms and Gauguin's generous use of unmodulated zones of yellow and orange-yellow to either side of the figure recalls works by van Gogh, for whom the color yellow had special spiritual significance. In *Vahine ne te vi*, of course, Gauguin complemented the yellow tones with

4. Reprinted in San Francisco 1986, 44, 481-482.

5. See, for example, Lemoisne 1946-1949, nos. 642, 848, 849.

6. Paris, Orangerie 1949, no. 109, transcribed in Appendix III, 100; Motoe in Tokyo 1987, 102, 170, identifies *Vahine no te miti* with the work referred in this letter.

7. Ribault-Menetière 1947.

the blue tones in the water and in the model's hair, and in conjunction both colors seem more vibrant.

A letter written by Gauguin to a potential collector after his 1895 auction lists five works still available for purchase, one entitled "Femme de dos sur sable jaune" (Woman seen from behind on yellow sand). This may refer to *Vahine no te miti*, or *Otahi* (see cat. 156). He set the highest price of all for this picture, explaining "I add this last item because I believe that it is an exceptional morsel."[6] In 1902, responding to an inquiry from a collector, Gauguin regretted that he did not know the present whereabouts of *Vahine no te miti*.[7]–C.F.S.

145
Nafea faaipoipo

1. See Bouge 1956, 162, no. 26; and Danielsson 1967, 231, no. 24.

2. Malingue 1949, CXXX; redated by Field 1977, 361.

3. Blair Collection, Chicago.

4. Dorival 1954, inv., 1892, 71–72.

5. For the sketchbook drawing see Rewald 1958, no. 46. One watercolor is in The Art Institute of Chicago (1922.4795) and the other is in Thielska Galleriet, Stockholm.

6. Field 1977, 136.

7. Johnson 1986, no. 356.

Nafea faaipoipo (*When Will You Marry?*),[1] a primarily decorative composition based on a resonant interplay of complementary colors, has a mood of adolescent mystery. It has frequently been associated with a letter from Gauguin to his wife, probably written in late April 1892, in which he reported, "I am hard to work, now I know the soil, its odor, and the Tahitians, whom I am doing in a very mysterious way, are no less Maoris and not [the ersatz] Orientals of the Batignolles [artists' quarter in Paris]."[2] Any attempt to give a precise date in 1892 to *Nafea faaipoipo*, however, must take into account the possibility that the flower worn over the ear of the foremost woman is a *pua* blossom, which blooms in December. The painting's relationship to *Aha oe feii?* (see cat. 153), with its comparably concentrated treatment of color, and *Where Are You Going?* (W 478 and W 501), which were painted in the second half of the year, may also be significant in terms of dating. In fact, a tiny sketch of the two figures in *Nafea faaipoipo* can be found on the reverse of a sheet of studies for *Aha oe feii?*[3]

Gauguin must have been obsessed with the crouching figure and determined to use it in a composition, since it appears in little preparatory sketches for paintings that he never realized.[4] He also inserted this figure into a small oil sketch (W 445), and it appears again on a sheet from one of his sketchbooks, in two watercolors,[5] and in a full-scale working drawing (see cat. 146).

Although Field has suggested a Japanese precedent,[6] Gauguin's point of departure for this particular figure would seem to have been the woman at the far right in Delacroix's *Women of Algiers* in the Louvre.[7] Such an allusion would have obvious significance, given Gauguin's enormous admiration for Delacroix's art, exemplified most clearly by the parallel between Delacroix's artistic pilgrimage to North Africa in 1832 and Gauguin's, nearly sixty years later, to Tahiti. The crouching figure in *Nafea faaipoipo* was among Gauguin's favorites, and he incorporated her into three other early Tahitian paintings (W 447, W 478, and W 501). Even the shape of the rock (with Gauguin's signature) in the foreground of *Nafea faaipoipo* can be understood as a counterpart to the solid, convoluted rhythms of this figure's legs and hips.

Gauguin's title for this picture, which should perhaps be associated with his own long account of Tahitian marriage in *Noa Noa*, if not with the best-selling novel about a European's love for a Polynesian, *Le Mariage de Loti* (1879), has been emphasized in virtually every scholarly discussion of the Staechelin painting. However, it is impossible to determine who poses the question to whom. Field

Nafea faaipoipo

1892

105 x 77.5 (41⅜ x 30½)

oil on coarse canvas

signed and dated at lower left, in black,
P Gauguin 92

inscribed at lower right, in black, *NAFEA
Faaipoipo*

Rudolf Staechelin Family Foundation

EXHIBITIONS
Paris, Durand-Ruel 1893, no. 19, *Nafea
faaipoipo? (Quand te maries-tu?)*; Paris,
Drouot 1895, no. 20, *Nafea faaipoipo*; Paris
1906?, no. 159, *Deux Tahitiennes accroupies*;
Paris, Orangerie 1949, no. 32; London 1979,
no. 90; Washington 1980, no. 53

CATALOGUES
Field 1977, no. 35; W 454; FM 172

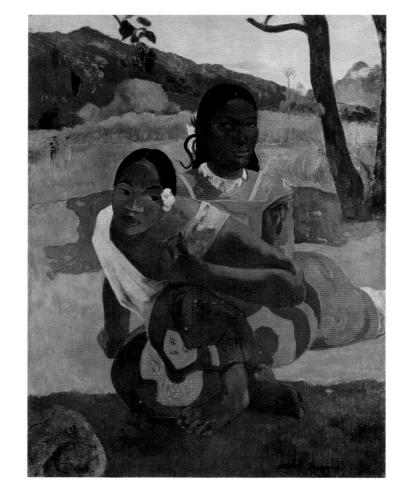

8. Field 1977, 132–141. The features of the
woman with a seemingly Buddhist gesture
are recorded in a drawing by Gauguin in the
Philadelphia Museum of Art.

9. Maurer 1985, 987.

10. Durand-Ruel Archives, Paris, *brouillard*
(June 1893–November/December 1897),
entry for 28 November 1893, received on
deposit and assigned stock number 8319.

suggests that the flower worn by the foremost woman indicates that she is looking for a husband, and he interprets the second figure as her alter-ego.[8] He further suggests that the gesture of the second figure's right hand derives from Buddhist art, and Maurer, who interprets these figures as representatives of two stages of awareness of the universal experience of love, has identified this gesture as a Buddhist *mudra*, which signifies teaching.[9]

Whereas Tehamana may have posed for both figures, it seems obvious that Gauguin meant to contrast these overlapped figures, one turned away from the other. Their eyes move in opposite directions and they dress differently, the foremost one wearing a bright red *pareu* (rather than the pale lavender one in the working drawing), while her companion wears a muted coral-colored missionary dress. These carefully orchestrated tones seem to characterize two distinct psychological temperaments, as surely as do the figures' different poses. Paired as they are, they would seem to have some relationship to the pair of tiny standing figures in the background. But it remains unclear whether any significance should be given to this detail or to the setting, with its limpid pool of water. The two leafy branches hanging down in the upper left corner of the composition like a decorative accent should perhaps be understood as a metaphorical foil to the apparently dead tree with two trunks at the side of the pool.

In preparation for this one-artist exhibition in November 1893, Gauguin placed six paintings on consignment with the dealer Durand-Ruel, including this one. The fact that he assigned the highest price of 1,500 francs only to this picture and one other is indicative of its importance to him.[10]—C.F.S.

146
Crouching Tahitian Woman, Study for Nafea faaipoipo (recto); Tahitian Woman, Study for Faaturuma (verso)

1892

555 x 480 (21¾ x 18⅞)

recto, pastel and charcoal over preliminary drawing in charcoal, selectively stumped, and squared in black chalk, on wove paper; verso, charcoal

The Art Institute of Chicago, Gift of Tiffany and Margaret Blake. 1944.578

EXHIBITION
Chicago 1959, no. 105

CATALOGUE
FM 173 (recto); FM 174 (verso)

Gauguin, *Tahitian Woman*, verso, cat. 146.

Full-scale working drawings survive for only four of Gauguin's early Tahitian paintings (see cats. 147, 149). Gauguin squared this sheet in order to guide his freehand transfer of the image. In two cases, he pricked the drawings in order to transfer those images by superimposing them directly onto canvases, a method that seems to postdate the more orthodox grid transfer method exemplified by this sheet and a related work (cat. 127). Since the Art Institute drawing represents only one of two overlapping figures in *Nafea faaipoipo*, it gives a rare insight into how Gauguin developed his compositions by studying separate parts in isolation. The faint trace of an alternative rendition of this figure's right arm suggests that this drawing may be Gauguin's very earliest version of this figure, which obsessed him and reappeared in reduced scale throughout his oeuvre, sometimes with no right arm, but never with the arm in this position.

 After lightly sketching the figure's pose in graphite, Gauguin reinforced most of the outlines with blue and brown pastels and then filled in her face, costume, and the immediate background with colors. His choice of colors for the drawing differs from that for the oil version. In the drawing the woman's hair is

Prussian blue rather than black, her *pareu* is pale lavender decorated with a yellow pattern rather than bright red, and she sits on emerald-green grass rather than vivid ocher sand.

Gauguin made this working drawing on the reverse of a sheet that he had already used to sketch a seated Tahitian woman wearing a missionary dress. Since in its present form the top of this figure's head is cropped, it seems that Gauguin cut down his sheet prior to working its clean side as the preparatory drawing for *Nafea faaipoipo*. Judging from the model's features and dress, the first drawing was a preliminary idea for *Faaturuma* (cat. 126), even though the model in the painting sits on a rocking chair and holds a handkerchief, whereas in this drawing no chair is indicated and she seems to hold a small pet.[1]–C.F.S.

1. A similar model holds a pet in a possibly related drawing in The Art Institute of Chicago, inv. no. 43.521.

147
Parau na te varua ino[1]

1. See Danielsson 1967, 232 no. 47; and Amishai-Maisels 1985, 209 n 50.

2. Field 1977, 125, and fig. 47; Amishai-Maisels 1985, 192.

3. Offentliche Kunstsammlung, Basel. Gauguin pasted a photograph of this drawing into his copy of *Noa Noa*, Louvre ms, 51.

4. The Art Institute of Chicago, inv. no. 49.649.

5. The Armand Hammer Collection.

6. Field 1977, 122-126; Amishai-Maisels 1985, 195-198; Teilhet-Fisk 1985, 76-77.

7. Teilhet-Fisk 1985, 74-75. Dorra 1970, 370, includes these among what he calls Gauguin's "observer" figures.

8. Field 1977, 325, no. 30; Amishai-Maisels 1985, 196.

9. Morice 1893b, 10-11.

10. Amishai-Maisels 1985, 183.

11. Teilhet-Fisk 1985, 75, suggests that this red may symbolize "the first blood of intercourse."

12. Andersen 1971, 185-186, interprets these trees as phallic symbols.

13. *Noa Noa*, Louvre ms, 38-39.

14. Maurer 1985, 1003, discusses the symbolism of bathing in reference to this picture.

Gauguin set this utterly simple standing nude against a landscape of richly orchestrated greens and lavenders accented with tropical flora. Like the outline of the figure in *Te nave nave fenua* (cat. 148), the one for this nude, her pose apparently derived from some medieval sculpture of Eve,[2] was transferred onto the canvas from a pricked full-scale cartoon that Gauguin subsequently colored with pastels and cut around the edges to develop as an elaborate work in its own right.[3] Although the figure's eyes are positioned lower down on her face in this working drawing, radiographic examination of *Parau na te varua ino* reveals an extra set of eyes, the lower pair eventually painted out by Gauguin. A little pen and ink sketch of the same figure, originally a page in one of Gauguin's notebooks, perhaps served as a study for that large transfer drawing.[4] Gauguin later adapted the figure for other works, including a pen and ink drawing,[5] a woodblock print (cat. 235), and a transfer drawing (cat. 25).

The dimensions of *Parau na te varua ino* (Words of the Devil), the way in which Gauguin developed it from a full-scale cartoon, and its apparent theme of Old Testament original sin all seem to relate this painting directly to *Te nave nave fenua*. Yet other specifically narrative or symbolic details relate *Parau na te varua ino* to a group of fairy-tale-like paintings about fear, including *Manao tupapau* (cat. 154), *Parau hanohano* (W 460), and *Contes barbares* (W 459), all executed around the same time.[6] The *varua ino* referred to in Gauguin's title is an evil spirit that can haunt Tahitians, and the artist invented grotesque figures to embody such superstitions.[7] In *Parau na te varua ino*, *Parau hanohano*, *Contes barbares*, and *Te po* (cat. 168), he used the same frontal figure of a kneeling woman with a masklike face, whereas for other pictures in this series, including the reworked transfer drawing for *Parau na te varua ino*, he invented a hooded figure in profile, sometimes mounted on horseback (cat. 256), referring to this type as *tupaupaus*, another variety of Tahitian phantom. Describing one of these paintings (possibly *Parau hanohano*[8]) included in Gauguin's 1893 one-artist exhibition in Paris under the title *Faire peur* (To Frighten), the artist's collaborator Morice explained in the

1892

91.7 x 68.5 (36⅛ x 27)

oil on coarse canvas

signed and dated at lower left, in black,
P Gauguin 92

inscribed at lower left, in orange, *Parau na te
Varua ino*

National Gallery of Art, Washington, Gift
of the W. Averell Harriman Foundation in
memory of Marie N. Harriman

EXHIBITIONS
Paris, Durand-Ruel 1893, no. 10, *Parau no
Varua Ino (Paroles du Diable)*; Brussels
1894, no. 192, *Paroles du Diable. Parau nate
Vanua ino*; Paris, Drouot 1895, no. 10, *Parau
no Varua Ino*; London 1910, no. 43, *L'Esprit
du Mal*; New York 1913, no. 175; Chicago
1913, no. 138; Boston 1913, no. 55; Basel
1949, no. 47; Lausanne 1950, no. 21; Houston
1954, no. 24; Chicago 1959, no. 42

CATALOGUES
Field 1977, no. 29; W 458; FM 240

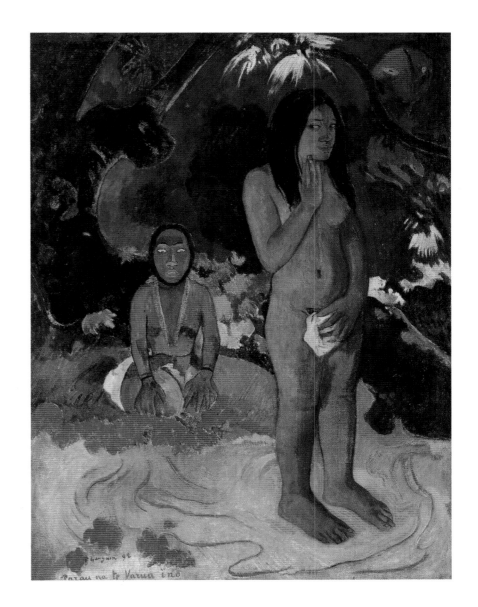

Gauguin, *Words of the Devil*, 1892, pastel
[Oeffentliche Kunstsammlung, Basel,
Kupferstichkabinett]

catalogue: ". . . someone tells a dangerous story and in the naïveté of one of the
listeners, the legend took shape, it distorts nature terribly in the widened phos-
phorescent eyes of the credulous woman, and the gentle Tahitian night is inhab-
ited by [such] watchful beings, formidable, unknown, ancient divinities, fallen from
grace or long dead. . . ."[9]

The gesture of modesty made by the standing nude in *Parau na te varua
ino* recalls figures of Eve in Western representations of the Expulsion from Eden.
The somewhat comical evil spirit clad in an intense blue décolleté shift seems,
then, maybe Gauguin's interpretation of Satan, a traditionally male role.[10] The
unnaturally brilliant vermilion of the dead leaves washed into clusters on the pink
sand around her knees has an evil intensity,[11] heightened by the exotic white *hutu*
blossoms and the gnarled lichen-spotted tree trunks.[12] The serpentine forms of
the dried pandanus leaves on the beach around the standing figure's feet appear in
several of Gauguin's earliest Tahitian paintings (W 430, W 431, W 432), and in *Noa
Noa* the artist compared these leaves to letters in a lost alphabet (cat. 183).[13] Since
neither figure in *Parau na te varua ino* appears to speak, these leaves may repre-
sent the words (*parau*) in Gauguin's title. The standing bather,[14] who turns her

eyes suspiciously toward the *varua ino*, would see the exotic flora, but the spirit would presumably be invisible to her.

Scholars have taken the *varua ino* to embody "evil" or "death" and proposed a variety of interpretations for *Parau na te varua ino*, ranging from the awakening of sexual conscience to meditations on the interrelated concepts of sin, birth, and death. Yet this painting's symbolism is ultimately indecipherable.[15] Perhaps the most telling clue to Gauguin's intended meaning is a small preparatory pencil drawing (R 40) of the two figures separated from one another by a slanted tree trunk in just the same way that the figures posed from life in his *Vision after the Sermon* (cat. 50) are separated from the imaginary figures in their minds' eyes that Gauguin represented in the background.[16] In this little sketch the *varua ino* holds an elongated mask with a stylized smile. Despite the fact that the exact model for this primitive mask (which Gauguin repeated again in the lower margin of this same sheet[17]) has never been identified, the way its expression contrasts with the somber features of the *varua ino* herself suggests that she may have worn it to tempt the bather, only to remove it and reveal some hidden, ugly truth.[18]

The most peculiar of all the odd details in the final painting is also a telling clue. This is the half-vermilion, half-green mask with one white and one yellow eye in the upper right corner. Barely visible just below this half face is a hand, the thumb extended toward where the mask's mouth should be, recalling the thumb-to-mouth gesture in numerous works by Gauguin, especially in the self-portrait that he included in the corresponding upper right zone of his 1889 polychromed wood relief *Be in Love and You Will Be Happy* (G 76), the ironic theme of which is the agony of sexual remorse.[19] The staring seated fox in this same relief, which Gauguin explained as the Indian symbol for perversity,[20] was quite clearly the prototype for the *varua ino* in his early Tahitian paintings.—C.F.S.

148
Te nave nave fenua[1]

Te nave nave fenua (*The Delightful Land*) is perhaps Gauguin's most uncompromisingly shocking painting, with its full frontal nudity and exposed pubic hair. It had its genesis around 1889 when Gauguin acquired photographs of the sculpted frieze from the Buddhist temple at Borobudur as part of his collection of images of details for his own subsequent works.[2] Early that year at the Centennale de l'art français he saw Courbet's *Woman with a Parrot* (1866),[3] the memory of which apparently inspired him three years later to juxtapose a birdlike lizard with a naked woman for a similar erotic effect in *Te nave nave fenua*. Gauguin developed the basic idea for this painting of a Tahitian Eve from a painting that he executed in 1890, before he ever went to Tahiti. This shows a nude, in the pose of one of the Borobudur figures, picking apples with the guidance of a snake coiled around a little tree set in an opulent landscape crowned with coconut palms.[4] Gauguin perhaps appreciated the irony of representing the spiritual descent of Eve in a pose designed to convey enlightenment in Buddhist art.[5] But most peculiar is the fact that the head of this little nude has the features of his mother, copied from a photograph (see cat. 106).

15. Dorra 1953, 200-202; Dorra 1954, 13; Field 1977, 124-125; Amishai-Maisels 1985, 191-193, and 198-201; Andersen 1971, 185-186; Teilhet-Fisk 1985, 75-77; Jirat-Wasiutynski 1978, 270-271; Maurer 1985, 999-1003.

16. Teilhet-Fisk 1985, 74.

17. Teilhet-Fisk 1985, 74; Amishai-Maisels 1985, 190-191, incorrectly identified the mask in the margin as an altar.

18. Amishai-Maisels 1985, 192.

19. Amishai-Maisels 1985, 199-200; Jirat-Wasiutynski 1978, 271.

20. Malingue 1949, LXXXVII; and Cooper, 1983, nos. 22, 35.

1. See Danielsson 1967, 231, nos. 35, 36, and page 233, no. 69; and Teilhet-Fisk 1985, 30.

2. Dorival 1951, 118-122; and Dorra 1967, 109-112.

3. Fernier 1978, no. 526.

4. W 389. Dorra 1953, 193-202. Other early images of Eve by Gauguin include W 333 and G 71.

5. Field 1977, 132.

1892

91 x 72 (35½ x 28)

oil on coarse canvas

signed and dated at lower left, in purple,
P. Gauguin 92; inscribed at lower left, in red,
Te NAVE NAVE FENUA

Ohara Museum of Art, Kurashiki, Japan

EXHIBITIONS
Paris, Durand-Ruel 1893, no. 16, *Nave nave
fenua (Terre délicieuse)*; Paris, Drouot 1895,
no. 18, *Nave Nave fenua*; Tokyo 1987, no. 60

CATALOGUES
Field 1977, no. 33; W 455; FM 232

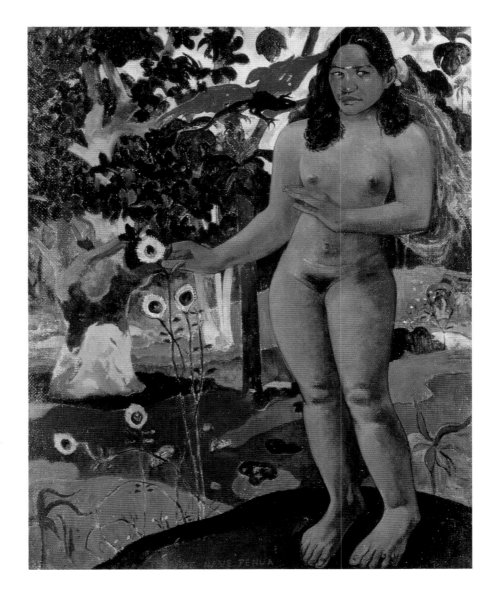

Gauguin, *Head of a Tahitian Woman*, 1892,
charcoal [private collection, Paris]

6. We are grateful to Mitsuhiko Kuroe for
providing us with the results of his radio-
graphic analysis.

7. Pickvance 1970, no. 73.

8. Both Amishai-Maisels 1985, 188-189, and
Jirat-Wasuitynski 1978, 271, incorrectly
identified the model as Titi. A sculpture of
Tehamana's head (cat. 150) has the *Te nave
nave fenua* figure on the back.

9. See *Diverses Choses*, ms, 256; Maurer
1985, 986-987, relates the text to this
painting.

10. Field 1977, 131; and Amishai-Maisels
1985, 200.

The head of the figure in *Te nave nave fenua* also must have had consider-
able personal importance for Gauguin. This head differs from the head in the full-
scale transfer drawing (cat. 149) that he used to develop the painting.

Recent radiographic analysis of the painting reveals a head, corresponding
to the one in the drawing, beneath the present head.[6] Referring to one of his
powerful portraits in charcoal[7] as a guide for the ultimate head in *Te nave nave
fenua*, Gauguin recorded the features of Tehamana, his mistress.[8] Presented in *Te
nave nave fenua* as a powerful nude, a little too tall to fit his canvas, Tehamana
embodies Gauguin's concept of the Tahitian Eve, which he described in detail in
Diverses Choses.[9]

Te nave nave fenua is apparently a pendant with similar dimensions to
Parau na te varua ino (cat. 147), Gauguin's Tahitian translation of the Western
theme of Eve's shame after the fall. *Te nave nave fenua* has usually been under-
stood as a free translation of the theme of Eve's temptation in a tropical setting.[10]

As scholars have pointed out, in *Le Mariage de Loti* (1879) the Tahitian
heroine, Rarahu, explains how missionaries described the serpent who tempted
Eve as a "long lizard without feet" *(long lézard sans pattes)* because there are no

snakes in Tahiti.[11] There are, however, no winged lizards like the one in *Te nave nave fenua* in Tahiti, or anywhere for that matter. And despite the fact that Gauguin could find no apple tree in Polynesia to illustrate this biblical theme, he likewise chose to invent a completely imaginary flower rather than adopt a local fruit as a substitute. The fantastical flowers and lizard in the otherwise naturalistic landscape of *Te nave nave fenua* set this painting apart from all of Gauguin's other Tahitian paintings, which record local flora and fauna, albeit sometimes in stylized fashion.

August Strindberg was, therefore, probably referring to *Te nave nave fenua* when he complained in a letter to the artist: "I saw verdant trees that no botanist would recognize, animals that [the distinguished naturalist] Cuvier never imagined, and men that you alone have been able to beget."[12] Two critics in Paris in 1893 stressed the same visionary qualities in *Te nave nave fenua*. Achille Delaroche[13] wrote: "a fictive orchard offers its insidious flora to the desire of an Eve from Eden whose arm extends timorously to pluck a flower of evil, while the beating red wings of the chimera whisper at her temples."[14] Morice, who probably consulted with Gauguin before writing his remarkably similar description of the painting, compared the flowers to "the dazzling eyes of peacock feathers, flowers of pride."[15]

Following up on Morice's analogy, most scholars have compared the tempting flowers in *Te nave nave fenua* to the visionary plant, part peacock feather, part eyeball, in an 1883 lithograph by Redon,[16] and some have interpreted the allusion to the peacock feather here in terms of vanity, courtship, vision, and knowledge.[17] Peacocks appear prominently in one of Gauguin's most ambitious early Tahitian landscapes (cat. 132) as well as a woodblock print.[18] Whether he intended a correspondence between the flowers in *Te nave nave fenua* and the striking plumage of the bird is not known, but the strange plant recurs in other early Tahitian works, including illustrations for *Ancien Culte Mahorie*.[19]

Another of Gauguin's notebook drawings records how the flying lizard developed in his imagination,[20] quite possibly as a recollection, like the flowers, of one of Redon's haunting lithographs. The isolated detail of the woman's head adjacent to the lizard, which Gauguin elaborated in a pastel drawing[21] and in a

11. Loti 1879, chapter 37; see Amishai-Maisels 1985, 185-186.

12. Strindberg 1895.

13. Malingue 1949, CLXXII.

14. Delaroche 1894, 37.

15. Morice 1893a, 296.

16. Mellerio 1913, no. 46.

17. Amishai-Maisels 1985, 185; and Andersen 1971, 176-178.

18. Cat. 232. He also recorded one of their feathers in a notebook drawing (*Album Briant*, 21); see Amishai-Maisels 1985, 181.

19. Huyghe 1951, *Ancien Culte Mahorie*, 13 and back cover.

20. Musée Saint-Denis, Reims. In an earlier drawing, known today only through a photograph (Schniewind Archives) but related to a zincograph from 1889 (Gu 1), Gauguin included a lizard, albeit without wings.

21. See *Tableaux modernes*, Paris, Palais Galliera, 7 June 1973, no. 5.

Gauguin, *Woman's Head*, related to *Te nave nave fenua*, pencil, pastel, and gouache [location unknown, *Palais Galliera*, 7 June 1973, no. 5]

Gauguin, *Noa Noa*, front cover [Musée du Louvre, Paris, Département des Arts Graphiques]

Redon, illustration from Flaubert's *Temptation of Saint Anthony*, "And a Large Bird that Descends from the Sky Hurls Itself on Top of Her Hair," lithograph [The Art Institute of Chicago, Stickney Collection]

22. Mellerio 1913, no. 86. *Tentation de Saint-Antoine*, "Et un grand oiseau qui descend du ciel vient s'abattre sur le sommet de sa chevelure."

23. Another watercolor is in *Noa Noa*, Louvre ms, 69. Amishai-Maisels 1985, 182-184.

24. We are grateful to Peter Zegers for bringing this detail to our attention.

little watercolor on the cover of his illuminated Noa Noa manuscript, is remarkably close in appearance to one of Redon's 1888 illustrations to Balzac's *Tentation de Saint-Antoine:* "And a great bird that descends from the sky hurls itself on top of her hair."[22]

The lizard's scarlet wings, which seem related to the fruity colors of the dried riverbed setting in *Te nave nave fenua*, cast an aura on Tehamana's black hair, which is adorned behind her left ear with a reddish ribbon (see also cat. 130). This ear, turned away from the monster as are her eyes, suggests the complex, self-conscious dialogue that is the supreme enigma of *Te nave nave fenua*. For an unexplained reason, in all of Gauguin's other versions of this figure, including the working drawing for the painting (cat. 149), transfer drawings (cats. 178, 179, 180), woodblock prints (cats. 172, 177), and watercolors (cat. 182) that obsessed Gauguin during the next half dozen years, her eyes face the monster.[23]

The painted version, which was purchased by the Irish artist O'Conor at Gauguin's auction in 1895, is unique in still another detail: Eve's right foot is polydactyl.[24] Whether Tehamana in fact had two extra toes is unclear from his other portraits of her, but there would seem to be no other explanation for the deformity of the giantess in this dream vision of paradise.–C.F.S.

149
Reworked Study for Te nave nave fenua (recto); Crouching Seated Figure, and Head of a Woman (verso)

1. Other examples are W 391 and Pickvance 1970, pl. X.

2. See also Rewald 1958, nos. 58, 59. Amishai-Maisels 1985, 181-183, reconstructed this complex sequence incorrectly.

The early Tahitian work for which Gauguin used the study on the verso, if it was ever brought to resolution, has not survived. Before Gauguin ultimately developed it as an independent work, however, the standing nude on the recto served as a working drawing for the figure in *Te nave nave fenua* (cat. 148). The sheet's present irregular outline is presumably a final refinement to this composition, which belongs to a small group of important preparatory drawings (see cats. 35, 45, 112, 163) that Gauguin reworked in this same way at some unknown date.[1] Although eventually obscured by the colored background that Gauguin added, his isolated meditations about how to render this figure's right hand and left elbow in detail are still visible at the right of this sheet, and holes pricked along the figure's contours can be discerned. The one-to-one equivalence in scale between this figure and the corresponding one in the oil painting leave no doubt that Gauguin superimposed the drawing on the canvas and forced charcoal through the pinpricks to transfer the outlines as a guide before beginning his work in oils. Curiously, Gauguin would not seem to have had any rationale for adopting such a method. He was hardly faced with the problems that led medieval fresco painters to invent this type of transfer drawing to facilitate the completion of mural decorations that had to be executed with the help of assistants working on scaffolds.

Some of the differences between the Des Moines drawing and its counterpart on canvas testify to a complicated sequence of changes that Gauguin felt obliged to make as he moved from the drawing to the painting, then back to the drawing, and then to still other related works (see cats. 178, 179, 180, 181).[2] Since

Reworked Study for Te nave nave fenua
(recto); *Crouching Seated Figure, and Head
of a Woman* (verso)

1892; reworked around 1894

940 x 475 (36⅝ x 18½), irregularly shaped

charcoal and pastel selectively stumped and
worked with brush and water (or solvent),
over preliminary drawing in black chalk;
punctured for transfer; on wove paper

signed and dated at lower right, in black
chalk, *P Go 92*

Des Moines Art Center, gift of Mr. and Mrs.
John Cowles

EXHIBITION
Chicago 1959, no. 104

CATALOGUE
FM 253

shown in Washington and Chicago only

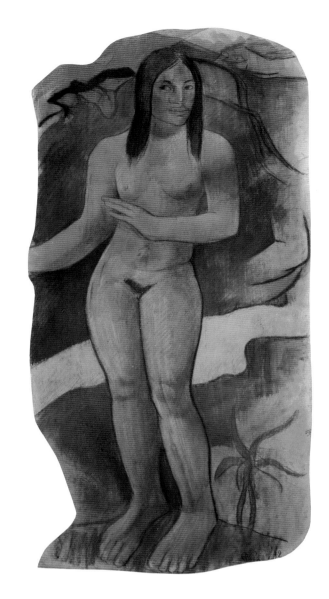

Gauguin, *Crouching Seated Figure and Head
of a Woman*, 1892, verso of cat. 149

the head of the figure in the drawing and the normal number of toes on her left
foot are deviations from the painting, it seems clear that Gauguin began the
composition from another model rather than Tehamana. In a later drawing (cat.
178), traces of Tehamana's head are visible, although, reversing himself, Gauguin
erased it and replaced it with the head of the model he had used in the first place
for the Des Moines drawing. In both drawings the figure's eyes are turned to the
left, whereas in the painting they are turned right.

The most salient differences between the oil version and the Des Moines
drawing are a factor of their different mediums. Reworked in pastels, the drawing
has an opulent texture of overlapping strokes. The stream is a detail that Gauguin
invented only when he returned to the preliminary drawing to rework it in colors,
and this new detail is a feature of all his other versions of the theme (cat. 177),
including the woodblock print (cat. 172). But with its irregular outline, the Des
Moines pastel is the most extraordinary of all these versions, embodying simul-
taneously every stage of Gauguin's thinking about a subject that obsessed him for
years.—C.F.S.

150

Head of a Tahitian Woman with a Standing Female Nude on the Reverse

probably 1892

height 25, diameter 20 (9¾ x 7¾)

pua wood polychromed with paint, stain, and gilding

Musée d'Orsay, Paris

EXHIBITIONS
Paris 1906, unnumbered, listed after no. 191 as *Six Bois Sculptés*; Munich 1960, no. 147; Paris 1960, no. 109; Paris 1986, no. 246

CATALOGUES
G 98; FM 236

1. G 101, G 129.

2. See also G 1, G 2.

3. See also G 39, G 52.

4. G 63.

5. Malingue 1949, CXXX.

6. Joly-Segalen 1950, XII, VI, respectively. We have redated no. XII to around August. See cat. 142, n. 3.

This two-sided object is something of a curiosity among Gauguin's early Tahitian works, his other wooden heads of Polynesian women[1] not excepted. The careful carving of the face recalls Gauguin's early efforts as a portrait sculptor (cat. 5),[2] and this head should be understood as an extension of his work in ceramics. His toby jugs (cats. 39, 62),[3] several of which are charged with symbolism (cats. 64, 65), or developed on two sides, in particular a vase[4] decorated with Eve or Leda on one side and a snake's or swan's neck and head on the other, are especially close in concept to the Orsay head. Taken as a whole, Gauguin's ceramic vases with decorations unfolding all around their bodies were the starting point for this head and for all the cylindrical sculptures (cats. 138, 139, 140, 151) that he made during his first trip to the South Seas. The contrasting styles of the opposite sides of the Orsay head, however, smooth and elegant for the face, rough and crude for the relief on the back, make it unique, and this contrast might be a clue to the object's meaning for Gauguin.

There is considerably less information about Gauguin's carving during his first stay in Tahiti than about his painting. An undated letter to his wife, probably written around April 1892,[5] refers to a few sculpted bibelots, and two letters to Monfreid, one of which should be dated around August 1892 and the other around October of that year,[6] likewise refer to sculpture. The August letter is perhaps the most pertinent, since it contains news that the artist's *vahine*, Tehamana, has become pregnant. This event may have motivated Gauguin to carve the Orsay

7. *Noa Noa* Louvre ms, 107. The pose of this figure, based on one of the Buddhist worshippers in a photograph that he owned, appeared in his work already in 1890 (W 389), and Gauguin repeated it in a number of Tahitian works, most important among them *Te nave nave fenua* (cat. 148). Amishai-Maisels 1985, 188.

8. Joly-Segalen 1950, V.

9. Rewald 1958, no. 69.

10. Field 1977, 128. Teilhet-Fisk 1985, 62-65, discussed the image of the decapitated head in detail.

11. W 320. De Haan was also the subject for one of Gauguin's wooden heads (cat. 94).

12. *Noa Noa* Louvre ms, 194-201.

13. Paris 1960, no. 109.

head. The Polynesian woman with flowers behind her ear on the recto of the Orsay sculpture is presumed to be Tehamana (cats. 126, 127, 130, 143, 148, 158). Moreover, the figure of Eve on the back of this sculpture embodies the artist's claim in *Noa Noa* that Tahiti became like paradise after he met her.[7]

In another letter to Monfreid that seems to date from around June 1892,[8] Gauguin described a bizarre painting of a decapitated head with closed eyes placed on a pillow, adding, "It is not completely my own, since I stole it from a pine plank." Although this may mean that Gauguin saw his painting's eventual composition in the wood grain patterns, Field suggested that Gauguin might actually have sculpted a head with open eyes, now lost, but recorded in a drawing,[9] from which he developed the final painting.[10] The simplified features of the head in the drawing and painting are more closely related in appearance to the sculpted head of Tehamana than any other work by Gauguin.

The way Gauguin cut off the back of his block to incorporate the figure into the Orsay sculpture as a relief suggests that he wanted this sculpture to be more than a routine portrait. If the Eve relief is understood as a sort of cross-section, revealing the inside of Tehamana's head, it in effect represents her thoughts as the fantasies of a temptress. For his 1889 portrait in oils of Meyer de Haan,[11] Gauguin had represented sexual thoughts in similar fashion by painting nude figures emerging from behind his colleague's head. In the Orsay sculpture, the sinful thoughts may have some sort of connection to Gauguin's doubts about Tehamana's fidelity to him, recounted at the very end of *Noa Noa*.[12] Her green eyes would seem to signify jealousy.

Gauguin gave this two-sided sculpture of his former mistress to Annette Belfis, the mistress of Monfreid, after she posed for one of his paintings in 1894 (see cat. 190).[13]—C.F.S.

151
Idol with a Shell

1. Joly-Segalen 1950, XIII.

2. The other is G 125.

3. Joly-Segalen 1950, XII; redated to around August, see cat. 142, n. 3.

4. Moerenhout 1837, 1: 421; transcribed in Huyghe 1951, 9.

5. Gray 1963, 57 n. 15; and Amishai-Maisels 1985, 360-361. Gauguin made a drawing of a similar seated figure in one of his notebooks; see Huyghe 1952, 12.

6. Amishai-Maisels 1985, 360; Teilhet-Fisk 1985, 54.

7. Teilhet-Fisk 1985, 54. Jénot 1956, 121, reported that Gauguin brought photographs of tattooed Marquesans with him from France.

8. Amishai-Maisels 1985, 360.

The most savage of what Gauguin described to Monfreid as his "ultra-savage sculptures,"[1] this complex idol incorporates elements from a variety of disparate sources to embody what the artist understood to be the fundamental episodes in the ancient Polynesian account of the creation of the universe. It is one of two known works[2] by Gauguin that might correspond to the ironwood sculpture the artist mentioned in a letter to Monfreid, probably datable to around August 1892. "Right now I am carving tree trunks to make a type of savage bibelot. I have a little piece of ironwood to bring back with me. It wore out my fingers, but I am satisfied with it."[3]

The presiding figure, who sits with his legs crossed, can be identified by the nimbuslike shell behind his head. According to Moerenhout, who implied that the natives worshipped idols similar to those found on Easter Island, "Taaroa is brightness; he is the seed; he is the base; he is the incorruptible, the force who created the universe, the great and sacred universe which is only the shell of Taaroa."[4] Given the lack of a Polynesian prototype upon which to base his own representation of Taaroa, Gauguin rendered him in the pose of Buddha or Siva, probably referring to one of the photographs of Far Eastern art in his collection, showing the same jewelry, belt, and halo.[5]

1892

height 27 (10⅝) diameter 14 (5½)

toa (ironwood); figure in lotus position decorated with mother-of-pearl (aureole and pectoral) and bone (teeth)

incised at top, *PGO*

Musée d'Orsay, Paris

EXHIBITIONS
Paris, Durand-Ruel 1893, probably one of a group catalogued as no. 46, *Les Tiis*; Paris 1906, unnumbered, listed after no. 191 as *Six Bois Sculptés*; Edinburgh 1955, no. 76; Paris 1960, no. 110; New York 1984, no. 35; Paris 1986, no. 247

CATALOGUES
G 99; FM 201

9. For a lost idol made later, see Segalen 1904, 680-681, and Amishai-Maisels 1985, 363.

10. Amishai-Maisels 1985, 349.

11. Loti 1879, part 2, 104.

12. Huyghe 1951, 7.

13. See also W 499. Bodelsen 1961, 167.

14. Teilhet-Fisk 1985, 55-56.

By embellishing the figure's Buddhist prototype with details characteristic of Marquesan art, Gauguin transformed Siva into a fierce Polynesian divinity. He blackened the skin and inlaid bone to represent teeth, perhaps to suggest cannibalism.[6] He adorned the god's chest with a Marquesan pendant and carved disklike tattoos on his legs,[7] which terminate in curiously stylized feet characteristic of Marquesan art. Still other Marquesan motifs carved into the background for Taaroa's head have been interpreted as a cruciform halo with Christian overtones.[8] Gauguin used a similar hybrid figure to represent Taaroa in another idol (cat. 138), and in a woodcut (cat. 169).[9]

Flanking Taaroa on either side of the *Idol with a Shell* are pairs of seated figures with tattoos on their legs. These paired figures in profile, with the hand of the rear figure placed on the other's shoulder, are based upon the tiki pairs used on handles in Marquesan art.[10]

Loti compared such crouching figures to human embryos, adding, "The natives still own a few images of their god. . . . The queen has four of these horrors sculpted on the handle of her fan."[11] Gauguin had used an identical pair of figures for a watercolor illustration[12] for the legend of Taaroa's consort Hina (cat. 139) and her son Fatu (cat. 140).[13] It has been suggested subsequently that one set of figures on the wooden idol represents this pair, while the other set of figures represents Hina with Taaroa as the union between matter and spirit in the universe.[14] The

same three elements—Taaroa by himself, Hina with Fatu, and Hina with Taaroa—make up the gods in Gauguin's woodcut *Te atua* (cat. 169).

Assuming that a closely related illustration in *Ancien Culte Mahorie* was executed before March 1892, Amishai-Maisels argued that the *Idol with a Shell* must have been done early in Gauguin's stay in the South Pacific.[15] As she observed, Gauguin's idol (without the shell) apparently served as the model for the large statue in a painting that was underway by that date.[16] Gauguin's reference to having just made a sculpture from ironwood in the letter written to Monfreid several months later, however, raises the possibility that the *Idol with a Shell* may itself be a close replica of one of Gauguin's earliest Tahitian sculptures, which crumbled not long after he finished them.[17] Before returning to France, Gauguin was evidently determined to make a durable version of this lost sculpture.

Around 1900 Monfreid cast copies of this idol, and in 1959 one of his heirs authorized an edition of six in bronze.[18]—C.F.S.

15. Amishai-Maisels 1985, 349-351. It seems much more likely that Gauguin did not begin *Ancien Culte Mahorie* until late 1893.

16. W 450. Sérusier 1950, 59-60, with illustration reproduced facing 144.

17. Jénot 1956, 120.

18. Gray 1963, 218.

152
Fatata te miti

Purchased by Degas' friend Ernest Rouart, presumably after it was exhibited in Brussels in 1897, *Fatata te miti* (Near the Sea) is among the simplest and most exclusively decorative genre scenes that Gauguin painted during his first stay in the South Seas. It epitomizes the Tahitian way of life that most fascinated Westerners. In Pierre Loti's words, his Tahitian bride's ". . . pursuits were extremely simple: reverie, bathing, above all bathing."[1] Naked nymphs innocently frolicking in the water characterize the Golden Age, represented over and again by Titian, Fragonard, Corot, Courbet, and even Degas.

Gauguin's fascination with this tradition began as early as 1885 (W 167). By 1889 the artist had become so obsessed with his own painting of a naked woman observed from the back as she throws herself into the sea (cat. 80) that he repeated it in the background of one of his self-portraits (W 297) and in a drawing.[2] The bather with her arms raised in *Fatata te miti* is a reprise of these earlier images.[3] And later still Gauguin used the figure in one of his woodblock prints (cat. 167).

Whereas men are absent in Gauguin's European bather compositions, in *Fatata te miti*, as if to stress how shame was unknown in Tahiti, a fisherman carrying a spear in the background lagoon is included, and this small figure's presence seems not to disturb the women. This is impossible to know for certain, however, since their facial expressions are hidden.

In contrast to the simple genre subject of *Fatata te miti*, Gauguin painted a pendant in identical dimensions charged with indecipherable symbolic details (W 514). Entitled *Arearea no varua ino* (Amusement of the Evil Spirit), it shows perhaps the same women, dressed, lounging on the beach near what appears to be the same inclined tree.

1. Loti 1879, chapter VIII.

2. Reproduced as the frontispiece of Paris 1889. An uncatalogued, and apparently lost painted version of this larger composition is represented in the background of an uncatalogued still life by Gauguin from around 1888–1889.

3. Maurer 1985, 1004-1005.

1892

68 x 92 (26½ x 35⅞)

oil on canvas

signed and dated at lower right, in violet,
P Gauguin 92

inscribed at lower left, in reddish brown,
Fatata te Miti

National Gallery of Art, Washington,
Chester Dale Collection

EXHIBITIONS
Paris, Durand-Ruel 1893, no. 24, *Fatata te
miti (Près de la mer)*; Brussels 1897, no. 277,
Fatata te miti; Paris 1906, no. 203, *Fatate
te miti*

CATALOGUES
Field 1977, no. 38; W 463; FM 292

shown in Washington only

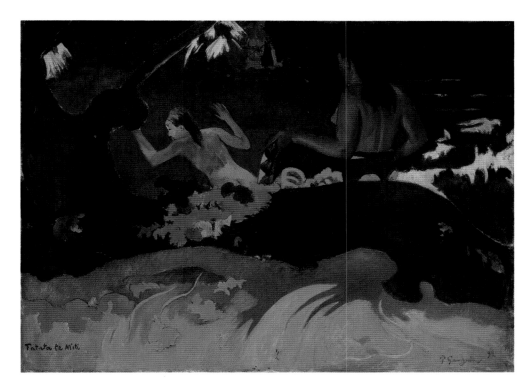

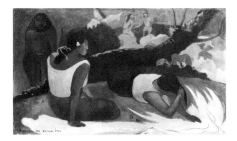

Gauguin, *Arearea no varua ino (The Amuse-
ment of the Evil Spirit)*, 1894, oil on canvas
[Ny Carlsberg Glyptotek, Copenhagen]

4. Malingue 1949, CXXXIV; Joly-Segalen
1950, VIII; and Damiron 1963.

5. Joly-Segalen 1950, VIII.

 The setting, divided in *Fatata te miti* into two zones of scumbled color by
the inclined tree, was apparently the basis for the ominous landscape background
in *Parau na te varua ino* (cat. 147). In both paintings clusters of dried leaves
stranded on the beach serve as bright accents. In *Fatata te miti* their decorative
silhouettes suggest the basis for the sort of bright organic patterns characteristic
of the *pareu* worn by Tahitian women. Gauguin's commitment to decorative pat-
terns as the basis for art was an extension of his appreciation of the Japanese
textiles that he used in several paintings in the early 1880s (cat. 13).

 No preparatory drawings have survived for *Fatata te miti*. The dark blue
contours visible around all of the forms indicate that Gauguin began the picture by
orchestrating a linear arabesque on the canvas, subsequently filling this in with
colors. Referring in December 1892 to *Manao tupapau* (cat. 154), Gauguin stressed
that this process constituted the "general harmony" or "musical part" of his art, in
distinction to the literary part.[4] To achieve maximum luminosity for the jewellike
colors that he used in *Fatata te miti* and other early Tahitian paintings, Gauguin
coated their surfaces with clear wax.[5]–C.F.S.

153
Aha oe feii?[1]

1892

68 x 92 (26½ x 35⅞)

oil on coarse canvas

signed below center along curving gray pattern printed on *pareu*, in black, *P Gauguin 92*[2]

inscribed at lower left, in purple or black, *Aha oe feii?*

Pushkin State Museum of Fine Arts, Moscow

EXHIBITIONS
Copenhagen, Udstilling 1893, no. 163, *Eaha oe Feii*; Paris, Durand-Ruel 1893, no. 18, *Aha oe feii (Eh quoi! tu es jalouse)*; Paris, Drouot 1895, no. 19, *Aha oe feü*; Moscow 1926, no. 7

CATALOGUES
Field 1977, no. 40; W 461; FM 239

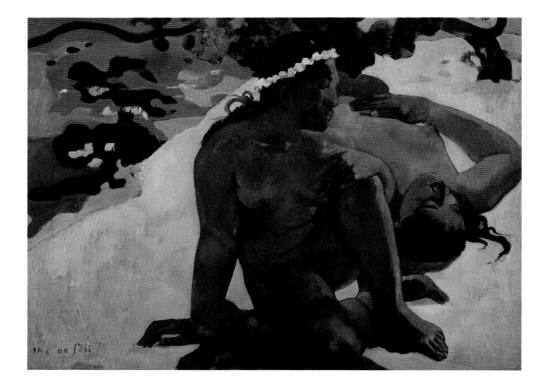

1. Danielsson 1967, 230, no. 1.

2. Cooper 1983a, 576, no. 19, pointed out that the date has been overpainted.

3. Joly-Segalen 1950, VI; see Field 1977, 364, no. 19, for a discussion of its date.

4. Joly-Segalen 1950, VIII.

5. Malingue 1949, CXXXIV.

6. Field 1960, 142, 148, 161.

7. Field 1960, 161, referring to *Noa Noa*, Louvre ms, 185. Such crowns of flowers, worn regularly by his *vahine* Rarahu, are described by Loti 1879, chapter IX.

8. Paris 1942, no. 49. This drawing corresponds to Rewald 1958, no. 39 and was exhibited in Paris 1960, no. 164. Gauguin evidently used it as the basis for a subsequent transfer drawing (F 42).

9. Blair Collection, Chicago.

Gauguin announced around September or October 1892 to Monfreid, "I recently did a nude without using a model, two women at the edge of the sea, I think that it is still my best thing to date."[3] Not surprisingly, *Aha oe feii?* (What! Are You Jealous?) was among the eight paintings (cats. 127, 154) that he decided to send to France in late 1892 for the Copenhagen exhibition.[4] As he explained to his wife, Gauguin wanted his paintings listed in the catalogue with only their Tahitian titles, but for her information he translated the title for this painting as "What, are you jealous or envious?"[5] In this same letter he stressed that it was among three paintings for which he wanted the highest prices. The 800 francs minimum for *Aha oe feii?* was exceeded only by the 1,500 francs for *Manao tupapau* (cat. 154). But, when he auctioned off his works in February 1895 to raise funds to return to Tahiti, he received only 500 francs for *Aha oe feii?*

Aha oe feii? is one of five paintings (cats. 144, 152, W 462, W 464) of bathing women that Gauguin apparently undertook in the summer of 1892, a series based on the nude comparable to one that he had undertaken in 1889 (cats. 79, 80, 84). The pose of the seated figure in *Aha oe feii?* is based on a photograph that Gauguin owned of the frieze from the Theater of Dionysus in Athens.[6] Several drawings represented on a sketchbook page that Gauguin eventually pasted into his Noa Noa manuscript are based on details from this same photograph, and the watercolor of the woman kneeling on a *pareu* at the right of this page clearly prefigures the seated figure in *Aha oe feii?* wearing an identical crown of white flowers.[7] A second drawing by Gauguin, one of those found in the album that he entitled *Documents Tahiti 1891/1892/1893*, appears to record his transformation of the kneeling pose of the Greek figure into the more modest seated one that he

10. *Noa Noa*, Louvre ms, 196-199, treats the subject of jealousy among Tahitians.

11. Malingue 1949, CLXXII.

12. Delaroche 1894, 37.

Gauguin, drawing of hands and feet related to *Aha oe feii?*, pencil [Edward McCormick Blair, Chicago]

incorporated into his painting.[8] In a third drawing, Gauguin studied this same figure's hands and right foot.[9] He was so fond of this particular figure that he incorporated it, sometimes in reverse, into four later paintings (W 512, W 574, W 579, W 596) and a woodblock print (cat. 167).

No preparatory drawing exists for the reclining figure in *Aha oe feii?*, although one of the illustrations on a drawing that Gauguin presented to M. Marolles (cat. 142) shows a similar supine woman observed in abrupt perspective. Given the awkward proportions of the figure in the painting, however, and the awkward relationship of the figure to the setting, it seems that Gauguin fitted her into the composition at a relatively late stage. Unconcerned, he repeated these overlapped figures without modification in a watercolor-transfer version (cat. 208) of the composition executed when he returned to France. This setting also appears in the middle ground of another 1892 painting, *Haere pape* (W 464).

Despite Gauguin's interrogatory title, one of several he used for early Tahitian paintings (cat. 145, W 466, W 478, W 501), there seems to be no dialogue between these two figures, whose indolence hardly suggests hostile rivalry. Moreover, if jealousy is at issue, it is difficult to understand why the seated figure turns her eye to peer out of the picture, as if she were aware of an intruder.[10] Indeed, the title's question would seem to be addressed to the painting's eventual spectators, who might be envious of Gauguin's tropical lifestyle. Delaroche, the critic whose comments Gauguin would later endorse for their accuracy,[11] suggested in 1893 that the psychological tension inherent in *Aha oe feii?* was the result of the artist's understanding of the abstract language of color. "If he represents jealousy, it is with a fire of pinks and violets where all of nature would seem to participate like a conscious and tacit being."[12]

Whether or not Gauguin himself understood his use of color in such terms, it is the decorative opulence of the setting that distinguishes *Aha oe feii?* from his other early Tahitian paintings. The picture is a harmony in red tones orchestrated without regard for realism. And every form, from the outline of the beach to the trunk of the tree in the background, undulates like a piece of ribbon. The structure of reality dissolves in the rippling shapes of shadows and reflections on the surface of the water, an emblem for the reverie sustained by the Tahitian paradise.—C.F.S.

154
Manao tupapau

1. Danielsson 1975, 125.

2. These were cats. 127, 153, 154, W 420, W 431 or W 432, W 435 or W 472, W 436, W 437, W 439, W 483.

3. Letter to Daniel de Monfreid, 8 December 1892, Joly-Segalen 1950, VIII.

In December 1892, Gauguin sent nine of his most recent Tahiti canvases[1] back to France with Audoye, a gunner serving under Lieutenant Jénot.[2] The paintings were intended for the exhibition of the artist's works at the Frie Udstilling at Copenhagen, due to open in March of the following year. Once in France, they became the responsibility of Daniel de Monfreid, who was to ensure that they reached Copenhagen safely. It is clear that Gauguin attached greater value to *Manao tupapau* (*The Specter Watches over Her*) than to other works he sent to France in 1892 for inclusion in the exhibition in Copenhagen.[3] This work represents a brilliant resumé of all the formal and theoretical progress he had made since his arrival in the South Seas.[4]

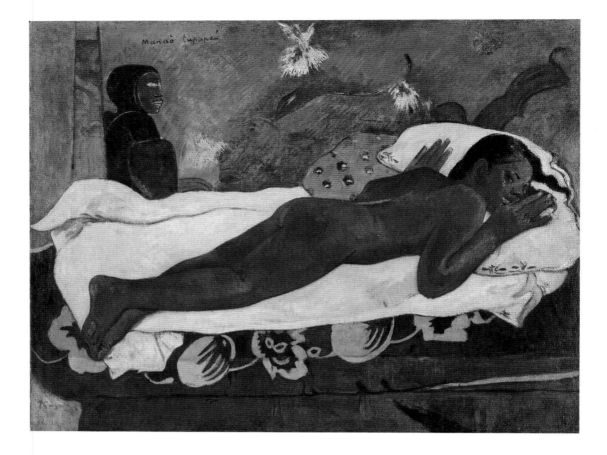

Manao tupapau

late 1892

73 x 92 (28½ x 35⅞)

oil on canvas

signed and dated at lower left, *P. Gauguin 92*;
inscribed at upper left, *Manaò tupapaù*

Albright-Knox Art Gallery, Buffalo,
A. Conger Goodyear Collection

EXHIBITIONS
Copenhagen, Udstilling 1893, no. 159; Paris,
Durand-Ruel 1893, no. 9; Brussels 1894, no.
191; Paris 1903, no. 32; London 1924, no. 47;
Chicago 1959, no. 41

CATALOGUE
W 457

In *Noa Noa* Gauguin related the original anecdote that gave him the idea for *Manao tupapau*:

"One day I was obliged to go to Papeete. I had promised to return that evening, but the carriage only took me half-way, so I had to do the rest on foot and I didn't get home till one o'clock in the morning. . . . When I opened the door. . . . I saw [her].

"Tehura lay motionless, naked, belly down on the bed: she stared up at me, her eyes wide with fear, and she seemed not to know who I was. For a moment I too felt a strange uncertainty. Tehura's dread was contagious: it seemed to me that a phosphorescent light poured from her staring eyes. I had never seen her so lovely; above all, I had never seen her beauty so moving. And, in the half-shadow, which no doubt seethed with dangerous apparitions and ambiguous shapes, I feared to make the slightest movement, in case the child should be terrified out of her mind. Did I know what she thought I was, in that instant? Perhaps she took me, with my anguished face, for one of those legendary demons or specters, the *Tupapaus* that filled the sleepless nights of her people."[5]

In the earlier draft of *Noa Noa* Gauguin began the story in the same way, but when he reached the description of Tehura the text changed to an outline of the *Manao tupapau* painting.[6] True or not, his memory of the event had at this stage already become one with the pictorial transcription.

Thus, according to Gauguin, *Manao tupapau* represents a memory, but it undoubtedly is also a Tahitian version of Manet's *Olympia*, which Gauguin had copied the year before at the Musée du Luxembourg (cat. 117).[7] Alfred Jarry, upon seeing it, made the visual connection, and transcribed these thoughts in the *Livre d'or* (Golden Book) of the Gloanec inn in 1 January 1894:

"Manao Tupapau/drowsy is the wall/and brown Olympia lies/on her couch of golden arabesques. . . ."[8]

Gauguin, *Noa Noa*, page 67 [Musée du Louvre, Paris, Département des Arts Graphiques]

Superville, *Allegory*, 1801, etching [Print Collection of the University of Leiden]

4. Gauguin explained the painting many times: in letters that he wrote to his wife (8 December 1892, Malingue 1949, CXXXIV) and to Monfreid (Joly-Segalen 1950, VIII) at the time he sent the canvas to France, he described its genesis. The next year, in 1893, he substantiated his theories in a chapter of the *Cahier pour Aline* accompanied by a watercolor sketch of *Manao tupapau* (Rewald 1958, no. 67). Finally, in his return to Paris, he discussed the painting further, in his *Noa Noa* manuscript.

5. *Noa Noa*, Louvre ms, 109–110.

6. *Noa Noa*, Getty ms, 20.

7. W 413.

8. Jarry 1972, 254–255.

9. Letter to Mette, Malingue 1949, CXXIV.

10. Giry 1970, 181–187.

11. Amishai-Maisels 1973, n. 15, identified the episode in *Mme Chrysanthème* (Paris, 1888). 257–258.

Gauguin thought the critics would set about Mette "with their malicious questions."[9] Recent writers have suggested two other possible sources for the painting: an engraving by the neo-classic Dutch painter Humbert de Superville representing a reclining youth, haunted by a specter with a death's head;[10] and a passage from the Pierre Loti novel *Mme Chrysanthème*, in which the heroine is described as tormented by night frights.[11] (We know that Gauguin had read this book.) But to ". . . those who always want to know the whys and wherefores,"[12] Gauguin, not without mockery, dedicated a chapter of his *Cahier pour Aline* entitled "The Genesis of a Painting." Here he developed the explanation he gave Mette in his letter of December 1892, offering a reading on two levels – one purely plastic, which he calls the "musical part"; the other, symbolic, "the literary part": "In this rather daring position, quite naked on a bed, what might a young Kanaka girl be doing? Preparing for love? This is indeed in her character, but it is indecent and I do not want that. Sleeping, after the act of love? But that is still indecent. The only possible thing is fear. What kind of fear? Certainly not the fear of Susannah surprised by the Elders. That does not happen in Oceania. The *tupapau* [spirit of the dead] is just the thing. . . . According to Tahitian beliefs, the title *Manao tupapau* has a double meaning . . . either she thinks of the ghost or the ghost thinks of her. To recapitulate: Musical part – undulating horizontal lines – harmonies in orange and blue linked by yellows and violets, from which they derive. The light and the greenish sparks. Literary part – the spirit of a living girl linked with the spirit of Death. Night and day. This [aforementioned] genesis is written for those who always have to know the whys and wherefores. Otherwise the picture is simply a study of a Polynesian nude."[13]

While Gauguin takes care to distinguish between the two ways in which *Manao tupapau* may be construed, the success of the painting resides in its incorporation within a single image of remembered experience: Tehura, or any other woman, surprised at night; a painter's eye – a painting of a nude and a symbolic intention, – "the spirit of a living girl, linked with the spirit of Death." The plastic vision came first, for Gauguin saw a naked girl lying on a bed, and was impressed by a surrounding mass of colors, including a yellow blanket, a blue *pareu*, and a violet background, which he invested with symbolic value. "In general, the harmony is somber and frightening, sounding on the eye like a funeral knell," he wrote to Mette.[14] This harmony is clearly intended to imbue the "literary part" of the painting with the fear of ghosts, while giving Gauguin an opportunity to strike at the core of Tahitian mythology, which he happened to be describing at that time in his manuscript *L'Ancien Culte Mahorie*. The belief in *tupapaus* is probably one of the rare survivals of the primitive Tahitian mentality that Gauguin experienced during his stay in Oceania. *Manao tupapau* was his way of penetrating that primordial strangeness and savagery. "In conclusion," he wrote to Mette, ". . . what is required is very simple painting, since the subject is so savage and childlike."[15]

Gauguin returned several times in *Noa Noa* to this idea: "The night is loud with demons, evil spirits, and spirits of the dead; also there are the Tupapaus, with pale lips and phosphorescent eyes, who loom in nightmares over the beds of young girls."[16] In the background of Gauguin's painting, the "flowers of the Tupapaus" represent the phosphorescent emanations of the spirits, but in reality, they are the *hotu* flowers that shine at night in Tahiti. Hence we should not look for the source of his Tupapau in primitive Maori art. The specter, in profile, with a frontal eye and the features of a "little woman," is dressed in a black shawl that closely resembles the working bonnets of the Le Pouldu peasant women (cat. 91 and W 304). The *tupapau* reappears full face, with the same phosphorescent flowers behind the Tahitian Eve, in *Parau na te varua ino* (cat. 147). The *tupapau* became part of Gauguin's pantheon, recurring often in paintings with diabolic and nocturnal themes: *Primitive Tales, Words of Terror, Still Life with Flowers and Idol;*[17] in his

12. *Cahier pour Aline*, Bibliothèque d'Art et d'Archeologie, Paris, Fondation Jacques Doucet, for facsimile see Damiron 1963.

13. Damiron 1963.

14. Malingue 1949, CXXXIV.

15. Malingue 1949, CXXXIV.

16. *Noa Noa*, Louvre ms, 15.

17. W 459, W 460, W 494.

18. Cachin 1968, 243.

19. Letter from Gauguin to Octave Maus [1894], Brussels, Musées Royaux des Beaux-Arts de Belgique, Contemporary Art Archives. Octave Maus documents, Van der Linden bequest, inv. 6854.

20. Letter from Camille Pissarro to his son Lucien, 23 November 1893, Danielsson 1975, 144.

21. Morice 1893a, 296.

22. W 420.

23. Roger–Marx 1894, 34.

24. Natanson 1893, 421.

25. Rotonchamp 1906, 134; minutes of the sale, no. 3.

26. Letter to Daniel de Monfreid, December 1896, Joly-Segalen 1950, XXVII.

27. Danielsson 1975, 304-305 n. 125.

28. Letter from Vollard to Daniel de Monfreid, 16 September 1901, Joly-Segalen 1950, 225.

woodcuts, cats. 176, 187, cat. 235, sketches, and monotypes, cats. 251, 274, and in a woodcarving, G107.

If one opts for a symbolist "literary" reading of the painting, then "the nude takes second place" and the *tupapau* becomes the principal subject of the painting. If one choses the "musical," purely plastic reading – and Gauguin himself seems to prefer this – the Tupapau is only "a decorative accessory."[18]

Gauguin sent this marvelously ambivalent painting to three great exhibitions of his works between the spring of 1893 and the winter of 1894 in Copenhagen, and at the *Libre Esthétique* at Brussels. At that time he fixed its value at 3,000 francs.[19] He also exhibited the painting at Durand-Ruel in November 1893 – an exhibition that proved a financial failure and unleashed the acrimony of numerous critics. Camille Pissarro himself accused Gauguin of "digging in other men's gardens" and of "pillaging the savages of Oceania"![20] Degas, however, confessed his admiration, and Charles Morice, who wrote the preface to the exhibition catalogue, was particularly prolix on *Manao tupapau* in the *Mercure de France*: "At the first glance, one is impressed by the technical mastery, glorious lines and colors, and sheer poetry of this painting. It is perhaps the greatest marvel of the exhibition. . . ."[21] Octave Mirbeau too published an equally enthusiastic review, while Roger Marx reproduced *Manao tupapau* along with *Vahine no te tiare*[22] in the "Revue Artistique" of the *Revue Encyclopedique*.[23]

"No doubt it matters little whether or not M. Gauguin had some real memory in mind when he created this woman; who, by herself, has earned the name "the Olympia of Tahiti," wrote Thadée Natanson in the *La revue blanche*,[24] echoing the sentiments Gauguin himself had expressed in his *Cahier pour Aline*. However, the general public remained stonily uncomprehending, and the painting met with a series of commercial failures and defaulting potential purchasers. At the auction of Gauguin's works before his final departure for Tahiti on 18 February 1895, he had to buy in *Manao tupapau*, along with most of his other paintings, for the sum of 900 francs.[25] He then turned it over to the dealer Lévy, from whom another dealer, Chaudet, attempted in vain to buy it in 1896.[26] The same year, Edmond Gérard, a young civil servant who later married Judith Molard (cat. 113), tried to instigate a petition to the inspector general of the Beaux-Arts to acquire *Manao tupapau* for the Musée du Luxembourg: "Today we are in a position to offer the State a van Gogh landscape and a painting by Gauguin which some consider to be his finest work: *La petite négresse couchée sur le ventre*, for 1050 francs."[27] This plan came to nothing, and in 1901 the picture was back with Vollard, who valued it at only between four and five hundred francs.[28]

Finally, after a spell at the Galerie Druet, the painting was acquired by Count Kessler of Weimar, a great art lover, a discriminating collector, and patron of the sculptors Rodin and Maillol, among others. As founder of the Cranach Press at Weimar, Kessler was responsible in 1906 for publishing the first monograph of Gauguin, by Jean de Rotonchamp.

The motif of *Manao tupapau* recurs in a fine pastel, which in turn generated two counterproofs (cat. 162 and F 12); it also emerges in an 1894 lithograph (Gu 50), and several woodcuts, some of which Gauguin included in the *Noa Noa* manuscript now in the Louvre (cat. 176). The title of *Manao tupapau* was given to another series of woodcuts of a different motif, in which a ghostly *tupapau* hovers in the background. Finally, in his *Self-portrait* of 1893-1894 (cat. 164), Gauguin poses in front of *Manao tupapau*; like *Nevermore* (cat. 222), which was painted five years later, the picture seems more than anything else to embody the oppressive, melancholy side of his Pacific existence.–C.F.-T.

155
Tahitian Pastorals

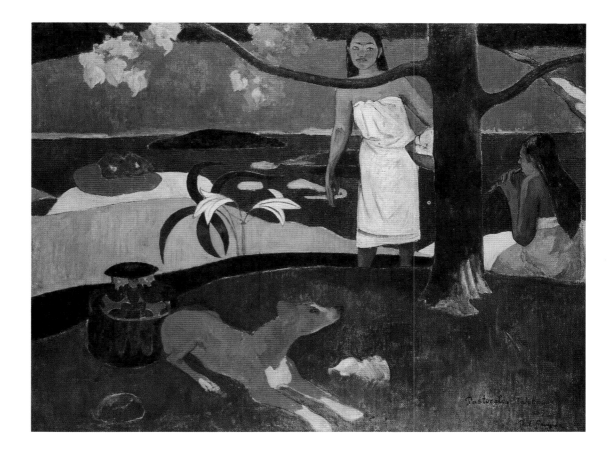

1892

87.5 x 113.7 (34⅛ x 44½)

oil on canvas

signed at lower left, in black, *Paul Gauguin.*; inscribed at lower left, *Pastorales Tahitiennes 1893.*

State Hermitage Museum, Leningrad

EXHIBITIONS
Paris, Durand-Ruel 1893, no. 3, *Pastorales tahitiennes*; Paris, Drouot 1895, no. 5, *Pastorales*; Moscow 1926, no. 10

CATALOGUES
Field 1977, no. 52; W 470; FM 308

On 8 December 1892 Gauguin wrote to inform Monfreid that he was sending eight paintings (including cats. 127, 153, 154) to him to forward to an exhibition in Copenhagen. At the same time he announced his hope to depart for France the following month.[1] But by the time Gauguin next wrote to Monfreid at the end of December, he had to revise his estimated date of departure until March at the earliest. In this letter Gauguin gave an account of three new paintings (cat. 155, W 467, W 468) evidently undertaken as a climax to his Tahitian campaign. "I have just finished three canvases, two size 30 and one size 50. I believe that they are my best, and since it will be the first of January in several days I have dated one, the best, 1893. Exceptionally, I gave it a French title: *Pastorales Tahitiennes*, not finding a corresponding title in the language of the South Seas. I don't know why—putting down pure Veronese green and pure vermilion—but it seems to me that it is an old Dutch painting—or an old tapestry—To what should that be attributed? Besides all my canvases appear dull in color: I think it has to do with no longer being able to see one of my old canvases or a painting from the school of the Fine Arts Academy as a point of departure or comparison. What a memory, I forget everything."[2] Of course, Gauguin's description here recalls his ambition around 1883 to make impressionist tapestries.[3]

The two smaller works in this little series show similar figures dressed in white in a similar setting, and a statue to the moon goddess Hina in the background of each indicates that they are imaginary representations of the pre-Euro-

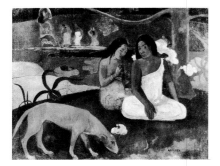

Gauguin, *Arearea* (*Amusement*), 1892, oil on canvas [Musée d'Orsay, Paris]

1. Joly-Segalen 1950, VIII.

2. Joly-Segalen 1950, IX.

3. Bailly-Herzberg 1980, no. 161.

4. *Noa Noa*, Louvre ms, 40-41.

5. Gerstein 1981, 11-12.

6. Tardieu 1895, 2.

7. The primitive figure on this vase is comparable to illustrations in Huyghe 1951, 10, 12.

8. Teilhet-Fisk 1985, 193 n. 11. Such a gourd from New Zealand, described as a receptacle for special foods such as birds and rats set in their own fat, is illustrated in T. Barrow, *An Illustrated Guide to Maori Art* (Auckland, 1984), 77.

9. Malingue 1949, CLXXII.

10. Delaroche 1894, 38. For a discussion of dogs as surrogate images for Gauguin see Gray 1963, 81.

11. Teilhet-Fisk 1985, 86, has suggested that she is carrying laundry.

12. It is worth noting that frangipani trees are common in Tahitian cemeteries. See Hermann and Celhay 1974, 121.

13. Thielska Gallieret, Stockholm.

14. The only other drawing related to this series shows the two women in W 468 (see Tokyo 1987, no. 102), probably a later study for a lithograph (Gu 87).

pean civilization in the South Seas. The Tahitian title that Gauguin inscribed on one of these, *Matamua*, is the equivalent of "Once Upon a Time." With its references to music and bucolic poetry, Gauguin's title for the Hermitage painting, the largest of the series of three, draws attention to the seated figure on the right who plays a Maori reed flute called a *vivo*. In *Noa Noa* Gauguin associated this instrument with the Tahitian night: "From my bed I made out in the filtered moonlight the rows of uniformly spaced reeds of my house. One has said [that it is like] a musical instrument, the pipe of the ancients, which the Tahitians call *vivo*. But this is an instrument that is silent during all the day: at night, in memory and thanks to the moon, it repeats the beloved airs. I fell asleep to this music."[4] Like *Arearea* in the same series, *Tahitian Pastorals* should perhaps be understood as a nocturnal scene illuminated by a full moon under the influence of Hina. A pair of yellow dots on a rock in the riverbed glows like eyes, and on the bank an amaryllis blooms. Curiously, in the two smaller pictures in the series, only their leaves remain. Moreover, only in *Tahitian Pastorals* does the frangipani or temple tree (probably Indian in origin), which appears in all three paintings, open its intense pink blossoms, and their fragrance may be what motivates the orange-red dog to sniff the air. This dog may be the one that was ridiculed at Gauguin's 1893 exhibition in Paris when all three pictures were placed on public view.[5] In 1895 when a newspaper interviewer asked Gauguin whether the dogs in his pictures were painted red on purpose, he replied: "Absolutely intentional! They are necessary, and everything in my work is calculated after long meditation. It's music, if you like! I obtain symphonies, harmonies that represent nothing absolutely real in the vulgar sense of the word, with arrangements of lines and colors given as a pretext by any subject whatsoever from life or nature. These do not express any idea directly, but should make one think the way music makes one think, without the help of ideas or images, simply by the mysterious affinities between our brains and such arrangements of colors and lines.[6]

In *Tahitian Pastorals* the dog lies with its rump against a vaselike object[7] identified by Teilhet-Fisk as a decorated Marquesan gourd.[8] Gauguin had already incorporated the same detail of a dog guarding a vase in the lower left corner of one of his most ambitious paintings of life in Brittany, *The Seaweed Gatherers*, and he repeated the detail again for one of his most ambitious woodblock prints (cats. 98, 185, 186). Although its meaning has never been explained, the critic Delaroche, whose review of the 1893 Paris exhibition greatly pleased Gauguin,[9] referred to the dog in *Tahitian Pastorals* as a heraldic genie of evil.[10]

Like the dog raising its head, the standing woman in *Tahitian Pastorals* appears to notice something outside the picture. Partly masked by the tree, the bowl that she holds[11] against her waist may contain gardenias, like the white blossom fallen on the ground near the dog. Since white is the color of mourning for Tahitians, this figure's dress may have some funereal significance.[12]

An uncharacteristically large watercolor, squared as if for transfer, clearly represents an earlier stage in the evolution of *Tahitian Pastorals*.[13] The tree does not mask the woman with a bowl in this magnificent watercolor; nor is the tree in blossom (although the amaryllis is). The dog is present, but not the gourd. In its place is an additional figure, edited out of the final oil version. This figure, one of Gauguin's many reprises of the foremost women in *Nafea faaipoipo* (see cat. 145), was perhaps included as a memory of the model Tehamana, who had apparently left Gauguin by December 1892 when he began work on this series of works.[14]

Tahitian Pastorals is one of the paintings in identical decoratively banded frames that is visible on the wall behind a group of his colleagues with musical instruments in a photograph taken in Gauguin's rue Vercingétorix studio in 1894.–c.f.s.

156
Otahi

1893

50 x 73 (19½ x 28½)

oil on coarse canvas

signed at lower left, in light gray, *P. Gauguin 93*; inscribed at lower left, in dark gray, *Otahi*

private collection

EXHIBITIONS
Paris, Durand-Ruel 1893, no. 17, *Otahi (Seule)*; Paris, Drouot 1895, no. 17, *Otahi*; Brussels 1904, no. 52, *Otahi*; Paris 1906, no. 192, *Femme de Tahiti*; Paris, Orangerie 1949, no. 36; Paris 1960, no. 177

CATALOGUES
Field 1977, no. 58; W 502

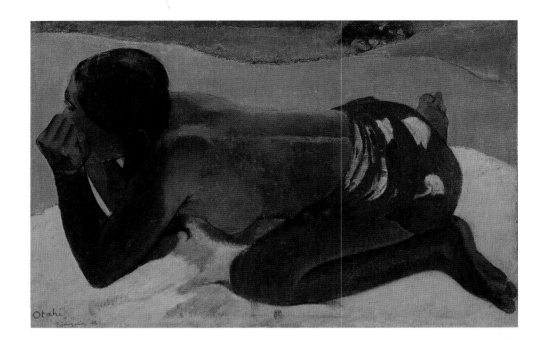

1. Perhaps developed from a sketch of a crouching woman holding her head (cat. 149), this watercolor was the basis for a monotype (F 73), and the same figure reappears in a woodblock print (cat. 232) and a late relief panel (G 122).

2. See also W 499 and W 462.

3. Duranty 1946, 42; for Gauguin's images of backs, see W 215, W 241, W 336, F 133; and Cachin 1968, 245-246.

4. Gauguin paid homage to Degas in a lengthy essay in *Avant et après*, facsimile, 72-75.

5. Lemoisne 1946-1949, no. 746.

6. Lemoisne 1946-1949, no. 1008; Roskill 1970, 144, discusses this page of studies after Degas' nude compositions in Gauguin's *Album Briant*, Louvre.

7. For Japanese prototypes for the pose of this figure, see Wichmann 1980, 45; and le Pichon 1986, 176.

8. Dortu 1971, no. P. 649.

Gauguin based *Otahi* (Alone) on a little watercolor "note" (P 78) taken from a model the previous year.[1] In both works the woman wears the same red *pareu* with a white floral pattern that appears in earlier paintings (cats. 130, 135), but in the sketch she kneels to play with a pig or a little dog, subsequently omitted from the oil version. Gauguin's composition in *Otahi*, with its minimal setting as decorative foil for a figure observed from close up, is related to earlier works (cat. 130) in which figures without any distinct context or motivation resemble details cropped from conventional nineteenth-century narrative paintings.

Gauguin's title makes little sense, since the model's pose is not especially characteristic of solitude, and her expression is similarly unrevealing. Nor does Gauguin's treatment of color express mood. Instead, the undulating bands of unmodulated colors that compose the landscape setting seem purely decorative, interacting with one another and the red of the woman's *pareu* as adjacent primaries and complementaries. With its exclusively decorative character, this painting is among the most modern of Gauguin's early Tahitian works, prefiguring the art-for-art's-sake attitude that became prevalent at the outset of our own century.

Foremost a painting of a model's back, *Otahi* should be related to several other works by Gauguin (cat. 144)[2] that attempt to answer the challenge that obsessed early French realists including Degas, for whom the careful observation of the back of a figure, according to Duranty's formulation of this important notion, could be potentially as revelatory of personality, status, and social history as a conventional frontal pose.[3] Indeed, *Otahi* is among several works by Gauguin (cats. 127, 144) that can be understood as gestures of admiration for Degas' art.[4] Whereas the watercolor sketch from which Gauguin derived *Otahi* recalls a play-

Degas, *Naked Woman on Her Knees*, charcoal and pastel [private collection]

ful encounter between model and dog in one of Degas' reworked monotypes,[5] the isolated figure in the oil version is ultimately a variation on a pastel by Degas that Gauguin had copied in a quick notebook sketch around 1888.[6] For this pastel Degas posed his model arbitrarily on her knees, extending her body forward to rest her arms and head on the floor so that her elbows, breasts, and buttocks took a decorative pattern of intersecting arabesques, devoid of narrative significance.[7] The white sheet upon which the woman in the painting poses suggests that Gauguin wanted to stress her role as a model, since no Tahitian would use such a sheet on the beach.

This same decorative pose also appealed to Toulouse-Lautrec, whose own variation, executed around 1897,[8] may have been influenced in turn by *Otahi*, which was on public view in Paris in 1893 and again in 1895 in the auction that Gauguin organized to raise funds to return to Tahiti.-C.F.S.

157
Pape Moe

Gauguin, *Pape Moe*, carved and painted oak [location unknown]

1. *Noa Noa*, Louvre ms, 87-88.

2. *Noa Noa*, Louvre ms, 15-16.

3. Field 1960, 165; and Field 1977, 291 nn. 49, 51.

4. Danielsson 1975, 127.

Pape Moe (Mysterious Water) is distinguished by a tapestrylike richness of color evocative of a fantasy world. It is at once among the most beautiful, and the silliest, of Gauguin's early Tahitian paintings. In *Noa Noa*, he explained how, during the course of a hike into the interior forests of Tahiti, he suddenly came upon a naked woman drinking and washing herself at a waterfall.[1] Although Gauguin tried to keep quiet, she sensed his presence and dived into the stream to disappear—that is, unless she was transformed into an eel. In his collaborator's role, Morice prepared another version of the same incident for *Noa Noa*, with several variations: the woman, dressed in purple, has come to drink in the forest as a ritual return to the savage state. Thus she fulfills Gauguin's own quest to attain a pure, primitive mentality.[2]

In the painting, however, the woman is neither naked nor dressed in purple, but wears a white skirt with a yellow pattern printed on it. Since none of Gauguin's letters refers to this solitary trip into the mountains, when or if it took place is unknown. The painting was made in 1893 as Gauguin readied himself to return to France. It is based closely on a photograph of a Tahitian man drinking from a waterfall in a grotto.[3] The photographer, Charles Spitz, had helped to prepare the Tahitian section of the Paris World's Fair of 1889.[4] Since the account in *Noa Noa* of the pilgrimage to reach interior waterfalls is so closely related to a chapter in *Le Mariage de Loti*, 1880, it has been suggested that Gauguin may well have plagiarized.[5]

Described as "mysterious" in Gauguin's title, the water in this picture issues from a rock that appears to be inhabited by a spirit. As Field pointed out, the Tahitian woman, poised to drink, looks up to encounter the apparition of a fish

1893

99 x 75

oil on canvas

signed at lower right, in dark blue,
P. Gauguin 93

inscribed at lower right, in dark blue, *PAPE
MOE*

private collection

EXHIBITIONS
Paris, Durand-Ruel 1893, no. 4, *Pape moe
(Eau mystérieuse)*; Paris, Drouot 1895, no. 9,
Pape moe

CATALOGUES
Field 1977, no. 54; W 498; FM 309

shown in Paris only

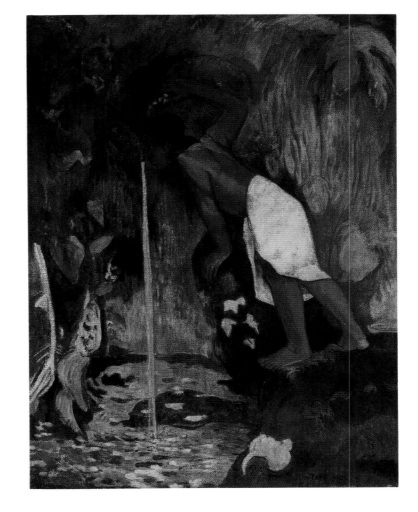

Vegetation in the South Seas, photograph
[Charles Spitz, *Autour du monde*, c. 1899,
pl. CCXLI]

5. Loti 1879, chapter XIX; see Maurer 1985,
1005-1007.

6. Field 1977, 190.

7. Joly-Segalen 1950, V.

8. Field 1977, 192, 291 n. 53.

9. Danielsson 1975, 127.

10. W 499; this parallel is discussed by Field
1977, 189; Andersen 1971, 215, and Maurer
1985, 1008-1009.

11. *Noa Noa*, Louvre ms. 88.

12. *Noa Noa*, Louvre ms, 92; see Field 1960,
166.

13. G 107.

head among the dark, wet rocks.[6] Gauguin, in surrealist fashion, often "saw" images in inanimate objects, including the knots in boards;[7] analogous animal faces appear in several other early Tahitian pictures (see cats. 147, 148).

While Field proposed that the fish might be a symbol for the mythical migration of the island of Tahiti or for Christ,[8] Danielsson interprets the "mysterious" in the title as a reference to the flood of light in Polynesian legend that revives the moon goddess, Hina.[9] His hypothesis cannot be dismissed, considering the parallels between *Pape Moe* and another 1893 painting, *Hina tefatou*.[10]

Corresponding in several details more closely to the *Noa Noa* account than does *Pape Moe*, *Hina tefatou* depicts a naked woman who beholds an apparition of a male head in the grotto wall. This represents the genie Fatu, who here refuses the plea of his mother, Hina, to grant immortality to mankind (see cat. 140). A badly damaged watercolor, dated 1894, proves that Gauguin himself was conscious of a connection between the two paintings, since it shows the figure from *Pape Moe* in conjunction with an apparition of the Hina and Fatu dialogue, their figures silhouetted against a white disc. Since, in *Noa Noa*, immediately following the *Pape Moe* episode, Gauguin describes a vision of Hina and Fatu in the moon,[11] this watercolor may have been made as an illustration for his text. If so, Gauguin eventually produced a different illustration for the same passage (R 52), including an image of an eel. In any case, for the illustration that Gauguin eventually incorporated into his own manuscript of *Noa Noa*, he used a seated figure next to a waterfall.[12] The relationship between *Pape Moe* and an undated sculpted wood relief of the same motif[13] has never been studied.—C.F.S.

158
Merahi metua no Tehamana[1]

1893

76 x 52 (29⅝ x 20¼)

oil on coarse canvas

signed and dated at bottom center, in dark blue, *P. Gauguin - 93*; inscribed at lower left, in blue, *MERAHI METUA NO/ TEHAMANA*

The Art Institute of Chicago, anonymous gift

EXHIBITIONS
Paris, Durand-Ruel 1893, no. 33, *Metua rahi no Tehamana (Les Aïeux de Tehamana)*; Paris, Drouot 1895, no. 32, *Metua rahi no Tehamana*, withdrawn; Béziers 1901, no. 53; Chicago 1959, no. 51; New York 1984-1985, no. 33

CATALOGUES
Field 1970, no. 56; W 497; FM 307

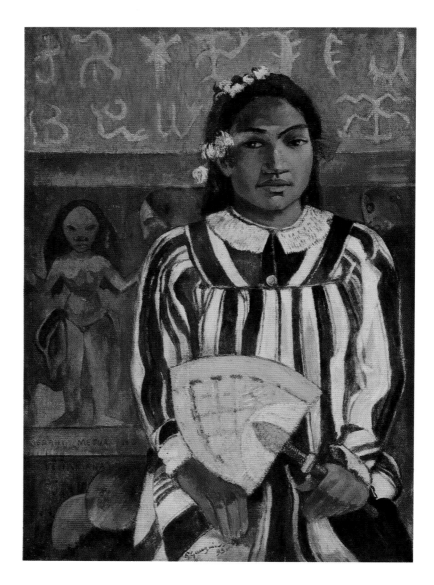

1. See Danielsson 1967, 231, no. 32.

2. Danielsson 1975, 126.

3. Field 1977, 331, no. 56.

4. Danielsson 1965, 135; Amishai-Maisels 1985, 216. Two native women hold similar fans in a photograph which Gauguin pasted into *Noa Noa*, Louvre ms, 55.

This stately portrait, *Merahi metua no Tehamana (Tehamana Has Many Parents)*,[1] has been considered a farewell, since it was evidently painted during the last months before Gauguin's return to France.[2] The fact that this painting, although listed in the catalogue of his 1895 auction, was not put up for bids on the day of the sale suggests that it may have had some special sentimental importance for the artist.[3] Wearing her finest European-style missionary dress, her hair elaborately decorated with flowers, Tehamana holds a plaited palm fan as if it were the scepter of a queen. Indeed, the exotic queens that Gauguin represented in other works (cats. 215, 248, G 74) carry similar fans, which have been interpreted as symbols of beauty.[4] With these props Gauguin intended to characterize Tehamana as a hybrid of East, West, past, and present. The two ripe mangoes next to her, as if placed on a low table, or *fata*, probably symbolize the bounty of Tahiti if not the fertility of the womb.

Her face, haunted by green shadows as if Gauguin wanted to suggest that her bronze skin had the patina of a statue, was based on a charcoal drawing of

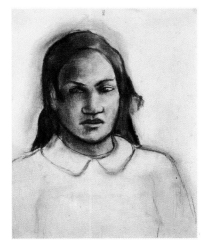

Portrait of Tehamana, see cat. 124.

5. Teilhet-Fisk 1985, 88.

6. *Noa Noa*, Louvre ms, 103-104.

7. See also W 561, Gu 42-43, P 83.

8. *Noa Noa*, Louvre ms, 129-131; for the Hina myth see 137, 145, and 147; as well as Huyghe 1951, *Ancien Culte Mahorie*, 9-11, 32-33; and the Huyghe postscripts.

9. Amishai-Maisels 1985, 374.

10. Amishai-Maisels 1985, 373.

11. Gray 1963, 68-69.

12. Gray 1963, 69 n. 20; Teilhet-Fisk 1985, 88; Danielsson 1975, 127.

Tehamana (R 95 verso). Taken together with the unreasonably short proportions of her arms in the painting, this preliminary drawing suggests that *Merahi metua no Tehamana* may not have been painted directly from the model.

The title refers both to the Tahitian custom of sharing children between real and foster parents and to the belief that all Tahitians descended from the union of the ancient deities Hina and Taaroa.[5] In *Noa Noa*, Gauguin described how he was baffled during his courtship of Tehamana by the fact that two different women referred to themselves as her mother.[6] A polychromed idol of the goddess Hina (cats. 139, 205, 227, 246) appears in a frieze in the background of this portrait. What seems to be a red flower in the idol's hair may stress her relationship to Tehamana, to whom Gauguin credited much of his knowledge of Tahitian mythology.[8]

This imaginary idol, probably based on a Hindu sculpture with a life-giving gesture,[9] appeared for the first time in Gauguin's art in 1892 in a group of related works (cat. 147) about the evil spirits in Tahitian superstitions. In one of these paintings, *Parau hanohano* (*Frightening Talk*, W 460), a winged head hovers at the upraised left hand of the idol. Identical heads visible behind Tehamana's shoulders hover near the idol in *Merahi metua no Tehamana*.[10] The earlier painting's title suggests that this detail signifies a dialogue between good and evil or between life and death.

In the uppermost zone of *Merahi metua no Tehamana*, Gauguin transcribed two rows of large decorative glyphs of the sort known from small tablets found in Easter Island. These indecipherable glyphs, the only form of writing to survive from ancient Polynesian culture, were of great interest after their discovery in 1864, and examples were included in the 1889 Exposition Universelle in Paris.[11] Bishop Jausson, associated with the Catholic mission in Papeete during Gauguin's first stay in Tahiti, had a number of examples in his care and wrote a book about his attempts to decode them.[12] Presumably the artist was familiar with Jausson's tablets, but even so the characters that Gauguin included in *Merahi metua no Tehamana* and on one of his cylinder sculptures (G 125) do not correspond to any known example of this lost language. Gauguin, who was intrigued with linguistics and even saw dried pandanus leaves as letters of a lost alphabet (cat. 183), evidently included glyphs in this portrait to suggest that the Tahitian mentality, rooted in a distant past, is unfathomable for Europeans. This sense of mystery, captured in Tehamana's Mona Lisa-like expression, was for Gauguin the ultimate source of her beauty.–C.F.S.

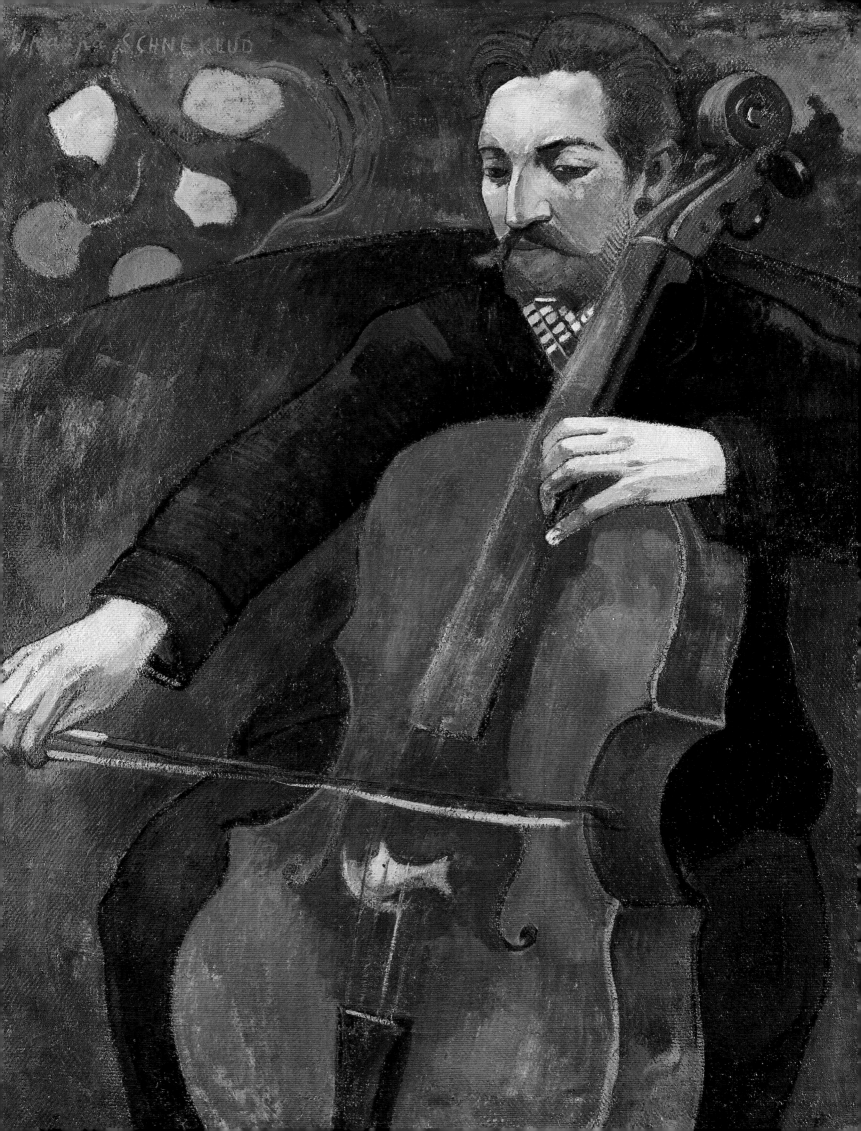

Chronology: August 1893–June 1895

GLORIA GROOM

1893

AUGUST 30

Arrives in Marseilles with four francs in his pocket (Danielsson 1975, 136).

AUGUST 31

Receives 250 francs from Paul Sérusier, wired to him by Monfreid (Sérusier 1950, 204). Takes train to Paris.

SEPTEMBER

Rents a room, 8 rue de la Grande Chaumière, from Mme. Caron, owner of a small restaurant and *crémerie* known as "Chez Charlotte." Alphonse Mucha offers Gauguin use of his studio in the same building (Danielsson 1975, 139; Mucha 1967, 53-57).

Fig. 66. *Madame Charlotte's "crémerie" with decorative painting by Mucha (left) and Slewinski (right)*, c. 1900 [The Royal Library, Stockholm. The Carlheim-Gyllensköld Collection]

SEPTEMBER 3-4

Goes to Orléans for the funeral of his Uncle Isadore (Zizi) (Joly-Segalen 1950, XV).

SEPTEMBER 10

Entreats Mette to come to Paris with their son Pola (Malingue 1949, CXL).

SEPTEMBER 12-15

Returns to Orléans to attend the reading of his uncle's will (Chassé 1921, 60). Inherits half the money from the estate; the other half goes to his sister (Danielsson 1975, 300 n72).

MID-SEPTEMBER?

Convinces the dealer Paul Durand-Ruel to hold a one-man show of his work (Malingue 1949, CXXXVIII; Joly-Segalen 1950, XVI) and asks Mette to send the Tahitian paintings in her possession as soon as possible (Malingue 1949, CXLI).

SEPTEMBER-OCTOBER

Stretches, retouches, and places in simple white frames forty to fifty canvases for the Durand-Ruel exhibition (Rippl-Ronaï 1957, 55). A Gauguin self-portrait and his portrait of Louis Roy (W 317bis) are included in the *Portraits du prochain siècle* exhibition at Le Barc de Boutteville gallery (Mauclair 1893, 119).

MID-OCTOBER?

Begins a book intended to "facilitate the understanding" of his Tahitian works (Malingue 1949, CXLIII).

OCTOBER-NOVEMBER

The fifth exhibition of modern art at Le Barc de Boutteville gallery includes Gauguin's *Copy of Manet's Olympia* (cat. 117). Gauguin gives Morice two manuscripts, *Ancien Culte Mahorie* and the first draft of *Noa Noa* (see Wadley 1985, 85-87). Gauguin agrees to pay for the invitations, posters, and catalogue for his upcoming exhibition totaling 237.25 francs (DR, *Journal*, 1893-1898, 41).

Fig. 67. Carrière, *Portrait of Charles Morice* 1892-1893 [present whereabouts unknown (Rewald 1962, 486)]

NOVEMBER 8?

Offers to donate his painting *Ia Orana Maria* (cat. 135) to the Musée du Luxembourg but it is refused (Vollard 1937, 197).

NOVEMBER 10

Public opening at Durand-Ruel's follows a private viewing of the previous day. The exhibi-

tion consists of forty-one paintings from Tahiti, three from Brittany, one ceramic, and *tii*s, or wood sculptures. Prices range from 1,000 to 4,000 francs (see priced catalogue, *Vente de tableaux de Paul Gauguin*, Metropolitan Museum of Art Library).

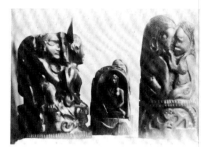

Fig. 68. *Three wooden sculptures, probably among the "Tiis" exhibited at the Durand-Ruel gallery in November 1893* [photo by Georges Chaudet, c. 1894, courtesy of Musée Gauguin, Papeari]

NOVEMBER 11
"Têtes de bois," a group of symbolist painters and writers, hold a dinner in Gauguin's honor (*Journal des Arts*, November 19, 1893, 370).

NOVEMBER 25
Gauguin's exhibition closes with only eleven paintings sold. Degas, who had been instrumental in the exhibition's organization, purchases *Hina Tefatou* (W 499) and *Te Faaturuma* (cat. 127). In appreciation, Gauguin gives him a carved cane from the exhibition (Morice 1919, 27). Press coverage during and after the show ranges from the enthusiastic remarks of Thadée Natanson in *La Revue Blanche* (Natanson 1893) to the caustic criticism of Olivier Merson in *Le Monde illustré* (Merson 1893). Although the exhibition was a financial disappointment, Gauguin considers the publicity a positive sign: "The most important thing is that my exhibition has had a very great artistic success, has even provoked passion and jealousy. The press has treated me as it has never yet treated anybody, that is to say, rationally, with words of praise" (Malingue 1949, CXLV). Gauguin pasted several of these critical reviews into the *Cahier pour Aline* (see Damiron 1963).

DECEMBER
Ambroise Vollard opens a new gallery at 6 rue Laffitte with impressionist paintings, including

early paintings by Gauguin (Pissarro 1950, 325). Gauguin writes to Mette that he cannot take time out from his book *Noa Noa* to come to Denmark (Malingue 1949, CXLV).

DECEMBER 14
Premier of Ibsen's *An Enemy of the People* at the Théâtre de l'Oeuvre. Morice proclaims Ibsen's drama and Gauguin's November exhibition as the two most significant cultural events of the year (Morice 1893a).

LATE DECEMBER
Gauguin receives first letter from his children in Denmark. Responds immediately (Malingue 1949, CXLVI).

1894

EARLY JANUARY?
Rents two large rooms on the top floor of 6 rue Vercingétorix and paints the walls chrome yellow (Joly-Segalen 1950, CXLVII). Covers the walls from floor to ceiling with his own paintings and others in his collection by Cézanne and van Gogh (Vollard 1937, 196). Meets his neighbors, William Molard, a composer, and his wife, Ida Ericson, a sculptor, as well as their daughter Judith Molard (unpub. trans., 3; see Gérard 1951). Takes in Annah la Javanaise, a thirteen-year-old native of Ceylon, whom he met through Vollard (Vollard 1937, 195-196).

Fig. 69. *Courtyard apartment at 6 rue Vercingétorix* [Carley 1975, 96]

Fig. 70. *William Molard*, c. 1894 [Danielsson Archives, Papeete]

JANUARY
A flattering article on Gauguin, one much admired by the artist, is published by Achille Delaroche in the symbolist journal, *L'Ermitage* (Delaroche 1894). Gauguin's article on van Gogh, "Natures mortes," is published in *Essais d'art libre* (Gauguin, 1894a).

JANUARY 11
Hosts his first in a series of Thursday receptions, for a coterie of painters, writers, and musicians, where he occasionally reads from *Noa Noa* (Loize 1951, 19, and Rotonchamp 1906, 129). Occasionally attends Mallarmé's Tuesday night gatherings throughout the next year (Chassé 1947, 69).

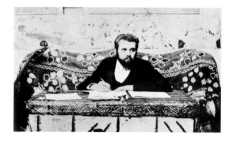

Fig. 71. *Gauguin's studio at 6 rue Vercingétorix. Seated: Fritz Schnedklud (center) and the musician Larrivel (right). Back row: Paul Sérusier, Annah la Javanaise, Georges Lacombe* [Musée Gauguin, Papeari]

FEBRUARY 5
Asks Mette to convince her brother-in-law, Edvard Brandès, to retrieve the Cézanne painting formerly in his collection, *Zola's House at Médan* (Venturi 1936, 325), by offering him several of his own paintings (Malingue 1949, CXLVIII). During this month, Jénot visits from Tahiti (Jénot 1956, 125).

FEBRUARY 15

Roger-Marx's illustrated review of the Durand-Ruel exhibition appears in *Revue Encyclopédique* (Roger-Marx 1894).

FEBRUARY 17

Attends the opening of the first exhibition of *La Libre Esthétique* in Brussels which contains five of his paintings (W 436, W 499 and cats. 144, 147, 154). Writes to Brandès in the hopes of buying back all the Pissarros and Cézannes which had been sold to him by Mette (Bodelsen 1968, 55-57). Brandès refuses (Malingue 1949, CIL).

Fig. 72. *Gauguin's letter to Octave Maus, director of La Libre Esthétique, listing the titles and prices of his five paintings to be exhibited* [Berton. Maus Archives, Musées Royaux des Beaux Arts, Brussels]

FEBRUARY 18-22

Visits museums in Brussels, Antwerp, and Bruges with Julien Leclercq. Gauguin's review of the Brussels exhibition appears in *Essais d'art libre* (Gauguin 1894b, 30). Sends 1,500 of his 13,000-franc inheritance to Mette (Loize 1951, 19, no. 69).

FEBRUARY-MARCH

Carves ten woodcuts from boxwood to illustrate *Noa Noa*. Prints them in his bedroom with some assistance from Flouquet, an engraver living on the same block (Danielsson 1965, 156).

MARCH 2

Opening of the sixth exhibition of modern art at Le Barc de Boutteville gallery. Gauguin con-

tributes *Nave Nave Moe* (W 512) and an unidentified "nude study" entitled *Taurna*.

MARCH 29

Writes to Theo van Gogh's widow, asking that she send him the paintings by Vincent that belong to him (Cooper 1983, 331-333).

MARCH-APRIL?

Juliette Huret, Gauguin's former model and mistress, insults Annah and leaves Gauguin for the last time (Rotonchamp 1906, 125-126). Works with the artist-engraver Louis Roy on the printing of twenty-five to thirty impressions of the *Noa Noa* woodcuts (Field 1968, 507; Kornfeld 1988, 14.C).

Fig. 73. *Noa Noa* (cat. 170) [The Art Institute of Chicago. Department of Prints and Drawings]

APRIL 7

Attends artists' dinner of the "Têtes de bois" *(Journal des Artistes*, 15 April 1894, 543).

APRIL 26

Attends opening of the Salon for the Société des Beaux Arts with, among others, Morice, Leclercq, Annah, and Judith (unpub. trans., 9; see Gérard 1951).

APRIL 27

Death of Charles Laval, Gauguin's painting companion who had accompanied him to Panama and Martinique in 1887 (Walter 1978, 290 n. 18).

END APRIL?

Gauguin leaves Paris for Brittany with Annah and her monkey (Danielsson 1975, 162-163). Julien Leclercq moves into Gauguin's apartment (Malingue 1949, CL).

EARLY MAY

Lodges briefly with the painter Wladyslaw Slewinski and his wife in their villa at Le Pouldu. Goes to Pont-Aven where he stays at the Hôtel Ajoncs d'Or, now run by Marie Jeanne Gloanec (Chassé 1921, 60-61). Learns that Marie Henry, the innkeeper at Le Pouldu and Meyer de Haan's mistress, refuses to return the paintings and sculptures that he left in her keeping during his trip to Tahiti (Chassé 1955, 89-90). Gauguin's article, "Sous deux latitudes," is published in *Essais d'art libre* (Gauguin 1894c).

MAY 25

A visit to Concarneau (near Le Pouldu) with the painters Armand Séguin, Emile Jourdan, and Roderic O'Conor and their girlfriends, ends disastrously when the group is assaulted by local sailors. Gauguin, whose leg is fractured above the ankle, is hospitalized briefly and incapacitated for the next two months (Malingue 1949, CL). Throughout the summer, takes morphine and alcohol for the pain and is unable to paint. Works on watercolor transfers and woodcuts (Loize 1966, 270-271).

Fig. 74. *Watercolor monotype pasted on inside cover of Noa Noa* [Musée du Louvre, Département des Arts Graphiques, Paris]

JUNE 2

Auction at the Hôtel Drouot of "Père" Tanguy's collection of paintings, organized by Octave Mirbeau to benefit Tanguy's widow. The six works included by Gauguin sell for very small sums (see priced catalogue, *Catalogue des tableaux . . . au profit de Mme Vve Tanguy*, Bibliothèque d'art et d'archèologie, Paris).

JUNE 11

Publication of the first volume of *Portraits du prochain siècle* (see reprint ed., Paris: L'Arche du livre, 1970). Gauguin's name is listed as "portraiteur (author)" for van Gogh. Gauguin's own "portrait" is to be undertaken by the writer Jean Dolent for the second volume, which never appeared (*Essais d'art libre*, vol. 5, 1894, 71–72).

END JUNE

The writer Alfred Jarry stays with Gauguin at the Gloanec inn in Pont-Aven. Jarry writes three poems dedicated to Gauguin and inspired by three of his paintings from the November Durand-Ruel exhibition (Jarry 1972, 2). Writes to Morice's wife, urging her to see that her husband finishes his section of the *Noa Noa* manuscript (Malingue 1949, CLXIX).

AUGUST-SEPTEMBER

Annah leaves Brittany for Paris. Eventually pillages Gauguin's apartment, leaving only his paintings (unpub. trans., 21; see Gérard 1951).

Fig. 75. *Photo of Annah la Javanaise, c. 1898, taken by Alphonse Mucha, whose model she became after 1895* [Jiri Mucha Collection. Danielsson 1965, 125]

AUGUST 23

Travels twenty-five miles to Quimper to attend the trial of his assailants at Concarneau. They are fined only 600 francs (Malingue 1949, CLII).

SEPTEMBER

Writes to Molard and Monfreid about his plans to return to the South Seas (Malingue 1949, CLII; Joly-Segalen 1950, XIX, redated by Loize 1951, 20).

NOVEMBER 14

Loses his suit against Marie Henry and returns to Paris immediately (Malingue 1959, 34-35).

NOVEMBER 18

Gauguin's letter to the director of *Journal des Artistes* about a fictitious visit to an artist's studio, presumably his own, is published (Gauguin 1894d).

NOVEMBER 22

Morice, Roger-Marx, Gustave Geffroy, and Arsène Alexandre organize a banquet in Gauguin's honor at the Café des Variétés (le Pichon 1986, 185).

DECEMBER 2

First day of a week-long exhibition in Gauguin's studio of his woodcuts, watercolor transfers, wood sculptures, and Tahitian paintings (Morice 1894 and Leclercq 1895).

DECEMBER 7

At a "Têtes de bois" dinner at the Café Escoffier, announces his intention to return to Tahiti: "Paul Gauguin had to choose between the savages here or the ones over there; without a moment's hesitation, he will leave for Tahiti" (*Journal des Artistes*, 16 December 1894, 862).

DECEMBER 13

Dressed in his astrakhan hat and a long robe, Gauguin attends the premier performance of Strindberg's *Father* at the Nouveau Théâtre (Sprinchorn 1968, 50).

Fig. 76. *Program for Père (The Father) by Félix Vallotton*, [Mauner 1978, 35]

MID-LATE DECEMBER?

Works on the large stoneware sculpture *Oviri* (cat. 211) in Ernest Chaplet's studio

(Danielsson 1975, 174) and the clay *Masque de Sauvage* (cat. 210; Bodelsen 1967, 221).

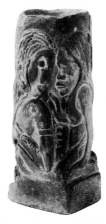

Fig. 77. *Square Vase with Tahitian Gods* (G 115), *probably executed in Chaplet's studio*, stoneware, 1893-1895 [Museum of Decorative Art, Copenhagen]

1895

JANUARY 16

Offers Paul Durand-Ruel thirty-five canvases at 600 francs each (typed transcript of letter from Gauguin, dated 16 January 1895, DR).

JANUARY 31

Invites Strindberg to his Thursday evening gathering and asks him to write a preface for the catalogue of his upcoming sale (Sprinchorn 1968, 62).

FEBRUARY

Strindberg, who has moved across the street from Mme Caron's *crémerie*, joins the circle of writers, painters, and musicians that frequent

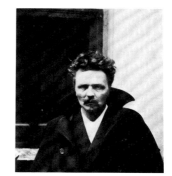

Fig. 78. *Strindberg*, c. 1893 [Strindberg 1981, 101]

6 rue Vercingétorix (Sprinchorn 1968, 131-132). Opening of Armand Séguin's exhibition at Le Barc de Boutteville gallery, with a catalogue preface by Gauguin, which is published also in the *Mercure de France* (Gauguin 1895a). His drawing of *Ia Orana Maria* is reproduced, together with prints by other artists in *L'Epreuve-Album d'Art* (March 4 1895, no. 62).

FEBRUARY 15

Gauguin sends Strindberg's letter of refusal and his open letter in response, to be published in *L'Eclair* as publicity for his upcoming sale (Strindberg 1895).

Fig. 79. *Gauguin's drawing after Puvis de Chavannes' "Hope" accompanied by a poem by Charles Morice, 1894. Published in Mercure de France, February 1895* [present whereabouts unknown (Rewald 1962, 459)]

FEBRUARY 16

Private showing at the Hôtel Drouot for Gauguin's auction (Loize 1951, 24).

FEBRUARY 17

Public opening for the February 18 sale (Paris, Drouot 1895).

FEBRUARY 18

The afternoon public auction at Drouot is poorly attended. Only nine paintings sell out of forty-seven works of art . Degas purchases two paintings, *Vahine no te vi* (cat. 143), *Copie de l'Olympia* (cat. 117), and six drawings (see *procès-verbal*, reprinted in Paris, Orangerie 1949). The sale realized 2,200 francs (*Journal des artistes*, 24 February 1895, 940), but 830 francs of that represented works bought back by Gauguin under various names (Loize 1951, 24), leaving only 464.80 francs for Gauguin after expenses (Malingue 1949, CLVIII). De-

cides to postpone trip to Tahiti and writes to Monfreid that he has caught "an unfortunate disease" (Loize 1951, 25).

Fig. 80. *Fatata te miti (cat. 152), one of several paintings bought back in by Gauguin at the February auction* [National Gallery of Art, Washington. The Chester Dale Collection]

MARCH

Exhibition at Vollard's gallery of several landscapes and a ceramic from Gauguin's Brittany period (Mauclair 1895, 358).

APRIL 23

Gauguin's open letter protesting the inauguration of a new kiln at Sèvres is published in *Le Soir* (Gauguin, 1895c).

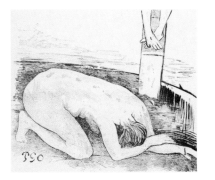

Fig. 81. *Gauguin's watercolor monotype The Penitent Magdalen reprinted as a woodcut La Madeleine* [in Alfred Jarry's deluxe art magazine *L'Ymagier 3*, (April 1895), 142]

APRIL 25

Opening of the salon of the Société Nationale des Beaux-Arts. Gauguin submits his stoneware statue *Oviri* (cat. 211), allegedly rejected from the show at first (Morice 1896, 9) but put back in when the ceramist Chaplet threatened to withdraw his works in protest (Vollard 1936, 201).

MAY 1

Gauguin's editorial protesting the selection of artists for the invitational *Exhibition of French Art* in Berlin is published in *Le Soir* (Gauguin 1895d).

MAY 13

An interview with Gauguin is published in *L'Echo de Paris* (Tardieu 1895), and is satirized by Camille Mauclair, art critic for *Mercure de France* (Mauclair 1895, 359).

LATE JUNE

Gauguin gives Morice his manuscript for *Ancien Culte Mahorie* (Loize 1966, 74-75, 80, and 126) and gives Molard special power of attorney for the publication of *Noa Noa* (Malingue 1949, CLXVII). Leaves unsold paintings with the young artist Georges Chaudet and the dealer Lévy, who agree to act as his agents while he is away (letter to Bauchy from Gauguin, *Les Arts*, 28 March 1947, 1).

JUNE 26

A final reception for Gauguin is held in his apartment by the Molards and the sculptor Paco Durrio (unpub. trans., 26; see Gérard 1951).

Fig. 82. Judith Gérard, *Portrait of Gauguin* etching [Carley 1975, 46]

JUNE 28

Le Soir publishes Morice's article championing Gauguin's decision to return to Tahiti (Morice 1895). The Molards and Paco Durrio accompany Gauguin to the station where he boards the train for Marseilles (unpub. trans., 30; see Gérard 1951).

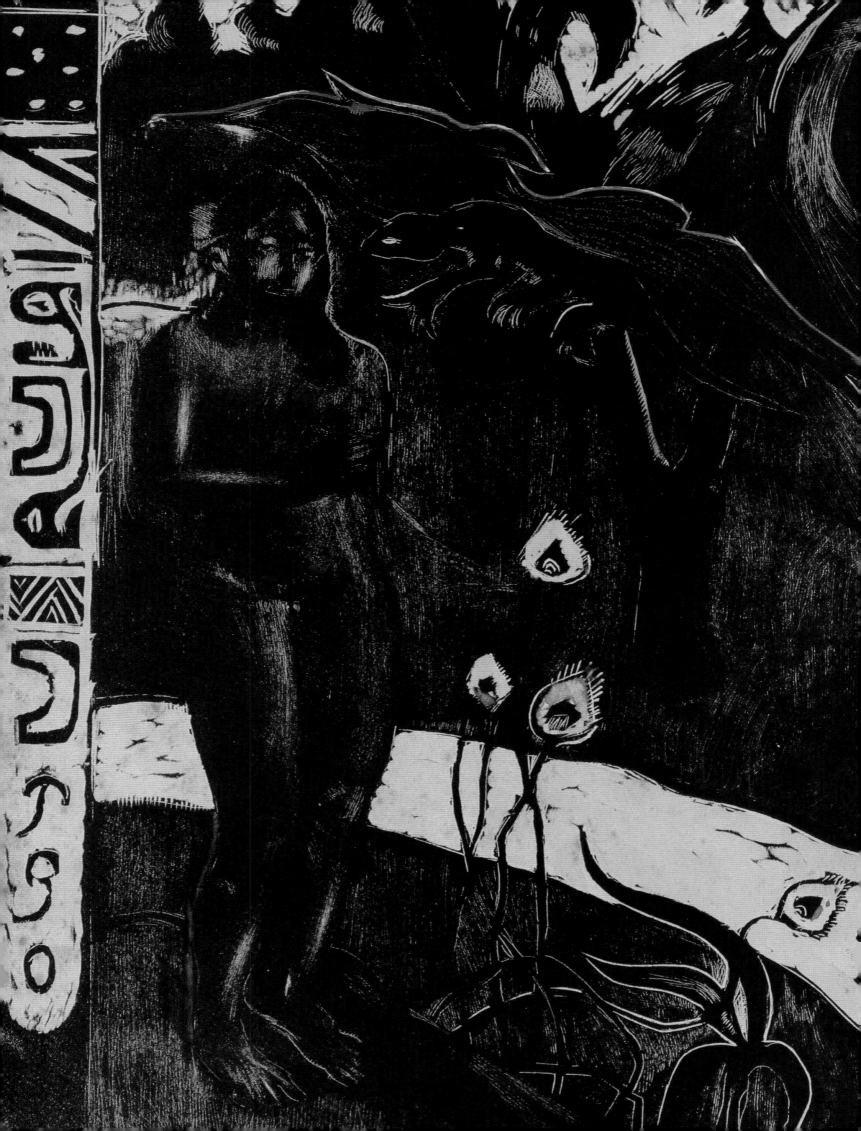

The Return to France

RICHARD BRETTELL

1. Salon d'Automne, Paris, Oct.-Nov. 1906.

2. See chronology, 1893.

3. See for example, the 1987 film, directed by Henning Carlsen, *The Wolf at the Door*, covering the Paris period, and based on the memories of Judith Gérard (see Gérard 1951).

No major exhibition of Gauguin's work has come to terms with his production as an artist and writer in the period 1893-1895. The first great retrospective of 1906[1] contained the best selection, including a good many woodcuts, watercolors, and color transfer drawings, as well as at least two paintings; but the greatest paintings were missing, and the works on paper were so scattered that their collective importance seems not to have been recognized by the critics. Gauguin's paintings had almost all been removed from the white, yellow, or dark blue frames that he had favored in 1893 and 1894, when he supervised the selection and installation of his last two exhibitions. Only three small notebooks, and no manuscripts, were included. Of the subsequent important retrospectives, none has approached even that of 1906 in the coverage of this short, but intensely productive, period, and this is surely because Gauguin's work during those years has been persistently misunderstood.

During his first Tahitian period, Gauguin was primarily a painter. His production was large, even by the standards of the prolific impressionists who taught him, and he seems to have worked hard to create a body of easel pictures that would provide him with fame and financial security when he returned to Europe. Yet, when he did arrive in Marseilles on 30 August 1893, he had almost no money,[2] few of his former friends had kept in touch with him, and his eventual rise to the position of notoriety he would occupy when he returned to Tahiti twenty-two months later was an exercise in energetic self-promotion. Gauguin became a salesman rather more than a painter during this short, intense period in France.

Because he spent most of those twenty-two months in Paris, then the publicity and information capital of the world, we know a good deal more about his life during this short period than we do about his long years in the South Seas. His exact movements between Marseilles and Paris can be traced, his various addresses pinpointed, his trips to Orléans and Belgium marked on maps, his friendships listed, his financial affairs dissected, and his dinner parties reconstructed. We know the name of his mistress and what she looked like. We know more about his exotic, if temporary, studio on the rue Vercingétorix than about any of his Tahitian houses. We often know what he ate for dinner, with whom he talked, and, in certain cases, what he said.[3]

All this knowledge about his life – and this is but a list that could stretch for nearly one hundred pages – has done a good deal to overshadow Gauguin's work during the period. Most biographers concede that he made very little of real consequence during those years because he was so busy arranging exhibitions and sales, supervising and clipping reviews, and attempting to publish his memoirs in the form of a book or even a series of books.

Yet, when we realize that "art" is not coequal with "easel painting," the real fullness and brilliance of Gauguin's achievement during this period can be recognized. Aside from nine paintings dated 1894 and seven or eight that might have been made in those twenty-two months, most of Gauguin's work during this period was in literature and the graphic arts. He spent a good deal of time during the last months of 1893 writing the draft for his book *Noa Noa*, and, in the year following his initial completion of the manuscript, made at least three separate groups of illustrations for that text in various mediums. It is also probable that he worked to assemble from earlier notes the superbly beautiful manuscript entitled

Ancien Culte Mahorie and that he finished copying and illustrating the intentionally disparate texts in another manuscript entitled *Cahier pour Aline* during this Paris period.

The latter books have almost always been dated to 1892 or 1893 before his return to France. However, there is no evidence that Gauguin wanted to create illustrated books or manuscripts before his Paris period. That his circle of friends during these years in Paris was almost exclusively a literary one makes it easier for us to assume that the texts were produced with and for these friends. This period of writing and illustrating books in the company of other writers initiated Gauguin's preoccupation with texts, which ended only shortly before his death in 1903. During that ten-year period he produced a group of manuscripts, some of which survive, while others have been lost. Collectively, these form the largest and most important body of texts, illustrated and otherwise, produced by any great artist in France since Gauguin's hero, Delacroix, whose *Journals* Gauguin devoured.[4] Only the letters of van Gogh, the vast majority of which were unpublished during Gauguin's lifetime, can compete in length and sheer intellectual range with the literary achievements of Gauguin. In a certain sense, Gauguin's ambitions were greater than those of his friend van Gogh, because he wrote a good many of the texts expressly for publication.

Unfortunately, these texts have not been fully integrated into the literature about Gauguin. The vast majority of art historical writing about his oeuvre either ignores the texts or uses them when convenient to interpret images. The many biographers of Gauguin have skirted the texts because they are so dense, rambling in construction, and apparently confused. What is worse for the study of Gauguin is that even literary historians have ignored the texts. *Noa Noa* is scarcely read in any of its various versions, and both the *Cahier pour Aline* and the *Ancien Culte Mahorie* have appeared in luxurious facsimile editions rather than as transcribed, edited texts.

Obviously, this is unfair to Gauguin. The artist was also the writer and, in certain senses, the journalist, and all these vocations intertwine to create a total portrait of Gauguin. That he has always been treated as a businessman-turned-artist rather than an artist-turned-writer shows the extent to which his literary achievement has been undervalued. In a sense, this was Gauguin's own fault. He was inexperienced in the world of publishing, and trusting his literary affairs to Charles Morice was not a particularly wise decision. Morice had enough trouble making a living from his own texts, and, while he did try sincerely to help Gauguin realize his dream of being a published writer, he probably did more to set back the cause than to aid it. Gauguin himself, by producing essentially unreproducible manuscripts with various forms of illustration integrated with the texts, did little to make it easy for future literary historians. Perhaps the only blessing in the unfortunate history of Gauguin's texts is that his handwriting was, and is, clearly legible!

When analyzing Gauguin's oeuvre of the Paris period, one must confront several basic problems with the paintings. The greatest of them, *Aita tamari vahine Judith te parari* (cat. 160) is unsigned and undated and seems never to have been exhibited in Gauguin's lifetime. Three other paintings of Tahitian subjects in Leningrad, Copenhagen,[5] and Chicago (cat. 205) are dated 1894, but only one of

4. Delacroix's *Journal* was published in 1893-1895 in Paris.

5. W 512, *Nave nave moe*, State Hermitage Museum, Leningrad; W 514, *Arearea no varua ino*, Ny Carlsberg Glyptotek, Copenhagen.

6. Paris, Le Barc de Boutteville 1894, no. 66.

7. *Self-portrait with Palette* could be a possible addition (cat. 159).

8. Danielsson 1967, 233.

9. See Gérard 1951, unpub. French trans., 26.

10. See cat. 150.

11. Hoog 1987, 231.

12. W 525, *Village in the Snow*, Musée d'Orsay, Paris.

13. Alexandre 1930, 251-252; see also Jénot 1956, 123, who gives a partial inventory of the things he took on his second trip to Tahitit.

these, *Nave nave moe*, was exhibited in Paris.[6] Gauguin never really explained whether they were simply finished in France after having been started earlier in Tahiti or whether they belonged to a period of reinterpretation of Tahiti in France. The only one of these paintings in the exhibition, *Mahana no atua* (cat. 205), can easily be interpreted in the latter context, but the other two might well have been begun in Tahiti and finished in France.

Of pictures with undeniably French subjects, only three portraits have been placed within the catalogue raisonné, those of William Molard (cat. 164, verso), *Aita tamari vahine Judith te parari* (cat. 160), and the cellist Schneklud (cat. 165). To these must be added a fourth, an untitled and undated picture currently catalogued as a painting of 1901 and entitled *The Guitar Player* (W 611, private collection).[7] This is perhaps a portrait of Gauguin's friend, the sculptor Francisco (Paco) Durrio, of whom he also made a drawing while Durrio was dressed as a Tahitian. With the exception of the portrait of Molard, these works attempt to create an aesthetic bridge between Europe and Polynesian experience. Durrio, a Spaniard, is dressed as a Tahitian; a half-caste girl is placed in a Chinese export chair with figures carved in its arm; and a Swedish cellist is given an apparent first name in Gauguin's inscription on the painting which is, in Tahitian, to dance or to play,[8] a word also associated with a sexually provocative female dance.[9]

Gauguin also made several paintings in Pont-Aven during this period. The reason for his return to his former home has never been explained. As he stayed at the same inn in Pont-Aven, this suggests that he was interested in reliving or reexperiencing his past. But the pictures he painted in Brittany lack the conviction that is so evident in his Tahitian paintings and even in the few paintings made in Paris. Indeed, only one of the pictures presumed to have been painted in Brittany is included in this exhibition (cat. 190), mostly because it transcends in quality and complexity his securely dated landscapes from 1894, when he revisited that hallowed place.[10]

The most problematic pictures that have been traditionally dated 1894 are the three representations of winter in Brittany. The most recent analyst of Gauguin's oeuvre admits that it is inconceivable that these pictures were painted from nature because there was no snow during the summer and autumn months when Gauguin was in Brittany.[11] Therefore, the paintings were made either in Brittany, where Gauguin "imagined" the snow, or at a later date. One of them was found in Gauguin's studio in the Marquesas at his death and purchased by Victor Segalen.[12] Arsène Alexandre, Gauguin's biographer, says that he took two Brittany winter scenes back to Tahiti with him.[13] Unfortunately, there is absolutely no real evidence that the three pictures were painted in France at all, and Rotonchamp, Gauguin's earliest biographer, provides no proof that Gauguin took any of them back with him. Indeed, it is equally plausible that the paintings were made considerably later, as late as 1900, when Gauguin sent one of them back to Vollard from Tahiti, and that they have more to do with the late paintings and prints and with Gauguin's memories than they do with the work of Gauguin's years in France.

Besides *Aita tamari vahine Judith te parari* (cat. 160), Gauguin's greatest prints and his masterpiece in sculpture also date from this period of return and renewal. The prints are the large woodcuts intended for *Noa Noa* and printed by

Gauguin himself in the winter and spring of 1893-1894. Certain other woodcuts of comparable quality were made by Gauguin slightly later in Pont-Aven. These later prints have been omitted from the exhibition not because they are of inferior quality, but in recognition of the fact that the ten *Noa Noa* woodcuts constitute a work of art of greater collective power than any of the single prints. The ceramic sculpture *Oviri* (cat. 211) has been included here for the first time since the major Gauguin exhibition of 1906. It was created under the supervision of the ceramist Ernest Chaplet, and has recently entered the collection of the Musée d'Orsay. Gauguin made a group of highly experimental prints in connection with the ceramic, two impressions that he double-mounted and gave to the symbolist poet Mallarmé.[14] It is therefore no surprise to learn that Mallarmé led a subscription drive to buy the sculpture for the French nation, a drive that has only recently succeeded.[15]

Perhaps the most important achievements of Gauguin's period of return to France were his two exhibitions, the first at Durand-Ruel Galleries in November 1893 and the second a semi-private opening of his own studio in December 1894.[16] He worked with equal intensity to make each exhibition a success, but surely the comparative failure of the first exhibition in a commercial gallery led him to favor the studio opening that he could completely control.

Unfortunately, Gauguin had little time to organize the exhibition of his recent Tahitian work at Durand-Ruel's gallery. During a period of two months at most, he had to touch up or finish and perhaps even sign, date, and inscribe fifty paintings, make plans for an ambitious catalogue with a preface by Charles Morice, frame all the paintings, and arrange for publicity. By October, he was aware that most people found the work incomprehensible. This was made all the more difficult because Gauguin refused to translate his Tahitian inscribed titles![17] He therefore began to expend much-needed energy in the preparation of a travel book or text that could aid the viewer in his quest for an interpretation of these exotic canvases. Needless to say, there was not enough time to complete both the book and the exhibition and, perhaps for that reason, Gauguin was less than pleased with the exhibition's success.

Yet, we must not be too hasty to treat it as a failure. Michel Hoog's recent account of its comparative success in his monograph on Gauguin is perhaps the most balanced view of the matter in print.[18] Gauguin himself kept a sort of "press book" in the *Cahier pour Aline*, and, from the evidence of it alone, Gauguin fared rather well. His cohorts gave him glowing reviews,[19] and one critic who used the pseudonym Fabien Veilliard wrote a particularly splendid article in the manner of Mallarmé.[20] While it is true that the sales barely covered Gauguin's expenses, a great many important people saw the exhibition and took it seriously. Of the impressionists, Monet, Renoir, and Pissarro rejected Gauguin's new art, but Degas embraced it utterly. Not only did he buy several important paintings by Gauguin during the Paris period, but he also did a good deal of private promotion for the younger artist.

On the literary side, Gauguin fared even better, gaining the support of another circle of young poets and writers that included Jean Dolent and the man who would become, as Danielsson has stated, "the shadow of Gauguin," Julien Leclercq.[21] The exhibition seen by these two eminent avant-gardists and their

14. *Oviri*, Gu 48, The Art Institute of Chicago acc. nos. 47.686.1 and 47.686.2; printed in black and ocher.

15. See cat. 211. Letter from Morice to Mallarmé, 1895, cited in Mondor 1982, vol. 7, 161-162.

16. See chronology, 2-9 December 1894.

17. Malingue 1949, CXXXIV.

18. Hoog 1987, 209-213.

19. Mirbeau 1893; Cardon 1893; Natanson 1893; Geffroy 1893a and b; Fénéon 1893; Morice 1893a.

20. Vielliard 1893.

21. Danielsson 1975, 152. Leclercq not only wrote an article on the occasion of Gauguin's December atelier exhibition in 1894 (see Leclercq 1895), but he had defended Gauguin against the tirade of the younger artist and art critic for the *Mercure*, Camille Mauclair (see Leclercq 1894b).

22. Rippl–Rónai 1957, 55. Also in Genthon 1958, 21. According to Rónai, after the exhibition at Durand-Ruel, Gauguin painted the frames yellow, for he attributed the failure of the exhibition to the white frames.

23. Fénéon 1893.

24. *Diverses Choses* in *Noa Noa*, Louvre ms, 155-156.

25. Rotonchamp 1906, 123.

26. Gauguin's first decorating effort, the inn of Marie Henri at Le Pouldu, could only be considered a collaborative one, a far cry from the artist's environment he had created on the rue Vercingétorix.

27. See note 22.

28. See Gérard 1951, unpub. French trans., 21.

29. Morice 1894, 2; Leclercq 1895.

30. Gauguin 1894d.

friends was startling. The catalogue lists forty-four paintings, all but three of which had been painted in Tahiti. Most of the paintings were framed in white, in a manner that had become standard for exhibitions of avant-garde painting by the late 1880s.[22] Two sculptures were also listed, and it is probable that other paintings were added to the exhibition during the installation process. Unfortunately, Gauguin had no control of the wall color, about which he was rather particular. Most critics regarded the paintings as decorative, although *La Revue Anarchiste*[23] said that they had a "barbaric, opulent, and taciturn character." As always, Gauguin's work inspired literary characterizations that abound in apparent contradictions. Gauguin mildly satirized these when he wrote his own review of the critics in the unpublished manuscript, *Diverses Choses*. In this text, he reveled in the critics' ignorance, paying particular attention to the fact that they found fault with his perspective and the almost surreal intensity of his colors.[24] Yet, as was often the case with Gauguin, he exaggerated both the strength and the stupidity of his detractors and overlooked the brilliant criticism of the many literate admirers who attempted interpretation of his difficult work.

Shortly after the completion of the Durand-Ruel exhibition, Gauguin began to decorate a fabulous studio in a large room in the rue Vercingétorix. The unsold paintings from the exhibition as well as his sculpture, his current work, and the ethnographic collection of his uncle Zizi were placed in an extraordinary space painted olive green and brilliant chrome yellow and lit with innumerable windows, one of which he painted with *Te faruru*.[25] In this environment furnished with flea-market exotica, Gauguin received guests at regular Thursday soirées, lectured about his method, told stories about his exotic travels, and played a good deal of music on his various instruments. In fact, the "Studio of the South Seas," as one might easily call it, was among the very greatest decors ever designed by Gauguin.[26] We know something about it from the descriptions of Vollard, Rippl-Rónai, Mucha, Monfreid, Gérard, and many others, and several photographs, probably made by Gauguin himself, survive. Unfortunately, none of the visual evidence is as evocative as the verbal descriptions. Corners of paintings in the photographs make it clear that he had scrapped his white frames for simple banded frames in varied hues, perhaps blue and yellow, and both the photographs and the accounts suggest that there was a casual mélange of works of art on the wall rather than a carefully designed, symmetrical hanging.[27] There were also many wood carvings and pieces of carved furniture, little of which survived the looting of Annah la Javanaise, Gauguin's mistress during his stay in Paris.[28]

By December 1894, Gauguin had created an elaborate enough environment to announce a private opening in at least two periodicals. There were short reviews by his friends Julien Leclercq and Charles Morice,[29] and a good many people from the circles of Mallarmé, Alfred Vallette, Vollard, and Degas must have come. Gauguin himself wrote an article in which he recommended that Parisians could learn more about art by visiting the studios of artists than by going to the commercial galleries.[30] The particular studio he discussed belonged to an unnamed young artist, but the descriptions of it tally well with those of Gauguin's own studio, and it seems clear that he wanted to make use of his own studio as a place of business, where his works of art could be not only viewed to their best advantage, but explained sympathetically by their maker and his friends.

Of the contents of Gauguin's studio at the time of the showing we know only a little. Of course, there were the unsold paintings from the Durand-Ruel exhibition, but both Leclercq and Morice stressed his more recent woodcuts and watercolor monotypes in their short reviews. These were mounted on mottled blue paper similar to that used in many artists' portfolios, and Gauguin could hold them up, pass them around, lay them on a table or sofa, or tack them to the wall or even to the frames of the paintings. All of these works were shown with the artist himself present in a situation that is far different from that of a commercial gallery. Unfortunately for the artist's financial health, this approach yielded results no better than the gallery system, and it, too, was abandoned as a sales strategy.

If the "Studio of the South Seas" was Gauguin's greatest total work of art created during the Paris period, the men and women who populated it were scarcely less interesting than the works of art on the walls, floors, and tables. Whatever his success with the two eminent avant-gardists, Degas and Mallarmé, it was primarily with a younger circle that Gauguin allied himself. Indeed, Gauguin persisted in surrounding himself with young male admirers as well as teenage mistresses throughout the rest of his life, and his best friends in Paris during the return voyage were generally almost a generation younger than Gauguin himself.[31] The youth cult was Gauguin's metier, and he tried – and almost succeeded – in keeping pace with the mad young men and women who made up the various circles of the avant-garde in Paris. Even a casual perusal of the chronology for this period in Gauguin's life will reveal list after list of names – contributors to causes, attendees at dinner parties, traveling companions, and friends. They range in nationality from Swedish to Rumanian and in fame from Durrio to Strindberg. In the end, these people both exhausted him and failed him.[32] He returned to the South Seas as much to escape the pressure cooker of Paris as to have time to create the major paintings in what was to be the last decade of his life. For these, he will never be forgotten. Had he stayed in Paris, trying until his death to publish and promote his art, the history of Western art would have been the poorer.

31. For example, Francesco "Paco" Durrio, Julien Leclercq, P. Napoléon Roinard, Charles Morice, Paul Ranson, Stadilas Slewinski, Armand Séguin, Fritz Schneklud, and according to Le Pichon 1987, the Brittany painters Maxime Maufra and Paul Sérusier and the sculptor Georges Lacombe.

32. With the exception of a few, that is. These early contacts with a multinational set did increase his notoriety, and the composer Frederick Delius, one of Molard's friends, purchased *Nevermore*; and Paco Durrio wanted to purchase *Where Do We Come from?* (W 561). Ironically, the same group (Morice, Delius, Durrio, Maufra, Leclercq) have all written accounts of those important months in Gauguin's *atelier* or at the *crémerie* of Mme Charlotte.

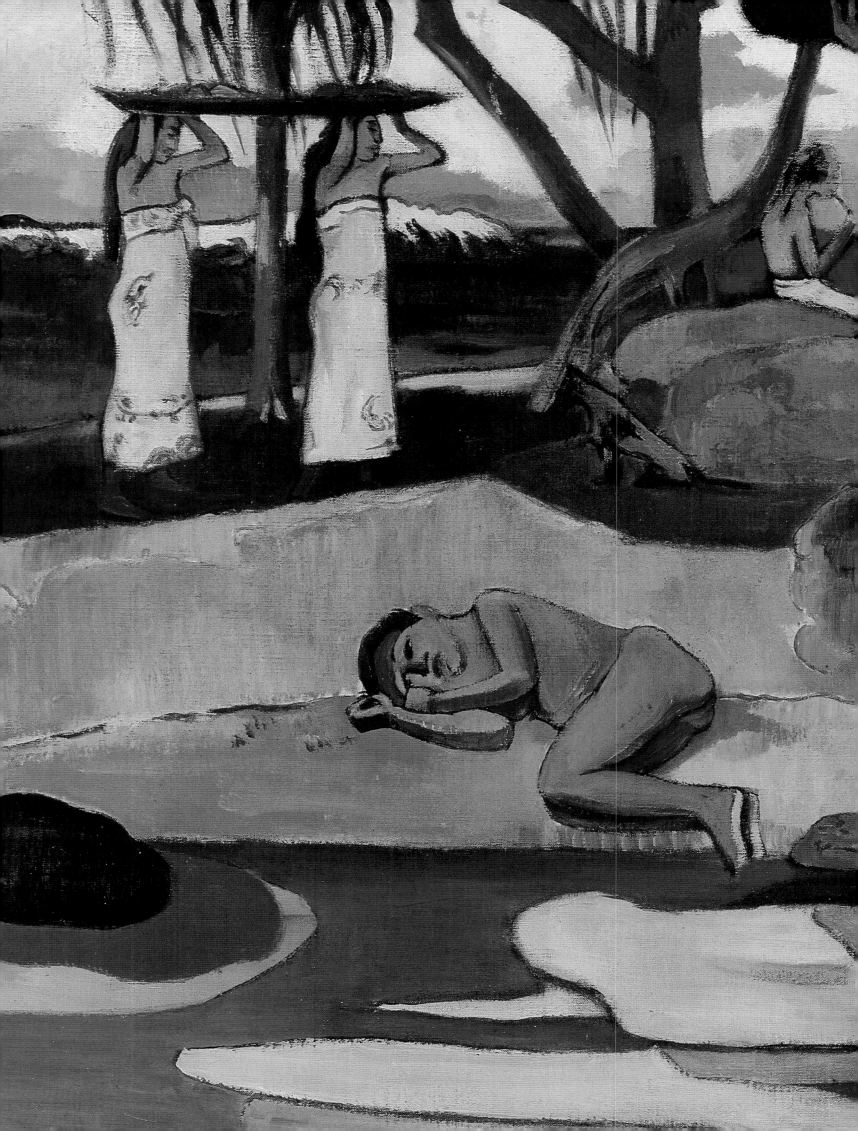

159
Self-portrait with Palette

c. 1894

92 x 73 (35⅞ x 28½)

oil on canvas

signed and dedicated at upper right,
A Ch. Morice de son/ami P.Go.

private collection

EXHIBITIONS
Paris 1906, no. 2; Paris, Orangerie 1949,
no. 41; Chicago 1959, no. 56

CATALOGUE
W 410 (incorrectly dated and sized)

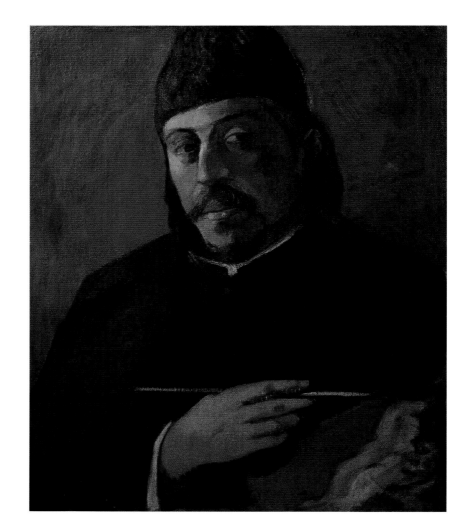

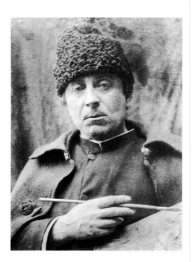

The Artist with His Palette, photograph
[Musée d'Orsay, Paris, Service de Documen-
tation]

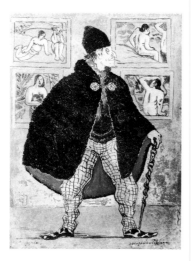

Manzana-Pissarro, *Gauguin at His Exhibi-
tion*, caricature [private collection]

On two occasions only did Gauguin represent himself at work with the traditional
tools of his art, the brush and palette. In the first of these self-portraits, which is
touching and slightly clumsy, we see the Gauguin of 1885 (W 138) with his easel,
chair, and paintbrush, looking furtive and oppressed by his Copenhagen garrett.
In *Self-portrait with Palette*, c. 1894, we see how far he has come since then. All
the painter's attributes have been eliminated except the palette with his Tahiti
colors – yellow, pink, and red. This detail, and the dedication to Charles Morice
(with whom Gauguin was in constant contact throughout his stay in Paris), suggest
that the picture was painted not in 1891, but in the winter of 1893-1894, or even in
1894-1895. Gauguin spent both winters in the French capital, and the scene de-
picted is clearly a cold-weather one. Most Paris ateliers were poorly heated, which
would explain the heavy outdoor clothes the painter is wearing. Armand Séguin
described Gauguin at this time, with ". . . his astrakhan hat and his huge dark blue
overcoat buttoned with a precious buckle, in which he looked to the Parisians like
a sumptuous, gigantic Magyar, or like Rembrandt in 1635."[1] This description of the
artist's appearance is borne out in a caricature by Camille Pissarro's son Manzana-
Pissarro, based on sketches of Gauguin taken from life at the Tahiti exhibition
in 1893.

1. Séguin 1903a, 160; note that Séguin did not meet Gauguin until 1894.

2. Malingue 1944, 17.

3. See Jirat-Wasiutynski 1978, 356-357.

4. Aurier 1891.

5. For an excellent analysis of Gauguin's collaboration with Morice on *Noa Noa*, see Wadley 1985, 100-107.

6. Gauguin and Morice *Noa Noa*, 1897.

7. Morice 1919.

Maurice Malingue published a photograph from the Schuffenecker archives that is usually accepted as the basis for *Self-portrait with Hat* (cat. 164).[2] This photograph, taken in 1888, shows Gauguin in an identical pose, with an astrakhan hat. Yet the hat in the painting is smaller, as though made of velvet. Also, the face is heavier, softer, and older (is this because in the photograph the man has short hair and no mustache?). The eyes, too, are dissimilar, and Gauguin's costume is less flamboyant; for example, the big buckles have been eliminated in the painting. The artist's eyes and hand have been emphasized, as is proper in a painter seeking to affirm his identity. The hand is strange, yellowish, and one-dimensional, as if encased in a glove. Was Gauguin thinking of Titian when he did this painting? The intention is clearly to produce a traditional portrait of a modern Rigaud or Largillière, invested with the authority of a master within a certain milieu[3] at a certain point in time. The sidelong glance, the whitish blue of the eyes, the red background, the horizontal brush that accentuates the lines of the face, and the perfection of technical simplicity all lend character and power to a composition that is otherwise thoroughly conventional.

The flat, red background behind the silhouette has not been chosen at random; it echoes that of another self-portrait (cat. 92). There is also an apparently deliberate allusion to *The Vision after the Sermon* (cat. 50), which had become the manifesto of the symbolist movement following the publication of Albert Aurier's article "Le Symbolisme en peinture."[4] Since Gauguin had just returned to Paris after a long absence, he included this reference to remind the world that he was still the master.

Because the signature and dedication of this self-portrait were added at the same time, we have good reason to conclude that the work was undertaken as a gift for Charles Morice, in gratitude for Morice's unfailing praise. Charles Morice (1860-1919) was a young poet and disciple of Mallarmé who played an important role as a critic of symbolist art following the death of Albert Aurier (probably a better writer and theoretician), in 1892. When Gauguin returned to Paris, he commissioned Morice to write the catalogue preface for his exhibition at the Durand-Ruel gallery, and later asked him to put his book *Noa Noa* into publishable form.[5] The two worked together on *Noa Noa* between 1893 and 1895, and after Gauguin's second departure for Tahiti, Morice reworked the text for publication in the 1897 *Revue Blanche*, along with some of his own poems.[6] Later, he wrote several articles on Gauguin before and after the artist's death, and one of the first Gauguin biographies, which appeared in 1919.[7]

Morice, who was often hard-pressed financially, seems to have sold his portrait at an early date. At the time of the Gauguin retrospective at the 1906 Salon d'Automne, it had already passed into the hands of Gustave Fayet.—F.C.

160
Aita tamari vahine Judith te parari

1893-1894

116 x 81 (45¼ x 31½)

oil on canvas

inscribed at upper right, *Aita Tamari vahine Judith te Parari*

private collection

EXHIBITIONS
(?) Paris 1903, no. 15, *Femme dans un fauteuil*; Basel 1928, no. 96 or 97 depending on the edition; Berlin 1928, no. 68; Paris, Orangerie 1949, no. 39; Basel 1949, no. 51; London 1979, no. 91; Washington 1980, no. 54

CATALOGUE
W 508

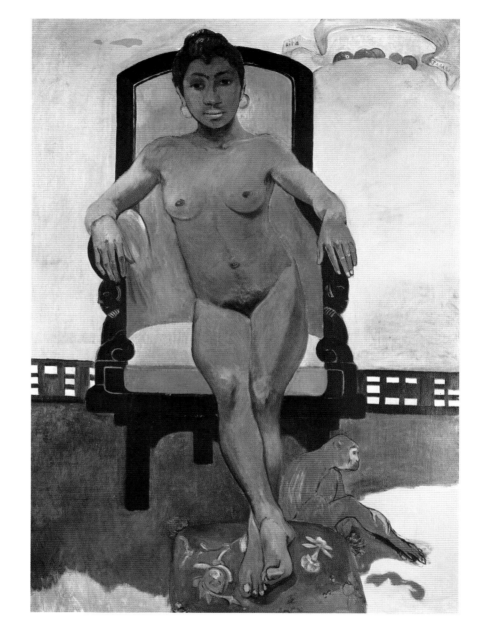

Unsigned and undated, this curiously titled painting (*The Child-woman Judith Is Not Yet Breached*) is without doubt the masterpiece of Gauguin's Paris period. Its vibrant palette, concise paint handling, and assured composition force us to rank it among his greatest works. Yet, like much of Gauguin's oeuvre from its period, the early history and original meaning of this painting are elusive. It was not included in the 1895 sale of Gauguin's paintings at Hôtel Drouot, but it may have been the laconically titled *Femme dans un fauteuil* (Woman in an Armchair) in the 1903 Vollard exhibition.[1] It was not mentioned in Morice's lengthy review of the exhibition, and it was never mentioned in other reviews or letters during Gauguin's

1. Paris 1903, no. 15.

306

2. Vollard 1936, 173; 1937 ed., 195-196.

3. Gérard 1951, 53-74.

4. For a translation of the title see Danielsson 1967, 230, no. 2.

Cézanne, *Achille Emperaire*, 1868, oil on canvas [Musée d'Orsay, Paris]

5. See Dorival 1954, 7, for a preparatory drawing of the monkey. The features of the monkey were not painted from life, as was the figure of Annah, but from a series of light pencil drawings.

6. Hoog 1987, 214.

7. See n. 1.

8. Annah's departure was most likely a response to Gauguin's invalid condition after the 25 May accident at Concarneau, which rendered him a virtual cripple and unable to paint for the next two months.

lifetime. It seems never to have belonged to Molard, Monfreïd, Chaudet, Lévy, or Vollard, among whom virtually every late painting can be located in the years before the painter's death in 1903.

There is a general consensus that the painting represents Gauguin's mulatto model, the so-called Annah la Javanaise, who lived with him between December 1893 and the fall of 1894. Annah and her pet monkey, Taoa, are picturesque characters in the Gauguin literature. Vollard related what may be a fanciful story of an encounter with this chambermaid-turned-model in his memoirs.[2] Yet Gauguin's elaborate and partially illegible Tahitian title tells us about a different woman, Judith. This is surely Judith Molard, the daughter of Gauguin's friends William and Ida Molard and the author of an affectionate account of the painter's stay in Paris.[3] Judith was thirteen years old in 1893, virtually the same age as Annah, but different in every other respect. Whereas Annah was a sexually experienced woman, Judith was a child; Annah was dark, Judith, fair. Gauguin, in painting this frank nude representation of one woman, acknowledged the other in his title.[4] If Judith's memoirs are to be believed, a sexual relationship between them, possibly alluded to by Gauguin's Tahitian title that would have been incomprehensible to Judith or her parents, was never consummated.

Gauguin posed Annah in an armchair, the comparatively large size of which makes her diminutive scale obvious. Her closest precedent in the history of French art is not a nude, but Cézanne's portrait of his dwarf friend, Achille Emperaire. Annah's companion, the monkey Taoa, sits at her feet, looking unconcernedly out of the picture.[5] The entire air of the picture is of posing, and Annah recognizes that we are studying her.

The setting for this picture is at once concise and exotic. It has nothing whatsoever to do with Gauguin's actual studio in Paris, which had chrome yellow walls crowded with works of art. There are no works of art on this pink wall, a field of pulsating color breaking forth into fruit and ribbon for the title cartouche in the upper right corner. The baseboard molding has been likened more to the later inventions of the Wiener Werkstätte[6] than to either Polynesian fretwork or French avant-garde design. It was later repeated by Gauguin in an 1896 painting, *Te tamari no atua* (cat. 221), where it adorns the bedstead of a Polynesian Virgin Mary.

The splendid chair in which Annah sits is probably a Chinese export. For all the exoticism of its Chinese legs and carved arms, the chair is forthrightly European in taste, the closest approximation in Gauguin's oeuvre to the *fauteuil* referred to in the title in the 1903 Vollard exhibition.[7]

We know that Annah returned to Paris from Pont-Aven in the late summer of 1894 and that she looted Gauguin's studio of everything but his paintings.[8] Is it possible that she took just one, this portrait of her? If so, we have only the negative evidence that no one seems ever to have mentioned it within the artist's lifetime. In 1922, the painting was purchased by the great Swiss collector Emile Hahnloser of Bern, where it was undoubtedly admired by Félix Vallotton, whose own nude and seminude figures owe a profound debt to this painting by Gauguin. —R.B.

161
Reclining Nude (recto); Study for Aita tamari vahine Judith te parari (verso)

1894/1895

300 x 620 (11¾ x 24¼)

charcoal, black chalk, and pastel on laid paper; verso worked over with brush and water

Mrs. Robert B. Eichholz

Gauguin, study for *Aita tamari vahine Judith te parari* [verso of cat. 161]

1895

245 x 400 (9½ x 15½), irregular

counterproof from a design in pastel, selectively reworked, on japan paper

dedicated, signed, and dated at lower center, with pen and ink, *à Amedée Schuffenecker/ Paul Gauguin - 1895 -*

private collection

EXHIBITION
Philadelphia 1973, no. 11

CATALOGUE
F 11

shown in Paris only

162
Reclining Nude

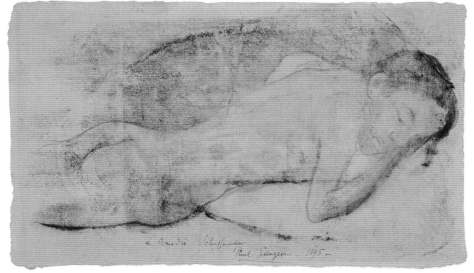

The superb pastel on the recto of the sheet in the Eichholz Collection appears to be a study for the reclining female nude in Gauguin's famous painting of 1892, *Manao tupapau* (cat. 154). However, the fact that it was made on the other side of a fully developed study for *Aita tamari vahine Judith te parari* (cat. 160) of 1894 forces us to date it and its counterproofs to 1894/1895. In fact, it and the sketch from the *Cahier pour Aline* show evidence of Gauguin's continued fascination with this pose. In style and technique, this pastel is unique to the years 1893–1895. One must return to the pastels (cats. 35, 46) made in connection with Gauguin's first major painting of a bather, made in 1886–1887 (cat. 47), to see works related to it.

The unceremonious beheading of *Annah la Javanaise* on the verso suggests that this side of the sheet preceded the recto. This image must have been made in the winter or early spring of 1894, when Gauguin and Annah lived in Paris. It is odd, given what we know of Gauguin's working habits, that he confined his study to the left half of a large sheet, especially at a time when he did not lack money. The drawing is fascinatingly different from the painting to which it obviously relates. Absent is the fabulous blue chair and the monkey, and Annah's pose, so oddly erect in the painting, is partially reclining here. Yet the principal oddity of the drawing is the indeterminate nature of the props. The stool on which she sits, as well as her upper body, apparently supported by a white pillow, have no clear position in illusionistic space.

It is tempting to theorize that Gauguin himself decapitated Annah by cutting the sheet when he returned from Brittany to find that she had stolen everything except the works of art from his Paris apartment. However, this scenario does nothing to explain the close resemblance in skin color and body type to the reclining nude on the later recto of the sheet. It is more likely that Gauguin, having finished the recto in Paris, took several works on paper with him to Brittany. There, he made the pastel of Annah on the verso before she deserted him in Brittany and returned to Paris.

Again, the differences between the pastel of Annah on the recto and the painting of the reclining Tehamana are striking. In the earlier work, the model has just been awakened, and looks, startled, at the viewer; in the pastel, her eyes are closed and we watch her sleep. The Tahitian woman is sturdily proportioned, with broad legs and strong arms; Annah is thin, her visible arm almost withered, her legs unaccustomed to exercise. Even the hands and feet contrast, with the Tahitian's almost dominating the body and Annah's either hidden or summarily rendered. Gauguin's representation of Annah in the pose of Tehamana presupposes no spirits of the dead; rather, it is a gentle evocation of sleep, recalling in a distant way Gauguin's own early painting of a sleeping child (cat. 13).

It is perhaps worth noting the androgynous quality of the figure on the recto. Without the wisp of hair, the nearly invisible earring, and the gentle swelling of the chest, one could almost imagine that the model was male. Even Tehamana, who could scarcely be called archetypically feminine, projects her sexual identity more strongly in the painting *Manao tupapau*. The very inaccessibility of Annah is part of the mystery of this haunting drawing. She is utterly vulnerable, yet, unlike Tehamana, unaware of her viewer. She is alone, her thoughts encased in dreams.

Gauguin himself was moved enough by this pastel to make at least two counterproofs of it, one that survives only as a fragment[1] and the other, inscribed to his friend Schuffenecker and dated 1895 (cat. 162), on paper of smaller dimensions. The date more likely coincides with the gift of the counterproof just before Gauguin's departure for Tahiti than it does with its creation, possibly in 1894, when Gauguin is known to have made the majority of his color transfers and counterproofs.

Yet its actual date is of little significance in the face of this counterproof. Indeed, the effect of a sleeping or dreaming woman is even greater in it than in the pastel source. The very paleness and indirectness of the image enhances the consciousness of the dream that Gauguin clearly sought, and one has only to recall the wraithlike *Madame Death* (cat. 114) or the huddled nude figure of *The Penitent Magdalen* published in *L'Ymagier* of April 1895[2] to place this image squarely in the context of the symbolist nude, to which Gauguin had been exposed during his years in Paris. When looking at this pastel and its counterproof on paper of smaller dimensions, one thinks of Redon more than of Manet, and looks forward to Munch more than to Picasso or Matisse.–R.B.

1. F12, *Oviri* on verso.

2. No. 3, 142. "Madeleine. - D'Après un bois originale de Paul Gauguin."

163
Tahitian Woman

1894 (?)

primary support 570 x 495 (22¼ x 19¼), irregularly shaped; secondary support 605 x 505 (23½ x 19⅝)

charcoal and pastel, selectively stumped and worked with brush and water on wove "pastel" paper, glued to secondary support of yellow wove paper mounted on gray millboard

signed at top left in charcoal, *P G O*

The Brooklyn Museum, Museum Collection Fund 21.125

CATALOGUE
W 424bis

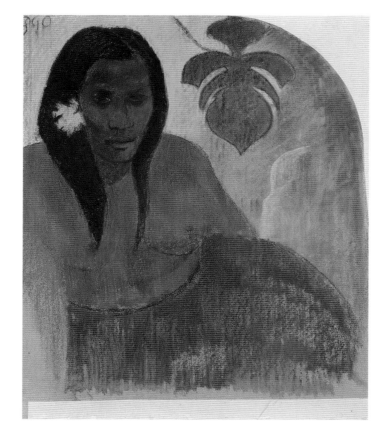

1. 1891 in W 424 *bis*; Pickvance 1970, pl. XI.

2. Pickvance 1970, pl. X, *The Devil's Words (Eve)*, pastel, Kupferstichkabinett, Basel.

3. Circa 1900 in Rewald 1958, no. 118.

4. F 23. Whereabouts unknown.

This iridescent pastel has been dated to the first Tahitian period[1] and linked with the stylistically similar drawing of a Tahitian Eve in Basel[2] and the related painting of 1892 (cat. 147). It has also been dated to the last years of Gauguin's life.[3] However, it is more likely that it was made in 1894, when Gauguin worked almost exclusively in various graphic mediums, and when he made the Eichholz pastel (cat. 161) and probably finished his preparatory transfer studies for *Nave nave fenua* (cats. 179, 180, 181). The evidence for the 1894 date is strengthened by a comparison to a watercolor transfer with the same head and hair arrangement[4] signed and dated in that year. It is even possible that the model was Annah la Javanaise rather than a Tahitian woman, as it at first appears. From the evidence of the Eichholz pastel, Annah had similar black hair that hung in thin plaits, and this is rather different from the luxuriant hair of all but one of his Tahitian models (cat. 251).

Neither the pose nor the head of the woman can be related to any single painting or drawing done in Tahiti, and the fact that the setting for the figure is nonspecific, indeed almost abstract, suggests that it was made in France. The yellow could easily be the yellow walls of the studio in Paris, where Annah posed many times, and the breadfruit leaf is so stylized that it, too, becomes a symbol for Tahiti rather than a carefully observed form.

The paper was wetted in many places and possibly worked over with a brush. Perhaps this is evidence that it was used as the matrix, or source, for a lost transfer onto another sheet of wetted paper as was the Eichholz pastel and several earlier works. However, in the absence of a counterproof, it is perhaps wiser to

assume that Gauguin wanted to achieve in pastel the effects of thickness and color massing that he had seen in the pastels of Degas and possibly Redon.

Yet, whereas everything in a Redon pastel is delicate and conventionally crafted, Gauguin subverted the medium. He denied the crumbly subtlety of the pastel surface, and spent a good deal of time and effort to make the drawing seem crude and primitive. The ostensible subject of the pastel, the figure, is almost invisible because of the sheer optical brilliance of the yellow background. She seems less real than the breadfruit leaf, and both these elements become little more than colored masses defined by the theatrical brilliance of the yellow backlighting.

Gauguin rounded the corner of the upper right and mounted the shaped pastel onto a large sheet of bright yellow paper similar to what he had used for the Volpini suite (cats. 67-77). This was then pasted onto millboard backed with a newspaper that can be dated to 1894. The deliberate shaping of the drawing after it was made is a pervasive aspect of Gauguin's graphic convention, and the layering of separately made and shaped collage elements anticipates in crucial ways the development of collage in the early twentieth century.–R.B.

164
Self-portrait with Hat (recto); Portrait of William Molard (verso)

In December 1893, about one month after his exhibition at Durand-Ruel gallery, Gauguin left rue de la Grande Chaumière and set up house at 6 rue Vercingétorix, in a two-room apartment built from the wood of the pavilions of the 1889 Exposition Universelle. He painted the walls of his new abode chrome yellow and olive green, ". . . and here and there, to lend the place an exotic touch, he hung Tahitian spears and Australian boomerangs that he had brought back with him. There were also reproductions of the works of his favorite painters, especially Cranach, Holbein, Botticelli, Puvis de Chavannes, Manet, and Degas, along with original works by van Gogh, Cézanne, and Redon, which had probably been kept for him by Schuffenecker and Daniel de Monfreid during his absence."[1] Amid these surroundings, he received his friends, worked on his manuscript of Noa Noa with Charles Morice, conducted a love affair with Annah "La Javanaise" (see cat. 160), and generally cultivated the image of a tropical exile.

In this self-portrait, Gauguin is seen in front of his painting Manao tupapau (cat. 154), in a bright yellow frame. This canvas had been recently shown at Durand-Ruel, and Gauguin considered it not only one of his best Tahiti efforts, but also the most significant and the richest in exotic undercurrents.[2] As in Self-portrait with Yellow Christ (cat. 99), the artist has carefully arranged his scene in front of a mirror; we know this because Manao tupapau is reversed. This time he has chosen to symbolize his recent work with a single painting, and the only hint of the studio's famous decor is provided by the yellow and blue Polynesian fabric on a chair below it. The oblique wooden structure and the main beam in chrome yellow that emphasize the outline of the hat are clearly recognizable as the studio in rue Vercingétorix. But a comparison of the two self-portraits shows the change that had taken place in Gauguin's technique over the previous three years. The earlier painting is still heavily influenced by Cézanne: the canvas is coarse and

1. Danielsson 1975, 149-150.

2. Letter to Mette, Malingue 1949, CXXXIV.

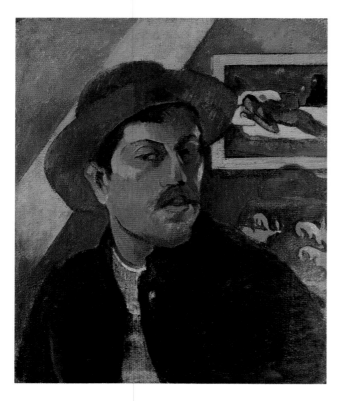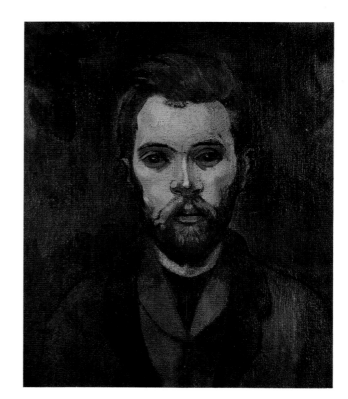

Self-portrait with Hat (recto); Portrait of William Molard (verso)

winter 1893-1894

46 x 38 (18 x 15)

oil on canvas

Musée d'Orsay, Paris

EXHIBITIONS
Paris 1906, no. 223 (verso); Basel 1928, no. 84; Oslo 1955, no. 30

CATALOGUE
W 506 and W 507 verso

3. Discovered and quoted by Danielsson 1975, 149.

4. Letter to Molard, March 1898, in Malingue 1949, CLXVII.

5. Danielsson 1975, 209.

rough-grained, of the type Gauguin used in Tahiti; the brushwork is less smooth, and the effect amounts to "writing" with colors. The costume is less theatrical than in the other portraits – we recognize the embroidered Breton smock, half painted over – but the main accent is placed on the harsh features and the vivid green of the left eye. The painting's two strongest points are the picture in the background and the look in the model's eye, which seems to tell us: "this is what I had the wit to see, and I painted it."

On the other side of the picture is a full-face portrait of William Molard (1862-1936). We have no way of knowing which side was painted first. Molard was a young musician who lived above Gauguin on rue Vercingétorix; he was married to a sculptress, Ida Ericson, who had a teenage daughter named Judith. Judith frequently played the daughter of the house for Gauguin when he entertained his artistic and literary friends, and she left a number of interesting souvenirs.[3] In fact the Molards turned out to be invaluable new friends for Gauguin in this year, when so many of his old ones were falling by the wayside. Relations had lapsed with Pissarro, Degas, and Bernard; Aurier and the van Gogh brothers were dead; and Laval and de Haan were dying.

William Molard was a fanatical Wagnerian whose works were reputedly unplayable. Through him Gauguin met several musicians, among them the cellist Schnecklud (cat. 165). When Gauguin returned to Tahiti, Molard remained a trusted correspondent, who looked after the painter's interests, collected money owed to him, and intervened with Morice in the disagreement over the publication of *Noa Noa*.[4] Later, Morice applied to Molard to write the music for the "lyrical pantomime" based on *Noa Noa*, which he planned in 1897.[5] The portrait clearly shows how Gauguin judged his friend to be: a man of thirty-one, kindly, honest, loyal, and perhaps a little naïve. At all events, he gave Molard this two-sided canvas as a sign of his friendship and gratitude.

In 1906, the picture was still in Molard's possession, and it was probably he who decided to hang it with his own face outward when it was shown at the Gauguin retrospective at the Salon d'Automne. Interestingly enough, it later passed into the hands of Douglas Cooper, the collector, art historian, and expert on cubism, who instigated the publication of Gauguin's letters to van Gogh in 1983, and who worked for many years to establish a coherent catalogue of Gauguin's works.—F.C.

165
Upaupa Schneklud

1894

92.5 x 73.5 (36 x 28⅝)

oil on canvas

inscribed at upper left, *Upaupa SCHNEKLUD*; signed and dated at upper right, *P Gauguin 94*

The Baltimore Museum of Art, Given by Hilda K. Blaustein, in Memory of her late Husband, Jacob Blaustein

EXHIBITIONS
Zurich 1917, no. 100; New York 1946, no. 28; Chicago 1959, no. 58; Stuttgart 1985, 52, no. 44

CATALOGUE
W 517

shown in Washington and Chicago only

1. Compositions by Fritz Schneklud include Girod: Airs espagnols; Dans la serre; Gavotte Louison; Landler, Valse lente; Simple romance; Souvenir d'etretat; Tzizanes et Bohémiens. F. Pazdireck, *Universal Handbuch der Musikliteratur aller Zeiten und Völker*, vol. 20. The Netherlands, 1967, 568. For a while Schneklud played the violincello in the *Quatuor Capet* with Pierre Monteux. Humbert 1954, 71.

2. See Paris 1878, no. 20, *Le violoncelliste*.

3. Marks-Vandenbroucke 1956, 35.

4. Paris 1878, 6.

Upaupa Schneklud (The Player Schneklud) represents a Swedish musician who frequented the circle of William and Ida Molard. Unfortunately, we know little of Fritz Schneklud as a musician,[1] and the portrait, although seemingly precise, presents us with a man who looks rather like Gauguin, who was also an amateur musician. The figure playing a cello at the center of a photograph taken in the artist's studio in 1894 is probably Schneklud, in spite of the fact that it has been persistently identified as Gauguin. Another photograph of Schneklud in the Malingue archives makes positive identification of the cellist in the portrait even more difficult. Confusion between the identities of Schneklud and Gauguin himself may have been the artist's intention.

Like many of Gauguin's paintings, this one has a mysterious analogue in the past. Gustave Arosa owned a wonderful portrait of a cellist by Courbet, now in the Nationalmuseet, Stockholm.[2] Gauguin possessed either an illustrated copy of Arosa's sale catalogue of 1878 or photographs of works from the collection.[3] Philippe Burty, in the introduction to the sale catalogue, noted that the cellist was none other than Courbet himself. Burty wrote: "This tall man with a romantic face, whose elegant hands wander through and attack the strings, is in fact the painter himself."[4]

Fritz Schneklud, photograph [Malingue Archives]

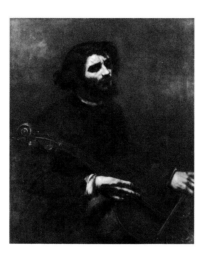

Courbet, *Self-Portrait as Cellist*, 1847-1848, oil on canvas [Nationalmuseum Stockholm, The National Swedish Art Museums]

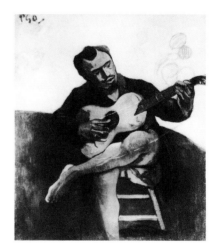

Gauguin, *The Guitar Player*, 1902, oil on canvas [private collection, photo: courtesy of Sotheby's]

5. Malingue 1949, CLXVII.

This passage, and the fact that Gauguin undoubtedly read it, makes our task of interpreting this portrait very difficult. We know that Gauguin knew Schneklud, for he is mentioned specifically as a cellist in an undated letter from Gauguin to Molard written from Tahiti in 1898. "If I were in Paris, I know I could have helped him with his orchestra, thanks to Schneklud, the violoncello player, and then with the choir to which he belonged, a group composed of amateurs. But as you say, one can manage with a piano and a harmonium."[5] However, we also know that Gauguin's principal art historical source for this portrait was a self-portrait by Courbet. Why, if Gauguin intended to represent himself, did he inscribe the name of another cellist on the picture?

This question is even more difficult to answer when we compare the photograph of Schneklud that Gauguin probably used as the source for the gestures and hand positions with the actual portrait. The Schneklud of the photograph is beardless and thinner than the man represented in the painting, suggest-

ing either that Gauguin borrowed an old photograph to use for the posture of the cellist, or that he applied many of his own features to the posture of Schneklud to create a portrait more or less in keeping with its source in Courbet. However one interprets *Upaupa Schneklud*, it has an element of self-portraiture in its conception and creation.

The portrait is among the most successful and, in a sense, musical representations of a musician in nineteenth-century art. The orange body of the cello rhymes in color with the reddish orange hair of its player, and in shape with the great arabesque curve of brown that envelops him and echoes his own gesture. Schneklud is less seated on a chair than surrounded by a gently pulsating field of brown, surmounted by a vegetable realm. The flowers in this region are impossible to name, but several of them resemble the squared flowers that surround Gauguin in his famous self-portrait of 1889, *Self-portrait with Halo* (cat. 92).

Why *upaupa*? The *upaupa* is the most famous, characteristic, and erotic dance of Tahiti. Its rhythms are less musical than sensual.[6] Gauguin himself evoked it at the farewell dinner held before his final departure for the South Seas, and there is little doubt that he had regaled his friends in Paris with stories of Polynesian musical performances,[7] which he may not himself have experienced (cat. 121). This dedication on the portrait of a friend-musician forges a link between Gauguin himself, his dreams of the South Seas, and his life in Paris.

There is yet another painting of a seated musician in the Gauguin corpus that is obviously related to *Upaupa Schneklud*. This is the mysterious *Guitar Player*,[8] conventionally dated 1902 and thought to have been painted in Atuona. This painting is virtually identical in dimension to *Upaupa Schneklud* and is in many senses analogous to it.[9] Both works share the swooping curved background, and each represents a musician in a vertical format. The *Guitar Player*, when considered in this sense, becomes a pendant to the Schneklud painting.–R.B.

6. Danielsson 1967, 233, no. 79.

7. Judith Gérard, "La Petite fille et le Tupapau," unpub. trans. of Gérard 1951, 26.

8. W 611.

9. The recent research of Peter Zegers indicates that *The Guitar Player* and a large uncatalogued charcoal drawing of a seated man (private collection) are possibly portraits of Gauguin's friend Paco Durrio, the Spanish sculptor.

166
Paris in the Snow

This complex winter landscape is unique in Gauguin's oeuvre of the 1890s. It is an impressionist picture, and its quotidian subject, informal composition, point of view, and temporal structure link it to many urban landscapes by Pissarro, Renoir, Monet, and Caillebotte. Painted from the window of Gauguin's studio, it dates from the last week of February 1894, shortly after his return from Belgium.[1]

Surely *Paris in the Snow*[2] was made in homage to Gustave Caillebotte, whose death on 21 February of that year had deeply affected the surviving impressionists and whose collection had been given to the Louvre amid public controversy between avant-garde artists and official quarters. After months of haggling, a group of impressionist paintings from Caillebotte's collection was exhibited at the Durand-Ruel Gallery. Two paintings by Caillebotte were part of the group exhibited there, and one of them, *Rooftops in the Snow*, was surely Gauguin's inspiration.[3]

Like virtually every source in Gauguin's oeuvre, this one was subsumed all but totally by the artist. Gauguin accepted the point of view, the format, the urban subject, and the time of year from Caillebotte, but there the similarity ends.

1. According to the *Annales du Bureau Central Météorologique de France*, in 1894 it snowed in Paris on January 1, 6, 8, 26, 29, February 24, November 26, December 30, 31.

2. Bodelsen 1966 titled it *Village sous la neige*.

3. Galerie Durand-Ruel, *Exposition rétrospective d'oeuvres de G. Caillebotte*, June 1894, no. 17 as *Vue de toits, effets de neige*, 1878. Gauguin's concern at this time was to buy back *Les Toits rouges*, the Cézanne painting he once owned, from Mette's brother-in-law, Edvard Brandes. Malingue 1949, CXLVIII.

Paris in the Snow

1894

71.5 x 88 (27⅞ x 34⅜)

oil on canvas

signed and dated at lower center,
P. Gauguin 94

Rijksmusem Vincent van Gogh, Amsterdam
(Vincent van Gogh Foundation)

EXHIBITIONS
Paris, Orangerie 1949, no. 45; Basel 1949,
no. 55; Edinburgh 1955, no. 52; New York
1956, no. 41

CATALOGUE
W 529

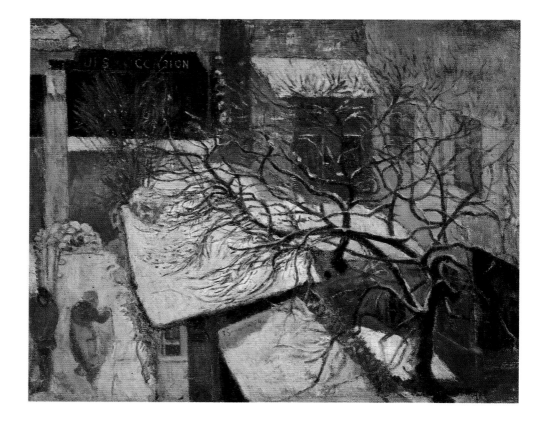

Caillebotte, *View of Rooftops* (*Snow Effect*),
1878, oil on canvas [Musée d'Orsay, Paris]

4. In 1894 Gauguin was to have sent this
painting and *Women by the River* (W 482,
1892) to the widow Johanna Bonger van
Gogh, Paris. See Rewald 1986, 85-86.

Whereas Caillebotte's canvas is a symphony of grays, blues, reddish purples, and browns, Gauguin's is brought to life with brilliant oranges, yellows, and greens. Caillebotte's composition is completely dominated by architecture, but Gauguin's is centered on the natural rhythms of a great tree that swoops over the angular roofs of Montparnasse. Caillebotte's purely residential rooftop panorama is interpreted by Gauguin to include a commercial building with a barely legible sign. Caillebotte's painting is unpopulated, but Gauguin's includes two humorous figures, whose presence in the corner recalls Japanese prints as well as figures in the earlier paintings of van Gogh, most of which Gauguin had last seen in the final months of 1888, when the two artists worked together in Arles.

The painting was sent to the widow of Theo van Gogh in the late spring in gratitude for paintings by Vincent that she had sent to Gauguin.[4] Both Vincent and Theo van Gogh, each a friend and supporter of Gauguin's, were dead when Gauguin painted this composition. Did Gauguin, who was the only witness of Vincent's tragic self-mutilation that had occurred at the same time of year six years earlier and who was lastingly obsessed with that momentous event, paint this picture at least partially in memory of it?–R.B.

167-176
1893-1894 Suite of Woodcut Illustrations for Noa Noa

1. *L'Ymagier* (January 1895), 138.

2. Leclercq 1895, 121-122; Morice 1895b.

3. Morice in Paris, Durand-Ruel 1893.

4. Morice 1895, 2.

5. Leclercq 1895, 122.

6. Dorra 1976, 175-179. Dorra speculated on the possibility that Munch was influenced by Gauguin's prints (zincographs) that he saw at the 1889 Volpini exhibition; Also Bente Torjusen, "The Mirror," in *Edvard Munch; Symbols and Images* [exh. cat., National Gallery of Art] (Washington, 1978), 198.

7. Baas and Field 1984, 108-118.

8. Malingue 1949, CXLIII. This could refer either to an early draft of *Noa Noa* or to his dated manuscript *Ancien Culte Mahorie*.

9. "Thanks for your suggestion to come to Denmark, but I shall be kept here all the winter by a huge volume of work. . . . a book about my voyage, which is causing me much labor." Malingue 1949, CXLV.

10. Letter, Hôtel Drouot, *Catalogue vente de la Bibliothèque de Lucien Graux*, 8e partie, 11-12 December 1958. We await the promised second volume of correspondence edited by Victor Merlhès to confirm the dates of many of Gauguin's letters.

In December 1894, Gauguin opened his studio to a small group of friends, admirers, and friends of friends. These artists, writers, collectors, and amateurs were the first to see the woodblock prints made to illustrate his book *Noa Noa* (Fragrance). Alfred Jarry and Rémy de Gourmont mentioned the exhibition in *L'Ymagier*, the journal devoted almost exclusively to the woodcut revival in 1895 and 1896,[1] and both Julien Leclercq and Charles Morice wrote rhapsodically about the prints.[2] Morice, whose collaboration with Gauguin is well known and who supplied the preface to the catalogue for the first Tahitian exhibition,[3] considered the woodcuts to be "a revolution in the art of printmaking," and he was surely correct.[4] Leclercq was fascinated by what he called their intermediate quality. "His woodcuts, from a design that his sculpture has already revealed to us, establish . . . the very personal harmony of the latter with his painting. Between sculpture and painting it is an intermediary medium that has as much in common with one as the other. Imagine very low reliefs, with full forms, thickly printed with a sober touch of red or yellow to break the monotony of blacks and whites. Powerful effects that are the secret of the artist's temperament emerge from them."[5]

These prints, when contrasted to the contemporary efforts in the field of woodcut printing by Lucien Pissarro, Armand Séguin, or Henri Rivière, exude a power and vitality that make the comparison absurd. There is no precedent in the medium for Gauguin's prints, and one must look to the great woodblock prints made at the end of the 1890s by Edvard Munch to find comparable quality.[6] The most recent and the best study of the woodcut in France during the nineteenth century places Gauguin's Noa Noa prints in a context that does little to explain them.[7] Not even the superb woodcut prints of Félix Vallotton can provide a comprehensible analogue.

Gauguin's choice of the medium was surely made in part because it was thought so adaptable to book illustration, especially in conjunction with hand-set type. However, Gauguin's prints were never printed with text. There were undoubtedly reasons other than textual association that led Gauguin, and other artists, to the woodcut; indeed, the medium was associated with the earliest European printmaking and with both primitive and popular art in Europe and the Far East in *L'Ymagier*.

The early history of the Noa Noa prints is not precisely known. In October of 1893, even before the exhibition of his recent paintings and sculpture at Durand-Ruel Gallery, he had written to his wife that he was hard at work on a book to aid the viewer of his paintings.[8] One can assume by a statement he made to Mette[9] that he was afraid of being interrupted. By April of 1894 he had written Charles Morice that he had finished the prints for the book; this is probably the first written evidence that he intended to illustrate his text.[10]

These dates for the conception of the book and the completion of its woodblock illustrations indicate that the artist worked on little else besides *Noa Noa* from December through March. The intensity of his graphic work more than matched his literary output for the same project. He purchased composite boxwood blocks that have identical stamped identifications, from which he created three vertical and seven horizontal prints, all of which are translations rather than reproductions of paintings, sculptures, or drawings made while in Tahiti.

Often the woodblocks stray far in composition, mood, and quality from the works of art that Gauguin actually made in Tahiti. What began as a book to guide perplexed viewers through the jungles of Gauguin's Tahiti became a work of art

that is denser, more difficult, and ultimately more mythic than anything he had produced in the South Seas. Yet what is frustrating about the Noa Noa prints produced in 1893/1895 is that they bear no clear relationship to any of the several surviving texts, either by Gauguin himself or by Gauguin with the active collaboration of Morice. And, to make matters worse, Gauguin included only one of the ten prints in its entirety in the final manuscript assembled in Tahiti in the last years of the decade. Indeed, the text and the illustrations seem to have gone their separate ways, and the modern commentator is hard pressed to explain one in terms of the other.

The earliest surviving manuscript of the *Noa Noa* text by Gauguin himself is virtually unillustrated, was probably written late in 1893 or early 1894 while he was working on the woodblocks, and was given to Charles Morice for amendment, correction, and alteration. This text, which has recently been reprinted in both French and English,[11] follows loosely the form of a memoir or travel journal. We learn of Gauguin's arrival in Tahiti, his disappointment with the scenery (compared to that of Rio de Janeiro), his sexual dalliances, his uncomfortable attraction to a young Tahitian man, his search for a wife, his first fishing expedition, and his eventually successful quest to become a "savage."

The prints from the woodblocks have no such personal verve or immediacy; indeed, many of them tremble on the brink of incomprehensibility. They embody dark, unenterable worlds populated by prehistoric fish, barely tangible figures, desperate lovers, hooded women, and nameless, culturally ambiguous idols. These forms are illuminated not by the sun, but by oil lamps, fire, and phosphorescent light. How unlike the night in Gauguin's Tahitian paintings, which is alive with green, purple, pink, and dark blue. Needless to say, Gauguin included beautiful nude females, but they lack the easy sensuality that animates the paintings. The world of the prints springs less from dreams than from nightmares.

Gauguin began cutting these blocks by making myriad surface lines with fine points and needles, creating an image spun from lines. This accomplished, he dug out the images with common gouges as well as with smaller engraver's gouges. Hence each block is at once powerfully crude and delicately refined in its techniques, and, as if to mimic this double aesthetic, he printed the blocks in experimental ways that must have confounded early viewers. In certain cases he printed the block twice on the same sheet of paper, carefully misaligning to produce a deliberately off-register print. He chose different colors for each of these printings, so subtly related to one another that the image seems to vibrate. For Gauguin, this must have heightened the feeling of the indeterminate that he sought. His most innovative printing technique involved the voids. In such areas as the beach in *Auti te pape* (*The Fresh Water is in Motion*) or the blanket in *Te po* (*The Night*), Gauguin gouged the areas that were to read as white or paper in the final print. But when he inked and printed these areas, he broke every rule of woodblock printing. Instead of carefully avoiding them in his inking of the block, he deliberately inked the gouged voids and then pushed the paper into these areas so that the gouges themselves would print positively. Hence, every "white" area reads as gouged. The beach cannot be read simply as a beach or the blanket as a blanket; instead, they must be read as having been gouged, cut, and, hence, formed by the artist. In this way, Gauguin heightened the effect of material immediacy or, as Leclercq would have it, of sculpture.

These crude techniques were countered always in Gauguin's Noa Noa prints by other processes of great refinement. For every gouge, there is a tiny, delicate line; for every double-printed impression, there is another that is subtly hand colored. Certain impressions were printed on vellum or on extremely fine Japanese papers, while others seem to have been printed on semitransparent sheets, giving the impression of a veil. Gauguin was as original a printmaker as any

11. Wadley 1985, text with three stories added by Gauguin, 11-57; Wadley refers to it as the Draft MS, 1893; and Artur 1987.

12. On the back of a print of *Nave nave fenua* that is inscribed *Budapest February 22, 1907; From Paul Gauguin; Only one, a rarest copy (woodcut).*

13. In the translation by Dr. István Genthon of the Museum of Fine Arts, Budapest, in Field 1968, 503: "I was then in the company of Noa Noa, his wife, Vistiti, a monkey. . . ."

14. P. Napoléon Roinard, editor of *Essais d'art*, 1894.

15. Probably William Molard.

16. From the verso of *Nave nave fenua* (G 27, National Gallery of Art, Washington Rosenwald Collection, 1947.12.53). Translated by Enok Dobner.

17. Although Gauguin thought of his book as a way of explaining his work to the public, this "public" was a small clique of symbolist sympathizers, mostly drawn from the "Têtes de Bois" group. The circulation of the luxury collaboration of Gauguin and Morice could not have been an easy one to sell to the publishing houses. Even *La Revue Blanche* refused to publish more than the text Morice supplied them with. Morice wrote to Mallarmé at the end of December, shortly after the publication of text only in *La Revue Blanche*: "But to return to *Noa Noa*, the Natansons will not publish it: they don't 'dare' as they say their publishing office is too new and the work is too out of the mainstream. I do not really understand their fears, and feel that it is foolish of them to look for other projects that are no less mysterious" (Delsemme 1958, 76). A few weeks later he again complained to Mallarmé of his efforts to find a publisher. "I am truly frustrated. I cannot get a decision from Monsieur Fasquelle for *Noa Noa*." (Letter dated 30 January, 1898, Delsemme 1958, 76.) In May, Morice was still asking others to help him search for a publisher, writing in his journal on Thursday, 11 May, "Dolent brought the manuscript for *Noa Noa* to the Publisher Perrin" (unpubl. journals, Paley Library, Temple University, Philadelphia). Morice in the end printed the book at his own cost in Louvain. It appeared in February 1900. His attempts to have the prints integrated with text were also unsuccessful, since the publishers refused to print Gauguin's drawings unless they were on smooth paper and Gauguin refused to comply (Malingue 1949, 229).

18. There is evidence of only one set of prints mounted by Gauguin in the catalogue of Degas' sale (Paris 1918). This was described as a "Series of ten woodcuts. Beautiful impressions, most *printed in many tones* and mounted on blue pages." Unfortunately, there are no known prints that survive with a Degas provenance, and we cannot know whether Degas' set consisted of impressions by Gauguin or by Louis Roy. *Catalogue des estampes anciennes et modernes composant la Collection Edgar Degas*, Hôtel Drouot, 1918, no. 128.

19. According to Field, based on Leclercq 1895, it appears that some of the more successful Roy impressions were hung in the exhibition. Field claimed that many of these, plus a few of the earlier Gauguin proofs and several monotypes, were mounted on gray cardboard. Field 1968, 511.

other in nineteenth-century France, and surely his most sustained achievement in the graphic medium was the series of ten prints made for *Noa Noa*.

Gauguin varied each impression so that no two are alike. Yet the precedent of Degas and Pissarro does not explain the variability of his impressions. Gauguin was less interested than his teachers in reworking the block or plate than in experimenting with its printing. Perhaps because the printing of a woodblock could be accomplished without a press and other paraphernalia, Gauguin could alter his modes of printing with less fuss than could either Degas or Pissarro. He varied inks, papers, colors, pressures, and even modes of printing with an almost delightful abandon (see *Te nave nave fenua*, cats. 177-182). The Hungarian artist Rippl-Rónai provided an eyewitness account of Gauguin's printing:[12] "I personally received [this] from him [Gauguin] In my presence he printed it in a most primitive fashion—putting his weight on his bed. . . . He invited me for tea at his rue Vercingétorix atelier where Noa Noa (his wife), Vistiti (a monkey)[13] was climbing up and down the rope suspended from the ceiling, Ruinard,[14] and someone playing the piano[15] and I with Gauguin stayed together from about nine until midnight. Meanwhile he continued quite seriously to print the woodcut, and he gave me another print that was from his old Breton period on yellow paper representing a milk cow. But on the other side from the Tahiti period was a hardly recognizable female nude figure."[16]

This inscription, together with the fact that several of the surviving impressions made by Gauguin himself were dedicated to friends, suggests that Gauguin failed to create a standard edition of his suite of Noa Noa prints; in this way, the project differed from the earlier Volpini suite. However, Gauguin must have felt anxious about his inability to make an edition for commercial purposes, because by the spring of 1894 he began to collaborate with the printer Louis Roy. Certain of the surviving impressions produced by Roy are unique, suggesting that Gauguin may have printed them with Roy to arrive at a standard technique for the edition.

It has been surmised that Roy produced editions of twenty-five to thirty impressions of each print, none of which were numbered or mounted in any systematic way. Hence, there are no surviving sets of Roy-printed Noa Noa impressions like those from the Volpini suite (cats. 67-77). The absence of such sets lends credence to the notion that Gauguin intended to use the prints as illustrations for a text and, for that reason, refrained from mounting them for independent distribution and sale. Unfortunately, from the vast quantity of material printed for inclusion in such a book, only a small part was ever used in the preparation of the final manuscript.[17]

Many of the surviving impressions from Roy's editions are both beautiful and strong. They are characterized by the stenciled areas of intense color, usually a brilliant red-orange, acid yellow, and ocher, with the block itself printed in black ink, yet they do not compare in subtlety and sheer beauty with those printed by Gauguin himself. Fortunately, a large enough group of Gauguin's wholly autograph prints survives in public and private collections so that further study may bring new conclusions about Gauguin's enterprise in producing the ten Noa Noa prints.[18]

Even the presentation of the Gauguin impressions is not known. Certain of the surviving impressions appear to have been mounted by Gauguin in a way similar to his mounting of watercolor transfers at the same period (cats. 191-202). One might deduce that these prints, pasted on cardboard covered with white or mottled blue paper, were the ones shown by Gauguin in his studio in December of 1894 along with his contemporary watercolor transfers.[19] Because so few of these original mounts have survived, it is impossible to conclude that Gauguin mounted all of the prints in this manner.

The majority of the surviving autograph impressions were trimmed by Gauguin to almost exactly the dimensions of the block. This may have been to make them resemble Renaissance prints, produced when paper was expensive and printers could not afford the luxury of large margins. This strategy apparently led him to cut prints even further, creating small works from larger ones. Such proto-collage reductions of the prints abound in Gauguin's own manuscript copy of *Noa Noa*, now in the Louvre.

The physical evidence suggests that Gauguin remained ambivalent about the enterprise. He created very few sets of prints for sale; he failed to mount prints consistently for exhibition; and he placed fewer than ten prints onto pages or in books. This was surely not due to lack of opportunity, for Gauguin could have persuaded Alfred Vallette, the editor of *Mercure de France*, or Alfred Jarry and Rémy de Gourmont, editors of *L'Ymagier*, to publish his prints with or without text. He could also have worked with Antoine de La Rochefoucault, who had recently formed a short-lived and esoteric publication called *Le Coeur*, where Gauguin's *Ia orana Maria* (cat. 135) had been reproduced in 1893.[20]

The chronology of the Noa Noa blocks and their various impressions has been subject to dispute. The ten woodblocks from 1893-1894 have been considered the earliest illustrations for *Noa Noa*. There are nine impressions, all in the collection of The Art Institute of Chicago (formerly of the Durrio collection), that are dated in Gauguin's own hand *15 Mars*. These dates were probably added when Gauguin later assembled the prints for a gift or for sale, in view of the fact that two impressions of *Oviri* (cats. 213b, 213f), which were probably made in 1895, are also dated *15 Mars* on the verso. From this scanty evidence, it is probable that Gauguin bought the blocks and worked with them in the winter and early spring of 1893/1894, and by May 1894 he had begun his printing collaboration with Louis Roy, leaving the blocks with Roy when Gauguin left for Brittany in June. While in Brittany, he worked on other woodblocks and color transfers as well, mounting some of these with presentation mounts.

In thinking about the Noa Noa project, the modern viewer should not be overly concerned with making sense of this self-consciously fragmentary endeavor. Not only was Gauguin inexperienced in the complex world of publishing, but he was also working at a time when both literary and visual artists made a cult of the fragment, the apparently incomplete, and the obscure. It is perfectly possible that, for Gauguin, *Noa Noa* was as much a pretext for diversifying his mode of production as a project with an endpoint. The processes, both intellectual and technical, were as interesting and important for Gauguin as the product.

With this in mind, one can confront the sequence of the Noa Noa prints. Each cataloguer or commentator has proposed a different order, and not one of them has presented any evidence to explain his particular solution. Even the beginning of the sequence, seemingly simple because there is a print entitled *Noa Noa* in the group, has not been generally agreed upon. Neither Guérin nor Field began the sequence with *Noa Noa* itself, Guérin opting for *Te po*, presumably because of the large signature cartouche in the upper left corner, and Field suggesting that *Te atua* starts what he calls "a deliberate life cycle."[21] But Field is unique in formulating an argument for a specific sequence intended by Gauguin. None of the other cataloguers, from Schniewind to Kornfeld, has made such an argument, in spite of the fact that they all have been forced by the cataloguing format to put the prints into a specific order.[22]

There is, however, a set of numbers written in graphite on the verso of the Chicago prints that is possibly by Gauguin himself. If this numbering is followed, the series begins with *Te atua* (*The God*), which is followed by *Auti te pape* (*The Fresh Water is in Motion*). This contrast between two horizontal scenes of the world of religion and of daily life is followed by the three vertical prints, *Noa Noa*

20. Gauguin's illustration of the Magdalen in *L'Ymagier* (April 1895), 142. Thomson 1987, 167, and Rewald 1956, 548. *Le Coeur* was a short-lived journal, edited and with foreword by Comte Antoine de La Rochefoucault.

21. See Field 1968, 509.

22. Guérin: 1) *Te po*, 2) *Noa Noa*, 3) *Manao tupapau*, 4) *Te faruru*, 5) *Maruru*, 6) *L'Univers est créé*, 7) *Nave nave fenua*, 8) *Te atua*, 9) *Mahna no varua ino*, 10) *Auti te pape*; Kornfeld/Schniewind: 1) *Noa Noa*, 2) *Nave nave fenua*, 3) *Te faruru*, 4) *Auti te pape*, 5) *Te atua*, 6) *L'Univers est créé*, 7) *Mahna no varua ino*, 8) *Manao tupapau*, 9) *Te po*, 10) *Maruru*; Field 1968, 509: 1) *Manao tupapau*, 2) *Nave nave fenua*, 3) *Te faruru*, 4) *Noa Noa*, 5) *Auti te pape*, 6) *Mahna no varua ino*, 7) *Te po*, 8) *Maruru*, 9) *Te atua*, 10) *L'Univers est créé*.

(Fragrance), *Te faruru* (*To Make Love*), and *Nave nave fenua* (*Delightful Land*). From these one is plunged into night with *Te po* (*The Night*), followed by a scene of cult worship, *Maruru* (*To Be Satisfied*). Then the creation of the world, *L'Univers est créé*, is juxtaposed with the last print, *Mahna no varua ino* (*Day of the Evil Spirit*), in which Tahitians gather around a great outdoor fire at night.

This order, if it is indeed that of Gauguin, is very different from Field's suggestion of a cycle. Field proposes what might be termed a full narrative, going from creation (of God, of man, of woman, and of religion), to daily human life (food gathering, bathing, and nocturnal congregation), to a trio of images that includes lovemaking, fear, and death. The first two segments of the sequence are at once unified and logical, but the third has no clear organizing principle. In fact, several of the prints could be described as being about fear, death, and love in equal parts, making it difficult to assign them such a meaning within a larger sequential order.

It is more than likely that there was no prescribed narrative sequence intended by Gauguin. Even the numbers recorded on the back of the Art Institute set could be interpreted as random inventory numbers, because their sequence continues on the backs of other prints unrelated to the Noa Noa set.[23] In fact, Gauguin's mental habits were far from methodical, and he tended to avoid any closed order, even in the creation of his one intentional masterpiece, *Where Do We Come From?* of 1897-1898 (W 561). The text for *Noa Noa* itself was conceived as an open series of scenes or tales, many of which assumed different places in the whole as the manuscript progressed, and, from the very beginning, Gauguin left blanks in his narrative to receive illustrations, poems, or texts written either by different people or at different times.

Gauguin probably began by conceiving of a text with illustrations by himself. As he worked, he realized his own literary shortcomings and asked the advice of others. The collaboration with Charles Morice is well known and often analyzed, but there is some evidence that he also worked with Alfred Jarry. In late 1894 or early 1895, Jarry wrote three poems about paintings by Gauguin, two of which relate to illustrations in the first manuscript of *Noa Noa*: *Ia Orana Maria* and *Manao tupapau*.[24] The young poet stayed in Pont-Aven with Gauguin in June 1894, during the period in which the artist was confined to his bed.[25] Unfortunately for posterity, the collaboration between Gauguin and Jarry never materialized, although they undoubtedly continued to communicate after the summer of 1894.[26]

It is perhaps to Jarry that one can turn for an explanation of the antithetical or dialectical relationship of text to illustration in *Noa Noa* and of the profound, polyvalent nature of the prints. The textual narrative is self-consciously (and artfully) autobiographical and matter-of-fact, the prints diabolical and imaginary. The text takes place in human time and mostly during the day, the woodcuts are set in an eternal night. The order of scenes in the text and the sequence of the woodcuts can be changed at will by the author or the artist, and the new combinations will reveal new meanings to readers and viewers. Gauguin was a storyteller, and he used his works of art as props or cues in his imaginary wanderings. Rippl-Rónai was the only witness whose remembrance of an evening with Gauguin evokes something of the interplay between talking and making that lay at the core of Gauguin's art in his last years in France. We must savor the residue of Gauguin's thoughts in the many fragmentary texts and images he left incomplete at his death.—R.B.

23. According to a recent finding by Peter Zegers.

24. *Noa Noa*, Louvre ms, 75, 125. The poems *Ia orana Maria, L'Homme à la hache, Manao tupapau* were recorded in the *Livre d'or* of the Pension Gloanec with the date of July 1894. Dedicated "Trois poèmes d'après et pour Gauguin." In Jarry 1972, 251-255. Published in *La Revanche de la nuit*, by *Mercure de France* 1949, 598-600.

25. Jarry 1972, 2.

26. There are fascinating parallels between *Noa Noa* (and the life of Gauguin) and Jarry's greatest and weirdest novel, *Gestes et opinions de Dr. Faustroll, Pataphysician*, begun in 1894 and finally published in 1898-1899. There is, in fact, a section of the novel called "De l'isle fragrante" dedicated to Paul Gauguin.

167
Auti te pape

203 x 354 (8 x 14)

woodcut printed in black over selectively applied brush and yellow, rose, orange, blue, and green liquid mediums on japan paper

signed and dated on verso, in pen and brown ink, *PG 15 mars* [changed from *10*]; in graphite, partially deleted, *n 2/no G160*; collector's mark, initials in black ink, *W.G./B* in circle (not in Lugt)

The Art Institute of Chicago. The Clarence Buckingham Collection, 1948.264

EXHIBITION
London 1931, no. 14

CATALOGUES
Gu 35; K 16 IIB

shown in Washington and Chicago only

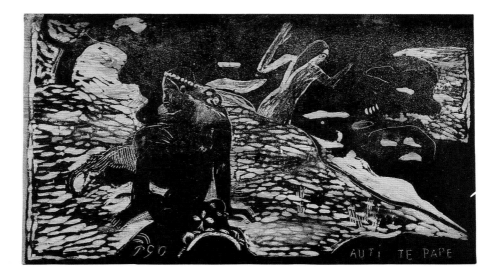

168
Te po

206 x 356 (8⅛ x 14)

woodcut from two separate printings of the same block in brown and black, heightened with orange, blue, rose, and gray water-based colors on japan paper

dated and signed on verso, in pen and brown ink, *15 mars* [changed from *10*]/*PG*; in graphite, *no G160/-6-*; collector's mark, initials in black ink, *W.G./B* in circle (not in Lugt)

The Art Institute of Chicago. The Clarence Buckingham Collection, 1948.253

EXHIBITION
London 1931, no. 4

CATALOGUES
Gu 15; K 21 III

shown in Chicago only

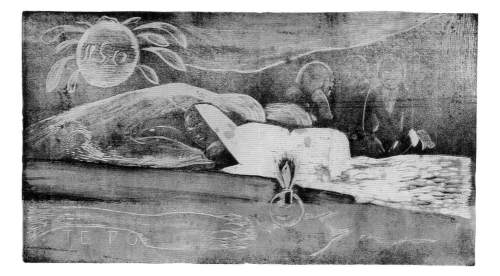

169
Te atua

203 x 352 (8 x 14)

woodcut from two separate printings of the same block in ocher and black over selectively applied green, yellow, and red liquid mediums on japan paper

signed and dated on verso, in pen and brown ink, *PG 15 mars* [changed from *10*]; in graphite, *no G160/n-1-*; collector's mark, initials in black ink, *W.G./B* in circle (not in Lugt)

The Art Institute of Chicago. The Clarence Buckingham Collection, 1948.262

EXHIBITION
London 1931, no. 10

CATALOGUES
Gu 31; K 17 IIIB

shown in Washington and Chicago only

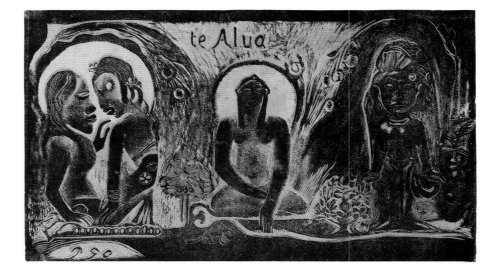

170
Noa Noa

357 x 204 (13⅞ x 8), irregular

woodcut printed in black over selectively applied yellow, ocher, orange-red and green liquid mediums on japan paper, laid down onto presentation mount, trimmed

dated and signed on verso of presentation mount, in pen and brown ink, *15 mars* [changed from *10*] *PG*; in graphite, *-3-*; *no G160*; collectors mark, initials in ink, *W.G./B* in circle (not in Lugt)

The Art Institute of Chicago. The Clarence Buckingham Collection, 1948.255

EXHIBITION
London 1931, no. 1

CATALOGUES
Gu 17; K 13 III

shown in Washington and Chicago only

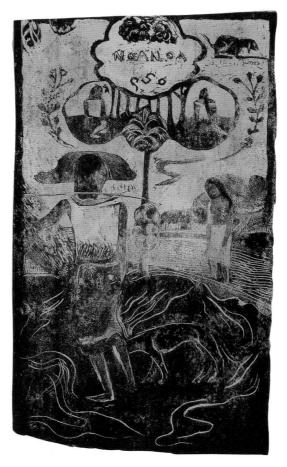

171
Te faruru

356 x 203 (14 x 8)

woodcut from two separate printings of the same block in dark ocher and black over selectively applied yellow and red liquid mediums, heightened with red on japan paper

The Art Institute of Chicago. The Clarence Buckingham Collection, 1950.158

CATALOGUES
Gu 22; K 15 III

shown in Washington and Chicago only

172
Nave nave fenua

354 x 201 (13⅞ x 7⅞)

woodcut printed in black selectively heightened with red, blue, orange, black, and green water-based colors on wove paper

dated and signed on verso in pen and brown ink, *15 Mars* [changed from *10*]/*PG*; in graphite, *n G160/-5-*; collectors mark, initials in black ink, *W.G./B* in circle (not in Lugt)

The Art Institute of Chicago. The Clarence Buckingham Collection, 1948.261

EXHIBITION
London 1931, no. 2

CATALOGUES
Gu 28; K 14 II

shown in Washington and Chicago only

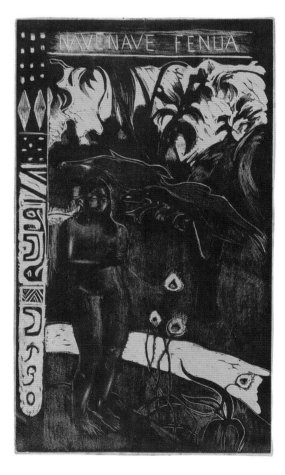

173
Maruru

205 x 355 (8 x 14)

woodcut from two separate printings of the same block in ocher and black over selectively applied red, yellow, and green liquid mediums on wove paper

collector's mark on recto, bottom left, monogram in violet ink, *H.S.* (Lugt 1376, Dr. Heinrich Stinnes)

The Art Institute of Chicago. Gift of Frank B. Hubachek, 1950.1444

CATALOGUES
Gu 24; K 22 IIIB

shown in Washington and Chicago only

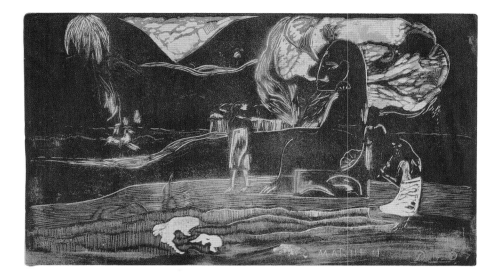

174
L'Univers est créé

203 x 351 (8 x 13¾)

woodcut from two separate printings of the same block in ocher and black over selectively applied orange, blue, green, and yellow liquid mediums on japan paper

inscribed on verso, in graphite, *no G160/-8-*; signed and dated, in pencil and brown ink, *PG 15 Mars* [changed from *10*]; collector's mark, initials in black ink, *W.G./B* in circle (not in Lugt)

The Art Institute of Chicago. The Clarence Buckingham Collection, 1948.259

EXHIBITION
London 1931, no. 5 or 15

CATALOGUES
Gu 26; K 18 IIB

shown in Chicago only

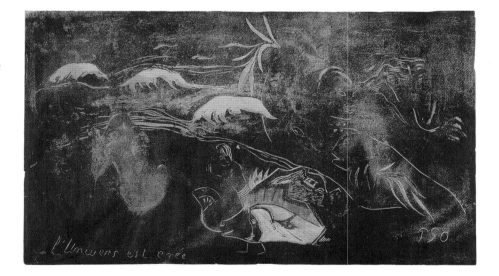

175
Mahna no varua ino

202 x 356 (8 x 14)

woodcut from two separate printings of the same block in olive green and black over selectively applied brush and yellow, green, red, brown, and gray liquid mediums on japan paper, laid down on presentation mount

inscribed on verso of presentation mount in graphite, *no G161/-10-*; collector's mark, initials in black ink, *W.G./B* in circle (not in Lugt)

The Art Institute of Chicago. The Clarence Buckingham Collection, 1948.263

EXHIBITION
London 1931, no. 9

CATALOGUES
Gu 34; K 19 IVB

shown in Washington and Chicago only

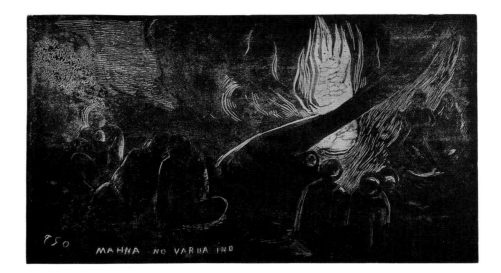

176
Manao tupapau

203 x 356 (8 x 14)

woodcut printed in a combination of brown and black, selectively inked on brown wove paper

The Art Institute of Chicago. The Clarence Buckingham Collection, 1948.256

EXHIBITION
London 1931, no. 20

CATALOGUES
Gu 19; K 20 III

shown in Washington and Chicago only

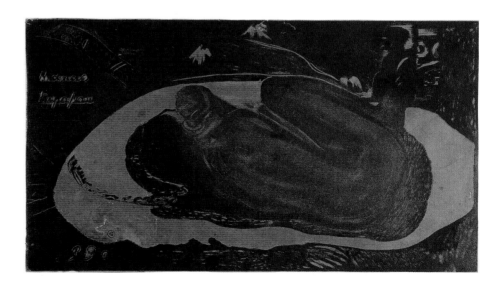

167a Auti te pape

203 x 354 (8 x 14)

woodcut printed in a combination of orange-brown and black, selectively inked, on wove paper

The Art Institute of Chicago. The Frank B. Hubachek Collection, 1954.1191

CATALOGUES
Gu 35, K 16 I

shown in Paris only

167b Auti te pape

203 x 354 (8 x 14)

woodcut printed in black over selectively applied yellow, ocher, and rose liquid mediums on japan paper

The British Museum, London (1949-4-11-3674)

CATALOGUES
Gu 35; K 16 IIA

shown in Paris only

167c Auti te pape

203 x 354 (8 x 14)

woodcut from two separate printings of the same block in ocher and black over selectively applied yellow, rose, and blue liquid mediums on tan wove paper

Lent by The Metropolitan Museum of Art, New York, Harris Brisbane Dick Fund, 1936 (36.6.2)

CATALOGUES
Gu 35; K 16 IIB

shown in Paris only

167d Auti te pape

203 x 354 (8 x 14)

woodcut from two separate printings of the same block in brown and black on paper

Graphische Sammlung Albertina, Vienna

CATALOGUES
Gu 35; K 16 BII

shown in Paris only

168a Te po

206 x 356 (8⅛ x 14)

woodcut printed in a combination of brown and black, selectively inked on tan wove paper

National Gallery of Art, Washington, Rosenwald Collection, 1947.12.55

CATALOGUES
Gu 15; K 21 III

shown in Washington only

168b Te po

206 x 356 (8⅛ x 14)

woodcut from two separate printings of the same block in brown and black on japan paper

Musée des Arts Africains et Océaniens, Paris (AF 14431 [1])

CATALOGUES
Gu 15; K 21 III

shown in Paris only

169a Te atua

204 x 355 (8 x 14)

woodcut from two separate printings of the same block in ocher and black over selectively applied brush and green, yellow, and red liquid mediums on japan paper, laid down on presentation mount

Sterling and Francine Clark Art Institute, Williamstown, Massachusetts

CATALOGUES
Gu 31; K 17 IIIB

shown in Paris only

170a Noa Noa

358 x 204 (14⅛ x 8)

woodcut from two separate printings of the same block in ocher and black over selectively applied yellow and red liquid mediums on wove paper

Musée des Arts Africains et Océaniens, Paris

CATALOGUES
Gu 16; K 13 IIIB

shown in Paris only

171a Te faruru

356 x 203 (14 x 8)

woodcut printed in a combination of brown and black on wove paper

Lent by The Metropolitan Museum of Art, New York, Harris Brisbane Dick Fund, 1936 (36.6.9)

CATALOGUES
Gu 21; K 15 II

shown in Washington only

171b Te faruru

356 x 203 (14 x 8)

woodcut from two separate printings of the same block in a combination of greenish gray and brown, and in black, heightened with brush and rose wash (faded) on japan paper

The Art Institute of Chicago. The Joseph Brooks Fair Collection, 1940.1073

CATALOGUES
Gu 21; K 15 II

shown in Washington only

171c Te faruru

356 x 203 (14 x 8)

woodcut printed in a combination of black and brown, selectively inked on tan wove paper

National Gallery of Art, Washington, Rosenwald Collection, 1947.12.54

CATALOGUES
Gu 21; K 15 II

shown in Washington only

171d Te faruru

356 x 203 (14 x 8)

woodcut from two separate printings of the same block in brown and black over selectively applied ocher liquid mediums, heightened with red, blue, and brown water-based colors and india ink on brown wove paper

inscribed on verso, left to right, in graphite, *no G 160*; signed and dated, in pen and brown ink, *PG/15 mars* [changed from *10*]; in graphite, *-4-*; collector's mark, initials in black ink, *W.G./B* in circle (not in Lugt)

The Art Institute of Chicago. The Clarence Buckingham Collection, 1948.257

CATALOGUES
Gu 21; K 15 II

shown in Washington only

171e Te faruru

356 x 203 (14 x 8)

woodcut from two separate printings of the same block in black over selectively applied ocher, yellow, and red liquid mediums, heightened with black water-based color on tan wove paper

Lent by The Metropolitan Museum of Art, New York, Harris Brisbane Dick Fund, 1936 (36.6.8)

CATALOGUES
Gu 22; K 15 III

shown in Washington only

171f Te faruru

356 x 203 (14 x 8)

woodcut printed in black on wove paper

Museum of Fine Arts, Boston. Bequest of W. G. Russell Allen 60.325

CATALOGUES
Gu 22; K 15 IVA

shown in Washington only

171g Te faruru

356 x 203 (14 x 8)

woodcut from two separate printings of the same block in ocher and black over selectively applied yellow and red liquid mediums on japan paper, laid down on presentation mount

Sterling and Francine Clark Art Institute, Williamstown, Massachusetts

CATALOGUES
Gu 22; K 15 IVB

shown in Washington only

171h Te faruru

356 x 203 (14 x 8)

woodcut printed in black over orange tone block, heightened in red using stencil on japan paper

National Gallery of Art, Washington, Rosenwald Collection, 1952.8.236

CATALOGUES
Gu 22; K 15 V

shown in Washington only

(For 172 a-n, see pages 334-338)

173a Maruru

205 x 355 (8 x 14)

woodcut from two separate printings of the same block in ocher and black over selectively applied yellow and red liquid mediums on japan paper, laid down on presentation mount

Sterling and Francine Clark Art Institute, Williamstown, Massachusetts

CATALOGUES
Gu 24; K 22 IIIB

shown in Paris only

174a L'Univers est créé

205 x 355 (8 x 14)

woodcut from two separate printings of the
same block in ocher and black over selec-
tively applied orange, yellow, and green liq-
uid mediums on japan paper, laid down on
presentation mount

National Gallery of Art, Washington, Rosen-
wald Collection, 1947.12.56

CATALOGUES
Gu 26; K 18 IIB

shown in Washington and Paris only

175a Mahna no varua ino

202 x 356 (8 x 14)

woodcut from two separate printings of the
same block in ocher and black on japan
paper

Musée des Arts Africains et Océaniens, Paris
(AF 14431 [4 bis])

CATALOGUES
Gu 33; K 19 III

shown in Washington only

175b Mahna no varua ino

202 x 356 (8 x 14)

woodcut printed in brown on alizarin
crimson wove paper (altered)

Musée des Arts Africains et Océaniens, Paris
(AF 14431 [4])

CATALOGUES
Gu 33; K 19 III

shown in Paris only

175c Mahna no varua ino

202 x 356 (8 x 14)

woodcut printed in black on wove paper

Josefowitz Collection

CATALOGUES
Gu 34; K 19 IVA

shown in Washington only

175d Mahna no varua ino

202 x 356 (8 x 14)

woodcut from two separate printings of the
same block in olive green and black over
separate yellow and ocher tone "block,"
with selectively applied green and red liquid
mediums on wove paper

Lent by The Metropolitan Museum of Art,
New York, Harris Brisbane Dick Fund, 1936
(36.6.3)

CATALOGUES
Gu 34; K 19 IVB

shown in Washington only

175e Mahna no varua ino

202 x 356 (8 x 14)

woodcut printed in black over yellow, red
and brown tone blocks, selectively height-
ened with brush and orange watercolor on
japan paper.

Museum of Fine Arts, Boston. Bequest of
W. G. Russell Allen 60.12

CATALOGUES
Gu 34; K 19

shown in Washington only

175f Mahna no varua ino

202 x 356 (8 x 14)

woodcut printed in black over selectively
applied orange, yellow, and blue watercolors
on japan paper

National Gallery of Art, Washington, Rosen-
wald Collection, 1950.17.81

CATALOGUES
Gu 34; K 19 D

shown in Washington only

175g Mahna no varua ino

202 x 356 (8 x 14)

woodcut printed in black on china paper

numbered and signed in aniline pencil, top
left, *no 55*; below composition, from left to
right, *Paul Gauguin fait*; *Pola Gauguin imp.*

National Gallery of Art, Washington, Rosen-
wald Collection, 1944.2.34

CATALOGUES
Gu 95; K 19 E

shown in Washington only

176a Manao tupapau

205 x 355 (8 x 14)

woodcut printed in black on wove paper

Musée des Arts Africains et Océaniens, Paris
(AF 14465)

CATALOGUES
Gu 20; K 20 IVA

shown in Paris only

172a-n
Translations of the Nave nave fenua Image and
177-182
Six Related Drawings for Te nave nave fenua

Gauguin's principal activity during his years in Paris was to explain and disseminate his enigmatic Tahitian images to the Parisian public in works of graphic art. His most productive efforts can be loosely categorized as "image translations." Using a painting as a basis, he created various graphic representations of it that can in no sense be considered reproductive. In many cases, the graphic representation is distant enough that one can scarcely recall the original, suggesting that the transformation was more important to Gauguin than the reproduction of his original intentions. This exhibition contains a number of these translations in diverse mediums. Here, the translation and dissemination of a particularly important painting, *Te nave nave fenua* (*The Delightful Land*, cat. 148), is analyzed in detail.

Te nave nave fenua was among the strongest and most memorable paintings in Gauguin's 1893 exhibition. His monumental Tahitian Eve was intended to shock and to titillate the artist's Parisian audience, as well as to create a confrontation of western European religious belief with Far Eastern and Polynesian cultures. Gauguin adapted the painting first as a print and then in a series of drawings and monotypes, several of which may have been intended for publication.

Although it is difficult to establish a firm chronological sequence for all these images, the prints made in connection with the Noa Noa suite are among the earliest. The block was carved in the winter of 1893/1894,[1] and the majority of the impressions printed by Gauguin were made before he went to Brittany for the next summer and autumn. Included in the exhibition are the block (cat. 172a), eleven of the nineteen surviving impressions created by Gauguin, two impressions printed by Louis Roy, perhaps in collaboration with Gauguin (cat. 172l, m), and one pulled from the block after Gauguin's death by his son Pola Gauguin (cat. 172n). Of the impressions printed by Gauguin, there is only one surviving from the first state and three from the second, indicating that these were probably trial proofs created so that Gauguin could evaluate his carving; two impressions of the second state are in the exhibition. There are, however, five impressions in the exhibition from the third state (cats. 172b, d-g) and four printed solely by Gauguin from the fourth (cats. 172h-k), allowing the viewer to study in detail the ways in which Gauguin inked, printed, and subsequently hand-colored individual impressions. In his impressions Gauguin revealed the generative quality of printing, interpreting the block in so many ways that his powers as a printer rival his talents as a carver. It is clear that he was utterly uninterested in making anything resembling a traditional edition of prints from the block.

Among the prints that compose the Noa Noa suite, *Nave nave fenua* most closely resembles its painted source. Gauguin retained the pose, compositional format, and major iconographic elements. He commenced his transformation of the painting with an approximation of a carved house-post that supports the right border of the print. The separate elements in this framing device have a linguistic quality, demanding the viewer to decode them as if they represent words, letters, sounds, or even ideas. Gauguin reinforced this notion by ending it with his famous signature device, "PGO," which is, itself, a code for his name. The title *Nave nave fenua* is carved along the top edge in crude capital letters. The pattern of carved marks that runs from top to bottom along the left edge of the print could very

1. Field 1968, 500.

2. Strindberg had refused to write the preface for the catalogue of Gauguin's 1895 sale at the Hôtel Drouot, because he felt Eve must speak a European language rather than Maori or Turanian. See Paris sale 1895, 3-8. Also published in *L'Eclaire* 1895, 2.

Gauguin, *Nave nave fenua*, woodcut, first state [Bibliothèque Nationale, Paris]

well be the speech of his Tahitian Eve, who, Gauguin imagined, spoke Maori or Turanian.[2]

Within the pictorial arena itself, Gauguin also transformed his painted composition. The painted Eve is a Buddhist giantess with extra toes, whose body fills the entire length of the picture. His printed Eve has a more elegantly attenuated body and stands within a large landscape in which palm trees and exotic foliage sway in the wind above her head. In the print, the once-dominating Eve is dominated by a troubled paradise. The central focus of this proportionally enlarged setting is the great winged lizard, who fights for attention within the tapestry of trees, flowers, and hills in the painting, but fills the very center of Gauguin's landscape in the print. The very restlessness of the setting suggests that this smaller Eve of the print will soon be attacked by the flying reptile, whose claws are poised to grasp her neck.

The first two impressions were printed in black and have no hand coloring or double printing. In the first, the forms are virtually illegible; however, he retained copies of it, as if to suggest that its vagaries of form appealed to him. The second state (cats. 172, 172c) has most of the major elements of the composition. The nude woman is fully defined, the great lizard makes its dramatic appearance, and the forms of the flowers in the foreground glow against the inky blackness of the landscape.

The remaining impressions are of fabulous beauty and variety. In some, Eve herself is virtually invisible, her body merging with the blackness of her setting almost as if night had fallen over paradise and the monster is a product of her dreams. In others, the monster scarcely exists, his body and wings combined in an inky mass surmounted by a trembling line. Certain of the impressions are deliberately off register, printed first in brown, gray, or beige and then again in black, Gauguin having moved the paper so that the resulting image appears to wobble or vibrate. This effect of instability heightens the emotional frenzy of the print.

When considered together, the various monotype-like impressions from a single block have an undeniable expressive force. Indeed, one can almost argue that each impression needs its companions in order to be read. What is clear in one is indistinct in another, and only when one sees a group of the prints does the deliberateness of Gauguin's transformations become apparent. We must remember, of course, that Gauguin saw Pissarro's various impressions from the same etched plate in a single frame at the impressionist exhibition of 1880.[3] Gauguin's translations from the block are much more extreme than those of Pissarro, and, when one sees Gauguin's prints together, one witnesses a mythic struggle between Eve and the monster, between paradise and damnation, between man and beast.

When Gauguin loaned the block to his friend Louis Roy, the edition Roy pulled from it emphasized all the elements in this mythic struggle equally. Eve is always strongly present, and the chimera has all of his feet and both of his wings. The landscape is legible, and the "peacock flowers" actually do seem to distract poor Eve from her plight. Perhaps because of their clarity of form, the Roy impressions have been consistently denigrated by students of Gauguin's graphic oeuvre. However, we must remember that all evidence points to the fact that Gauguin collaborated on the printing of this edition,[4] at least in its initial stages, and that

3. *5ᵉᵐ Exposition de Peinture*, 1–30 April (Paris, 1880), cats. 139–143.

4. Kornfeld 1988, no. 14.

5. "Pas écouter li li menteur."

6. See note 3.

7. W 333.

8. Malingue 1949, XCI.

9. W 532.

10. Julien Munhall, *Ingres and the Comtesse d'Haussonville* (New York, 1986), ch. 7, "Costume," 102-103.

the Roy impressions have an infinitely greater power and clarity than the delicate prints made from Gauguin's blocks by his son Pola. These posthumous impressions are carefully and evenly inked, so that each tiny line scratched in the block by Gauguin is printed. Gone are the nuanced colors, the double printing, the clotted, overinked passages, and the mystery of either Gauguin's or Gauguin-Roy's impressions.

Gauguin's fascination with *Te nave nave fenua* did not stop with the making and printing of the woodblock. In fact, the image of Eve and her chimera obsessed him throughout much of the rest of 1894 and 1895, and the figure appeared as late as 1898-1899 as a watercolor in the final manuscript version of *Noa Noa* and in one of the late group of woodcut prints sent to Vollard early in 1900 (cat. 235). The first translation of the subject is a drawing in the National Gallery of Art that is utterly dependent on the print (cat. 177). Its inscription in pidgin French, "Don't listen to the liar,"[5] must surely relate to an argument with August Strindberg,[6] but it also has a longer history in Gauguin's oeuvre. Gauguin himself had placed the identical inscription on a watercolor called *Eve Bretonne*[7] before the Volpini exhibition of 1889, and apparently erased it after being criticized by Jules Antoine for presuming to know that Eve spoke that particular jargon! In a letter, Gauguin admitted, "It seems that Eve did not speak pidgin, but good Lord, what language did she speak, she and the serpent?"[8] Gauguin also used similar pidgin French in a small still life inscribed with a date of April 1894.[9]

The pidgin inscription does inject a welcome note of humor into this troubling drawing. Like the prints from the *Noa Noa* series, the drawing is the very antithesis of the golden-skinned Eve in an opulent, colorful landscape. Here, we see a figure more akin to Baudelaire's "Black Venus," who seeks enlightenment in darkness. Aglow with white, the little stream and the fantastical flowers suggest an eerie moonlight, while the glossy black india ink shimmers, heightening the mood of anxiety. The supernatural light seems, moreover, to be colored by emanations from the red-winged lizard, enlarged here as in the woodcuts, but rendered with greater clarity. The National Gallery drawing has more concentrated energy than the woodcuts, avoiding the distracting presence of the carved framing device in the print. Yet it is only a step on a path toward greater clarity that Gauguin was to pursue first in a drawing in the British Rail Pension Fund and then in three color transfers made from it.

These four works were based not on the painting, but on the preparatory drawing that Gauguin made for it now in Des Moines (cat. 149). This irregular sheet was reworked extensively by Gauguin, most probably in 1894, when he made the similar pastel transfer (cat. 162) and the Brooklyn pastel (cat. no. 163). Gauguin probably borrowed the small figure of Eve in the British Rail Pension Fund collection directly from the large preparatory drawing. In the smaller drawing, he concentrated his attention on the figure of Eve herself, placing her directly in the center of the sheet and avoiding almost altogether the chimera that had preoccupied him in the earlier translations of the painting. If the woodblock prints stress the ambiguity of the chimera, the British Rail Pension Fund drawing and its related monotypes emphasize Eve. In translating her from the preparatory drawing, Gauguin made her shoulders thinner, her face more agreeable, and her breasts firmer. He also provided her with a then-fashionable slave bracelet.[10] Because he derived her from the preparatory drawing in which she has no hand, he had to invent a hand, and the various reworkings in this area attest to his dissatisfaction with that part of the drawing and suggest that it was made in

11. F 3, *Te fare Maorie (The Tahitian Hut)*, whereabouts unknown.

12. No. 61?, *Chaumière*, 40 francs.

Brittany, where he had no access to the painting. Interestingly, there are two studies on the verso of the drawing, one of which was used in another monotype made in the summer of 1894[11] and bought by Degas at the Gauguin sale in 1895.[12]

When Gauguin achieved the form of his newly idealized Eve, he made three color transfers. While in most other cases he printed these from a watercolor or gouache drawing matrix (see cat. nos. 192-199), he seems to have employed a different technique here. Since all three surviving works are absolutely identical in scale and proportion to the figure and minimal setting in the British Rail Pension Fund drawing, and since there is no evidence that this drawing acted as a matrix itself, one must create a hypothesis. Peter Zegers has suggested that Gauguin used a sheet of glass as an intermediary matrix, placing it on top of the drawing, painting on it with water-based colors, and then printing the traced image. By this method, each print could be made unique. In this way, the *Te nave nave fenua* transfers could be viewed as true monotypes, made roughly in the manner employed by Degas, whose monotypes Gauguin has seen, rather than watercolor transfers.

The color transfers lead us to the superb watercolor of this subject at the Musée des Beaux-Arts in Grenoble (cat. 182). This pointillist watercolor is unique in Gauguin's oeuvre, and has long puzzled scholars. Virtually everyone accepts a date of 1892 because of its connection to the painting. However, when seen in the context of the monotypes of 1894, its similarities to them in composition and scale preclude an earlier date. The only similarly created drawing in Gauguin's oeuvre is a technically related watercolor of a head seen in fragmentary form underneath the endpaper of his manuscript, *Cahier pour Aline*.

However, none of this helps us to place the Grenoble watercolor. Its assured handling, its lack of a relationship in scale with another work in the group, and its stylistic distinctness all conspire against an early date. Gauguin approximated the technique of neo-impressionism more closely in this small watercolor than at any point in his career, even though he detested the scientific color theory of Seurat and Signac.[13] There is little hint of subversive or satirical intention in it. Indeed, he followed the drawn contours of the forms with dots for a dual purpose, as if to mimic the device of pricking a drawing for transfer to the canvas, as he had in 1892 when transferring the body of Eve from the large drawing in Des Moines to the painting (cat. 149). It seems increasingly clear that he finished that drawing in connection with the watercolor transfers of 1894, and one can easily imagine this superb watercolor in connection with that later project.–R.B.

13. *Avant et après*, facs., 4.

172a-n
Translations of the Nave nave fenua Image

172a Nave nave fenua

356 x 203 (14 x 8)

boxwood

titled in block along top, in reverse, NAVE NAVE FENUA; signed in block, lower right, monogram, P/G/O; on verso, manufacturer's mark in block, KIESSLING/*J. Lacroix Sucr./Paris*

Museum of Fine Arts, Boston. Bequest of W. G. Russell Allen 60.361

CATALOGUES
Gu 29; K 14

shown in Chicago only

172b Nave nave fenua

356 x 203 (14 x 8)

woodcut printed in black on wove paper

Musée des Arts Africains et Océaniens, Paris (AF 14431 [2])

CATALOGUES
Gu 28; K 14 III

shown in Paris only

172c Nave nave fenua

356 x 203 (14 x 8)

woodcut printed in black on wove paper

National Gallery of Art, Washington, Rosenwald Collection, 1947.12.53

CATALOGUES
Gu 28; K 14 II

shown in Chicago only

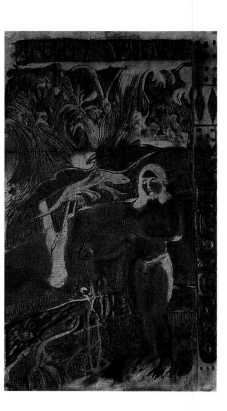

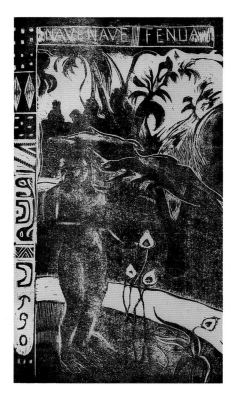

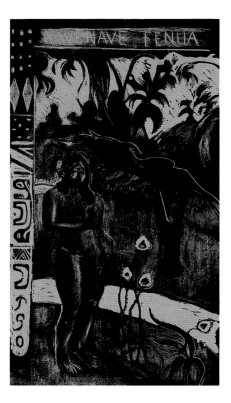

172d Nave nave fenua

356 x 203 (14 x 8)

woodcut printed in black on wove paper

Musée des Arts Africains et Océaniens, Paris
(AF 14431 [2 *bis*])

CATALOGUES
Gu 28; K 14 III

shown in Chicago only

172e Nave nave fenua

356 x 203 (14 x 8)

woodcut printed in black selectively height-
ened with brush and black and brown water-
based colors on wove paper, laid down on
presentation mount

Lent by The Metropolitan Museum of Art,
New York, Rogers Fund, 1922 (22.26.11)

CATALOGUES
Gu 28; K 14 III

shown in Chicago only

172f Nave nave fenua

356 x 203 (14 x 8)

woodcut printed in brownish-black on tan
wove paper

Museum of Fine Arts, Boston. Bequest of
W. G. Russell Allen 60.331

CATALOGUES
Gu 28; K 14 III

shown in Chicago only

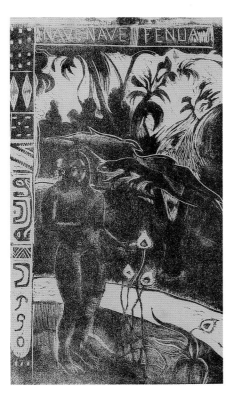

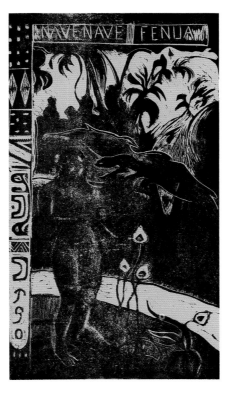

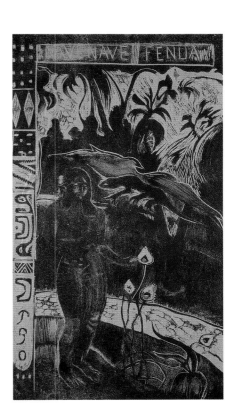

172g Nave nave fenua

356 x 203 (14 x 8)

woodcut printed in brown mixed with residual black ink from previous printings on tan wove paper

The Art Institute of Chicago. Gift of the Print and Drawing Club, 1945.92

CATALOGUES
Gu 28; K 14 III

shown in Chicago only

172h Nave nave fenua

355 x 205 (14 x 8)

woodcut from two separate printings of the same block in ocher and black over selectively applied ocher and green liquid mediums on wove paper

Lent by The Metropolitan Museum of Art, New York, Harris Brisbane Dick Fund, 1936 (36.6.4)

CATALOGUES
Gu 29; K 14 IVB

shown in Chicago only

172i Nave nave fenua

356 x 203 (14 x 8)

woodcut from three separate printings of the same block, once in ocher, twice in black, over selectively applied ocher and green liquid mediums on wove paper

Lent by The Metropolitan Museum of Art, New York, Harris Brisbane Dick Fund, 1936 (36.6.5)

CATALOGUES
Gu 29; K 14 IVB

shown in Chicago only

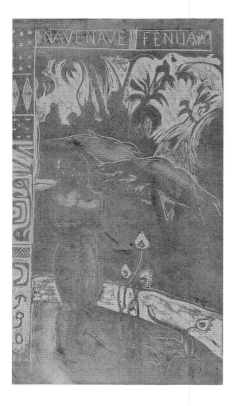
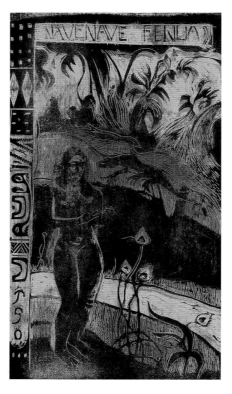
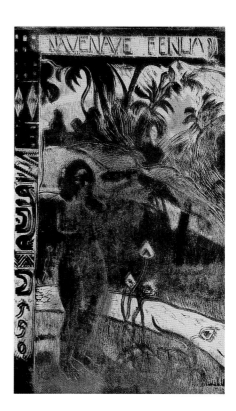

172j Nave nave fenua

356 x 203 (14 x 8)

Woodcut from two separate printings of the
same block in ocher and black over selec-
tively applied yellow, red, and green liquid
mediums on japan paper

private collection

CATALOGUES
Gu 29; K 14 IVB

shown in Chicago only

172k Nave nave fenua

356 x 203 (14 x 8)

woodcut from two separate printings of the
same block in ocher and black over separate
yellow tone "block," selectively heightened
with red liquid medium on japan paper

Edward McCormick Blair

CATALOGUES
Gu 29; K 14 IVB

shown in Chicago only

172l Nave nave fenua

356 x 203 (14 x 8)

woodcut printed in black over yellow,
orange, and red tone blocks on japan paper

Sterling and Francine Clark Art Institute,
Williamstown, Massachusetts

CATALOGUES
Gu 29; K 14 IVC

shown in Chicago only

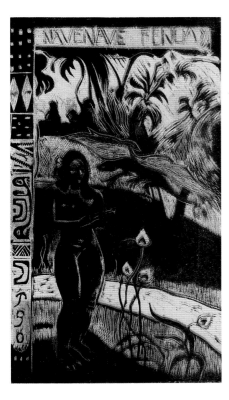

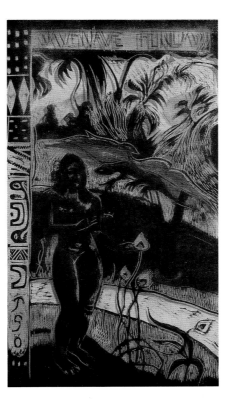

172m Nave nave fenua

356 x 203 (14 x 8)

woodcut printed in black over yellow, orange, and red tone blocks on japan paper

Dr. and Mrs. Martin L. Gecht

CATALOGUES
Gu 29; K 14 IVC

shown in Chicago only

172n Nave nave fenua

356 x 203 (14 x 8)

woodcut printed in black on china paper

numbered and signed, in aniline pencil, top left, *no 50*; below composition, from left to right, *Paul Gauguin fait*; *Pola Gauguin imp.*

The Art Institute of Chicago. Gift of the Print and Drawing Club, 1924.1201

CATALOGUES
Gu 28; K 14 IVD

shown in Chicago only

probably 1894

419 x 260 (16½ x 10¼)

brush, gouache, and india ink with pen and india ink on dark tan wove paper

titled and signed along top in brush and ink, *Pas Ecouter li/li menteur.- / PGO*; numbered, top left, in blue crayon pencil, *12*

National Gallery of Art, Washington, Rosenwald Collection

EXHIBITIONS
(?) Sale, Paris 1895, no. 62; Paris 1906, no. 34, *Pas écouter li; li menteur*

shown in Chicago only

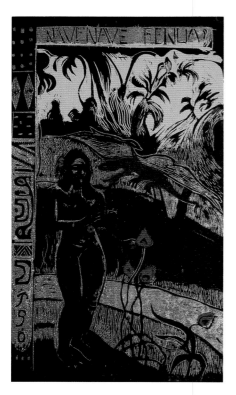

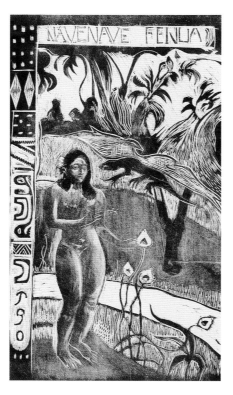

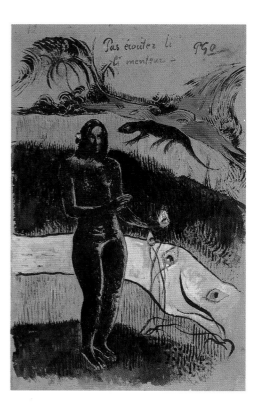

178
Standing Nude Tahitian Woman, Te nave nave fenua (recto); Standing Tahitian Man Swinging a Hatchet, and Two Seated Women (verso)

around 1894

475 x 313 (18¾ x 12¼)

charcoal on laid paper

watermark: *Lalanne*

British Rail Pension Fund Collection, London

shown in Chicago only

179
Te nave nave fenua

1894

405 x 242 (16 x 9½)

watercolor monotype selectively heightened with brush and water-based colors on japan paper

signed, lower right, with artist's stamp, *PGO*

Museum of Fine Arts, Boston. Bequest of W. G. Russell Allen 60.368

CATALOGUE
F 6

shown in Chicago only

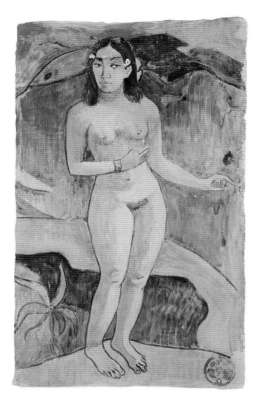

180
Te nave nave fenua

1894

395 x 245 (15½ x 9⅝), irregular

watercolor monotype selectively heightened with brush and water-based colors and white chalk on japan paper

signed, lower left, with artist's stamp, *PGO*

private collection

EXHIBITION
Philadelphia 1973, 7

CATALOGUE
F 7

shown in Chicago only

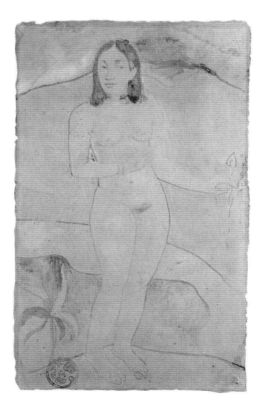

181
Te nave nave fenua

341

1894

384 x 223 (15⅛ x 8¾), irregular

watercolor monotype selectively heightened
with brush and water-based colors on japan
paper, laid down on presentation mount; the
presentation mount consists of one-ply
pasteboard faced with mottled-blue and
white wove papers; a Roy impression of *Ma-
ruru* (cat. 173) is glued to the verso

signed, lower left, with artist's stamp, *PGO*;
dedicated and signed below on presentation
mount, in brush and blue watercolor, *à mon
President J. Dolent/P. Gauguin*

uncatalogued

Courtesy of Libby Howie Prints and
Drawings

shown in Chicago only

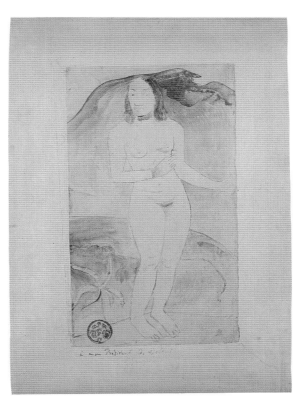

182
Te nave nave fenua

around 1892

400 x 320 (15¾ x 12½)

brush and gouache on wove paper

Musée de Grenoble

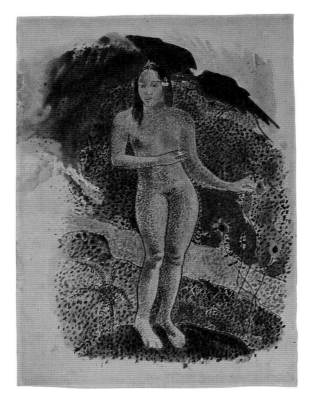

341

183
Drawing after The Man with an Ax

1893–1894

388 x 280 (15⅛ x 11), irregular

pen and brown ink and india ink heightened with brush and gouache on tracing paper, once folded and presently mounted on two sheets of wove paper

signed and dedicated at bottom center in pen and brown ink, *PGo / à l'ami Daniel*

Edward McCormick Blair

shown in Washington and Chicago only

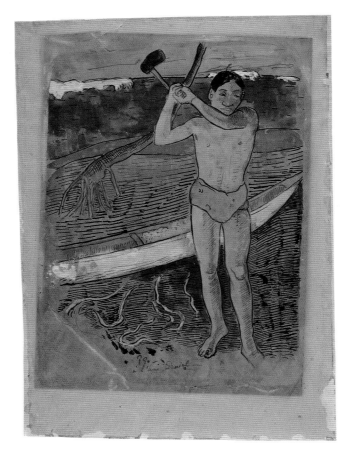

1. "Fendeur de bois," Dorival 1954, 2.

2. Durand-Ruel Gallery, Paris, 9-25 November 1893.

3. *Noa Noa*, Louvre ms, 38-39.

4. "L'Homme à la hache," recorded in the *Livre d'or* of the Pension Gloanec, dated July 1894. Quimper 1950, 25.

The painting *The Man with the Ax* (W 430), dated 1891 and listed in Gauguin's inventory of 1892 as "Woodcutter,"[1] was exhibited in the 1893 Gauguin exhibition.[2] The artist evidently considered it among the most important works there, because he included a literary evocation of it in the draft manuscript of *Noa Noa* in the winter of 1893–1894.[3] Because there is no evidence of Gauguin's interest in literary texts or illustrated manuscripts dating from the Tahitian period, it is unlikely that this small reduction of the painting was made in preparation for the painting, but instead as an illustration for the manuscript. A poetic translation of the painting was written by Alfred Jarry late in 1893 or possibly in the summer of 1894.[4]

Gauguin's prose translation of the image first sets the scene, then concentrates on the figure. "Near my hut [in Mataiea] there was another hut (*Fare amu*, house to eat in). Nearby a native canoe—while the diseased coconut palm looked like a huge parrot, with its golden tail drooping and a huge bunch of coconuts grasped in its claws. The nearly naked man was wielding with both hands a heavy ax that left, at the top of the stroke, its blue imprint on the silvery sky and, as it came down, its incision on the dead tree, which would instantly live once more in a moment of flames—age-old heat, treasured up each day. On the ground, purple with long, serpentine, copper-colored leaves, a whole oriental vocabulary—letters (it seemed to me) of an unknown, mysterious language. I seemed to see the word, of Oceanic origin: *Atua*, God. As *Taäta* or *Takata*, it reached India and is found everywhere or in everything (Religion of Buddha): In the eyes of Tathagata, all the

fullest magnificence of the kings and their ministers are merely like spittle and dust./ In his eyes purity and impurity dance like the dance of the six *nagas*. In his eyes, the search for the way of the Buddha is like flowers set before a man's eyes./ A woman was stowing nets in the native canoe, and the horizon of the blue sea was broken by the green of the waves' crests against the coral breakers."[5]

By contrast, Jarry's poem strays less insistently into comparative religion than Gauguin's and stresses the setting and the male figure, without mentioning the female figure that is an integral part of both Gauguin's description and the painting.

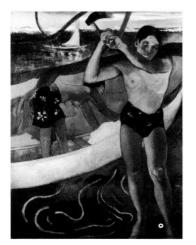

Gauguin, *Man with an Ax*, 1891, oil on canvas [Galerie Beyeler, Basel]

The Man with the Ax
> After and for P. Gauguin
> On the horizon, with sea-mists blown,
> Vague hazards roar and moan;
> Waves, our demons we array
> Where troughs of mountains shift and sway.
>
> Where we sweep into a bay
> A giant towers above the clay.
> We crawl beneath him, lizards, prone.
> Whilst, like a Caesar on his throne
>
> Or on a marble column, he
> Carves a boat out of a tree,
> Astride in it will give us chase
>
> To where the leagues' green limits lie.
> From shore his copper arms in space
> Upraise the blue ax to the sky.[6]

5. Wadley 1985, 17-19.

6. Translated by Simon Watson Taylor in Roger Shattuck and Simon Watson Taylor, eds., *Selected Works of Alfred Jarry* (New York, 1965), 97.

The drawing itself relates more closely to Jarry's text than it does to Gauguin's, and it is possible, even likely, that Gauguin made the drawing in Pont-Aven during Jarry's visit in June and early July of 1894. Stylistically, the drawing is very close to the illustrations in the manuscript *Ancien Culte Mahorie*, which was probably also made in 1893–1894 after Gauguin's arrival in Paris. The paper suggests that it was traced from another work. However, it is smaller than the figure in the painting, nor does it correspond to any other work from the mid-nineties. Perhaps the drawing was made by Gauguin to serve as an illustration for Jarry's text.

The simplifications of the painting can be explained by the reduction in scale. The extraneous figure and the background canoe were omitted so that the composition would be clearly legible. The coloring of the drawing corresponds with the painting, but with differences to reduce the palette, perhaps for printing, to four simple colors. The drawing was folded in quarters, perhaps to be sent to a printer or to Jarry.

Technically, the drawing is complex. Using what appears to be a reed pen, Gauguin first made the drawing in brown writing ink. He then redrew many of the contours and added rhythmic lines with india ink before coloring the work with gouache. He left the underdrawing uncovered in the figure itself, strengthening only the contours and major forms and leaving the hatched shading pale. Because tracing paper is nonabsorbent, the gouache puddled before drying. After the sheet had been folded, Gauguin mounted it onto a secondary support, repairing the missing rectangular region in the lower right corner. This may have been done when he dedicated the drawing to his friend Daniel de Monfreid, undoubtedly before his return to Tahiti in 1895.–R.B.

184
Pape moe

1893–1894

354 x 256 (13¾ x 10)

pen and ink, brush and watercolor, on wove paper; signed at bottom right with decorative initials in pen and brown ink, *PGO*

The Art Institute of Chicago. Gift of Mrs. Emily Crane Chadbourne

EXHIBITIONS
New York 1913, no. 180; New York 1946, no. 45; Chicago 1959, no. 109; Philadelphia 1973, not in catalogue

shown in Washington and Chicago only

1. cat. 157

2. Loize 1966, 31; trans. in Wadley 1985, 32.

3. Loize 1966, 58, 59; See the Louvre ms, 89-92. Also in Louvre ms there is another poem entitled "Pape Moe I" that is not related to the painting, but refers to the *Mango Tree*, cats. 200 and 201.

4. A selection of these pen and ink, brush and wash drawings on coarse-textured watercolor paper are known to us firsthand (see for example Philadelphia 1973, 48 nn. 17-19; Washington 1978, nos. 38 and 39). Others are known to us from photographic records (Druet/Vizzavona; Rewald 1958, nos. 78, 85, and 87; Pickvance 1970, no. 85). A few have actually been reproduced photomechanically in such publications as *Mercure de France* (drawing after Puvis de Chavannes; *Hope*, 163, February 1895), and *l'Epreuve* (*la orana Maria* G 51/K 26 and *Two Maori Women Crouching* G 87; Tokyo 1987, no. 102, illustrated). In turn this body of wash drawings is related closely to and at times confused with some of the watercolor transfers, displaying similar textural

This superb watercolor drawing was made after the famous painting in the Bührle Collection,[1] which was one of the principal works in Gauguin's 1893 exhibition. Gauguin described the scene in *Noa Noa*: "Reaching a detour what I saw — Description of the picture *Pape moe* [Mysterious Water] — I had made no sound, when she had finished drinking she took water in her hands and poured it over her breasts, then, as an uneasy antelope instinctively senses a stranger, she gazed hard at the thicket where I was hidden. Violently she dived, crying out the word *tachae* (fierce) . . . I rushed to look down into the water: vanished. Only a huge eel writhed between the small stones of the bottom."[2] The painting was also the subject of a poem by Charles Morice, which was probably written as part of a collaborative book about Gauguin's travels, and is included in the Louvre manuscript of *Noa Noa*.[3]

Richard Field and Peter Zegers identified at least thirteen technically related works.[4] All of them are "dry-brush" watercolors and wash drawings, in which the paper is kept dry and the image created with a less than saturated brush. Gauguin applied such washes to a granular, coarse-textured paper, and the effect is similar to that of a scumbled surface in oil painting. Certain colors penetrate all the fibers of the paper, while others, applied either drier or with a lighter touch, skim the peaks of the paper surface, allowing the viewer to perceive either the paper itself or another color that has saturated it fully. It is well known that the image of the girl at the waterfall was based on a photograph taken by Charles Spitz,[5] Gauguin's friend and photographer for the Paris magazine *L'Illustration*.

qualities, albeit altered by transferring and additional reworking. This aspect of Gauguin's work will be dealt with in depth in a forthcoming publication by Douglas Druick and Peter Zegers.

5. Charles Spitz, "Végétation sous le vent," (c. 1890). Reproduced in *Autour du monde*, vol. 3 (Paris, c. 1899), ed. Boulanger, pl. CCCXLI. See Field 1977, 165.

6. Field 1968, 510.

7. Letter from Morice to Gauguin, Brussels, 5 March 1897. Bengt Danielsson archives.

8. Letter from Morice to Gauguin, Watermael, Belgium, 22 May 1901; Joly-Segalen 1950, 217.

There is a letter to Gauguin from Morice dated 5 March 1897 that may refer to these particular wash drawings. If so, one can easily deduce that they were made as part of yet another cycle of illustrations for a published version of *Noa Noa*, and that they, like the other cycles, were unsuitable.[6] According to Morice, "It is impossible to reproduce your drawings by the process: the colors do not come out and the grain of the paper does. I would like to know if you authorize me to have them reproduced by an artist who understands you. Séguin, for example. Or, if I should publish only the text."[7] We do not know what reproductive process Morice referred to or whether he was negotiating with the eventual publishers of *La Plume*. However, it is clear that he kept these wash drawings along with the various copies of the manuscript in his possession after Gauguin returned to Tahiti.[8] This, together with the similarity of these wash drawings to certain of Gauguin's watercolor transfers from the summer and early fall of 1894, suggests that they were made simultaneously.—R.B.

185-189
Five Woodcuts from Manao tupapau

Gauguin, *Manao tupapau*, lithograph, 1894 [The Art Institute of Chicago, Gift of Jeffrey Shedd]

Gauguin, *Te poipoi* (*The Morning*), 1892, oil on canvas [Payne Middleton]

1. Gu 39, K 27.

2. K 30.

During the summer of 1894, while living in Brittany, Gauguin made the largest and most impressive woodcut of his career (cat. 185). The artist brilliantly hand-colored impressions of this print, which represents a woman in the fetal position, in an imaginary pond in the midst of a Tahitian village. Earlier, Gauguin had used a similar figure in a vague setting. He titled these images *Manao tupapau* (The Specter Watches over Her). These were, in every sense, the opposite of the reclining female in an interior that Gauguin has also called *Manao tupapau* and that had served as the subject not only for Gauguin's most prized painting from the first Tahitian period (cat. 154), but also for his most recent lithograph (Gu 50). In one, an adult woman awaits her own birth; in the other, she reacts in terror to the spirit of the dead. Gauguin linked forever these disparate images by giving them the same title.

Gauguin reinforced the link by carving the face and upper body of the frightened Tehamana from the painting into the reverse of the huge block.[1] Lacking materials in Brittany, after Gauguin had carved and printed the recto of the block, he carved smaller scenes into its verso. One impression in the Musée des Arts Africains et Océaniens[2] contains three such scenes: the head, hands, and upper body of Tehamana from *Manao tupapau*, a portion of the superb Tahitian landscape in the Middleton Collection, with the squatting woman, and a representation of a standing Tahitian on the beach. Each of these had been individually inked before one large sheet was laid on the block and printed. This sheet seems to be the only surviving instance in which we can prove that Gauguin carved multiple images onto a single block, printed them, and then cut the sheet into separate images.

Of the three images on the sheet, two – Tehamana against another Tahitian landscape, and the woman squatting along the lower edge – are immediately juxtaposed. The two images have no apparent relationship in scale or in background, and the psychological quality of each excludes the other. The fact that Gauguin chose not to cut them apart suggests that, in his mind, the two images

were somehow linked. We know from the painting that the squatting woman is urinating Gauguin's intention in juxtaposing this figure with the face and upper torso of a frightened nude may have been to convey a sense of taboo or shame at having been caught unaware.

The *Manao tupapau* woodcut (cat. 189) is a summary reduction, almost an intensification of Gauguin's famous painting. It includes the terrified face of Tehamana and the unseeing profile of the *tupapau* in the background. Yet, because Gauguin excluded the stunning torso and buttocks of Tehamana, one is free to interpret the print as an image of fear rather than as a sexually charged nude. Moving the *tupapau* from the far side of the nude in the painted composition to a position of vigilence near her head concentrated the power of the image.

Perhaps Gauguin intended to carve the entire body of Tehamana and, possibly because of blunders in the carving, he was forced to reduce the composition. While this theory is certainly plausible because of the position of the head and hands of Tehamana on the block, the evidence is inconclusive. There are too few precise similarities between the lithograph and the woodblock print (cat. 189) to prove it, and the likelihood that Gauguin chose simply to carve several small images on the back of a large block is perhaps more plausible.

The various impressions of this block that survive show the extent of Gauguin's experimentation in the printing. In most of them, some of the tacky ink was rolled conventionally into the block while other portions were blotted or sponged with ink diluted with water or another solvent. Both wet and dry areas are found in a single impression, lending an even greater air of the indeterminate to an already ambiguous image.–R.B.

185
Manao tupapau

230 x 400 (9 x 15¾)

woodcut printed in black heightened with brush and water-based colors on japan paper

Edward McCormick Blair

CATALOGUES
Gu 36; K 29 III

shown in Washington only

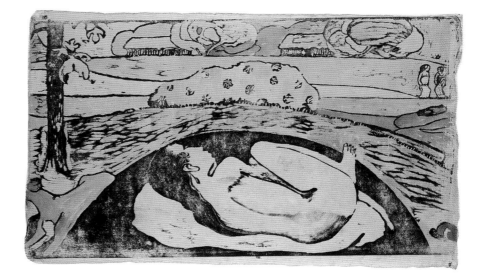

186
Manao tupapau

228 x 520 (9 x 20½)

woodcut printed in black over selectively applied water-based colors on japan paper

on verso, collector's mark, initials in black ink, *RH* in circle (Lugt Suppl. 2215b)

The Art Institute of Chicago. The John H. Wrenn Memorial Collection. 1946.341

CATALOGUES
Gu 36; K 29 III

shown in Chicago only

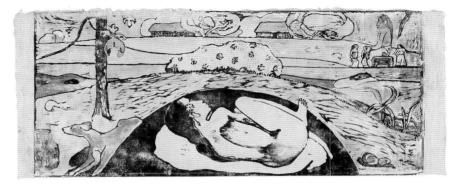

187
Manao tupapau; Standing Maori Woman

410 x 320 (16⅛ x 12½)

woodcut from two separate printings of the same block in ocher and red-brown on laid paper

Musée des Arts Africains et Océaniens, Paris (AF 14464)

CATALOGUES
Gu 40-41; K 30 ABC

shown in Paris only

347

188
Maori Woman in the Forest; Manao tupapau

225 x 256 (8⅞ x 10⅛)

woodcut printed in black on japan paper

Sterling and Francine Clark Art Institute,
Williamstown, Massachusetts

CATALOGUES
Gu 40-41; K 30 AB

shown in Paris only

189
Manao tupapau

170 x 120 (6⅝ x 4¾) irregular

woodcut printed in black selectively worked
with brush and solvent on japan paper

The Art Institute of Chicago. Gift of the Print
and Drawing Club. 1950.109

CATALOGUES
Gu 40; K 30 A

shown in Paris only

190
The Young Christian Girl

1894

65 x 46 (25⅜ x 18)

oil on canvas

signed and dated at lower right,
P Gauguin 94

Sterling and Francine Clark Art Institute,
Williamstown, Massachusetts

EXHIBITIONS
Edinburgh 1955, no. 50; Paris 1960, no. 128;
Munich 1960, no. 62

CATALOGUE
W 518 as *Bretonne en prière*

1. As has been suggested by Charles Stuckey.
See cat. 150.

2. On Annah's style, see Gérard 1951.

This small devotional image is without doubt the finest canvas painted by Gauguin in his last Brittany period. Although a good deal of his time between April and November 1894 was spent on writing *Noa Noa* and working on various prints, transfer drawings, and watercolors with which to adorn the text, he did find time to paint. Yet most of his efforts were of lower quality than the paintings of the 1880s. Only here, in a work with deep art historical resonance, did Gauguin confront Brittany with the force that he had brought to Tahitian subjects.

Gauguin chose a red-haired girl as his model. Her identity, however, remains in question. Was she a Breton girl, or was she the mistress of Daniel de Monfreid, Annette Belfis, to whom Gauguin once gave a wooden Tahitian mask as a token of his thanks for having posed for him?[1] Her surroundings defy easy identification with the title, since there are no religious buildings in the setting to help us explain her actions. There are other oddities about the picture, the most obvious of which is the wonderful yellow dress that is, more than anything else, the visual subject of the picture. Gauguin seems to have brought this missionary dress to Brittany from Tahiti and loaned or given it to his model. He was living at the time with Annah la Javanaise, whose taste in clothes was exotic, and it was perhaps from Annah's wardrobe that this superb Tahitian missionary dress was chosen.[2]

3. Paris 1895, no. 46, as *Jeune chrétienne*.

4. Leclercq 1895, 121. "Between the paintings on the yellow walls of the radiant studio, where color loses nothing of its quality, there are Japanese prints and photographs of old works (Cranach, Holbein, Botticelli) and modern ones (Puvis de Chavannes, Manet, Degas) whose company, so dangerous for others, proves that the master of this house is from the great family, the beautiful family of the strong; of those whose presence inspires him; there are also sketches by Odilon Redon, paintings by Cézanne and van Gogh."

5. The dates of the Brussels trip are 16–22 February.

6. Medieval Renaissance woodcut imagery decorating *l'Epreuve*, see chapter *Noa Noa*.

7. Just as Gauguin alluded to Judith, the thirteen-year-old daughter of his composer neighbor, William Molard, in the title of *Aita tamari*, the fair-skinned virginal girl of *Jeune chrétienne* may too be an indirect reference to her. Certainly she was in his thoughts at this time, as she asked her father if she could come to Brittany where, Gauguin assured Molard, he would treat her "as a father should." Malingue 1949, CLI, letter to Molard, 259.

The girl's hair falls loosely on her shoulders, like that of a Tahitian or a very young girl. The image is so different from the numerous representations of praying Breton women coiffed in their local style and dressed in gray and black, which abound in paintings made in that region during the 1880s and 1890s, that it makes sense to accept the earliest recorded title for the picture, *The Young Christian Girl*, indicated in the catalogue of the Gauguin sale at the Hôtel Drouot in 1895,[3] rather than the recently used modern title, *Breton Girl in Prayer*.

The painting has strong affinities with portraits and devotional paintings by Flemish and German artists of the Renaissance. We know from Julien Leclercq that Gauguin had photographs of paintings by Cranach and Holbein in his studio on the rue Vercingétorix.[4] Leclercq accompanied Gauguin on a trip to Brussels and Bruges in February of 1894, before the painter arrived in Brittany.[5] They may have seen the fabled collections of northern Renaissance painting at the Royal Museum of Fine Arts in Brussels, and the important collection of Memlings in Bruges. But Gauguin could also have found precedents for this composition without straying farther than the Louvre. The famous Braque Triptych by Rogier van der Weyden contains both a praying Virgin and a side panel of the Magdalen that have affinities with Gauguin's devotional image. All of this suggests that, far from

Van der Weyden, *Braque Triptych*, c. 1450, oil on oak panel
[Musée du Louvre, Paris]

rejecting European art as a source for his new universal primitivism, Gauguin sought models in early Renaissance art. The scale, composition, and dignity of this painting have many prototypes in northern Renaissance painting,[6] proving that Gauguin's intention may not have been to quote from a particular source. Rather, in the manner of many modern artists, from Courbet and Manet to Pissarro and Seurat, Gauguin chose to combine compositional strategies from many sources, and to inject a new life and brilliance of color into these eclectic images.

This young girl exists completely in her own world. The disparity between her Tahitian missionary dress and the obviously Breton landscape means that one cannot link figure and ground to form a regional whole. Rather, this virginal girl possesses a universal innocence and impenetrability, her eyes downcast, her arms protecting her from advances. She is the very opposite in scale, pose, and accessibility from Gauguin's other great painting of a woman from 1893–1894, *Aita tamari vahine Judith te parari* (cat. 160), the dazzling portrait of his naked mistress, Annah.[7] We long to know just who this young girl was and why Gauguin chose to ennoble her. One thing is clear from the painting: by this time, Christianity was for him a religion as foreign as the complex polytheism of the South Seas.—R.B.

191
The Angelus

1894

275 x 300 (10¾ x 11¾), irregular

watercolor transfer on wove paper; laid down on presentation mount

signed at bottom right, in brush and water-color, *PGO*; dedicated, signed, and dated on presentation mount, below composition, right side, in pen and brown ink, *for my friend O Conor/one man of Samoa/ P. Gauguin/1894*

Josefowitz Collection

EXHIBITIONS
London 1966, no. 65; New York 1966; Philadelphia 1973, no. 25

CATALOGUE
F 25

shown in Chicago and Paris only

1. Also Armand Séguin. Malingue 1949, CLII.

2. Between 16–22 February, he went to Brussels with Julien Leclercq to see the opening of "La Libre Esthétique," and to Antwerp and possibly Bruges.

3. See also cat. 190.

This charming work relates directly to a painting Gauguin executed in 1894 in Brittany (cat. 190). He made the color transfer for Roderick O'Conor, the Irish artist he met in Pont-Aven who he had hoped would accompany him to Tahiti.[1] However, O'Conor changed his mind, and Gauguin returned to Tahiti alone.

In many cases, Gauguin borrowed a composition, a figure, or a portion of a composition from a painting as the basis for a transfer. He rarely did the opposite, that is enlarge upon the painting when translating the image, as he did here. Only the red-haired girl in the yellow dress can be found in the painting; neither of her companions, carefully dressed in Breton costume, nor the large landscape setting, derived by Gauguin from a lost transfer (F 28), are here. The translation into a color transfer gives the composition the quality of a miniature.

Gauguin had made the brief trip to Belgium in February of 1894 before this work was made.[2] Perhaps the profile figures of the Breton girls were derived from donor figures in fifteenth-century Flemish paintings he had seen there. Here, they pray with the young girl whose position in the center of this trio of praying girls gives her the character of a devotional image.[3]–R.B.

192-199
Watercolor and Gouache Transfers of Tahitian Themes

Gauguin's first group of watercolor, gouache, and pastel transfers with Tahitian subjects was made in 1894, mostly while he recuperated from his broken leg in Pont-Aven during the summer and early autumn.[1] At that time he was confined largely to his hotel room and worked on a small scale with portable materials. Having finished printing the first impressions of his *Noa Noa* woodcuts, he had already explored the mysterious world of the Tahitian night, and, from the evidence of the color transfers, his new investigations took him resolutely into the Tahitian daytime. These figures are virtually all women who stand talking, sit listlessly, bathe, or preen. Absent are the Tahitian gods, the scenes of group celebration, and the raging fires or lamps of the tropical night.

Gauguin was not alone in making color transfers in 1894, yet there are very few real similarities in style and technique between the color transfers of Gauguin and the monotypes of Degas and Pissarro,[2] and there is no evidence that he had seen the recent color monotypes of his older colleagues. Gauguin's experiments stand alone. In fact, Gauguin himself had made "printed drawings," usually from a pastel matrix, as early as 1887.

As Peter Zegers has discovered, the technique of Gauguin's color transfers is often based quite simply on the principle of taking counterproofs. Gauguin prepared a "matrix" drawing (two of which are in the present exhibition, cats. 161 and 197) using as a medium watercolor, gouache, or pastel – pigments soluble in water. He would then thoroughly dampen another sheet of paper, place it on top of the matrix drawing, and by applying pressure to the back of the dampened sheet with a spoon, release the pigment and thus transfer the design, in reverse, to the second, dampened sheet. He could obtain as many as three transfers from a single matrix, and he strengthened certain weak areas of the transfers or even added additional passages to the resulting impressions. For this reason, no two are exactly alike; most of them are, in fact, hybrids, both print and drawing. There is no direct physical evidence that he further complicated the process by pasting Japanese tissue paper on top of the transfer to make it appear even paler and more distant.[3] On the contrary, the transfers were in most cases made on sheets of relatively thin but sturdy Oriental or European papers.

The figure of a woman in *Tahitian Girl in a Pink Pareu* has no direct counterpart in Gauguin's previous oeuvre, and seems to have been invented for the occasion. The matrix of this transfer, strictly speaking a counterproof, survives (cat. 197), as do two printed versions (cats. 198, 199). The example in the collection of the Art Institute of Chicago, because it seems never to have been mounted, reveals clearly the nature of Gauguin's techniques. Since there are only two major figures on the matrix, Gauguin had no need to put pressure on the entire surface of the paper to print the image. Thus, we can see clear evidence of vigorous spooning on the paper of the print only in the areas of these two figures.

Gauguin's studio exhibition of December 1894 featured a group of color transfers together with the 1893-1894 woodcuts, as well as paintings from the first Tahitian trip. Both Leclercq and Morice mentioned the color transfers in their brief reviews of the exhibition.[4] Physical evidence suggests that Gauguin mounted the small-scale works on one-ply pasteboard covered with mottled blue and white facing papers. In at least one case Gauguin placed two transferred impressions from a single matrix onto one presentation mount. They appeared together in the sale of the contents of Degas' studio in 1918,[5] were subsequently separated, and are here reunited (cats. 192, 193). These impressions were transferred on sheets of

1. See chronology, May-September 1894.

2. Shapiro and Melot 1975, 17, and Shapiro in New York 1980.

3. F 9, 59.

4. "Impressions en couleurs," Morice 1894, 2; "Un procédé d'impression à l'eau," Leclercq 1895, 121.

5. Paris 1918, no. 127, *Parau no varua*: "Two color monotypes of the same composition, under glass."

different sizes, and Gauguin made extensive additions in watercolor to the transferred design, thereby creating two separate works of art taken from the same source. Mounting the transfers together provided the viewer with a clear demonstration of the versatility of the medium. There is also evidence that other transfers were mounted doubly. At least one of them was given the title *Croquis* (sketch) by Gauguin himself, suggesting that the artist wanted these transfers considered drawings rather than prints.[6] Although no pair of originally mounted color transfers survives on an uncut presentation mount, certain transfers have fragments of their original mounts, cut in ways that make it clear that another image was mounted on the same board.

This suggests that the color transfers from 1894 were made in a period of concerted work, to be shown together. Clearly, Gauguin intended a contrast between them and the *Noa Noa* woodcuts as well as with the other woodcuts made during the summer of 1894. In all of these color transfers, Gauguin stressed the soft aspects of form, and it seems as if he wanted to defy the conventions of printing from a hard block or plate. Trees and shrubs were rendered as orbs, and figures were formed from relaxed, calligraphic contours; even the areas of pale, almost evanescent color manage still to retain the quality of wetness. These works could not be discussed in the same way as his exactly contemporary woodcuts, and neither Leclercq nor Morice attempted to do so. Evidently, Gauguin himself was equally fascinated with both, for, when he assembled his final manuscript of *Noa Noa* late in the decade, he pasted works in both mediums, woodcut prints and watercolor/gouache transfers, as well as actual watercolors on the pages of his text.

In spite of the fact that they seem to have been mounted and presented together, the color transfers of 1894 lack a narrative sequence. It is perhaps for that reason that Gauguin may have called them sketches, stressing their informal character. Yet they are anything but spontaneous. On the contrary, they have the collective quality of a daydream or a series of memories. No viewer would imagine that they were made from life. Rather, we are encouraged by their very paleness and subtlety to imagine a lost original, of which they are the residue. In this way, the prints relate to the symbolist aesthetic of artists like Carrière and Redon and writers like Mallarmé, Jarry, and Morice.

These color transfers share a certain casualness and repetitive informality with the small working drawings and watercolors Delacroix made on his first trip to the north of Africa. These might well have been familiar to Gauguin, whose admiration for the first great modern colorist of French art is well known. In fact, Delacroix's Morocco sketchbooks were acquired by the Louvre in 1891,[7] just when Gauguin was in France. It requires no great leap of faith to suspect that Gauguin, on his return from the exotic colony of Tahiti, might turn to the work of his great aesthetic forebear.—R.B.

6. Private collection, Chicago.

7. Delacroix's journal from his trip to Morocco and Spain of January to June 1832, illustrated with numerous sketches, watercolors, and written commentary, was left to the Louvre by Philipe Burty and became part of the collection in 1891.

192
Arearea no varua ino

1894

245 x 165 (9⅝ x 6⅛) irregular

watercolor transfer selectively heightened with brush and water-based colors on japan paper, laid down on presentation mount, which consists of one-ply pasteboard faced with mottled blue and white wove papers, containing on the verso the right half of a Roy impression of *Auti te pape*

signed at lower right, with artist's stamp, *PGO*

National Gallery of Art, Washington, Rosenwald Collection, 1943.3.9078

EXHIBITIONS
Paris 1927, no. 41; Chicago 1959, no. 193; Munich 1960, no. 121; Vienna 1960, no. 60; Philadelphia 1973, no. 8

CATALOGUE
F 8

shown in Washington only

193
Parau no varua

1894

243 x 235 (9½ x 9¼) irregular

watercolor transfer selectively heightened with brush and water-based colors on japan paper, laid down on cardboard of recent manufacture

entitled at top right, in brush and watercolor, *Parau no Varua*; signed at top right, with artist's stamp, *PGO*

Dr. and Mrs. Martin L. Gecht

EXHIBITIONS
Paris 1936, no. 123; Philadelphia 1973, no. 9

CATALOGUE
F 9

shown in Washington only

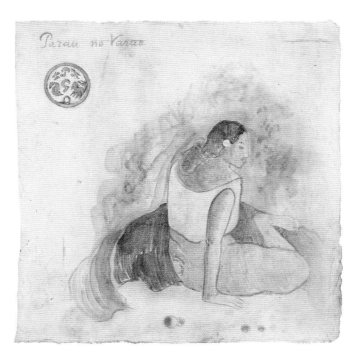

194
Two Standing Tahitian Women (I)

1894

186 x 167 (7¼ x 6⅝)

watercolor transfer selectively heightened with brush and water-based colors on japan paper, laid down on presentation mount

dedicated, signed, and dated below on presentation mount, in graphite, *a' l'ami Baven PGO-1894-*

private collection, Courtesy Anthony d'Offay Gallery, London

EXHIBITIONS
London 1966, no. 64; Zurich 1966, no. 51; Philadelphia 1973, no. 16

CATALOGUE
F 16

shown in Washington only

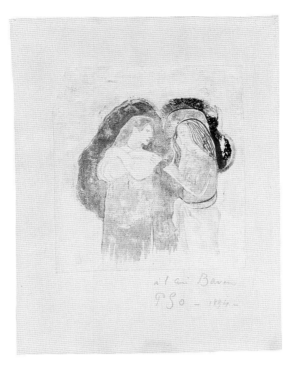

195
Two Standing Tahitian Women (II)

1894

185 x 145 (7¼ x 5¾)

watercolor transfer selectively heightened with brush and water-based colors on japan paper

signed along right edge, in brush and watercolor, *P/G/O*

Fondation Dina Vierny, Paris

EXHIBITIONS
Philadelphia 1973, no. 17; Tokyo 1987, no. 77

CATALOGUE
F 17

shown in Washington only

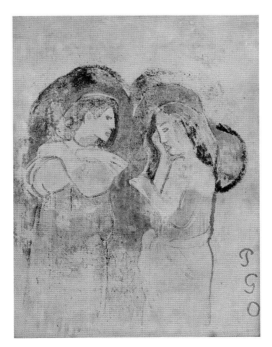

196
Two Standing Tahitian Women (III)

1894

260 x 200 (10¼ x 7⅞)

watercolor transfer selectively heightened with brush and water-based colors on japan paper

signed at lower left, in watercolor, *PGO*

The Cynthia Warrick Kemper Trust

EXHIBITION
Philadelphia 1973, no. 18

CATALOGUE
F 18

shown in Washington only

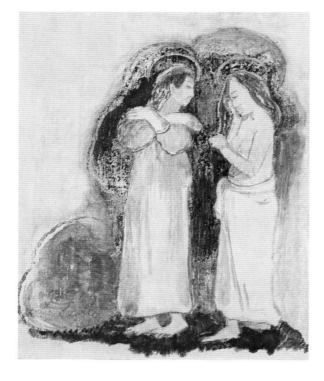

197
Tahitian Girl in a Pink Pareu (I)

1894

250 x 240 (9⅞ x 9⅜)

brush and gouache on cardboard

Collection: William S. Paley

CATALOGUE
W 425

shown in Chicago only

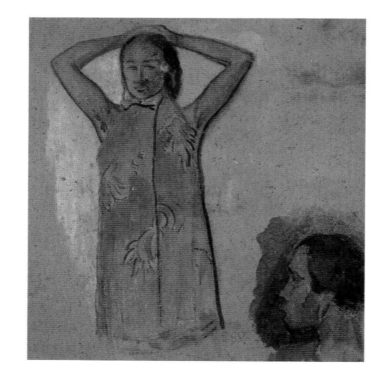

198
Tahitian Girl in a Pink Pareu (II)

357

1894

275 x 268 (10⅞ x 10½)

counterproof from a design in gouache on laid paper

The Art Institute of Chicago. Gift of Walter S. Brewster. 1949.606

EXHIBITIONS
San Francisco 1936, no. 17; Munich 1936, no. 135; Vienna 1960; Philadelphia 1973, no. 22

CATALOGUE
F 22

shown in Chicago only

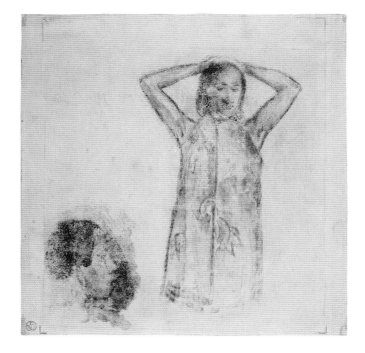

199
Tahitian Girl in a Pink Pareu (III)

1894

300 x 200 (11¾ x 7⅞)

counterproof from a design in gouache on laid paper

watermark, *ED&Cie*

Edward McCormick Blair

EXHIBITIONS
Paris 1926, no. 27; Basel 1928, no. 225; Berlin 1928, no. 221; Philadelphia 1973, no. 21

CATALOGUE
F 21

shown in Chicago only

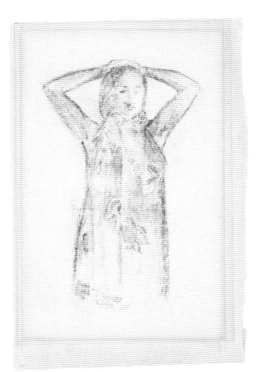

200
Mango Tree

201
Mango Tree

1894

264 x 177 (10¼ x 6⅞)

watercolor transfer selectively heightened
with water-based colors and white chalk on
wove paper, laid down on presentation
mount

signed at bottom right, in brush and water-
color, *OGP*

Département des Arts Graphiques, Musée
du Louvre, Paris (RF 30.256)

EXHIBITION
Philadelphia 1973, no. 4

CATALOGUE
F 4

shown in Chicago only

1894

170 x 177 (6⅝ x 6⅞);
support 240 x 232 (9⅜ x 9)

watercolor transfer selectively heightened
with water-based colors and white chalk on
wove paper; laid down on presentation
mount

signed at bottom left, in brush and water-
color, *PGO*; annotated on presentation
mount along lower right edge in pen and
brown ink, *Paul Gauguin/acheté par Maurice
Clouet, vraisemblablement/à Moline, ami de
Vollard*

Edward McCormick Blair

EXHIBITION
Paris 1936, no. 125

CATALOGUE
F 34

shown in Chicago only

1. See especially *Noa Noa*, Louvre ms, 83-84.
"The great tree, once proud of its foliage;
The tree, now dead, green only with ivy
throws, with a sharp gesture an inhospitable
 shadow
As an obstacle over sea of soil and grass.

O morning! Love hurls its bolts of light
To the sleeping tower the harvest
and the voice of Diana enchants the clearing -
But the humiliated tree desolates the
 horizon. . . ."

These two color transfers were printed from the same matrix, now lost. Because
they are both pale impressions from a watercolor or gouache matrix, each has the
quality of a dream or memory; it is likely that they were made either in Paris or
Brittany, far from the Tahitian scene they represent. In fact, the prototype for the
two is a superb Tahitian landscape of 1892 now in the Hermitage Museum,
Leningrad (cat. 136). The painting represents an enormous mango tree next to a
group of coconut palms at the foot of a mountain.

It is likely that the transfers were made in loose connection with the
preparation of *Noa Noa*, for there are several important passages in the man-
uscript that include either a large mango tree or a dead coconut palm.[1] In these
prints the two elemental trees of Tahiti are orange and yellow, indicating the dry
season. The sun shines brightly, and, in contrast to most of Gauguin's pastoral
representations of Tahiti, the landscape is populated by a horse and rider racing
across the middle ground. This tiny event disturbs the sense of timelessness
and leisure that suffuses so many of Gauguin's impressions of this tropical
paradise.—R.B.

202
Tahitian Landscape (recto); Breton Peasants (verso)

1894

215 x 247 (8⅜ x 9⅝) irregular

watercolor transfer (recto) selectively
heightened with brush and water-based
colors and chalk on wove paper; graphite
(verso)

signed at lower left in brush and watercolor,
PGO

Edward McCormick Blair

shown in Chicago only

1. See cats. 179-181.

2. W 512.

This rarely published Tahitian landscape undoubtedly dates from 1894, when the vast majority of Gauguin's watercolor monotypes and transfers was made. It was not available to Richard Field for inclusion in his catalogue of the monotypes. Technical and stylistic evidence, as well as its genuine signature, makes its attribution to Gauguin inevitable, in spite of the fact that neither a matrix nor another related transfer survives. Judging from the surface quality alone, this image was made as a transfer or counterproof on wetted paper from a lost watercolor matrix. The intentionally pale, almost dreamlike character of the surface could not have been achieved had Gauguin used the elaborate technique of creating a temporary matrix on a glass plate.[1] Gauguin obviously favored this paleness, for he selectively heightened certain areas of the foreground with an equally pale watercolor wash, and initialed the print in a subtle rose-pink.

The landscape is perceived as if through a mist or cloud and, like so many of the color transfers, appears to arise from a dream or from the subconscious. Figures dance on the wooded hill to the left while two women bathe in the pool in the lower right. The dancing figures relate directly to three rubbery dancers in the background of *Nave nave moe*[2] and, in more generic terms, to the dancers in the middle ground of *Mahana no atua* (cat. 205). These dancers derive, in turn, from those in two paintings of 1892 (see cat. 155, W 467). In both 1894 paintings, Gauguin created mythic Tahitian scenes in which worship involving dancing is set in a landscape dominated by female figures either sitting near a stream or bathing. Thus, he relates the rites of bathing to religious activities.

There is no hint of religion in the Blair landscape on paper; absent is the idol that explains the dancing in both the 1892 and the 1894 versions of the composition. Instead, Gauguin contrasted dancing and bathing, each set in a different segment of a spacious landscape. The dancers are deemphasized in the transfer, almost merging with their luxuriant forest setting. Our attention is di-

rected to the pair of bathers, and these make an interesting contrast with each other as well as with the analogous pair of figures in the painting *Nave nave moe*. In both cases, there is a bathing figure and an attendant who carries a towel or garment of the bather. The attendant in the transfer is identical to (though reversed from) the attendant in the painting, but the bather herself is completely different. Whereas Gauguin simply borrowed in miniature the monumental bather from *Aha oe feii?* (cat. 153) for the painting of 1894, there is a stranger and more interesting analogy for his nude for the transfer. This bather relates in pose and character to Gauguin's unusual symbolist print of the penitent *Mary Magdalen*, published in *L'Ymagier* in April of 1895.[3] In the transfer, the bather rests on a red cloth and appears to be rinsing or drying her hair; in the painting the figure weeps at the foot of the cross, naked and penitent.

We have no way of knowing whether Gauguin intended us to make such a connection. The fact that he provided one of the Tahitian figures in *Nave nave moe* with a halo indicates that he was fascinated by the relationships between Christian and native religion. We do not know exactly the date of conception for the *Magdalen* print, nor can we be precise about the date for the transfer. If, as some would want to argue, the print was made before or in connection with this watercolor transfer, then Gauguin's intentions may have been more complex than they appear at first glance. However, it is equally possible that Gauguin borrowed the penitent Magdalen from this simple figure of a Tahitian bather and that its religious meanings cling only to the print and not to this evanescent vision of paradise on earth.—R.B.

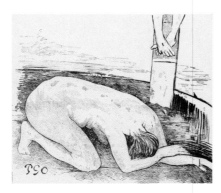

Gauguin, *The Magdalen*, after a woodcut [*L'Ymagier*, April 1895, no. 3, page 142]

203
Fan Decorated with Motifs from Te raau rahi (recto); Wash Drawings (verso)

One of at least five fans (see also cats. 134, 204) based on early Tahitian paintings by Gauguin, this colorful composition corresponds to a picture inscribed *Te raau rahi* (The Big Tree) (W 437) and dated 1891. Curiously, Gauguin inscribed the same title on another painting of 1891 (W 439) representing a different landscape. He also painted a second version (W 436) of the scene recorded on this fan, albeit in more somber colors, and inscribed it with another title, *Te Fare Maori* (The Maori House). The house depicted on the fan and in the two related paintings may be the one that the artist rented in Mataiea in the autumn of 1891 (cat. 132), and the women, some of his new neighbors. If so, the house with the red roof just beyond the native hut in the fan should probably be identified either as the communal dining house referred to in *Noa Noa*,[1] or as the house of his landlord, Anani.[2]

Like most of these fans, this was probably executed while Gauguin sojourned in France between his trips to Tahiti. It was intended as a keepsake for his Spanish sculptor friend, Francesco Durrio.[3] In terms of style, characterized here by thin, perhaps blotted touches of color, the Carrick Hill fan resembles many of the watercolor transfers Gauguin printed at this time.[4]

Gauguin, *Noa Noa*, page 126 [Musée du Louvre, Paris, Département des Arts Graphiques]

1. *Noa Noa*, Louvre ms, 38.

2. Danielsson 1975, 88-89.

3. Gerstein 1978, 337-338.

4. Gerstein 1978, 338-339; and Gerstein 1981, 10-11.

5. Jénot 1956, 121.

6. Teilhet-Fisk 1985, 130.

7. *Noa Noa*, Louvre ms, 126; see Gerstein 1978, 339.

Aside from its rich color, which testifies to an ongoing dialogue between Gauguin and Redon, the most distinctive feature of the Carrick Hill fan is the semicircular frieze of Marquesan decorative motifs along the lower border. Unrelated to Gauguin's paintings of this landscape scene, the band is similar to a border Gauguin incorporated into one of the woodblock prints he made around 1894 (cat. 172). A slightly discolored area at the far right of the fan's border is caused by a watercolor wheel on the verso that has bled through the paper.

Gauguin was interested in Marquesan art even before he arrived in Tahiti for the first time,[5] and his continuing interest is evident in watercolors that he executed in his *Noa Noa* manuscript. These sketches record rubbings made from such Marquesan objects as bowls or clubs decorated with carvings, or from similar objects, now lost, that Gauguin himself sculpted in Marquesan fashion.[6] One in particular has a border of masklike motifs nearly identical to those Gauguin added along the inner edge of the Carrick Hill fan.[7]—C.F.S.

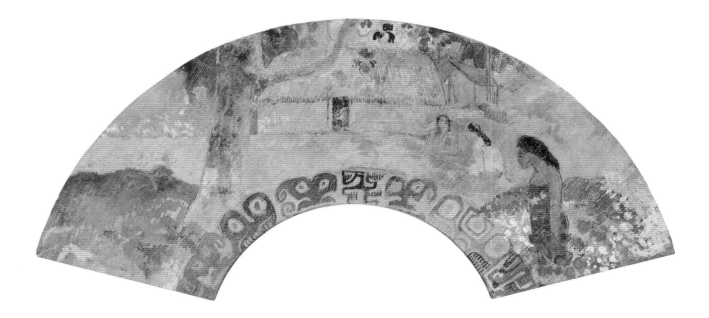

probably 1894

172 x 575 (6¾ x 22⅝)

brush and gouache on crêpe paper

Carrick Hill Collection, South Australia

EXHIBITIONS
Paris 1906, no. 127, *Tahiti*; Basel 1928, no. 114; London 1931, no. 66

CATALOGUES
W 438; Gerstein 1978, no. 26

204
Fan Decorated with Motifs from Arearea

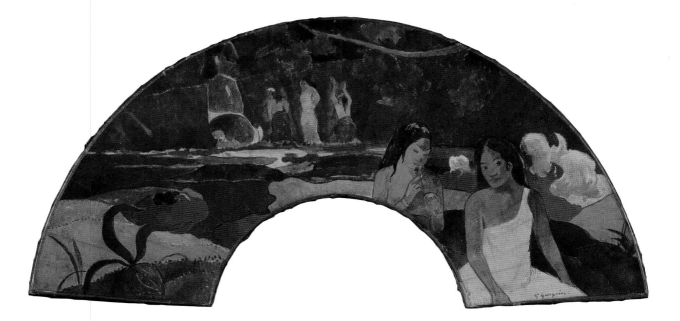

probably 1894 or 1895

260 x 553 (10⅛ x 21½)

brush and gouache over preliminary design in graphite on fabric mounted on wooden stretcher

signed at lower right in brush and gray watercolor, *P. Gauguin*; dedicated at lower left, partially abraded, *Brunaud* (?)

The Museum of Fine Arts, Houston, The John A. and Audrey Jones Beck Collection

EXHIBITIONS
Paris 1906, no. 92, *Eventail;* Chicago 1959, no. 107

CATALOGUES
W 469; Gerstein 1978, no. 27

1. Béguin 1961, 215-216; Field 1977, 167; Gerstein 1981, 9-11.

2. Gerstein 1981, 11-12.

3. Gerstein 1981, 7-8.

4. Béguin 1961, 217; Field 1977, 330, no. 50; Danielsson 1967, 230, no. 4; Gerstein 1981, 8.

This fan, like several others (cat. 203), was probably painted when Gauguin returned to France between trips to Tahiti. It repeats the composition of *Arearea* (W 468), one of a series of paintings that Gauguin did in late 1892[1] and included in his November 1893 exhibition in Paris. The exaggerated red of the dog in the lower left corner of the painting became the butt of ridicule during that exhibition, which might explain its absence in the later fan.[2] The name of the fan's first owner is unfortunately no longer legible in the original inscription, but this owner presumably resided in France, since Vollard had acquired the fan by 1906. It is the only fan from this period that Gauguin painted on fine linen and folded, as if to prepare it for mounting on wooden spokes as a functional object.[3]

Like the oil painting, the title of which Gauguin translated as *Joyeusetés* ("amusement," "celebration," or "joyfulness"),[4] the fan depicts a dried riverbed with an ironwood tree on the near side and an imaginary sanctuary with a stone idol to Hina (cat. 139) on the far side.[5] As in the other paintings by Gauguin with the same setting (W 467, W 500), tiny figures of female celebrants are gathered around the idol in *Arearea.* Although the variant compositions are all clearly daytime scenes, the saturated colors in *Arearea* might indicate bright moonlight.

One of the two female figures in the foreground of *Arearea* is barebreasted and plays the *vivo,* a Maori reed flute,[6] perhaps to accompany the distant dancers, but more likely to entertain her companion in white. The latter's gesture has been partly cropped in the process of transposing the original rectangular composition to a fan-shaped format, but her pose in the oil version recalls the carved figure in the pose of the enlightened Buddha in Gauguin's *Idol with a Pearl* (cat. 138), the back side of which shows dancers and a seated figure of Hina similar

5. As Béguin 1961, 219; and Gerstein 1981, 15, point out, Gauguin described this setting in *Noa Noa*, Louvre ms, 98-99.

6. This figure was added by Gauguin in watercolor to one of his monotypes (F 19). Gauguin described the song of the *vivo* in *Noa Noa* (Louvre ms 40-41; Wadley 1986, 17; Getty ms 7 insert) and in fact associated it with nighttime (see cat. 158). For a related drawing of both figures see Tokyo 1987, no. 102. A photomechanical reproduction was made after the drawing and published in *l'Epreuve* around 1895 (Gu 87). A slightly different version of the figures is included in a drawing published by van Dovski 1973, 117.

7. Amishai-Maisels 1985, 352–354; and Teilhet-Fisk 1985, 85-86.

to the idol in the background of *Arearea*.[7] Just behind the figure in white are fallen clusters of white flowers, possibly gardenias.

Gauguin's emphasis here on white, the color of mourning for Tahitians, has never been explained, but in the Houston fan and in the related paintings it adds to the rich harmonies of color. Indeed, with its flute player and rhythmic arabesques, *Arearea* is one of Gauguin's most lyrical compositions, embodying the spirit of his remarks about the essential musical element in pictorial expression. In 1895 when a newspaper interviewer, evidently referring to *Arearea* or to *Tahitian Pastorals* (cat. 155), asked Gauguin whether the dogs in his pictures were painted red on purpose, he replied that such liberties were calculated to make us experience painting as we do music.—C.F.S.

205
Mahana no atua

Puvis de Chavannes, *The Sacred Wood*, 1887, fresco [L'Hémicycle de la Sorbonne, Paris]

1. First documented in René Huyghe's introduction to *Ancien Culte Mahorie* (1951), 26.

2. Varnedoe in New York 1984, 179-209.

Although small in size, *Mahana no atua* (Day of the God) is monumental; in fact, the painting has the character of a great religious fresco, a sort of *summa theologica* of Polynesia. One can easily compare it with the monumental decorations of Puvis de Chavannes. Gauguin divided the canvas into three horizontal zones. The uppermost area, farthest from the viewer, is paradoxically the most real. In a more or less conventional Tahitian landscape, figures perform activities associated with daily life or with a presumed religious ritual. This "real" landscape is dominated by a monumental sculpture of a god, who acts to center and, in that sense, organize the diverse activities around him. It is anything but a Tahitian deity; the figure derives from Gauguin's reading about the Easter Island figures in J. A. Moerenhoet's *Voyages aux îles du grand océan* (1837)[1] as well as from photographs of the figures at the great temple complex at Borobudur. Here, Gauguin's intention was to create a composite god rather than to simulate in paint an ethnographic Tahiti.[2] A drawing of Hina exists, which was made in connection with either *Ancien Culte Mahorie* or this painting.

Immediately in front of the great god is the second zone, a band on which three nude figures are arranged in hieratic formation. At first, they appear to be women, but only the central figure is clearly identifiable as such. She is the archetypal bather, apparently unaware of the two figures beside her. The viewer is

Mahana no atua

1894

68.3 x 91.5 (26⅞ x 35⅝)

oil (possibly mixed with wax) on canvas

signed and inscribed at lower left, *Gauguin 94/MAHANA no Atua*

The Art Institute of Chicago, Helen Birch Bartlett Memorial Collection

EXHIBITIONS
Boston 1925; New York 1936, no. 29; Chicago 1959, no. 57

CATALOGUE
W 513

shown in Washington and Chicago only

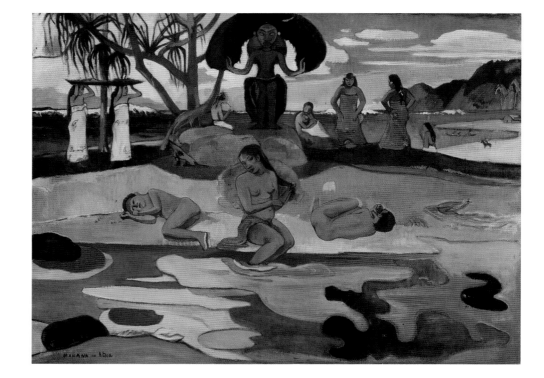

Gauguin, *Sketch of Hina*, photo by Jean Pierre Charpentier [Collection Galerie Charpentier]

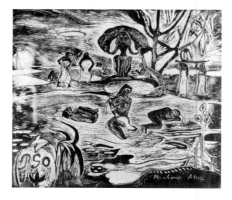

Gauguin, *Mahana atua*, woodcut [The Art Institute of Chicago, Clarence Buckingham Collection]

3. Gu 42, K31.

4. Gu 43, K31.

5. Boston 1925.

tempted to read the three as representations of birth, life, and death, but their poses evade such easy categorization. The figure at the right is at once a memory of a South American mummy bundle and a figure in the fetal position, and the figure at the left appears to be simply resting. Above the figure is a small nonrepresentational dab of pink paint.

The most spectacular and mysterious portion of the painting is the zone in the lower third of the canvas. Here, color reigns. If it were not for the ripples around the feet of the bathing woman or the small section of green earth at the lower left, the entire area would be nonrepresentational. Yet, those few clues indicate that the surface is a sacred pool that reflects not the world of appearances, but the ultimate essence of form, color. The left portion of the pool reads as a flat plane perpendicular to the surface, within the illusionistic world of the picture. The right side, however, is totally flat, parallel to the picture surface, and its dialogue of colors has few precedents in the history of western easel painting.

The figures in *Mahana no atua* have innumerable prototypes or resonances within Gauguin's earlier and later oeuvre, yet the total composition resembles nothing else he painted. Its closest parallel is a woodcut[3] from whose block, now in the National Gallery of Art, Washington,[4] Gauguin pulled very few impressions. The painting and print can be interpreted as attempts to create a collective image of the South Seas that transcends all his earlier painted images.

When considered in this way, the most plausible date for the picture is the period just after the Durand-Ruel exhibition of 1893, when so many critics were confused by the iconography of his paintings and when he began to compose and illustrate *Noa Noa*. Many of the figures in the painting recur in the woodcut illustrations he made expressly for the manuscript, and become a visual grammar of the painting and its related print. The picture seems to have been made as a synthesis of the diverse elements present in the truly Tahitian paintings exhibited in 1893.

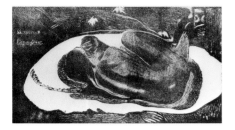

Gauguin, *Manao tupapau*, woodcut [Musée du Louvre, Paris]

It is tempting to read the painting as a kind of failure because its synthetic enterprise did not continue to hold Gauguin's imagination. This would surely be wrong. Although there is no evidence that he ever exhibited it, the painting is fully titled, signed, and dated, and the fact that Gauguin plundered his own *summa* for figures and ideas cannot be ignored. Whatever Gauguin thought of the picture, it has been almost universally admired by twentieth-century critics and historians. The painting was first exhibited in 1925[5] and has been seen in virtually every major exhibition devoted to Gauguin since that date. Its abstract foreground appealed to the relentlessly formal concerns of so many twentieth-century modernists just as its indecipherable iconography fascinates those with a more literary cast of mind.—R.B.

206
Reclining Tahitian

1894

245 x 395 (9½ x 15⅜), irregular

watercolor transfer selectively heightened with brush and water-based colors on japan paper

signed at lower right with artist's stamp, *PGO*

private collection

EXHIBITIONS
Chicago 1959, no. 189; Philadelphia 1973, no. 15

CATALOGUE
F 15

shown in Washington and Chicago only

This subtle color transfer depicts a nude Tahitian girl who rests with open eyes. With her legs pulled up and held firmly together and her breasts covered by her arms, she projects an image of innocence and vulnerability. Yet the figure becomes less "real" than elemental when it appears at the left in Gauguin's painting of 1894, *Mahana no atua* (Day of the God, cat. 205). As is often the case in Gauguin's work, it is difficult to assign precise meaning to the figure. When she is alone and represented on a pale peach-colored paper, she shares a dreamlike quality with the other color transfers of that year.

Although a second impression from the same matrix exists,[1] the one shown here can be considered "finished" by Gauguin because it was stamped with the same chop that he used frequently in 1894. One of these was printed on identical paper and survives on a portion of its original presentation mount. The mottled blue paper of the mount is the same as that used by Gauguin to mount certain *Noa Noa* prints for the private exhibition of his graphic work held in his studio in December 1894. Unfortunately, the vast majority of these works have been either trimmed or removed from their mounts. Yet the survival of a closely related transfer print on a mount on which Gauguin inscribed the word *croquis* (sketch) suggests that two or possibly more transfers were assembled on a sheet that might have read "Croquis Tahitiennes."—R.B.

1. F 14.

207
Te faruru

1894

334 x 231 (13¼ x 9⅛)

watercolor transfer selectively heightened with brush and water-based colors on japan paper

Edward McCormick Blair

CATALOGUE
F 5

shown in Washington only

This watercolor transfer ("To Make Love" in English) relates more directly than any other such image to a woodblock print in the *Noa Noa* group, suggesting that it was made shortly after the blocks were carved. In any case, it is different in mood, tonality, and palette from the watercolor transfers from the summer of 1894, and shares with the woodcuts the quality of an indeterminate time so different from the quotidian haziness of the watercolor transfers. It, as does *Reclining Tahitian* (cat. 206), represents not only the lovers from the woodblock of the same title, but also a pair of figures huddling near the idol in the middleground of *Mahana no atua* (cat. 205).

We see the lovers as the dominant elements of the watercolor transfer, just as in the woodcut (cat. 171). The woman, white and supine, is interlocked in a mysterious embrace with her protector-lover, and, as with the print, it is difficult to know whether she is alive or dead—whether this embrace is final. In the watercolor transfer medium the motif gains a certain ambiguity, and there is a sense that the figures are almost submerged in liquid rather than planted firmly on the ground.

We know nothing of Gauguin's plans for this transfer, because neither its matrix nor another transfer exists. Its dependence on the woodblock suggests that he may have intended it to be part of a suite of translations from one medium into another. Yet the magic of the medium gained control over him, and his transformation of the woodblock is all but total. In the woodblock print, the lovers are represented at night, and the fire near them creates smoke that, in turn, forms inexplicable and terrifying faces. In the transfer, Gauguin set the lovers in a daytime landscape. In the humid atmosphere of a tropical day, the fire rages behind them and the black smoke of the flames fills the upper right corner. What, we must ask, is the nature of their love?–R.B.

208
Aha oe feii?

1894

195 x 242 (7⅝ x 9½)

watercolor transfer selectively heightened with brush and water-based colors, brown ink, and white chalk on japan paper[1]

Edward McCormick Blair

EXHIBITIONS
Paris 1926, no. 21? as *Eve* (dessin colorié); Philadelphia 1973, no. 10

CATALOGUE
F 10

shown in Chicago and Paris only

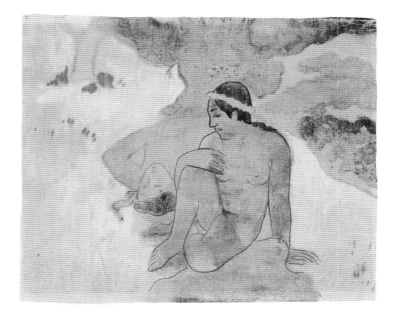

1. This image is transfered on the verso of a fragment of a three-color lithograph by Hermann Paul entitled *Modistes* (Milliners), published in the June 1894 installment of *L'Estampe original* (VI); the same installment contained Gauguin's lithograph *Manao tupapau* (Gu50, K23).

2. Cat. 167.

3. According to Danielsson the literal translation is "Why are you angry?" But Gauguin translated it as "What! Are you jealous?" Danielsson 1967, 230.

This superb transfer derives its basic composition from a painting of 1892 (cat. 153) and relates closely to a woodcut of 1894 made in connection with *Noa Noa*.[2] The title is translated "What! Are you jealous?"[3] It resembles neither of these prototypes in tonality, mood, and hence meaning, and shows Gauguin's eagerness to translate a composition into different formal languages by altering the medium. Like most of the color transfers of 1894, it was made from a matrix now lost. The resulting transfer is suffused with gentle colors. Gone is the brilliant pink beach of the painting and the stunning, multicolored sea; gone, too, is the almost barbaric strength of the woodcut, which probably predates the transfer slightly.—R.B.

209-210a
Three Masks of a Savage

1. Joly-Segalen 1950, XXVII, 97.

2. Bodelsen 1964, 146, suggested that this mask might be the horned devil, a photograph of which was pasted into the Louvre manuscript of *Noa Noa*, 56.

Neither Gray nor Bodelsen knew of the existence of the bizarre ceramic mask from the Ile de la Réunion when they published their respective studies of Gauguin's sculpture and ceramics. Both authors noted Gauguin's reference, in a letter to Monfreid written in December of 1896,[1] to an "enameled head of a savage," but neither could conclusively link this tantalizing phrase to an object.[2] In fact, the ceramic mask was given to the Musée Léon Dierx by Lucien Vollard, and is here published for the first time with the plaster and bronze casts from it.

Gauguin probably made the ceramic head during the period of intensive experimentation at the studio of Chaplet in the winter of 1894-1895. Its mottled glaze of brown and brilliant turquoise seems almost to erupt from the surface,

209 *Mask of a Savage*
1894-1895
25 x 19.5 (9⅞ x 7⅝)
glazed and painted(?) ceramic
Musée Léon Dierx, St. Denis de la Réunion

210 *Mask of a Savage*
painted plaster
The Phillips Family Collection
CATALOGUE
G 110

210a *Mask of a Savage*
bronze
Musée d'Orsay, Paris
CATALOGUE
G 110

Gauguin, *Hina tefatou* (*The Moon and Earth*), 1893, oil on burlap [Museum of Modern Art, Lillie P. Bliss Collection]

refusing to cling to the skin or hair. The mouth is drained of color, and the eyes are blindingly white. The mysteriously indeterminate quality of the surface is approached in Gauguin's oeuvre only by the exactly contemporary prints of *Oviri* (cat. 213).

The form of a disembodied head or mask fascinated Gauguin as well as many of his symbolist friends. Gray has assembled all the references to them in the Gauguin letters and documents.[3] No one, however, has speculated about the function of these masks. No precedents are found in the art of Polynesia, and nowhere does Gauguin himself discuss them in any substantial way. Although the surviving masks catalogued by Gray are of human scale,[4] they were probably not made to be used in performance. Hence, their ritual character is only suggested. No physical evidence exists to indicate how Gauguin would have mounted or displayed them.

The origin of this particular mask can be found in a painting of 1893, *Hina tefatou* (The Moon and the Earth, W 499), now in the Museum of Modern Art in New York. This painting relates more clearly than any other in Gauguin's oeuvre to his partially plagiarized text on Polynesian religion called *Ancien Culte Mahorie*.[5] The god Fatu,[6] who was associated with the earth, was mentioned in several

3. Gray 1963, 243.

4. Gray 1963, nos. 110, 111.

5. Derived from Moerenhout 1837.

6. Gauguin spelled the name "Tefatou" in his text, but the correct spelling is "Fatu." See Danielsson 1967, 231.

7. Joly-Segalen 1950, XXVII, and Rewald 1959, 62, and 1986 reprint, 178-179.

8. Rewald 1959, 32, 62, and 1986 reprint, 179.

9. It is possible that Monfreid may have made the plaster cast. In an unpublished letter from Monfreid to Vollard (typescript, Rewald Archives), dated 18 October 1900, Monfreid mentioned "the ceramic head of Christ that you spoke to me about." He explained that he had not cast another since the one he did for M. Viau (the one hanging in his studio was only a plaster cast), that the mold was in the country, and that he did not want to sell copies of it because it was intended for his family tomb. It is not clear, however, if this is a reference to *Mask of a Savage*.

10. Gray 1963, no. 115. Three versions of this vase exist: Kunstindustrimuseet, Copenhagen; Musée du Louvre, Paris; and private collection, New York.

ancient Polynesian tales transcribed in Gauguin's text. However, none of these tales helps to explain either the painting or the ceramic mask. Although the mask is literally the embodiment in clay of the head of Fatu in the painting, Gauguin disassociated the mask from the painting in two letters, referring to it as "The Head of a Savage."[7]

The Phillips family plaster of the head has been previously published by Rewald together with a letter from Gauguin to Vollard dated April 1897. In this letter, Gauguin explicitly requested that an edition in bronze be created. "And the mask, *Head of a Savage*, what a beautiful bronze it would make, and not expensive. I am convinced that you would easily find thirty collectors who would pay 100 francs apiece, which would mean 3000 francs, or 2000 after deduction of the expenses. Why don't you consider this?"[8] Evidently, Vollard did consider making a bronze casting, but not quite so rapidly as Gauguin expected nor with the same optimism about the market. In fact, only the Phillips plaster and three bronze versions have survived.

No substantial evidence exists to deny the attribution of the plaster to Gauguin himself.[9] It is possible, given that the exactly contemporary ceramic *Square Vase with Tahitian Gods*[10] was created in three nearly identical versions, that Gauguin made a mold from which various plaster or ceramic masks could have been made. Yet the painted plaster is very different from that of the mottled, glazed ceramic mask, suggesting that Gauguin's intention was to beautify the ceramic, probably to appeal to collectors. The three masks in ceramic, plaster, and bronze are presented together for the first time in the present catalogue, and further conclusions about their relationship can only be drawn after detailed comparative examination.—R.B.

211
Oviri

1. Committee of 5 February 1987.

2. W 561.

3. Gray 1963, 245.

Oviri (Savage), one of Gauguin's most crucial works, has recently been acquired by the Musée d'Orsay.[1] The artist himself described *Oviri* as a "ceramic sculpture"; it is probably his greatest work in this discipline, which he never again seriously attempted after his second departure for Tahiti in July 1895. Various references to this piece are found in his correspondence, and the *Oviri* theme recurs frequently in later paintings, prints, and monotypes. Such abundant repetition, coupled with the complex symbolism of the original piece, places *Oviri* on a level with the great canvas *Where Do We Come From? What Are We? Where Are We Going?*,[2] which was painted two years later.

The variety of surface and the range of colors and textures achieved for the two animals and the woman's body and hair all testify to the technical mastery that Gauguin had acquired since 1886 through his association with Chaplet, the greatest of ceramists. Gauguin's own fruitful experiments with technique are also in evidence. Gray mentions three plaster casts of *Oviri*,[3] the fissured surfaces of which point intriguingly to the existence of an undocumented example in wood. The plaster copy, which was given to Daniel de Monfreid, now belongs to the Musée départemental du Prieuré in Saint-Germain-en-Laye and was recently used to make a series of bronzes; one of these was placed on the artist's grave in Atuona in 1973.

Oviri

1894

75 x 19 x 27 (29½ x 7½ x 10⅝)

stoneware, partially glazed

signed in relief, on the right-hand side, *P. Go.*; inscribed in relief on the front of the base, *Oviri*; dated in relief on the left foot, *1894* (?)

Musée d'Orsay, Paris

CATALOGUE
G 113; B 57

EXHIBITIONS
Paris 1895; Béziers 1901, no. 162; Paris 1906, no. 57; London 1955, no. 75; Paris 1988, no. 5

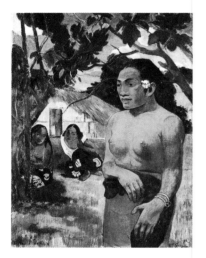

Gauguin, *E Haere se i hia* (*Where Are You Going?*), 1892, oil on canvas [Staatsgalerie, Stuttgart]

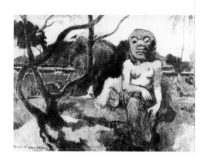

Gauguin, *Rave te hiti ramu* (*The Idol*), 1898, oil on canvas [State Hermitage Museum, Leningrad]

4. Gray 1963, 64 n. 7, citing Teuira Henry, *Ancien Tahiti*, Bulletin XLVIII, Bernice Pauahi Bishop Museum, Honolulu, 1928.

5. *Noa Noa*, Louvre ms, 50-51.

6. Danielsson 1975, 116-117.

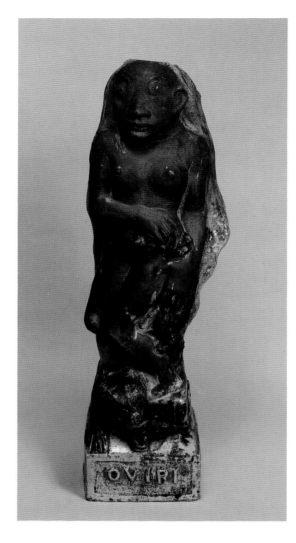

The title of this work requires some explanation. "Oviri" means "wild" or "savage" in Tahitian, and in the primitive mythology of the island, "*Oviri-moe-aihere*" (the savage who sleeps in the wild forest) is one of the gods who presides over death and mourning.[4] *Oviri* is also the title of a melancholy Tahitian song transcribed by Gauguin in the original manuscript for *Noa Noa*,[5] and later translated by Danielsson: "Solo: Now it is night; the sky is sad, the sky is sprinkled with stars. / My heart has been taken by two women / and both are weeping: / but still my heart sings with the flute. Chorus: What are the thoughts in his heart? / Does he dream of wild music, of dancing on the beach? / What are the thoughts / In his savage, restless heart?"[6]

Thus the title *Oviri* is by no means unequivocal: however, it is clear that the dominant notion is that of the savage. The work embodies Gauguin's ambition to reestablish contact with a primitive state of nature and to turn his back on Western civilization, by definition pernicious and corrupt. Gauguin's wretched situation in the autumn and winter of 1894-1895, when he had to cope with his injury at Concarneau, the loss of his lawsuit against Marie Henry to recover his paintings, and finally the failure of the Drouot auction on 18 February 1895, gave a special edge to his longing for wildness. His departure for Polynesia was merely the logical conclusion of this series of disasters. "*You* were wrong," he wrote to Charles Morice, "that day when you said I was wrong to say I was a savage. It's true

370

enough: I am a savage. And civilized people sense the fact. In my work there is nothing that can surprise or disconcert, except the fact that I am a savage in spite of myself. That's also why my work is inimitable."[7]

This sense of being a savage in spite of himself is exactly what Gauguin expressed with such uniquely violent intensity in *Oviri*; hence the parallel association of the word "Oviri" in Gauguin's plaster self-portrait (cat. 214). Gauguin also included an impression of his woodcut entitled *Oviri* on page 61 of the Louvre's manuscript copy of *Noa Noa*.

Bodelsen and Landy have provided the most convincing of several differing symbolic interpretations of *Oviri*.[8] A woman of monstrous proportions, with a moonstruck expression, crushes a wolf that lies at her feet in a pool of blood. In her arms, clasped against her side, is a wolf cub; we do not know if she is smothering the creature or hugging it.

The figure of *Oviri* combines two different images and two different ideas. Gray believes that the head is modeled on the mummified skulls of primitive chiefs in the Marquesas, the eye sockets of which were traditionally encrusted with mother-of-pearl and which were held to be divine.[9] The body of the woman is based on the Borobudur images of fecundity. In this way, life and death are inextricably linked in a single image.

In a letter written to Ambroise Vollard in 1897, Gauguin asked for "models of sculptures to cast in bronze." This letter, quoted by Rewald and noted by Bodelsen,[10] also refers to his ceramic as *La Tueuse* (The Murderess). ". . . You ask for woodcarvings, bronzes etc . . . all mine have been in Paris for four years and not one has been sold. Either they're bad – in which case any I do now will be bad also, and equally unsalable – or else they are art objects. Why don't you try and sell them? I think my big ceramic statue, *La Tueuse*, is an exceptional piece, and no ceramist has ever produced anything like it before. In bronze, without retouching or patina, it would be very good. The eventual buyer of the ceramic would be able to have the same piece in bronze."

Hence Gauguin, without much conviction, was toying with the idea of making a handsome profit from a series of bronzes based on his ceramic. His attachment to *Oviri* again comes to the surface in a letter to Daniel de Monfreid (October 1900): "You know my big ceramic figure which remains unsold, while Delaherche's hideous pots go for a fortune and end up in museums; well, I'd like to have it on my tomb in Tahiti when I die, and before then I'd like to have it in my garden. Which is to say, I want you to send it to me, well wrapped, the moment you make a sale and can pay the packing and transportation costs."[11]

In 1895, Gauguin had sent his friend Mallarmé two copies of his *Oviri* woodcut, mounted on the same support (cat. 213), with the following dedication: "A Stéphane Mallarmé cette étrange figure cruelle enigme" (To Stéphane Mallarmé, this strange figure and cruel enigma).

This "cruel enigma" probably will never be solved. In 1892, the woman with the wolf cub appears in a canvas entitled *E haere oe i hia* (Where Are You Going?), now in the Staatsgalerie at Stuttgart.[12] She then reemerges in a mysterious landscape of 1898 entitled *Rave te hiti ramu* at the State Hermitage Museum in Leningrad;[13] and in a drawing on a manuscript copy of *Le Sourire* (no. 1, erroneously dated August 1891), preserved by the Département des arts graphiques, Musée du Louvre.[14] This drawing is accompanied by the following mysterious inscription: "Et le monstre, étreignant sa créature, féconde de sa semence des flancs généreux pour engendrer Séraphitus-Séraphita" (And the monster, embracing its creation, filled her generous womb with seed and fathered Séraphitus-Séraphita). The name Séraphitus-Séraphita is an allusion to Balzac's novel *Séraphita*, influenced by Swedenborg, in which the hero is androgynous. Bodelsen correctly points out that this theme was very much à la mode in contem-

7. Letter from Gauguin to Charles Morice, April 1903, Malingue 1949, CLXXXI.

8. Bodelsen 1964, 146-152. See also Landy 1967, 244-246; and Jirat-Wasiutynski 1975, 373-383.

9. Gray 1963, 65.

10. Rewald 1959, 62. Bodelsen 1964, 146. See also letter from Gauguin to Daniel de Monfreid [April 1897], Joly-Segalen 1950, XXXI.

11. Joly-Segalen 1950, LXIII.

12. W 478.

13. W 570.

14. The first issue of *Le Sourire* was actually published in August 1899.

15. Bodelsen 1964, 149.

16. *Noa Noa*, Louvre ms, 78-80, and Getty ms, 12.

17. Morice 1896, no. 440.

18. Landy 1967, 245-246.

19. There are two different versions of this story: that of Morice (1920, 171) according to whom the piece was "literally expelled," and that of Vollard (1937, 184), who stated that Oviri was only admitted when Chaplet threatened to withdraw all his own works if it was not.

20. Letter from Charles Morice to Mallarmé, cited in Mondor 1982, vol. 7, 161-162.

21. Loize Archives, Musée Gauguin, Papeete, Tahiti. This is an astonishing misconception of the part of Vollard. Since the statue is completely open at the back, it is hard to see how it could be "used for flowers."

22. Joly-Segalen 1950, LXXI.

23. Letter from G. Fayet to G. D. de Monfreid, 2 November 1903, cited by Loize 1951, no. 433.

24. Letter from G. Fayet to G. D. de Monfreid, 2 October 1905, cited by Loize 1951, no. 437.

25. Letter from G. Fayet to G. D. de Monfreid, 2 December 1905, cited by Loize 1951, no. 439.

porary symbolist literature[15] (compare the writings of Sâr Péladan) and appears in a moving episode of *Noa Noa*. In this episode Gauguin describes a young Tahitian who goes with him into the forest as the ideal savage, whose moral and formal perfection is matched by a complete lack of sexual differentiation.[16]

As a symbol of death and fertility, *Oviri* is the "Huntress Diana" described by Charles Morice in an extravagant page of his "Les Hommes d'Aujourd'hui."[17] She represents the destructive/regenerative value of a return to a state of nature, which, as conceived by Gauguin, is the necessary condition for all authentic creativity. This is interpreted by Landy, who theorized that Gauguin had to discard his civilized ego altogether in order to derive the full benefit from this, his final return to Tahiti and to nature.[18]

The strangeness of *Oviri*, as well as its formal originality, amply accounts for the trouble Gauguin encountered in persuading people to appreciate its beauty at the close of the nineteenth century. *Oviri* was refused by the Salon de la Nationale in 1895,[19] and this was a terrible blow to him. It was then entrusted to the dealer Lévy at 57 rue Saint-Lazare, with whom Gauguin had concluded an agreement prior to his departure for Tahiti, with a view to ensuring his future subsistence by the sale of his works. This is corroborated by a letter from Charles Morice to Mallarmé in February-March 1895:

"My dear friend,

I would like to see you as soon as possible . . . I am just finishing a book written with Paul Gauguin [*Noa Noa*], which I think rather fine. It's in prose and verse; I want to show you some of it. Apart from this, there is a supremely beautiful Gauguin sculptural work, a ceramic, to be seen [at Lévy's] at 57 rue Saint-Lazare. Gauguin's situation vis-à-vis official art, the official art administration and the public, is a unique theme for the venting of our hatred of the above-mentioned three banes of human existence. We should offer Gauguin's work, which is called *Diane Chasseresse* [Diana the Huntress] to the Luxembourg, so it can be refused; thereby giving us the chance to write and say one or two well-chosen words on the matter. You can answer for several people; a word from you to one of them and we shall have a good name at the top of our list of amateurs. We can assemble about fifty artists, and the necessary three thousand francs will be found. The fifty are all prepared . . . Why don't we discuss the matter further on Saturday?"[20]

This was not the only occasion on which an attempt was made to raise a public subscription to procure one of Gauguin's works for the Musée du Luxembourg (see cat. 154). Sadly, it was unsuccessful.

When Gauguin wrote to Vollard in 1897 suggesting that some money might be made from a series of bronze casts of *Oviri*, he did so without much conviction. In 1900, the piece was still on deposit with Monfreid. A letter from Vollard to Monfreid on 21 October 1900 shows that he was interested in it: "As to the big ceramic statue, it represents a monstrous standing woman which could be used for flowers. As we should be ready for any eventuality should you be entrusted with the sale. . . . let me know, just in case."[21] In 1901, Gauguin considered that there was only one person likely to buy *Oviri*, and that was Gustave Fayet. "The price of 2000 francs is not excessive," he wrote. "Also, I believe M. Fayet is a good judge of ceramics."[22] It was not until 1905, two years after Gauguin's death, that Fayet finally decided to buy the piece, having first had it on deposit,[23] then having offered to buy it for 700 francs.[24] The price he finally paid to Mette Gauguin was 1,500 francs.[25]

Gauguin, who was quite sure *Oviri* was the best ceramic he had ever done, was intensely irritated by the lack of a buyer. He wrote, "The best thing of mine, but also perhaps *the only example* of a sculptured ceramic by Chaplet, because everything else in the way of sculpture done by artists is molded and has the same characteristics as the plaster it is taken from . . . I was the first to attempt ceramic

26. Unpublished letter from Gauguin to Vollard, 25 August 1902, cited by Danielsson 1975, 302 n. 105.

27. Toronto 1981-1982 and New York 1984-1985.

28. Rubin in New York 1984-1985, 245-246.

sculpture, and I believe that, although this is forgotten now, one day the world will be more grateful to me. At all events, I proudly maintain that nobody has ever done this before."[26]

Gauguin's posthumous retrospective at the 1906 Salon d'Automne was to prove him right. Without a doubt, the presentation of *Oviri* profoundly affected the leading Paris artists of the day, notably Picasso. Its savage character, made palpable by the raw treatment of the material and its subjection to the fire, made Gauguin the pioneer of primitivism in sculpture at the beginning of the twentieth century. Further, recent exhibitions devoted to primitivism[27] have revealed the influence of Gauguin's sculpture on Picasso by way of his friend Paco Durrio. In fact, one of the figures in Picasso's *Les Demoiselles d'Avignon*, 1907, could be based on *Oviri*.[28]–C.F.-T.

212-213
One Transfer Drawing and Two Woodcuts from Oviri

212
Oviri

1894

282 x 222 (11 x 8¾)

watercolor transfer selectively heightened with brush and water-based colors on japan paper, laid down on secondary cardboard support

signed at lower left with artist's stamp, *PGO*

From the collection of Mr. and Mrs. Alexander E. Racolin, New York City

CATALOGUE
F 30

shown in Washington and Chicago only

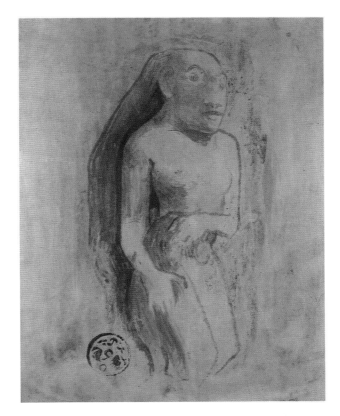

213
Oviri

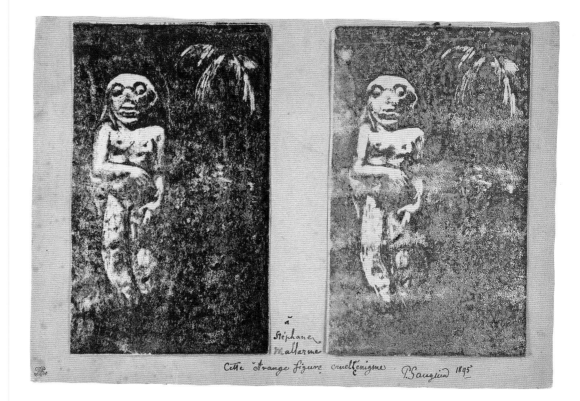

208 x 120 (8¼ x 4¾) irregular

woodcut printed in brown with residual black ink from previous printing, on japan paper, laid down on left side of presentation mount; printed on the verso of a fragment of *Mahna no varua ino* (Gu 34, K 19)

dedicated, signed, and dated on presentation mount, lower center, in pen and brown ink, *à Stéphane / Mallarmé / cette étrange figure cruelle enigme / P. Gauguin 1895*; collector's mark on presentation mount, lower left, monogram in black ink, *MG* (not in Lugt)

The Art Institute of Chicago. Print and Drawing Department Funds. 1947.686.1

CATALOGUES
Gu 48; K 35

shown in Washington and Chicago only

207 x 120 (8⅛ x 4¾) irregular

woodcut from two separate printings of the same block in brown and black on japan paper, laid down on right side of presentation mount; printed on the verso of a fragment from the center of a Roy impression of *Mahna no varua ino* (Gu 34, K 19)

The Art Institute of Chicago. Print and Drawing Department Funds. 1947.686.2

CATALOGUES
Gu 48; K 35

shown in Chicago only

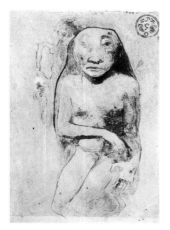

Gauguin, *Oviri*, watercolor transfer [location unknown]

Gauguin, *Le Sourire*, special issue [Musée du Louvre, Paris, Département des Arts Graphiques]

1. Guérin 1927, XXVII. This drawing appears in a unique issue of Gauguin's newspaper *Le Sourire* dated August 1891 and now in the Louvre. If the autograph date can be accepted as the actual date of creation, then the Oviri drawing is by far the earliest manifestation of this mysterious figure. If, however, the date is part of the "illusion" of the unique issue, it was more likely made in 1894-1895 when Gauguin was at work on the ceramic and the related prints.

213a Oviri

204 x 117 (8 x 4⅝) irregular

woodcut printed in black on japan paper; printed on the verso of a fragment of a counterproof of the pastel *Reclining Female Nude* (cat. 166, F 12)

on verso along top left to right, in graphite, *no G 157/17*; collector's mark, initials in black ink, *W. G./B* in circle (not in Lugt)

The Art Institute of Chicago. The Charles Buckingham Collection. 1948.273

CATALOGUES
Gu 48; K 35

shown in Chicago and Paris only

213b Oviri

205 x 123 (8 x 4⅞)

woodcut printed in brown on japan paper; printed on the verso of a fragment from the left side of a Roy impression of *Mahna no varua ino* (Gu 34, K 19)

signed at lower center, in pen and brown ink, *Gauguin*; signed and dated on verso along lower edge in pen and brown ink, *PG/15 mars*

National Gallery of Art, Washington, Rosenwald Collection, 1953.6.248

CATALOGUES
Gu 48; K 35

shown in Washington and Chicago only

213c Oviri

205 x 123 (8 x 4⅞)

woodcut printed in dark brown on wove paper

Museum of Fine Arts, Boston. Bequest of W. G. Russell Allen 60.338

CATALOGUES
Gu 48; K 35

shown in Washington and Chicago only

213d Oviri

208 x 123 (8¼ x 4⅞) irregular

woodcut from two separate printings of the same block in brown and black on japan paper; printed on the verso of a fragment from the left side of a Roy impression of *Mahna no varua ino* (Gu 34, K 19)

signed and dated on verso in pen and brown ink, *PG/15 mars*; along left side, from left to right in graphite, *no G 157/15-*; on recto, collector's mark, initials in black ink, *W. G./B* in circle (not in Lugt)

The Art Institute of Chicago. The Clarence Buckingham Collection. 1948.272

CATALOGUES
Gu 48; K 35

shown in Washington and Chicago only

The ceramic *Oviri* (Savage) is only one manifestation of that mysterious creature; Gauguin made at least one drawing,[1] two color transfers,[2] and two related prints,[3] one of which survives in at least seventeen unique impressions. All of these graphic works have been considered to postdate the ceramic sculpture, reproducing it rather than having been made in preparation for it. However, significant differences between the woodcut prints and the drawing, on the one hand, and the ceramic, on the other, raise the possibility that Gauguin invented the figure in prints and drawings before making an object in ceramic of his terrifying vision. For example, the figure of Oviri in the pen and wash drawing, as well as in the woodcuts, has straight legs rather than the oddly bent, Michelangelesque legs of the ceramic sculpture.[4] The figure in the print is also unreversed from the sculpture, suggesting that Gauguin started the series with the block, subsequently printed it, and then created the ceramic sculpture from the print.

Eberhard Kornfeld concluded that Gauguin created the print in Pont-Aven and Paris "after sketches and drawings from Tahiti."[5] If Kornfeld is correct, then the woodcut as well as the closely related drawing were both made in Pont-Aven or Paris before he began work at Chaplet's studio on the ceramic.

2. F 30, F 31.

3. Gu 48 and 49; Kornfeld 35, 36.

4. There are fascinating parallels between *Oviri* and various sculptures by Michelangelo, including not only the *Bound Slaves* in the Louvre, but also the unfinished sculptures that Gauguin could have known from several publications, including John A. Symonds, *The Life of Michelangelo Buonarroti*, 2 vols. (London, 1893).

5. Kornfeld 1988. However, there is only a single image that approximates the figure of Oviri, in the painting *Where Are You Going?* (W 478). Yet the head in the print is so different than that in the painting that the head must have a different source. The female figure in the painting is represented as three-quarter-length, and her legs are straight because she is standing.

6. Gu 49.

7. See cat. 185.

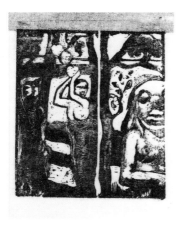

Gauguin, *Women Picking Fruit and Oviri*, woodcut [The Art Institute of Chicago, Gift of the Print and Drawing Club]

8. Gu 52, *Head of a Sleeping Man*, K 37, Gu 53, *Memory of Meyer de Haan*, K 38, Gu 54, *Young Maoris*, K 39, Gu 55, *Two Maoris*, K 40.

It is equally possible that the Oviri prints were made in Paris late in 1894, after Gauguin had made the ceramic. A great many of the surviving impressions of the Oviri woodblock are printed on the back of Louis Roy's impressions of various *Noa Noa* prints. If, as is generally thought, Gauguin left the *Noa Noa* blocks with Roy in Paris before he left for Brittany, it is likely that he didn't receive the majority of Roy's impressions from those blocks until he returned to Paris in November, dating many of the Oviri prints to the last weeks of 1894 at the earliest.[6]

We also know that *Oviri* was carved into the back of the large block for *Manao tupapau* (cats. 185, 186), made and undoubtedly printed in Brittany before his return to Paris. An impression of the Oviri woodcut in the Museum of Fine Arts, Boston, shows clearly that the large block had begun to split at its seams, and it is, therefore, possible that the block had been exposed to a change in climate and had reacted by breaking. None of this splitting is apparent in any of the surviving impressions of *Manao tupapau*, and this evidence raises the possibility that there was a lapse in time between the making and printing of the block in Brittany and the various stages of *Oviri* on its verso.

The woodblock for *Oviri* is unique in Gauguin's graphic oeuvre because of the manner in which it was printed. In Pont-Aven during the summer, Gauguin had experimented with his methods of inking the block.[7] The impressions of *Oviri* take this experimental inking to extremes that defy description. Indeed, most of the surviving impressions seem not to have been printed with printer's ink, but with mixtures of oil paint, ink, and solvents dabbed either on the block or possibly on a secondary support like rough canvas or cardboard and then transferred to the block. For this reason, the figure of Oviri seems to arise from a primordial ooze of earthy blackness. There is no sense of the dog that she holds in her arm in the painting or the baby fox in the ceramic. Nor is her sex apparent. She is a primal androgyne in a setting that is defined only by the flamelike leaves of a palm tree with no trunk, no roots, and, ultimately, no reality.

It seems that Gauguin's primary interest in printing the block of *Oviri* was with the texture of the printed surface. In this way the print is closely related to the alternatively rough and glazed surfaces of the ceramic sculpture. Gauguin seems to have worked further on the block after it had begun to split, for he began to recarve at least the upper left portion of the *Oviri* image and to link it with the image of a female fruit picker, who looks over her shoulder toward Oviri (Gu 49). The fact that the figure of Oviri in the later print is identical in position, scale, and detail to the figure in the earlier print indicates that Gauguin simply recarved this large block and began to extend its landscape. Interestingly, there are certain aspects of this extension that relate the later print to Gauguin's later painting of *Oviri*, signed and dated 1898 and now in the Hermitage (W 570). The left half of the painting is virtually identical to the print in proportion and in the relative position of the figure and the palm tree. And it is possible that the extensive landscape on the left side was first studied by Gauguin when he began to work on the small print with the fruit picker.

Perhaps due to the persistent splitting of the large block, Gauguin eventually admitted defeat and began to carve many smaller woodblock prints. These later prints[8] could have been made early in 1895, shortly before Gauguin's departure for Tahiti, or, as is most often claimed, shortly after his arrival there. In any case, Gauguin's struggle with the splitting back of his greatest woodblock occupied him not only during the time he spent devoted to Oviri but for a short period before he temporarily abandoned the medium of woodblock printing.—R.B.

214
Self-portrait, Oviri

1894-1895

36 x 34 (14¼ x 13⅜)

bronze

signed at upper left, *P.Go, Oviri*

private collection

CATALOGUE
G 109

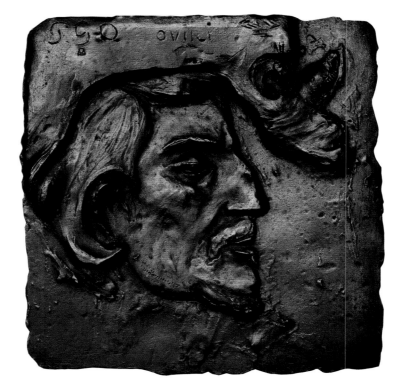

1. Compare Gray 1963, 241. It is probably one and the same bronze that can be traced through several exhibitions: Basel 1928, Edinburgh 1955, and Copenhagen 1948 and 1956.

2. Danielsson 1975, 157.

3. W 418, W 420, W 423, and W 494.

The date of this bronze is not known, but it was probably cast in the 1920s from the Schuffenecker plaster model now lost. Only a few other casts from this plaster are known.[1]

The piece stands out in Gauguin's gallery of self-portraits for several reasons. First of all, Gauguin had never before worked directly with plaster; the idea came to him one day while he was posing for Ida, William Molard's wife (see cat. 164), a Scandinavian sculptress whose artistic output mostly consisted of plaster busts and bas-reliefs.[2] Subsequently, Gauguin created his plaster self-portrait using a double mirror, which allowed him to capture his famous Inca profile. The result echoes his jug in the form of a head (cat. 64).

Second, this is one of the earliest occasions on which Gauguin applied the Tahitian word "Oviri" (savage) to himself (see cat. 214). The word later became a kind of battle cry for him: here he uses it in Homeric style. The motif on the top right hand side of the bronze is a Tahitian flower that appears frequently in Gauguin's paintings of the previous year;[3] by all accounts it is a *tiaré*, which he uses for a second signature, just as Whistler used a butterfly. The *tiaré* is meant to express Gauguin's exoticism, and also (given the exuberance of the pistil in the blossom) his sexuality.–F.C.

Chronology: July 1895–November 1903

GLORIA GROOM

1895

JULY 3

Leaves Marseilles aboard the steamer *L'Australien* (Danielsson 1975, 181).

AUGUST 9-29

Stops at Sydney, then Auckland, New Zealand, where he remains until the 29th (misdated letter, Malingue 1949, CLVIX). Studies and sketches the collections of Maori art in the newly opened wing of the Auckland Ethnological Museum (Collins 1977, 173; Danielsson 1975, 182).

Fig. 83. *1895 Register, with Gauguin's signature* [Auckland City Art Gallery, New Zealand]

SEPTEMBER 9

Arrives in Papeete aboard the *Richmond* (Danielsson 1975, 183). Complains in a letter to Molard of the many changes that have occurred since his departure and announces his intention to leave for the Marquesas (Malingue 1949, CLX). Lodges in one of Mme Charbonnier's unfurnished bungalows (Danielsson 1975, 188).

Fig. 84. *Port of Commerce in Papeete*, c. 1895 [Musée de l'Homme, Paris]

SEPTEMBER 26

Sails to Huahine, a neighboring island, with several government officials (Danielsson 1975, 186 n. 113). Meets two amateur photographers, Jules Agostini and Henry Lemasson (Lemasson 1950, 19).

SEPTEMBER 28-29

Group sails to neighboring village of Bora Bora (Danielsson 1975, 184-187).

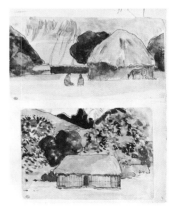

Fig. 85. *Tahitian woman*, c. 1895 [photo by Henry Lemasson, courtesy of O'Reilly Collection, Paris]

EARLY OCTOBER

Returns to Papeete (Danielsson 1975, 187).

NOVEMBER

Having decided against going to the Marquesas, moves to Punaauia, three miles from Papeete on the west coast. Rents a small plot of land and enlists native help to build a traditional Tahitian hut of bamboo canes and palm leaves (Danielsson 1975, 189). Paints windows of his studio (Joly-Segalen 1950, XX).

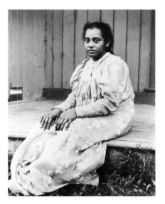

Fig. 86. *Two watercolor scenes of Tahitian huts that Gauguin pasted into Noa Noa* [Louvre ms, 71, Département des Arts Graphiques, Paris]

EARLY DECEMBER

Sends for Tehamana who, although now married, comes to Punaauia. She is frightened at

the sight of Gauguin's diseased skin (eczema) and soon returns to her husband, Ma'ari (Danielsson 1975, 190 n. 121).

1896

EARLY JANUARY?

Takes in Pahura, a fourteen-year-old girl from the district, as his *vahine* (Danielsson 1975, 182).

MARCH 23

Opening of an exhibition at the Librairie de l'art indépendente, 11 rue de la Chaussé d'Antin, Paris, which includes several unidentified works by Gauguin (*La Chronique des arts et de la curiosité*, March 1896, 124).

EARLY APRIL

Penniless, depressed, and suffering from severe leg pain for which he takes morphine, Gauguin writes to Morice that he is on "the verge of suicide" (Malingue 1949, CLXII).

APRIL 10

Asks Schuffenecker to sell his two Van Gogh paintings "of sunshine" to Vollard and send him the money. Is upset with Schuffenecker for having sent paintings to Mette but suspects that it is Mette who cajoled him (letter to Schuffenecker – Alfred Dupont collection, Hôtel Drouot, 3-4 December, 1958, no. 115). Sends Monfreid a drawing and description of *Te arii vahine* (cats. 215 and 215a), which he says is his best painting to date (Joly-Segalen 1950, XXI).

JUNE

An issue of *Les Hommes d'aujourd'hui*, entitled "Paul Gauguin," is written by Morice and published with a cover illustration by Schuffenecker (Morice 1896). Desperately poor and in need of hospitalization, writes to Monfreid and the artist Maufra to propose that they start a subscription society of fifteen art collectors to purchase his paintings (Joly-Segalen 1950, XXII).

JULY 6

Enters hospital at Papeete. The register of patients lists Paul Gauguin as "indigent" (le Pichon 1986, 200, pl. 6). Sends several paintings with an officer to Monfreid in Paris (Joly-Segalen 1950, XXIII).

JULY 14

Leaves hospital, weak but not in pain, without paying the 118.80 franc bill (le Pichon 1986, 200; Joly-Segalen 1950, XXIV).

Fig. 87. *View of the rue de la Petite Pologne (now rue Paul Gauguin) in Papeete*, c. 1900 [Gleizal/Encyclopédie Polynésie]

AUGUST

Gauguin is furious to learn that Schuffenecker has asked the Minister of Fine Arts to help him financially (Joly-Segalen 1950, XXIV). In need of funds, asks the lawyer Goupil to commission a painting. Paints portrait of Goupil's nine-year-old daughter, Vaïte (cat. 216). Gives drawing lessons to Vaïte and her sisters (Oral communication with Mme. D. Touze, niece of Vaïte Goupil). Gauguin's health gradually improves (Danielsson 1975, 198).

Fig. 88. *The Goupil daughters, Aline, Louise, and Madeleine in front of their villa in Outumaoro. Vaïte is seen standing next to her father*, c. 1895 [Mme Touze, Paris]

OCTOBER 11

Failed petition submitted to the Ministry of Fine Arts, Paris, by Judith Molard's future husband, to buy Gauguin's *Manao tupapau* (cat. 154) for 1,050 francs, as well as paintings by van Gogh (Danielsson 1975, 195 and 304 n 125).

END OCTOBER

Gauguin's employment at the Goupils is terminated. Shortly thereafter, he sculpts a deliberately crude statue of a woman to mock the antique copies that Goupil kept in his garden (Loize 1951, 101 no. 202).

NOVEMBER 2

Monfreid receives in Paris the shipment of paintings sent by Gauguin in July (Loize 1951, 100, no. 200).

NOVEMBER 12

Schuffenecker lends Gauguin's painting *The Yellow Christ* (cat. 88) to the exhibition of *L'Art mystique* at the Petit Théâtre Français in Paris, 10 Faubourg Poissonière (letter to Schuffenecker from R. de Villejuiz, LA).

LATE NOVEMBER

Gauguin exhibition opens at Galerie Vollard (Natanson 1896, 517).

EARLY DECEMBER?

Pahura, Gauguin's *vahine*, has a daughter who dies shortly after birth (Danielsson 1975, 199). Receives 200 francs from the Ministry of Fine Arts (requested by Schuffenecker) but disdains such "charity" and returns the money (letter, sale, Hôtel Drouot, 8 December 1980, no. 87).

DECEMBER 27

Arrival of Christmas boat in Papeete (Danielsson 1975, 199) with a check for 1,200 francs from Chaudet who promises another 1,600 francs (Malingue 1949, XXVIII).

Fig. 89. *Colonials and native women in front of wooden house in Papeete* [photo by Charles Spitz, c. 1900, Musée Gauguin, Papeari]

1897

JANUARY 7

Julien Leclerq asks Molard to send him some Tahitian paintings, in particular *Olympia noire* (cat. 215), for an exhibition of French modern

art he is organizing in Stockholm (typescript of letter in the Danielsson Collection, Papeete, 168-172). Receives 1,200 francs from Chaudet and tells Monfreid that he will enter the hospital since his poor health still prevents him from working (Joly-Segalen 1950, XXVIII).

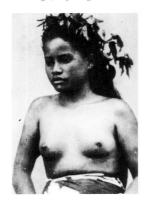

Fig. 90. *Tahitian girl in pareu*, c. 1895 [photo O'Reilly Collection, Gleizal/Encyclopédie Polynésie]

AROUND MID-JANUARY
The hospital classes him as indigent and he refuses to be admitted with soldiers and servants (Malingue 1949, CLXIII). Receives 1,035 francs from Chaudet (Joly-Segalen 1950, XXX). Writes in an optimistic letter to Sérusier, "I want no other life, only this" (letter, collection Edmond Sagot, sale, Hôtel Drouot, 5 June 1962).

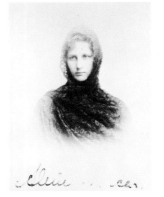

Fig. 91. *Aline Gauguin*, c. 1895 [courtesy of Malingue Archives, Paris]

JANUARY 19
Aline, Gauguin's twenty-year-old daughter, dies in Copenhagen of complications from pneumonia (Loize 1951, 91, no. 121).

FEBRUARY 25
Opening of the fourth exhibition of *La Libre Esthétique* in Brussels. Gauguin is represented by six paintings (cat. 221 and W 464, W 451, W 500, W 538, W 540) (Dujardin, 1897).

MARCH 12
Sends back eight paintings including a self-portrait dedicated to Monfreid (W 556; Joly-Segalen 1950, XXX).

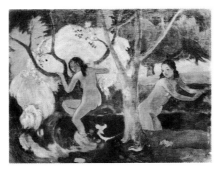

Fig. 92. *Bathers at Tahiti*, 1897 [The Barber Institute of Fine Arts, The University of Birmingham, England]

APRIL
Learns of his daughter's death in what he terms a short and brutal letter from his wife (Joly-Segalen 1950, XXXI). Writes to Vollard that he cannot make drawings for commercial purposes and that he will not make more woodcuts or sculptures until those he left in Paris have sold. Instead, sends the dealer "several poor attempts at making woodcuts" (probably Gu 52-55; Rewald 1986, 178-179).

END APRIL
The French colonial who owns Gauguin's land dies and the heirs sell the property. Forced to move, Gauguin obtains a loan of 1,000 francs from the Caisse Agricole (Joly-Segalen 1950, XXXII; deed of conveyance in Musée Gauguin, Papeete, published in Jacquier 1957, 678-681).

MAY 11
Purchases two parcels of land in Punaauia for 700 francs, and begins to add a studio to a large wooden house (Danielsson 1975, 203 n. 135).

Fig. 93. *Street in Papeete with building for the U.S.S. Co. (Société Commercial des Océanies) in Papeete*, c. 1900 [Danielsson 1965, 65]

MAY-JUNE
Works on the house, adding more sculpted panels to those he has already made (Lemasson 1950, 19). His eczema flares up and he is unable to paint (Malingue 1949, CLXIV).

Fig. 94. Agostini, *Gauguin's house and added studio in Punaaiua with statue of a nude woman in imitation of Goupil's classical statues* [courtesy of Danielsson Archives, Papeari]

JULY 14
Writes to Monfreid that he is bedridden from illness and has "lost all hope" (Joly-Segalen 1950, XXXIX).

JULY-AUGUST
His health deteriorates. He suffers from an eye infection, complications from his ankle, eczema, and syphilis. His skin "eruptions" from the latter affliction are mistaken for a kind of leprosy by the natives and colonials (Danielsson 1975, 205-106). Financially destitute, he awaits word from Chaudet or Vollard (Malingue 1949, CLXIV). Begins writing long tract, "L'Eglise Catholique et les temps modernes," which becomes part of "Diverses choses" (*Noa Noa*, Louvre ms, 273-310).

Writes bitter, reproachful letter to his wife that so upsets her that she ceases to correspond with him (Malingue 1949, CLXV).

SEPTEMBER 10

Morice finishes definitive version of *Noa Noa*, which he sends to Félix Fénéon, editor of *La Revue Blanche* (MA, Cahier IV).

Fig. 95. *"Parahi te Marae," a poem by Morice intended for Noa Noa published with illustrations by Séguin* [*L'Image*, September 1897, 37f]

AROUND OCTOBER 10-12

Suffers a series of heart attacks and writes Morice that he will probably not live to see *Noa Noa* published (Malingue 1949, CLXVI, redated by this author).

OCTOBER 15

First part of *Noa Noa* is published in *La Revue Blanche*. Receives 126 francs from Monfreid's mistress, Annette. Foregoes his intention to commit suicide (Joly-Segalen 1950, XXXVIII).

NOVEMBER 1

Second part of *Noa Noa* is published in *La Revue Blanche*.

NOVEMBER 10

Chaudet, plans with Monfreid and Schuffenecker, an exhibition of Gauguin's recent Tahitian works at the Galerie Vollard, sends 700 francs to Gauguin (letter in LA).

DECEMBER 1

Opening of the fifteenth exhibition of modern art at Le Barc de Boutteville gallery, which includes a still life, *Fleurs*, by Gauguin (Fontainas 1898, 307).

EARLY DECEMBER

Gauguin suffers heart attack and plans to enter hospital. Begins work on the large "testa-

ment" painting *Where do we come from? What are we? Where are we going?* (W 561; Joly-Segalen 1950, XL).

DECEMBER 30

The mail boat brings Morice's first installment of *Noa Noa*, but no money (Joly-Segalen 1950, XXXIX). Gauguin goes into the mountains and tries to commit suicide with arsenic. Returns to town the next morning, exhausted but alive. Describes the failed attempt in a letter to Monfreid with a drawing and description of *Where do we come from?* (W 561; Joly-Segalen 1950, XL).

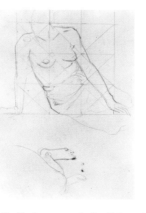

Fig. 96. *Preliminary study for Where Do We Come from? What Are We? Where Are We Going?* [photo courtesy of Musée Gauguin, Papeari]

1898

FEBRUARY 9

Leclercq organizes an exhibition of French modern art at the Swedish Academy of Arts. In addition to two early paintings by Gauguin from Brittany and Martinique, Molard has sent *Manao tupapau* (cat. 154), *Arearea* (W 468), and *Te arii vahine* (cat. 215; L 1959, XLI). *Manao tupapau* is considered indecent and is removed from the exhibition by the Academy director (Danielsson 1964).

END MARCH

Feeling healthier, Gauguin applies for the post of Secretary Treasurer of the Caisse Agricole in Papeete. He is not hired and is forced to accept a job at six francs a day as a draftsman in the Public Works Department (Lemasson 1950, 19; Joly-Segalen 1950, XLII). Loses membership in the officer's prestigious military club (Danielsson 1975, 218).

Fig. 97. *Julien Leclercq, Gauguin's promoter, who died, poor and forgotten*, 31 October 1901 [Carley 1975, 41]

MARCH-APRIL

In order to be nearer his job and a hospital, moves with Pahura to Paofai, a western suburb of Papeete. Rents a small house from a friend of Tehamana (Danielsson 1975, 215). Gives up painting for the next five months (Joly-Segalen 1950, XLII, XLV, XLVI). Receives request from Julius Meier-Graefe, the German art historian and editor of the avant-garde journal *Pan*, for information for a serious study of the artist (Joly-Segalen 1950, XLII).

MAY 15

Receives 300 francs from Monfreid for the sale of *No te aha oe riri* (cat. 219; Loize 1951, 147, no. 446) and the remaining 150 francs owed to him by Maufra (Joly-Segalen 1950, XLI).

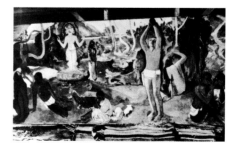

Fig. 98. *The painting Gauguin called his spiritual testament, taken in his studio on 2 June, 1898 by the postmaster, Henry Lemasson* [Danielsson 1965, 208]

JUNE 7

Degas and his friends, Henri and Ernest Rouart, each purchase paintings by Gauguin from

Monfreid in Paris. Monfreid sends the proceeds, 650 francs, to Gauguin (Loize 1951, 107, no. 257).

Sends Monfreid Lemasson's photograph of his enormous painting, *Where Do We Come from?* (W 561; Joly-Segalen 1950, XLIV).

MID-JULY
Sends *Where Do We Come from?* and eight related paintings with an officer returning to France (Joly-Segalen 1950, XLIV).

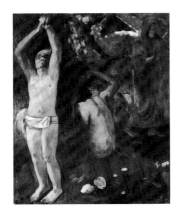

Fig. 99. Gauguin, *Tahitian Man with His Arms Raised*, 1897 [private collection]

AUGUST
Pahura leaves him but returns occasionally to pilfer his belongings (Leblond 1903, 536-537; Danielsson 1975, 219). When her friends break in and steal a ring, Gauguin unsuccessfully presses charges. The verdict is appealed to a higher court and dropped (Danielsson 1975, 218). Ambroise Millaud commissions a "comprehensible and recognizable" painting from Gauguin. The result, *The White Horse* (cat. 228), is refused and shipped by Millaud back to Monfreid (Danielsson 1975, 219-220).

SEPTEMBER
Gauguin's foot troubles him again and he enters the hospital for twenty-three days (Joly-Segalen 1950, XLVII).

Gustave Kahn's article on art criticism is published in *Mercure de France.* Gauguin excerpts passages and copies them into the notebook of essays and opinions that he com-

piles over the next four years and calls *Racontars de Rapin* (Kahn 1898; Gauguin 1951, 43, 45).

Gauguin's July shipment of paintings arrives in Paris. Monfreid gives them to Chaudet to stretch and frame for the exhibition (Joly-Segalen 1950, 209).

Exhibition at Galerie Vollard of *Where Do We Come from?* and eight other paintings related to one another in size and subject matter (reviews include Geffroy 1898; Natanson 1898; and Fontainas 1899, 238). Vollard buys all the paintings (through Monfreid) from the exhibition for 1,000 francs (Joly-Segalen 1950, 211), a price which angers Gauguin when he learns of it in February (Joly-Segalen 1950, LI).

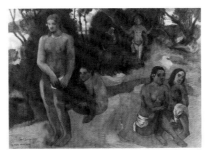

Fig. 100. *Te pape nave nave (cat. 227), one of the paintings exhibited at Vollard's gallery,* 1898, [National Gallery of Art, Washington. Collection of Mr. and Mrs. Paul Mellon]

Unable to paint or walk, Gauguin confesses to Monfreid that he has lost all his "moral reasons for living" (Joly-Segalen 1950, XLIX).

1899

Receives 1,000 francs from Monfreid. The amount includes 500 francs for the sale of *Nevermore* (cat. 222; Joly-Segalen 1950, L).

LATE JANUARY
Quits his job at the Public Works Department and returns to Punaauia where he discovers Pahura is five months pregnant. Rats have destroyed the roof of his house, it has rained in,

and cockroaches have eaten several drawings and an unfinished painting (W 569; Joly-Segalen 1950, LI).

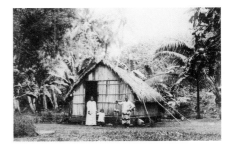

Fig. 101. *Tahitian family in front of their bamboo hut or case,* c. 1900 [photo O'Reilly Collection, Gleizal/Encyclopédie Polynésie]

EARLY MARCH
Sends his etching of Mallarmé (cat. 116) to André Fontainas, art critic for the *Mercure de France,* with a long letter on color and music (Rewald 1943, 22-23).

EARLY APRIL
Writes to Monfreid that he is still unable to paint but is growing vegetables and flowers so that when he resumes painting, he will have paradise at hand (Joly-Segalen 1950, LIII).

Pahura gives birth to a baby boy whom Gauguin names Emile (Danielsson 1975, 221 n153).

MAY
Writes Monfreid that he has only 100 francs to live on (Joly-Segalen 1950, LIV).

Refuses Maurice Denis' invitation to participate in a reunion exhibition of the Café Volpini (Malingue 1949, CLXXI).

The first of Gauguin's numerous essays and editorials appears in the satirical journal (*Les Guêpes* (The Wasps) in Papeete.

JULY
Complains to Monfreid that he has only a few colors and three meters of canvas with which to paint (Joly-Segalen 1950, LV).

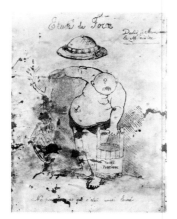

Fig. 102. *Unpublished caricature showing Governor Gallet carrying a bucket of "public hate" and titled Study of Force* [photo courtesy of O'Reilly Collection, Paris]

AUGUST

Begins his own four-page broadsheet, *Le Sourire (The Smile)*, which he writes, illustrates, edits, and prints (Joly-Segalen 1950, LIX).

SEPTEMBER

Having received a shipment of primed canvases from Monfreid, writes him that he wants to complete a dozen paintings in time for the Exposition Universelle in Paris in January (Joly-Segalen 1950, LVIII).

SEPTEMBER 19

Georges Chaudet dies (declaration of death, January 2, 1900; PA, DQ7 12.594, no. 118). Gauguin only learns of the young artist's death the next year when he attempts to recover his paintings and the money owed to him (Joly-Segalen 1950, LX).

DECEMBER

Writes to Monfreid that he has completed fifteen woodcuts (Gu 56-71), which he will send to Paris (Joly-Segalen 1950, LIX).

1900

JANUARY

Exposition Universelle of 1900 opens but Gauguin's paintings have not arrived in time. He is represented only by a *Brittany Landscape* (no. 307). Outlines his terms for a contract with Vollard in a letter to the dealer (Rewald 1943, 34).

MID JANUARY

Sends shipment of 475 prints, ten drawings, and ten paintings to Paris with instructions for their distribution (Malingue 1949, CLXXIII) but uses the wrong address for Monfreid's studio, causing a nine-month delay (Joly-Segalen 1950, LXIX).

EARLY FEBRUARY

Becomes editor-in-chief for *Les Guêpes*, increasingly devoted to attacking the Protestant Party and Governor Gallet, and writes six of the seven articles in the February issue (O'Reilly 1966, 13-14).

Fig. 103. *Governor Gustave Gallet flanked by his wife and daughter* [photo by Henry Lemasson, c. 1898. O'Reilly and Danielsson 1966, VIII]

MARCH

Agrees to contract with Vollard (naming Monfreid as his private dealer and intermediary), whereby he sends the dealer twenty to twenty-four paintings a year at 200-250 francs, in return for a monthly salary of 300 francs (Joly-Segalen 1950, LX).

MARCH 28

Emmanuel Bibesco, a Rumanian prince, who had purchased six paintings by Gauguin in January, writes Monfreid with an offer to replace Vollard as Gauguin's dealer (Loize 1951, 147, no. 448). Gauguin eventually declines the offer (Joly-Segalen 1950, LXIV).

APRIL

Gauguin discontinues his own monthly, *Le Sourire*, to concentrate his energies on *Les Guêpes*. Enjoys period of relative security and begins to hold dinner parties for the friends he has made through his journalistic endeavors (O'Reilly 1966, 15). Occasionally, makes illustrated menus (some of which are compiled in *Onze Menus*, Rey 1950).

Fig. 104. *The printing house of Les Guêpes on the outskirts of Papeete*, c. 1900 [O'Reilly and Danielsson 1966 VII]

APRIL-MAY?

At least one drawing (of *Ia Orana Maria*, cat. 135) is exhibited with the "Esoteric Group" at the home of Paul Valéry on the rue de Londres in Paris (Fontainas 1900, 546).

EARLY MAY

Writes Monfreid that he is sick and that he has not been able to paint for six months (Joly-Segalen 1950, LXIV).

MAY 16

Gauguin's son Clovis dies at the age of twenty-one. Gauguin seems never to have learned of the death (Malingue 1949, 337).

JUNE OR JULY

Receives shipment of canvas and tubes of color from Vollard (Rewald 1943, 38).

SEPTEMBER 23

Delivers speech in Papeete to the Catholic Party against Chinese emigration (excerpted in *Les Guêpes*, 12 October 1900, no. 21).

OCTOBER

Complains constantly about money owed to him by Vollard, in spite of occasional payments from him, and the brother of Chaudet. Fears that his sculptures will be dispersed to those who "don't appreciate them" and wills them to Monfreid. Asks that *Oviri* be sent to Tahiti to be placed on his tomb (Joly-Segalen 1950, LXVIII).

DECEMBER 18 OR 19

Receives a check for 1,200 francs from Gustave Fayet, director of the museum of Béziers. Enters the hospital (Loize 1951, 144, no. 425).

DECEMBER 27

At Gauguin's request, Monfreid, who has already retrieved several paintings from Vollard, informs the dealer that Gauguin wants all of his sculptures returned, and that none is for sale (typescript of original letter, Rewald Archives).

1901

JANUARY

Fragments of *Noa Noa* are published by Morice in the Belgian magazine, *L'Action humaine* (Loize 1951, 158, no. 529).

FEBRUARY 2-MARCH 23

In and out of the hospital three times. Receives payment of 600 francs, the full amount owed to him by Vollard (Rewald 1943, 44). Begins making plans to move to the Marquesas where "life is simple and cheap" (Joly-Segalen 1950, LXXIII).

APRIL 12

Publishes excerpts from *Noa Noa* in *Les Guêpes*.

APRIL-MAY

Four paintings and one ceramic (*Oviri*, cat. 211) by Gauguin included in the Société des Beaux-Arts exhibition in Béziers, organized by Gustave Fayet (Loize 1951, 146-147, no. 445).

MAY 1

First chapter of *Noa Noa* published in *La Plume* as an advertisement for the "Original Edition of the First Version" to be published in Louvain the same month (Loize 1951, 158, 531). Makes final preparations for his move to the Marquesas (Rewald 1943, 46).

JULY

Morice informs him that he has sent 100 copies of *Noa Noa*, which Gauguin never receives (Joly-Segalen 1950, 217), and that there is a plan underway to purchase *Where do we come from?* by subscription for the Luxembourg Museum (Malingue 1949, CLXXIV). The plan falls through and Vollard sells the painting to a doctor in Bordeaux for only 1,500 francs, much to Gauguin's displeasure (Joly-Segalen 1950, LXXVIII).

AUGUST 7

Sells his land in Tahiti for 4,500 francs (Danielsson 1975, 243 and 307 n174). Edits his last number of *Les Guêpes* (O'Reilly 1966, 17-18).

SEPTEMBER 10

Leaves Tahiti for the Marquesas on the steamship *Croix de Sud* (Danielsson 1975, 247 n.181).

Fig. 105. *Embarkation on the steamboat La Croix du Sud from Papeete to the Marquesas*, c. 1901 [photo by Henry Lemasson, O'Reilly Collection, Paris, Gleizal/Encyclopédie Polynésie]

SEPTEMBER 16

Arrives in Atuona on the island of Hivaoa in the Marquesas. Receives enthusiastic welcome from the islanders who know his name from articles in *Les Guêpes*. One welcomer, Nyuyen Van Cam (called Ky Dong) becomes Gauguin's close friend (Danielsson 1975, 248-249). Learns that the land he wants to buy is owned by Bishop Martin. Attends mass to demonstrate his piety *(Avant et après*, 1923 ed., 71-72).

SEPTEMBER 27

The bishop sells Gauguin two plots of land for 650 francs in the center of the village, between the Catholic mission and the Protestant church (Jacquier 1957, 682). With the help of his neighbors, begins to construct his "House of Pleasure" (Le Bronnec 1954, 209).

OCTOBER

Van Gogh's letters are published in *Mercure de France*, where Gauguin's name is often mentioned (Malingue 1949, CLXXVI; Joly-Segalen 1950, 201-202).

Fig. 106. *Bishop Martin*, c. 1894 [*Les Missions Catholiques* IV (1902), 44]

Fig. 107. *Gauguin's "House of Pleasure" in Atuona*, drawing by Gauguin's neighbor Timo [Le Bronnec 1956, 196]

OCTOBER 31

Julien Leclercq dies, poor and forgotten. Gauguin learns of it in March 1902 (Loize 1951, 99, no. 178).

NOVEMBER

Settles into his new home in Atuona with a cook (Kahui), two other servants, his dog, Pegau, and a cat (Le Bronnec 1954, 210). Sends Monfreid a sketch of his new residence (Joly-Segalen 1950, LXXVIII).

NOVEMBER 18

Persuades a Marquesan chief to remove his fourteen-year-old daughter, Vaeoho Marie Rose, from the Catholic school to become his *vahine* (Le Bronnec 1954, 202).

Fig. 108. *Reconstruction by Danielsson showing Gauguin's house entered through second-floor studio* [Danielsson 1975, 253]

1902

JANUARY-MARCH

Works on his house and on completing the manuscript *L'Esprit moderne et le catholicisme*. Enters productive period of painting. Announces shipments for April of twelve paintings to Monfreid (Joly-Segalen 1950, LX-XIX) and twenty to Vollard (Rewald 1943, 50; Loize 1951, 143, no. 424).

Fig. 109. *Sisters of the School of Atuona at Hivaoa* [*Les Missions Catholiques* IV (1902), 45]

Fig. 110. *The "trading post" in Hivaoa for the S.C.O. (Société Commerciale de l'Océanie), whose branch in Hamburg handled Vollard's payments to Gauguin in the Marquesas* [photo courtesy of Glezial/Encyclopédie Polynésie]

EARLY MARCH

Receives first shipment of mail in the Marquesas, with payments from Fayet and Vollard (Joly-Segalen 1950, 202).

EARLY APRIL

Sends twenty canvases to Vollard (Loize 1951, 143, no. 424).

APRIL

Incurs wrath of colonial authorities by refusing to pay taxes and encouraging the natives to do likewise (*Danielsson* 1975, 260-261).

JUNE-JULY

Unable to walk without difficulty, Gauguin buys a horse and wagon (Le Bronnec 1954, 211).

MID-AUGUST

Vaeoho, pregnant, returns to her parents' home to have her baby. She never returns to live with Gauguin (Danielsson 1975, 270). His attempts to dissuade native parents from sending their daughters to school are thwarted by the bishop's intervention. Gauguin retaliates by placing sculptures in caricature of the bishop (cat. 259) and his nude chambermaid outside of his [Gauguin's] home (Chassé 1938, 60).

AUGUST 25

Discouraged, Gauguin writes to Monfreid that he is seriously considering leaving the islands and settling in Spain (Joly-Segalen 1950, LXXXII).

SEPTEMBER 14

Birth of daughter, Tahiatikaomata, to Vaeoho (Danielsson 1975, 309). Sends manuscript for *Racontars de Rapin* to Fontainas in the hopes of having it published in the *Mercure de France* (Rewald 1943, 55), but the magazine's editors refuse to publish the piece (Malingue 1949, CLXXVII).

END OCTOBER-NOVEMBER

His attack on Governor Petit is published in *L'Indépendant*, the monthly successor to *Les Guêpes* (Danielsson 1975, 310 n212; Siger 1904, 569-573).

DECEMBER

Gauguin's eczema flares up, and he is unable to paint. Works almost exclusively on his

diary-like book of recollections and observations, *Avant et après* (Joly-Segalen 1950, LXXXIV).

Fig. 111. *Although the tatooed men in the Marquesas were few, Gauguin wrote about them in Avant et après, and would have seen this photo* [*Les Missions Catholiques* IV, (1902), 56]

1903

JANUARY 7-13

A cyclone hits the islands, striking Hivaoa but sparing Gauguin's house. Gives a section of his property to Tioka, his friend and neighbor whose house was destroyed in the storm (Danielsson 1975, 280).

Fig. 112. *Photograph of Tioka (center), who helped Gauguin to build his "House of Pleasure" in Atuona and who Gauguin helped after the cyclone hit Tioka's home* [photo courtesy of Danielsson Archives, Papeari]

FEBRUARY

Writes to Fontainas of his desire to have *Avant et après* published (Rewald 1943, 59 and asks Monfreid to sell paintings to ensure its pub-

lication (Joly-Segalen 1950, LXXXIV). Unsuccessfully defends twenty-nine natives accused of drunkenness. He is sent home on the first day of the trial for appearing in court wearing nothing but a dirty *pareu* (Danielsson 1975, 285 and 292).

MARCH-MAY
Armand Séguin writes a series of three articles on Gauguin for the review *L'Occident* (Séguin 1903a,b,c).

MARCH 26
Writes to Vollard that he has fifteen paintings and twelve drawings to send with the next courier (Rewald 1943, 62).

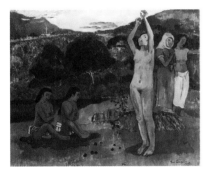

Fig. 113. *The Invocation*, 1903 [National Gallery of Art, Washington. Gift from the collection of John and Louise Booth in memory of their daughter, Winkie]

MARCH 27
Charged with libel against the governor and given three days to prepare his defense (Joly-Segalen 1950, LXXXV).

MARCH 31
Fined 500 francs and sentenced to three months in prison (Malingue 1949, CLXXXI).

APRIL 2
Appeals for a new trial in Papeete (Danielsson 1975, 272). Very sick, Gauguin writes to the Reverend Paul Vernier, "I am ill. I can no longer walk" (Malingue 1949, CLXXXII). Vernier finds the artist suffering from severely ulcerated sores on his legs (O'Brien 1920, 230).

AROUND MID-APRIL
Sends fourteen canvases to Vollard, most from 1899, as well as a group of transfer drawings.

Asks the dealer to send the money owed him as he is desperately in need of funds for his upcoming trial (Rewald 1943, 63).

END APRIL
In Papeete, Gauguin is fined 500 francs and sentenced to one month in prison for slandering a M Guicheray (Chassé 1938, 72-73). Writes a scathing letter to the chief of police, M Claverie.

MAY 8
Gauguin's health deteriorates. Tioka sends for the Reverend Vernier. Gauguin dies at 11:00 a.m. after a large dose of morphine and possibly a heart attack (Rotonchamp 1925, 225).

Fig. 114. *Gauguin's death certificate, written by the gendarme Claverie in Atuona*, 8 May, 1903 [photo Malingue Archives, Paris]

MAY 9
Gauguin is buried at 2:00 pm in a Catholic cemetery above Atuona.

JULY 20
Public auction of Gauguin's miscellaneous household goods in Atuona (Jacquier 1957, 31-36).

AUGUST 23
Monfreid learns of Gauguin's death and circulates the news among friends and clients of the artist, claiming the death took place on May 9. Announcements appear in *l'Art moderne* (20 September, 324) and *Revue Universelle* (15 October, 535).

SEPTEMBER 2-3
Public auction of Gauguin's belongings, works of art, and other items from his home, in Papeete (Jacquier 1957, 707-711).

Fig. 115. *The "faire-part" or death announcement Monfreid sent out to Gauguin's friends, misdated "May 9, 1903"* [Musée d'Orsay, Centre de Documentation]

OCTOBER 31-DECEMBER 6
First exhibition of the Salon d'Automne at the Petit Palais honors Gauguin with a room (organized by Morice) with five paintings, including *Self-portrait with Yellow Christ* (cat. 99) and four studies (Hoog 1987, 319).

NOVEMBER 4-28
Exhibition at the Ambroise Vollard gallery of fifty paintings and twenty-seven transfer drawings (*Exposition Paul Gauguin*, copy of catalogue in DR).

NOVEMBER 13
Morice delivers a lecture on "The Master of Tahiti" (MA, notebook 16).

Fig. 116. *Gauguin's tomb in Hivaoa, with the ceramic Oviri.*

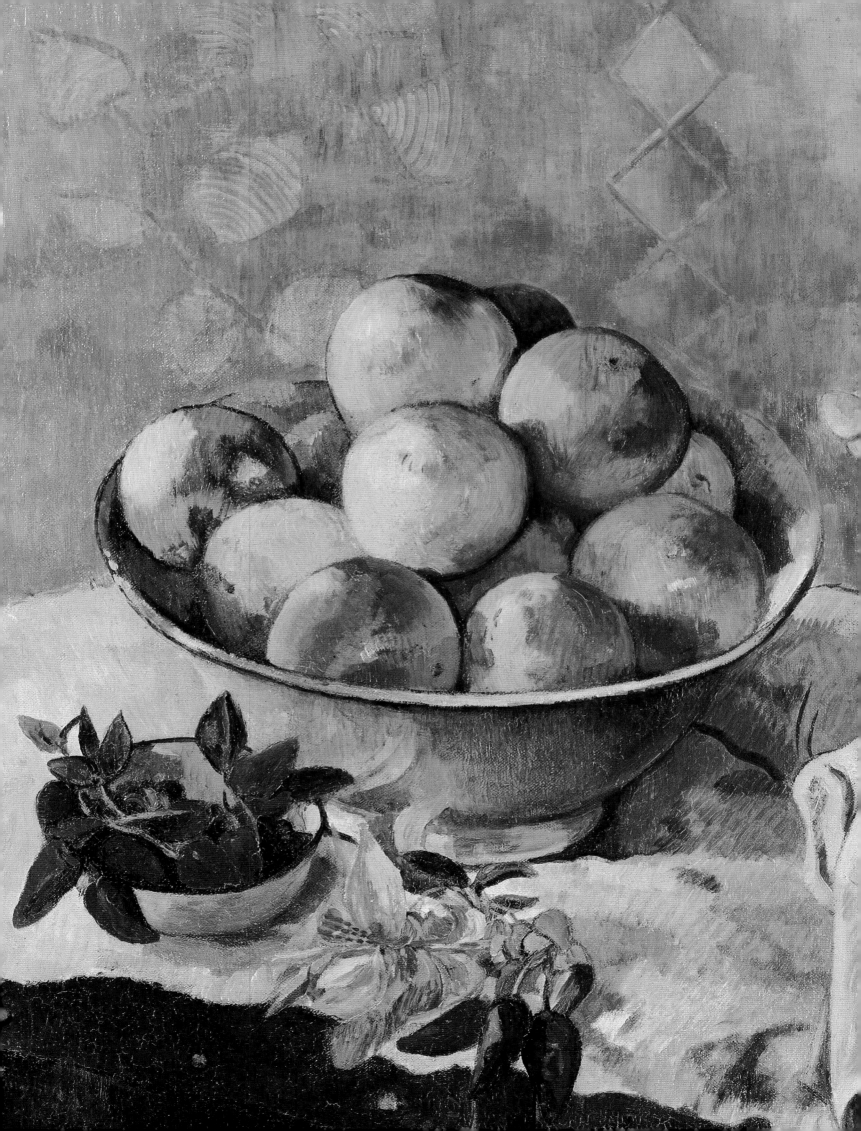

The Final Years: Tahiti and Hivaoa

RICHARD BRETTELL

1. See Malingue 1949; Joly-Ségalen 1950, and Rewald 1943.

2. Hivaoa is generally referred to as La Dominique both in the Gauguin literature and by Gauguin himself (in his letters). This island was named La Dominique by its Spanish discoverer, Mendaña, in 1595. Today, however, the island is referred to by its Polynesian name, Hivaoa. Danielsson 1975, 308, n. 182.

3. See Herta Hesse-Frielinghaus, *Karl Ernst Osthaus: Leben und Werk* (Recklinghausen, 1971) for Osthaus and Beverly Whitney Kean, *All the Empty Palaces* (New York, 1983) for Morosov and Shchukin, chap. 4 and 5.

Gauguin left France on 3 July 1895, never to return. He had presided over a failed sale of his earlier work and had left the majority of his paintings in the hands of at least two obscure men, Auguste Bauchy and Georges Chaudet. Together with his literary agent, Charles Morice, his faithful friend Daniel de Monfreid, and later, Ambroise Vollard, his dealer, these men kept Gauguin informed about his business affairs in France and made it possible for him to enjoy periods of prosperity amid bouts of depression, illness, and poverty. Because they oversaw Gauguin's financial well-being from afar, the many letters he wrote to them are full of information about financial matters and the state of his health.[1] When these letters are read as an ensemble, his life sounds more miserable than it was, and almost masks the brilliant paintings, drawings, and prints that survive him.

During the eight years that elapsed between Gauguin's final departure from France and his death on the distant island of Hivaoa in the Marquesas,[2] he was in the hospital at least four times, often for prolonged periods; claimed to have attempted suicide once and perhaps succumbed to its temptations in 1903; built three houses; fathered at least three children; edited one newspaper and wrote, designed, and printed another; completed three booklength texts; sent paintings and drawings to many European exhibitions; finished nearly 100 paintings; made over 400 woodcuts; carved scores of pieces of wood; wrote nearly 150 letters and fought both civil and ecclesiastical authorities with all the gusto of a youth. He was only fifty-four years old when he died, but he had lived his life with such fervor and worked so hard when he was healthy that we must remember the achievements even as we read the litany of the failures and miseries in the chronology.

Unfortunately, none of the great monographic exhibitions devoted to Gauguin since his death has done justice to this extraordinary phase in his working life. By the time the French organizers of the 1906 exhibition had begun their work, a good many of the most important paintings had already left France for private collections in Russia and Germany. Indeed, without the paintings bought by Karl Ernst Osthaus, Sergei Shchukin, and Ivan Morosov, it is difficult to understand the late Gauguin fully, and many of these paintings were not in France to be loaned to the 1906 Gauguin exhibition.[3] Only the 1903 exhibition held in Vollard's gallery a few months after Gauguin's death had a generous enough selection of major paintings and transfer drawings to give full measure to the achievement of the artist in his last years. Yet even this large exhibition was insufficient for a full understanding of his oeuvre from 1896 to 1903 because it contained almost exclusively works made in the last three years of his life.

The present exhibition presents a large and balanced selection from Gauguin's considerable body of works from the last Polynesian period. Thanks to generous loans from the Soviet Union, these works can be seen in the context of the major collections in Europe and America for the first time, and two of the greatest paintings bought from Vollard by Osthaus have been lent to the exhibition (cats. 279 and 280). We have also attempted to give coverage of the artist's achievements in other mediums, and our selection of woodcuts and printed drawings, as well as the inclusion of one of the surviving manuscripts, gives some sense of Gauguin's achievements as a writer and illuminator of texts. However, an exhibition is not the ideal medium for literature, and a full reappraisal of Gauguin's texts must wait for a readily accessible printed edition of these scattered documents.

There are several important ways in which Gauguin's oeuvre from the last Polynesian period can be differentiated from that of the first. During the first trip, Gauguin's work took two different directions, both of which were recognized by critics of the 1893 exhibition. First, he represented scenes of daily life just as his hero, Delacroix, had done in Morocco; second, he created idealized illustrations of Polynesian tales of religious and mythical events about which he read. Both these enterprises were characterized by a sort of ethnographic focus on Tahiti before its colonialization. Indeed, hints of the colonial presence are so rare in the paintings that, even when they do exist, one must be sensitized to recognize them.[4]

Neither of these ethnographic concerns was so evident in Gauguin's work of the last Polynesian period. Indeed, Gauguin returned to Tahiti with his mind full of new ideas about comparative religion, politics, and social philosophy. He also took with him an even larger stock of photographs and reproductions of other works of art than he had in the years 1891 to 1893, and, as many scholars have pointed out, he made considerable use of this material. Two of the photographs he often referred were of the Javanese temple of Borobudur. The Tahiti to which Gauguin returned in 1895 had become even more colonial in the two years since he had left, and there is little doubt that Gauguin disliked most of the "progress" that he saw. Yet we must also remember that Tahiti had changed in those years perhaps less than Gauguin himself had, and that given his earlier experience, the painter could have predicted what he was going to find on his return.

4. The only major exception to this rule, *Ia orana Maria* (cat. 135), was considered unique by Gauguin himself and acts as the most important prototype from the first trip for the paintings of the second.

Borobudur Relief. top: *The Tathagat Meets an Ajiwaka Monk on the Benares Road*; bottom: *Maitrakanyaka – Jataka. Arrival at Nadana*, photograph, c. 1880-1889 [Private Collection]

Borobudur Relief. top: *The Assault of Mara*; bottom: *Scene from the Bahllatiya – Jataka*, photograph, c. 1800-1889 [Private Collection]

His late paintings, traced and transferred drawings, and sculpture lack the vivid directness of the work from his earlier, ethnographic phase. In these years, he was more interested in the creation of works of art that transcended the particular place in which they were made. His late work is more obviously mediated than the earlier, and he created works of art as if to decorate a new mythic universe. His overt worldliness, his conflation of religious traditions, of East, West, and Oceania, of ancient and modern, must have seemed strange to the majority of Eurocentric Parisians for whom his art was made. Today, in an age of rampant international capitalism, his world view is easier to find relevant and even important.

Gauguin, *Where Do We Come from? What Are We? Where Are We Going?*, 1897, oil on canvas
[Museum of Fine Arts, Boston, Tompkins Collection]

5. These paintings are all about 96 x 130 cm. They are cats. 219, 220, 221, and 223; W 542, and W 544, *Te Vaa*, The State Hermitage Museum, Leningrad.

6. W 561, Museum of Fine Arts, Boston.

Gauguin renovated and added to a native dwelling on rented land in November 1895. This became the studio in which he created six horizontal paintings of identical dimension, the largest works he had painted since 1881 (cat. 7). Five were completed in 1896 and the sixth in 1897. Unfortunately, they were sent to France in several shipments and were never even seen together by Gauguin himself. For this reason, we have no documentary evidence that they were conceived as a series. The six paintings are now in Leningrad, Munich, Chicago, Lyon, Moscow, and London,[5] and they have never been shown together. They are, unfortunately, only partially reunited in this exhibition. Together they would constitute the greatest group of paintings by Gauguin made up to that point. Even when compared in reproduction, however, they make it clear both that he intended to concentrate his efforts by making fewer but more important works, and that his efforts were successful.

This trend toward the mythic and monumental led him to conceive and create a self-conscious masterpiece, *Where Do We Come from? What Are We? Where Are We Going?*[6] This crucial painting was made during several concerted

7. Geffroy 1898, 1.

8. Joly-Segalen 1950, XLV, July 1898.

9. Natanson 1898, 544-546. The paintings from the 1898 Vollard exhibition are W 561 *Where Do We Come from?* Museum of Fine Arts, Boston; W 568, *Te pape nave nave*, National Gallery of Art, Washington, cat. 227; W 570, *Rave te hiti ramu (The Idol)*, The State Hermitage Museum, Leningrad; W 565, *Man Picking Fruit*, The State Hermitage Museum, Leningrad; W 562, *Landscape with Two Goats*, The State Hermitage Museum, Leningrad; W 563, *Te bourao II*, Private Collection; W 564, *Tahitian Bathers*, The Barber Institute, Birmingham, England; W 560, *Figure from Where Do We Come from?*, Private Collection, Buenos Aires; W 559, *Vairumati*, Musée d'Orsay; W 576 *Tahitian Woman*, Ordrupgaard Collection, Copenhagen.

10. ". . . these are eight motifs inspired by the decor where the painter lives and by the large decorative, mysterious panel that brings them together, but they can also represent fragmentary-replicas rather than studies," Natanson 1898, 545.

11. W 559, *Vairumati*, Musée d'Orsay, Paris; W 560, *Tahiti*, private collection, Buenos Aires.

12. Paris 1918, no. 47, *Tahiti Paysage*, W 567.

13. From a letter to Morice of February 1898, published in Artur 1982, 16. See also letter to Fontainas, March 1899 in Rewald 1943, 21-24; 1986 reprint, 182-184.

periods of activity late in 1897 and in the first half of 1898. Even more than the large paintings of 1896 to 1897 that preceded it, *Where Do We Come from?* was designed to embody a total philosophy of life, civilization, and sexuality. Gauguin himself described and, hence, decoded it, as he had done several times with other key works, and sent it to France for exhibition. He also sent a number of other works to the exhibition that included a coherent group of paintings closely related to *Where Do We Come from?*. These works were shown together at Vollard's gallery in November and December 1898, when they were described by Gustave Geffroy as "a series of canvases that continue to express his same grand decorative style."[7] Although this exhibition is discussed in various imprecise ways in letters from Gauguin to Monfreid (as early as 1897),[8] there is nothing in the published correspondence that can help to reconstruct it. Fortunately, a lengthy review in the December issue of *La Revue Blanche* (1898) by Thadée Natanson makes the reconstruction a relatively easy task.[9]

The 1898 Vollard exhibition was clearly conceived as a total work of art. The major painting *Where Do We Come from?* dominated it but was surrounded by eight paintings that, according to Natanson, could be interpreted as both "fragmentary replicas of and studies for" the large panel.[10] All of these paintings survive, but no one has recognized that they were painted specifically for exhibition with his masterpiece, *Where Do We Come from?* Therefore, the true nature of Gauguin's ambition in creating a total decorative ensemble has never been realized.

Each of the eight canvases represents a figure, a group of figures, or a portion of the setting from the large canvas and analyzes the fragmentary part of the whole, usually in a dominant tonality. Where the Musée d'Orsay's *Vairumati* is a horizontal canvas saturated with oranges, yellows, and reds, the painting called simply *Tahiti*[11] is a vertical rectangle dominated by deep blues, purples, and various grays. Other paintings are suffused with yellow or green or purple. All of them are painted on standard size 30 canvases. The Vollard archives have not as yet yielded any information about the installation of this historic exhibition, and Natanson's review, in spite of its importance in helping to identify the works, is mute on the order of their installation, the color of the walls, and the precise nature of the relationships evoked by this arrangement. We know that Degas went to the exhibition and bought a small painting that was included in his own death sale and subsequently lost.[12] These shreds of evidence are all that remain of an exhibition that was a financial failure but must have been among the two or three major artistic triumphs of the 1890s.

Gauguin himself wrote a text that might have helped with the interpretation of this exhibition more than anything else. In February 1898, he wrote to Charles Morice and announced that he had completed an essay on color. He enclosed the essay and asked Morice to arrange for its publication. Unfortunately, only a typescript of the original letter survives.[13] There is no copy of the essay in the Morice archives at Temple University, nor is there an anonymous article or one with a likely *nom de plume* published in 1898 or 1899 that could reasonably be identified as Gauguin's text. Therefore, we can only surmise its content from the various passages about color in *Diverses Choses*, the collation of various man-

uscript materials assembled in 1896 and 1897, while Gauguin was working on *Where Do We Come from?*

There are at least two sustained passages about color and many scattered references in this, the most important unpublished Gauguin manuscript. The first concerns Delacroix's use of color and derives not only from Gauguin's study of the earlier master's paintings, but also from his close reading of Delacroix's journal, first published in 1893. As a footnote to a sustained quotation from the Delacroix journal, Gauguin wrote several eloquent sentences about color.[14] "It is shocking that Delacroix, so strongly preoccupied with color, considers it as much as he does physical law and the imitation of nature. Color! This profound, mysterious language, a language of the dream. Also in all his work I perceive the trace of a great struggle between his romanticism and the earthiness of the painting of his time. And despite himself his instincts revolt; often in many places he tramples these natural laws and permits himself to go off in pure fantasy. I enjoy imagining Delacroix having arrived in the world thirty years later and undertaking the struggle that I dared to undertake."

The second passage is so complex and lengthy that it cannot be fully quoted here. However, it makes Gauguin's ultimate ambitions as a painter clear. He situated himself at the end of what he considered a false struggle between line and color and after a period of equally false scientific naturalism, exemplified by the writing of Rood, Chevreul, and other scientists. His ultimate aim in painting was to reconnect the plastic arts with human ideas and dreams and thus to embody thought in color-form rather than to paint actual sensations. This well-known symbolist trope was repeated with particular conviction by Gauguin in *Diverses Choses*, and, when we reinterpret *Where Do We Come from?* in its original context, we must remember above all Gauguin's intellectual ambitions. As he himself said in a letter to Morice written in February 1898, when the painting was probably still incomplete, "I think that the painting explains the legend. . . . I also think that this painting crowns the article on color that I sent you."[15] Each of these otherwise unremarkable sentences makes it clear that the paintings themselves are ideas and that they do not need to be explained with words. And the sustained passage about color in *Diverses Choses* identifies color as the language of these ideas.[16]

Gauguin's production in the years 1896 to 1898 was so brilliant and confident that one can scarcely imagine he could sustain it, but the paintings of late 1898 and much of 1899 are of fabulous quality. In them, perfectly realized human forms move effortlessly through pulsating, colored realms. Trees and shrubs occasionally define the stately spaces. Yet, more often, colored areas become landscapes without the distracting presence of bark, leaves, or roots. The largest of these paintings, *Rupe Rupe (Luxury)*,[17] was brought by Shchukin, probably from Vollard, and has never been exhibited outside of the Soviet Union. Although smaller than *Where Do We Come from?*[18] it is among the most monumental canvases of Gauguin's career and attains a level of mythic calm that had always eluded the artist. This same sense of fullness and metaphysical clarity persists in most of the great paintings produced by Gauguin in the last year of the nineteenth century. And, almost as if he were unable to carry this perfection forward, no paintings survive from the year 1900.

14. *Diverses choses* in *Noa Noa*, Louvre ms, 220-221.

15. See note 13.

16. See also his letter to Fontainas of March 1899. "These repetitions of tone, in monotone chords (in the musical sense of color), wouldn't they be analogous to Oriental chants, sung in a shrill voice and accompanied by resonant notes which juxtapose and enrich the chants by way of their opposition. Beethoven frequently used this (as far as I know) in the *Pathétique* sonata, for example. Delacroix, in his repetitive harmonies of chestnut brown and muted violet, somberly cloaked to suggest drama. You often go to the Louvre; thinking about what I say, look closely at Cimabue. Think also about the musical part to be played in modern painting from now on. Color, which is vibration as well as music, attaining what is more general, and hence more vague, in nature: its interior force," Malingue 1949, CLXX.

17. W 585, The State Hermitage Museum, Leningrad.

18. *Rupe Rupe*, 128 x 200 cm; *Where Do We Come from?*, 139 x 375 cm.

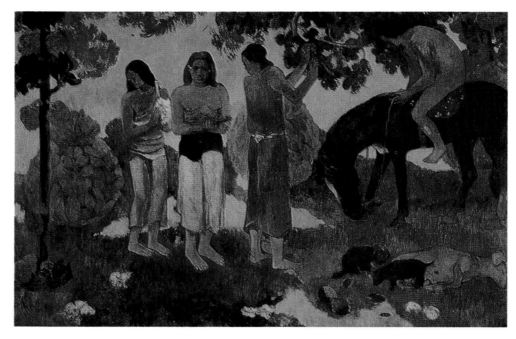

Gauguin, *Rupe Rupe*, (Luxury), 1899, oil on canvas [The Pushkin State Museum of Fine Arts, Moscow]

19. This phrase has been popularized by Matisse's painting which he entitled *Luxe, calme, et volupté*. Here the artist made a specific literary association to the refrain in Charles Baudelaire's poem "L'invitation au voyage" (Invitation to a Journey) from his famous collection of poems *Les Fleurs de mal* (The Flowers of Evil).

Là, tout n'est qu'ordre et beauté,
Luxe, calme, et volupté
(There, all is loveliness and harmony
Enchantment, pleasure, and serenity.)

It is, in a sense, tragic that *Rupe Rupe*, the masterpiece of Gauguin's career after *Where Do We Come from?* should be unable to travel to this exhibition. Its absence from the major books and exhibition catalogues about Gauguin has resulted in an imbalance in the critical and historical understanding of the artist. The accessible masterpiece in Boston has been reproduced and written about almost excessively by American and European historians of art, who have relished its overt symbolism and its foreboding of the fall of man. *Rupe Rupe*, by contrast, is utterly paradisaical, placing the fruitpicker, the traditional figure of temptation, in the center of a landscape abounding in luxuriant beauty. Here, fruits have already been picked and will be picked again, and there is no necessity for the fall of man. As viewers, we are placed in front of what might be called the ultimate decoration, the painting that, even more than anything by Matisse, embodies Baudelaire's ideal, "luxe, calme, et volupté" (enchantment, pleasure, and serenity).[19]

It seems from the written evidence that Gauguin had more or less stopped painting by August 1899, turning instead to his manuscripts and his alternative career of journalism. As first a writer and then editor of *Les Guêpes*, and for nine months the publisher of *Le Sourire*, Gauguin entered fully into the political life of Tahiti. The contrast between his combative, bristling journalism and the paintings just discussed is total. In fact, it is almost impossible to place these two sides of Gauguin's achievement within the same sensibility, and few students of Gauguin have accepted them both fully. Yet surely Gauguin's striving for the ideal did not take place only within the arena of art. His constant meddling in the affairs of colonial government was an equal part of his search for a utopia on earth, a search that is no less important for having been futile.

The mediating factor between these two apparent extremes can be found in Gauguin's manuscripts, the most important of which, *L'Esprit moderne et le catholicisme*, he had written in draft form in 1896-1897. This book, and its companion essays on family life and morality, were written in the manner of treatises for a highly literate public, and they are obviously based on his tacit assumption that, by explaining his political, social, religious, and sexual theories clearly, he would convince people to change their behavior. His immediate confidence in the power of these texts must not have been very great, however, because his efforts to publish them were desultory at best. For that reason, they, like his earlier texts, have been published either in a fragmentary way or as facsimiles and consequently have been read attentively by few scholars.

It becomes clear as one studies Gauguin's relationship with his European audience in the last years of his life that he created the majority of works of art, as well as his texts, for posterity. His position in the South Seas, far from the people who bought and sold his paintings, meant that he could do little more than imagine the response his work would produce in France, and he had come to assume that they would be negative. There are ways in which this very distance had its psychic advantages for Gauguin. Because of it, he could "posture" as a genius and make pronouncements about the state of the world without fear of contradiction. The very innocence of his Tahitian audience made both his art and his ideas bolder than they might have been in the competitive, even combative atmosphere of Paris.

In 1900, Gauguin moved to the even more distant island of Hivaoa, part of the most remote island group on earth. From the tiny village of Atuona, where he lived the last two years of his life, he kept abreast of world news, followed artistic and literary events throughout Europe, and busied himself with the decoration of his last total work of art, the famous House of Pleasure. After years of struggle, he came to a financial agreement with Ambroise Vollard who, in exchange for a more-or-less regular income, imposed a certain level of productivity upon Gauguin. Since his works were then in demand, he finished them relatively quickly and sent them in batches to France; perhaps this is why the paintings from the Marquesan period are not so carefully wrought as were their predecessors. Yet it would be wrong to think of them as slapdash or to undercut their esthetic value simply because they were made as part of a financial agreement. Instead, the rapidity with which he worked had a liberating effect on Gauguin. His compositions became more varied, and he experimented even more dramatically with relationships of color.

For all the greatness of much of the Marquesan work, it lacks the focus and absolute assurance of the paintings from 1896 to 1899. Perhaps the greatest works for their sheer power and originality, as well as for their impact on Matisse and Picasso, are the transfer drawings, twenty-seven of which dominated Vollard's last major Gauguin exhibition. Unfortunately, Gauguin had been dead for five months by the time this exhibition opened in November 1903. There are no letters from him specifying the arrangment of the works, and he had all but ceased to inscribe titles in Tahitian or French on the paintings. Because of this lack of documentation, there has been no systematic attempt to reconstruct the 1903

20. A complete reconstruction of the 1903 Vollard exhibition is still being worked out and will be published in a forthcoming article by Richard Brettell.

21. Joly-Segalen 1950, LXVIII.

Vollard exhibition, and few of the late works published in the catalogue raisonné list this crucial exhibition in their histories.

Unfortunately, the task of reconstructing this exhibition is a difficult and ultimately frustrating one. It seems from the published exhibition catalogue that Vollard invented the titles with little thought or time; this resulted in a series of generic titles, only five of which have been clearly connected to known pictures. The same problem persists with the group of transfer drawings, called simply "drawings" in Vollard's catalogue. However, if one works carefully through the surviving paintings and transfer drawings from 1899 to 1903, it is possible to assign pictures to titles with a fair degree of certainty. In fact, many late works in the present exhibition are associated with the 1903 exhibition in the catalogue entries for the first time.[20]

While critics and painters crowded into Vollard's small gallery to see the latest works by Gauguin in 1903, the artist lay buried in a small, Catholic cemetery in Atuona. At that time his grave was adorned with a simple white cross like those of many of his neighbors. This is not what he had intended. He had asked Monfreid in October 1900 to send him the ceramic sculpture *Oviri* for his tomb.[21] Indeed, Gauguin knew perfectly well when he arrived in Papeete in 1895 that he would never return to Europe. His art was made for a future world he could never have quite predicted and is today admired for many reasons that he would find loathsome or trivial. He himself bitterly resented the high prices fetched by the works of his friend van Gogh after the artist's suicide and the death of Theo, and we can only imagine the snide invective that would come from Gauguin's pen or his mouth if he attended a sale at Sotheby's or Christie's today.

Yet, first in 1903 and then later in greater numbers in 1906 and subsequently, artists have flocked to see the works of Gauguin. Picasso was clearly devastated by the power and raw, crude strength of the printed drawings. Matisse was overcome by the color and the apparently casual draftsmanship of the late paintings. Indeed, if one can measure the strength of an artist by that of his most brilliant followers, Gauguin would be among the very greatest from the late nineteenth century. Perhaps only Cézanne could rival him. Fortunately for Gauguin's reputation, his works entered the collections of major museums shortly after his death and have been part of the staple diet of modern artists since the 1920s. He still lies buried in Atuona, with a small bronze cast of *Oviri* now on his tomb, but his art can be found on every continent, in socialist and capitalist countries, in public and private collections, and, in reproduction, on the walls of hundreds of thousands, perhaps millions of rooms across the world. In this exhibition, we can once again study him in the original.

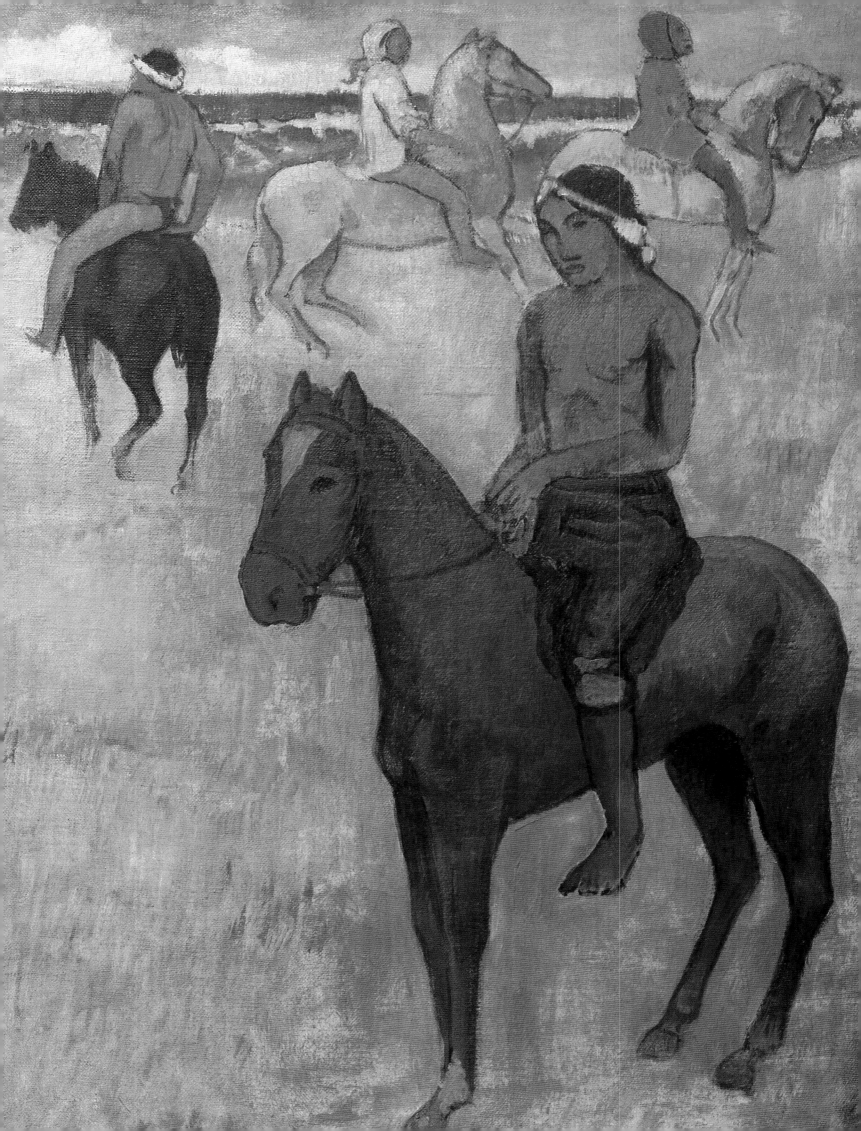

215-215a
Te arii vahine

215
Te arii vahine

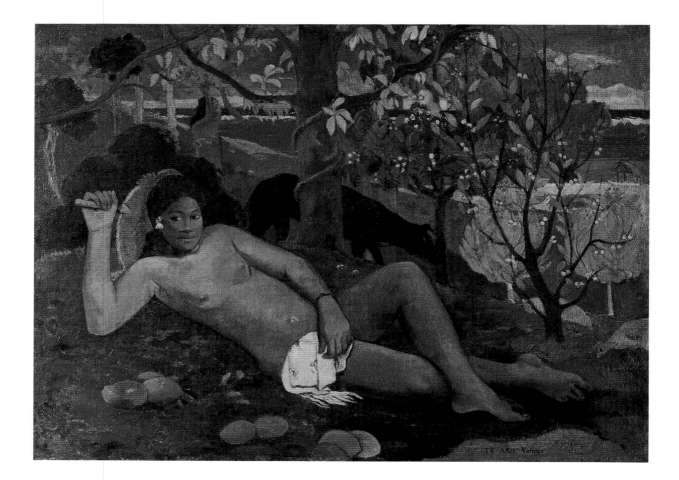

1896

97 x 130 (37⅞ x 50¾)

oil on canvas

inscribed, signed, and dated at lower right,
TE ARII Vahine/P. Gauguin/1896.

Pushkin State Museum of Fine Arts, Moscow

EXHIBITIONS
Stockholm 1898, *Den Swarta Jungfrun* (*The
Black Virgin*); Paris 1906, no. 13, *La Femme
aux mangos*; Moscow 1926, no. 13; Brussels
1958, no. 98

CATALOGUE
W 542

Gauguin himself wrote the first and best description of *Te arii vahine* (*The Noble Woman*) in a long, illustrated letter to Daniel de Monfreid, usually dated April 1896 (cat. 215a). "I have just finished a canvas of 1.30 by 1 meter that I believe to be much better than anything I've done previously: A naked queen, reclining on a green rug, a female servant gathering fruit, two old men, near the big tree, discussing the tree of science; a shore in the background: this light trembling sketch only gives you a vague idea. I think that I have never made anything of such deep sonorous colors. The trees are in blossom, the dog is on guard, the two doves at the right are cooing."[1]

Curiously, Gauguin failed to mention the mangoes in the foreground, the superb fan, and the delightfully insufficient piece of cloth held by the great queen. Nor did he dwell in any way on the figure herself, in spite of the fact that virtually every aspect of this archetypal queen has art historical resonance. Her pose has an obvious but generic antecedent in Manet's *Olympia*, which Gauguin had copied in

Cranach, *Diana Reclining*, detail, c. 1537 [Musée des Beaux-Arts, Besançon]

Scene from the *Awadenas* and the *Jatakas*, frieze at Borobudur Temple, Java [Beschrijving van Barabudur, series II (B) plate VI]

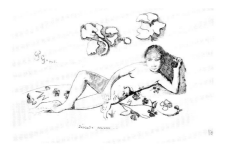

Gauguin, *Te arii vahine*, *Avant et après*, page 121 [facs. ed.]

1. Joly-Segalen 1950, XXI.

2. Gauguin's copy was purchased by Degas at the 1895 sale at the Hôtel Drouot.

3. For Leclercq's role in the 1898 Stockholm exhibition, see Danielsson 1964.

4. Leclercq, Jan. 1895, 121, mentioned that Gauguin had photographs of paintings by Cranach. Le Pichon 1986, 208, illustrated a photograph of *Diana Reclining*, credited to the firm of Lauros-Giraudon. A Giraudon stamp also appears on the reverse of the photograph that Gauguin owned of the Egyptian fresco from the British Museum.

5. "A Puvis de Chavannes," *Mercure de France* (February 1895).

Paris[2] (cat. 117). In fact, *Te arii vahine* was called by Leclercq "The Black Olympia" when it was first exhibited in 1898.[3] There it was intended to be shown with Gauguin's most famous female nude, *Manao tupapau* (cat. 154), which was withdrawn for moral reasons. The position of the arms and legs as well as the outdoor setting have been related to one of several versions of Lucas Cranach's *Diana Reclining*, a photograph of which was probably in Gauguin's possession.[4] There are also hints of Puvis de Chavannes' famous *L'Esperance* (*Hope*), of which Gauguin had made a drawing in 1894 that was published with a short poem by his friend Morice, in *Mercure de France* in February of 1895.[5] This was surely Gauguin's first great native reclining nude, and in it and the other monumental canvases of 1896-1897, Gauguin westernized and classicized Tahiti.

However, one important non-Western source has never before been published: the reclining figure of a monk (*biksu*) from the high-relief frieze on the second corridor of Borobudur. The scenes represented in these corridor reliefs illustrate a series of early Buddhist moral tales called *The Awadanas* and *The Jatakas*.[6] We have no positive evidence that Gauguin saw this figure either in the Exposition Universelle of 1889 or in photographic form. However, the physiognomy of the head, the swollen proportions of the limbs, the softening of the contours, and the exaggeration of the feet that characterize Gauguin's nude are all more evident in the Borobudur figure than in any of the western prototypes mentioned above. In addition to the figure, many of the plants, birds, and animals present in the relief can be related to similar elements in this and other works by Gauguin from the second Tahitian period. In fact, the oddly proportioned "raven" in Gauguin's *Nevermore* of 1897 (cat. 222) might be related to the awkward, large-beaked birds that can be found in profusion in this superb relief.

Perhaps Gauguin's great nude was intended as a sort of pendant to the identically sized and compositionally analogous canvas, *Te tamari no atua* (cat. 221), painted either simultaneously or somewhat later in the same year. Unfortunately for modern Western art, this superb painting was separated from *Te tamari no atua* almost at once, and, in fact, the two have not yet been shown side by side. Yet their comparative color harmonies and their dialectical relationship have meanings that the artist himself must have intended. While the later painting invests a Tahitian woman with the attributes of the Virgin Mary, exhausted from having just given birth, *Te arii vahine* is a Tahitian Diana. However, when it was first shown in an exhibition of modern French painting in Stockholm in 1898, critics responded to it as an Eve,[7] in spite of the fact that the first woman of the Judeo-Christian tradition would never have been presented in a landscape with three other figures!

The somber chromatic harmonies that Gauguin himself mentioned lend an aura of mystery and depth of time to the painting. The queen rests on a cool lawn at the very end of the day, in eternal twilight, and the flowers, the two golden croton shrubs, and her embroidered cloth seem to glow from the verdure. Her head, like Olympia's, is upright, indicating that she is the seductress and not the seduced, and the very presence of the large black dog and the two old women makes it impossible for the viewer to be truly alone with this noble woman. Diana, the huntress, and Eve, the seductress, were conjoined by Gauguin to form a native queen at once classical and biblical. But the waves of Tahiti break over the coral reefs, and the sky darkens with a mystery almost unknown in the western imagination. The great queen of the night, the eternal queen of the island, is forever silent, remote, and inaccessible.

215a
Te arii vahine

1896

210 x 270 (8¼ x 10⅝)

letter to Daniel de Monfreid, illustrated with a watercolor sketch

Annick and Pierre Berès Collection, Paris

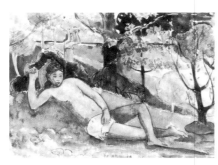

Gauguin Drawing after *Te arii vahine*, 1896 or later, watercolor [private collection]

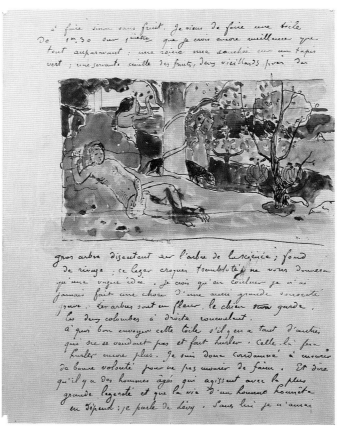

6. Since two of its related friezes have been destroyed, it is not possible to specify exactly which *Awadana* or *Jataka* this frieze depicts. See N.J. Krom and T. van Erp, *Beschrijving van Barabudur*, 1920, vol. III, 461-462 for text; see series II (B), plate VI for plate.

7. Danielsson 1964.

8. *Avant et après*, facs. ed., 121.

Gauguin had not forgotten this figure when he shipped the painting to Europe for exhibition in 1897. Aside from a watercolor probably executed shortly after the painting, her image appeared later in a traced drawing of 1900 (cat. 215a), in a woodcut for his newspaper, *Le Sourire* (Gu 80), and even among the illustrated pages of his last manuscript, *Avant et après* of 1903.[8]–R.B.

216
Portrait of Vaïte (Jeanne) Goupil

1896

75 x 65 (29½ x 25⅝)

oil on canvas

signed and dated at upper left, *P. Gauguin. 96.*

The Ordrupgaard Collection, Copenhagen

EXHIBITION
Humlebaek 1982, no. 11

CATALOGUE
W 535

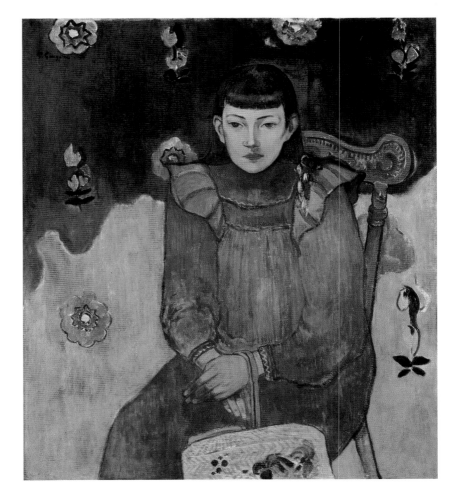

1. Danielsson 1975, 196–198.

2. Oral communication with Madame Denise Touze, niece of Jeanne Goupil (1987).

When Gauguin made his first exotic trip as an artist to Panama in 1887, he imagined that he would earn a living painting for the expatriate French community there; and he did receive a portrait commission. Unfortunately, this painting does not survive. But a rare commissioned portrait from Gauguin's second Tahitian trip remains. It represents Jeanne Goupil, the youngest daughter of Auguste Goupil, a wealthy lawyer who lived near Papeete. Although the large colonial mansion built for Goupil has been demolished, photographs of the house, its large garden, and the family make clear that Goupil was among the wealthiest Tahitians of the late nineteenth century and that he lived in considerable comfort.

Evidently, Gauguin met Auguste Goupil in mid-1896 and was commissioned shortly thereafter to paint this portrait. According to Danielsson, Gauguin himself convinced Goupil of the need for a portrait. Family tradition has it that Goupil, afraid of being humiliated by commissioning an unusual portrait, selected his youngest daughter rather than one of her more important siblings as Gauguin's subject. But Goupil was reportedly so pleased with the results that he began to invite Gauguin to dine regularly with the family at their home and hired him to give drawing lessons to the Goupil children.[1] Current members of the family question the latter.[2]

No records survive to document the portrait commission, but the painting was definitely a commissioned work, for it remained in the Goupil family collection until the mid-1920s. The girl's milky white head is so smooth and refined as to be extraordinary in Gauguin's oeuvre of 1896. Indeed, it anticipates the almost enameled surface of *Nevermore* (cat. 228), indicating that Gauguin worked on the painting over a protracted period. In Gauguin's portrait, the nine-year-old Jeanne Goupil, whose Tahitian nickname was Vaïte, sits passively in a carved colonial chair wearing a simple missionary dress of a brownish orange. In her hand is a native-made straw bag embroidered with colorful flowers, and over her shoulder droops a blossom.

If the young girl and her belongings are carefully observed and conventionally represented, the background is not. A pink and purple wall covered by printed or stenciled flowers presents many inconsistencies. The deep purple across the top of the wall can be read as a shadow from the jigsawed eaves of the porch or from a nearby tree. Yet the stenciled pattern is almost, but not quite, regular. The patterns of the wall are not irregular enough to be "natural" or regular enough to be "architectural." Gauguin frequently juxtaposed his portrait figures against such divided backgrounds with no direct analogue in reality.

The portrait is careful not to reveal too much about the sitter or the painter's attitude toward her. Gauguin found a place for his art within the limits of Goupil's taste, but not a place where there was much room for experimentation. Perhaps for that reason, the painting represents a perfectly inscrutable young girl, who sits as if waiting forever on her chair.—R.B.

217
Still Life with Teapot and Fruit

Gauguin, *Le Sourire*, cover [Musée du Louvre, Paris, Département de Arts Graphiques]

1. Joly-Segalen 1950, XXIX.

2. Bodelsen 1962, 208.

In a letter of 14 February 1897 to Daniel de Monfreid, Gauguin says that he will soon be sending six or seven canvases to France.[1] Two of these were still lifes, and surely the one called simply "Nature morte" is *Still Life with Teapot and Fruit* painted in 1896. There are no other still lifes from the first year of Gauguin's second Tahitian trip that could be given even this generic title, and Gauguin's signature and date on the painting mean that he considered it good enough to send back to France. The one other candidate, *Still Life with Mangoes* (W 555), is neither signed nor dated.

The painting itself is intensely powerful, with each form clearly delineated in an almost cloisonist fashion, and the brilliant yellows of the wallpaper and oranges of the mangoes set against the deep blues and bright whites. It seems to have been made more or less in homage to the great Cézanne still life owned by Gauguin, *Fruit Bowl, Glass, and Apples* of 1879–1880 (fig., see cat. 111).[2] Gauguin included a careful copy of this painting in the background of his *Portrait of a Woman with Still Life by Cézanne* of 1890 (cat. 111). Here, however, Gauguin "translates" Cézanne into Tahitian. Cézanne's compote is replaced by a Chinese or Japanese teapot, his glass by an earthenware jug, his ivory-handled knife by a wooden spoon, his apples by mangoes, his French wallpaper by a piece of Japanese block-printed paper pasted on the wall. Gauguin also depicts a Tahitian woman outside a doorway or window at the right of the composition.

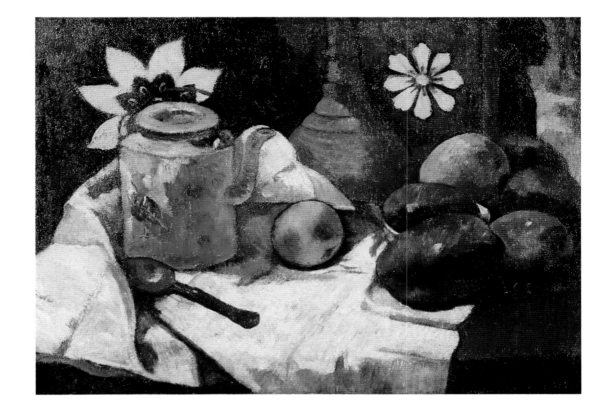

1896

48 x 66 (18⅞ x 26)

oil on canvas

signed and dated at lower right, *P Gauguin 96*

Mr. Walter H. Annenberg

EXHIBITION
Paris, Kléber 1949

CATALOGUE
W 554

shown in Washington and Chicago only

3. Malingue 1943, opp. 196; Malingue 1948, opp. 200.

While Cézanne put a pile of apples in the center of his composition, Gauguin isolated one fruit from the rest, and painted it against a cool, middle-valued blue. Its identity is not clear, but all the other fruits are mangoes, and this fruit shares certain qualities with the yellow mango on the far right of the composition. If it is not a deliberately foreshortened mango, it may be a lemon for the tea. Whatever it is, Gauguin treats it forthrightly as a female breast, the nipple of which is lovingly modeled, and its very isolation encourages us to read it as a special fruit and to linger over it.

The yellow flowers floating against the deep greenish blue of the background have been interpreted as "synthetist" or imaginary flowers by commentators eager to find elements of the artificial in Gauguin's paintings. But we know that they are flower patterns printed or stenciled on paper, because Gauguin chose identical paper to wrap the cover of his newspaper collection, *Le Sourire*, sent to Daniel de Monfreid. In *Still Life with Teapot and Fruit* Gauguin used the printed flowers as a powerful design element that he intended as a primitivizing replacement for Cézanne's atmospheric blue wallpaper with its amorphous leaves. Once again, the exotic Far East replaces Europe in Gauguin's most "European" of Tahitian still lifes.

This painting was probably not exhibited during Gauguin's lifetime, and it is impossible to identify among the contributions to the 1906 Gauguin exhibition at the Salon d'Automne. It was among the late Gauguin still lifes best known to the European public of the 1940s, however, because Maurice Malingue selected it as one of the few colorplates in his beautifully illustrated monograph on Gauguin first published in 1943.[3]–R.B.

218
Self-portrait near Golgotha

[summer] 1896

76 x 64 (30 x 25¼)

oil on canvas

annotated, signed, and dated at lower left,
Près/du golgotha/P. Gauguin-96

Museu de Arte de São Paolo

EXHIBITIONS
Cambridge 1936, no. 30; Baltimore 1936, no.
19; Tokyo 1987, no. 108

CATALOGUE
W 534

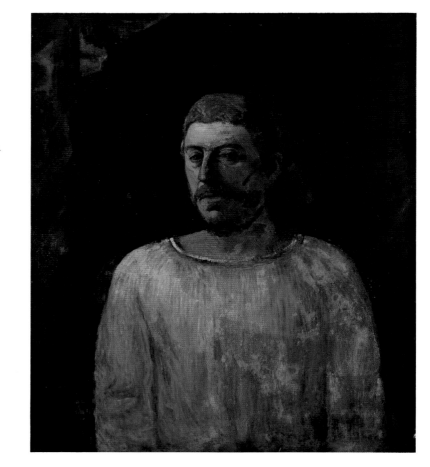

1. Segalen 1904.

2. Danielsson 1975, 194.

3. Henri Ravachol (1859-1892) was a
nineteenth-century French anarchist who
was sentenced to death.

4. Compare Rosenberg in Washington 1984,
no. 69.

5. Amishai-Maisels 1985, 101, 102.

6. Rothschild 1961 and Mittelstädt 1966,
cited by Kunio Motoe in Tokyo 1987, 176.

7. Kunio Motoe in Tokyo 1987, 176.

8. Andersen 1971, 184; Dorra 1978.

9. Joly-Segalen 1950, XXXII.

10. Bought for 15 francs; see Jacquier 1957.
Later sold to Ambroise Vollard.

Shortly after Gauguin's death, Victor Segalen visited his studio in the Marquesas and described "... a jumble of native weapons ..., a small organ, a harp, and various pieces of furniture; but very few paintings, because the master had just sent his final batch home to France when he died. However, he had kept for himself an older self-portrait, very melancholy, in which his powerful torso is placed against a distant backdrop of what one assumes are calvaries. The neck is muscular, the lip is drawn down, and the eyes are very heavy."[1] The painting certainly creates a strong impression: one again, Gauguin identifies his own life with the Passion of Christ; the scene is "near Golgotha," just before the Crucifixion, as he wrote carefully beside his signature.

The rough blue-white garment, with its biblical aspect, is probably a hospital smock; we are reminded that Gauguin had just spent time in the hospital.[2] But there is also something about this smock that suggests the condemned man. Far from resembling Christ, Gauguin looks like one of the anarchists who were being executed in Paris at the time; Gauguin has the embittered, reproachful face of a Ravachol.[3] The whole composition seems aimed at a public that had abandoned and rejected him; in short, the Paris art world, with its critics, dealers, and collectors. The artist is seen full-face, in white, like Mantegna's Christ, which Gauguin must have seen in the Louvre. There is also something of Watteau's Pierrot – the artist as tragic actor – in Gauguin's figure against its somber background.[4] This latter is very hard to decipher; it could be a framework for theater

decor, or even a stone wall with two figures sculpted on it in relief. Some have seen these figures as the two men who led Christ to a cross, the base of which is visible at top left, while others interpret them as the two sides of Gauguin's personality. Thus the Tahitian at left represents Gauguin's "savage" side, and the pensive face at upper right, with its medieval cowl, symbolizes the "sensitive"[5] part of his nature. Others have discerned the face of the Virgin in the left-hand figure, and that of Saint John[6] at right; there has even been speculation that this relief is a transposition to Tahiti of the two "magus" kings in the Breton calvary, *Christmas Eve*, painted two years earlier.[7] Finally, there are those who believe that the right-hand figure is the same cowled image of death that occurs in many other Gauguin canvases, from *Bonjour Monsieur Gauguin* to *Manao tupapau* (cats. 95, 154).[8]

There is no doubt that Gauguin intended the spirit of death to brood over this painting. As always in his work, the artistic pose is mingled with a genuine sense of despair. Segalen catches this dichotomy to perfection: ". . . from the moment he arrived in the islands, twelve years before his death, Gauguin dreamed of death: his own death, not some imaginary one. Thus his existence throughout the final twelve years was a spectacle of tragedy, with a beautiful but fatal ending."[9] Curiously, it was Segalen who bought the painting at the sale of Gauguin's effects in Papeete, and carried it home to Paris.[10]–F.C.

Gauguin, *Christmas Night*, detail, 1894, oil on canvas [Josefowitz Collection]

219
No te aha oe riri

Gauguin, *Te raau rahi (The Big Tree)*, 1891, oil on canvas [Cleveland Museum of Art and an anonymous collector]

Installation of *La Libre Esthétique*, Brussels, 1904 [photo: Musées Royaux des Beaux-Arts de Belgique, Brussels, Archives de l' Art Contemporain]

No te aha oe riri (Why Are You Angry?) is unique among Gauguin's monumental canvases of 1896–1897 in being based closely on an earlier Tahitian painting. The basic landscape setting, with the hut and the three main figures, derives almost directly from *Te raau rahi* (The Big Tree) of 1891 (W 437). But it is possible that Gauguin left this earlier painting in Tahiti in 1893, for there is no clear evidence that it was exhibited in France or Brussels during the years Gauguin was in Europe. Hence we do not know whether Gauguin based his "remaking" of the 1891 canvas on the actual painting, on a photograph of it, or on memory.

The changes are obvious. The basic setting with the centralized native hut has been retained, but all features of the landscape have been altered. The great mango and breadfruit trees that dominated the foreground of the 1891 painting have been replaced by a decorous palm tree that anchors the center of the 1896 canvas. A more profound change is the enlargement of the figures, who now have ascendancy over the setting and thus justify the change of title from "The Big Tree" to "Why Are You Angry?" (Gauguin's translation). The new title invites the viewer to read the painting as a narrative. Who is angry in this utterly placid scene? Not the tranquil and dignified standing figure, but the seated female closest to her with bowed head and pouting expression. Perhaps the woman at the far left who turns toward the angry one is asking the very question Gauguin poses in the title. Her lips are not visible, but she appears to be speaking to her friend.

How are we to understand the enigma of anger in this paradise? The house with its guardian keeps us both outside and in the foreground of the composition, its cool depths inaccessible. But at the center of the painting two hens with their broods of chicks, half white and half black, provide a clue. Gauguin was

fascinated with fables and parables throughout his career. His writing is resolutely aphoristic and full of seemingly simple tales with complex moral messages. In this painting, the chickens act out a narrative of independence versus child-rearing that is made especially clear by the presence of the rooster and the hens without chicks in the middle distance to the right of the standing woman. These two hens correspond almost directly with the two female figures at the far right in the

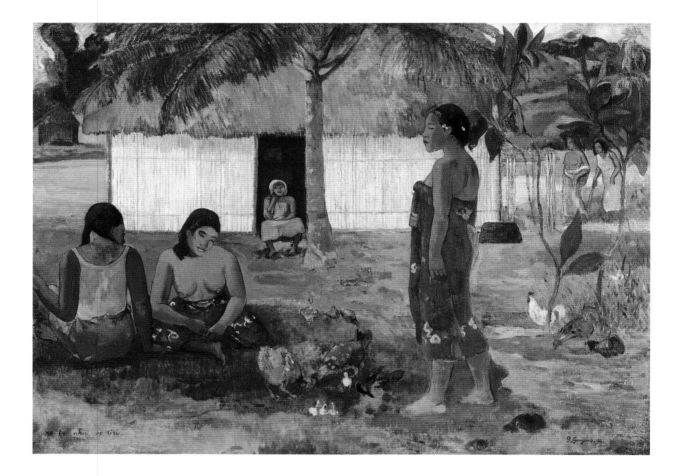

No te aha oe riri

1896

95 x 130 (37⅜ x 51⅛)

oil on canvas

inscribed at lower left, *No te aha oe riri*; signed and dated at lower right, *P. Gauguin 96*

The Art Institute of Chicago, Mr. and Mrs. Martin A. Ryerson Collection

EXHIBITIONS
Brussels 1904, no. 55, *No te aha se riri*; Edinburgh 1955, no. 54; Chicago 1959, no. 60

CATALOGUE
W 550

painting, one of whom seems to move languorously with her breasts bared, while the other limps along using a cane. A hen in the shade corresponds to each of the seated figures in the shade, and a hen in the sun corresponds to each of the figures in the sun.

Together with the title, the hens and chicks suggest that the angry woman is a mother, whose breasts are heavy with milk and whose nipples are extended from suckling. Perhaps she has been reminded of her former freedom by the young woman walking serenely through the landscape, a coconut purse in her hand, her hair dressed with fragrant oils, her ears adorned with frangipani.

There is an affinity between the monumental standing woman at the right of this painting and the profile female figure in an analogous position in Georges Seurat's *Sunday Afternoon on the Island of La Grande Jatte* (1884–1886). Surely Gauguin would never forget Seurat's precocious masterpiece, for it was the painting that doomed his own contributions to the final impressionist exhibition. Gauguin retreated from Paris and from the "scientific" avant-garde after this defeat. Yet here in Tahiti, ten years after Seurat's painting had been exhibited, he created a sort of native equivalent to Seurat's great presentations of Parisians at leisure.—R.B.

220
Nave nave mahana

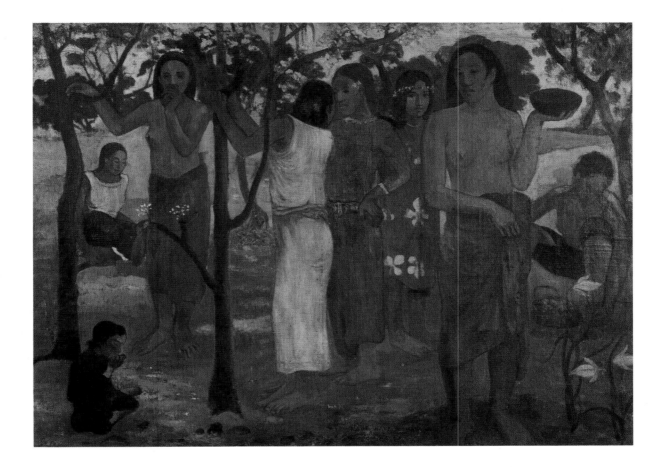

1896

95 x 130 (37⅜ x 51⅛)

oil on canvas

inscribed, signed, and dated at lower center,
NAVE NAVE MAHANA/P. Gauguin, 1896

Musée des Beaux-Arts, Lyon

EXHIBITIONS
Brussels 1904, no. 53, *Nave Nave Mahana*;
Paris 1906, no. 218, *Nave Nave Nahama*;
Basel 1928, no. 100; Basel 1949, no. 58

CATALOGUE
W 548

shown in Washington and Paris only

Gauguin sent this frieze of Tahitian women, *Nave nave mahana* (*Delightful Day*), to Daniel de Monfreid in February of 1897 in a shipment of six recent paintings.[1] Of the six, two canvases of the same large size, this work and *No te aha oe riri* (cat. 219),[2] must be considered companion pieces. Each represents Tahitian women at leisure, with the figures more monumental and the settings more subtly composed than those in any of the Tahitian genre scenes from Gauguin's first voyage. Another pair of identically sized canvases, *Te tamari no atua* (cat. 221) and *Ta arii vahine* (cat. 215), depict single monumental female nudes in both interior and exterior settings, and were sent to Europe for exhibition some months before Gauguin completed and sent *Nave nave mahana* and *No te aha oe riri*. The first pair wrestles particularly with the example of Manet, while the frieze compositions have clearer prototypes in the work of Puvis de Chavannes.

The best existing descriptive analysis of *Nave nave mahana* was written more than thirty years ago by Madeleine Vincent, discussing the meaning of the title, the contrast between Gauguin's physical suffering and the healing imagery of the painting, and its complex chromatic structure. "Regarding the tonality of the entire painting, it is a sort of condensation of life in Oceania, of this enigmatic life, not only enigmatic in its penumbra but in its explosive brightness. It is the pic-

1. Joly-Segalen 1950, XXIX.

2. Gauguin must have mistranscribed the title of the second picture, which he called *Nave Aha Ve Riri, Pourquoi es-tu faché?* in the letter. There is no picture that accords with that title other than cat. 219.

3. Vincent 1956, 255–256.

4. Several Tahitians interpreted this figure as a "runt" or sickly child who is kept with the women rather than sent to play with companions.

torial transposition of a torpid climate, of the burning heat of different superimposed reds and copper tones of carnations, saturated with a strong odor of a dense flowering that explodes in a golden sky. A transposition that is moreover not only from a climate but from an age, since everything in this canvas exudes the immobile archaism and the arrogance of a free and intact nature, which is welcoming to man, of a childlike and happy race that allows itself to be lulled and nourished with the most passive and serene filiation."[3]

Nave nave mahana shows seven Tahitian women and a child near a rivulet lined with small trees. Gauguin seems to have been fascinated by the rhythmic interplay between the supple gesturing figures and the gentle curves of the trunks and branches. The two women in the center wear full-length tunics of contrasting white and reddish purple and appear to converse. The one in white holds onto the branch of a tree, and the turn of her head makes her the most animated figure in the composition. Immediately behind this pair stands a stunningly beautiful younger woman dressed in a brilliant red-and-white printed *pareu* tied discreetly around her breasts. Unlike the central figures, she looks out toward the viewer. Her head has been garlanded with small white flowers like those that grow forlornly on the foreground tree, and it seems almost as if she is being protected by the other women.

At either side of this trio are two women wearing simple reddish *pareus* tied at their waists. Their hair falls down their backs, and their breasts are bare. The figure on the right holds a small wooden bowl, presumably as an offering, and both figures look straight out at the viewer. At the far sides of the frieze two seated figures seem absorbed in their own activities. In the lower left corner a small child clothed in dark brownish green is eating a piece of fruit. In his minuteness, isolation, and prominent placement, this child lends an unsettling note to the painting.[4] It is perhaps worth noting that Gauguin's first child by his Tahitian wife, Pahura, died a few days after his birth in December 1896, less than two months before this painting was shipped to Monfreid.

Nave nave mahana has few parallels in Gauguin's earlier oeuvre. It is not based on either a work from his first Tahitian voyage, as is its pendant *No te aha oe riri*, nor do its figures derive clearly from other sources. None of the surviving figure drawings from Tahiti can be linked precisely with the figures in this painting.—R.B.

221
Te tamari no atua

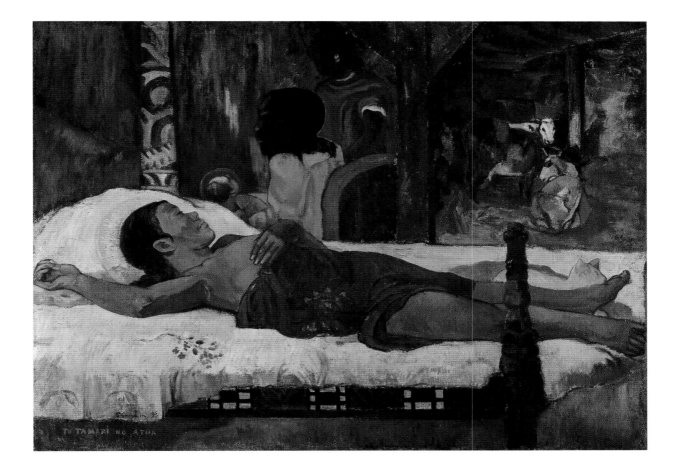

1895-1896

96 x 128 (37½ x 50)

oil on canvas (hemp)

signed, dated, and inscribed at lower left,
P Gauguin 96 / TE TAMARI NO ATUA

Bayerische Staatsgemäldesammlungen,
Munich, Neue Pinakothek

EXHIBITIONS
Brussels 1897, no. 282, 1000 francs *Te
Tamari no atua*; Berlin 1906, no. 98
Geburt Christi; Stuttgart 1913, no. 306

CATALOGUE
W 451

shown in Washington only

The title, translated as *The Child of God*, is not quite the subject of this famous painting. Rather, it is the child's mother on a monumental bed with sheets of a radiant chrome yellow. The christological background, secondary in visual importance to the main figure, is as well an elaborate pastiche of two other paintings. The left portion derives from Gauguin's own *Bé Bé* (W 540) of the same year, and the right from *Interior of a Stable* of 1837 by the nineteenth-century genre painter, Octave Tassaert. Gauguin must have owned a photograph of the Tassaert, which had been in the collection of his friend and mentor, Gustave Arosa.[1] Gauguin may have chosen the Tassaert as a source for correctly observed cattle, few of which could be found in Tahiti. As is often the case with Gauguin, Europe and Polynesia are combined in a single image.

 Scholars have discussed the meaning of the picture and the sources of its parts. The Tahitian title has been argued about, Danielsson finding fault with its grammar,[2] but Teilhet-Fisk correctly defending it, admitting only a mistake in the spelling of the word *tamari'i,* meaning child.[3] Others have speculated about the libertine and sexual implications of the cat who sleeps on the bed with the mother, the manifestations of night in the background, and the premonitions of death that abound in the painting. The autobiographical interpretation is that Gauguin painted the picture near the end of 1896, just after his Tahitian mistress Pahura gave birth to their child who died a few days later.[4] Gauguin met Pahura early in

1. Paris 1878, no. 71.

2. Danielsson 1967, 232.

3. Teilhet 1979, 110 and Teilhet-Fisk 1983, 116-117.

4. Teilhet 1979, 110 and Teilhet-Fisk 1983, 116-117.

5. Danielsson 1965, 182-183; Danielsson 1975, 190-191.

6. Dujardin 1897.

Gauguin, *Bé Bé* (Baby), 1896, oil on canvas [State Hermitage Museum, Leningrad]

7. C.V.Z. 1897; and an anonymous reviewer in *La Libre Critique*, 7 March 1897.

8. Postscript addressed to Aline, in letter to Mette, December 1893. Malingue 1949, CXLVI.

9. *Le Forum Républican*, 30 December 1888.

10. Danielsson 1975, 182.

1896, and Danielsson, the best and most persistent student of Gauguin in Tahiti, characterized her as a slovenly, lazy young woman of dubious moral character. Nonetheless, she consented to live with the aging artist and bore him two children, the first of which was born in December 1896 or early January 1897.[5]

The notion that this picture represents that child as Christ is difficult to defend. The painting itself is too large, ambitious, and complex to have been executed in the period of one or two weeks between its birth and death. The surface is refined and multilayered, suggesting that Gauguin labored over a protracted period so that he could rework colored areas to achieve maximum harmony and strength. Gauguin must have started work on the composition in anticipation of the birth, for he had already finished this picture well before the birth of his child and had sent it and its companion, *Bé Bé*, to Brussels for exhibition by early December. It is probable that it was created as a successor to *Ia orana Maria* (cat. 135), to become the picture from his second voyage that would guide viewers and critics into the complex, multivalent meanings of the other Tahitian pictures.

Unfortunately, this superb canvas made very little direct impression on the critics of the 1897 *Libre Esthétique* exhibition in Belgium. Only one, Jules Dujardin in *La Reforme*,[6] mentioned the painting by name, but in a list of incomprehensible Tahitian titles. Neither Dujardin nor other critics of the exhibition who chose to mention Gauguin singled out any particular work for comment. This is strange, because *Te tamari no atua* has an accessible, non-Tahitian subject. The stable setting for this virgin birth as well as the halo on the infant Christ are scarcely difficult to recognize. The rejection of this wonderfully lucid and monumental canvas by the critical press in Brussels may have had more to do with the artist's notoriety than with his works of art. During his Parisian sojourn of 1893-1895, Gauguin attained eminence in the artistic-literary avant-garde, and at least two of the Belgian critics resented it.[7]

Te tamari no atua is the last in a distinguished series of Gauguin's Christmas paintings. The most famous of these was *Ia orana Maria* (cat. 135), the most popular painting in the Durand-Ruel exhibition of 1893. Gauguin had many reasons to be fascinated, even obsessed, with this most festive of Christian holidays. Crucial events of his life occurred at or just before Christmas. The first and most resonant was the birth of his favorite daughter, Aline, born on Christmas Eve of 1877 (Gauguin remembered her birth date as Christmas Day, 1876).[8] Van Gogh's tragic self-mutilation also occurred the day before Christmas Eve, in 1888.[9] Gauguin identified himself with Christ at many points in his career, and, for that reason, it is all too easy to assume that this picture represents the birth of Christ in a Tahitian setting, but with the added significance of the birth of a child of Gauguin's.

The most fabulous and persistently obscure form in the picture is the bed on which the mother rests. Beds were not used by Tahitians. Perhaps for that reason, Gauguin employed his most extraordinary powers to invent them. The great bed-throne of Vairumati dominates Gauguin's painting of 1897 (W 559), and the invention in *Te tamari no atua* is equally interesting. The painted fretwork that decorates the runners of the bed is directly related to the geometric floor molding Gauguin had already created for his painting of *Aita tamari vahine Judith te parari* (cat. 160), and the carved posts at the head and foot derive less from Gauguin's own sculpture than from the Maori architectural decoration that he had studied in the Auckland [New Zealand] City Art Gallery en route to Tahiti.[10] The bed itself is a work of art. It brings to mind the eclectic furniture of Victor Hugo or the superb art furniture created at that time by artist-decorators in Paris.—R.B.

222
Nevermore

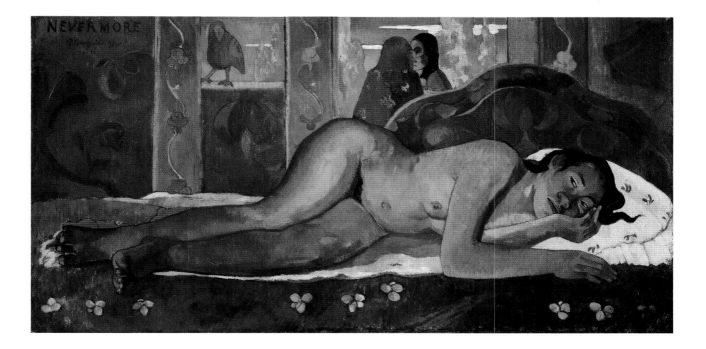

1897

60.5 x 116 (23⅞ x 45⅝)

oil on canvas

inscribed at upper left, *NEVERMORE/
P. Gauguin 970/O. Taïti*

Courtauld Institute Galleries, London (Courtauld Collection)

EXHIBITIONS
Paris 1906, no. 216, *Never More*; Cologne 1912, no. 168, *Nevermore*; London 1924, no. 52; Paris 1949, no. 48; Edinburgh 1955, no. 55; Cleveland 1987, no. 40

CATALOGUE
W 558

shown in Washington only

1. The passage has often been quoted in part. See John House, *Impressionist and Post-Impressionist Masterpieces: The Courtauld Collection* (no. 40); Maurer 1985, and Joly-Segalen 1950, 101. Translation by R. B.

Gauguin's own descriptive commentary on *Nevermore* was included in a long letter from Gauguin to Daniel de Monfreid dated 14 February 1897.[1] After listing six other canvases that he was about to send to Monfreid, Gauguin discussed *Nevermore*, which was not yet completed: "I am trying to finish a canvas to send with the others, but *will I have the time?* I recommend that you observe the vertical well when you stretch it; I don't know if I'm mistaken but I believe that it's a good thing. I wished to suggest by means of a simple nude, a certain long-lost barbaric luxury. It is completely drowned in colors which are deliberately somber and sad; it is neither silk, nor velvet, nor muslin, not gold that creates this luxury but simply the material made rich by the artist. No nonsense. . . . Man's imagination alone has enriched the dwelling with his fantasy.

"As a title, *Nevermore*; not exactly the raven of Edgar Poe, but the bird of the devil who is keeping watch. It is badly painted (I am so nervous and I work only in bouts), but no matter, I think that it's a good canvas – A naval officer will send it all to you in a month, I hope."

The smooth surface of *Nevermore* shows no evidence of the roughly textured hemp canvas on which it was painted – probably because Gauguin had primed the canvas, painted a landscape with several figures on it, and laid a thick, white primer layer over this painting, before beginning *Nevermore*. Because the second priming layer is white, it inhibits X-rays; thus a real assessment of the landscape under *Nevermore* is difficult. However, the serpentine trunks of palm trees, at least one large seated female figure in the center of the composition, as well as a baby in the lower left corner, are visible. These elements link the "underpainting" to *Te Vaa* (W 544), finished in 1896, as well as *Nave nave mahana* (cat. 220), on which Gauguin may have been working when he finished *Nevermore*.

Although the letter quoted above has often been used as proof that Gauguin painted the picture quickly, surely this is not the case. It is possible that

2. According to the Courtauld technical analysis, the painting, like others produced by Gauguin during the 1890s, was coated with wax rather than varnish.

the painting had been in process for some time before mid-February and that Gauguin worked on it for as much as a month after the letter was sent. A sophisticated technical analysis of the painting performed at the Courtauld Institute has revealed that a good deal of the painting was executed "wet on wet," permitting the combination of hues of closely related value within the same painted area. This does not necessarily mean that the painting was painted quickly. Indeed, Gauguin must have worked very deliberately to produce the even, clearly organized surface that survives today.[2]

The passage in Gauguin's letter about the vertical element in the stretcher may be significant. Gauguin probably realized that the extreme horizontality of the painting and the unusual thickness of the painted surface necessitated a vertical member in the stretcher, to add stability. The dimensions of *Nevermore* are unique in Gauguin's oeuvre. Among the many small horizontal paintings from the first Tahitian trip, the closest in scale to *Nevermore* is *Arearea no varua ino* (W 514), made in 1894 expressly for Gauguin's innkeeper, Mme. Gloanec, possibly as a decoration. *Nevermore* may have been cut from a larger canvas, perhaps one similar in dimension to the six monumental canvases of 1896–1897 mentioned above.

3. At Gauguin's going-away banquet on 23 March 1891 at the Café Voltaire, Mallarmé's translation of Edgar Allen Poe's *The Raven* was recited. See Rewald 1962, 485-486.

In his letter Gauguin was careful to disassociate his painting from the text of Poe's *The Raven*, from which its title derives. The poem was well known to members of the French avant-garde after its publication in 1875—more than twenty years before *Nevermore* was painted—in a translation by Mallarmé with lithographic illustrations by Manet. The fact that Gauguin had renewed his own interest in the art of Manet and that he had always been closely aligned with Mallarmé makes it tempting to reinvestigate the connections between the text and Gauguin's picture.[3]

Poe's hypnotic text with its famous alliterations, repetitions, and rhymes introduces the raven, a devil messenger, who haunts the poet-reader and whose diabolical presence prevents him from adoring the image of his ideal woman, Lenore. In the text, the raven is predominant while Lenore is absent. When viewed after a reading of Poe, Gauguin's painting must be read as a subversion of the great American writer's text. For Gauguin, the female figure, his "simple nude," is absolutely dominating, and Poe's fearful raven is reduced to toylike presence in the background. Whereas Poe's text abounds with references to luxurious silk and velvet, Gauguin actually denied their presence in his letter to Monfreid. Whereas Poe's poetic text takes place in a timeless midnight disturbed by icy blasts of wind, Gauguin's painted poem is set in the equal but opposite timelessness of a tropical day undisturbed by storms. The sun even manages to creep into the beautifully decorated house, where it plays over the upper part of the body, the arms, and the face of Gauguin's "Lenore," his model and wife Pauhura.

4. Gauguin had a reproduction of *Olympia* in his hut in Tahiti and he made a copy after the painting in Paris. See cat. 117.

Perhaps the only point of intersection between painting and poem is the setting. Poe's interior is replete with velvet cushions, windows, and a doorway surmounted by a bust. It is full of form and meaning, but empty of people other than the poet and the hideous raven. Gauguin's interior is simpler and resonant with human presence. Two figures converse quietly in the depths of the space, and the nude seems to be as much turned away from them as facing us, her viewers. Yet her eyes are turned in their sockets, in mute awareness of the raven and the conversing couple; we are given no sense of our presence in the scene. Hence, Gauguin's "Lenore" is as inaccessible to us as is Poe's, and she has little of the brazen presence of Manet's *Olympia* to whom she has often been compared.[4]

Gauguin had thought deeply about the relationship between poetic and painterly texts during the period of his work on *Nevermore*. In his collaborative enterprise with Charles Morice on *Noa Noa*, Gauguin's paintings preceeded the poetic texts, written by Morice for precise points in a narrative assembled by the

painter. Thus, for Gauguin in *Noa Noa*, image preceded text. Here, in *Nevermore*, Gauguin reversed this order and created a kind of subversive anti-illustration.

The fact that this particular painting explored relationships among the separate arts was surely a part of Gauguin's pleasure when he learned in 1898 or early 1899 that the work had been sold to the English composer Frederick Delius, whom he had met through the Molards at the rue Vercingétorix.[5] Delius subsequently loaned *Nevermore* to the great Gauguin exhibition at the Salon d'Automne in 1906. Here it was seen by virtually every great artist of the early twentieth century, and its effect on Picasso and Matisse was extraordinary. One can scarcely imagine Matisse's *Blue Nude*[6] of 1907 without it, and the somber, brownish purple tonalities as well as the schematic modeling of the female form must have appealed immensely to the young Picasso.—R.B.

5. For more information about Delius and the Molard-Gauguin circle see chronology. See also Carley 1975, ch. 4, 45-62.

6. The Cone Collection, Baltimore Museum of Art, Maryland.

223
Te rerioa

Delacroix, *Women of Algiers*, 1834, oil on canvas [Musée du Louvre, Paris]

Te rerioa (The Dream) is the last of the great canvases of 1 by 1.3 meters made by Gauguin in 1896–1897 (cats. 215, 219, 220, 221, W 544). Gauguin himself thought it even better than the earlier pictures, in spite of the fact that he claimed to have painted it in great haste over a ten-day period before the delayed departure of a ship for France.[1] Gauguin's haste is betrayed only in the comparative thinness of the application of paint and in the chromatic simplicity.

Gauguin's letter makes clear that he did not have a specific program for the five large paintings exhibited here. Indeed, this painting was made during a time of relative tranquility for Gauguin: he did not learn until April of the death in January of his favorite daughter Aline, and he had moved to his most impressive Tahitian dwelling in late January or early February. *Te rerioa*'s measured rhythms, stable composition, and almost classical calm must surely have resulted from a peaceful state of mind.

In the painting, the interior of a Tahitian house is decorated with an elaborate carved or painted frieze unlike anything in Tahiti and unlike anything Gauguin had ever before painted. A baby sleeps in a fabulously carved wooden cradle that Gauguin seems to have invented, and its gnarled guardians protect the child in sleep. The mother's companion is shown in profile before a vertical landscape, with the horseman mentioned in Gauguin's descriptive text. In the human inventory of the painting that Gauguin made for Monfreid, Gauguin did not mention the companion, listing only the child, the mother, and the horseman. Yet, when considered as a "pair," the mother and her companion immediately recall the central figures in Delacroix's great canvas, *Women of Algiers*.[2] The precise relationship between that early icon of French "Orientalism" and Gauguin's "decadent" late painting is unknown, but Gauguin seems to have thought deeply about Delacroix while in France and had even modeled his manuscript for *Noa Noa* on the famous travel journal kept by Delacroix in 1832 in North Africa.

1. Joly-Segalen 1950, XXX.

2. Acquired from the Salon of 1834 by Louis Philippe for the state.

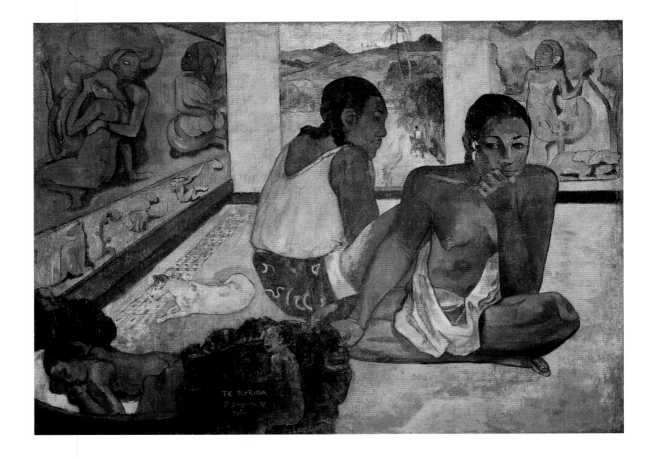

1897

95 x 130 (37⅜ x 51⅛)

oil on canvas

inscribed, signed, and dated at left center,
TE RERIOA/P. Gauguin 97/TAÏTI

Courtauld Institute Galleries (Courtauld
Collection)

EXHIBITIONS
Béziers 1901; (?) Weimar 1905, no. 30,
Träume; Paris 1906, no. 4, *Intérieur de case à
Tahiti*; Edinburgh 1955, no. 41; Cleveland
1987, no. 41

CATALOGUE
W 557

shown in Washington only

3. Analogous embracing couples exist in the
woodcut *Te faruru* (cat. 171) and in
Delacroix's *Massacre at Chios*. Field 1960,
131; 1961 ed., 147.

Together with *Nevermore*, painted about one month earlier, this canvas is evidence of Gauguin's renewed interest in interior decoration. He had just been forced to move from his house in Punaauia and had purchased a nearby Tahitian house to which he had added a very large studio built for him more or less in the manner of a traditional native house. Unfortunately, the sole surviving interior photograph of this studio shows us only a single painting. Yet, from what we know from the exterior and from Gauguin's next decorated house in the Marquesas, we can imagine a splendid interior freely adapted from Tahitian designs in Gauguin's own manner.

The decorative frieze in *Te rerioa* is difficult to interpret. The long wall perpendicular to the picture plane has two distinct zones, the lower one decorated with an "animal" frieze with elements similar to those found in his woodcuts from 1898 and 1899 (cats. 232-245). The upper part of the frieze is dominated by an embracing couple in which the woman nestles in the arms of a man who looks wide-eyed into the world.[3] His consort is completely passive, though not in a sexual sense, and appears almost to be sleeping. On their right is an unusually costumed female with a profile head emerging from leaves or flower parts. This latter figure is elaborately decorative in contrast to the embracing couple.

To the right of the landscape is a section of painted or carved decoration in which the separate animal and human bands of the other decoration have been collapsed into one large zone. This is dominated by a single figure whose arms are raised in a position analogous to that of the goddess Hina in *Mahana no atua* of 1894 (cat. 205) or *Parau Hanahano* of 1892 (W 460). Here, as in the idol, the figure lacks sexual definition, and Gauguin perhaps intended here to contrast the realm

Gauguin, *Te Vaa* (*The Canoe*), 1896, oil on canvas [State Hermitage Museum, Leningrad]

of the gods, where androgyny prevailed, with that of men, where sexuality dominates.

Gauguin himself likened the painting to his own dreams as well as to those of the baby or her mother. In any case, it is a dream divided into mysterious zones, none of which serve quite to clarify the others. Even the landscape, the "simplest" part of the picture in terms of its imagery, is very difficult to read, and we are forced to ask outselves whether it is a "real" landscape or a painting of a landscape placed in the room as a decorative escape. Indeed, the represented and the real court one another eternally in *Te rerioa* to create an enigma inside a dream. It is likely, given similarities in scale, imagery, and texture, that *Te rerioa* was conceived as a pendant to *Te vaa*.—R.B.

224
Bathers

1897

60.4 x 93.4 (23½ x 36½)

signed and dated at lower right, in beige-violet, *P. Gauguin 97*

National Gallery of Art, Washington, Gift of Sam A. Lewisohn 1951.5.1

EXHIBITIONS
New York 1946, no. 33; Tokyo 1987, no. 72

CATALOGUES
W 572, *Baigneuses*; W 567, *Tahiti. Paysage*

1. Kunio Motoe in Tokyo 1987, 172.

2. Joly-Segalen 1950, 209.

3. See Degas sale, Paris 1918, no. 47, *Tahiti, paysage*. Also see Wildenstein catalogue entry for 567.

This lush landscape with female bathers has long baffled Gauguin scholars. It has been published with varying titles and dates, and the most recent analysis has changed the date radically from the conventional 1898 to 1893.[1] This shift has resulted from the illegibility of Gauguin's own date, which can now be read clearly as "97." The catalogue raisonné cites a letter written on 11 November 1898 in which Monfreid referred to a painting "of women bathing in a fluttering landscape"[2] to justify its dating of 1898. Yet both the inscription and the dimensions of the painting correspond exactly to those of a painting bought by Degas from Monfreid on 7 June 1898 and catalogued in the sale of Degas' collection.[3] It is therefore likely that *Bathers* was owned by Degas and purchased at the Degas sale by Hessel before being sold to Vollard, who subsequently sold it to Alfred

4. See Brettell and Folds McCullagh in Chicago 1984, no. 91, 188-191.

5. W 539.

6. W 615.

7. Cézanne's first one-man show, which took place in November and December.

Lewisohn. Perhaps this small canvas as well as Cézanne's bathers prompted the older Degas to create his own group of bathers during the last years of the century.[4]

The figures in this bather composition were drawn from a wide variety of sources in Gauguin's own oeuvre, and the fact that the central figure of the seated nude seen from the back relates to a painting of 1892 has led the defenders of an earlier date to underestimate the importance of other figures that relate clearly to later works. The two women at the left are related distinctly to a painting of 1896[5] and the frontal nude on the far right relates to a figure painted in 1902.[6] As we have often seen, Gauguin borrowed figures from his own notebooks just as he pillaged the art of others for sources. It is tempting to identify the bather compositions of Cézanne as the ultimate source for this painting. Yet Gauguin left Paris before the Cézanne exhibition of 1895[7] at Vollard's and he had probably never owned one of his friend's earlier bather compositions.

In spite of the lack of a specific source in Cézanne's oeuvre, there is much in the figural proportions, physical scale, and compositional rhythms of this painting that relate it to many of Cézanne's compositions with bathers. Like Cézanne, Gauguin chose a canvas with a pronounced horizontality, and may even have cut 10 to 12 centimeters from a standard size 30 canvas (72 x 92 cm) to arrive at these unusual dimensions. Yet, unlike Cézanne, he represented the bathers in the depths of a forest rather than arranged in a foreground frieze. Hence, the viewer seems to come upon these women as if by accident, and they are completely unaware of him.

The colors in it link this painting absolutely to Gauguin's other works of 1897, and it was undoutbtedly painted in the months prior to the artist's masterpiece, *Where Do We Come From? What Are We? Where Are We Going?* (W 561, see fig. at next entry). How well it would have looked in Vollard's Gauguin exhibition so admired by Degas. The painting is suffused with an ease and geniality; the gentle rhythms of the water, the lushness of the vegetation, the implied scent of the flowers, and the warm brown bodies of the women form an image of a timeless innocence. Indeed, the painting is in every sense the opposite of *Where Do We Come From? What Are We? Where Are We Going?* While that masterpiece poses questions that resound throughout the history of mankind, this smaller painting has an easier, yet ultimately more mythic message. The mural is Gauguin's "Paradise Lost," *Bathers* is "Paradise Regained."–R.B.

225
Where Do We Come From? What Are We? Where Are We Going?

1. Joly-Segalen 1950, XL, XLI; Malingue 1949, CLXXIV.

2. Joly-Segalen 1950, pl. 8 (between 128 and 129), XL.

The existence of this pale, evanescent drawing on tracing paper, squared for transfer, contradicts a statement made by the artist about the famous painting to which it relates, *Where Do We Come From? What Are We? Where Are We Going?* (see fig. p. 391 W 561). At several points in his correspondence[1] Gauguin asserted that he made no drawings or oil sketches for the painting and that the composition was executed directly on an immense canvas in a period of intense work before his attempted suicide at the end of 1897.

Gauguin made the earliest dated drawing of the painting at the bottom of a letter to Daniel de Monfreid dated February 1898.[2] This pen drawing records all

the main features of the painting, but places them in a much longer pictorial field, and gives dimensions of the canvas (1.7 x 4.5m, 66⅝ x 175½ in.) considerably larger than those of the canvas that survives today (1.39 x 3.75 m, 54¼ x 146¼ in.).

One assumes from the first letter to Monfreid that the canvas was finished in some form by February 1898. However, it remained in Gauguin's studio until at least the middle of that summer. The artist retouched the painting with pastel so that it could be photographed in June of 1898.[3] The photograph reveals a work of art that appears almost to be in an unfinished stage just weeks before the painting would have been shipped to France for its first exhibition at Vollard's gallery in

1898

205 x 375 (8 x 14⅝)

brush and blue watercolor and brown crayon pencil over preliminary drawing on tracing paper laid down on wove paper, squared in graphite

entitled, top left, in pen and ink, *D'òu venons-nous?/Que sommes-nous?/Où allons-nous?*; dedicated, signed, and dated at lower left, in pen and ink, *de l'amitié dans le souvenir/[name deleted]/cette pale esquisse/Paul Gauguin – Tahiti – 1898*

Musée des Arts Africains et Océaniens, Paris (AF 14341)

EXHIBITION
Paris 1906, no. 79, *D'où venons-nous?*

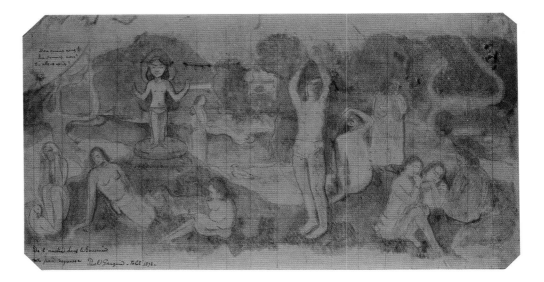

Gauguin, letter to Daniel de Monfreid, February 1898

3. Joly-Segalen 1950, XLIV. See also Lemasson 1950, 18.

4. *Avant et après*, ms, 8-16.

November. This evidence suggests that Gauguin worked extensively on the painting throughout the first half of 1898, in spite of the 1897 date on the canvas. Perhaps he was intent on linking the making of the painting with his suicide attempt. In view of his later musings about the suicide of van Gogh,[4] one wonders about his motivations for forging so strong a link.

There is a good possibility that Gauguin never attempted suicide and that virtually everything he said about the shortness of the period of work on the painting is open to question. If we interpret this drawing as a preparatory work, it becomes yet another piece of evidence that Gauguin is not always to be believed. It is difficult to interpret the drawing as a work made after the painting, either in the preparation of a print or as a souvenir for a friend. The absence of either a print or plans for a catalogue of the 1898 exhibition, and the fact that the drawing was made on tissue paper and that its squaring is so prominent, force us to accept its preparatory status.

The drawing was made in blue and pale orange pastel on tissue paper, then squared in graphite for transfer, and, finally, titled and dedicated in ink. It was pasted onto a secondary support soon after it was made, making it impossible to examine the verso for additional evidence. The drawing omits the large area at the far right of the painting, which includes a running dog above which Gauguin signed and dated the painting. For that reason, the fruit picker, who stands just right of the center in the painting, occupies a place in the drawing that is not nearly so prominent. In fact, the various figural elements in the drawing vie with one another for attention, and the figure of the goddess Hina, of secondary importance in the painting, is as dominating a presence as is the fruit picker in the drawing.—R.B.

226
Self-portrait

This drawing, which was found among Gauguin's effects in Atuona after his death in May 1903, is often assumed to be the last self-portrait. This is unlikely, though not impossible;[1] for the face depicted is younger, and the complexion is less pasty than in what is more likely his final self-portrait (W 634). Also, he wears no spectacles in this drawing, which is probably closer to the 1897 *Self-portrait for My Friend Daniel*, W 556, where the beard and long hair of *Self-portrait near Golgotha* (cat. 218) have disappeared. Here, Gauguin's precise, nervous lines are very effective in expressing the fierce solitude and bitterness of the mouth. The hand raised to protect the face echoes the *Portrait of Gauguin as a Grotesque Head* (cat. 65), and *Be in Love, You Will Be Happy* (G 76), in which he is seen sucking his thumb.

Victor Segalen bought this drawing at the sale of Gauguin's goods in Papeete on 2 September 1903. It is probably a page from one of the artist's albums (lot nos. 119 and 122 of the sale), or from a sketchbook (lot no. 135).[2] Segalen, the author of *Les Immemoriaux*, never knew Gauguin personally, but was greatly influenced by his example. The writer treasured this moving portrait for the rest of his life.–F.C.

1. Pickvance dated it c. 1896 (1970, 43).

2. Jacquier 1957, 707.

150 x 100 (5⅞ x 4)

graphite on wove paper

private collection

EXHIBITIONS
Paris 1928, no. 5; Paris, Orangerie 1949, no. 79

shown in Paris only

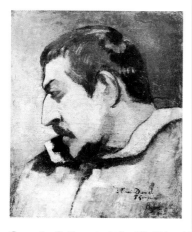

Gauguin, *Self-portrait for His Friend Daniel*, 1897, oil on canvas [Musée d'Orsay, Paris]

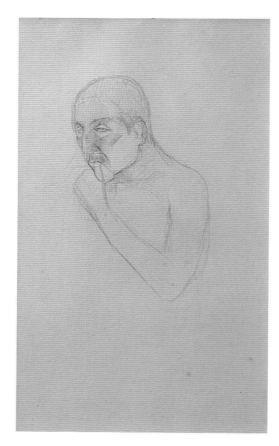

227
Te pape nave nave

1898

74 x 95.3 (29⅛ x 37½)

oil on canvas

signed and dated at lower left, *Paul Gauguin/98*; inscribed at lower left, *TE PAPE NAVE NAVE*

National Gallery of Art, Washington, Collection of Mr. and Mrs. Paul Mellon 1973.68.2

EXHIBITIONS
Paris 1898;[1] Chicago 1959, no. 63

CATALOGUE
W 568

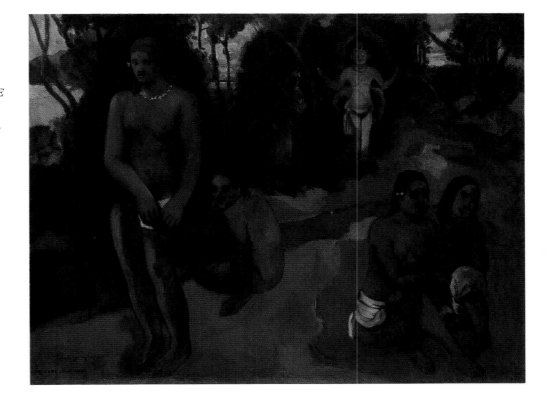

1. The Wildenstein catalogue has mistakenly placed this painting in the 1903 Vollard exhibition as no. 4 [*La Joueuse de la flûte*], when in fact they were probably referring to the painting with this title, W 468.

2. Natanson 1898.

In 1898, Gauguin sent a group of paintings to Paris for an exhibition planned by his friend Chaudet at Vollard's gallery. Gauguin's most important painting of 1897-1898, *Where Do We Come From?* (W 561), has long been known to have been included in that exhibition, but only recently have the other paintings in the exhibition been identified. In an important review by Thadée Natanson, eight paintings that relate to *Where Do We Come From?* as either "fragmented replicas or studies" are discussed.[2] This phrase, together with his more specific discussion of the pictures, makes it possible to identify *Te pape nave nave* (Delightful Water) as one of the eight.

Because it is signed and dated 1898, *Te pape nave nave* must be interpreted as a "fragmentary replica" of *Where Do We Come From?* (see fig. p. 391). Its main figures are derived from the right half of the large decoration, but there are significant variations in color, pose, and composition. The two seated figures on the right and the hooded woman in the background retain their poses and relative positions. However, Gauguin replaced the standing companion of the hooded woman with a child and altered the pose of the seated figure to the right of the standing nude. In *Where Do We Come From?*, this is the figure of *Pape moe* (cat. 157), whose raised arm and head turn away from the viewer. In *Te pape nave nave*, the figure turns toward us. To anchor the middle ground, Gauguin borrowed the statue of the Tahitian goddess Hina from the left side of *Where Do We Come From?*

The major invention in the picture is Gauguin's replacement of the fruit picker with a standing female nude derived ultimately from the fallen Eve. The pose and proportions of the figure relate it clearly to Borobudur, but there is no

Gauguin, study for *Te pape nave nave*, 1898, charcoal [location unknown; photo: Vizzavona, Paris]

3. Amishai-Maisels 1985, 245-246.

4. Letter to Morice in Artur 1982, 60.

5. Malingue 1949, CLXX.

precise prototype in the frieze, and Gauguin seems to have worked out the pose in a large drawing (R 105) before making the painting. Amishai-Maisels has interpreted the picture as a contrast between Sin/Death on the left and Eden on the right.[3] It seems equally possible to interpret the four female bathers in the foreground as manifestations of Christian, Tahitian, and Far Eastern paradise as one reads from left to right. Like the bathers in *Mahana no atua* (cat. 205), they seem to inhabit a special realm. They are separated from the landscape by a stream of water, and, like the women in the chromatically similar painting, *Nave nave mahana* (cat. 220), they look toward the viewer as if posing.

Gauguin was developing new ideas about color as he worked on these paintings in late 1897 and throughout 1898. He seems even to have sent a manuscript on the subject of color to Charles Morice in 1898, but this has been lost,[4] and the only real evidence we have for his chromatic theories comes from a famous letter to Fontainas, written in February of 1899. This letter contains his longest late text devoted to color, and, when looking at the series of paintings from 1897 to 1898, one should keep this passage in mind: ". . . are they not analogous to oriental chants sung in a shrill voice, to the accompaniment of pulsating notes which intensify them by contrast? Beethoven uses them frequently (as I understood it) in the 'Sonata Pathèthique,' for example. Delacroix too with his repeated harmonies of brown and dull violets, a somber cloak suggesting drama. You go often to the Louvre: think of what I said, look attentively at Cimabue. Think also of the musical role color will henceforth play in modern painting. Color which is vibration just as music is, is able to attain what is most universal yet at the same time most elusive in nature: its inner force."[5]—R.B.

228
The White Horse

1. This painting was originally commissioned by the pharmacist Ambroise Millaud in Tahiti. However, when Millaud saw the painting he refused it because the horse appeared green to him. See Danielsson 1975, 219–220; Danielsson 1965, 208. Danielsson received this information from Millaud's daughter Mme Marcel Peltier.

2. Kane 1966, 361–362, nn. 37 and 38.

3. Joly-Segalen 1950, 10 April 1902, 226; 5 July 1902, 230.

4. W 579.

Little is known of the early history or the meaning of *The White Horse*. Even the title is subject to dispute, because the picture was first exhibited in 1905 as *White Horse in a River* and a year later as *Riders in the Forest*. Its first owner, Daniel de Monfreid, gave the picture its present title when he published it in 1923 in the Gauguin retrospective he arranged for the Galerie Dru in Paris. Since then, *The White Horse* has become both the title and, by extension, the subject of the picture.[1]

Previous literature has burdened this painting with sophisticated source analysis, and caused it to take on an unnecessary degree of complexity. Not only is Gauguin said to have "borrowed" the horse from Phidias via a photograph of a plaster cast of the original Parthenon frieze, but also, the color white had connotations of the supernatural, of death, and of power in Polynesian culture.[2] Hence, the classical source combines with the color symbolism to produce a set of meanings, many of which are dependent upon Monfreid's title. We have no direct evidence for the title from Gauguin himself, and even Monfreid described the picture variously in letters to Gauguin written in the spring and summer of 1902 as "the white horse in the river, with riders in the background" or "the horse in the river in the woods."[3]

The largest and most ambitious picture Gauguin painted in 1898, and almost identical in scale to *The Great Buddha* of 1899,[4] *The White Horse* might even have been conceived together with this masterpiece as part of a vast collec-

1898

140 x 91 (55⅛ x 35⅞)

oil on canvas

signed and dated at center right, in dark blue, *P. Gauguin/98*

Musée d'Orsay, Paris

EXHIBITIONS
Weimar 1905, no. 11, *Weisses Pferd im Fluss*; Paris 1906, no. 181, as *Cavaliers sous bois*; Paris 1923, no. 26; Venice 1928, no. 2; New York 1936, no. 39; Paris, Orangerie 1949, no. 53; Basel 1949, no. 60

CATALOGUE
W 571

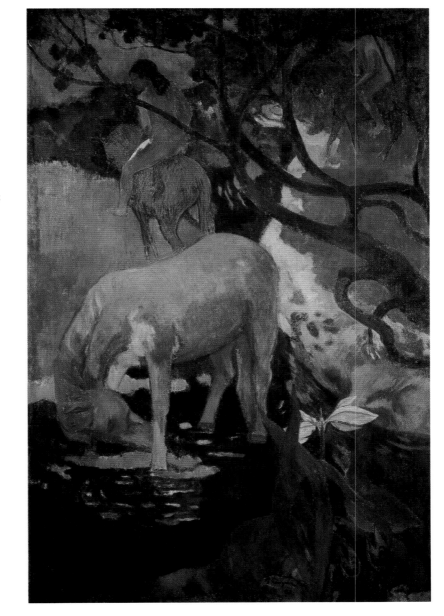

5. See Edwin N. Ferdon, *Early Tahiti: As the Explorers Saw it 1767–1797* (Tuscon 1981).

6. Danielsson 1964, 288 n. 60.

tive ensemble related to *Where Do We Come From?* (W 561). All three works have similar vertical dimensions and figures that are precisely analogous in scale. *The White Horse* was the first in a late series devoted to the relationship between men and horses, which had been introduced into Polynesia by the Spaniards in the sixteenth century.[5] Although horses were comparatively rare in Tahiti, by the nineteenth century a hardy "native" population of horses lived on the major islands of the Marquesas, where Gauguin moved in 1901.[6] However, *The White Horse* was painted almost three years earlier.

The riderless horse seems to frolic in the pool, emphasized by the play of ripples in the cool water. Gauguin gloried in the supple curves of the burao trees that line the rivulets approaching the sea in Tahiti. The curvilinear order they establish is in strict contrast to the architectural or tectonic ordering principles that define *The Great Buddha*. Indeed, *The White Horse* is characterized by free, gentle movement: the water glides from one pool to another, the naked riders seem free to move in any direction. Even the horse, the most European of animals, has become native to the South Seas.

The symbolic meaning of Gauguin's white horse can be considered in the same way as the black dog in Seurat's *Sunday Afternoon on the Island of La Grande Jatte* (The Art Institute of Chicago). For each artist, an animal of a non-color was chosen almost as a demonstration of the fact that even white and black are in fact colors. *The White Horse* is not white, but rather an amalgam of the colors found throughout the rest of the canvas, but in lighter forms. It is whitened rather than white, almost as if in agreement with the various impressionist optical theories in which Gauguin was first trained by Pissarro.

By 1902, at the latest, Gauguin sent the painting to Monfreid, whose attempts to sell it failed.[7] It seems that at Gauguin's death he became the owner of the picture by default, though there was considerable interest in the picture later. Indeed, a letter, dated 1912, from Monfreid to the Marseilles collector Frizeau indicates that a copy of the painting had already been sold to M. C. H. (possibly Chenard Huche). This copy was exhibited in 1938, after the original painting entered the Musée du Luxembourg.[8] The acquisitions committee of the Musée du Luxembourg did not readily agree to buy *The White Horse*.[9]

When the original painting was exhibited in 1906, the young artists working in Paris must have been moved by it. The animal paintings of Franz Marc are scarcely conceivable without it. Whether or not Marc saw the painting in Paris, he must have seen the reproduction published in 1910 in *Kunst und Künstler* where it illustrated an article by Maurice Denis and was called *Fantasy!*[10]–R.B.

7. Joly-Segalen 1950, letter from Monfreid to Gauguin, 10 April 1902, 226, and 7 June 1902, 228.

8. Letter, Archives Musée Gauguin, Papeete. A copy by Monfreid is dated 1939 in Saint-Germain-en-Laye 1986, no. 429, 215.

9. See Rey 1950, 38-40.

10. Denis 1910, 89.

229
Women at the Seaside

1. Wildenstein 1964, 245. The posthumous title *Motherhood* has given rise to a series of misinterpretations. Teilhet-Fisk 1983, 137, connects it directly with the birth of Gauguin's son Emile by his Tahitian "wife" Pahura in April of 1899. She goes so far as to say that Gauguin "commemorated the event by painting *Maternité*." This reading is then appended to that of Andersen 1971, 248, who found analogies with "the three graces of womanhood, one holding flowers in the bloom of her youth and attractiveness, another holding fruit, plucked from the tree and ready to be eaten, and a third holding a suckling infant- the fruit of her flower." Several other writers (Motoe in Tokyo 1987, 177), have decided that the black dog on the right represents Gauguin.

2. Receipt from Vollard, dated from Paris, 17 October 1900. Rotonchamp 1925, 221, has changed the wording in this passage. Further, he says that this list represents the final shipment to Vollard, which is incorrect.

3. We have no idea whether the text was written by Gauguin or by the receiver of the paintings, either Vollard or an agent.

This painting has traditionally been called *Motherhood* (Maternité), though there is no evidence that this title was intended by Gauguin. Wildenstein tentatively identitied it with *Woman Feeding Her Child* (Mère allaitant son enfant) in the catalogue of the important 1903 Gauguin exhibition held at Vollard's gallery,[1] though this seems highly unlikely. In fact, the mother feeding her child is only one of three major female figures in this composition.

Women at the Seaside was among a group of ten paintings by Gauguin received by Vollard in October of 1900. It is described precisely in an early list, "8. Three figures: in the first plane, a crouched woman nursing a baby, at the right a small black dog; at the left a standing woman in a red dress, with a basket; behind, a woman in a green dress holding flowers. Background of blue lagoons on orange-red sand with a fisherman."[2] While this description is somewhat bland, all of the figures and their fabulous setting are given the same prominence that they have in the painting itself. Only the dog, which is of minor importance in the painting, is accorded special attention.

In fact, it is the color of the figures and their setting as much as their individual activities or attributes that struck the writer of that early description.[3] The throbbing harmonies of red-orange near a similarly valued red, of deep blue and a dark bottle-green, give the picture an almost spectral quality that contrasts with the ambiguous brown tonalities of the figures themselves. The time appears to be sunset, when the Pacific Ocean takes on the hues of the sky, and the figures have an air of classical repose. Indeed, the depth of the hues recalls Poussin; the picture seems to be a hymn to beauty and youth, set both at the end of day and at the end of time.

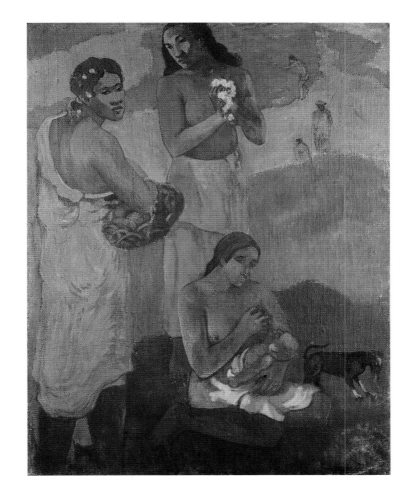

1899

95.5 x 73.5 (37¼ x 28⅝)

oil on canvas

signed and dated at lower right in dark blue, *Paul Gauguin 99.*

State Hermitage Museum, Leningrad

EXHIBITIONS
Paris 1903, no 43, *Femmes sur le bord de la mer*; Moscow 1926, no. 21; Tokyo 1987, no. 119

CATALOGUE
W 581

Matisse, *Luxe, Calme, et Volupté II*, 1904, oil on canvas [Musée d'Orsay, Paris]

4. Artur 1982, letter to Morice, 16. See also cat. 227.

Gauguin painted a somewhat smaller version of the composition (W 582). This work is much more brilliant in hue. It is signed, but not dated, and we know it was kept by Gauguin because it was included in the sale of his estate in Tahiti. The smaller version has a light-struck background of acid yellow-green, and a salmon-pink cloud floats behind the figures. Here, the women recline in the shade. This smaller painting has never been adequately explained. While Gauguin had painted two versions of several earlier compositions, none but this is known from the last decade of his career. For that reason, his motivation in translating the composition into another language of color is not clear. That he was deeply concerned with the expressive and pictorial power of color is evident, for he had sent an essay on that subject to Morice for publication in 1898.[4] Unfortunately, this crucial document has not been found, and, for that reason, Gauguin's own ideas on color theory must be pieced together from passages scattered throughout his letters and criticism.

Perhaps the principal "oddity" about *Women at the Seashore* is its size. When viewed in reproduction, the composition has an undeniable monumentality. Indeed, it is easy to imagine as a canvas six or even seven feet high, dominated by life-size figures against an almost abstract colored ground. However, the painting is a standard size 30, and its monumentality lies, in fact, in its ambitions. The painting must have been profoundly moving to Matisse and Picasso when they saw it among Gauguin's last works in Vollard's gallery. It also affected the Russian collector Shchukin, who bought it from Vollard shortly after the close of the exhibition. This is the first time since 1903 that the painting has been exhibited in either Western Europe or the United States.—R.B.

230
Two Tahitian Women

1899

94 x 72.2 (37 x 28⅜)

oil on canvas

signed and dated at lower left, *99/P. Gauguin*

Lent by The Metropolitan Museum of Art, New York, Gift of William Church Osborn, 1949

EXHIBITIONS
Paris 1906, no. 14, *Deux Tahitiennes*; New York 1936, no. 41; New York 1946, no. 35; Paris, Orangerie 1949, no. 54; Basel 1949, no. 61; Chicago 1959, no. 64

CATALOGUE
W 583

shown in Paris only

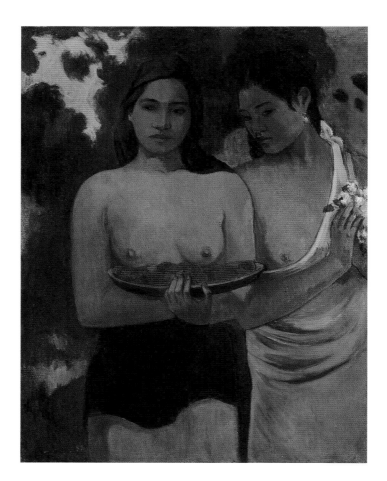

1. Jamot 1906, 471. "Never has Gauguin better rendered the delicate beauty or the unconscious aristocracy of the Maori woman."

2. In fact, its European rather than savage quality was first noted in Wilenski c. 1940, 133, 138, pl. 45A.

3. Sterling and Salinger 1967, 176.

4. Dorival 1960, 60; 1961 ed., 44; 1986 ed., 47; Nochlin 1972, 9-11.

5. See New York 1983, 431-432.

Two Tahitian Women was among the few paintings in the major 1906 Gauguin retrospective that were especially praised by the critics.[1] It has been reproduced countless times since and has come to embody for many writers Gauguin's ideal of feminine beauty. The figures have a quality of classic ease, innocence, and grace that would have been immediately acceptable to a French bourgeois public accustomed to nudes from the Salon.[2]

Much has been written about this picture. The model for the major figure has been identified, probably mistakenly, as Gauguin's Tahitian mistress Pahura.[3] Specific sources in French popular imagery of the Third Republic have been put forward by Dorival, Nochlin, and others,[4] and much has been made of Gauguin's use of the same figures in other paintings, drawings, and prints. Yet there has been no sustained analysis of the significance of the painting in Gauguin's oeuvre and no convincing identification of the orange substance in the carved Tahitian tray carried by the main figure.

Like many other figures in Gauguin's paintings of 1898 and 1899, the two women appear to make offerings of fruit or flowers. In most other paintings, such offerings are made to another figure or an idol within the confines of the picture itself. In this case, the women turn forthrightly toward the viewer. Thus Gauguin's *Two Tahitian Women* evokes memories of Manet, whose nudes so often confront the viewer. In March 1894 Vollard had purchased a painting of a blond nude model from Suzanne Manet while Gauguin was still in Paris.[5] While Manet's picture was

Gauguin, *Tahitian Woman*, charcoal drawing [location unknown; photo: Boudaille 1964, page 170]

6. Dorival 1960, 60; 1961 ed., 44; 1986 ed., 47, reproduces the cover of the 30 November 1884 issue of *Le Courrier Français* (this illustration reappeared in the 5 July 1885 edition), by M. Gray with an illustration of a woman carrying apples entitled *La Marchande de Pommes*, which he links directly to this painting. (He attributes this discovery to Mme Thirion in her un-published Ecole du Louvre thesis, 1947). Also, Nochlin 1972, 11-12, illustrates a nine-teenth-century photograph of a nude woman holding a tray of apples entitled "Achetez les pommes," taken from a late nineteenth-century popular French magazine.

7. Boudaille 1964, 170.

8. W 585.

9. Danielsson 1956, 193-194.

not a direct source for Gauguin, the two artists did share an interest in this type of nude, which was common in both popular imagery and painting.[6]

Two drawings relate almost directly to the heads in the painting. Neither drawing has been convincingly dated, but they were most probably made on Gauguin's first Tahitian trip. The head of the central figure is directly related to a charcoal drawing (location unknown)[7] and that of the woman to the right to cat. 124. If Gauguin did borrow the features of these two beautiful nudes from earlier drawings, the identification of the central figure as Pahura cannot be sustained. Further, this reuse of earlier drawings suggests that Gauguin worked strictly in a symbolist manner. Even the seemingly natural pose has its roots in the Buddhist frieze at Borobudur.

As if in support of this notion, neither of the women wears her Tahitian costume in a conventional manner. The *pareu* would not have been worn over one shoulder, as the figure on the right wears it, not was it usual to lower the top as the central figure does. Women frequently tied their *pareus* to reveal their breasts, though. Also, neither fabric is similar to those found in the countless contemporary photographs of Tahitian woman wearing *pareus*. Both figures reappear in virtually identical costumes in the central masterpiece of Gauguin's painting of 1899, *Rupe Rupe* (see fig. at p. 394).[8] However, the costumes of the figures in both paintings seem to derive from non-Tahitian sources. General parallels for the folds, colors, and draping of the fabric can be found in both classical or medieval European art as well as in the well-known Borobudur narrative friezes.

What are these women doing? The figure at the right holds an informal bouquet of flowers and turns her head, as if to listen to the viewer. Although she wears what seems to be a pink flower beneath her ear, the position suggests that it may be an earring. Both its color and position indicate that Gauguin wanted the viewer to be aware of the woman's ear and that he may also have wanted to create a contrast to the simplicity and absence of ornament that characterize the central figure. The main figure carries a tray filled with what has been identified as mango flower petals. Yet in both *Two Tahitian Women* and *Rupe Rupe* the material on the tray has a palpability and apparent weight that suggest a different identification. Perhaps it is a mash of papaya and mango fruits, and Gauguin added intensity to the color for expressive purposes.

What then can be said about the offering? Clearly, Gauguin has avoided the traditional comparison in Western art between breasts and apples. He could easily have substituted the Polynesian "apple," the mango, but chose instead to paint a substance that no Western viewer has been able to identify securely. Can one argue that his intention was simply to represent a superb nude making an offering that, in being neither fruit nor flowers, has the quality of both? Is the offering simply color? Surely this is not too great a leap to make in interpreting the work of an artist who, the year before, had written an unpublished essay about the emotional and musical qualities of color. When considered in this way, Gauguin chose to represent two nudes who emerge from the shade of a grove into the sunlight. Their faces remain in shadow, but the offering of the central figure is illuminated by the sun. The warmth and bounty of the earth become the subjects of this noble painting.

In traditional Polynesian society, men and women were forbidden to eat together.[9] Given the probability that Gauguin was aware of this taboo, the painting may have had another level of meaning if the substance is identified as food. When interpreted in this way, we are given a private viewing of a female realm where we do not belong unless we, too, are females. The gentle, accepting expressions of the female figures make our presence seem natural, and we have only to ask what it is we will eat.—R.B.

1899-1900

73 x 92 (28½ x 35⅞)

oil on canvas

Walter H. Annenberg

EXHIBITIONS
(?) Paris 1903, no. 6 or 49, *Portraits de femmes*; Munich 1910; Saint Petersburg 1912, no. 116; Chicago 1959, no. 65

CATALOGUE
W 610

shown in Washington and Chicago only

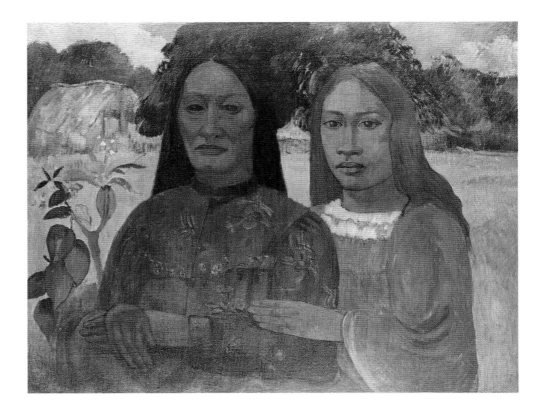

Two Women, c. 1894 [O'Reilly Collection; photo: Henri Lemasson]

This double portrait of two women may well have made its first public appearance at Vollard's 1903 exhibition with the simple title *Portraits of Women*, for there are no other paintings from the last years of Gauguin's life in which the quality of portraiture is as undeniable and pervasive as in this particular painting. In fact, the younger woman has been identified as Teahu A Raatairi, and the older woman is said to have been her aunt by marriage.[1]

Gauguin failed to date or to sign this painting. This has caused considerable confusion among Gauguin scholars, one of whom has gone so far as to identify the figures as creoles from Martinique![2] Most others have sensibly placed the picture in the last three years of the painter's life, and dates vary from 1900 to 1902 in the published literature. The catalogue raisonné adopted the later date, with which le Pichon agreed, comparing the picture to a presumed pendant, *The Lovers*, signed and dated 1902.[3] Yet the absence of a signature and date remains troublesome in the face of Gauguin's painted oeuvre from the last years, in which virtually every example is signed and often dated. Yet one cannot consider the painting to be unfinished, in view of the artist's rapidly executed, almost self-consciously sloppy paintings of 1903.

As with *Pape moe* (cat. 157) and *Girl with a Fan* (cat. 279), there is a photograph that is closely related to this painting. It was in the collection of Mme Joly-Segalen and was most probably found by Victor Segalen in the studio of the House of Pleasure when he arrived there just after Gauguin's death. It has a professional appearance, suggesting that it was made by one of Gauguin's photographer friends, Jules Agostini or, as O'Reilly contends, Henri Lemasson.[4]

1. Oral information received in Tahiti from Mme Manjard, the granddaughter of Teahu A Raatairi.

2. Alexandre 1930, 105.

3. W 614. Le Pichon 1986, 242-243.

4. Danielsson 1964, 180 and 286, no. 153. O'Reilly, *Les Photographes de Tahiti* (1969), 40-41. Lemasson also took the photograph of *Where Do We Come From?* (W 561), in 1898. O'Reilly dates the photograph to 1894, but according to Danielsson, Lemasson did not arrive in Tahiti until 1895.

5. Wadley 1985, 38-39; Loize 1966, 39.

6. Or to 1891, when Gauguin lived in Mataiea, where the sister is said to have resided. Oral information from Mme Manjard, Tahiti.

7. *Mir Iskusstva* 9:222.

8. Morice 1919, 112; Morice 1920, opp. 236.

9. Richardson 1959, 190.

10. Bodelsen 1966, 38. Mlle Bacou has said there are no traces in the Fayet archives that this passed through the Fayet family collections.

The two heads completely dominate the painted composition, which, in the photograph, revolves around the interplay of facial features, gesture, and drapery. The photographer also situated the two women on the stoop of a native house, where they are seated, whereas Gauguin placed them outdoors in the middle of a large field, where they seem vulnerable. Only with certain subtle bulges in the drapery at the very bottom of his horizontal composition did he make it clear that they are seated at all. Gauguin's most important shift was in the relative strengths of the two women. While the younger woman clearly protects her frailer and smaller mother in the photograph, Gauguin reversed the roles. Indeed, the old woman is a definite matriarch, to whom the younger woman turns for guidance.

There is one important and unillustrated paragraph in the first *Noa Noa* manuscript in the Getty Center that might well relate to the painting. Gauguin described a wedding banquet. "In the place of honor at the table the admirably dignified wife of the chieftan of Punaauia, clad in an orange velvet dress: a pretentious, strange costume, very like those you see at a fair. And yet the inborn grace of that people [and] her consciousness of rank made all that fancy dress beautiful; ... Next to her sat a centenarian relative, a death mask made yet more terrible by the intact double row of her cannibal teeth. Tattooed on her cheek, an indistinct dark mark, a shape like a letter. I had already seen tattoo marks, but not like that one, which was certainly European. (I was told that formerly the missionaries had raged against indulgence and had branded some of the women on the cheek as a warning against hell. . . .)"[5]

The passage is the only one that contrasts two generations of Tahitian women in terms of their experience with missionaries. Given the fact that both women in the painting wear missionary dress and that the dress of the younger woman is a red-orange, we are forced to ask whether the small mark on the left cheek of the old woman is the tattoo discussed with such indignant rage by Gauguin. If it is, the painting might well date from the first Tahitian trip.[6] It is difficult to know whether Gauguin recalled the painting when writing the text or the reverse. He had already made a watercolor and a monotype portrait of the old woman in 1894/1895 (F 24), possibly for inclusion in *Noa Noa*. Or perhaps the photograph rekindled memories of his own earlier text.

The painting seems to have been well-received early. It was reproduced in 1904 in the prestigious Russian art journal *Mir Iskusstva*,[7] and Morice included it in both the 1919 and 1920 editions of his biography on Gauguin, where he called it simply *Tahitiennes*.[8] Yet John Richardson, in his lengthy review of the 1958 Gauguin exhibition in Chicago and New York, called the picture "unpleasant" and asserted that it had not been in the Fayet collection, as both the catalogue of that exhibition and the subsequent catalogue raisonné attest.[9] This notion was reaffirmed in Bodelsen's superb and detailed review of the catalogue raisonné.[10] It seems clear that the attempts to remove the picture from the Fayet Collection, which was surely the most important collection of Gauguin's late work formed at the beginning of this century, carry a suggestion that the painting is not of the first rank. Surely this is not the case. In fact, the hypnotic intensity of the faces turns these Tahitian women into icons.—R.B.

232-245
Suite of Late Woodcuts, 1898-1899

1. Malingue 1949, CLXXIII, 297, mis-attributed it to Bibesco. Also in Rewald 1943.33.

2. Joly-Segalen 1950, LXI.

3. Rewald 1943, 39.

4. Four woodcuts were in an exhibition in April-May 1902 in Béziers and were sold for 40 francs each; Loize 1951, 144, no. 427. See Vollard letter to Monfreid, 16 September 1901 (Joly-Segalen 1950, 224). "He also sent this package of prints which are worthless to me."

5. See letter to Fayet, in which he describes the process; Joly-Segalen 1950, 203.

In January 1900, Gauguin wrote a long letter to Vollard proposing a business arrangement between the two men and announcing that he would soon send a large group of prints for sale. "Next month I am sending, by someone who is traveling to France, about 475 wood engravings – 25 to 30 numbered prints have been made from each block, and the blocks then destroyed. Half of the blocks have been used twice, and I am the only person who can make prints that way. I shall give Daniel instructions concerning them. They should be profitable to a dealer, I think, because there are so few prints of each. I am asking 2500 francs for the lot, or else 4000 francs if sold by the piece. Half the money at once and the balance in three months."[1]

On the 27th of January, he wrote to Monfreid that he had already sent "some prints" and that he had made a technological discovery that would revolutionize printing and create beautiful impressions.[2] This seems to have been his "discovery" of the technique used to create the transfer drawings that dominate his late graphic oeuvre. All in all, the letters from early 1900 are full of such optimism, but it was not to last. In fact, after several months of silence from France, Gauguin wrote an impassioned letter to Vollard in September asking him whether he ever even received the prints![3]

Throughout this correspondence, Gauguin was referring to a group of woodblocks, all of which he printed himself on Japanese tissue paper and most of which he numbered and initialed to form editions. Fortunately, these prints did arrive in France, though it it not clear exactly when. Yet Vollard did not seem to have been as keen on them as Gauguin had anticipated, for he never included them in any exhibitions devoted to Gauguin, and there is no evidence either that he paid the artist in the manner proposed or that he sold them in any quantity during the painter's lifetime.[4] Although these prints were listed and reproduced in Guérin's catalogue of Gauguin prints and have been included in various Gauguin exhibitions, they have been discussed very little in the literature devoted to Gauguin in the South Seas. The late prints, rather like Gauguin's late texts to which they relate, seem to have been relegated to the sidelines of Gauguin studies.

The neglect of the Vollard prints, which represent Gauguin's single most sustained printing activity at any point in his life, is unjustified. The fourteen prints were pulled by Gauguin himself from irregular blocks of tropical wood with surfaces far from the uniformly flat planes on which Gauguin had worked for his two earlier series of prints. This late group of prints can be interpreted as a third series, directly comparable to the Volpini zincographs of 1889 (cats. 67-77) and to the *Noa Noa* prints of 1894 (cats. 167-176). They were a summary in printed form of his artistic and intellectual activity between 1896 and 1900.

Gauguin had entrusted the printing of the Volpini prints to others, and after some struggle to print the *Noa Noa* blocks himself, relinquished these to his artist-friend Louis Roy for proper editions. But in Tahiti he had no such artist colleagues, and Gauguin had become expert enough in the manipulation of inks and the printing of dampened sheets of paper to take charge of the printing of this project himself.[5] The quality of the surviving impressions is high enough and the consistency of the editions is such that they must have surprised even their maker, unused as he was to methodical work. As is too often the case with Gauguin, he left us no clue as to the ultimate purpose of this group of prints. We know approximately how many there were, that he printed them himself, and that he wanted them to be sold. Yet all the basic questions of his intentions in producing such a large body of prints remain unanswered.

What did Daniel de Monfreid think when he opened the small packet that contained nearly five hundred sheets of fine tissue paper printed by his friend Gauguin? What was he to do with them? There is no evidence that any of these fragile objects were mounted at the time they were sent. Even if Gauguin did intend that the prints be sold individually, as he indicated to Vollard, we know absolutely nothing about the way in which he wanted them to be presented. Because he chose to print them on the thinnest and finest of papers, they would need to have been mounted for presentation or for sale, and Gauguin's omission of instructions to either Monfreid or Vollard is uncharacteristic for an artist so concerned with matters of display.

It seems fair to assume that, for Gauguin, the prints were conceived as a group and, therefore, that they might be interpreted in a serial way. Fortunately, there is one print that can be interpreted as the title image. It is *Te atua* (The God), which bears exactly the same title as a print in his earlier *Noa Noa* series. Although one other print in the group of fourteen also bears a title, *Te atua* is at once stronger and more graphically suited than *Be in Love* to its role as the definer of a sequence of related prints. *Te atua* is almost symmetrical and has an arched top, which, in certain impressions, Gauguin cut from the rectangular sheet, giving the image an iconic quality.

It is fascinating to compare the *Te atua* of 1898-1899 to its predecessor created in the winter of 1893-1894. Where the earlier image is strictly hieratic and closed, the latter has a charming lateral shift, with its main devotional image on the far left of the sheet rather than in its center. The earlier *Te atua* is deliberately mysterious and non-Western. The central figure has a Buddhist pose, and the surrounding gods have a Polynesian character. Little about the earlier print would have meant much to its original French viewers, unless Gauguin himself had explained it. The later *Te atua* is almost the opposite. The ancient Polynesian deity, Taaroa, who presides at the top is mimicked in a figure with an almost identical face that has been identified as Oviri and is included in the center of the scene as a prostrate worshipper of the infant Christ! The figure on the right, who looks out of the composition, has been related to Buddhist sources, but it derives directly from the representation of the Virgin Mary with her attendant at the right of Gauguin's painting, *Christmas Night* (W 519). Here, as in many of of Gauguin's paintings of the second trip, Polynesian culture is grafted carefully onto a Western or European stem.[6]

Even the modes of printing in Gauguin's two *Te atuas* can be contrasted. While the earlier print was created in a series of absolutely unique impressions by Gauguin, the later was produced in a real edition with two distinct stages. Gauguin worked the block and printed an edition of this state using dark gray or black ink on tissue paper. He then reworked the block more aggressively, hollowing out new areas on the head of Taaroa and throughout the middle ground, and printed another edition in black. After this was completed, he pasted the second printing on top of the first so that the the two states are viewable simultaneously and presented in their true sequence. In this way, Gauguin suggested that the print itself has depth.

Whatever its technical complexities, the second *Te atua* has a delightfully naive or archaizing quality, which can be found throughout the 1898-1899 series. This suggests that Gauguin renewed his interest in popular woodblock prints like those reproduced in abundance in *L'Ymagier*.[7] These included not only the woodblock prints produced in late-fifteenth-century northern Europe, but also popular

6. Gauguin used many elements of this print in what seems to be a later drawing made for inclusion in *Avant et après*. Here, Taaroa is at the bottom of the print, and the Virgin Mary and her attendant flank a scene of the deposition taken by Gauguin from the Nizon Calvary. The later drawing is more blatantly christological than *Te atua*, in which Gauguin attempted to balance Polynesian and European elements.

7. During this time Rémy de Gourmont, Alfred Jarry, Emile Bernard, and other symbolist artists produced woodcuts in a deliberately crude and primitive early Renaissance style. For a detailed study of the symbolist woodcut, see Baas 1982, chapter VI, 177-211.

prints of the seventeenth and eighteenth centuries, particularly the famous *Images d'Epinal* as well as certain Japanese and Chinese woodblocks, the latter of which have undeniable formal affinities with several of Gauguin's late prints. Indeed, Gauguin reveled in the strength and almost crude power of the woodblock print in this latter series. Gone was the almost aristocratic obsession with subtle surface incident and finesse in hand printing that had preoccupied him in the *Noa Noa* suite.

Twelve of the fourteen prints in the series can be considered in pairs or even friezes related by size, format, mode of printing, and composition. When considered in this way, the grouped images have a greater iconological power and formal clarity, resulting in an "architecture" of the series that is clearer and more interesting than a separate analysis of each individual image. (The sequence here is not in the least meant to be rigid or final.)

The pendant of *Te atua* in size and figural scale is *The Rape of Europa*. While the figure on the far right of *Te atua* looks beyond the image, toward the right, the figure on the far left of *The Rape of Europa* receives her glance. While a dark peacock, a conventional symbol of heaven, resurrection, and/or immortality, occupies the center of *Te atua*, a virtually identical white peacock occupies a cartouche at the upper right of *The Rape of Europa*. Again, as in *Te atua*, are conflated Polynesia and Europe, but this time, his Europe is not Christian but pagan, and his heroine was not impregnated by the Judeo-Christian God through the Holy Ghost, but by Zeus in the guise of a white bull. Europa's most famous son by Zeus was Minos, the king of a Mediterranean island paradise that might have served Gauguin as a Western equivalent for Tahiti.

Another possible pairing of large vertical prints, *Buddha* and *Eve* (cats. 234, 235), is among the most bizarre in its contrast of opposites. Because they are the largest prints in the group, these two prints have the character of book covers. One can easily imagine *Eve* on the cover of Gauguin's evolving text on Catholicism, which came to be called *L'Esprit moderne et le catholicisme* in its final manuscript form of 1902. The Buddha, which might well have dominated the back of the book, is represented on a completely dark background in a position that Teilhet-Fisk, through Saunders, has identified with "the Right Way," "the Demon-suppressing Seat," "the Seat of Good Fortune," or "the Attitude of the Hero."[8] Curiously, the particular image of the Buddha used by Gauguin has never been precisely identified. Surely, Gauguin took the Buddha directly from a photograph of a carved stone figure, and not only did he own a photograph of a Buddha surrounded by attendants at Borobudur,[9] but there was also a print or a photograph of a Buddha on the wall of his studio in Atuona.[10] The apparent thickness of the object and the fact that the right hand of the Buddha appears to be broken both point to a stone original. Yet, always wary of direct borrowing, Gauguin has given Buddha a baldachino of his own invention, the basic concept of which derives from the Borobudur frieze. With intertwined snakes or branches of Maori origin as well as two bilaterally symmetrical pairs of figures, this device serves to usurp Buddha from the realm of the Buddhists and to let him fit into Gauguin's personal version of a universal religion.

What is most startling, and modern, about Gauguin's appropriation of the Buddha is that the holy man is shown off-axis. Gauguin made it perfectly clear that he borrowed the Buddha from a photograph of a work of art, thereby casting the beholder in the role of spectator rather than worshipper. For this reason, the print

8. Teilhet-Fisk 1983, 155; Saunders 1960, 125-126. Half (lotus) position: Hanka-za.

9. Gauguin owned two photographs of Borobudur, which were brought back from Tahiti by Victor Segalen after Gauguin's death. They are now in the collection of Mme Joly-Segalen. See Dorival 1951, 118.

10. Gauguin's *Buddha* has usually been linked with a Buddha from the photographs of Borobudur that Gauguin had in his possession (see n. 9). However, the Buddha in the woodcut is depicted at an angle and the Buddha in the frieze is presented frontally.

is completely different from the utterly devotional *Te atua* of 1893-1984, in which the Buddha figure is not only centrally placed but absolutely frontal. The earlier print becomes an object of devotion for the viewer in a way that is not possible with the later image. This surely suggests that Gauguin had come to have a fully modern understanding of Buddhism as one element in a new universal religion.

For *Eve*, Gauguin ransacked his own bank of images and borrowed the figure of Eve after the fall from *Parau na te varua ino* (cat. 220). Although she is reversed, her pose is identical, suggesting that Gauguin made the print from an intermediary work, probably the photograph of his own punctured/pricked pastel drawing that he pasted into the manuscript copy of *Noa Noa*, on which he was working at the same period.[11] Behind Eve, as in the drawing, is the disembodied head of the *tupapau* from *Manao tupapau* (cat. 154), which, together with the fact that Eve is covering her sexual organs, indicates that she has already been violated. Even the Polynesian rat perched at the left and exactly at the same level as the *tupapau* adds to this theme, because rats were considered to be the "shadows of ghosts," another allusion to *tupapau*.[12] Both these symbols of death together with an archetypal image of guilt and violation are given particular potency in Gauguin's print because they are so radically separated from each other and placed so strongly against the blank white void of the paper.[13] Here, Gauguin's initials float as the fourth major element in this struggle of symbols. He had also initialed *Buddha* in the same place and in a similarly powerful way, thereby imposing his identity as an artist on the symbolic images he chose, carved, and printed for interpretation.

The next pair of images (cats. 236, 238) also features a juxtaposition of the sexes, but this time the settings are virtually identical, and the theme of the pair is less one of contrast than of terrestrial bliss in a promised land. The masculine print has become known as *The Banana Carrier*, while the feminine one has been given a title adopted from the painting containing the same figure, *Te arii vahine* (W 542). In the masculine print, a hooded and possibly bearded male, nude except for a loincloth, carries a staff over his shoulder from which hangs a large bunch of fruit balanced by a mysterious long leaf. Next to him stands a large cow taken from a painting by Octave Tassaert and already used by Gauguin in another painting (cat. 221). The source for this image of plenty in Gauguin's own work is a similar figure in *I Raro Te Oviri* (W 431 and W 432), which the artist had already borrowed for a *Noa Noa* print. Yet the figure in *The Banana Carrier* is sufficiently different from these general prototypes to make a precise link with the earlier images unnecessary. Indeed, anyone familiar with the history of French painting makes an immediate leap to Poussin's *Autumn* (*The Promised Land*), the third in the series of the four seasons commissioned by Richelieu in the early 1660s and one of the principal treasures of the Louvre. Although Gauguin is not known to have possessed a photograph of this famous painting, the relationship between his single figure carrying oversize fruit and the pair of figures at the center of Poussin's composition is surely not accidental. This is just one of the images that Gauguin borrowed because of its associations of a kind of pastoral arcadia or land of plenty in which food is simply available for the carrying.

The Banana Carrier is literally surrounded by a landscape of leaves and trees. In the bushes is a fragmentary figure of a voluptuous nude woman, who appears almost to be part of another stage of the print. She gives a relaxed air to this scene of simple labor, and also relates the print to its pendant, *Te arii vahine*,

11. *Noa Noa*, Louvre ms, 51.

12. Gray 1963, 83; Field in Philadelphia 1969, unpaginated.

13. See Field in Philadelphia 1969, disputing the notion that the Eve from the door jamb sculpture in the church of Guimiliau in Brittany is the sole source for this print. It does help explain one aspect of the image, that the relationship between Eve and the Serpent is the same as that between Gauguin's Eve and the *tupapau*.

in which a native queen or noblewoman reclines on a surface decorated with scattered flowers. Here the enlarged leaves of the luxuriant foliage recall not only Poussin, but Borobudur. The source of the figure, as we have seen, lies also in Western art, specifically in the *Diana* by the northern Renaissance artist Lucas Cranach, of which Gauguin probably owned a photograph. If the two prints are related, as they seem by their size and character to be, this earthly paradise is a secular one, presided over by a benign but powerful queen.

The next pair of prints is perhaps more problematic because one of the two, the so-called *Plate with the Head of a Horned Devil* (cat. 239), was neither signed nor numbered by Gauguin. For this reason, it is impossible to treat it as a full member of the group. However, there are as many surviving impressions of this print as of the others, and it has so many formal affinities with *Women, Animals, and Foliage* (cat. 237) that they can profitably be considered together.[14] Both prints have numerous small figures juxtaposed with animals and leaves, and, although they are each related in format to the pair just discussed, they are more complex. *Women, Animals, and Foliage* was printed in an edition larger than the "25 to 30" mentioned in Gauguin's letter to Vollard.[15] An existing impression number "35" indicates that the edition was at least that large.

Each print represents human figures and animals floating in a vegetative realm. In *Women, Animals, and Foliage*, two seated women in the center converse or trade secrets beneath the limb of a great breadfruit tree. Although these figures appear in a painting (W 538) of 1896, each derives from the reliefs at Borobudur to which Gauguin was so attached. To the right of this conversing group is the figure from *Eve Exotique* (W 389), whose pose the artist borrowed ultimately from Borobudur through several intermediary works (cat. 148). She is about to pluck an enormous fruit from the bunch dangling from the tree at the far right edge of Gauguin's primitive paradise. The figure on the far left is difficult to place. Although many similar figures appear in Gauguin's paintings and drawings of the years 1896-1899, none is quite the same as this. She seems to function as a kind of guardian figure in this mythic paradise who also adds compositional balance to the more interesting figure of Eve. Yet simply by being present and by being clothed, she forces us to realize that this is not a Judeo-Christian paradise inhabited only by Adam and Eve. Women here abound – one plucking the fruit, others talking. Gauguin mounted this print inside the back of cover of his manuscript *L'Esprit moderne et le catholicisme* with the caption "Paradis Perdu" (Paradise Lost).

This daytime "paradise lost" is here juxtaposed to the considerably darker *Plate with the Head of a Horned Devil* within which images of evil predominate. At the center, the raven from Gauguin's *Nevermore* (cat. 222) strangles a lizard in its talons while the great horned devil, used so often in Gauguin's late works on paper, looks on impassively. The horned devil, whose basic character surely derives from the devil of popular Christianity, is juxtaposed with Fatu, the Tahitian god of the moon. This male god looks down toward a lone woman seated beneath a gently curving tree trunk, her eyes downcast. At the left a dog that resembles a fox appears to eat recently killed prey. The entire print is suffused with a mystery that links it to certain of the *Noa Noa* prints, most notably *L'Univers est crée* (The Creation of the Universe, cat. 174). Yet here, as in the other prints sent to Paris in 1900, Gauguin has reduced the number of elements and simplified their presentation.

14. These two woodcuts received these titles from Guérin – not Gauguin.

15. See n. 1.

Suggested arrangement of cats. 236-239 in
the form of a frieze

16. Gauguin, transcription of *L'Esprit moderne et le catholicisme*, ms, St. Louis Art Museum, 1.

The preceding four images could be mounted next to each other to form a continuous frieze of scenes that starts with *Te arii vahine*, followed by *Women, Animals, and Foliage* and *The Banana Carrier*, and completed by *Plate with the Head of a Horned Devil*. The order can be rearranged somewhat, but the latter print is "closed" at the right and must always dominate the right side of the frieze. The marked discontinuity of figural size and iconography is no greater than the degree of the discontinuity within individual prints. When the prints are arranged as a frieze, a paradaisical world unfolds like a scroll. This manner of presenting visual texts was surely not unknown to Gauguin. One is reminded of several sections In the poetic introduction to *L'Esprit moderne et le catholicisme*, where, after passages about gardens, bouquets, and flowers, "reason remains, distracted no doubt, but animate, and it is then that the bursting into leaf begins."[16]

Suggested arrangement of cats. 240-241 in
the form of a frieze

The most visually persuasive pair of images in the Vollard prints consists of *Change of Residence* and *Be in Love, You Will Be Happy* (Soyez amoureuses, vous serez heureuses, cats. 240, 241). These prints, virtually identical in size, were also similarly printed, using the modified chiaroscuro technique already discussed for *Te atua*. Unlike the previous three pairs of images in which a few highly symbolic figures and animals are clearly juxtaposed, these two prints are crowded with various sensations. Yet when mounted together, with *Change of Residence* on the left and *Be in Love* on the right, the two prints read as a single work of art. The gentle hillside that slopes down in *Change of Residence* meets the upwardly sloping hill of *Be in Love*. The tail of the dog in *Change of Residence* joins with the signature cartouche in *Be in Love*, and the mysterious, disembodied head and arm that float in the sky above the horsewoman in *Change of Residence* make a certain

sense in the context of the jumble of heads and bodies that crowds the sky in *Be in Love*.

With these two prints, it is clear for the first time that Gauguin thought of the prints in this Vollard group not only as individual objects, but also as parts of various schemes or projects. They form pairs, friezes, columns, book covers, and frontispieces. It is possible that Gauguin left these possible juxtapositions to be discovered and re-created by various purchasers, depending upon their needs. We have no evidence of the artist's preferred arrangement, and it is possible that it never existed. Rather, Gauguin made most of his art both to be integral and to function in combination with other works. The pairing of *Change of Residence* and *Be in Love*[17] makes the frieze of paradise discussed above easier to accept, and, when one begins to rearrange the images, other decorative combinations result.

This brings us again to the problem of the size and medium of the prints. As we have already seen with Gauguin's impressions of the *Noa Noa* blocks, most surviving impressions of the Vollard prints were cropped to the edge of the image. This, together with the fact that they were printed on very fine tissue paper, meant that they must have been mounted on some sort of secondary support. Gauguin's own penchant for decoration makes it possible to imagine the prints placed on panes of glass, pasted in various combinations on board mounts, put into books, or used as simple interior decorations, attached directly onto walls or moldings. They have the quality of inexpensive artist-produced decorations made purposely to have a variety of uses.

Suggested arrangement of cats. 242-244 in the form of a frieze

Certain prints in the group, in particular the three devoted to Brittany subjects, cannot easily be placed in these various sequences. None can be related in scale to any of the paradisaical prints already discussed. In *Human Misery* (cat. 244) Gauguin returned to a subject that had become a virtual obsession in the late 1880s and that had been explored in his first suite of lithographs, the Volpini prints. Yet here Gauguin takes the brooding young woman, transforms her into a Polynesian, and places her beneath a tree whose branches are bulging with fruit in a landscape presided over by two French peasants. Again, Europe and Polynesia are conflated, and the two ends of his career are brought self-consciously together.

The other Breton prints, *Breton Calvary* and *The Ox* Cart (cats. 242, 243), relate to two paintings that have troubled students of Gauguin since the 1920s, *Christmas Night* (W 519) and *Village in the Snow* (W 525). Each has been dated 1894 in Wildenstein's catalogue raisonné, most probably following Arsène Alex-

17. For a discussion of *Be in Love*, see Field in Philadelphia 1969, who interprets this print as being one of despair.

andre's undocumented suggestion that the paintings were taken with Gauguin from France to Tahiti in 1896.[18] Unfortunately, neither of the paintings is dated, and one, *Village in the Snow*, was found by Segalen in Gauguin's studio just after the painter's death in 1903. Following Segalen's romantic suggestions, this painting was considered for a short time to have been Gauguin's last work. Unfortunately, it is impossible here to discuss the difficult problem of the dating of these pictures, or to determine whether they were painted in Brittany during the summer and autumn of 1894 (when it did not snow), or whether they were painted from memory in Tahiti, in contradiction of Alexandre's claim. However, they do represent Brittany and thus may be said to form part of Gauguin's memory of that small Breton village, Pont-Aven.

While the smaller of the two prints is completely finished, illegible areas remain surrounding the central scene in the larger one. One can clearly read the ox cart, the male peasant, and the snow-covered roofs of the village, but the remaining area is blurred and indistinct. The irregularity of the block, obvious in most impressions, is also problematic, because the print was made in a signed and numbered edition. We are therefore forced to accept it on equal footing with the more fully realized members of this distinguished group.

Gauguin completely omitted the church tower of Pont-Aven that commands the valley in both paintings of the same scene to which the prints otherwise relate. In the smaller of the two prints, Gauguin has included the famous sculpture of the Calvary from the village of Nizon that he had first used in his *Green Christ* of 1889 (W 328). As in the painting, Gauguin enlarged the sculpture to epic proportions. In fact, it dominates the gentle landscape and sets this biblical event not in historical time but in nineteenth-century Brittany.[19]

Perhaps the clue to the meaning of these prints as well as of the paintings to which they so clearly relate lies in Gauguin's text, *L'Esprit moderne et le catholicisme*. This lengthy text was sketched out in 1896-1897, discussed as being finished in a letter to Monfreid from November 1897, bound in draft form into the section of the Louvre *Noa Noa* manuscript known as *Diverses choses*, and finally reinscribed by Gauguin in finished manuscript form and given its title in 1902. The period just after the completion of the draft manuscript coincides precisely with the carving and printing of the Vollard prints, and two of these, *Be in Love* and *Women, Animals, and Foliage*, were pasted in the inside covers of the bound manuscript.

The manuscript contains a lengthy, densely argued text that attempts to reconcile the gospels of the New Testament with the spirit of modern science. While the manuscript is anticlerical and anti-Catholic, it is anything but unChristian. In fact, Gauguin searches through the original religious texts of European culture for the meaning of life. Needless to say, Gauguin had to reconcile these gospel texts with his own diverse and extraordinary experiences as well as with a very rich knowledge of comparative religion. His ideas about religion can be related to those of Madame Blavatsky and other late-nineteenth-century theorists. However, unlike these other writers, Gauguin was obsessed by the power of images as carriers of ideas, and there is little doubt that the works of graphic art that he made during this period have as much to do with his own religious ideas as they do with independent theories of art or decoration. In many ways, these prints can be interpreted as visual equivalents of parables or fables, the most elementary modes of instruction, which, in Gauguin's understanding of Christian, Buddhist, Hindu, and Egyptian teaching, begin the process of enlightenment.

18. Alexandre 1930, 251-252.

19. See Kane 1966, 356 n. 12, who points out that the cattle are probably derived from an Egyptian fresco in the British Museum, London (Eighteenth Dynasty, from the Tomb of Nebamun at Thebes, cat. no. 37,976), which is from the same tomb as that in the photograph of the banquet scene (British Museum, London, cat. no. 37,984) that Gauguin owned (Dorival 1951, 120-121, now in the collection of Mme Joly-Segalen). The bulls in this print, *Breton Calvary*, *The Ox Cart*, and in the painting *Winter Landscape in Brittany* (W 519) resemble this fresco in terms of the stylization and the placement of the cattle in two rows.

20. A surviving trial proof of one (Gu 5) has the following annotation in Gauguin's own hand: "30 numerotés à 8f." This suggests either that Gauguin himself sought to sell them in Tahiti or that he indicated the price appropriate for individual sale to Monfreid and, thus, to Vollard. If one multiplies the total number of prints by 8 francs, the total is roughly the 4,000 francs demanded by Gauguin if the prints were to be sold individually.

Gauguin's desire for enlightenment is everywhere manifest in his writings and images, and, as further evidence for this, one can turn to the fourteenth and final print in the Vollard series, *Interior of a Hut* (cat. 245). This is the only print that is literally set at night and that relates directly to a painting from the first Tahitian period, *Te fare hymanee* (The House of Hymns, W 477). Yet the subject is the conquest of night by light and, perhaps, by religion. One sees the bamboo walls of a Tahitian house gleaming in the light of an unseen fire. In the foreground, one woman sleeps and another appears to be rising as she looks to a group of people in the background of the hut. We have no clear idea what they are doing, but the scene has a holy quality, like the Last Supper or the Birth of Christ. Is the burst of light in the midst of the figures the Tahitian birth of Christ? Is it a scene of immense consequence that occurs illegibly in the background of a print whose basic subject seems to be the two states of consciousness – dreaming and awakening? Unfortunately, we can never know, and Gauguin's texts of this period do little to make our task as interpreters any easier. One can say only that the sleeping woman in the foreground rests her head on a pillow of light into which Gauguin carved his initials. Whatever mystery he created was and is emphatically his.[20]–R.B.

232
Te atua

224 x 227 (8⅞ x 9)

woodcut printed in black, pasted down verso to recto on impression of first state printed in black and ocher on japan paper, laid down on wove paper

The Art Institute of Chicago. Gift of the Print and Drawing Club. 1945.93

CATALOGUES
Gu 60; K 53 B6

shown in Chicago only

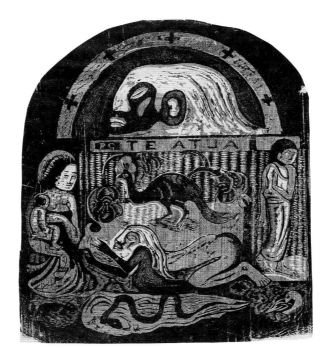

233
The Rape of Europa

240 x 230 (9½ x 9)

woodcut printed in black on japan paper numbered in pen and ink, 4

The Art Institute of Chicago. Gift of the Print and Drawing Club. 1949.934

CATALOGUES
Gu 65; K 47

shown in Chicago only

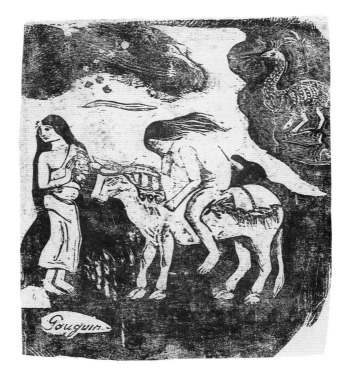

234
Buddha

295 x 222 (11⅝ x 8¾)

woodcut printed in black on japan paper

numbered in pen and ink, *1*

The Art Institute of Chicago. Print and Drawing Department Funds. 1947.687

CATALOGUES
Gu 63; K 45

shown in Chicago only

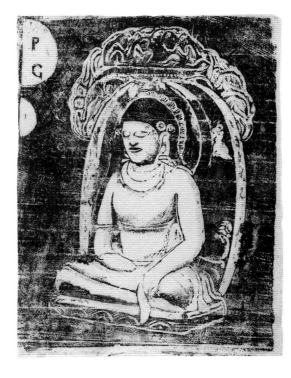

235
Eve

287 x 215 (11¼ x 8½)

woodcut printed in black on japan paper

numbered in pen and ink, *21*

The Art Institute of Chicago. The Frank Hubachek Collection. 1951.5

CATALOGUES
Gu 57; K 42 II

shown in Chicago only

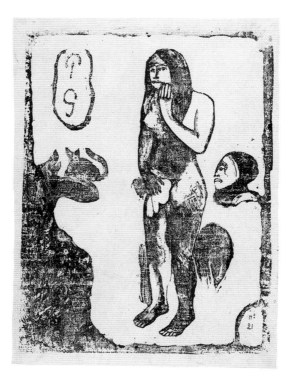

236
Te arii vahine

164 x 304 (6½ x 12)

woodcut printed in black on japan paper

numbered in graphite, *25*

The Art Institute of Chicago. Gift of the Print and Drawing Club. 1955.15

CATALOGUES
Gu 62; K 44A

shown in Chicago only

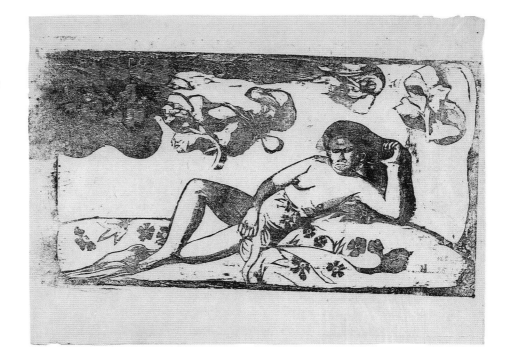

237
Women, Animals, and Foliage

163 x 305 (6⅜ x 12)

woodcut printed in black on japan paper

numbered in pen and ink, *29*

The Art Institute of Chicago. Gift of the Print and Drawing Club. 1949.933

CATALOGUES
Gu 59; K 43 II

shown in Chicago only

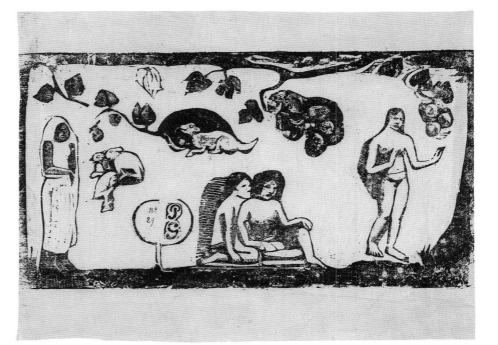

238
The Banana Carrier

162 x 287 (6⅜ x 11¼)

woodcut printed in black on japan paper

numbered in pen and ink, *7*

The Art Institute of Chicago. The William McCallin McKee Memorial Collection. 1954.1192

CATALOGUES
Gu 64; K 46

shown in Chicago only

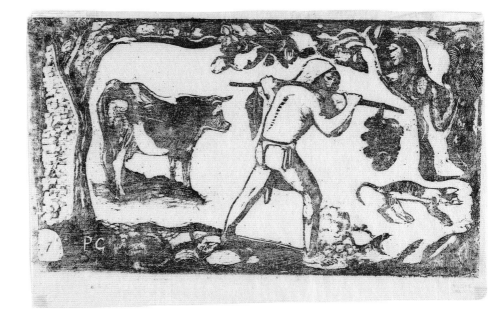

239
Plate with the Head of a Horned Devil

162 x 287 (6⅜ x 11¼)

woodcut printed in black on japan paper

The Art Institute of Chicago. Gift of the Print and Drawing Club. 1945.95

CATALOGUES
Gu 67; K 48

shown in Chicago only

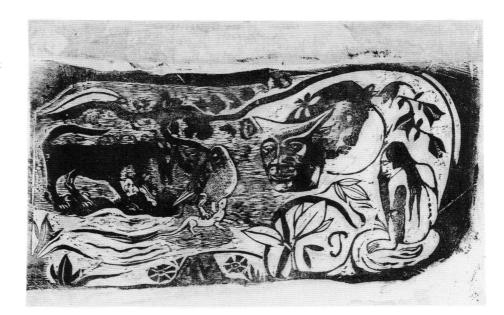

240
Change of Residence

163 x 305 (6⅜ x 12)

woodcut printed in black, pasted down on impression of first state printed in ocher

numbered in pen and ink, *21*

The Art Institute of Chicago. The Albert H. Wolf Memorial Collection. 1939.322

CATALOGUES
Gu 66; K 54 IIB

shown in Chicago only

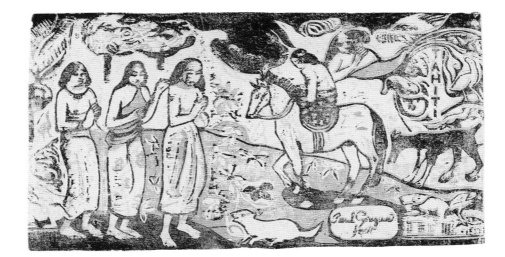

241
Soyez amoureuses, vous serez heureuses

162 x 275 (6⅜ x 10⅞)

woodcut printed in black, pasted down on first impression of first state printed in ocher on japan paper, laid down on wove paper

numbered in pen and ink, *20*

The Art Institute of Chicago. The Joseph Brooks Fair Collection. 1949.932

CATALOGUES
Gu 58; K 55 IIb

shown in Chicago only

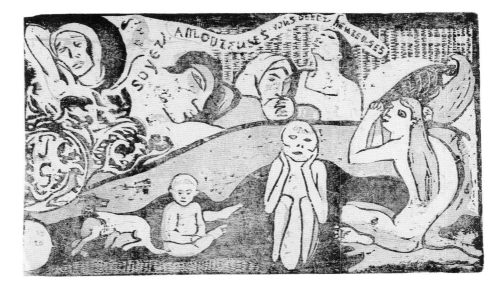

242
Breton Calvary

160 x 263 (6¼ x 10⅜)

woodcut printed in black on japan paper

numbered in pen and ink, *P/13*

The Art Institute of Chicago. Gift of Frank B. Hubachek. 1947.435

CATALOGUES
Gu 68; K 50

shown in Chicago only

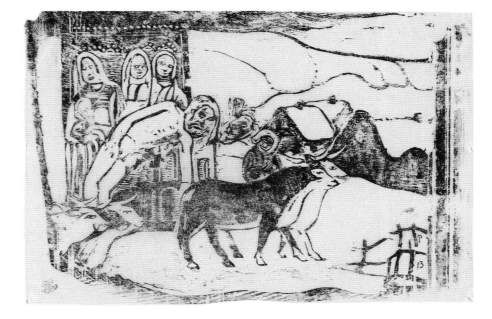

243
The Ox Cart

160 x 285 (6¼ x 11¼)

woodcut printed in black on japan paper

signed and numbered in pen and ink, *PGO/26*

The Art Institute of Chicago. Print and Drawing Department Funds. 1949.935

CATALOGUES
Gu 70; K 51

shown in Chicago only

244
Human Misery

194 x 295 (7⅝ x 11⅝)

woodcut printed in black on japan paper

numbered in graphite, *16*

The Art Institute of Chicago. Gift of Frank B. Hubachek. 1947.436

CATALOGUES
Gu 69; K 49

shown in Chicago only

245
Interior of a Hut

113 x 212 (4½ x 8⅜)

woodcut printed in black on japan paper

numbered in pen and ink, *7*

The Art Institute of Chicago. Gift of the Print and Drawing Club. 1950.1517

CATALOGUES
Gu 56; K 41

shown in Chicago only

232a Te atua

224 x 227 (8⅞ x 9)

woodcut, first state, printed in black on wove paper, mounted face down on an impression of the second state, printed in black on very thin japan paper

numbered 27 on the verso of the second state

National Gallery of Art, Washington, Rosenwald Collection, 1943.3.4608

CATALOGUES
Gu 60 and Gu 61; K 53 Bb

shown in Washington only

232b Te atua

224 x 227 (8⅞ x 9)

woodcut, second state, printed in black on thin japan paper laid over an impression of the first state, printed in black on wove paper

numbered in pen and ink, 11

National Gallery of Art, Washington, Rosenwald Collection, 1943.3.4609

CATALOGUES
Gu 60 and Gu 61; K 53 Ba

shown in Paris only

233a Woodblock, The Rape of Europa

240 x 230 (9½ x 9) irregular, uneven thickness

Museum of Fine Arts, Boston. Harriet Otis Cruft Fund 36.624

CATALOGUES
Gu 65; K 47

shown in Washington and Chicago only

233b The Rape of Europa

240 x 230 (9½ x 9)

woodcut printed in black on japan paper

numbered in pen and ink, 13

National Gallery of Art, Washington, Rosenwald Collection, 1950.16.65

CATALOGUES
Gu 65; K 47

shown in Washington and Paris only

234a Buddha

295 x 222 (11⅝ x 8¾)

woodcut printed in black on japan paper

numbered in pen and ink, 10

National Gallery of Art, Washington, Rosenwald Collection, 1950.16.62

CATALOGUES
Gu 63; K 45

shown in Washington only

235a Eve

287 x 215 (11¼ x 8½)

woodcut printed in black on japan paper

numbered in pen and ink, 18

National Gallery of Art, Washington, Rosenwald Collection, 1948.11.117

CATALOGUES
Gu 57; K 42 II

shown in Washington only

236a Te arii vahine

164 x 304 (6½ x 12)

woodcut printed in black on japan paper

numbered in pen and ink, 22

National Gallery of Art, Rosenwald Collection, 1948.11.119

CATALOGUES
Gu 62; K 44A

shown in Washington only

237a Women, Animals, and Foliage

163 x 305 (6⅜ x 12)

woodcut printed in black on japan paper

numbered in pen and ink, 9

National Gallery of Art, Rosenwald Collection, 1950.16.66

CATALOGUES
Gu 59; K 43 II

shown in Washington only

238a The Banana Carrier

162 x 287 (6⅜ x 11¼)

woodcut printed in black on japan paper

numbered in pen and ink, 25

National Gallery of Art, Washington, Rosenwald Collection, 1943.3.4607

CATALOGUES
Gu 64; K 46

shown in Washington only

239a Plate with the Head of a Horned Devil

162 x 287 (6⅜ x 11¼)

woodcut printed in black on japan paper

National Gallery of Art, Washington, Rosenwald Collection, 1950.16.70

CATALOGUES
Gu 67; K 48

shown in Washington only

240a Change of Residence

163 x 305 (6⅜ x 12)

woodcut printed in black, pasted down on impression of first state printed in ocher

numbered in pen and ink, 22

Lent by The Brooklyn Museum, 37.152

CATALOGUES
Gu 66; K 54 IIb

shown in Washington only

241a Soyez amoureuses, vous serez heureuses

162 x 275 (6⅜ x 10⅞)

woodcut printed in black, pasted down on impression of first state printed in ocher on japan paper, laid down on wove paper

numbered in pen and ink, *3*

National Gallery of Art, Washington, Rosenwald Collection, 1950.16.71

CATALOGUES
Gu 58; K 55 IIb

shown in Washington and Paris only

242a Breton Calvary

160 x 263 (6¼ x 10⅜)

woodcut printed in black on japan paper

numbered in pen and ink, *9*

National Gallery of Art, Washington, Rosenwald Collection, 1943.3.4605

CATALOGUES
Gu 68; K 50

shown in Washington and Paris only

243a The Ox Cart

160 x 285 (6¼ x 11¼)

woodcut printed in black on japan paper

numbered in pen and ink, *9*

National Gallery of Art, Washington, Rosenwald Collection, 1950.16.63

CATALOGUES
Gu 70; K 51

shown in Washington only

244a Human Misery

194 x 295 (7⅝ x 11⅝)

woodcut printed in black on japan paper

numbered in pen and ink, *9*

National Gallery of Art, Washington, Rosenwald Collection, 1943.3.4610

CATALOGUES
Gu 69; K 49

shown in Washington only

245a Interior of a Hut

113 x 212 (4½ x 8⅜)

woodcut printed in black on japan paper

numbered in pen and ink, *1*

National Gallery of Art, Washington, Rosenwald Collection, 1955.16.

CATALOGUES
Gu 56; K 41

shown in Washington only

246
Fan Decorated with Motifs from Mahana no atua

1900-1903

208 x 417 (8½ x 16½)

brush and gouache over preliminary drawing in graphite on wove paper

signed in composition at lower right, in brush and red gouache, *PGO*

Edward McCormick Blair

CATALOGUE
Gerstein 1978, no. 30

This well-preserved landscape drawing in the shape of a fan is among the most luminous, mythic landscapes made by Gauguin around 1900. Its gently undulating rhythms relate it to dated landscape paintings from 1899 and 1901. It could perhaps date from 1900, when his production of oil paintings halted and he worked mainly as a graphic artist and journalist. The landscape is presided over by an enormous stone deity, the goddess Hina, whom Gauguin represented many times after he read Moerenhout's *Voyage aux îles du grand océan* in 1892. Here, as in *Where Do We Come From? What Are We? Where Are We Going?* (W 561, see fig. on p. 391), Hina faces the viewer as if we, rather than the figures in the work of art, are her worshippers. The inclusion of the deity in this seemingly quotidian landscape indicates that Gauguin intended to represent the pre-colonial Polynesian past, though such idols probably never existed in Tahiti, and Gauguin had not yet visited the Marquesan Islands, where immense stone *tikis* could be found in relative profusion even at the turn of the century.

 The fan can be divided roughly into two parts. Its left side is crowned by the figure of Hina, and a lyre bird or perhaps a peacock inhabits the lower left portion. In other works by Gauguin from 1899-1900, a similar bird seems to symbolize Christ; here, the bird is located by the side of the reflective waters of a sacred river. Gauguin had begun to represent the waters of such a river with reds, purples, and oranges by 1892 (W 468 and cat. 155) and continued to use these colors for sacred waters throughout the decade. Hina's position in the illusionistic space described in the fan is unclear. In fact, she appears almost to float above the river, her hands placed at exactly the point at which the earth meets the sea.

 If the left half of the fan is sacred, the right seems utterly secular. The figure of Hina is balanced by the archetypal primitive hut set alone in the landscape. It sits near the sea at the foot of the great blue and purple mountains that rise to unseen heights above it. In the lower right corner, balancing the peacock, is

a horse and rider, similar, though not identical, to many of the riders in Gauguin's paintings from 1898 to his death in 1903. Its source can surely be found in the art of Degas, from whom Gauguin was to borrow several horses for his *Horsemen on the Beach* of 1902 (cat. 278). Its three-quarter angle rules out his other major sources for horse figures, the Parthenon frieze and Dürer's *Knight, Death, and the Devil* (see fig. at cat. 256). The rider, whose age and sex are ambiguous, moves away from the house and river, as if on a journey from home. The fact that the destination is unclear lends further mystery to this composition.

Like virtually all of Gauguin's fan compositions, this one was never mounted for use. Rather, the decorative shape of the European fan was simply used by Gauguin for its associations with leisure, warmth, and ease. The Blair fan is the last surviving composition in this format by Gauguin, who, in moving farther and farther from Europe, began to rely less and less on its fashions.—R.B.

247-251
Suite of Transfer Drawings

These five large transfer drawings belong to a group of ten identified by Richard Field as those sent by Gauguin to Vollard in the spring of 1900.[1] The sole evidence of this shipment is a letter from Gauguin to Monfreid dated March 1900, in which Gauguin wrote, "I am sending him 10 drawings this month, at the 40 francs that he is offering me *makes* 400 francs. In my response, I established 30 francs only as a reserve in which to put a few [drawings] of little importance but only if he accepts the agreement that I proposed to him in its entirety."[2] As always Gauguin's obsession with money and anxiety about being cheated were his chief concerns. Yet these works can be ranked among the masterpieces of graphic art.

Although Gauguin, who used words carefully, called these works "drawings," they are in fact indirect or transfer drawings, printed on the verso of — and reversed from — the actual drawing. Gauguin's later description of the process in a letter to his patron Gustave Fayet has often been quoted in the literature; this may be the revolutionary printing process that Gauguin hinted at in his letter to Monfreid of 27 January 1900.[3] Gauguin's method was to completely ink a sheet, place another sheet over it, and draw with pencil and crayon on the top sheet. The drawing is thus transferred to the verso of the drawn sheet through contact with the inked paper below. It seems clear that Gauguin did not intend to exhibit the drawing. Rather, the indirect or transfer drawing on the verso was the work of art.

Gauguin made the transfer drawings in the months immediately following the Vollard series of woodcuts. While the woodcuts are printed in editions, each transfer drawing is unique and most are of a monumental scale. Gauguin often used two overlapped sheets of paper for the inking, indicating that his supply of large sheets of paper was limited.

1. Philadelphia 1973, 28-31.

2. Joly-Segalen 1950, LXII.

3. Joly-Segalen 1950, LXI.

4. Loize archives.

5. Joly-Segalen 1950, letter from Vollard to Monfreid, 16 September 1901, 224.

6. For a complete exposition of the various uses to which Gauguin put this figure see Philadelphia 1973, 95.

7. H 74, 1513. F. W. H. Hollstein, *German Engravings, Etchings and Woodcuts ca. 1400-1700* (Amsterdam 1962), vol. 7, 68-69.

8. Amishai-Maisels 1985, 264-265.

9. Gu 71.

10. Letter to Fayet, March 1902, Joly-Segalen 1950, 203.

Vollard seems to have been less than enthralled with this shipment, as he did not list the ten transfer drawings in his receipt of works dated 17 October 1900[4] (in spite of the fact that he did receive them). He sent them to Monfreid in September 1901, along with a packet of woodcut prints.[5] However, the exhibition of Gauguin's late work at Vollard's gallery in November 1903 included twenty-seven drawings, most of which must have been transfer drawings. As with the fifty paintings exhibited, only the most generic of titles were used, making precise identification difficult. Some, if not all, of the ten printed drawings sent in 1900 probably were returned to Vollard and exhibited with titles such as *"Tahitians," "Family," "Bust of a Woman," "Study of a Nude,"* and *"Group of Women."*

Working from the generic titles, it is possible to reconstruct the exhibition with some degree of certainty. *The Nightmare*, cat. 251, was certainly included as *"no. 8, Eve"* or *"no. 5, Dream"*; *"Tahitians," "Tahitian Family,"* and *"Interior"* are probably cats. 247, 249, and 250. It is impossible to speculate about *"L'Espirit veille."*

The Nightmare features the violated Eve, whose figure derives from *Parau na te varua ino* (The Words of the Devil, cat. 147) of 1892 and from the woodcut *Eve* included in the Vollard series.[6] The woodcut translation has a starkness and clarity that is the opposite of Gauguin's slightly later printed drawing, dominated by the same figure. Where Eve stands virtually alone in a white field in the woodcut, she is placed to the side of a mysterious, dark realm filled with other important forms in the printed drawing. A hooded rider does not reappear until 1901, in a painting (W 527) and another printed drawing (cat. 277) with a *tupapau* on horseback. In the later works, the horse derives from Dürer's famous engraving *The Knight, Death, and the Devil.*[7] The source for the earlier works is probably classical. Other scholars have linked the horse to those on the Parthenon frieze,[8] of which Gauguin owned a photograph; yet the parallels do not show conclusively that the frieze was Gauguin's source.

The mysterious rider is the least of our problems in interpreting the background of the transfer drawing, for Gauguin included not only the traditional serpent (by which Eve has presumably already been tempted), but also a figure that at first seems to be a woman swimming in the waves. Her upraised arms, as well as her position with respect to the water, recall another bather in *Ondine* (cat. 80) that Gauguin had repeated in his woodcut, *Black Rocks*, of 1899-1900.[9] However, the almost frantic, open-handed gesture of the figure in *The Nightmare* is unique in Gauguin's oeuvre and therefore impossible to interpret by analogy. In the face of the work of art itself, one can only ask if the figure is indeed a woman, if she is a bather, and the purpose of her gesture.

The combined symbolic elements in this transfer drawing are baffling, making it difficult to understand why it came to be called *The Nightmare*. Images of innocence and guilt, fear and authority, form and formlessness, land and water, East and West coexist uneasily. The murkiness and ambiguity of the surface, too, add to our frustration. Not only did Gauguin use various tools, but he seems also to have washed the finished print with turpentine or another solvent to liquefy the penumbral areas around the guilty Eve. Gauguin himself called this technique of printed drawing "infantile" when he explained it to Fayet in 1902.[10] The oxidation of a metallic component in the dark ink has made the image even more mysterious then it was when it was printed in the first year of this century.

"Tahitians" (cat. 247) seems simpler. It represents two female Tahitians talking, one turned toward the viewer and the other apparently hanging from a

11. Field has erroneously related this transfer drawing to a lithograph by Delacroix (Delteil 1908, vol. 3, no. 95), *Tangier Woman Hanging Laundry*.

branch or vine. Perhaps because of the gesture of the latter figure, the print has been dubbed *Two Tahitians Gathering Fruit*. The fruit, clearly visible in the drawing, is barely evident in the final transfer drawing. The figure seems to reflect the stock pose of a paid model who held onto bars or moldings for the long periods of time necessary, while countless iconographic precedents exist for an image of fruit pickers, but none relate closely enough to this mysterious work of art to justify the use of the traditional title.[11]

The two Tahitian women are gloriously beautiful and of relatively decorous appearance. They exchange confidences in a paradise inaccessible to the viewer. Like other figures in the group of ten transfer drawings, they have no direct prototypes in Gauguin's other works. The poses and bare-shouldered costumes have only general prototypes in the paintings of 1899.

Tahitian Woman with Evil Spirit (cat. 248) is among the most powerful images in the group. Gauguin borrowed the upper body and head of the nude female figure from his earlier *Te arii vahine* of 1896 (cat. 237), but he partially dressed her. (Her face might even derive from a photograph of a Marquesan king and his wife that Gauguin possessed). The artist juxtaposed her upper body with the figure of a devil who seems possibly human, with a shoulder and a large hand. Yet the devil stares into space as if unaware of the presence of his beautiful, human companion. Perhaps because she gazes so forthrightly at the viewer, the juxtaposition of the beautiful, and clearly available, young woman and her otherworldly companion create an enigma.

Two of the largest and most beautiful prints from the series were part of the famous Fayet collection. *Nativity* (cat. 249), often erroneously entitled "*Tahitian Nativity*," was perhaps included in the Vollard exhibition as "*Family*." A young woman stares blankly at the viewer with white eyes. She holds a large baby, who clenches his small fist and moves impatiently on her lap. His obvious halo identifies him as Christ. A second older child seems to imitate Christ's gesture and looks intently at the preoccupied infant-God.

Gauguin's setting is a barnyard, the fence and the pair of cows borrowed from his painting, *Christmas Night* (W 519) of 1899-1900, and contemporary woodcut, *The Ox Cart* (cat. 244). These cattle, together with Mary's medieval headdress, make it difficult to call this nativity Tahitian. It seems, rather, to be a self-consciously primitive, transcultural image, partaking of both Brittany and Tahiti. The powerful, tubular arms of the Virgin must have appealed to the young Picasso, who was moved not only by traced drawings such as this, but also by the series of Nativities that followed it (cats. 260, 261, 262, 263).

Tahitians Ironing (cat. 250) must have been entitled "*Interior*" in Vollard's exhibition. It has a refreshingly simple genre quality when compared with the mythic and religious prints that dominated the 1900 shipment. Here two large Tahitian woman work together in an interior. The foreground figure wears a missionary dress and appears to be involved in a Western domestic activity, either sewing or ironing. Her companion holds what appears to be a large quilt or perhaps a bundle of laundry; she is bare-breasted and therefore native. Gauguin stressed the awkwardness of the seamstress or ironer's position as she works on the floor. With one leg stretched out and the other bent beneath her body, the figure is oddly imbalanced. The angularity of her pose rhymes with the architecture of the room. This figure derives from a drawing that Gauguin included in the portfolio *Documents Tahiti-1891/1892/1893*. In that drawing, the figure is precisely drawn and squared for transfer to the large traced drawing. Stylistically, the

smaller drawing could easily belong to the earliest group of figural studies made by Gauguin in Tahiti. Certain of these were used in the production of paintings and prints during the first trip, while others remained in the portfolio for later use. It is probable that Gauguin retrieved this earlier drawing, worked with it later to produce a small traced transfer drawing (F 39), and squared it for transfer to the larger surface of *Tahitians Ironing*. The latter steps took place in 1899 or 1900, but the figure may well have originated in the first months of Gauguin's earliest trip to Tahiti.

Because of their technique, all of these transfer drawings share the rugged, primitive quality of wall painting; certain accidents of surface remind one of the stains on the wall of a cave or the irregularities of a stucco wall. We must, in the end, accept the seemingly accidental and even messy aspects of these prints as intentional. Gauguin's aim was not to be inventive but, rather, to create images that would resound deeply through the history of art, reminding us of rubbings, cave paintings, and wall drawings. Because the late transfer drawings are virtual images, representing, as they do, the reaction of certain materials to the action of the artist, they possess the quality of tracings from lost original works or plans for incompleted projects just begun by the artist. We can sense the raw power that these indirect drawings must have exuded in Vollard's gallery in November 1903 when we witness their impact in Picasso's 1904 drawings.–R.B.

247
Two Tahitians Gathering Fruit

1899/1900

630 x 515 (24½ x 20)

recto, transfer drawing in black and ocher, on wove paper; verso, graphite and blue crayon pencil

signed in graphite at lower right, *P. Gauguin*

From the Collection of Mr. and Mrs. Paul Mellon, Upperville, Virginia

EXHIBITIONS
(?) Paris 1903, no. 10 or 14 as *Tahitiennes*; Paris 1906, no. 43 as *Deux Tahitiennes cueillant des fruits*; Philadelphia 1973, no. 64

CATALOGUE
F 64

shown in Washington and Chicago only

verso

248
Tahitian Woman with Evil Spirit

1899/1900

561 x 453 (21⅞ x 17⅝)

recto, transfer drawing in black and ocher, on wove paper; verso, graphite and blue crayon pencil

signed in graphite at lower right, *P. Gauguin*

Mr. h. c. Max Schmidheiny

EXHIBITIONS
Munich 1960, no. 124; Paris 1960, no. 139; Philadelphia 1973, no. 66

CATALOGUE
F 66

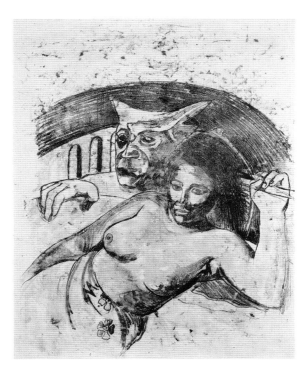

verso

249
Nativity

1899-1900

585 x 450 (22¾ x 17½)

transfer drawing in black and brown on wove paper

signed at lower right in graphite, *P. Gauguin*

Mlle Roseline Bacou

EXHIBITIONS
(?) Paris 1903, no. 4 as *Famille*; (?) Paris 1906, no. 36 as *Nativité*

CATALOGUE
F 68

shown in Paris only

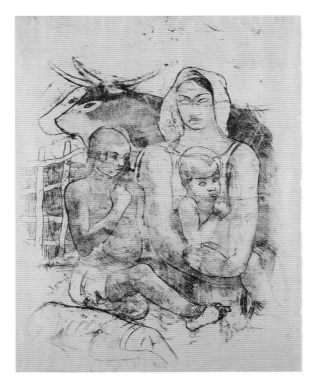

250
Tahitians Ironing

1899-1900

580 x 450 (22⅝ x 17½)

transfer drawing in black and brown, squared in graphite on wove paper

signed at lower right in graphite, *P. Gauguin*

Mlle Roseline Bacou

EXHIBITIONS
(?) Paris 1903, no. 7 as *Intérieur*; (?) Paris 1906, no. 49 as *Intérieur de case*

CATALOGUE
F 69

shown in Paris only

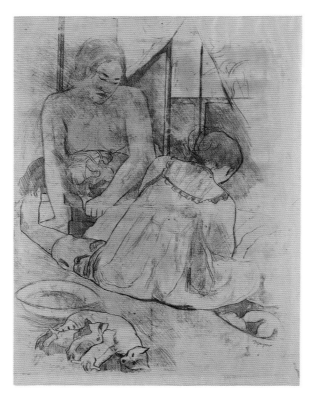

251
The Nightmare

1899/1900

584 x 430 (22¾ x 16¾)

recto, transfer drawing in black and ocher, on wove paper; verso, graphite and blue crayon pencil

signed at lower right in graphite, *P. Gauguin*

private collection

EXHIBITIONS
(?) Paris 1903, no. 5 as *Rêve* or no. 8 as *Eve*; (?) Paris 1906, no. 39 as *Eve*; Paris 1936, no. 121

CATALOGUE
F 70

shown in Washington and Chicago only

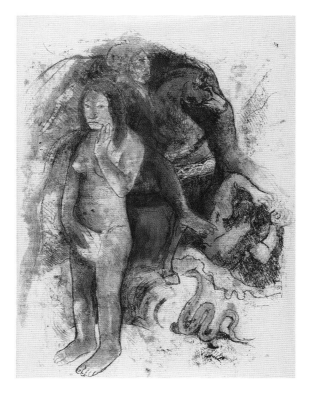

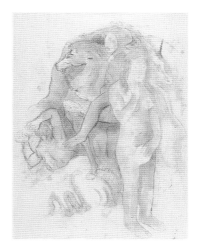

verso

252
The Departure

Detail of *Column of Trajan*

This is among the most impressive and important of Gauguin's late transfer drawings. Its scale, mystery, and economy of style separate it from many other late transfer drawings, most of which share linear character and intentional crudeness of contour. Here, the fluidity of line, graceful rhythm, and conciseness of the figural elements make this work virtually unique in Gauguin's corpus of late transfer drawings.

The related works do not help to explain either the subject or the date of this work. The title used here comes from the list of transfer drawings in the 1903 Vollard exhibition. Indeed, it is the only late transfer drawing that could be called by this title.[1]

The dominating figure of the man has both a clear art historical source in the figure of a soldier from Trajan's Column and a series of incarnations in Gauguin's own oeuvre. Gauguin's "first" use of the figure occurs in a painting now in the Pushkin Museum (W 537), signed and dated 1896. This painting is almost impossible to accept within the corpus of documented works from that year, in spite of the fact that the signature and date are both legible and apparently

The Departure

c. 1900

530 x 400 (20⅝ x 15⅝)

transfer drawing in black, squared in graphite on laid paper

signed in graphite lower right, *Paul Gauguin*

ex collection Gustave Fayet, Igny

EXHIBITIONS
Paris 1903, no. 18, *Le Départ*; Paris 1906, no. 38, *Le Départ*; Paris 1927, no. 49

CATALOGUE
F 105

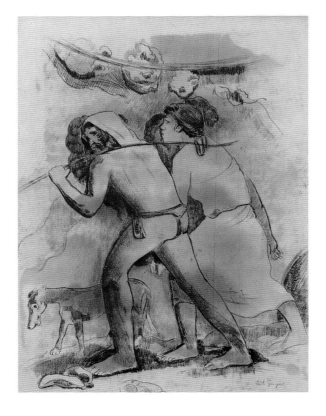

1. But there is no more evidence that Gauguin created those titles than there is that he intended the work to be called *Adam and Eve*. See Philadelphia 1973, no. 105.

autograph. All of the figures included in it relate to later prints, transfer drawings, and paintings, and even the stylistic evidence points to a date in the last years of the decade or even later. Unfortunately, we have no persuasive documentary evidence to corroborate the earlier date, and the painting does not seem to have been included in a Gauguin exhibition until 1926. The figure appears again in *The Banana Carrier* (cat. 236) of 1898-1899 as well as in *War and Peace* (G 127) of 1901 and one of the untitled transfer drawings in *Avant et après* of 1903. In no other case is this figure similar enough to prove that a transfer was made, in spite of the fact that the transfer drawing was squared for transfer by Gauguin.

This figure is shown in every other representation carrying something – an ax or some bananas. Here he holds a stick that repeats the curve of a branch above the figures. The female figure, also derived from a male soldier on Trajan's Column, does not reappear in Gauguin's oeuvre. With their companion dog, the two figures seem to stride purposefully toward a destination we can only guess. The head of the male figure is covered with a hood and his face is deeply shadowed, and the female figure looks slightly upward in a manner that is focused. Like many of Gauguin's late works, this one could easily be titled *Where Do We Come From?, What Are We?,* or *Where Are We Going?*–R.B.

253
Still Life with Sunflowers on an Armchair

1901

73 x 91 (28½ x 35½)

oil on canvas

signed and dated at lower right, *Paul Gauguin 1901*

State Hermitage Museum, Leningrad

EXHIBITIONS
(?) Paris 1903, *Nature morte*; Moscow 1926, no. 27; Tokyo 1987, no. 141

CATALOGUE
W 603

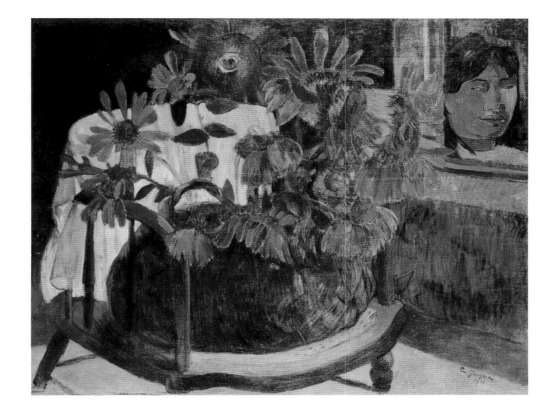

1. W 602.

2. Joly-Segalen 1950, XLVII, 131.

3. The earliest surviving example is an 1880 still life exhibited in the sixth impressionist exhibition and entitled *Pour faire un bouquet* (W 49).

Gauguin painted two variants of this mysterious still life before he left Tahiti for the Marquesan Islands in September of 1901.[1] In October 1898, Gauguin had written to Monfreid for sunflower seeds, and he celebrated his most spectacular harvest more than a year later by painting four still lifes dominated by these supremely French flowers grown in exile.[2] Gauguin's letter from Tahiti requesting the sunflower seeds was written almost exactly ten years after his arrival in Arles, when he first saw van Gogh's paintings of sunflowers.

The Hermitage still life is markedly, indeed deliberately different from van Gogh's paintings. Indeed, one could almost say that Gauguin wanted to make a still life using sunflowers that was the opposite of those by his former colleague. Whereas van Gogh's paintings are light, bright, and vertical, Gauguin's are dark, brooding, and horizontal. Van Gogh's flowers burst forth from a ceramic pot sitting on a table; Gauguin's are placed loosely in a basket that rests not on a table, but in an armchair. This latter "antidevice," the alternative to the table, was developed by Gauguin early in his career and used with some frequency.[3] Few other modern artists adopted the strategy, which is, like much else in Gauguin's oeuvre, a contrary one. Just as Cézanne defied the conventions of still-life painting and the laws of pictorial gravity by suggesting that his fruits could tumble forth from the table, so Gauguin broke the most absolute convention of still-life painting, the tabletop. By doing so, he altered the physical relationship between the viewer and the objects in the still life by placing them in their own space rather than on display for the viewer.

The elements of this still life present themselves less for our delectation than for analysis. The white cloth is folded over the back of the resolutely colonial chair as if to dry in the breeze. The basket is of humble, local origin and is placed

Redon, *The Eye as a Bizarre Balloon*, plate I from *To Edgar Poe*, 1882, lithograph [The Art Institute of Chicago, Stickney Collection]

on the finely woven rush caning of the imported chair. Several of the flowers droop from the heat and lack of water, and they turn in various directions as if looking for help. The most spectacular of them is the "eye-flower" that presides over the darkened part of the room behind the chair. It adds another artificial element to this arrangement. The all-seeing eye that emerges from the darkness is, in a sense, the opposite of the sunflowers, the very existence of which is determined by the sun. By placing the sunflowers in a darkened interior, Gauguin has deprived them of their most important source of power.

The final element in the painting is the head of a Tahitian woman framed in the window. There is clearly an element of ambiguity in this figure. She stands against a green background with no clear landscape depth, giving the quality of a framed painting within the painting; yet, Gauguin's clear delineation of the windowsill and the wooden elements of the window makes it clear that she is both real and out-of-doors. The head itself is typical of Gauguin's broad-faced Polynesian females, but has less grace and beauty than many other heads from the last years in Tahiti. The slit eyes of the figure look out of the picture. She is at once strongly asserted and inaccessible to the viewer, both real and illusory.

Like many of Gauguin's late paintings, this one grapples with a collision of cultures. Here European sunflowers and furniture vie for dominance with the Polynesian basket and figure. And the "natural" sunflowers of van Gogh are presided over by the "artificial" all-seeing eye of Redon. The entire still life is apparently rejected by the native woman, who looks away from the "subject" of the painting that commands our attention. This creates a tension between the European viewer of the painting and the indigenous population of Polynesia.–R.B.

254
Still Life with Sunflowers and Mangoes

There is certain evidence that Gauguin painted floral still lifes at the behest of his dealer Vollard, and that he did so reluctantly. His letter to Vollard of January 1900 devoted two paragraphs to the subject, making clear his annoyance. "You mention flower paintings. I really don't know which ones you mean, despite the small number that I have done, and that is because (as you have doubtlessly perceived) that I am not a painter who copies nature—today less than before. With me everything happens in my crazy imagination and when I tire of painting figures (my preference) I begin a still life and finish it without any model. Besides this is not really the land of flowers. And you add (which seems to be contradictory), that you will take everything I paint. I would like to understand. Do you mean only flowers, or figures and landscapes as well?"[1]

In spite of his reluctance, the results were spectacular, and one is grateful to Vollard for insisting that Gauguin paint floral still lifes. Of those that survive, the very best date from 1901, and, of these, four represent sunflowers. This particular still life, which has been called Gauguin's masterpiece in the genre by Douglas Cooper,[2] is perhaps the closest in construction and composition to the great series of sunflowers made by van Gogh as decoration for the Yellow Studio in 1888. There is little doubt that Gauguin's painting and its three horizontal companions were made in homage to van Gogh a decade after the Dutch painter's tragic suicide.

1. Rewald 1943, 32.

2. Cooper, in Edinburgh 1955, 35.

1901

93 x 73 (36¼ x 28½)

oil on canvas

signed and dated at lower left, *Paul Gauguin/1901*

private collection, Lausanne, Switzerland

EXHIBITIONS
(?) Paris 1903, *Fleurs*; Edinburgh 1955, no. 61

CATALOGUE
W 606

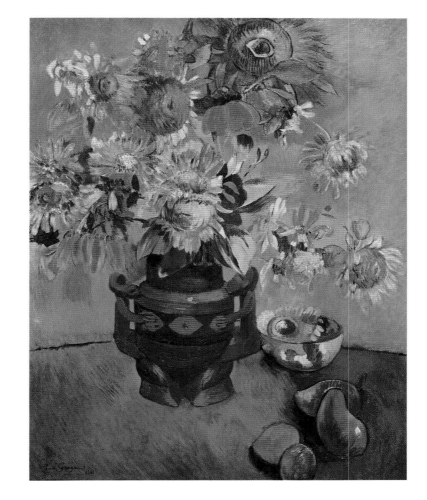

3. Cooper, in Edinburgh 1955, no. 61.

4. Barrow 1979, 42-46.

5. G 140.

6. Teilhet-Fisk 1975, 331-332.

Gauguin arranged the sunflowers in a carved wooden vessel. Curiously, this object has never been discussed in the literature devoted to the artist's own ceramics and wood carvings, suggesting by its very absence that this carved vessel is not considered to have been made by Gauguin. Yet, evidence that it was a native vessel is equally scanty. Although the best short entry on the painting[3] refers to it as "the negro vase with primitive carvings," it is surely not African. The closest parallels can be found in the art of Tahiti, where crouching wooden figures with enlarged heads and protruding jaws can be found in many forms.[4] However, none of these have been found on cylindrical vessels, and the basic form of the object in Gauguin's still life is European in spite of the Polynesian figures carved on it. There are even certain affinities of form between the vessel and a wooden jar carved in the South Seas by Gauguin himself.[5] Teilhet-Fisk related the two figure-handles of the bowl of the vessel to the figures on the carved cradle in *Te rerioa* (cat. 223).[6]

Whatever the origins of the vessel, its function in the still life is to symbolize the exotic world into which Gauguin, the transplanted European, introduced the sunflowers of France. The blossoms fill the upper half of the composition. At the very top of the picture is the "eye-flower" of Gauguin's friend Redon that he had used in two of his horizontal still lifes with sunflowers of the same year (cat. 253, W 602). Here the eye-flower is given a stem, and thus it becomes an integral part of the bouquet rather than an intrusion from the realm of the painter's imagination.

The metal bowl in the lower half of the composition appeared in another still life of the same year (W 607), and Gauguin also frequently used the common

mango in his Tahitian and Marquesan still lifes. This is perhaps because mangoes have variable shapes as well as variable colors. Unfortunately, we know very little about the early history of this picture. It may have been one of the four canvases called simply *Fleurs* in the 1903 Vollard exhibition, but there is no evidence of its inclusion in any other important Gauguin exhibition before 1955.–R.B.

255
Still Life with Grapefruits

1901

66 x 76 (25¾ x 29⅝)

oil on canvas

signed and dated at lower left, *Paul Gauguin 01* (?)

private collection, Lausanne, Switzerland

EXHIBITION
(?) Paris 1903, as *Nature morte*; Chicago 1959, no. 35

CATALOGUE
W 631

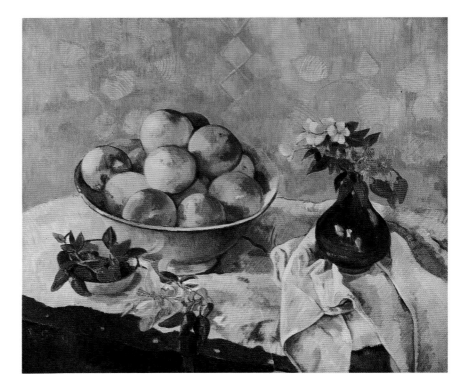

This superb late still life has been given various titles and dates. The fruits in the large bowl are surely the grapefruits that grow in abundance in Tahiti. The date of the painting has never been clearly deciphered. The catalogue raisonné omitted reference to the remnants of a date near the signature at the lower right, but related it to the dated still lifes of 1902. Another writer has suggested that it was painted in 1891![1]

It seems most likely that the painting was made in Tahiti in 1901. The same leather-covered steamer trunk on which Gauguin arranged the fruit appears even more clearly in an undated floral still life probably painted in 1899 (W 594). Gauguin had received seeds for European flowers and vegetables from Monfreid that year and reported that he would paint "flower studies" in April.[2] Yet, surely, he would have had the same trunk in 1901, when he painted the closely related and identical-size *Still Life with Knife* (W 607). The abraded portions of the date that do survive on this picture seem to read "01" or "02," and the fact that Gauguin painted most of his late still lifes in 1901 and stylistic evidence support the earlier date.

1. Chicago 1959, no. 35.

2. Joly-Segalen 1950, LII.

Gauguin's principal aesthetic debt in *Still Life with Grapefruits* was to Cézanne. The fruits are painted with a rigor and clarity of form that derives from the Provençal painter's still lifes of the 1870s, of which Gauguin had owned at least one (see fig. at cat. 111), and even the glorious wallpaper in the Gauguin is analogous to the patterned papers that one finds so often in the active backgrounds of Cézanne's still life paintings of the 1870s and 1880s. Yet, Gauguin's relationship to his source was far from a subservient one. Gauguin made a still life that is at once an homage to Cézanne and a subversion of its prototypes. The wallpaper is rendered in a color that is almost an exact opposite of Cézanne's blue. And Cézanne's famous red apples, about which so much has been written since his death, become grapefruit. Even the other minor elements of Gauguin's still life—the hot peppers, the orchids, and the fragrant frangipani flowers—are consciously exotic in contrast to the quotidian elements of Cézanne's still-life. All that remains inviolate is the tablecloth that both painters refused to paint white. However, Gauguin's shades of white are more exaggerated than Cézanne's subtleties.

For all the force of his "opposition" to Cézanne, Gauguin's *Still Life with Grapefruits* has an undeniably classical presence. The balances between fruit and flowers, black and white vessels, taste and smell, warm and cool colors, volume and void are carefully sought, and all the elements of the picture fit perfectly together as if to achieve absolute clarity.–R.B.

256
Riders

1. Bodelsen 1966, 38.

2. Kane 1966, 361.

3. Gauguin asked Schuffenecker for a photograph of this painting, *Naufrage de Don Juan*, which entered the Louvre in 1883, in his letter of 24 May 1885. Malingue 1949, XXII.

This painting has the quality of an illustration to a lost mythic tale. The picture has been persistently given two titles, *The Flight* and *The Ford*, neither of which is original. However, one was given to it in the great 1906 Gauguin exhibition at the Salon d'Automne in Paris. Bodelsen has convincingly argued that the painting was exhibited as *The Ford*, but no scholar has questioned the validity of either title.[1] It seems more than likely that this painting was first exhibited at Vollard's 1903 Gauguin exhibition simply as *The Riders* and that the various attempts by modern scholars to interpret the picture using one or both of the early titles are misguided.

Great progress has been made in interpreting the painting, mostly through the identification of its sources. Kane, in his seminal article of 1966, connected the head of the white horse as well as the dog running beneath the feet of the brown horse to Dürer's famous etching, *Knight, Death, and the Devil*, of which Gauguin owned a reproduction. Kane also related the pose of the male rider to that of a standing figure in the Parthenon frieze. With these sources in mind, Kane and most subsequent interpreters of the painting conclude that the hooded figure is a transformation of the western image of death on a pale horse into a Polynesian devil or *tupapau*, the "spirit of the dead" who leads a young man across a stream into the land beyond death.[2] Only Field refused to identify the hooded figure as a *tupapau*, relating her instead to one of the figures in Delacroix's *Shipwreck of Don Juan*, of which the painter also owned a reproduction.[3] Reading such a painting as a Westernized Polynesian myth, it has been easy for Gauguin's interpreters to explain the painting as a manifestation of the artist's own fears of or preoccupation with his own death. While there is little doubt from the painter's correspondence

1901

73 x 92 (28½ x 35⅞)

oil on canvas

signed and dated at lower right, *Paul Gauguin/1901*

Pushkin State Museum of Fine Arts, Moscow

EXHIBITIONS
Paris 1903, no. 34, *Cavaliers*; (?) Weimar 1905, no. 19 or no. 27, *Die Flucht*, or no. 20, *Die Furt*; Paris 1906, no. 20 *La Fuite* or no. 22 *La Gué*; Moscow 1926, no. 28; Tokyo 1987, no. 138

CATALOGUE
W 597

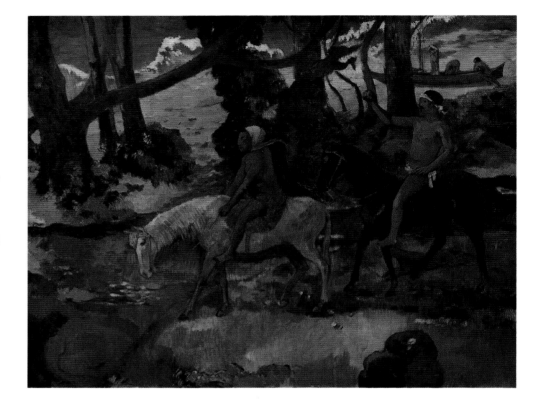

that he was in poor health throughout the early years of this century and that he suffered a good deal, there is no evidence that a preoccupation with death dominated his thoughts. Much of the painter's behavior was as life-affirming as morbid. This brilliantly colored painting of a mythic journey into death is one of many works devoted to that great theme made throughout Gauguin's life.

Riders is only one of several images of men on horses painted by Gauguin in the last three years of his life. There were four paintings with "cavalier" in their titles in the 1903 exhibition. Virtually all of these have resonance in Western art, and the sources vary from the Parthenon through Dürer to Degas. Gauguin might also have remembered the two wonderful sets of woodblock prints illustrating poems about horsemen published in *L'Ymagier* in 1894 and 1895.[4] Yet horses abounded on the Marquesan Islands. Gauguin himself owned a horse and a horse trap in Atuona,[5] and seeing them every day must surely account for their sudden dominance in his art.—R.B.

4. "Les Cavaliers," *L'Ymagier* 1 (October 1894), 57-61; 2 (January 1895), 95-101.

5. *Bulletin de la société des études Océaniennes* (1957), 695, nos. 20 and 21.

Dürer, *Knight, Death, and the Devil*, 1513, engraving. A reproduction of this print was glued to the back cover of *Avant et après*, 1903 [The Art Institute of Chicago, The Robert Walker Fund]

L'Ymagier, October 1894, page 57

257a-d, 258, 259
Sculpture from the House of Pleasure

1902

lintel 242.5 x 39 (94½ x 15¼)

redwood, carved and painted

inscribed, *MAISON DU JOUIR*

right jamb 159 x 40 (62 x 15⅝)

left jamb 200 x 39.5 (78 x 15⅜)

right base 205 x 40 (80 x 15⅝)

inscribed, *SOYEZ aMOUREUSES ET VOUS SEREZ hEUREUSES*

Musée d'Orsay, Paris

EXHIBITIONS
Paris 1928, no. 24; Paris 1938, no. 172; Paris, Kléber 1949, no. 55; New York 1984

CATALOGUE
G 132

1. Segalen 1904, 679-685.

2. Le Bronnec 1954, 198-211.

3. Danielsson 1975, 250-254.

4. Le Bronnec 1954, 209.

Gauguin's last house in the town of Atuona on the Marquesan island of Hivaoa was his most complex decorative ensemble. His dwellings from the first Tahitian voyage were simple, and his earliest Polynesian environment was constructed not in the South Seas, but in Paris. The two houses that he inhabited in Tahiti during his second stay were elaborate and important, but neither of them compares with what he built in Atuona.

We know both a great deal and too little about this house. Several attempts have been made to create a visual reconstruction, but these are all based on scanty primary evidence. The earliest account of the house was published by Victor Segalen in 1904 after a visit.[1] More facts about the house were gathered in a survey of Gauguin's surviving friends made by an inhabitant of Atuona years after his death and published in 1954.[2] These together with Gauguin's own brief description in a letter to Monfreid are the best evidence for the recent reconstruction by Danielsson.[3]

The two-story house had public spaces—a kitchen, an outdoor dining space, a workroom for making sculpture, and possibly a covered area for his horse trap—on the ground floor that were accessible to all visitors. They were defined by wooden columns, with certain spaces between them filled in with bamboo and others open to the breezes, and had earthen floors. One had to climb up to enter Gauguin's private realm, the bedroom and studio that were open only to Gauguin's friends and intimate acquaintances. It is surely not accidental that one entered Gauguin's "House of Pleasure," his studio, only through the small room dominated by his great bed. Witnesses report that he covered the walls of his bedroom with pornography.[4] Access was gained through the carved door frame reproduced here.

The work of art that figured most prominently in Segalen's description was this magnificent surround that led to Gauguin's second-story bedroom and studio. Unfortunately, the precision of Segalen's description owes more to the fact that he bought most of it in Gauguin's death sale than from his experience of the house. Segalen made clear that the carved decoration was on the outside of the house surrounding the door to the bedroom. Segalen also brought other decorative material from the house back to Paris, but there is little doubt that the carved door frame was the major element in Gauguin's last total work of art.

left base 153 x 40 (59⅝ x 15⅝)

redwood, carved and painted

inscribed, *SOYEZ MYSTERIEUSES*

private collection on loan to the Musée Gauguin, Tahiti

EXHIBITIONS
Paris 1906, no. 173, *Un bois sculpté "soyez heureuses"*; Paris 1917, no. 19; Paris 1923, no. 58; Paris 1928, no. 10; Paris 1936, no. 46; Basel 1949, no. 71

CATALOGUE
G 132

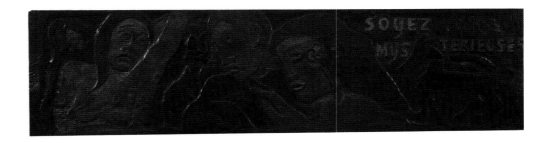

Neither Segalen nor any other commentators mentioned a door itself, but the fact that there is space for its latch indicates that there was one, and it, too, must have formed part of this ceremonial entry. "House of Pleasure" was carved in large letters into the panel above the door. Gauguin's favorite moralisms "Be mysterious" and "Be in love and you will be happy" were carved into the lowest panels in smaller letters, all easily readable from the ground. The imagery of the doorframe itself is derived from Gauguin's paintings of the second Tahitian trip, and most of the relevant motifs can be found in the last suite of crudely carved woodblock prints made before Gauguin left Tahiti for the Marquesas.

Gauguin divided the images brilliantly. The lower two panels are dominated by a series of heads, torsos, animals, and words, most of which overlap to form a series of illusionary objects in the shallow relief space. The heads all derive from paintings dated 1902 and represent figures in motion. The two vertical panels on either side are dominated by two standing female nudes. The pose of neither is directly from a painting, and they have the naive charm of real women rather than the mythic symbolic power associated with Gauguin's Eve, Diana, Vairumati,

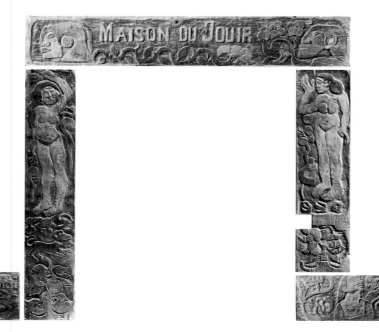

Reconstruction of the door frame of The House of Pleasure

Europa, or Mary. Above them, in the highest panel, are two profile heads that relate to those of Taaroa, the ancient Polynesian god who surmounted the framing elements in the title print for the Vollard series of woodcuts, *Te atua* (The God, cat. 232). Here too is the peacock that joined the figure of Taaroa in the same print.

These figures are surrounded by a paradisiacal jungle of vines and leaves that fills the unfigured space. There is balance between words and images, between gods and men, between animal and vegetable. The doorway eschews the convoluted iconography that fills the prints and paintings. There are no overt quotations from Western works of art, nor are there figures with strongly religious and mystical associations. Yet, the figures have a rawness and power that separates

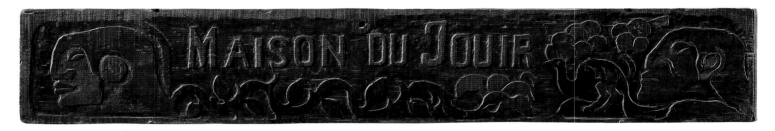

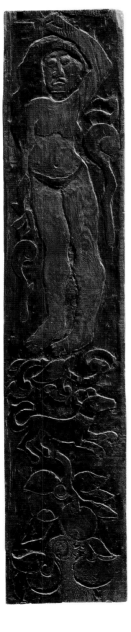

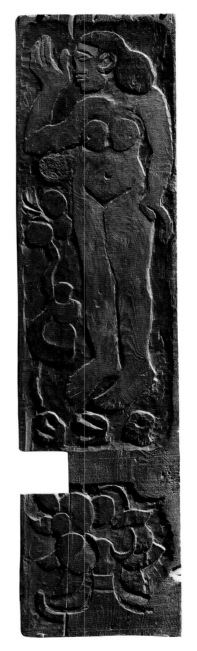

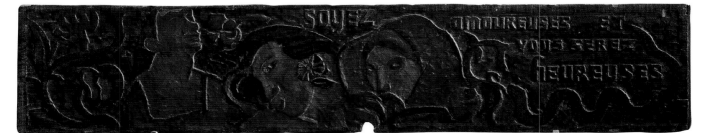

House of Diane de Poitiers, Rouen

House on rue des Arpents, Rouen

5. From Le Bronnec 1954, 200, we also know that the thirty-nine-foot-long studio was lit by six large windows.

6. Jacquier 1957, 673-711.

7. Jacquier 1957, 695.

8. Jacquier 1957, 696.

them from the refined carvings that Gauguin made for others. How wonderful they must have looked as one climbed the ladder, surrounded by woven panels and a great peaked gable.[5] In certain ways they hark back to the carved decoration found on many French Renaissance houses, whether the elaborate stone carvings of Parisian *hôtels* or the naive wooden figures so common in the half-timber dwellings of Rouen and other Norman towns.

The inventory of Gauguin's house made just after his death[6] lists virtually every object in it, some of which were sent to Tahiti for auction while others remained on the island. Local history tells us that the house was bought by the American merchant, Varney, that he sold certain parts of it locally, and subsequently tore it down. The house itself is listed as Lot 20 and described as "Wooden house, bamboo, covered with coconut leaves."[7] Aside from the usual supply of spoons, dishes, suitcases, umbrellas, and other paraphernalia of daily life, the inventory lists tantalizing objects such as photographs, thirteen manuscripts (only five of which survive), twelve notebooks, books, and musical instruments including a harmonium, a harp, a guitar, and a mandolin. There was furniture, but only the bed was described to suggest that it was carved by Gauguin.

The inventory lists other carved material, and, when one recalls the ground-floor studio for wood sculpture, the importance of Gauguin's activities as a decorative sculptor in the Marquesas becomes evident. Canes, a gilded tiki, two stone tikis, nine carved spoons, five wood sculptures, three wax sculptures, a carved letter opener, and several pieces of wooden jewelry make it clear that Gauguin carved as extensively as he painted. In addition, the wording of Lot 61 indicates that he pasted impressions of his woodcuts directly onto interior walls so that these printed carvings exist in the same decorative environment as the carvings themselves.[8]

As for serious sculpture, very little survives. *Father Lechery* was carved by Gauguin as a public joke about the local bishop Martin, who had condemned Gauguin's sexual dalliances while philandering himself as well. Gauguin placed this figure and one of a woman, *Thérèse*, in front of his house in Atuona, where they served as a permanent reminder of the hypocrisy of the church in matters sexual. Yet, it would be a mistake to allow this charming story to act as an explanation of these two late sculptures. Both of the figures are carefully carved and project a hieratic intensity. Their quality of form transcends the trivial joke that caused their creation.

Gauguin's final work of art is all but completely lost, and these small fragments from it are scarcely more evocative of the whole than is a doorjamb or a corbel figure from a Gothic cathedral. Although the environment from which they came was perishable, the ambitions of its maker were no less complex and no less mythic than were those of the architects of Chartres.–R.B.

259
Father Lechery

height 65 (25⅜)

miro wood (Thespia populnea)

signed, *PGO*; inscribed, *PERE PAILLARD*

National Gallery of Art, Washington.
Chester Dale Collection

EXHIBITIONS
Paris 1910; Paris 1917, no. 23; Paris 1923,
no. 59; Paris 1928, no. 22; New York 1956,
no. 102; Chicago 1959, no. 124

CATALOGUE
G 136

Gauguin, *Noa Noa*, page 56 [Musée du
Louvre, Paris, Départment des Arts
Graphiques]

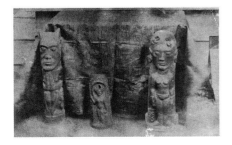

Père Paillard (*Father Lechery*), *Cylinder with
Two Figures*, and *Thérèse*, c. 1903, photo-
graph [Musée Gauguin, Papeari, Tahiti]

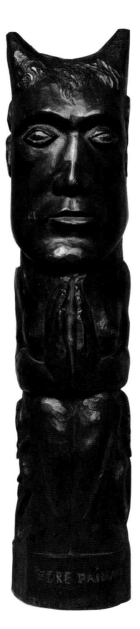

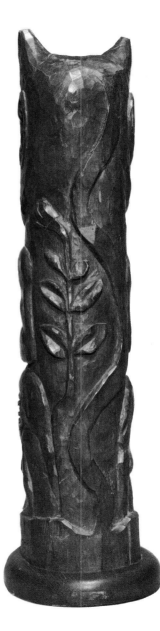

260-263
Four Transfer Drawings of Religious Fantasies

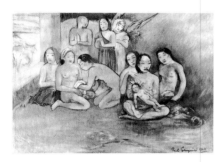

Gauguin, *Nativity*, 1902, oil on canvas [private collection; photo: Courtesy of Wildenstein & Co.]

1. Louvre, ms.

2. Paris 1903, no. 28 or no. 47; W 621.

3. Paris 1903, nos. 17, 18.

4. Amishai-Maisels 1985, 72-121.

5. His treatment both of "Mary" and of "Christ" is complex, and each is given various identities that derive from different pre-Christian sources. His text succeeds in situating the supernatural birth of God as man in a cave, rather than the "traditional" stable and evokes at various points both divine witnesses and human attendants to the scene.

In 1902, Gauguin painted a small canvas of the *Nativity* (W 621), finished the copying and assembly of his important manuscript, *L'Esprit moderne et le catholicisme*, and made at least five transfer drawings related to the *Nativity*. He pasted two of these on the front and back covers of the manuscript. All of these endeavors must be considered in terms of his fascination with comparative religion and his theories about sexuality, prostitution, and family life. The treatise on religion was probably intended to have been 'paired' with a text on human sexuality, draft passages of which exist in *Diverses choses*[1] and at the Getty Center for Art Historical Research. Together these texts would have comprised a "metatheory" larger in scope and intellectual ambition than the writings of any artist since the Renaissance.

We know that the 1902 painting of the *Nativity* was included, with that title, in the Vollard exhibition of 1903.[2] Perhaps because of its overtly christological subject and its small size, it was overlooked by contemporary critics and has always been considered peripheral to Gauguin studies. None of the transfer drawings of the same subject is mentioned by title in the 1903 exhibition catalogue, but the largest of the so-called Nativity transfer drawings may have been exhibited as *Group of Women*, another of the transfer drawings might have been *Women and Children*.[3] Gauguin's manuscript *L'Esprit moderne et le catholicisme* was unknown in 1903, and few of his contemporaries had worked their way through the dense arguments of the draft bound into *Diverses choses*. Therefore, the vaunting intellectual background of this small series of images was lost, and though the group has been recognized, it has been rarely discussed in the terms that Gauguin himself set forth clearly.

Gauguin was deeply informed on the subject of Christianity. Not only had he read and reread the Old and New Testaments, but he was also an avid reader of texts about comparative religion. In the fashion of many intellectuals of the time, he was fond of comparing religious philosophies not only with each other, but with prevailing European dogmas of science and economics. He was passionately interested in the life of Christ, which, as he knew, had been "predicted" in various other religious texts and had, in its turn, produced a brilliant body of literary work. Yet unlike other religious painters of the period, he was not only anticlerical but a foe of the Catholic Church itself. In fact, his criticism of Catholicism, the religion of his childhood, was as thorough and relentless as were his better-known antibourgeois ideas about free love.

How, given this fascination with Christ, did Gauguin represent the birth of the Savior? We know that Gauguin identified himself with Christ at many points in his own earlier art,[4] and we also know that his own study of the christological myths became increasingly sophisticated as he prepared his treatise on religion in 1897 and 1898. Gauguin's writings on the birth of Christ are so extensive that they cannot be adequately summarized here. Nor have they ever been clearly linked to the several images of the Nativity that can be related to them.

Gauguin's writings make clear his belief that the birth of Christ was a supernatural and not a historical event. Gauguin "proved" that the birth of Christ had not only been foretold in various texts, but that its manifestations were by no means exclusively "Christian."[5] The total impression given by his many passages about the Nativity is that of a complex phenomenon existing outside of time. Surely this "event" is the subject of the last great series of Nativities.

The painting, *Nativity*, is set in a dark, reddish brown cave with an opening that reveals a landscape with a cow, the symbol of Christ, derived, like most of

260
Women and Angels in a Studio

1902

530 x 480 (20⅝ x 18¾)

transfer drawing on wove paper

signed at lower right, *P. Gauguin*

Monsieur Marcel LeJeune

CATALOGUE
F 81

EXHIBITIONS
(?) Paris 1903, no. 17, *Groupe de femmes;*
Paris 1936, no. 120

shown in Washington and Chicago only

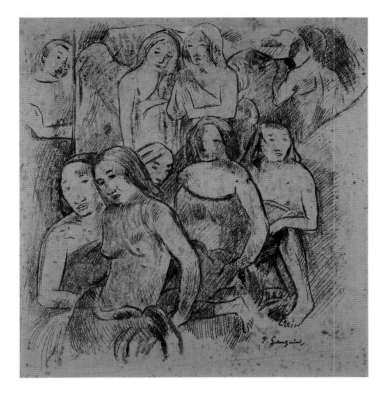

6. Paris 1878, no. 72.

7. *Avant et après*, facs., 203.

8. *Avant et après*, facs., 205.

Gauguin's European cows, from the painting *Cow in a Stable* by Octave Tassaert of which he owned a photograph.[6] The figures are not the ordinary participants at a Nativity or Adoration scene. Three distinct figure groups can be identified; the two in the foreground are separated by Gauguin in the various transfer drawings. On the left a nude woman wearing a red headdress is being bathed, apparently after sex or giving birth, by a nude attendant who uses a pure white cloth. Another woman sits passively. This scene was given the title *Rengaines classiques* (The Same Old Story) by Gauguin when he included the three figures in his last manuscript, *Avant et après*.[7] It is juxtaposed in *Avant et après* with another transfer drawing of the Nativity in which appear two of the three figures at the right of the 1902 painting, one holding the infant Christ. This time the title is *Fantaisies religieuses* (Religious Fantasies),[8] which might be the best title for the whole group of images.

It is possible that the two groups of figures in the foreground of the painting represent two of the three Marys, the Magdalen on the left and the Virgin Mary on the right. Yet, even this explanation does not help to make Gauguin's Nativity any more acceptable. Indeed, Gauguin seemed to revel in breaking the proper codes of representation of the Virgin birth just as he gloried in denigrating the Catholic Church in his *L'Esprit moderne et le catholicisme*. Not only is the Virgin in a cave rather than the "correct" stable, but she is surrounded by nude female attendants who would seem more appropriate in a harem or Turkish bath than in a traditional Nativity scene. Gauguin's inclusion of a woman being washed after sex or birth would undoubtedly have struck any French Catholic as blasphemous.

The primitive grandeur and clarity of Gauguin's religious fantasy makes most viewers realize that, by undercutting the codes of representation approved

261a
L'Esprit moderne et le catholicisme: Nativity
(front and back covers)

1902

front cover: 320 x 180 (12⅝ x 7⅛); transfer drawing: irregular, 245 x 165 (9⅝ x 6½); back cover: 320 x 175 (12⅝ x 6⅞); transfer drawing: irregular, 282 x 200 (11⅛ x 7⅞)

transfer drawing in black on wove paper, laid down onto outside of front and back covers

inscribed and dated on last page of the manuscript, *ouvrage 1897 et 98/Transcrit à Atuana 1902/Paul Gauguin*

The Saint Louis Art Museum, Gift of Vincent Price in memory of his parents

EXHIBITION
Chicago 1959, no. 193a

CATALOGUE
F 82a, 82b

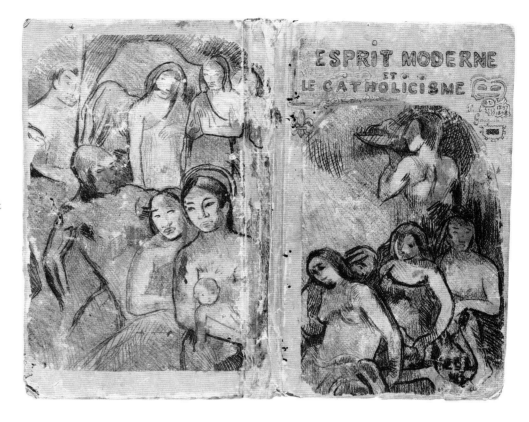

261b-c
L'Esprit moderne et le catholicisme: Soyez amoureuses, vous serez heureuses (inside front cover);
Women, Animals, and Foliage (inside back cover)

162 x 275 (6¼ x 10¾)

woodcut printed in black and ocher on japan paper, laid down onto wove paper, subsequently mounted onto inside front cover

The Saint Louis Art Museum, Gift of Vincent Price in memory of his parents

CATALOGUE
Gu 58

163 x 305 (6⅜ x 11⅞)

woodcut printed in black on japan paper, mounted onto inside back cover

inscribed on the end paper of the back cover, in pen and brown ink, *Paradis perdu.*

The Saint Louis Art Museum, Gift of Vincent Price in memory of his parents

CATALOGUE
Gu 59

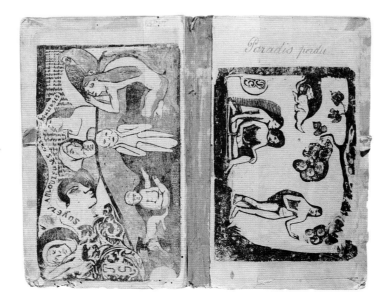

by the official Catholic church, the artist was denying neither the reality nor the importance of the birth of Christ. Indeed, Gauguin's various Nativities succeed in reinvigorating the story by altering absolutely the conventions of its representation. For his "new" Nativity, he read widely, accepted various elements from various texts, and then "fantasized" to create an enigmatic yet accessible painted image.

The various transfer drawings related to the painting are considerably more complex and difficult to intepret. The largest is published here as *Women and Angels in a Studio* (cat. 260). Its conventional title, *Nativity*, is unjustified because there is no Christ Child. Gauguin borrowed from the painting, in modified form, five foreground figures and two background figures. All of these figures are altered in certain crucial ways. Some, though not all, are reversed; others are clothed. Most important, the Virgin and Child are omitted. Instead, nude and clothed women are presided over by two angels. Gauguin filled the corners of this odd brothel-like scene with a male fruit bearer on the right and perhaps an artist at his easel on the left. Neither figure is present at the holy event represented in the painting, and they lend two different moods or aspects to this scene.

It is possible, and even likely, that this ambitious transfer drawing was the one entitled *Nativity* lent by Vollard to the 1906 Gauguin exhibition at the Salon d'Automne, where it was perhaps seen by Picasso. Its relationship to Picasso drawings for *Nudes in the Forest* as well as the early stages of *Les Demoiselles d'Avignon* seems almost certain. Curiously, the style of this group of transfer drawings differs from that of the earlier "Vollard Group" of c. 1900 (cats. 242, 248, 249, 250, 251). While those earlier transfer drawings are characterized by curving outlines and large areas of wash, these tightly compacted, almost baroque figural scenes are defined by strongly drawn cross-hatching and angular contours. In certain ways, they can be related to the most crude and powerful wall paintings in the Christian catacombs in Rome (Gauguin owned at least two photographs of these). Their primitive urgency and power is undeniable. In fact, in cat. 260 Gauguin transformed the scene of the birth of Christ almost completely. The cave becomes the studio, God becomes the artist-creator, and the "virgins" become his prostitutes.

The other transfer drawings of the *Nativity* seem to have been conceived in pairs, one representing the "brothel" of the Magdalen and the other the presentation of the infant Jesus by the Virgin. The various attendant figures – angels, fruit bearer, artist, and companions – appear in various combinations in the different versions. Gauguin placed the brothel with the fruit bearer on the cover of the manuscript for *L'Esprit moderne et le catholicisme* (cat. 261a, F82a) while the Nativity itself is relegated to the back cover (cat. 261a, F82b). Also illustrated here are the two earlier woodcuts that Gauguin pasted into the inside covers of his manuscript; *Soyez amoureuses, vous serez heureuses* (Be in Love and You Will Be Happy, cat. 261b) and *Women, Animals and Foliage* (cat. 261c). Perhaps he intended a parallel here between the old and new testament subjects and his old and new techniques of woodcut and transfer.

The *Nativity* in Chicago (cat. 262) relates to another of almost identical dimensions (cat. 263). In the Chicago transfer drawing, Gauguin represented the Nativity itself, but with two figures that once again alter our reading of it. One is a massively proportioned male figure who leans back to the left of the Virgin. Is he

Picasso, study for *Bathers in the Forest*, 1908, graphite [Musée Picasso, Paris]

262
Nativity

1902

243 x 222 (9½ x 8⅝)

transfer drawing in black and brown on
wove paper (recto); graphite and brown
crayon pencil (verso)

The Art Institute of Chicago. Gift of Robert
Allerton. 1922.4317

EXHIBITIONS
(?) Paris 1903; Chicago 1959, no. 191; Phila-
delphia 1973, no. 84

CATALOGUE
F 84

shown in Washington and Chicago only

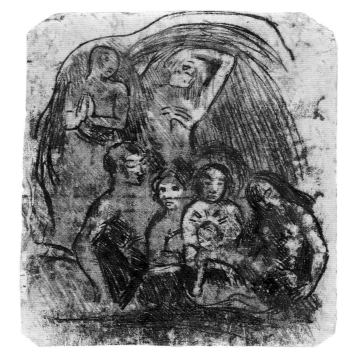

263
Nativity

1902

225 x 225 (8¾ x 8¾)

transfer drawing in black and brown (recto);
graphite (verso)

Musée des Arts Africains et Océaniens, Paris

EXHIBITIONS
(?) Paris 1906, no. 86; Saint-Germain-en-
Laye 1985, no. 384; Philadelphia 1973, no. 85;
Tokyo 1987, no. 142

CATALOGUE
F 85

shown in Paris only

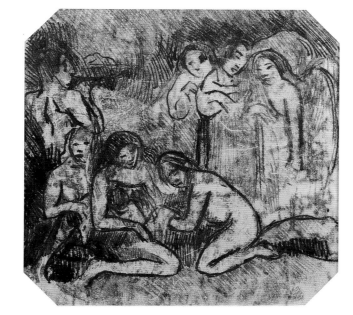

the father? Is he Gauguin? The second figure is at once more important and more disturbing. This ancient, haggard being, with sunken chest, emaciated face, and dramatic gesture, disrupts the serenity of the foreground scene. The gesture of the figure recalls that of the *Pape moe*[9] figure from the manuscript *Noa Noa*[10] as well as the similar figure in *Where Do We Come from?* (W 561). Yet, while that figure is a young androgyne who turns from the viewer, this hideous figure of death faces us, forcing us to rethink the "Nativity" itself. Gauguin chose to repeat this figure in even more caricatural form in the final transfer drawing, *Religious Fantasies* in *Avant et après*.–R.B.

9. W 498.

10. *Noa Noa*, Louvre ms, 92.

264-265
Drawings Related to The Sister of Charity

264
Seated Female

1902

142 x 222 (5½ x 8⅝)

transfer drawing in black on japan paper

Edward McCormick Blair

CATALOGUE
F 43

shown in Paris only

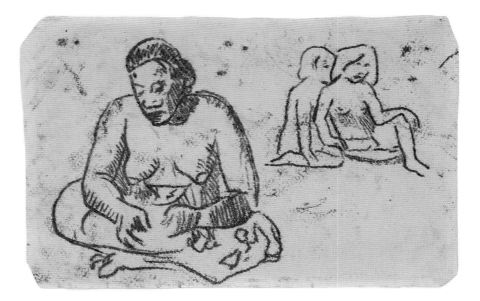

265
Seated Tahitian

1891/1892-1902

170 x 145 (6⅝ x 5⅝)

pen and ink selectively traced with graphite on wove paper

inscribed by the artist, top center, in pen and ink, *tête plus gros*

Edward McCormick Blair

shown in Paris only

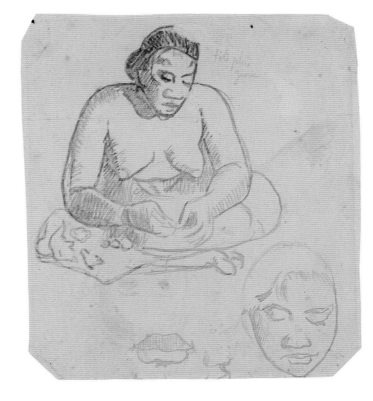

1. F 119; *Avant et après* facs., 179.

2. Paris 1942, nos. 38, 39; 9-13.

3. Philadelphia 1973, 77.

The pen and ink drawing in the Blair collection (cat. 265) is here published for the first time as the direct source for the seated figure in both the transfer drawing (cat. 264) and the one bound in Gauguin's manuscript *Avant et après*.[1] When compared in the original, the pencil lines on the drawing correspond precisely to the transferred lines in both transfer drawings. All three images relate closely to the seated female figure in *The Sister of Charity* (cat. 266), and it is most likely that both transfer drawings and at least the graphite tracing lines of the drawing were all made in 1902 at Atuona.

There has always been some question about the dating of the matrix drawing and the Blair transfer drawing, because they were included in the portfolio assembled by Gauguin, *Documents Tahiti-1891/1892/1893*, partially published before its dispersal in 1942.[2] Marcel Guérin recognized that many of the drawings and transfer drawings in the portfolio were made after 1893. In virtually every case he enumerated the connections between works in the portfolio and demonstrably later paintings, drawings, and prints. By recognizing that the seated woman in the Blair drawing is posed similarly to a seated woman in *No te aha oe riri* (Why Are You Angry?, W 550), Guérin led Richard Field to date the Blair drawing incorrectly to 1896, when that painting was made.[3] However, the figure in W 550, while similarly posed, is decidedly different in age, body type, and coiffure from the figure in the drawing, who is almost identical to the figure in the painting *The Sister of Charity* of 1902.

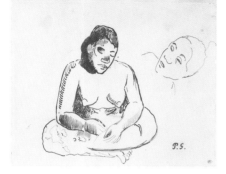

Gauguin, *Seated Woman*, related to *The Sister of Charity* [Musée du Louvre, Paris, Département des Arts Graphiques]

Gauguin, *In the Family, Avant et après*, page 179 [facs. ed.]

4. For a complex reconstruction of *Documents Tahiti*, see Philadelphia 1973, 24-27.

5. W 538 and W 596.

6. *Avant et après* facs., 179.

This similarity, together with the fact that the drawing was the definite source for the transfers, proves that at least the transfers were made in 1902, when Gauguin finished the manuscript *Avant et après* and the painting *The Sister of Charity*. It is easy to assume, then, that Gauguin made a portfolio for some of his earlier Tahitian drawings in 1894 or 1895, that he subsequently took the portfolio with him when he returned to the South Seas, and that he continued to add loose sheets to it throughout his life. Thus, the dates on the cover of his manuscript conflict with the dates of most works found in it.[4]

One should not, however, exclude the possibility that the Blair drawing was made in 1891-1892 and reused in 1902, when Gauguin selected it from his portfolio because he wanted the figure of an amply proportioned, bare-breasted Polynesian woman. The style of the sheet is not strictly that of 1901-1902, and the model for the woman on the verso is very close to one used by Gauguin in 1891 for the seated woman in *On the Beach* (cat. 130). If this reading is true, the ink lines of the matrix drawing were made in 1891 or 1892 and the pencil lines that correspond exactly to the transfers were drawn in 1902, in the process of creating the traced drawings. A related drawing in the Louvre was also part of the album *Documents Tahiti-1891/1892/1893*. In this sheet the figure of the woman is placed to the left side of the sheet and juxtaposed with the head of a sleeping woman. Without precise physical comparison, it is difficult to date this sheet. However, the placement on the page suggests that it too was made in 1902, when Gauguin was working on the transfer project.

To vary the composition of the transfer drawings, as Peter Zegers has demonstrated in his experiments to reconstruct Gauguin's working methods, Gauguin placed the seated woman to one side of each transfer sheet and then traced two different scenes into the background. The two seated figures in the background in cat. 264 relate generically to seated figures in two paintings,[5] but the drawing from which they were traced or on which they were indirectly based is lost. However, the urinating pig and the suckling kittens in the background of the transfer drawing entitled *In the Family* in *Avant et après*[6] are found in two other transfers (F 80, *Reclining Cow and Pigs*, whereabouts unknown, and cat. 251). These transfers too are probably directly related to cats. 264, 265. In this way, Gauguin gave the central figure different meanings by varying the backgrounds.

The figure of the woman is reversed in one of these drawings but appears in the same direction in the other. The fact that the two transfers probably were made simultaneously suggests that Gauguin inked one sheet of paper on both sides and sandwiched it between two blank sheets. He then placed the small ink drawing of the woman on top of the "sandwich" and redrew certain of the inked lines in pencil. These pencil lines were therefore printed in reverse on the top sheet and in the same sense on the bottom sheet of the sandwich. However, he must at that point have altered the "sandwich" to add the remaining elements in the two prints. The fact that these probably correspond precisely with portions of other prints suggests that Gauguin's "sandwiches" of inked sheets changed repeatedly so as to produce variable results that, in certain cases, must have surprised even Gauguin himself.—R.B.

473

266
The Sister of Charity

1902

65 x 76

oil on canvas

signed and dated at lower left, *Paul Gauguin 1902*

Courtesy the Marion Koogler McNay Art Museum, San Antonio, Bequest of Marion Koogler McNay

EXHIBITIONS
Paris 1903, no. 38, *La Soeur de charité*; Paris 1906, no. 65, *La Religieuse*

CATALOGUE
W 617

shown in Washington and Chicago only

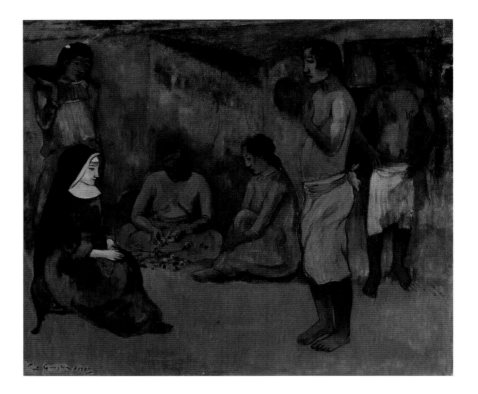

Parlor of the Boarding School of the Mother of God in Alexandria [Les Missions catholiques français aux XIX^e siècle, c. 1901, vol. I, page 427]

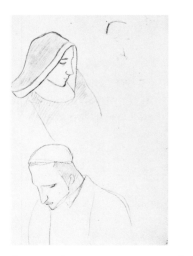

Gauguin, *Carnet de Tahiti*, page 97 [Musée du Louvre, Paris, Département des Arts Graphiques]

Although Gauguin was often fiercely anticlerical, his attacks on the Catholic clergy seem to have been confined mostly to his writings. The portrayal of the priest in *Vision after the Sermon* (cat. 50), while a caricature, is certainly not unsympathetic. In Gauguin's only truly anticlerical work of art, *Father Lechery* of 1902 (cat. 259), the priest is shown as a lecherous, horned devil without the ecclesiastical robes. In *The Sister of Charity*, first exhibited by Vollard in 1903, a Catholic nun is seated on a small European chair or stool surrounded by Marquesan natives. Her pallor indicates that she is a European rather than a native Catholic and that she worked among the missionaries, most of whom Gauguin detested. The figure itself was not derived directly from life, but from two distinct sources: the head, from a drawing executed by Gauguin on his first trip to Tahiti,[1] and the body, from a photograph of a French Catholic sister in Alexandria, which Gauguin found in a book entitled *Les Missions Catholiques Françaises au XX Siècle*.[2]

The press ignored *The Sister of Charity* when it was exhibited in 1903 and 1906. Likewise, it is mentioned seldom in the Gauguin literature.[3] The simple room has no obvious Polynesian associations and in fact recalls the settings painted by Giotto and other masters of early Italian Renaissance art. It also is reminiscent of the spaces Gauguin himself created in the *Idol* (W 580) or the *Nativity* (W 621), painted at the same time. Like all of Gauguin's imaginary spaces, this one is ambiguous. Neither of the irregular rectangles along the wall of the painting can be read as an opening. Do these indicate works of art, tapestries, or even wall drawings?

The figures, too, are ambiguous. The nun seems to preside over a Catholic mission from a chair or stool. One of the two native women is seated on the floor,

perhaps bare breasted; she relates directly to a drawing and two transfer drawings that are clearly contemporary with the painting (cats. 264, F 43). However, her clothed companion has no direct parallel in Gauguin's oeuvre. Behind the nun, another woman brings a wooden bowl of food, probably as an offering to their visitor. This figure relates generally to the food bearers in Gauguin's contemporary transfer drawings of the *Nativity* (cats. 260-263). Females dominate the left side of the painting, but only the nun seems aware of the two men who stand on the right. She looks directly at the largest of the two standing males. Her gaze is not directed to his face, but to the lower part of his body, possibly even to his covered genitalia. His companion, who might be standing at the entrance to the space, also looks at the nun. If the situation in the painting is read as action on a stage, it seems as if the young male figure is speaking, perhaps, as his gesture suggests, about himself, to the nun. The women in the mission have various reactions. Two of them are clad in missionary dresses and appear attentive to the nun, while the older woman, wearing native dress, occupies herself making a flower chain just as the nun fingers her rosary. No clue is given as to the nature of the conversation between the nun and the young man. Nor do Gauguin's voluminous texts about religion help much. Gauguin attempted to convince Marquesan parents not to send their young girls to the convent school in Atuona, and it is possible, though unlikely, that Gauguin intended the male figures to represent fathers coming to the school to retrieve their daughters.

The nun herself clearly represents European, Christian civilization transposed to the South Seas. Her presence does not seem in the least to threaten the local population represented by Gauguin. Perhaps the men are arguing with the nun, attempting to persuade her of the value of their ways. Yet, as the evidence of the two women in missionary dress makes clear, Gauguin was aware of the effect of organized missionary activity on Marquesan culture. Here, he represents the Marquesans as strong, capable people, who reason with the nun while treating her respectfully.

Who was this "sister of charity"? Although it is easy for us to read the painting as a representation of a generic nun, it is perfectly possible that the model for the original drawing was Sister Louise, originally Anne Barnay, who was the director of the school in Mataiea, where Gauguin made many of the drawings in the Tahitian sketchbook of 1891. She was a successful and formidable enough figure to be included in O'Reilly's famous biographical dictionary of Tahitians in 1962.[4] Although Amishai-Maisels incorrectly maintained that the habit of the Marquesan sisters was white, Sister Louise and her colleagues in the Marquesas wore habits almost exactly like that represented by Gauguin in 1902.–R.B.

1. Dorival 1954, p. 97. This drawing is erroneously identified in Amishai-Maisels 1985, 458 as being in the *Carnet Huyghe*, Brittany Sketchbook, 97d (see Huyghe 1952).

2. Gauguin received the book in 1902. Père J. B. Piolet, s.j. (Paris, 1901), 427. See *Avant et après* facs., 95.

3. The only sustained passage about this curious painting appears in Amishai-Maisels 1985, 458, who interprets it in a rigorously anticlerical manner, as a confrontation between native and European cultures, calling the figure of the nun "a cold 'black' spot amidst warmth" (358). Much of the weight of this interpretation depends upon her identification of the figure who stands in front of the nun as a pregnant woman. If this is true, we are indeed presented with a contrast between warm and cold, native and European, barren and fecund, clothed and virtually naked. There is little persuasive evidence that the figure is a woman, much less a pregnant one, and, when it is compared with exactly analogous figures in other contemporary images by Gauguin, the probability that it is an androgyne or, more likely a man, is unavoidable. The comparable figures in *Bathers* (cat. 272) and *Horsemen on the Beach* (cat. 278) have short hair and appear in the company of other men. Only in one of the transfer drawings (F 97) is the figure given long hair and a more strongly protruding belly. Surely Maisels' reading is both too strong and premature to sustain, and a thorough reading of all the figures in the painting presents the opportunity for a more complex and interesting interpretation.

4. O'Reilly and Teissier 1962, 29.

267
The Offering

Painted during a year that Gauguin devoted to representations of male sexuality, religious beliefs, and aging, this painting is like a ray of hope. It shows two young women, one offering her breast to her baby and the other offering a gift of flowers to the new mother and child. How much more natural and easy this image of motherhood is than all of Gauguin's contemporary representations of the birth of

The Offering

1902

68.5 x 78.5 (27 x 30⅞)

oil on canvas

signed and dated at upper left, *P. Gauguin 1902*

Foundation E. G. Bührle Collection, Zurich

EXHIBITIONS
(?) Paris 1903, no. 2, *Mère allaitant son enfant*; Berlin 1927, no. 101; Berlin 1928, no. 77; Basel 1928, no. 90 or 106; Basel 1949, no. 64; Edinburgh 1955, no. 64

CATALOGUE
W 624

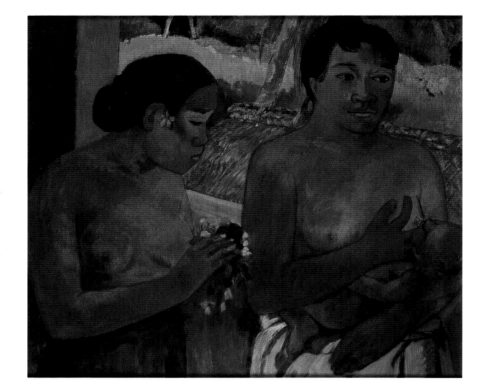

1. Cat. 269; F 90; and a drawing in *Avant et après* facs., 129.

2. F 89.

Christ in a cave crowded with women! Here the two young women stand at a second-story window overlooking a lush Marquesan landscape. This dramatic background is dominated by the roof of a native dwelling made of braided palm leaves. The palm tree, with its brilliant, red-orange dead leaves, crowns the landscape. The very fact that the landscape is viewed from above is unusual within Gauguin's Polynesian oeuvre. Here, he evokes urban and specifically Parisian codes of representation recalling the many paintings of Parisians overlooking their city by Manet, Caillebotte, Degas, Monet, and Morisot. These associations must surely have been unconscious for Gauguin, who was resigned to living out his life in exile.

In this painting, the view from above lends a sense of ambiguity that enlivens the image, forcing us to wonder just where these two Marquesan women really are. We know of only three buildings in Hivaoa that were two stories high: Gauguin's own house, the American Ben Varney's store, and the church. We know from photographs that Varney's store had vertical windows with wooden mullions, and that the church had very small vertical openings in its complex, tripartite spire. We know too little of Gauguin's house to be positive in our identification, but it seems the likeliest building of the three. Witness accounts of his life there make it easy for us to imagine that he invited these two young women up to his studio to model for him.

Little is known about the early history of this picture. Its first documented appearance was in 1927 in the inaugural exhibition of the Thannhauser Gallery in Berlin. Yet it was probably owned by Vollard and exhibited as "Mother Nursing Her Child" in the 1903 Gauguin exhibition at his gallery. As is most often the case with Gauguin's 1902 paintings, several related transfer drawings for *The Offering* exist. Three feature the head of the woman giving flowers[1] and one is centered on the head of the mother.[2] In none of these is either the entire composition or any aspect of the landscape view repeated.

Gauguin signed and dated this painting twice, the first time in red-orange and the second time, slightly below the earlier signature and date, in a rich brown. If one can assume that Gauguin followed the practice of his first great teacher, Pissarro, this would indicate that he had finished the picture and then reworked it, resigning and redating the painting at that time. Unfortunately, the painting has not been X-rayed, and it is difficult from surface evidence alone to speculate on the nature of Gauguin's changes.—R.B.

268-270
Late Transfer Drawings

268
Two Marquesans

c. 1902

321 x 510 (12½ x 19⅞) irregular

transfer drawing in brown on wove paper (recto); graphite (verso)

signed at lower right, *P. Go.*

The British Museum, London

EXHIBITIONS
(?) Paris 1903, no. 12 or 27, *Deux têtes*; Paris 1906, no. 42, *La Fuite*; Paris 1927, no. 43; Paris 1936, no. 115; Philadelphia 1973, no. 86

CATALOGUE
F 86

shown in Chicago only

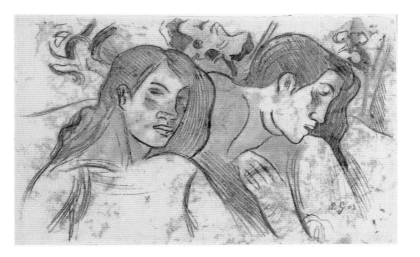

Of these three transfer drawings, at least two, cats. 269 and 270, must have been included in the 1903 Vollard exhibition as *Deux têtes* (Two Heads). Although closely related to each other, the difference in scale and the fact that the heads are not exactly the same rule out a direct relationship. All three transfer drawings contain figures that also appear in two paintings of 1902, *The Offering* (cat. 267) and *Two Women*.[1] The drawing in the National Gallery (cat. 270) derives almost completely from the painting of two women, yet Gauguin reversed one of the figures. In the translation into the drawing, he omitted the praying figure from the painting and altered the position and scale of the horse and rider in the background.

The scale of the Philadelphia transfer drawing, cat. 269, is virtually identical to that of a lost transfer drawing, *Two Marquesans*,[2] and might have been made as its companion. The upper head is virtually identical to the upper head in

269
Two Heads

c. 1902

372 x 312/325 (14½ x 12⅛/⅝) irregular

transfer drawing in black, selectively heightened with brush and water-based colors and residual paint on tan wove paper (recto); graphite and black crayon pencil (verso)

signed at lower right, *P. Gauguin*

Philadelphia Museum of Art, Philadelphia, Purchased, Alice Newton Osborn Fund

EXHIBITIONS
(?) Paris 1903, no. 12 or 27, *Deux têtes*; Philadelphia 1973, no. 87

CATALOGUE
F 87

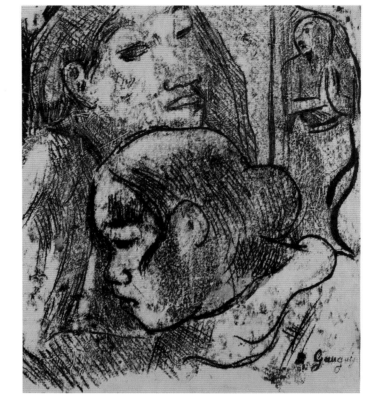

1. W 626.

2. F 89.

3. W 561.

4. F 109; *Avant et après*, facs., 155.

5. W 561.

6. W 614.

the painting *Two Women*, while the lower head derives from the figure on the left of *The Offering*. Gauguin retained the praying figure from *Two Women* and omitted the horse and rider in the landscape.

Gauguin used the transfer drawing medium as a way to scramble or recombine aspects of his paintings to create new images. This process recalls the various paintings made either before or after *Where Do We Come From?*[3] that include parts of the large painting translated into different scales and tonalities. The fact that Gauguin sent this painting and eight related works to be exhibited together at Vollard's gallery in Paris in 1898 reveals his interest in the simultaneous presentation of related works. In 1902, he seems to have used the drawing medium either as a means of working out figural combinations that could be translated into paintings or as an experimental extension of his paintings into printed realms. The very fact that the transfer drawings hover between print and drawing creates difficulty in interpreting them either as preparatory or as vaguely reproductive works. Gauguin included another, even smaller transfer drawing of two heads in *Avant et après*, where he inscribed it "conversations without words."[4] This title might help us to identify the painting currently called *Two Heads*[5] as no. 17 in the 1903 exhibition catalogue, where it was called *Causeries* (Conversations). *Two Marquesans* (cat. 268) relates directly to another painting, *The Lovers*.[6] Both figures as well as the setting appear virtually identical in the painting and the transfer drawing. However, the sense of dramatic urgency and physical movement is much stronger in the transfer drawing, perhaps because of the strength and apparent velocity of Gauguin's lines. The painting projects a mood

270
Two Heads

1902

458 x 352 (17⅞ x 13¾) irregular

transfer drawing in black and olive green, on tan wove paper (recto); graphite and black crayon pencil (verso)

signed at lower left, *PGO*

National Gallery of Art, Washington, Rosenwald Collection

EXHIBITIONS
(?) Paris 1903, no. 12 or 27, *Deux têtes*; Chicago 1959, no. 196; Paris 1960; Munich 1960; Philadelphia 1973, no. 88

CATALOGUE
F 88

shown in Washington and Chicago only

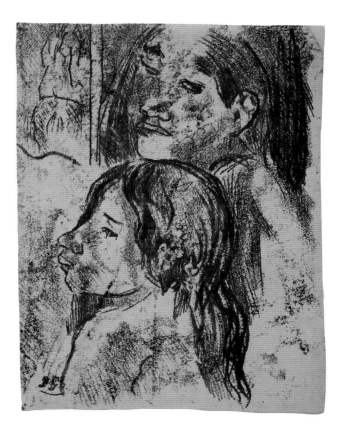

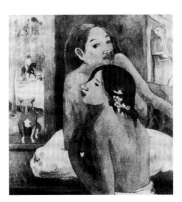

Gauguin, *Two Women*, 1902, oil on canvas [Archives Durand Ruel]

7. "You must remember that there are two natures within me: The Indian and the sensitive man. My sensitive side had disappeared which permits the Indian to come forward strongly;" letter to Mette, February 1888, Malingue 1949, LXI.

of fear and even guilt, while the transfer drawing has little of that quality. Rather, the two figures seem to hurry away from some unknown person or force to some mysterious destination.

The woman on the left is typical of Gauguin's youthful Polynesian women; her features are regular and well disposed and her hair falls casually down her back. The second figure is very odd. The head, with its distinctively expressionist profile, has been shown to derive from a head in Delacroix's *Shipwreck of Don Juan*, which entered the Louvre in 1883. Yet it is equally possible that the source was the head of the young half-Indian woman in Delacroix's *The Natchez* of 1835, which Gauguin saw at the Delacroix retrospective of 1885. If the latter case could be proved, the source may have had particular meaning for Gauguin, who imagined himself to be part Indian.[7]

Whatever its source in Delacroix, Gauguin reused this figure in several paintings of 1902. Undoubtedly, Gauguin was attracted to the Delacroix head less for its value as a quotation to be recognized by visually literate viewers than for its expressive quality. Gauguin's training as an artist had not emphasized the portrayal of emotional states in the human face or body, yet many of his works from 1902 possess a heightened emotional intensity. This may reflect the influence of Delacroix, the premier colorist of nineteenth-century art and the artist most grudgingly admired by the modernists of the 1860s and 1870s, as well as by Gauguin's friend and rival Paul Cézanne.—R.B.

271-272
Marquesan Male Figures

1. Basel 1949, 43.

2. *Deutsche Kunst und Dekoration*, November 1910, 112.

3. *Academy Notes*, no. 1-2 (Buffalo Fine Arts Academy 1925-1926), 8.

These two paintings, like most of Gauguin's latest works, have had many titles. *Marquesan Man in a Red Cape* (cat. 271), has been called by the more dramatic titles *The Enchanter* or *The Sorcerer of Hivaoa*, the latter of which seem to have been invented in 1949 when the painting was exhibited in Basel.[1] In spite of the fact that cat. 271 and its pendant, cat. 272, probably were both in the 1903 exhibition at Vollard's gallery, none of the titles used in the exhibition list agree with the titles by which the two paintings have since come to be known. The first published photograph of cat. 271 was entitled *On the Marquesan Islands*,[2] but it may well have been called *The Spirit Watches over* (*L'Esprit veille*) in the 1903 exhibition. The traditional title *Tahitian Family* is obviously incorrect for cat. 272, its pendant, both because the painting was made in the Marquesas, not in Tahiti, and because it does not appear to represent a family at all. Many viewers may have thought that the central figure was a woman, as she was identified in the earliest published discussion of the painting in the 1926 issue of the *Academy Notes* of the Buffalo Fine Arts Academy.[3] The figure seems rather to be a long-haired man, who protects his genitalia from view with a white cloth either after or before bathing in the sea.

The male figure in both paintings is so similar in scale and position that the two identically sized pictures must have been conceived as a pair, using the same model. When interpreted in this way, the *Bathers* becomes a celebration of the quotidian world of the body just as its pendant or opposite evokes the mysterious world of a costumed man with obscure, secret knowledge. *Bathers* is set on a fabulous pink and yellow coral beach in the full light of day, while the *Marquesan Man* stands in a grove of trees in a shaded river valley. The costumed man looks intently, almost hypnotically, into the eyes of the viewer, and his face is carefully described by Gauguin. The bather projects very little self-awareness, and his features are painted in such a way that one passes quickly over the face without pausing to examine it in detail. Gauguin was principally interested in his body and scanty costume. Both Danielsson and Teilhet-Fisk have identified the model for the *Marquesan Man* as Haapuani, a well-known figure in Hivaoa.[4] Their knowledge of Haapuani, a friend of Gauguin, is based on Guillaume Le Bronnec's discussion, which makes clear that Haapuani was a *taua*, or traditional native priest, before the arrival of the missionaries. After their arrival he renounced his priesthood to become "the organizer and master of ceremonies of festivals and celebrations in Hivaoa."[5] Both Danielsson and Teilhet-Fisk accept the traditional title, *The Sorcerer of Hivaoa*, and discuss the painting as a study of native Marquesan religious practices. Their evidence seems to be a single witness' account of a *taua* in the Marquesas wearing a red blanket "in the sacred place of that valley."[6] This, when combined with the fact that Gauguin knew a former *taua* named Haapuani and the modern title, seems to form the grounds for their interpretation of this enigmatic painting.[7]

In 1902 Gauguin painted a series of works that represent men wearing long hair. No clear precedent is found in his earlier work, though several female nudes from the first Tahitian trip have an ambiguous, almost androgynous quality. In the earlier pictures, most particularly in *Pape moe* (cat. 157), female figures have a muscularity that makes them appear masculine. Yet we are rarely in doubt about their real sex. In cats. 271, 272, and *The Lovers*,[8] all of 1902, Gauguin performed the opposite trick: he painted effeminate men, whose long, flowing hair is their chief attribute. There must have been such a man at Hivaoa, though we have no evidence that he was Haapuani. Gauguin's repeated use of this model in both

4. Danielsson 1975, 257; Teilhet-Fisk 1975, 356; 1983, 154.

5. Le Bronnec 1956, 196.

6. Handy 1971, 227.

7. Fortunately, there is another painting with the same figure, although it too has a strange history of interpretation. First published as *The Incantation* (Alexandre 1930, 175), it was called *The Apparition* by 1948, and neither title exists in the 1903 or 1906 exhibition catalogues! Again, one confronts a history of modern interpretation depending on suggestive titles that have no basis in fact.

8. W 614, location unknown.

271
Marquesan Man in a Red Cape

1902

92 x 73 (35⅞ x 28½)

oil on canvas

signed and dated at lower left, *Paul Gauguin 1902*.

Musée d'Art Moderne, Liège

EXHIBITIONS
Paris 1903, no. 32, *L'esprit veille*; Munich 1910; Paris, Orangerie 1949, no. 58; Basel 1949, no. 63; Humlebaek 1982, no. 20; Saint-Germain-en-Laye 1985, no. 391

CATALOGUE
W 616

shown in Washington and Chicago only

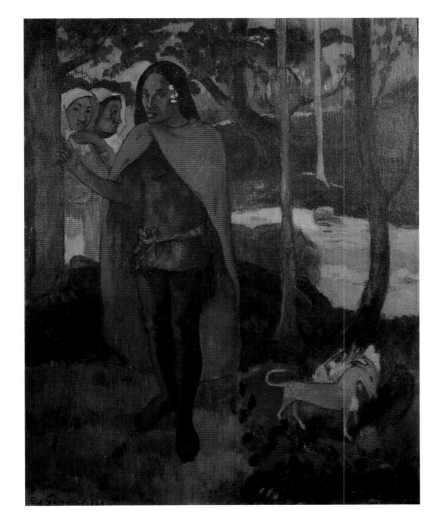

9. Levy 1973, 130-141.

10. Danielsson 1956, 150.

11. Venturi 1936, nos. 273, 274, 276.

12. Venturi 1936, no. 276.

paintings and prints seems to indicate a fascination with him. The existence of effeminate men, or *mahu*, has long been noted in Polynesian society. Robert Levy, the social anthropologist who has recently worked with Tahitians, discussed male homosexuality in Polynesia and found that a type of effeminate man raised from childhood as a woman was perfectly acceptable.[9] Bengt Danielsson has also reported long-haired male homosexuals as *mahu* in both missionary literature and in fact.[10] Gauguin must have been familiar with *mahu*, and he may already have painted a *mahu* child in 1896 in *Nave mahana* (cat. 220). He seems to have become almost obsessed with ambiguous male sexuality in 1902. In the so-called *The Lovers*, the long-haired man places his arm protectively around the shoulders of a beautiful nude woman. The sexuality of the bather in cat. 272, and that of his various companions, is more problematic.

The title *Bathers* is here because the central figure has an obvious source in a male bather who wears trunks or shorts in three paintings by Cézanne called *Bathers in Repose*.[11] Unfortunately, we do not know which version Gauguin saw. The most famous one[12] was owned by Gustave Caillebotte, whose collection would probably have been accessible to Gauguin only in the late 1870s and early 1880s. However, the picture was among those refused by the French government from the Caillebotte bequest, and it is possible that Gauguin became familiar with it during

13. Venturi 1936, no. 273.

14. Paris 1877, no. 26, *Les Baigneurs; Etude de projet de tableau.*

15. Venturi 1936, no. 274.

16. Philadelphia 1973, 34-35. Related monotypes are F 97, F 98, F 99.

Cézanne, *Bathers at Rest*, 1877, oil on canvas
[Photo: Copyright by The Barnes Foundation]

17. Musée du Louvre, Département des Arts Graphiques.

18. *Noa Noa*, facs., 52-53.

that period of controversy in 1894-1895. A smaller version[13] was probably included in the 1877 impressionist exhibition as "Bathers, Study, Project for a Painting."[14] We can only speculate as to whether Gauguin remembered this small study and quoted the painting in Caillebotte's collection, or saw the small third version[15] in the collection of Leclanché, who was one of the few buyers at the Gauguin sale in 1895. However, there is a good possibility that Gauguin saw all three versions of this unusual composition at some point during his lifetime.

Two other connections exist between the Cézanne figure and Gauguin's Marquesan figure. Sometime in 1898, Vollard commissioned Cézanne to make a drawing for a lithograph, and the composition he chose was the Caillebotte version of *Bathers in Repose*. The black and white edition of this print has many formal affinities with the transfer drawings by Gauguin that seem to have been made in preparation for the painting.[16] Perhaps Vollard sent a copy of Cézanne's print to Gauguin during the period of their business association; this print, then, rather than one of the paintings, would have led to the creation of the painting.

It seems odd that Gauguin would make references to the work of his greatest French predecessors and contemporaries – not only Cézanne, but Poussin, Delacroix, Manet, Puvis de Chavannes, van Gogh, and Redon – during his last years in the Pacific. He rarely painted male nudes, and one wonders whether, in this case, he used a Western prototype in order to give a certain resonance to this native scene and even perhaps to link the covering of this nude with the Old Testament mythology of the covering of Adam and Eve after the Fall. The presence of a baby and other figures does little to undercut this view. Here the gesture of the bather, derived from Cézanne, makes it clear that he has either just covered himself or is about to remove his garment. Gauguin painted the lining of the white cloth in a brilliant red with yellow-orange patterns, suggesting that there is something more beautiful under the white cloth. When considered in this way, the Cézanne prototype begins to make more sense, because the figure in Cézanne's painting is similarly involved in either taking off or putting on his shorts in the midst of other nude or scantily clothed figures. Both artists shied away from male frontal nudity in their paintings, yet Gauguin seems to have created his painting in partial defiance of the convention of modesty. We know that Gauguin displayed himself with abandon in Hivaoa and that the issue of prudishness interested him. Here, where the clothed adult male is juxtaposed with a fully nude infant male, the white cloth covering the adult's genitalia takes on an additional weight of convention, and this notion is further strengthened when we realize that the two covered figures in this painting are also present in Gauguin's *The Sister of Charity* (cat. 266), where they stand in front of a nun.

The setting of the picture was painted not from nature, but, rather, was derived almost exactly from an earlier painting, *Landscape with Two Goats* (W 562) that Gauguin had sent to Vollard in 1898. This painting and the drawing from it that Gauguin included in the manuscript *Noa Noa*,[17] both painted with saturated purples and deep blues, have the effect of evening or even night scenes. For the later cat. 272, Gauguin not only introduced the male figure derived from Cézanne, but also completely changed the time of day. Interestingly, the resulting painting is very closely related to a poem, presumably by Charles Morice, that precedes the evening version of the landscape in *Noa Noa*.[18] Unlike the earlier painting and its watercolor version, the poem is a celebration of daytime and of the seaside, where a male Tahitian sings in a landscape of flowers. The poem is entitled *Vivo* and is more than anything else a celebration of the beauties of life in

272
Bathers

1902

92 x 73

oil on canvas

signed and dated at lower left, *P. Gauguin/ 1902*

John Goulandris, Lausanne

EXHIBITION
(?) Paris 1903, no. 9, *Scène de paysans*

CATALOGUE
W 618

shown in Washington and Chicago only

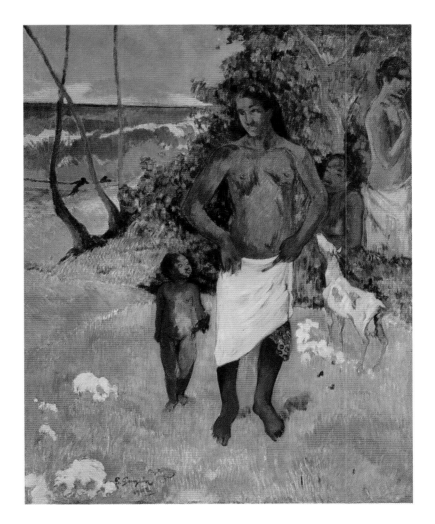

19. *Avant et après*, facs., 46.

20. Teilhet-Fisk 1983, 155.

paradise. For Morice, there were no mysteries in paradise, and Gauguin, in painting *Bathers*, seemed almost to embody this forced optimism of his young friend.

The text helps us little in interpreting the she-goat who seems to nuzzle the figure in the middle ground, but whose nose visually touches the great foreground bather. The earlier painting on which the landscape was based includes a pair of goats who sit placidly on the beach; here, we see only one, who has the quality of a pet. Gauguin rarely represented goats, preferring dogs, cattle, pigs, and various birds. His animals can virtually always be interpreted in terms of fables or popular tales, and surely this goat was used for a reason. Is she here an emblem of greed, rapaciousness, or insatiability in paradise? After all, Gauguin referred to his enemy, the lecherous priest, Père Paillard, as a goat,[19] and, given this association, one wonders all the more about the goat in *The Bathers*.

However complex and problematic, Gauguin's excursion into the troubled realm of male sexuality and its representations does not make our interpretation of *The Sorcerer* any easier. Interestingly, the figure has never to our knowledge been identified as a woman, in spite of his long hair and oddly effeminate clothing. None of the males in Gauguin's other paintings wear such costumes, and there is a quality of exoticism or orientalism about this painting that Gauguin rarely approached. Teilhet-Fisk claims that the figure is snapping his fingers,[20] but this is

surely not the case, for he is holding a small green object, which he may be passing to the woman behind him. In light of the fact that we have no positive evidence that the figure is either Haapuani or a sorcerer, it is just as easy to consider the painting as a representation of an effeminate man in costume. Danielsson paraphrased the memory of Cook's companion Forster of a flotilla of Ariori wearing "yellow leaf girdles and red cloaks."[21] In light of this, one wonders about the sorcerer's exotic costume. His hair is adorned with fragrant frangipani, and he holds a small leaf in his hand. Is it a drug, a medicine, an aphrodisiac?

Perhaps the answer can be found in the visual parable in the lower right corner. A small, foxlike dog appears to nibble affectionately on the wing of an exotic bird. This visual parable derives directly from one of Gauguin's *Le Sourire* prints (Gu 75), but it also relates to an odd watercolor of a bird frolicking with two dogs that Gauguin called *Love One Another*.[22] Clearly, an affectionate relationship between a dog and a bird is unnatural, and perhaps by including this emblem with the effeminately costumed man, Gauguin has forced us to ponder the issue of what is "natural" in human sexuality.—R.B.

273-274
Two Transfer Drawings

273
Tahitian Family

21. Danielsson 1956, 176.

22. Field 1977, no. 33.

c. 1902

480 x 290 (18¾ x 11¼)

transfer drawing in black, squared in graphite on wove paper (recto); graphite and black crayon pencil (verso)

signed at lower right, *Paul Gauguin*

Musée des Arts Africains et Océaniens, Paris

EXHIBITIONS
(?) Paris 1903, no. 4 as *Famille*; Paris 1906, no. 91 as *Famille Tahitienne*; Philadelphia 1973, no. 99; Saint-Germain-en-Laye, 1985, no. 389; Tokyo 1987, no. 143

CATALOGUE
F 99

274
Rider

1901-1902

500 x 440 (21½ x 17⅛)

transfer drawing in black and gray on wove paper, laid down on secondary support

signed at lower left, *Paul Gauguin*

Musée des Arts Africains et Océaniens, Paris

EXHIBITIONS
(?) Paris 1903, no. 9 as *Chevauchée* or no. 13 as *Le Cavalier* or no. 19 as *Homme à cheval*; Paris 1906, no. 84 as *Le Cavalier*; Philadelphia 1973, no. 99

CATALOGUE
F 104

These two large transfer drawings are related directly to paintings. *Rider* is a transcription of the central figure of a painting of 1901 (cat. 256). *Tahitian Family* has much in common with a painting from 1902, *Bathers* (cat. 272), but its relationship to the painting is a good deal more complex than is the case for *Rider*. The major figure in *Tahitian Family*, an almost nude male bather, is made larger with respect to the landscape setting, and the principal figure in the background is moved; in many ways, the translation from oil to transfer drawing (or from transfer drawing to oil) involves major changes in mood and meaning. Conversely, *Rider* seems to be a clarification or simplification of its painted source.

The difference in this relationship is reflected in the appearance of the transfer drawings. The entire composition in *Rider* comprises a series of lines of roughly equal length and character, and, although it is the result of two separate transfer procedures using black and gray inks, there are no problems of registration. The entire image has a uniformity and decorative clarity.

The *Tahitian Family*, by contrast, is a collection of figures uneasily coexisting on an irregular sheet of paper covered with stains and marks. Even the artist's signature is smudged and illegible, giving us more reason to wonder whether its appearance was Gauguin's conscious intention. Yet, it most probably was sent by Gauguin to France, and, because so many of the other printed drawings from the last years share this sense of the inconclusive, we can do little but struggle to understand this one in the context of the others.

Another color transfer of this subject survives in the Fayet family collection, but its dimensions have not been published, and it is therefore impossible to relate directly to this one. Even if its figures are identical in scale, they are in different places on the pictorial surface, indicating that Gauguin repositioned the sheets of paper as he worked.

The idea that Gauguin created original prints by repositioning various sheets of paper as he worked is a tantalizing one. If he did this, he could have used the medium to experiment with compositions before they attained final form in painting. This idea is tentatively put forward by Richard Field in his discussion of *Tahitian Family* and similar prints, all of which he calls "studies related to the 1902 paintings."[1] Unfortunately, it is impossible to interpret in what sense the word "studies" is used – whether, to put it precisely, they are studies for or studies after the painting.

If one puts them into the context of Gauguin's prints, the latter is more easily acceptable. If one treats them as drawings, the decision is more difficult. Gauguin made drawings after paintings almost as frequently as he made them before, and the fact that in all the 1902 printed drawings he altered mostly the positions of the figures with respect to the background and each other rather than the figures themselves suggests that Gauguin worked on the drawings during the period of execution of the painting or afterward. Like the earlier prints, they seem to have been made as part of a separate series of images to be considered apart from and in relation to the paintings from which they seem to derive. They are intentionally indeterminate works of art.–R.B.

275-277
Three Gouache Transfers

275
Marquesan Landscape with Figure

1. Philadelphia 1973, 122.

c. 1902

310 x 550 (12 x 21½)

gouache transfer selectively heightened with white chalk on tan wove paper

private collection

EXHIBITION
Tokyo 1987, no. 151

CATALOGUE
F 136

shown in Washington and Chicago only

276
Bather

c. 1902

532 x 283 (20¾ x 11)

gouache transfer, selectively heightened with white chalk, on tan wove paper

signed at top right, in graphite, *P. Gauguin*

Mr. and Mrs. Eugene Victor Thaw

EXHIBITIONS
Paris 1936, no. 124; Chicago 1959, no. 194; Philadelphia 1973, no. 133

CATALOGUE
F 133

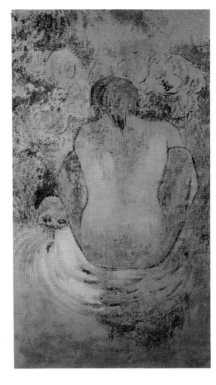

277
The Pony

c. 1902

333 x 596 (12⅞ x 23)

gouache transfer selectively heightened with white chalk and residual gum arabic on tan wove paper

signed at top left in graphite, *P. Gauguin*; at bottom left in graphite (partially deleted), *P.G.*

National Gallery of Art, Washington, Rosenwald Collection, 1947.7.60

EXHIBITIONS
Chicago 1959, no. 198; Munich 1960, no. 134; Philadelphia 1973, no. 134

CATALOGUES
F 134

shown in Washington and Chicago only

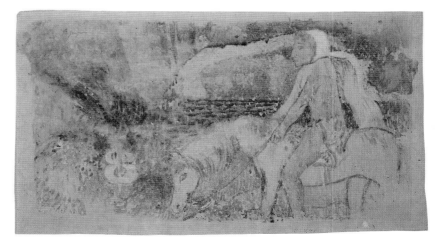

1. The fourth is F 135.

These three color transfers form part of a group of four technically complex works printed by Gauguin in 1902 or early 1903.[1] Their early history is unknown, and it is unlikely that they were included by Vollard in the 1903 exhibition. All of them were printed from a matrix made up of water-based colors, sharing with the so-called watercolor transfers of 1894-1895 a charming softness and indirectness and lacking the crudity and strength of the contemporary printed drawings. Gauguin seems to have made fewer color transfers in his last years, preferring to work with tools and inked sheets rather than with the delicate materials of the color transfer. Like their cousins from 1894 to 1895, they have little to do with his late aesthetic.

The superb *Bather* is directly related to the figure in a painting of 1902 (W 613). In the painting, the figure sits on a rock in the middle of a stream that flows through a large, spacious landscape dominated by great trees. The transfer is in every way more intimate. The figure is seated directly in the water and juxtaposed with a wonderfully foliated embankment. Because the bather is placed almost directly in the center of a transfer composition, the figure has the quality of a sign, and the stylized regularity of the pose is more evident than in the painting. The bather is an androgyne. The graceful contours and pose indicate that the figure is a woman, but the short hair, evident in both the painting and transfer, gives the viewer pause in recognizing its gender.

The Pony is slightly larger than *Bather*, but technically related. Its figure is derived from a painting of 1901 (cat. 256) and was used or reused in other works by Gauguin. The figure in this almost childlike transfer has been conclusively identified as a figure of death in its painted context. The horseman is placed on the edge of the composition in a landscape dominated by the same flower sign that Gauguin used in the landscape setting for the painting related to *Bather*. This easy exoticism combines with the inherent prettiness of the technique to sap the iconic power from the rider and to create a paradisiacal world in which not even death is a threat.

It is, in fact, the sense of an inhabited paradise that pervades all of the late color transfers, especially the *Marquesan Landscape with Figure*. The trunks of three ancient trees define a landscape space suffused with the scents of fruit and flowers. Only at the very center does Gauguin allow a human figure, who is unaware of our presence as she moves into the vegetation. The mysterious, otherworldly landscape is in virtually every sense ideal. The red-orange fruits on the foreground tree could be the apples of temptation, but, if they are, no one is tempted. The viewer can wander through these sacred groves, reflecting about not only Gauguin's paradise but also that of William Blake. Indeed, Blake's *Songs of Innocence* and *Songs of Experience* may have been known to Gauguin.—R.B.

278
Riders on the Beach

1902

73 x 92 (28½ x 35⅞)

oil on canvas

signed and dated at lower left, *Paul Gauguin/1902*

private collection

EXHIBITIONS
Paris 1903, no. 39 or 42, *Cavaliers au bord de la mer*; Cologne 1912, no. 173; Basel 1928, no. 105; New York 1956, no. 51; Chicago 1959, no. 69; Paris 1960, no. 170; Munich 1960, no. 75

CATALOGUE
W 620

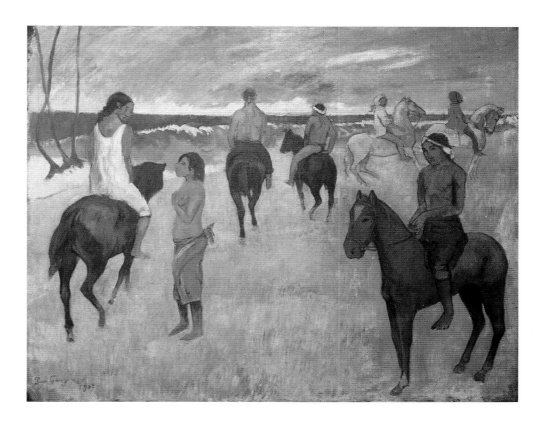

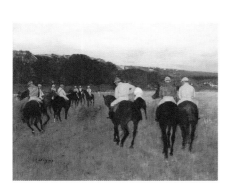

Degas, *Racehorses at Longchamp*, 1873-1875, oil on canvas [Museum of Fine Arts, Boston, S.A. Denio Collection]

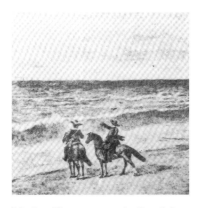

Merino, *Horsemen on the Beach* [ex. collection Gustave Arosa; photo: Bibliothèque Nationale, Paris]

Gauguin painted two compositions in 1902 of men riding horses along great pink expanses of beach in which six horsemen are strategically arranged across the picture surface in a manner that immediately recalls racecourse pictures from the late 1860s and early 1870s by Degas.[1] As in most of Gauguin's paintings from the last decade of his life, Polynesian civilization is represented with the conscious use of Western paradigms, presumably to create a mythic, universal art.

Gauguin swerved insistently from the reality of Hivaoa in making this and a similar painting in Essen (W 619). While the real islands are defined by steep, overgrown mountains that plunge precipitously into small valleys lined with black sand beaches, the paintings represent a broad, flat stretch of pink, coral beach with three spare tree trunks as the sole vegetation. Hivaoa is not what is conveyed by the paintings; like everything from Gauguin's last years, it is a deeply meditated reflection upon the nature and origin of art.

Degas is the dominating presence in this aesthetic contemplation from a distant island, just as Cézanne, Redon, or van Gogh dominate other paintings of that year. Gauguin rarely approached Degas as closely as he did in *Riders on the Beach*. The horses in this picture can be found in Degas' *Racehorses at Longchamp* (L334) in reverse, and it is not clear which of the variant pastels with similarly posed horses was seen by Gauguin. The single print of a racecourse seen in Thornley's 1889 portfolio of reproductions after Degas, which Gauguin undoubtedly saw, is not related, and Gauguin's drawings do not contain the answer.

The world represented in *Riders on the Beach* is an utterly masculine one. The four men on brown horses and the single standing figure seem to be actual Marquesans, while the two colorfully costumed figures riding the gray-white

1. See Kane 1966, 358, who compared it to three Degas pictures, *Chevaux de courses à Longchamp*, c. 1873-1875 (MFA, Boston, L334); *Avant le cours*, pastel, c. 1884-1886 (formerly collection of Durand-Ruel, Paris, L878); *L'Entraînement*, 1894, pastel (private collection). Also see, L 1145, le Pichon 1986, 248. Other searchers after Gauguin's numerous sources have pointed to certain horses in the Parthenon frieze (Chicago 1959, no. 69) and to a painting with an identical title by the obscure Ignacio Mérino in the Arosa collection.

2. See note 1.

horses in the middle ground are related to Gauguin's *tupapau* or spirit figures. Their horses derive from the Parthenon frieze,[2] and they ride away from the sea into an unseen landscape. They are figures of death, riding, perhaps, into the world beyond, and the mortals on the beach seem at once oblivious to them and unaffected by them. Gauguin himself had a new lease on life when he painted this picture in 1902. His new house was completed, and he amused himself by riding around the village in his horse trap, having discussions with his friends and neighbors. The comparative ease and freedom of his life in that year was not to last very long, and this painting, with its departing spirits and slightly ominous, cloud-streaked sky, has only hints of something that will break the camaraderie of these Marquesans.—R.B.

279
Woman with a Fan

If Gauguin ever painted a color field painting, it is this one. Both figure and background are suffused with a generalized warmth of color that seems to emanate from the flesh of the woman. In the background, it becomes a mustard hue with green tints at the right. The skin of the young woman is variably orange, her nipples grayed violet, her lips rose and orange, and her hair a ruddy orange highlighted with purple and green. The irises of her eyes are a chestnut brown emerging from grayed beige whites. Even the chair on which she perches is warm, and its gnarled wooden arms are carved in fantastic shapes that encourage the viewer to explore their nooks and crannies.

This delicately modulated symphony of wood and flesh is set into contrast against the white of the model's wrap and her single attribute, a white feathered fan. The model's white wrap is startlingly simple, and, were it not that white had connotations of power and death in Marquesan culture, the western viewer would ascribe a virginal purity to this noble savage.

As he did on many other occasions, Gauguin based this painting on a photograph that was sent to Monfreid by Gauguin's Marquesan friend, the Pastor Vernier, after the painter's death. The model, Tohotaua, appears also in *Primitive Tales* (cat. 280) as the mysterious figure in the center. Tohotaua had natural red hair, which was unusual[1] on the island of Hivaoa where she visited Gauguin.

There are numerous differences between the painting and the photograph. Indeed, the only similarities have to do with the pose and facial features of Tohotaua. This suggests that Gauguin used the photograph not as the basis for the painting, but as a stand-in for the model, who lived on another island. In the photograph, Tohotaua wears a conventional printed *pareu* tied around her neck to cover her breasts. The costume in the painting is not the same, and it is reasonable to assume either that Gauguin invented the costume or that he painted it from life before completing the remainder of the picture from the photograph. Perhaps more important to any psychological reading of the picture are the changes in the hair and eyes of Tohotaua. In the photograph, her flowing hair is a richly curled

1902

92 x 73 (35⅞ x 28½)

oil on canvas

signed and dated at upper left, *Paul Gauguin/1902*

Museum Folkwang, Essen

EXHIBITION
(?) Paris 1903, no. 15, *Femme dans un Fauteuil*

CATALOGUE
W 609

shown in Washington only

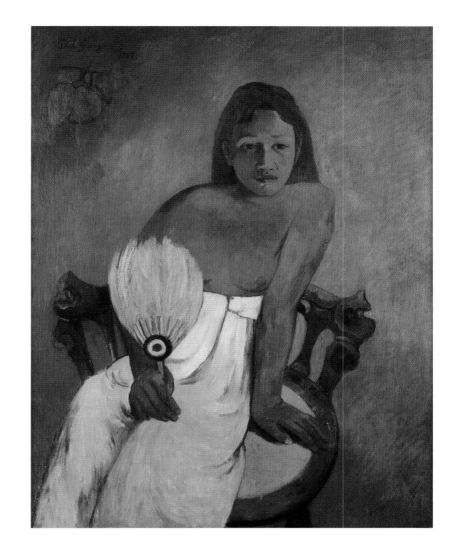

Photograph of *Tohotaua* taken in Gauguin's studio, 1901

1. Danielsson 1975, 256.

2. Barrow 1979, 73.

cascade that breaks over her shoulders and reemerges behind her arm and back. Gauguin deemphasized the hair in the painting itself, concentrating on its color rather than its luxurious length and softness. What makes the painting so mysterious is that the figure stares into space, as if lost in her thoughts, in marked contrast to the photograph, where she looks directly and openly at the viewer.

The photograph, presumably taken in the studio of the House of Pleasure, is remarkable as a document of Gauguin's last and greatest studio environment. The walls behind Tohotaua appear to be woven grasses on which Gauguin placed several reproductions, including the famous Hans Holbein *Woman and Child* and Puvis de Chavannes' *Hope*, Edgar Degas' *Harlequin*,[1] and a photograph of a Buddha. The photograph does not contain the extraordinary chair on which the model sits in the Essen painting. This suggests that the chair did not actually exist, but was invented by Gauguin, just as he invented Tahitian interiors in his paintings of early 1897 (cats. 222, 223).

The white, feathered fan carried by Tohotaua is unique in Gauguin's work. Feathered fans appear in none of his other Tahitian or Marquesan paintings, although Tehamana carries a plaited fan in *The Ancestors of Tehamana* (cat. 158), to which this painting has often been compared. The single other plaited fan is the one displayed by the figure of a noble woman in the two variants of *Te arii vahine* (W 542 and 543). Fans were identified with the Polynesian aristocracy, and many symbolized rank.[2]

It is possible that this late portrait was called *Woman in an Armchair* in the exhibition of Gauguin's late work held at Vollard's gallery late in 1903. The only other painting that could be similarly titled was probably painted in 1894 and had an inscribed Tahitian title, *Aita tamari vahine Judith te parari* (see cat. 160). Whatever the case, the title customarily applied to the painting is misleading. The woman represented is likely not merely a woman, but a queen.—R.B.

280
Primitive Tales

Gauguin inscribed titles on only a very few of his late paintings, perhaps because of the strong criticism hurled at his earlier Tahitian titles, and *Primitive Tales* is among the most important of these. The painting was included in the first major exhibition of the late work of Gauguin held at Vollard's gallery in November 1903, where, with the only other comparably scaled painting of 1902, *The Call* (W 612), it must have dominated. While *The Call* is a study in pink, pale orange, watermelon, and lavender, *Primitive Tales* is made up primarily of cool hues, night blues and purples. Two grave Tahitian women and one enigmatic European man emerge from the flowery mists. These figures and their evocative setting must have appealed immediately to Karl Osthaus (of Hagen) who was forming an important collection of modern French painting in the first decade of the century. He purchased the painting from Vollard just after the 1903 exhibition, and for this reason it was not included in the most important Gauguin exhibition of this century, the 1906 Salon d'Automne.

The male figure, who appears elsewhere in Gauguin's oeuvre, is often discussed in the literature on *Primitive Tales*. He can be identifed as Meyer de Haan, the wealthy Belgian painter who worked in Gauguin's entourage in Brittany, who supported the French painter with funds from his own regular allowance, and whose interest in occult literature is well known. Gauguin's feelings toward de Haan have often been discussed, but few clues are found in the artist's own writings as to why his old friend should have been used as the central figure in his late painting. It is clear that Gauguin was haunted by the features of this strange dwarflike painter, whom he represented as a leering figure, at once faun and devil.

In *Primitive Tales*, de Haan's bare feet have claws or talons rather than toes; he wears a violet missionary dress, more suitable to women than to men, as well as a decidedly French beret; and he sucks on his hand while staring with hypnotic intensity at the viewer.[1] His face is fleshy and pink, his hair red-orange, and his eyes an unearthly green. In the absence of positive evidence to the contrary, it is tempting to say that Gauguin invented these colors. However, Meyer de Haan did have red hair and green eyes, and Gauguin may have exaggerated their hues in keeping with the palette of his painting.

The figure has been likened to a cat and to a fox.[2] Still others see him as an embodiment of the Western or European world. Yet none of these notions account for all the oddities of dress, pose, and identity. The figure remains one of many

1. The entire hand and face are derived directly from the painting (cat. 93) of 1889, which Gauguin painted for the armoire of Marie Henry, his innkeeper in Le Pouldu. He also used this figure in a woodcut of 1896-1897, Gu 53.

2. Teilhet-Fisk 1983, 155; Andersen 1971, 101.

1902

131.5 x 90.5

oil on canvas

inscribed, signed, and dated at lower right,
CONTES BARBARES/*Paul
Gauguin*/*1902*/*Marquises*

Museum Folkwang, Essen

EXHIBITIONS
Paris 1903, no. 24, *Contes barbares*; Dresden
1914, no. 47; Berlin 1928, no. 75; London
1979, no. 93; Washington 1980, no. 57

CATALOGUE
W 625

shown in Chicago only

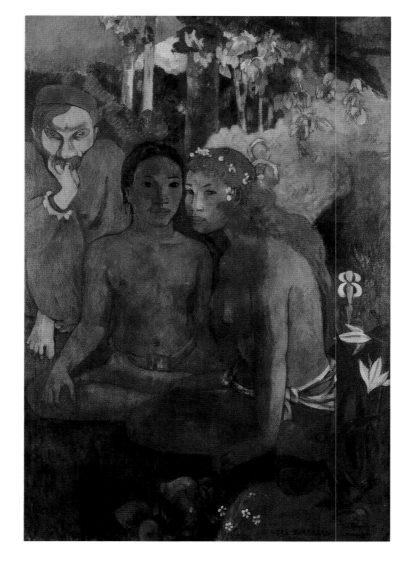

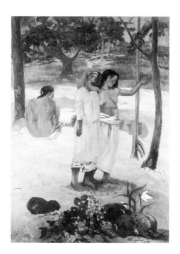

Gauguin, *The Call*, 1902, oil on canvas [The
Cleveland Museum of Art, Gift of Hanro
Fund]

3. Teilhet-Fisk 1983, 155. See also Saunders
1960, 125-126. The various "meanings" of
this position are also discussed.

4. House in London 1979, 79.

deliberate enigmas in Gauguin's late works. The figure is peripheral to the com-
position, though de Haan is perhaps the strongest – and strangest – of the three
figures.

The female figures are no easier to explain. The black-haired woman sits
in a Buddhist pose identified as a "Virasana" position by Teilhet-Fisk.[3] Other
scholars have determined that the pose derives from the sculptural monument of
Borobudur, which Gauguin used frequently as a source for figures and plants.[4]
Clearly, the pose is easily recognizable as Buddhist and therefore associated with
the East in an analogous way to the association between the figure of Meyer de
Haan and the West. Surely, though, the woman must be Polynesian, not Oriental,
and the various allusions created by Gauguin do not present a solution or
meaning.

The central figure, a red-haired Polynesian, is automatically exotic. How-
ever, we know from photographs and other works of art that the model actually
was red-haired and that her name was Tohotaua. Gauguin painted a portrait of
this woman (cat. 279) as well as at least two paintings of her husband, Hapuani,
who has been called a sorcerer in the Gauguin literature (cat. 271, W 615). This
evidence has lead some scholars to link the figure in *Primitive Tales* with the
supernatural elements in Polynesian society. Following this reading, Meyer de

Haan is "the West"; the Buddhist figure is "the East"; and Tohotaua is Polynesian. Yet, again, the visual evidence is more ambiguous. Both the pose of the figure and her elegant if scanty costume are also derived from the Buddhist monument at Borobudur, making any discussion of her Polynesian identity implausible.

Naomi Maurer has approached the problem through the painting's title, *Primitive Tales*: if the two women are storytellers, de Haan may be listening to "the women's tales of symbolic mythic truths with. . . . uncomprehending intensity."[5] House proposes that the "tales" are being told "in" the picture.[6] Unfortunately, there is no evidence for this. None of the figures opens its mouth; none makes a gesture of speech; and each appears as much to be listening to "barbarous tales" told outside of the picture as to be telling them.

Flaubert – and other French masters of the "tale" – did not mean "story" when he used the word "conte." A more correct interpretation is "popular tale," a tale told rather than read, and relating more to indigenous oral traditions than to literature. For that reason, the major characters in Flaubert's *Trois contes* (1876) are illiterate. Again, Gauguin, who was supremely conscious of the problem of literary form, used a word that was self-consciously folkloric rather than literary to entitle an enigmatic painting.

Perhaps because Gauguin scholars are often working from photographs, the meanings they find emerge mostly from the figures. The actual experience of the painting is very different. In fact, the pervasive mystery of the setting, with its vaporous mists, almost palpable "scent," and exotic melange of fruits, flowers, and trees all but overwhelms the figures, who emerge from rather than dominate their exotic setting. The staring eyes of the three figures are scarcely more important than the comparably scaled white flowers scattered about the picture, and the central figure's cascade of red hair does not keep our eyes from the pink orchids that hang over her head. The flowers, with their implied scents, are as powerful in the picture as the figures, and the abstracted iris at the right of the central figure, together with the "lotus" plants used so often by Gauguin in Tahiti, pull our attention away from the staring faces.–R.B.

5. Maurer 1985, 1052.

6. House in London 1979, 79.

Bibliography

COMPILED BY MARLA PRATHER

Adhémar 1958
Adhémar, Hélène, and Charles Sterling, *Peintures: Ecole française. XIXᵉ Siècle* [Musée du Louvre] (Paris, 1958-1961).

d'Albis 1968
d'Albis, Jean, "La Céramique impressionniste à l'atelier de Paris-Auteuil (1873-1885)," *Cahiers de la céramique, du verre et des arts du feu*, no. 41 (1968), 32-42.

Alexandre 1930
Alexandre, Arsène, *Paul Gauguin: Sa vie et le sens de son oeuvre* (Paris, 1930).

Alhadeff 1979
Alhadeff, A., "Minne and Gauguin in Brussels: An unexplored encounter," *La scultura nel XIX secolo* (Bologna, 1979), 177-188.

Amishai-Maisels 1973
Amishai-Maisels, Ziva, "Gauguin's 'Philosophical Eve,'" *Burlington Magazine*, 115, no. 843 (June 1973), 373-382.

Amishai-Maisels 1985
Amishai-Maisels, Ziva, *Gauguin's Religious Themes*, Ph.D. diss., Hebrew University, Jerusalem, 1969 (New York and London, 1985).

Amsterdam 1986
The Prints of the Pont-Aven School: Gauguin and His Circle in Brittany [exh. cat., Smithsonian Institution Traveling Exhibitions Service, The Rijksmuseum Van Gogh, Amsterdam; The Phillips Collection, Washington, D.C.; Detroit Institute of Art; The Art Gallery of Ontario, Toronto; Museum of Modern Art, New York; Cleveland Museum of Art; Museum of Fine Arts, Boston; Museum of Fine Arts, Houston; Fine Arts Museums of San Francisco; The Art Institute of Chicago; Royal Academy of Arts, London].

Andersen 1964
Andersen, Wayne V., "Review of Christopher Gray, *Sculpture and Ceramics of Paul Gauguin*," *Art Bulletin*, 46, no. 4 (December 1964), 579-586.

Andersen 1967
Andersen, Wayne V., *"Gauguin and a Peruvian Mummy,"* *Burlington Magazine*, 109, no. 769 (April 1967), 238-242.

Andersen 1971
Andersen, Wayne V., *Gauguin's Paradise Lost* (New York, 1971)

Anonymous 1893a
"Gauguin et l'Ecole de Pont-Aven," *Essais d'art libre*, vols. 4-5 (November 1893), 164-168.

Anonymous 1893b
"Opinions d'artiste," *L'Escarmouche* (19 November 1893), 3.

Antoine 1889
Antoine, Jules, "Impressionnistes et Synthétistes," *Art et Critique* (9 November 1889), 369-371.

Artur 1982
Artur, Gilles, "Notice historique du Musée Gauguin de Tahiti suivie des quelques lettres inédites de Paul Gauguin," *Journal de la Société des Océanistes*, 38, nos. 74-75 (1982), 7-17.

Aurier 1889
Aurier, Albert, "Concurrence," *Le Moderniste* (27 June 1889), 2.

Aurier 1891
Aurier, G. Albert, "Le Symbolisme en peinture," *Mercure de France*, 2, no. 15 (March 1891), 155-65.

Aurier 1892a
Aurier, Albert, "Les Symbolistes," *Revue Encyclopédique*, 2, no. 32 (April 1892), 474-486.

Aurier 1892b
Aurier, Albert, "Deux expositions: Deuxième exposition des peintres Impressionnistes et Symbolistes," *Mercure de France*, 5, no. 31 (July 1892), 260-263.

Aurier 1892c
Aurier, G. Albert, "Choses d'art," *Mercure de France* 6, no. 33 (September 1892), 92.

Aurier 1893
Aurier, G. Albert, *Oeuvres Posthumes* (Paris, 1893).

Baas 1982
Baas, Jacquelynn, "Auguste Lepère and the Artistic Revival of the Woodcut in France," Ph.D diss., University of Michigan, Ann Arbor, 1982.

Baas and Field 1984
Baas, Jacquelynn, and Richard S. Field, *The Artistic Revival of the Woodcut in France 1850-1900* [exh. cat., University of Michigan Museum of Art; Yale University Art Gallery, New Haven].

Bacou 1960
See page 513, Writings by Paul Gauguin.

Bailly-Herzberg 1980, 1986
Bailly-Herzberg, Janine, ed., *Correspondance de Camille Pissarro*, vol. 1, 1865-1885, (Paris, 1980); vol. 2, 1886-1890 (Paris, 1986).

Bantens 1983
Bantens, Robert James, *Eugène Carrière: His Work and His Influence*, Ph.D. diss., Pennsylvania State University, University Park, Pennsylvania (Ann Arbor, 1983).

Barrow 1979
Barrow, Tui Terence, *The Art of Tahiti* (London, 1979).

Barth 1929
Barth, Wilhelm, "Eine unbekannte Plastik von Gauguin," *Das Kunstblatt*, 13 (June 1929), 182-183.

Béguin 1961
Béguin, Sylvie, "Arearea," *La Revue du Louvre et des Musées de France*, 11 (1961), 215-222.

Bernard 1895
Bernard, Emile, "Lettre ouverte à M. Camille Mauclair," *Mercure de France*, 14, no. 66 (June 1895), 332-339.

Bernard 1903
Bernard, Emile, "Notes sur l'école dite de 'Pont-Aven,'" *Mercure de France*, 48, no. 168 (December 1903), 675-682.

Bernard [1939]
Bernard, Emile, *Souvenirs inédits sur l'artiste peintre Paul Gauguin et ses compagnons lors de leur séjour à Pont-Aven et au Pouldu*, preface by René Maurice (Lorient [1939]).

Bernard 1942
See page 513, Writings by Paul Gauguin.

Berryer 1944
Berryer, Anne-Marie, "A propos d'un vase de Chaplet décoré par Gauguin," *Bulletin des Musées Royaux d'art et d'histoire*, 3rd ser., 16, nos. 1-2 (January-April 1944), 13-27.

Bessanova 1985
Bessanova, Marina et al, *Impressionists and Post-Impressionists in Soviet Museums* (Leningrad, 1985).

Bidou 1903
Bidou, Henry, "Paul Gauguin," *Journal des Débats* (11 September 1903), 499.

Bjürstrom 1986
See page 514, Writings by Paul Gauguin.

Blanche 1928
Blanche, Jacques-Emile, *De Gauguin à la Revue nègre* (Paris, 1928).

Bodelsen 1957
Bodelsen, Merete, "An Unpublished Letter by Theo van Gogh," *Burlington Magazine*, 99, no. 651 (June 1957), 199-202.

Bodelsen 1959
Bodelsen, Merete, "The Missing Link in Gauguin's Cloisonism," *Gazette des Beaux-Arts*, 6th ser., 53 (May-June 1959), 329-344.

Bodelsen 1959a
Bodelsen, Merete, "Gauguin's Bathing Girl," *Burlington Magazine*, 101, no. 674 (May 1959), 186-190.

Bodelsen 1961
Bodelsen, Merete, "Gauguin and the Marquesan God," *Gazette des Beaux-Arts*, 6th ser., 57 (March 1961), 167-80.

Bodelsen 1962
Bodelsen, Merete, "Gauguin's Cézannes," *Burlington Magazine*, 104, no. 710 (May 1962), 204-211.

(B) Bodelsen 1964
Bodelsen, Merete, *Gauguin's Ceramics: A Study in the Development of His Art* (London, 1964).

Bodelsen 1965
Bodelsen, Merete, "The Dating of Gauguin's Early Paintings," *Burlington Magazine*, 107, no. 747 (June 1965), 306-313.

Bodelsen 1966
Bodelsen, Merete, "The Wildenstein-Cogniat Gauguin Catalogue," *Burlington Magazine*, 108, no. 754 (January 1966), 27-38.

Bodelsen 1967
Bodelsen, Merete, "Gauguin Studies," *Burlington Magazine*, 109, no. 769 (April 1967), 217-227.

Bodelsen 1968
Bodelsen, Merete, *Gauguin og Impressionisterne* (Copenhagen, 1968).

Bodelsen 1970
Bodelsen, Merete, "Gauguin, the Collector," *Burlington Magazine*, 112, no. 810 (September 1970), 590-615.

Boston 1984
Edgar Degas: The Painter as Printmaker [exh. cat., Museum of Fine Arts, Boston: Philadelphia Museum of Art; Hayward Gallery, London].

Boudaille 1964
Boudaille, Georges, *Gauguin* (first published Paris, 1963; Engl. trans. by Alisa Jaffa, London, 1964).

Bouge 1956
Bouge, L.-J., "Traduction et interprétations des titres en langue tahitienne inscrits sur les oeuvres océaniennes de Paul Gauguin," *Gazette des Beaux-Arts*, 6th ser., 47 (January-April 1956 [published 1958]), 161-164. Reprinted in *Gauguin, sa vie, son oeuvre* (Paris, 1958).

Bouret 1951
Bouret, Jean, "Gauguin toujours inconnu," *Arts* (27 April 1951), 1 and 8.

Brettell 1977
Brettell, Richard, "Pissarro and Pontoise: The Painter in a Landscape," Ph.D. diss., Yale University, New Haven, 1977.

Brettell 1987
Brettell, Richard, *French Impressionists* [in The Art Institute of Chicago] (New York, 1987).

Breton 1957
Breton, André, *L'Art magique* (Paris, 1957).

Le Bronnec 1954
Le Bronnec, Guillaume, "La Vie de Gauguin aux îles Marquises," *Bulletin de la Société des Etudes Océaniennes*, 9 (March 1954), 198-211.

Brussels 1896.
Troisième Esposition de la Libre Esthétique.

Buffalo 1942
Painting and Sculpture from Antiquity to 1942 [exh. cat., Albright-Knox Art Gallery, Buffalo, New York].

Cachin 1968
Cachin, Françoise, *Gauguin* (Paris, 1968).

Cachin 1979
Cachin, Françoise, "Un bois de Gauguin: *Soyez mystérieuses*," *La Revue du Louvre et des Musées de France*, 29 (1979), 215-218.

Cardon 1893
Cardon, Louis, "Exposition Paul Gauguin chez Durand Ruel," unidentified clipping pasted into "Cahier Pour Aline," 42.

Carley 1975
Carley, Lionel, *Delius, the Paris Years* (London, 1975).

Castel 1982
Castel, Jane, "Gauguin to Moore: Primitivism in Modern Culture," *RACAR*, 9, nos. 1-2 (1982), 94-98.

Chassé 1921
Chassé, Charles, *Gauguin et le groupe de Pont-Aven* (Paris, 1921).

Chassé 1922
Chassé, Charles, "Gauguin et Mallarmé," *L'Amour de l'art*, 3 (August 1922), 246-256.

Chassé 1938
Chassé, Charles, "Les Démêlés de Gauguin avec les gendarmes et l'évêque des îles Marquises," *Mercure de France*, 288 (15 November 1938), 62-75.

Chassé 1947
Chassé, Charles, *Le mouvement symboliste dans l'art du XIXᵉ siècle* (Paris, 1947).

Chassé 1955
Chassé, Charles, *Gauguin et son temps* (Paris, 1955).

Chassé 1959
Chassé, Charles, "Le sort de Gauguin est lié au Krach de 1882," *Connaissance des Arts*, no. 84 (February 1959), 41-43.

Chicago 1984
Degas in The Art Institute of Chicago [exh. cat., The Art Institute of Chicago].

Christophe 1893
Christophe, Jules, *La Plume*, no. 107 (14 October 1893), 416.

Cogniat and Rewald 1962
See page 514, Writings by Paul Gauguin.

Collins 1977
Collins, R.D.J., "Paul Gauguin et la Nouvelle Zélande," *Gazette des Beaux-Arts*, 6th ser., 90 (November 1977), 173-176.

Cooper 1983
See page 513, Writings by Paul Gauguin.

Cooper 1983a
Cooper, Douglas, "Lugano: French Paintings from Russia," *Burlington Magazine*, 125, no. 966 (September 1983), 575-576.

C.V.Z. 1897
C.V.Z., *La Gazette* (28 February 1897).

Damiron 1963
See page 514, Writings by Paul Gauguin, "Cahier pour Aline."

Danielsson 1956
Danielsson, Bengt, *Love in the South Seas* (London, 1956).

Danielsson 1964
Danielsson, Bengt, "När Gauguin censurerades i Stockholm (When Gauguin Was Censored in Stockholm), *Svenska Dagbladet* (11 November 1964).

Danielsson 1965, 1966
Danielsson, Bengt, *Gauguin in the South Seas* (London, 1965; New York, 1966).

Danielsson 1967
Danielsson, Bengt, "Gauguin's Tahitian Titles," *Burlington Magazine*, 9, no. 760 (April 1967), 228-233.

Danielsson 1975
Danielsson, Bengt, *Gauguin à Tahiti et aux îles Marquises* (Papeete, 1975).

Dayot 1894
Dayot, Armand, "La Vie artistique: Paul Gauguin," *Figaro Illustré*, 12, no. 46 (January 1894), 110-111.

Delaroche 1894
Delaroche, Achille, "D'un point de vue esthétique: A propos du peintre Paul Gauguin," *L'Ermitage*, 5 (January 1894), 36-39.

Delouche 1986
Delouche, Denise, et al, *Pont-Aven et ses peintres à propos d'un centenaire* (Rennes, 1986).

Delsemme 1958
Delsemme, Paul, *Un Théoricien du symbolisme: Charles Morice* (Paris, 1958).

Delteil 1908
Delteil, Loys, *Le peintre-graveur illustré XIXᵉ et XXᵉ siècles: Ingres et Delacroix*, vol. 3 (Paris, 1908).

Denis 1890
Denis, Maurice, "Définition du néo-traditionnisme," *Art et Critique* (August 23 and 30, 1890). Reprinted in *Théories, 1890-1910, du symbolisme et de Gauguin vers un nouvel ordre classique* (Paris, 1912, Paris, 1913; Paris, 1920; Paris, 1964).

Denis 1909, 1910
Denis, Maurice, "De Gauguin et de van Gogh au classicisme," *L'Occident*, no. 90 (May 1909), 187-202. Reprinted in *Théories, 1890-1910, du symbolisme et de Gauguin vers un nouvel ordre classique* (Paris 1912, Paris 1913; Paris 1920; Paris 1964). "Von Gauguin and Van Gogh zum Klassizismus," *Kunst und Künstler*, 8 (1910), 86-101.

Denis 1942
Denis, Maurice, "Paul Sérusier: Sa vie, son oeuvre," in Paul Sérusier, *ABC de la Peinture* (Paris, 1942).

Dolent 1891
Dolent, Jean, "Chronique: Paul Gauguin," *Journal des Artistes* (22 February 1891), 49.

Dorival 1951
Dorival, Bernard, "Sources of the Art of Gauguin from Java, Egypt and Ancient Greece," *Burlington Magazine*, 93, no. 577 (April 1951), 118-122.

Dorival 1954
See page 514, Writings by Paul Gauguin.

Dorival 1960, 1961, 1986
Dorival, Bernard, "Le Milieu," *Gauguin* (Paris 1960; Paris 1961; Paris 1986).

Dorra 1953
Dorra, Henri, "The First Eves in Gauguin's Eden," *Gazette des Beaux-Arts*, 6th ser., 40 (March 1953), 189-202.

Dorra 1954
Dorra, Henri, "Gauguin and His Century," *Art Digest*, 28 (15 March 1954), 12-13.

Dorra 1967
Dorra, Henri, "More on Gauguin's Eves," *Gazettes des Beaux-Arts*, 6th ser., 49 (February 1967), 109-12.

Dorra 1970
Dorra, Henri, "Gauguin's Unsympathetic Observers," *Gazette des Beaux-Arts*, 6th ser., 76 (December 1970), 367-372.

Dorra 1976
Dorra, Henri, "Munch, Gauguin, and Norwegian Painters in Paris," *Gazette des Beaux-Arts*, 6th ser., 88 (November 1976), 175-179.

Dorra 1978
Dorra, Henri, "Gauguin's Dramatic Arles Themes," *Art Journal*, 38, no. 1 (Fall 1978), 12-17.

Dorra 1980
Dorra, Henri, "Extraits de la correspondance d'Emile Bernard des débuts à la Rose Croix (1876-1892)," *Gazette des Beaux-Arts*, 6th ser., 96 (December 1980), 235-242.

Dorra 1984
Dorra, Henri, "Le 'Texte Wagner' de Gauguin," *Bulletin de la Société de l'Histoire de l'Art Français* (1984), 281-288.

Dortu 1971
Dortu, M.G., *Toulouse-Lautrec et son oeuvre*, 6 vols. (New York, 1971).

van Dovski 1950
van Dovski, Lee [Herbert Lewandowski], *Paul Gauguin oder die Flucht von der Zivilisation* (Bern, 1950).

van Dovski, 1973
van Dovski, Lee [Herbert Lewandowski], *Die Warheit über Gauguin* (Darmstadt, 1973).

Dujardin 1897
Dujardin, Jules, *La Reforme* (26 February 1897).

Duranty 1876, 1946
Duranty, Edmond, *La Nouvelle peinture à propos du groupe d'artistes qui expose dans les Galeries Durand-Ruel* (Paris, 1876; rev. ed., Paris, 1946; see San Francisco 1986, 477-484).

Duranty 1879
Duranty, Edmond, "La quatrième exposition faite par un groupe d'artistes indépendants," *La Chronique des arts et de la curiosité* (19 April 1879), 126-128.

de La Faille 1970
de La Faille, J. B., *The Works of Vincent van Gogh: His Paintings and Drawings* (New York, 1970).

Fénéon 1888a
Fénéon, Félix, "Calendrier de décembre 1887: V. Vitrines des marchands de tableaux," *La Revue Indépendante* (January 1888). Reprinted in Félix Fénéon, *Oeuvres plus que complètes*, Joan U. Halperin, ed., vol. 1 (Geneva, 1970), 90-91.

Fénéon 1888b
Fénéon, Félix, "Calendrier de janvier," *La Revue Indépendante* (February 1888, 307-308). Reprinted in Félix Fénéon, *Oeuvres plus que complètes*, Joan U. Halperin, ed., vol. 1 (Geneva, 1970), 94-96.

Fénéon 1889a
Fénéon, Félix, "Autre groupe impressionniste," *La Cravache Parisienne*, (6 July 1889), 1-2. Reprinted in Félix Fénéon, *Oeuvres plus que complètes*, Joan U. Halperin, ed., vol. 1 (Geneva, 1970), 157-159.

Fénéon 1889b
Fénéon, Félix, "Certains," *Art et Critique*, December 14, 1889. Reprinted in Félix Fénéon, *Oeuvres plus que complètes*, Joan U. Halperin, ed., vol. 1 (Geneva, 1970), 171-173.

Fénéon 1893
Fénéon, Félix, "Expositions," *La Revue anarchiste* (15 November 1893). Reprinted in Félix Fénéon, *Oeuvres plus que complètes*, Joan U. Halperin, ed., vol. 2 (Geneva, 1970), 930.

Fernier 1978
Fernier, Robert, *La Vie et l'oeuvre de Gustave Courbet: catalogue raisonné*, 2 vols. (Geneva, 1977-1978).

(FM) Fezzi and Minervino 1974
Fezzi, Elda, and Fiorella Minervino, *"Noa Noa" e il primo viaggio a Tahiti di Gauguin* (Milan, 1974).

Field 1960, 1961, 1986
Field, Richard S., "Plagiaire ou créateur?," in *Gauguin* (Paris, 1960; Paris, 1961; Paris, 1986).

Field 1968
Field, Richard S., "Gauguin's Noa Noa Suite," *Burlington Magazine*, 110, no. 786 (September 1968), 500-511.

(F) Field 1973
Field, Richard S., *Paul Gauguin, Monotypes* [exh. cat., Philadelphia Museum of Art].

Field 1977
Field, Richard S., *Paul Gauguin: The Paintings of the First Trip to Tahiti*, Ph.D. diss., Harvard University, Cambridge, 1963 (New York and London, 1977).

Fontainas 1898
Fontainas, André, "Art moderne," *Mercure de France*, 25 (January 1898), 300-307.

Fontainas 1899
Fontainas, André, "Art moderne," *Mercure de France*, 29 (January 1899), 235-242.

Fontainas 1900
Fontainas, André, "Art moderne," *Mercure de France*, 34 (May 1900), 540-547.

Fouquier 1891
Fouquier, Henry, "L'Avenir Symboliste," *Le Figaro* (24 May 1891), 1.

Gauguin, Paul
See pages 513-515, Writings by Paul Gauguin.

Pola Gauguin 1937, 1938
Gauguin, Pola, *My Father, Paul Gauguin* (New York, 1937; trans. from Norwegian by Arthur G. Chater); *Paul Gauguin, mon Père* (Paris, 1938; trans. by Georges Sautreau).

Geffroy 1891
Geffroy, Gustave, "Paul Gauguin," *La Justice* (22 February 1891), 1.

Geffroy 1893a
Geffroy, Gustave, "Paul Gauguin," *La Justice* (12 November 1893), 1.

Geffroy 1893b
Geffroy, Gustave, "Paul Gauguin," *Le Journal* (12 November 1893).

Geffroy 1898
Geffroy, Gustave, "L'art d'aujourd'hui: Falguière-Chauval-Gauguin," *Le Journal* (20 November 1898), 1-2.

Geffroy 1924
Geffroy, Gustave, *Claude Monet, sa vie, son oeuvre* (Paris, 1924).

Genthon 1958
Genthon, István, *Rippl-Rónai: The Hungarian "Nabi"* (Budapest, 1958).

Gérard 1951
Gérard, Judith, "Den lilla flickan och gengangaren" in Gerda Kjellberg, *Hänt och Sant* [Events and Truths] (Stockholm, 1951), 53-74 (unpub. French trans., "La Petite fille et le Tupapau," Danielsson Archives).

Gerstein 1978
Gerstein, Marc S., "Impressionist and Post-Impressionist Fans," Ph.D. diss., Harvard University, Cambridge, Massachusetts, 1978.

Gerstein 1981
Gerstein, Marc S., "Paul Gauguin's Arearea," *Bulletin, The Museum of Fine Arts Houston*, 7, no. 4 (1981), 2-20.

Gerstein 1982
Gerstein, Marc S., "Degas' Fans," *Art Bulletin*, 64, no. 1 (1982), 105-118.

Gide 1924
Gide, André, *Si le grain ne meurt* (Paris, 1924).

Giry 1970
Giry, Marcel, "Une source inédite d'un tableau de Gauguin," *Bulletin de la Société d'Histoire de l'Art Français* (1970), 181-187.

van Gogh 1952-1954
van Gogh, Vincent, *Verzemelden brieven van Vincent van Gogh*, 4 vols. (Amsterdam, 1952-1954).

van Gogh 1960, 1978
van Gogh, Vincent, *Correspondance complète de Vincent van Gogh*, 3 vols. (Paris, 1960; Engl. trans., Boston, 1978).

Goulinat 1925
Goulinat, J. G., "Les Collections Gustave Fayet," *L'Amour de l'Art* (1925), 131-142.

(G) Gray 1963
Gray, Christopher, *Sculpture and Ceramics of Paul Gauguin* (Baltimore, 1963; reprint, New York, 1980).

(Gu) Guérin 1927
Guérin, Marcel, *L'Oeuvre gravé de Gauguin* (Paris, 1927; rev. ed., San Francisco, 1980).

Handy 1927
Handy, Edward Smith Craighill, *Polynesian Religion* (Honolulu 1927).

Handy 1971
Handy, Edward Smith Craighill, *The Native Culture in the Marquesas* (Honolulu, 1929; reprint, New York, 1971).

Hartrick 1939
Hartrick, Archibald S., *A Painter's Pilgrimage through Fifty Years* (Cambridge, 1939).

De Hauke 1961
de Hauke, C.M., *Seurat et son oeuvre*, 2 vols. (Paris, 1961).

Havard 1882
Havard, Henry, "Exposition des artistes indépendants," *Le Siècle* (2 March 1882).

Heller 1985
Heller, Reinhold, "Rediscovering Henri de Toulouse-Lautrec's *At the Moulin Rouge*," *Museum Studies*, 12, no. 2 (1985), 115-135.

Hennequin 1882
Hennequin, Emile, "Beaux arts: Les expositions des arts libéraux et des artistes indépendants," *La Revue littéraire et artistique* (1882), 154-155.

Hepp 1882
Hepp, Alexandre, "Impressionnisme," *Le Voltaire* (3 March 1882).

Herban 1977
Herban III, Mathew, "The Origin of Paul Gauguin's *Vision after the Sermon: Jacob Wrestling with the Angel* (1888)," *The Art Bulletin*, 59, no. 3 (September 1977), 415-420.

Herbert 1958
Herbert, Robert, "Seurat in Chicago and New York," *Burlington Magazine*, 100 (1958), 146-155.

Hermann and Celay 1974
Hermann, B., and J. Cl. Celay, *Plants and Flowers of Tahiti* (Singapore, 1974).

Hoog 1987
Hoog, Michel, *Paul Gauguin: Life and Work* (New York, 1987).

Van Hook 1942
Van Hook, Katrina, "A Self-Portrait by Paul Gauguin from the Chester Dale Collection," *Gazette des Beaux-Arts*, 6th ser., 22 (December 1942), 183-186.

Hulsker 1980
Hulsker, J., *The Complete van Gogh: Paintings, Drawings, Sketches* (Oxford and New York, 1980).

Humbert 1954
Humbert, Agnès, *Les Nabis et leur époque, 1888-1900* (Geneva, 1954).

Huret 1891
Huret, Jules, "Paul Gauguin devant ses tableaux," *Echo de Paris* (23 February 1891), 2.

Huyghe 1951
See page 514, Writings by Paul Gauguin, "Ancien Culte Mahorie."

Huyghe 1952
See page 514, Writings by Paul Gauguin.

Huyghe 1959
Huyghe, René, *Paul Gauguin* (Paris, 1959).

Huyghe 1967
Huyghe, René, *Paul Gauguin* (Paris, 1967).

Huysmans 1883
Huysmans, Joris-Karl, "L'exposition des indépendants en 1881," *L'Art moderne* (Paris, 1883), 85-123.

Jacquier 1957
Jacquier, Henri, "Histoire locale: Le dossier de la succession Paul Gauguin," *Bulletin de la Société des Etudes Océaniennes* (September 1957), 673-711.

Jamot 1906
Jamot, Paul, "Le Salon d'Automne," *Gazette des Beaux-Arts*, 3d ser., 36 (1906), 465-471.

Jarry 1972
Jarry, Alfred, *Oeuvres complètes* (Paris, 1972).

Jénot 1956
Jénot, Lieutenant, "Le premier séjour de Gauguin à Tahiti d'après le manuscrit Jénot (1891-1893)," *Gazette des Beaux-Arts*, 6th ser. (January-April 1956) [published in 1958], 115-126. Reprinted as *Gauguin, sa vie, son oeuvre* (Paris, 1958).

Jirat-Wasiutynski 1976
Jirat-Wasiutynski, Vojtech, "Vincent van Gogh's Magical Conception of Portraiture and Paul Gauguin's *Bonjour Monsieur Gauguin*," *RACAR*, 3, no. 1 (1976), 65-67.

Jirat-Wasiutynski 1975
Jirat-Wasiutynski, Vojtech, *Paul Gauguin in the Context of Symbolism*, Ph.D. diss., Princeton University, 1975 (New York and London, 1978).

Jirat-Wasiutynski et al 1984
Jirat-Wasiutynski, Vojtech, H. Travers Newton, Eugene Farrell, and Richard Newman, *Vincent van Gogh's Self-portrait dedicated to Paul Gauguin: an historical and technical study* (Cambridge, Massachusetts, 1984).

Jirat-Wasiutynski 1987
Jirat-Wasiutynski, Vojtech, "Paul Gauguin's Self Portrait with Halo and Snake: The Artist as Initiate and Magus," *Art Journal*, 46, no. 1 (Spring 1987), 22-28.

Johnson 1975
Johnson, Ronald, "Primitivism in the Early Sculpture of Picasso," *Arts Magazine*, 49, no. 10 (June 1975), 64-68.

Johnson 1986
Johnson, Lee, *The Paintings of Eugène Delacroix: A Critical Catalogue*, vol. 3 (Paris, 1986).

Joly-Segalen 1950
See page 513, Writings by Paul Gauguin.

Jouin 1888
Jouin, Henry, *Musée de portraits d'artistes [. . .] nés en France et y ayant vécu, état de 3000 portraits* (Paris, 1888).

Kahn 1898
Kahn, Gustave, "Roger-Marx," *Mercure de France*, 28, no. 196 (October 1898), 43-52.

Kahn 1925
Kahn, Gustave, "Paul Gauguin," *L'Art et les artistes*, no. 61 (November 1925), 37-64.

Kane 1966
Kane, William M., "Gauguin's *Le Cheval Blanc*: Sources and Syncretic Meanings," *Burlington Magazine*, 108, no. 760 (July 1966), 352-362.

Kopplin 1984
Kopplin, Monika, *Kompositionen im Halbrund: Fächerblätter aus vier Jahrhunderten* [exh. cat., Staatsgalerie Stuttgart Graphische Sammlung, 1984].

(K) Kornfeld
Kornfeld, Eberhard, Harold Joachim, and Elizabeth Morgan, *Paul Gauguin: Catalogue Raisonné of his Prints* (Bern, 1988).

Kostenevich and Bessonova 1983
Kostenevich, Albert, and Marina Bessanova, *Capolavori impressionisti dai musei sovietici* (1983).

Lausanne 1985
L'Autoportrait [exh. cat., Musée Cantonal des Beaux-Arts Lausanne; Württembergischer Kunstverein Stuttgart].

Landy 1967
Landy, Barbara, "The Meaning of Gauguin's 'Oviri' Ceramic," *Burlington Magazine*, 109, no. 769 (April 1967), 242-246.

Leblond 1903
Leblond, Marius-Ary, "Gauguin en Océanie," *Revue Universelle* 3, no. 96 (15 October 1903), 536-537.

Leclercq 1892
Leclercq, Julien, "Albert Aurier," *Essais d'art libre*, 2 (November 1892), 201-208.

Leclercq 1894
Leclercq, Julien, "Sur la peinture (de Bruxelles à Paris)," *Mercure de France*, 10, no. 53 (May 1894), 71-77.

Leclercq 1894b
Leclercq, Julien, "La Lutte pour les peintres," *Mercure de France*, 12 (November 1894), 254-271.

Leclercq 1895
Leclercq, Julien, "Choses d'art: Exposition Paul Gauguin," *Mercure de France*, 13, no. 61 (January 1895), 121-122.

Lemasson 1950
Lemasson, Henri, "La vie de Gauguin à Tahiti," *Encyclopédie de la France et d'outremer* (February 1950), 18-19.

Lemoisne 1946-1949
Lemoisne, Paul-André, *Degas et son oeuvre*, 4 vols. (Paris, 1946-1949); reprint with supplement by Philippe Brame and Theodore Reff (New York and London, 1984).

Levy 1973
Levy, Robert I., *Tahitians: Mind and Experience in the Society Islands* (Chicago, 1973).

Loize 1951
Loize, Jean, *Les Amitiés du peintre Georges-Daniel de Monfreid et ses reliques de Gauguin* (Paris, 1951).

Loize 1961
See page 515, Writings by Paul Gauguin, "Noa Noa."

Loize 1966
See page 515, Writings by Paul Gauguin, "Noa Noa."

London 1981
Camille Pissarro, 1830-1903 [exh. cat., Galeries Nationales du Grand Palais, Paris; Hayward Gallery, London; Museum of Fine Arts, Boston].

Longuy 1979
Exposition Paul Aubé [exh. cat., Musée Municipal de Longuy].

Loti 1879
Loti, Pierre [Julien Viaud], *Le Mariage de Loti* (Paris, 1880). Originally published as *Rarahu: idylle polynésienne* (Paris, 1879).

Luthi 1982
Luthi, Jean-Jacques, *Emile Bernard: Catalogue raisonné de l'oeuvre peint* (Paris, 1982).

Malingue 1943, 1948
Malingue, Maurice, *Gauguin, le peintre et son oeuvre* (Paris, 1943; Paris 1948).

Malingue 1949
See page 514, Writings by Paul Gauguin.

Malingue 1959
Malingue, Maurice, "Du nouveau sur Gauguin," *L'Oeil* (July-August 1959), 35 and 38.

Mantz 1881
Mantz, Paul, "Exposition des oeuvres des artistes indépendants," *Le Temps* (23 April 1881).

Marks-Vandenbroucke unpub. thesis 1956
Marks-Vandenbroucke, Ursula, "Gauguin – Ses origines et sa formation artistique," *Gazette des Beaux-Arts*, 6th ser., 47 (January-April 1956) [published 1958], 9-62. Reprinted in *Gauguin, sa vie, son oeuvre* (Paris, 1958).

Marks-Vandenbroucke 1956
Marks-Vandenbroucke, Ursula, "Paul Gauguin," Ph.D. diss., Université de Paris, 1956.

Mauclair 1893
Mauclair, Camille, "Les Portraits du prochain siècle," *Essais d'art libre*, 4 (1893), 117-121.

Mauclair 1895
Mauclair, Camille, "Choses d'art," *Mercure de France*, 14, no. 66 (June 1895), 357-359.

Maugham 1949
Maugham, Somerset, *A Writer's Notebook* (London, 1949).

Mauner 1978
Mauner, Georges, *The Nabis: Their History, Their Art 1886-1896* (New York, 1978).

Maurer 1985
Maurer, Naomi, "The Pursuit of Spiritual Knowledge: The Philosophical Meaning and Origins of Symbolist Theory and its Expression in the Thought and Art of Redon, van Gogh, and Gauguin," Ph.D. diss., University of Chicago, 1985.

Maus 1889
Maus, Octave, "Le Salon des XX à Bruxelles," *La Cravache*, no. 417 (16 February 1889), 1.

Mellerio 1913
Mellerio, André, *Odilon Redon* (Paris, 1913).

Menard 1981
Menard, Wilmon, "Author in Search of an Artist," *Apollo*, 114, no. 234 (August 1981), 114-117.

Merki 1893
Merki, Charles, "Apologie pour la peinture," *Mercure de France*, 8, no. 42 (June 1893), 139-153.

Merlhès 1984
See page 514, Writings by Paul Gauguin.

Merson 1893
Merson, Olivier, "Chronique des Beaux-Arts: Exposition Paul Gauguin," *Le Monde illustré* (16 December 1893), 395.

Millard 1976
Millard, Charles W., *The Sculpture of Edgar Degas* (Princeton, 1976).

Mirbeau 1891
Mirbeau, Octave, "Paul Gauguin," *L'Echo de Paris* (16 February 1891), 1. Published as preface to *Catalogue d'une vente de 30 tableaux de Paul Gauguin* (Paris, 1891), 3-12. Reprinted in *Des Artistes* (Paris, 1922), 119-129.

Mirbeau 1891a
Mirbeau, Octave, "Paul Gauguin," *Le Figaro* (18 February 1891), 2.

Mirbeau 1893
Mirbeau, Octave, "Retour de Tahiti," *Echo de Paris* (14 November 1893), 1.

Mirbeau 1914
Mirbeau, Octave, *Cézanne* (Paris, 1914).

Mirbeau 1922
Mirbeau, Octave, "Letters à Claude Monet, *"Les cahiers d'aujourd'hui*, no. 9 (1922), 161-176.

Mittelstädt 1966
Mittelstädt, Kuno, *Die Selbstbildnisse Paul Gauguins* (Berlin 1966; Engl. trans. by E.G. Hull, Oxford and London, 1968).

Moerenhout 1837
Moerenhout, J.-A., *Voyages aux îles du grand océan*, 2 vols. (Paris, 1837).

Mondor 1973-1983
Mondor, Henri, ed., *Stéphane Mallarmé: Correspondance*, 11 vols. (Paris, 1959-1985).

Monfreid 1903
de Monfreid, Daniel, "Sur Paul Gauguin," *L'Ermitage*, 3 (December 1903), 265-283.

de Mont 1881
de Mont, Elie, "L'exposition du Boulevard des Capucines, *La Civilisation*, (21 April 1881).

Morice 1891
Morice, Charles, Review of *La Décoration et l'art industriel à l'Exposition Universelle de 1889* by Claude Roger-Marx, *Mercure de France*, 2, no. 14 (February 1891), 123-124.

Morice 1893a
Morice, Charles, "Paul Gauguin," *Mercure de France*, 9, no. 48 (December 1893), 289-300.

Morice 1893b
Morice, Charles, Introduction to *Exposition d'oeuvres récentes de Paul Gauguin* [exh. cat., Galerie Durand-Ruel, Paris, 1893].

Morice 1894
Morice, Charles, "L'Atelier de Paul Gauguin," *Le Soir* (4 December 1894), 2.

Morice 1895
Morice, Charles, "Le Départ de Paul Gauguin," *Le Soir* (28 June 1895), 2.

Morice 1896
Morice, Charles, "Paul Gauguin," *Les Hommes d'aujourd'hui*, 9 (1896). Published in abridged form in "Paul Gauguin," *Journal des artistes* (19 April 1896).

Morice 1903a
Morice, Charles, "Paul Gauguin," *Mercure de France*, 48, no. 166 (October 1903), 100-135.

Morice 1903b
Morice, Charles, "Quelques opinions sur Paul Gauguin," *Mercure de France*, 48, no. 167 (November 1903), 413-433.

Morice 1919, 1920
Morice, Charles, *Gauguin* (Paris, 1919; 2d ed., Paris, 1920).

Mucha 1967
Mucha, Jirí, *The Master of Art Nouveau, Alphonse Mucha* (Prague, 1966; reprint, Prague, 1967).

Natanson 1893
Natanson, Thadée, "Expositions: Oeuvres récentes de Paul Gauguin," *La Revue Blanche*, 5, no. 26 (December 1893), 418-422.

Natanson 1896
Natanson, Thadée, "Peinture," *La Revue Blanche* (1 December 1896), 516-518.

Natanson 1898
Natanson, Thadée, "Petite Gazette d'art: De M. Paul Gauguin," *La Revue Blanche*, 17 (December 1898), 544-546.

New York 1980
The Painterly Print: Monotypes from the Seventeenth Century to the Twentieth century [exh. cat., Metropolitan Museum of Art, New York; Museum of Fine Arts, Boston].

New York 1983
Manet [exh. cat., Galeries Nationales du Grand Palais, Paris; Metropolitan Museum of Art, New York].

New York 1984
Van Gogh in Arles [exh. cat., Metropolitan Museum of Art, New York].

Nochlin 1972
Nochlin, Linda, "Eroticism and Female Imagery in Nineteenth-century Art," *Woman as Sex Object* (New York, 1972).

O'Brien 1920
O'Brien, Frederick, "Gauguin in the South Seas," *The Century*, 100, no. 2 (June 1920), 225-235.

Olin 1891
Olin, Pierre-M., "Les XX," *Mercure de France*, 2, no. 16 (April 1891), 236-240.

O'Reilly
O'Reilly, Patrick, *La Danse à Tahiti* (Paris, n.d.).

O'Reilly 1962, 1966
O'Reilly, Patrick, and Raouol Teissier, *Tahitiens: Répertoire bio-bibliographique de la Polynésie Française* (Paris, 1962). *Tahitiens: Supplément* (Paris, 1966).

Paris 1877
3e Exposition de peinture [exh. cat., Paris).

Paris 1878
Catalogue de tableaux modernes composant la collection de M. G. Arosa (Paris, sale, 25 February 1878).

Paris 1985
L'Impressionnisme et le paysage français [exh. cat., Galeries Nationales du Grand Palais, Paris].

Passe 1891
Passe, Jean, "Impressionnistes et symbolistes," *Journal des artistes* (27 December 1891), 390.

Pazdirek 1967
Pazdirek, Franz, ed., *Universal-Handbuch der Musikliteratur aller Zeiten und Völker* (Hilversum, 1967).

Le Paul and Dudensing 1978
Le Paul, C. G., and G. Dudensing, "Gauguin et Schuffenecker," *Bulletin des amis des musées de Rennes* (Summer 1978), 48-60.

Perruchot 1961
Perruchot, Henri, *La vie de Gauguin* (Paris, 1961).

Philadelphia 1973
Paul Gauguin, Monotypes [exh. cat., Philadelphia Museum of Art].

le Pichon 1986
le Pichon, Yann, *Sur les Traces de Gauguin* (Paris, 1986). Published in English as *Gauguin. Life. Art. Inspiration*, trans. by I. Mark Paris (New York, 1986).

Pickvance 1970
Pickvance, Ronald, *The Drawings of Gauguin* (London, New York, Sydney, Toronto, 1970).

Pickvance 1985
Pickvance, Ronald, "Review of *Correspondance de Paul Gauguin: Tome Premier, 1873-1888*. Ed. Victor Merlhès," *Burlington Magazine*, 127, no. 987 (June 1985), 394-395.

Pissarro and Venturi 1939
Pissarro, Ludovic, and Lionello Venturi, *Camille Pissarro: son art son oeuvre*, 2 vols. (Paris, 1939).

Pissarro 1950
Pissarro, Camille, *Camille Pissarro: Lettres à son fils Lucien*, John Rewald, ed. (Paris, 1950).

Pope 1981
Pope, Karen Kristine Rechnitzer, "Gauguin and Martinique," Ph.D. diss., University of Texas, Austin, 1981.

Psichari 1947
Psichari, Henriette, *Renan et la guerre de 1870* (Paris, 1947).

Rachilde 1891
Rachilde [Marguerite Vallette], *Théâtre, avec un dessin inédit de Paul Gauguin et une préface de l'auteur* (Paris, 1891).

Reff 1967
Reff, Theodore, "Pissarro's Portrait of Cézanne," *Burlington Magazine*, 109, no. 776 (November 1967), 627-633.

Reff 1967a
Reff, Theodore, *Degas: The Artist's Mind* (New York, 1976).

Reff 1976b
Reff, Theodore, *The Notebooks of Edgar Degas*, 2 vols. (Oxford, 1976; 2d rev. ed., New York, 1985).

Renan 1947
Renan, Ernest, *Lettres familières* (Paris, 1947).

Renard 1894
Renard, Jules, *Journal* (Paris, 1894).

Reverseau 1972
Reverseau, Jean-Pierre, "Pour une étude du thème de la tête coupée dans la littérature et la peinture dans la sec-onde partie du XIXᵉ siècle," *Gazette des Beaux-Arts*, 6th ser., 80 (September 1972), 173-184.

Rewald 1938
Rewald, John, *Gauguin* (Paris, 1938).

Rewald 1943
See page 514, Writings by Paul Gauguin.

Rewald 1958
Rewald, John, *Gauguin Drawings* (New York and London, 1958).

Rewald 1959
Rewald, John, "The Genius and the Dealer," *Art News*, 58, no. 3 (May 1959), 30-31, 62-65.

Rewald 1961, 1973, 1975
Rewald, John, *The History of Impressionism* (3d rev. ed., New York, 1961; 4th rev. ed., New York, 1973; French trans., Paris, 1975).

Rewald 1956, 1962, 1978
Rewald, John, *Post-Impressionism from van Gogh to Gauguin* (New York, 1956; 2d rev. ed., New York, 1962; 3d rev. ed., New York, 1978; French trans., Paris, 1961).

Rewald 1973
Rewald, John, "Theo van Gogh, Goupil, and the Impressionists," *Gazette des Beaux Arts*, 6th ser., 81 (January and February 1973), 1-108. Reprinted in Rewald 1986, 7-115.

Rewald 1986
Rewald, John (Irene Gordon and Francis Weitzenhoffer, eds.), *Studies in Post-Impressionism* (New York, 1986).

Rey 1927
Rey, Robert, "La Belle Angèle de Paul Gauguin," *Beaux Arts*, 5, no. 7 (April 1927), 105-106.

Rey 1928
Rey, Robert, "Les Bois sculptées de Paul Gauguin," *Art et Décoration* (February 1928), 57-64.

Rey 1950
Rey, Robert, *Onze Menus de Gauguin* (Geneva, 1950).

Ribault-Menetière 1947
Ribault-Menetière, J., "Une lettre inédite de Gauguin," *Arts* (28 March 1947).

Richardson 1959
Richardson, John, "Gauguin at Chicago and New York," *Burlington Magazine*, 101, no. (May 1959), 188-192.

Rippl-Rónai 1957
Rippl-Rónai, József, *Emlékezései* (Budapest, 1957).

Rivière 1882
Rivière, Henri, "Aux Indépendants," *Le Chat Noir* (8 April 1882).

Robaut 1905
Robaut, Alfred, *L'Oeuvre de Corot* (Paris, 1905).

Roger-Marx 1891a
Roger-Marx, Claude, "Paul Gauguin," *Le Voltaire* (20 February 1891), 1-2.

Roger-Marx 1891b
Roger-Marx, Claude, "Arts Décoratifs et industriels aux Salons du Palais de l'Industrie et du Champ de Mars," *Revue Encyclopédique* (15 September 1891), 586-587.

Roger-Marx 1894
Roger-Marx, Claude, "Revue artistique: Exposition Paul Gauguin," *Revue Encyclopédique*, 4, no. 7 (1 February 1894), 33-34.

Roger-Marx 1910
Roger-Marx, Claude, "Souvenirs sur Ernest Chaplet," *Art et Décoration* (March 1910).

Roinard et al, 1894
Roinard, P.-N. et al, *Portraits du prochain siècle: Poètes et prosateurs*, vol. 1 (Paris, 1894; reprint Paris, 1970).

Roskill 1969
Roskill, Mark, Unpublished supplement to *Van Gogh, Gauguin, and the Impressionist Circle*, 1969.

Roskill 1970
Roskill, Mark, *Van Gogh, Gauguin, and the Impressionist Circle* (Greenwich, Connecticut, 1970).

Rostrup 1956
Rostrup, Havaard, "Gauguin et le Danemark," *Gazette des Beaux-Arts*, 6th ser., 47 (January-April 1956) [published in 1958], 63-82. Reprinted in *Gauguin, Sa Vie, Son Oeuvre* (Paris, 1958).

Rostrup 1960
Rostrup, Haavard, "Eventails et pastels de Gauguin," *Gazette des Beaux-Arts*, 6th ser., 56 (September 1960), 157-164.

Rothschild 1961
Rothschild, Ruth Deborah, "A Study in the Problems of Self-Portraiture: The Self-Portraits of Paul Gauguin," Ph.D. diss., Columbia University, New York, 1961.

Rotonchamp 1906, 1925
de Rotonchamp, Jean [Louis Brouillon], *Paul Gauguin* (Weimar, 1906; reprint, Paris, 1925).

Rouart and Wildenstein 1975
Rouart, Denis, and Daniel Wildenstein, *Edouard Manet: Catalogue Raisonné*, 2 vols. (Lausanne and Paris, 1975).

Saint-Germain-en-Laye 1981
Filiger [ex. cat., Musée Départemental du Prieuré, Saint-Germain-en-Laye]

San Francisco 1986,
The New Painting: Impressionism 1874-1886 [exh. cat., The Fine Arts Museums of San Francisco, M.H. de Young Memorial Museum; National Gallery of Art, Washington].

Saunders 1960
Saunders, E. Dale, *Mudra: A Study of Symbolic Gestures in Japanese Buddhist Sculpture* (New York, 1960).

Segalen 1904
Segalen, Victor, "Gauguin dans son dernier décor," *Mercure de France*, 50, no. 174 (June 1904), 679-685.

Segalen 1918
Segalen, Victor, "Hommage à Gauguin," in *Lettres de Paul Gauguin à Georges-Daniel de Monfreid* (Paris, 1918, 1-77; rev. ed., Paris, 1950, 11-47).

Séguin 1903a
Séguin, Armand, "Paul Gauguin," *L'Occident* (March 1903), 158-167.

Séguin 1903b
Séguin, Armand, "Paul Gauguin," *L'Occident* (April 1903), 230-239.

Séguin 1903c
Séguin, Armand, "Paul Gauguin," *L'Occident* (May 1903), 298-305.

Sérusier 1950:
See page 514, Writings by Paul Gauguin.

Shapiro and Melot 1975
Shapiro, Barbara, and Michel Melot, "Les Monotypes de Camille Pissarro," *Nouvelles de l'estampe*, no. 19 (January-February 1975), 16-17.

Siger 1904
Siger, Carl, "Paul Gauguin colon," *Mercure de France* (August 1904), 569-573.

Silvestre 1880
Silvestre, Armand, "Le Monde des arts: Exposition de la rue des Pyramides," *La Vie moderne* (24 April 1880), 262.

Sprinchorn 1968
Sprinchorn, Evert., ed., *Inferno, Alone and Other Writings* (Garden City, New York, 1968).

Sterling and Salinger 1967
Sterling, Charles, and Margaretta M. Salinger, *French Paintings, a Catalogue of the Collection of the Metropolitan Museum of Art*, vol. 3 (New York, 1967).

Strindberg 1981
Strindberg, Auguste, *Folke Olffon* (Stockholm, 1981).

Strindberg 1895
Strindberg, Auguste, "L'Actualité: Le misogyne Streinberg [sic] contre Monet," *L'Eclair* (15 February 1895), 1.

Stuckey and Maurer 1979
Stuckey, Charles, and Naomi E. Maurer, *Toulouse-Lautrec: Paintings* [exh. cat., The Art Institute of Chicago, 1979].

Sutton 1949
Sutton, Denys, *"La Perte du pucelage* by Paul Gauguin," *Burlington Magazine*, 91, no. 553 (April 1949), 103-105.

Tardieu 1895
Tardieu, Eugène, "M. Paul Gauguin," *L'Echo de Paris* (13 May 1895), 2.

Teilhet 1979
Teilhet, Jehanne H., " 'Te Tamari No Atua': An Interpretation of Paul Gauguin's Tahitian Symbolism," *Arts*, 53, no. 5 (January 1979), 110-111.

Teilhet-Fisk 1983
Teilhet-Fisk, Jehanne, *Paradise Reviewed: An Interpretation of Gauguin's Polynesian Symbolism*, Ph.D. diss., University of California at Los Angeles, 1975 (Ann Arbor, Michigan, 1983).

Thirion 1956
Thirion, Yvonne, "L'Influence de l'estampe japanaise dans l'oeuvre de Gauguin," *Gazette des Beaux-Arts*, 6th ser., 47 (January-April 1956), 95-114. Reprinted in *Gauguin, Sa Vie, Son Oeuvre* (Paris, 1958).

Thomson 1987
Thomson, Belinda, *Gauguin* (London, 1987).

Trianon 1881
Trianon, Henry, "Sixième exposition de peinture par un groupe d'artistes, 35 boulevard des Capucines," *Le Constitutionnel* (24 April 1881).

Trollope 1840
Trollope, T. Adolphus, *A Summer in Brittany*, 2 vols., (London, 1840).

Venturi 1936
Venturi, Lionello, *Cézanne, son art, son oeuvre* (Paris, 1936).

Vielliard 1893
Vielliard, Fabien, "Paul Gauguin," *L'Art littéraire*, no. 13 (December 1893), 51.

Viirlaid 1980
Viirlaid, H.K., "The Concept of Vision of Paul Gauguin's *Vision After the Sermon*," Ph.D. diss., National Library of Canada, Ottawa, 1980.

Vincent 1956
Vincent, Madeleine, *La Peinture des XIXe et XXe siècles, Musée de Lyon* (Lyon, 1956).

Vollard 1936, 1937
Vollard, Ambroise, *Recollections of a Picture Dealer*, trans. from original manuscript by Violet M. Macdonald (London, 1936); *Souvenirs d'un marchand de tableaux* (Paris, 1937).

Vollard 1938
Vollard, Ambroise, *En écoutant Cézanne, Degas, Renoir* (Paris, 1938).

Wadley 1985
See page 515, Writings by Paul Gauguin, "Noa-Noa."

Walter 1978
Walter, Elisabeth, "Madeleine au Bois d'Amour par Emile Bernard," *Revue du Louvre*, 28 (1978), 286-291.

Washington 1984
Watteau [exh. cat., National Gallery of Art, Washington].

Washington 1987
Master Drawings from the Armand Hammer Collection [exh. cat., National Gallery of Art, Washington, D.C.].

Wauters 1891
Wauters, A.J., "Aux XX," *La Gazette* (20 February 1891).

Welsh 1988
Welsh, Robert, *Revue de l'Art* (forthcoming in 1988).

Wichmann 1980
Wichmann, Siegfried, *Japonismus: Ostasien-Europa, Begegnungen in der Kunst des 19. und 20. Jahrhunderts* (Herrsching, 1980).

Wichmann 1981, 1985
Wichmann, Siegfried, *Japonisme: the Japanese Influence on Western Art in the 19th and 20th Centuries* (New York, 1981; 2nd ed., New York, 1985).

Wildenstein 1956
Wildenstein, Georges, "Gauguin in Bretagne," *Gazette des Beaux-Arts*, 6th ser. (January-April, 1956) [published in 1958], 83-94. Reprinted in *Gauguin, Sa Vie, Son Oeuvre* (Paris, 1958).

List of Exhibitions and Sales

(W) Wildenstein 1964
Wildenstein, Georges, *Gauguin*, edited by Raymond Cogniat and Daniel Wildenstein, vol. 1, Catalogue (Paris, 1964).

Wilenski [1940]
Wilenski, Reginald Howard, *Modern French Painters* (New York, [1940]).

de Wysewa 1886
de Wysewa, Teodor, "Notes sur la peinture Wagénerienne et la salon de 1886," *La Revue Wagérienne* (8 May 1886), 100-113.

Only exhibitions and sales including works by Gauguin mentioned in this catalogue are listed here.

Paris 1876
Salon, Palais des Champs Elysées

Paris 1879
4ᵐᵉ Exposition de peinture [fourth impressionist exhibition]

Paris 1880
5ᵐᵉ Exposition de peinture [fifth impressionist exhibition]

Paris 1881
6ᵐᵉ Exposition de peinture [sixth impressionist exhibition]

Paris 1882
7ᵐᵉ Exposition des artistes indépendants [seventh impressionist exhibition]

Rouen 1884
Exhibition of the Murer Collection at the Hôtel Dauphin et d'Espagne

Rouen 1884
Exposition municipale de Beaux-Arts

Kristiana [Oslo] 1884
Kunstudstillingen

Copenhagen 1885
Exhibition of the Society of the Friends of Art

Nantes 1886
Exposition des Beaux-Arts, Palais du Cours St-André

Paris 1886
8ᵐᵉ Exposition de peinture [eighth impressionist exhibition]

Paris 1887
Exhibition of paintings and ceramics, Boussod & Valadon.

Paris 1888
Works on exhibit throughout the year and exhibition in the basement in November, Boussod & Valadon

Paris, Boussod & Valadon 1889
Works on exhibit throughout the year, Boussod & Valadon.

Brussels 1889
Les XX, sixième exposition annuelle

Paris 1889
L'Exposition de peintures du groupe impressionniste et synthétiste, Café des Arts [Café Volpini], Champ-de-Mars

Copenhagen 1889
Nordiske og Franske Impressionister [Scandinavian and French impressionists], Kunstforeningen [Society of the Friends of Art]

Paris 1890
Works on view throughout the year, Boussod & Valadon

Brussels 1891
Les XX, huitième exposition annuelle

Paris, Drouot 1891
Vente de tableaux de Paul Gauguin, Hôtel Drouot (exhibition, 22 February 1891; sale, 23 February 1891)

Paris 1891
Salon de la Société Nationale des Beaux-Arts, Champs-de-Mars

Paris 1891
Exhibition in the foyer of the Vaudeville Theater (21 May 1891)

Paris 1891
Peintres impressionnistes et symbolistes, Galerie Le Barc de Boutteville

Paris 1892
Deuxième exposition des peintres impressionnistes et symbolistes, Galerie Le Barc de Boutteville

Paris 1892
Exhibits first Tahitian painting (W 420) at Boussod & Valadon in September

Paris 1892
Troisième exposition des peintres impressionnistes et symbolistes, Galerie Le Barc de Boutteville

Copenhagen, Kleis 1893
Martsudstillingen [The March Exhibition of Nabi and Symbolist Art], Kleis Gallery

Copenhagen, Udstilling 1893
Den frie Udstilling [Free Exhibition of Modern Art]

Paris 1893
Exhibits works at Galerie Le Barc de Boutteville in the summer

Paris 1893
Portraits du prochain siècle, Galerie Le Barc de Boutteville

Paris, Durand-Ruel 1893
Exposition d'oeuvres récentes de Paul Gauguin, Galerie Durand-Ruel

Paris, Le Barc de Boutteville 1893
Cinquième exposition des peintres impressionnistes et synthétistes, Galerie Le Barc de Boutteville

Brussels 1894
Première exposition de la Libre Esthétique

Paris 1894
Sixième exposition des peintres impressionnistes et symbolistes, Galerie Le Barc de Boutteville

Paris 1894
Vente Mme Vve Tanguy, Hôtel Drouot (1-2 June 1894)

Paris, Drouot 1895
Vente de tableaux et dessins par Paul Gauguin, Hôtel Drouot, (18 February 1895)

Paris 1895
Exhibits several works in March at Galerie Ambroise Vollard

Paris 1895
Salon de la Société Nationale des Beaux-Arts, Champ-de-Mars

Paris 1896
Exhibits works at Librairie de l'Art Indépendant, 11 rue de la Chaussée d'Antin

Paris 1896
Exposition de l'art mystique, Petit Théâtre Français (12 November 1896)

Paris, Vollard 1896
Exhibition at Galerie Ambroise Vollard

Brussels 1897
Quatrième exposition de la Libre Esthétique

Paris 1897
Quinzième Exposition des peintres impressionnistes et symbolistes, Galerie Le Barc de Boutteville

Stockholm 1898
Exhibition of Modern French Art, Swedish Academy of Arts

Paris 1898
Exhibition at Galerie Ambroise Vollard

Paris 1900
L'Exposition centennale de l'art français de 1800 à 1889, Exposition Universelle

Paris 1900
Groupe Esotérique, 9bis, rue de Londres (home of Paul Valéry)

Béziers 1901
Société des Beaux-Arts, Salle Berlioz, rue Solférino

Paris, Salon d'Automne 1903
Salon d'Automne, Petit Palais

Paris 1903
Exposition Paul Gauguin, Galerie Ambroise Vollard

Brussels 1904
Exposition des peintres impressionnistes, La Libre Esthétique

Weimar 1905
Exhibition at the Grossherzoglichen Museum am Karlsplatz

Berlin 1906
Berliner Sezession

Paris 1906
Salon d'Automne, 4me exposition: Oeuvres de Gauguin, Grand Palais

Budapest 1907
Gauguin, Cézanne et al., Nemzeti Szalon

Paris 1910
Exposition d'oeuvres de Paul Gauguin, Galerie Ambroise Vollard

Paris 1910
Galerie E. Blot

Munich 1910
Die Sammlung Vollard, Modernen Galerien Thannhauser;Arnold Kunstsalon, Dresden

London 1910
Manet and the Post-Impressionists, Grafton Galleries

London 1911
Exhibition of Pictures by Paul Cézanne and Paul Gauguin, Stafford Gallery

Saint Petersburg 1912
Exposition centennale de l'art français 1812-1912, Institut français

Cologne 1912
Internationale Kunstausstellung des Sonderbundes, Städtische Ausstellunghalle

New York [Chicago-Boston] 1913
The Armory Show: International Exhibition of Modern Art, Armory of the Sixty-ninth Infantry [The Art Institute of Chicago; Copley Hall, Boston]

Frankfurt 1913
Union Artistique

Stuttgart 1913
Grosse Kunstausstellung, Königliches Kunstgebäude

Dresden 1914
Französische Malerei des 19. Jahrhunderts, Ernst Arnold Kunstsalon

Paris 1917
Exposition Paul Gauguin, Galerie Nunès & Fiquet

Zürich 1917
Französische Kunst des XIX. u XX. Jahrhunderts, Züricher Kunsthaus

Paris 1918
Catalogue des tableaux modernes et anciens composant la collection Edgar Degas, Galerie Georges Petit (26 and 27 March 1918)

Paris 1919
Paul Gauguin: Exposition d'oeuvres inconnues, Galerie Barbazanges

New York 1921
Loan Exhibition of Impressionist and Post-Impressionist Paintings, The Metropolitan Museum of Art

Paris 1923
Exposition rétrospective de Paul Gauguin, Galerie L. Dru

London 1924
Paul Gauguin, Leicester Galleries

Boston 1925
Boston Art Club

Paris 1926
Exposition rétrospective: Hommage au génial artiste Franco-Péruvien, Association Paris-Amérique Latine

Moscow 1926
Gauguin, Moscow Museum of Modern Art

Oslo 1926
Foreningen Fransk Kunst: Paul Gauguin, Nasjonalgalleriet

Berlin 1927
Erste Sonderausstellung in Berlin, Galerien Thannhauser (at the Berliner Künstlerhaus)

Paris 1927
Sculptures de Gauguin, Musée du Luxembourg

Paris 1928
P. Gauguin, sculpture et gravure, Musée du Luxembourg

Venice 1928
XVI^A Esposizione internationale d'arte della città di Venezia: Mostra retrospettiva di Paul Gauguin, Pallazzo dell' esposizione

Basel 1928
Paul Gauguin, Kunsthalle Basel

Berlin 1928
Paul Gauguin, Galerien Thannhauser

London 1931
Exhibition of The Durrio Collection of Works by Paul Gauguin, The Leicester Galleries

New York 1936
Paul Gauguin 1848-1903: A Retrospective Loan Exhibition for the Benefit of les Amis de Gauguin and the Penn Normal Industrial and Agricultural School, Wildenstein and Company

Cambridge 1936
Paul Gauguin, The Fogg Art Museum

Baltimore 1936
Paul Gauguin: A Retrospective Exhibition of his Paintings, Baltimore Museum of Art

San Francisco 1936
Paul Gauguin: Exhibition of Paintings and Prints, San Francisco Museum of Art

Paris 1936
La Vie ardente de Paul Gauguin, Gazette des Beaux-Arts

Paris 1938
Georges-Daniel de Monfreid et son ami Paul Gauguin, Galerie Charpentier

Paris 1942
Gauguin: Aquarelles, monotypes, dessins, Galerie Marcel Guiot

New York 1946
A Loan Exhibition of Paul Gauguin for the Benefit of the New York Infirmary, Wildenstein and Company

Copenhagen 1948
Paul Gauguin, 1848-1903: Retrospectiv Udstilling i Anledning af Hundsedaaret for hans Fødsel, Ny Carlsberg Glyptothek

Paris, Kléber 1949
Gauguin et ses amis, Galerie Kléber

Paris, Orangerie 1949
Gauguin: Exposition du centenaire, Orangerie des Tuileries

Basel 1949
Ausstellung Gauguin zum 100. Geburtsjahr, Kunstmuseum

Lausanne 1950
Gauguin: Exposition du centenaire, Musée Cantonal des Beaux-Arts

Quimper 1950
Gauguin et le groupe de Pont-Aven, Musée des Beaux-Arts de Quimper

Pont-Aven 1953
Commemoration du cinquantenaire de la mort de Paul Gauguin – Exposition d'oeuvres de Paul Gauguin et du Groupe de Pont-Aven, Hôtel de Ville

Houston 1954
Paul Gauguin: His Place in the Meeting of East and West, Museum of Fine Arts of Houston

Edinburgh 1955
Paul Gauguin: Paintings, Sculpture, and Engravings, The Royal Scottish Academy, Edinburgh; The Tate Gallery, London

Oslo 1955
Paul Gauguin, Kunstnerforbundet

Palm Beach 1956
Paul Gauguin, The Society of the Four Arts

New York 1956
Gauguin, Wildenstein and Company

Copenhagen 1956
Gauguin og hans Venner, Winkel & Magnussen

Brussels 1958
Cinquante ans d'art moderne, Exposition universelle et internationale, Palais International des Beaux-Arts

Chicago 1959
Gauguin, The Art Institute of Chicago; The Metropolitan Museum of Art, New York

Paris 1960
Cent oeuvres de Gauguin, Galerie Charpentier

Munich 1960
Paul Gauguin, Haus der Kunst

Vienna 1960
Paul Gauguin, Osterreichische Galerie im Oberen Belvedere

Paris 1960-61
Les Sources du XX^e siècle: Les arts en Europe de 1884 à 1914, Musée National d'Art Moderne

London 1966
Gauguin and the Pont-Aven Group, The Tate Gallery

Zürich 1966
Gauguin und sein Kreis in der Bretagne, Kunsthaus

New York 1966
Gauguin and the Decorative Style, Solomon R. Guggenheim Museum

Philadelphia 1969
Gauguin and Exotic Art, University Museum, University of Pennsylvania

Stockholm 1970
Gauguin i Söderhavet, Etnografiska Museet, Nationalmuseum

London 1972
French Symbolist Painters: Moreau, Puvis de Chavannes, Redon and Their Followers, Hayward Gallery; Walker Art Gallery, Liverpool

San Diego 1973
Dimensions of Polynesia, Fine Arts Gallery of San Diego

Philadelphia 1973
Gauguin: Monotypes, Philadelphia Museum of Art

Paris 1976
Ernest Chaplet, Musée des Arts Décoratifs

Paris 1978
De Renoir à Matisse: 22 Chefs-d'oeuvre des musées soviétiques et français, Grand Palais

London 1979
Post-Impressionism: Cross Currents in European Painting, Royal Academy of Arts

Washington, D.C. 1980
Post-Impressionism: Cross-Currents in European and American Painting, 1880-1906, National Gallery of Art

Toronto 1981
Vincent van Gogh and the Birth of Cloisonism, Art Gallery of Ontario, Toronto; Rijksmuseum Vincent van Gogh, Amsterdam

Paris 1981
Gauguin et les chefs-d'oeuvre de l'Ordrupgaard de Copenhagen, Musée Marmottan

Toronto 1981-1982
Gauguin to Moore: Primitivism in Modern Sculpture, Art Gallery of Ontario

Humlebaek 1982
Gauguin pa Tahiti, Louisiana Museum Humlebaek, Denmark

Los Angeles 1984
A Day in the Country: Impressionism and the French Landscape, Los Angeles County Museum of Art; The Art Institute of Chicago; Réunion des Musées Nationaux, Paris

New York 1984-1985
Primitivism in 20th-Century Art, Museum of Modern Art; Detroit Institute of Arts; Dallas Museum of Art

Copenhagen 1984
Gauguin and van Gogh in Copenhagen in 1893, Ordrupgaard

Copenhagen 1985
Gauguin og Denmark, Ny Carlsberg Glyptotek

Stuttgart 1985
Die Musik in der Kunst des 20. Jahrhunderts, Staatsgalerie

Saint-Germain-en-Laye 1985
Le Chemin de Gauguin: Genèse et rayonnement, Musée départemental du Prieuré 2d rev. ed. of the catalogue: Saint-Germain-en-Laye 1986

Paris 1986
La sculpture française au XIXᵉ siècle, Galeries Nationales du Grand Palais

Tokyo 1987
Paul Gauguin, The National Museum of Modern Art, Tokyo; Aichi Prefectural Art Gallery

Cleveland 1987
Impressionist and Post-Impressionist Masterpieces: The Courtauld Collection, The Cleveland Museum of Art; The Metropolitan Museum of Art, New York; The Kimbell Art Museum, Fort Worth; The Art Institute of Chicago; The Nelson-Atkins Museum of Art, Kansas City

Paris 1988
Les Demoiselles d'Avignon, Musée Picasso

512

Writings by Paul Gauguin

Articles published during the artist's lifetime

Gauguin 1889a
"Notes sur l'art à l'Exposition Universelle," Parts 1 and 2, *Le Moderniste* (4 and 13 July 1889), 84-86 and 90-91.

Gauguin 1889b
"Qui trompe-t-on ici?" *Le Moderniste* (21 September 1889), 170-171.

Gauguin 1894a
"Natures mortes," *Essais d'art libre,* 4 (January 1894), 273-275; reprinted in *Essais d'art libre* (Geneva, 1971).

Gauguin 1894b
"Exposition de la Libre Esthétique," *Essais d'art libre,* 5 (February-April 1894), 30-32; reprinted in *Essais d'art libre* (Geneva, 1971).

Gauguin 1894c
"Sous deux latitudes, *Essais d'art libre,* 5 (May 1894), 75-80; reprinted in *Essais d'art libre* (Geneva, 1971).

Gauguin 1894d
"Lettre de Paul Gauguin," *Journal des artistes,* no. 46 (18 November 1894), 818.

Gauguin 1895a
"Armand Séguin," *Mercure de France,* 13, no. 62 (February 1895), 222-224. Preface to the exhibition of new works by Armand Séguin at the Galerie Le Barc de Boutteville.

Gauguin 1895b
"Strindberg contre Monet," *L'Eclair* (16 February 1895), 2.

Gauguin 1895c
"Une lettre de Paul Gauguin à propos de Sèvres et du dernier four," *Le Soir* (23 April 1895), 1.

Gauguin 1895d
"Les peintres français à Berlin," *Le Soir* (1 May 1895), 2.

Guérin 1974
Guérin, Daniel, ed. *Oviri, Ecrits d'un sauvage* (Paris 1974). Contains selections from Gauguin's letters, articles, and manuscripts.

Les Guêpes, 1899-1901, Gauguin's twenty-four articles from this newspaper, are collected in Bengt Danielsson and Patrick O'Reilly, *Gauguin journaliste à Tahiti & ses articles des 'Guêpes'* (Paris, 1966).

Le Sourire, 1899-1900, Gauguin's newspaper circulated in Papeete, *Le Sourire de Paul Gauguin* (Paris, 1952), facs. ed., L.-J. Bouge. This does not include the issue of *Le Sourire* dated, probably incorrectly, "August 1891," Musée du Louvre, Département des Arts Graphiques, RF 28: 844.

Articles published after the artist's death

"Quatre pages inédites de Gauguin," an essay in *Arts* (July-September 1949).

"Huysmans et Redon," an essay in Jean Loize, "Un inédit de Gauguin," *Les Nouvelles Littéraires* (7 May 1953).

"Notes sur Bernard," an essay in Henri Dorra, "Emile Bernard and Paul Gauguin," *Gazette des Beaux-Arts,* 6th ser., 45 (April 1955), 227-260.

Letters

Included here are published volumes that contain letters from Gauguin. One volume of the complete letters of Gauguin has been published by Victor Merlhès, and two additional volumes are forthcoming. The major sources for unpublished letters have been the Danielsson Archives, Papeete, the Loize Archives, Papeari, the Archives of the Getty Center for the History of Art and the Humanities, Los Angeles, Musée du Louvre, Département des Arts Graphiques, and the National Archives, Paris.

Bacou 1960
Bacou, Roseline, and Ari Redon, eds. *Lettres de Gauguin, Gide, Huysmans, Jammes, Mallarmé, Verhaeren . . . à Odilon Redon* (Paris, 1960).

Bernard 1942
Bernard, Emile, *Lettres de Vincent van Gogh, Paul Gauguin, Odilon Redon, Paul Cézanne, Elémir Bourges, Léon Bloy, Guillaume Apollinaire, Joris-Karl Huysmans, Henry de Groux à Emile Bernard* (Brussels, 1942).

Cooper 1983
Cooper, Douglas, ed. *Paul Gauguin: 45 Lettres à Vincent, Théo, et Jo van Gogh* (Gravenhage and Lausanne, 1983). Facsimiles of letters with editor's annotations. Redates letters from Malingue.

Gauguin 1921
Lettres de Gauguin à André Fontainas (Paris, 1921). Introduction by André Fontainas.

Gauguin 1954
Lettres de Paul Gauguin à Emile Bernard, 1888-1891 (Geneva, 1954).

Joly-Segalen 1950
Joly-Segalen, A., ed. *Lettres de Paul Gauguin à Georges-Daniel de Monfreid* (Paris, 1918; rev. ed., Paris, 1950). Introductory essay by Victor Segalen. Revised edition includes the names and passages deleted from the original edition with new appendix and annotations by Mme A. Joly-Segalen.

Malingue 1949
Malingue, Maurice, ed. *Lettres de Gauguin à sa femme et à ses amis* (Paris, 1946; rev. ed., Paris, 1949). Revised edition includes expanded appendix; some incorrect datings remain. English trans. by Henry J. Stenning (London, 1946).

Merlhès 1984
Merlhès, Victor, ed. *Correspondance de Paul Gauguin* (Paris, 1984). Definitive edition of letters from 1873 through 1888. Also contains important letters written to Gauguin. Two additional volumes are forthcoming.

Rewald 1943
Rewald, John, ed. *Paul Gauguin: Letters to Ambroise Vollard and André Fontainas* (San Francisco, 1943; Engl. trans. by G. Mack). Reprinted in Rewald 1986 (with one additional letter), 168-213.

Rey 1950
See page 505, Bibliography. Contains letters to the Minister of Fine Arts, Paris.

Sérusier 1950
Sérusier, Paul *ABC de la Peinture: Correspondance* (Paris, 1950).

See also *Oeuvres écrites de Gauguin et Van Gogh* [exh. cat., Institut Néerlandais, Paris, 1975].

Published Sketchbooks, arranged alphabetically by editor

Bjurström 1986
Bjurström, Per, *French Drawings: Nineteenth Century* (Stockholm, 1986); includes reproductions of each page from a sketchbook dating from 1877-1887, National-museum, Stockholm.

Cogniat and Rewald 1962
Cogniat, Raymond, and John Rewald, *Paul Gauguin, A Sketchbook* (Paris and New York, 1962); facs. ed. of sketchbook, c. 1884-1888, Armand Hammer Collection, which includes Gauguin's essay from 1885, "Notes synthétiques" (first published as "Notes synthétiques de Paul Gauguin," *Vers et Prose*, 1910, 51-55, with introduction by Henri Mahaut).

Dorival 1954
Bernard Dorival, *Carnet de Tahiti* (Paris, 1954); sketchbook from 1891-1893, now disassembled and dispersed.

Huyghe 1952
René Huyghe, *Le Carnet de Paul Gauguin* (Paris, 1952), sketchbook from 1888, The Israel Museum, Jerusalem.

Unpublished sketchbooks

Album Briant, undated sketchbook [1885-1887], with one Tahitian sketch, Musée du Louvre, Paris, Département des Arts Graphiques, RF30273.

Album Walter, undated sketchbook [1888-1889], Musée du Louvre, Paris, Département des Arts Graphiques, RF30569.

Album RF 29877, undated sketchbook with drawings from 1882 to the Tahitian period, Musée du Louvre, Paris, Département des Arts Graphiques.

Manuscripts

"Ancien Culte Mahorie," manuscript, probably begun late 1893, Musée du Louvre, Département des Arts Graphiques RF 10.755. *Ancien Culte Mahorie*, René Huyghe, ed., facs. ed. (Paris, 1951), includes essay by the editor, "Présentation de l'ancien culte mahorie – la clef de Noa Noa."

"Avant et après," manuscript, 1903, private collection; *Avant et après*, facs. ed. (Leipzig, 1918; reprint, Copenhaghen, 1951; transcription, Paris, 1923). Published in English as *The Intimate Journals of Paul Gauguin* trans. by Van Wyck Brooks; preface by Emil Gauguin (London, 1921).

"Cahier pour Aline," manuscript, begun c. December 1892, Bibliothèque d'art et d'archéologie, Paris, Fondation Jacques Doucet. Includes Gauguin's essay, "Genèse d'un tableau." *Cahier pour Aline*, S. Damiron, ed., facs. ed. with commentary by the editor (Paris, 1963).

"Diverses choses," 1896-1897; manuscript that follows "Noa Noa," Musée du Louvre, Paris, Département des Arts Graphiques; unpublished (except for excerpts in Guérin 1974).

"L'Esprit moderne et le catholicisme," 1902; manuscript, St. Louis Art Museum; first draft, from 1896-1897, included "Diverses choses" as "L'Eglise catholique et les temps modernes." Excerpts and illustrations from 1902 manuscript published by H. S. Leonard, "An Unpublished Manuscript by Paul Gauguin," *Bulletin of the St. Louis Art Museum* 34, no. 3 (Summer 1949), 41-48. Engl. trans., with annotations by Frank Lester Pleadwell, 1927, on file at St. Louis Art Museum.

The following section is arranged according to the order in which the three versions of "Noa Noa," were written.

"Noa Noa," Getty manuscript. Probably begun in October 1893, J. Paul Getty Museum, Malibu. First draft of "Noa

Index of Titles

Noa," unillustrated manuscript in Gauguin's hand, before the collaboration of Charles Morice. *Noa Noa*, Berthe Sagot-le Garrec, ed. (Paris, 1954); first facs. ed. of Getty manuscript. *Paul Gauguin: Noa Noa, Voyage to Tahiti*, Jean Loize, ed. (Oxford, 1961); first English trans. (by Jonathan Griffin) of Getty manuscript; includes essay by Jean Loize, "The Real Noa Noa and the Illustrated Copy." *Noa Noa par Gauguin*, Jean Loize, ed. (Paris, 1966); transcription of Getty manuscript. Includes extensive notes and an essay by the editor. *Noa Noa, Gauguin's Tahiti*, Nicholas Wadley, ed. (London, 1985), Engl. trans. of Getty manuscript (by Jonathan Griffin) with substantial annotations by the editor. *Noa Noa*, Gilles Artur ed. (Papeari and New York, 1987), enlarged facs. ed. of Getty manuscript with illustrations of Louvre manuscript; *Noa Noa*, Pierre Petit, ed. (Paris, 1988), transcription of Getty manuscript.

"Noa Noa," Louvre manuscript, in collaboration with Charles Morice, 1893-1897, Musée du Louvre, Département des Arts Graphiques. In Gauguin's hand with abundant illustrations. "Noa Noa," excerpts in *Les Marges*, no. 21 (May 1910), 169-174. *Noa Noa, Voyage de Tahiti* (Paris, 1924), transcription of Louvre manuscript. *Noa Noa* (Berlin, 1926), and *Noa Noa, Voyage à Tahiti* (Stockholm, 1947) are facs. eds.

"Noa Noa," *La Plume* edition, 1901, in collaboration with Charles Morice. The unillustrated manuscript, in Morice's hand and dated 1897, is in the Morice Archives, Paley Library, Temple University, Philadelphia. "Noa Noa," excerpts published in *Revue Blanche*, 14, no. 105 (15 October 1897), 81-103; no. 106 (1 November 1897), 166-190 (first publication of "Noa Noa" in any form). "Noa Noa," excerpts published in *L'Action humaine* (January 1901). "Noa Noa" excerpts published in *La Plume* (1 May 1901), 294-300. *Noa Noa* (Paris, 1901) definitive "La Plume" edition published as a book. "Noa Noa" excerpts published in *Kunst und Künstler*, 6 (1907), 78-81, 125-127, 160-164. *Noa Noa* (New York, 1919), Engl. trans. by O. F. Theis.

"Racontars de Rapin," manuscript, compiled 1898-1902, Josefowitz Collection, *Racontars de Rapin* (Paris, 1951), transcription of original manuscript.

"Le Texte Wagner," manuscript, 1889, Bibliothèque Nationale Département des Manuscrits, NAF 14903, ff, 43-46; later recopied into "Diverses choses."

"Manuscrit tiré du livre des métiers de Vehbi-Zumbul Zadi," winter 1885-1886, Bibliothèque Nationale, Département des Manuscrits, later recopied into "Diverses choses" and "Avant et après (see Dorra 1984).